Mushrooms

and other fungi of Great Britain and Europe

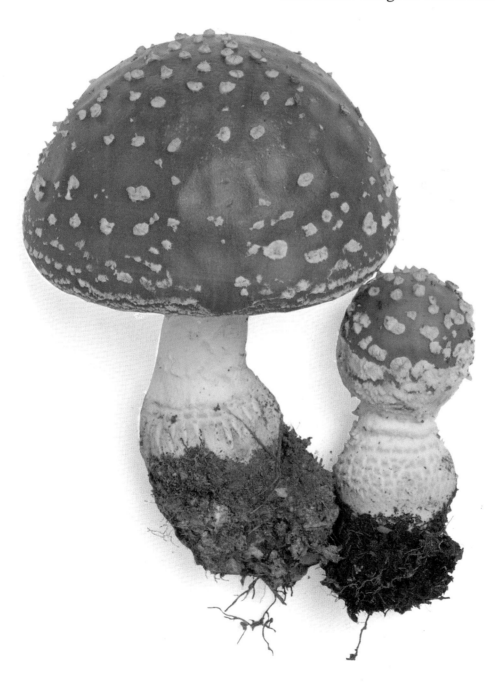

for Nicky Foy

Mushrooms

and other fungi of Great Britain and Europe

by

Roger Phillips

assisted by Lyndsay Shearer

Editor Derek Reid

Russula and Lactarius Editor
Ronald Rayner

A Pan Original

Acknowledgements

To collect the fungi needed to do the 900-odd photographs in this book, I calculate that more than 25,000 actual specimens have passed through my hands. This has only been possible through the help enthusiastically given to me by mycologists in the field. Firstly, I would like to thank Ted Green and Geoffrey Kibby who have given up so much of their time, energy and skill to the project; Brian Spooner for his work determining Ascomycetes; Geoff and Jenny Stone, Malcolm Storey, Audrey Thomas, Irene Palmer and Joyce Pitt also must have a special mention.

Among the others who have helped me in one way or another are: Susan Alnut Dede and Roland, Claire Appleby, Beverley Behrens, Rod Bevan, Bert Brand, Alan Christie, Beverly Clark, Malcolm and Marjorie Clark, Ray Cowell, Jenny Deakin, Vincent Demoulin, R. Evans, Nicky Foy, Sheila Grant, Margaret Holden, F. Bayard Hora, Bruce Ing, Richard Jennings, Paul Kirk, Stephan Koepf, Joy Langridge, Alan Lucas, Marie Mann, Jack Marriott, A. Newton, Mary Oubridge, John Palmer, Bobby Phillips, Cathy Phillips, Ian Phillips, Simon Plant, Mervyn Rayner, Martyn Rix, George Taylor, Shimon Tzabor, Roy Watling, Jo Weightman, John and Jean Williams, Mike and Jean Woolner.

Geoffrey Kibbey for the photograph of *Cortinarius violaceus* (p.133) and Alan and Patie Outen for the photograph of *Serpula lacrymans* (p.238). Kate Penoyre gave me an enormous amount of help with the layout. I am also grateful to the following organisations:

The Royal Botanic Gardens, Kew
The British Mycological Society
The British Museum (Natural History)
The Royal Botanic Gardens, Edinburgh
The Nature Conservancy Council
The Mushroom Growers Association
The Darwin Museum, Royal College of Surgeons

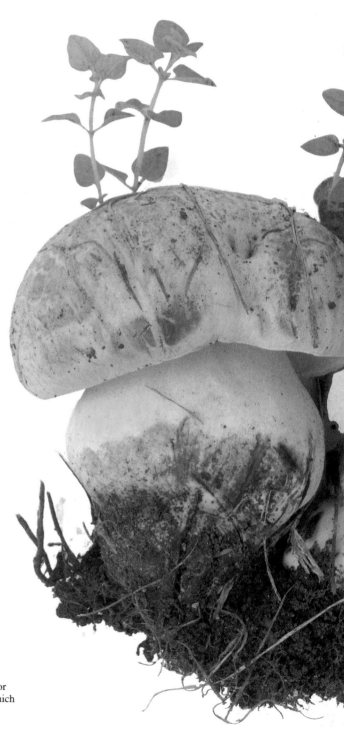

The author and publishers believe the information contained in this book to be correct and accurate at the time of going to press. It is essential to be sure of the identification of a mushroom before cooking and eating it. If in doubt, don't. Neither the author nor the publishers can accept any legal responsibility or liability for any errors or omissions that may be made.

First published 1981 by Pan Books Ltd,
Cavaye Place, London SW10 9PG
11 13 15 17 19 18 16 14 12 10
Text © Roger Phillips 1981
Illustrations © Roger Phillips 1981
ISBN 0 330 26441 9

Photoset by Parker Typesetting Service, Leicester

Printed in Italy by New Interlitho S.p.A. - Milan

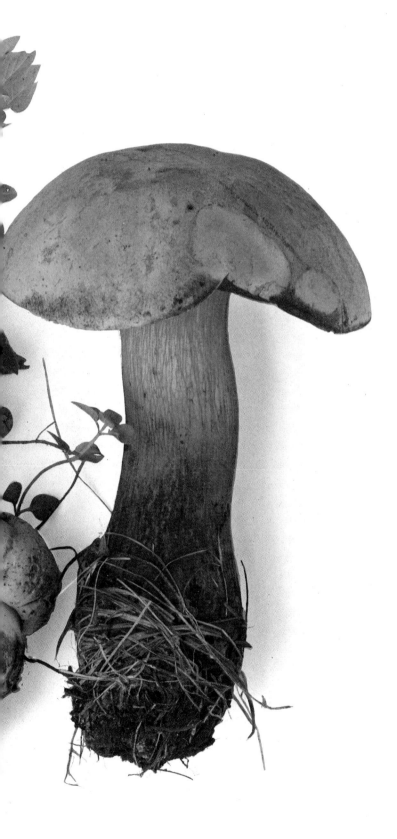

Contents

Introduction

Mushrooms have become an obsession with me. In fact, after the work I have done on them over the last five years, I think I am qualified to call myself a fully fledged 'mushroom maniac'.

As a child I lived with my grandparents on their farm near Sarrat. In the autumn, the most exciting activity was mushroom collecting. I remember one year when we picked seventy pounds in a single day. My grandmother, however, would only allow us to eat the ordinary field mushrooms and she instructed me at great length in the dangers of even touching any other kind. This traditional fear that the British have of mushrooms is very deeply felt and tenaciously stuck to. Why?

In his revised introduction to *The Greek Myths*, Robert Graves discussed the use of hallucinogenic mushrooms in religious ceremony. Is the British attitude a deeply ingrained tradition from Druidic times that mushrooms contain magical properties and may only be eaten under the control of the Druids themselves?

Far-fetched? Perhaps, but it needs a weird theory to explain our fears when you think how the nations that surround us relish eating fungi of diverse kinds.

My first consideration in doing this book has been to produce as many illustrations as possible from the very large number of fungi to be found in Britain. In each photograph I have attempted, when I could find the species in sufficient quantity, to show all the salient aspects: the varieties of colour, size, age and details of stem and gills. The 914 species illustrated represent every fungus I, and all the mycologists who have helped me, have been able to find and identify over the last five years, excepting only those too old, damaged or incomplete to include.

Although the primary aim of this book is to be a visual guide, it is always important when trying to identify a specimen to check aspects that cannot be seen: the taste, smell, habitat and so on; and for those who wish to pursue their study in greater depth I have also incorporated information on the microscopy.

There are somewhere in the region of three thousand larger fungi to be found in the British Isles and the task of producing a complete set of photographs is impossible! For example, my photograph of *Lentaria delicata* (p.260) shows a fungus which has apparently not been collected since Fries described it in 1821. Then again, I made a collection of a small mushroom on the burnt heath near Wisley, which I found impossible to identify. However, after much study, Dr Derek Reid at Kew eventually came to the conclusion that it was a new species. This he has written up and sent for scientific publication in the *Mycological Society Bulletin* and he has done me the honour of naming it *Galerina phillipsii* (p.157).

All this serves to demonstrate that there is still much work to be done in illustrating our fungi, and one day, in the distant future, perhaps I shall produce a second volume.

What is a mushroom?

A mushroom, or indeed any fungus, is only the reproductive part of the organism (known as the fruit body), which develops to form and distribute the spores.

Fungi are a very large class of organisms which have a structure that can be compared to plants, but they lack chlorophyll and are thus unable to build up the carbon compounds essential to life. In fact, in the same way that animals do, they draw their sustenance ready-made from living or dead plants or even animals.

A fungus is made up entirely of minute, hair-like filaments called hyphae. The hyphae develop into a fine, cobweb-like net and grow through the material from which the fungus obtains its nutrition. This is known as the mycelium. Mycelium is extremely fine and, in most cases, cannot be seen without the aid of a microscope. In other cases, the hyphae bind together to make a thicker mat which can readily be observed.

To produce a fruiting body, two mycelia of the same species band together in the equivalent of a sexual stage. Then if the conditions of nutrition, humidity, temperature and light are met, a fruit body will be formed.

The larger fungi are divided into two distinct groups:

(i) The spore droppers, Basidiomycetes (pp.15–264). In this group the spores are developed on the outside of a series of specialized, club-shaped cells (basidia). As they mature, they fall from the basidia and are normally distributed by wind. Most of the fungi in this book are of this kind, including the gilled agarics, the boletes, the polypores and the jelly fungi.

(ii) The spore shooters, Ascomycetes or 'Ascos' (pp.264–281). The spores in this group are formed within club- or flask-shaped sacs (asci). When the spores have matured, they are shot out through the tip of the ascus. The morels, cup fungi and truffles are in this group.

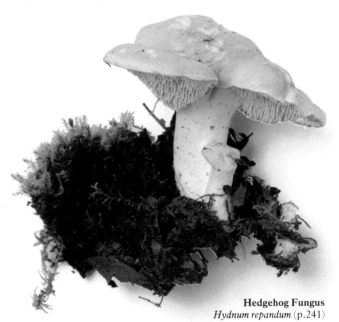

Hedgehog Fungus
Hydnum repandum (p.241)

How to use the book

Mushrooms and fungi are a large and very diverse group of organisms, and although this book only deals with the larger forms, there is nevertheless a bewildering selection to choose from. When you have leafed through the pages and got a general feel for the diversity of species that are illustrated, the next step in making an identification is to refer to the lists and keys (i–v) below:

(i) *The poisonous species* (p.7). This is a short list of the main deadly poisonous species. Anyone considering eating wild mushrooms should look up each reference and learn to recognize those mentioned.

(ii) *The edible species* (p.8). This is a list of the most common and important edible types.

(iii) *The very common species* (p.8). This is a list of the nineteen most common species recorded in Britain.

(iv) *The visual index* (pp.10–12). On these pages examples of the most common genera and species are laid out in the order that they appear in the book. By comparing a specimen you have collected with the visual index, you will get a good idea which page to turn to.

(v) *The keys* (p.13). These are very basic, dichotomous keys to the main genera of the gilled mushrooms illustrated, designed specifically for the beginner. To consult these keys you will first have to ascertain the spore colour of any specimen.

Collecting

When making a collection it will facilitate identification if you note the salient characteristics of a species in the same order that they are mentioned in the text:

Cap. Note the size in centimetres, the shape, the colours, the texture. Is it smooth or sticky, fibrous or scaly?

Stem. Note the height and width in millimetres, the colours, the presence of a ring, volva, root or basal bulb. (Make sure you get the whole stem out of the ground.)

Flesh. Note the colour, the texture. Is it fibrous or crumbly? Does it exude milk? Check the smell and taste. (To ascertain taste, nibble a little bit and break it up on the tip of your tongue without swallowing it, spit out the remains and completely clear your mouth; if done carefully even the most poisonous species can be tasted in this way, though in practice you will soon learn to recognize and so avoid tasting the main poisonous genera.)

Gills. Note the colour, the shape, the attachment to the stem.

Spores. Note the spore colour. (This can sometimes be observed beneath the cap on the grass or leaves. If this is not the case make a spore print.)

Habitat. Note if it grows on wood, soil or manure. Does it grow in grassland or woodland? Under or near what species of tree or plant? Is the soil chalky or acid?

(i) *Poisonous species*

Amanita phalloides, The Death Cap (p.18), is the most common of the deadly poisonous types. The symptoms occur some time after eating, from about eight hours to two days. There is then an onset of vomiting, diarrhoea, sweating and insatiable thirst, followed by a pale, haggard appearance with cold hands and feet, accompanied by a state of deep anxiety. Death can take up to eight or twelve days and after the first onset of illness there may be a period when the patient feels better. Do not be fooled by this. If you think you have eaten some dangerous mushroom, or if you get strong symptoms, go immediately to a hospital casualty department, taking with you some of the mushroom if possible.

Amanita virosa (p.21) and *Amanita pantherina* (p.18) are also deadly poisonous with similar symptoms to *Amanita phalloides*.

All Inocybes should be avoided: *Inocybe patouillardii* (p.149) has been definitely known to cause death.

Cortinarius speciosissimus (p.134) is a deadly species which has been mistaken for Chanterelle. The onset of illness may be delayed as long as ten days, when the affected person will suffer kidney failure. Modern medicine, with the use of a kidney machine, can save life but there have been many deaths in Europe where the problem was not correctly diagnosed.

Cortinarius orellanus (p.134), very rare in Britain but occasionally found in Europe, has similar symptoms.

Gyromitra esculenta (p.267) has been sold in European markets as an edible species, but in fact, if eaten in quantity or not properly prepared, can be deadly.

Entoloma sinuatum (p.114), *Paxillus involutus* (p.142) and *Amanita muscaria* (p.15) have all had one or more deaths attributed to them.

Agaricus xanthodermus (p.167) although not deadly sometimes causes very severe stomach upsets; it can be confused with the edible field mushrooms.

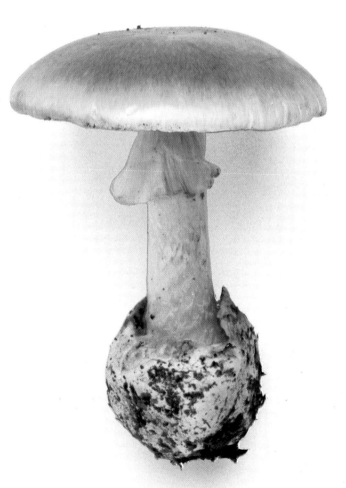

The Death Cap *Amanita phalloides* (p.18)

(ii) *Edible species*

A great many mushrooms and fungi found in Britain are good or very good to eat, although some must be cooked first. Before eating any mushroom that you have found, by far the safest thing is to have the identification confirmed by an expert. The following are the best and most common edible species:

Field Mushroom	*Agaricus campestris* (p.162)
	Boletus badius (p.196)
Cep	*Boletus edulis* (p.192)
Chanterelle	*Cantharellus cibarius* (p.191)
Shaggy Ink Cap	*Coprinus comatus* (p.176)
Horn of Plenty	*Craterellus cornucopioides* (p.191)
Hedgehog Fungus	*Hydnum repandum* (p.241)
Chicken of the Woods	*Laetiporus sulphureus* (p.222)
Giant Puff-ball	*Langermannia gigantea* (p.247)
	Leccinum versipelle (p.211)
Parasol Mushroom	*Lepiota procera* (p.25)
Shaggy Parasol	*Lepiota rhacodes* (p.25)
Field Blewit	*Lepista saeva* (p.114)
Wood Blewit	*Lepista nuda* (p.113)
Fairy Ring Champignon	*Marasmius oreades* (p.66)
Morel	*Morchella esculenta/vulgaris* (p.264)
Oyster Mushroom	*Pleurotus ostreatus* (p.182)
Cauliflower Fungus	*Sparassis crispa* (p.255)
	Tricholoma flavovirens (p.35)
St George's Mushroom	
	Tricholoma gambosum (p.41)
Truffle	
	Tuber aestivum (p.279)

(iii) *Very common species*

To help the newcomer to the fungus hunt, I have drawn out from Ronald Rayner's list of frequencies those that have been recorded as appearing on more than 25% of mushroom forays run by the British Mycological Society. It may be helpful to look up and study each one of those listed, as on every outing you will be sure of finding some from this group.

Amanita rubescens (p.17) 29%
Armillaria mellea (p.33) 31%
Boletus chrysenteron (p.204) 28%
Collybia dryophila (p.54) 26%
Collybia peronata (p.57) 25%
Coriolus versicolor (p.235) 43%
Heterobasidion annosum (p.227) 26%
Hypholoma fasiculare (p.159) 50%
Laccaria laccata (p.52) 36%
Lactarius subdulcis (p.89) 25%
Mycena sanguinolenta (p.70) 25%
Paxillus involutus (p.142) 31%
Phallus impudicus (p.257) 25%
Piptoporus betulinus (p.227) 29%
Pluteus cervinus (p.118) 33%
Russula cyanoxantha (p.97) 32%
Russula nigricans (p.92) 30%
Russula ochroleuca (p.94) 29%
Stereum hirsutum (p.236) 35%

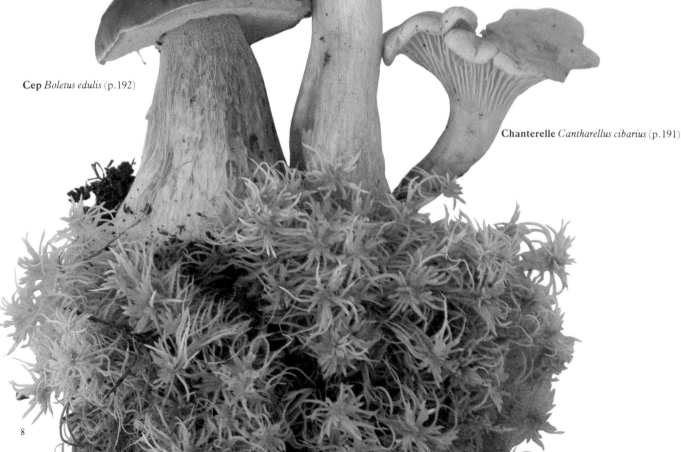

Tricholoma flavovirens (p.35)

Cep *Boletus edulis* (p.192)

Chanterelle *Cantharellus cibarius* (p.191)

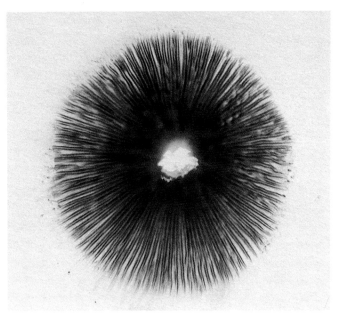

Spore print from *Coprinus domesticus* twice life size

Spore print

Take a fresh, mature cap and lay it on a clean piece of glass.
Cover it by placing an upturned glass over it, which stops it
drying out. In addition, it may be necessary to moisten the
cap with a drop of water. Left overnight, or possibly longer,
you should get a good print. Scrape the spores together with a
razor blade and you will be more easily able to observe the
colours. The spore droppers (Basidiomycetes) will make a
print below the cap you put out. The spore shooters
(Ascomycetes) will make a halo around the cap.
Note, the letters A to H used in the Russula and Lactarius
text refer to the Crawshay (1930) colour code. A full
discussion and comparison of all colour codes can be found in
Rayner, *Key to British Species of Russula*. The letters can be
briefly summed up as signifying: A = pure white, B = very,
very pale cream, C = very pale cream, D = pale cream, E =
yellowish cream, F = yellow cream, G = pastel yellow, H =
yellow ochre.

Determinations

In all cases the specimens and photographs have been
examined by a senior mycologist. The vast majority of this
work was undertaken by Dr Derek Reid and Brian Spooner
at Kew. The Russula and Lactarius species were checked by
Ronald Rayner. The dried material is either deposited in the
Herbarium at Kew or is in my personal collection, or that of
Mr Rayner.

Plant protection

When collecting fungi in the countryside, make sure not to
damage flowering plants. Fungi, however, as they have
generally distributed vast numbers of spores by the time they
are developed enough for you to find them, may be collected
without threat to future populations.

Drying specimens

I have fixed a fine wire mesh 5cm above a radiator. This is an
excellent arrangement as it gives heat and a good flow of air,
the two essentials for quick and effective drying. I have tried
drying in a slow oven with the door open, but I find it difficult
to control the temperature.

Societies

The British Mycological Society is open to all interested in
mycology. If you would like to join as an associate or full
member, write for a proposal form to: Dr N. J. Dix,
Department of Botany, University of Stirling, Scotland. In
the autumn, 'fungus forays' are held on most Saturdays and
Sundays, often in conjunction with a local, natural history
society.

The photographs

The majority have been taken on a Pentax 6×7cm camera
with a Macro lens and extension tubes as needed.
The light source was a Super Fish Fryer powered by 5,000
Joules of strobe flash. The aperture was *f*.32 for the Pentax
and *f*.22 for the Nikon. When travelling great distances, I
sometimes used a 35mm Nikon with two Vivitar LUP-1s. All
the film stock was Kodak Ektachrome 64ASA.

Nomenclature

With a few exceptions, the following works have been followed:
Agarics: *New Check List of British Agarics and Boleti*, R. W. G. Dennis, P. D.
Orton and F. B. Hora (reprint, J. Cramer, W. Germany 1974)
Boletes: *British Fungus Flora 1*, R. Watling (HMSO 1970)
Polypores and Resupinates: *Fungi I & II*, Stanislaw Domanski (photo
reprint, National Technical Information Service, USA)
Hydnums: *The Terrestrial Hydnums of Europe*, R. A. Maas Geesteranus
(North-Holland Publishing Company, Amsterdam 1975)
Clavarias: *Clavaria and Allied Genera*, E. J. H. Corner (1967)
Ascomycetes: *British Ascomycetes*, R. W. G. Dennis (reprint, J. Cramer
1978)

Chemicals

SV sulpho-vanillin: a few crystals of vanilla dissolved in 2ml conc. sulphuric
acid + 2ml distilled water to give a yellow solution. A drop placed on a
Russula stem discolours violet-purplish in most cases or carmine in other
species.
$FeSO_4$ solution or crystal applied to Russula stems may give significant
colour change
Melzer's Reagent: 1.5g iodine, 5g potassium iodide + 100g chloral hydrate
dissolved in 100ml warm distilled water;
amyloid reaction: positive if reagent added to a mass of spores gives a
blue-black colour change;
dextrinoid reaction: positive if the spore mass turns reddish-brown with the
reagent
Ammonia: a 50% aqueous solution
Phenol: a 2% aqueous solution
NaOH or KOH sodium or potassium hydroxide: a 10% aqueous solution

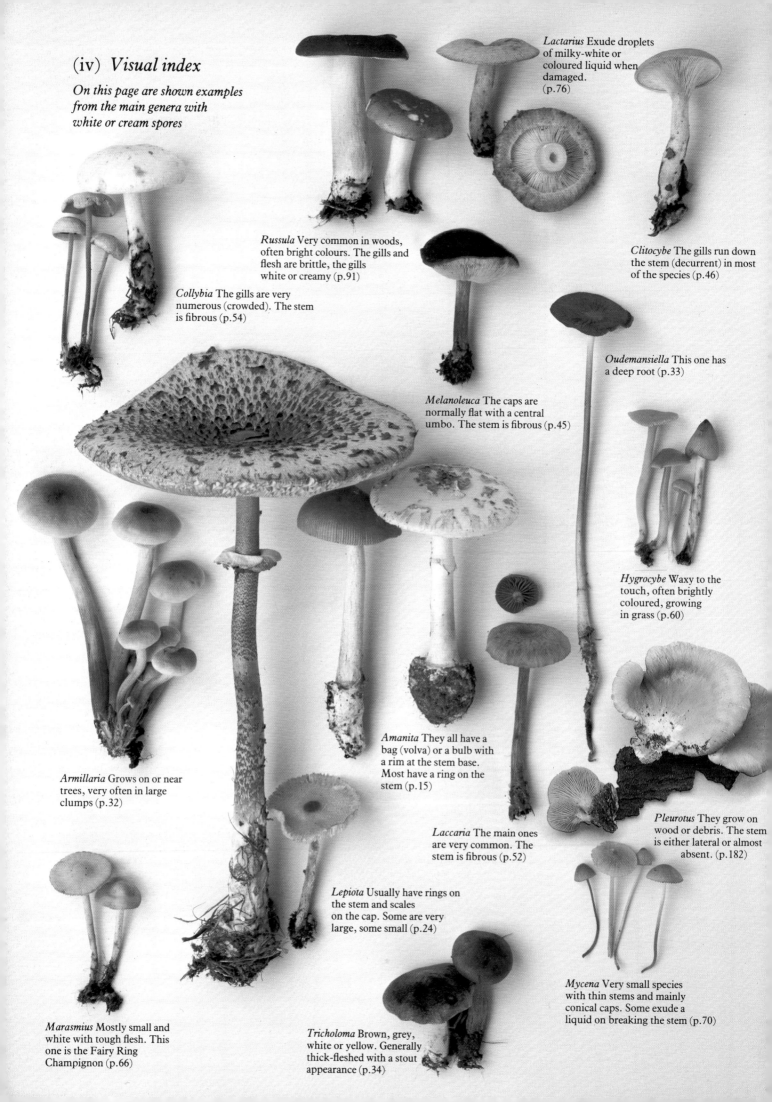

(iv) Visual index

On this page are shown examples from the main genera with white or cream spores

Russula Very common in woods, often bright colours. The gills and flesh are brittle, the gills white or creamy (p.91)

Lactarius Exude droplets of milky-white or coloured liquid when damaged. (p.76)

Clitocybe The gills run down the stem (decurrent) in most of the species (p.46)

Collybia The gills are very numerous (crowded). The stem is fibrous (p.54)

Melanoleuca The caps are normally flat with a central umbo. The stem is fibrous (p.45)

Oudemansiella This one has a deep root (p.33)

Hygrocybe Waxy to the touch, often brightly coloured, growing in grass (p.60)

Amanita They all have a bag (volva) or a bulb with a rim at the stem base. Most have a ring on the stem (p.15)

Armillaria Grows on or near trees, very often in large clumps (p.32)

Laccaria The main ones are very common. The stem is fibrous (p.52)

Pleurotus They grow on wood or debris. The stem is either lateral or almost absent. (p.182)

Lepiota Usually have rings on the stem and scales on the cap. Some are very large, some small (p.24)

Mycena Very small species with thin stems and mainly conical caps. Some exude a liquid on breaking the stem (p.70)

Marasmius Mostly small and white with tough flesh. This one is the Fairy Ring Champignon (p.66)

Tricholoma Brown, grey, white or yellow. Generally thick-fleshed with a stout appearance (p.34)

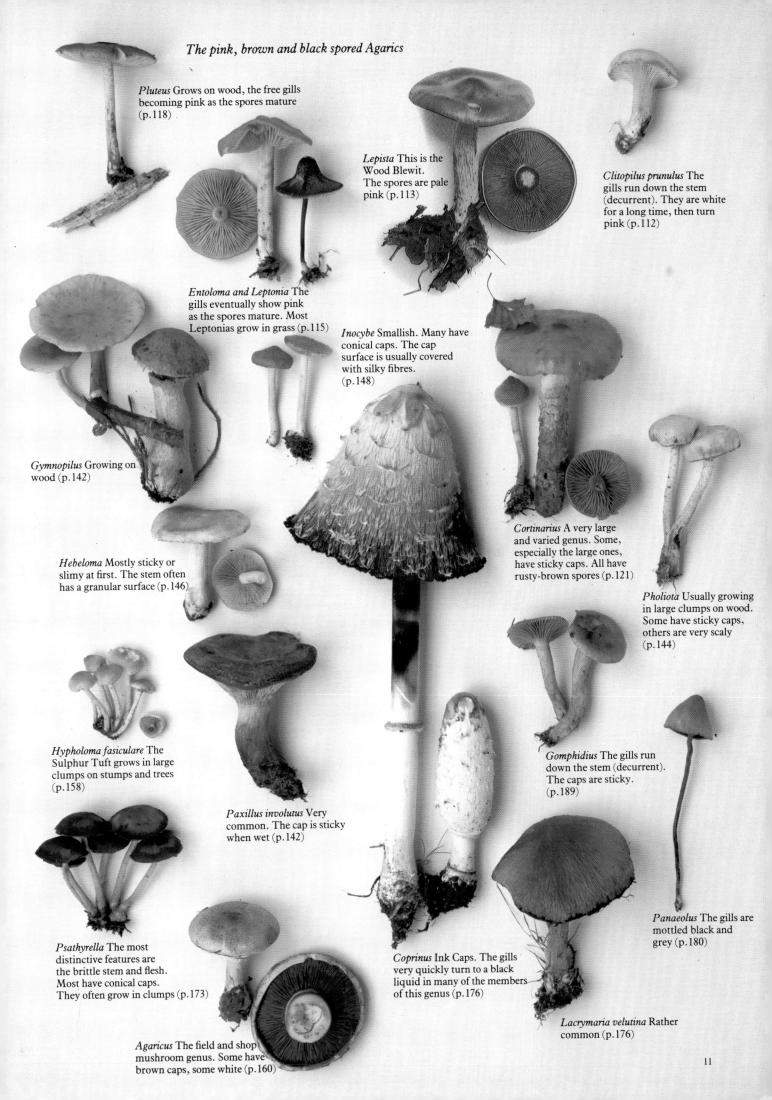

The pink, brown and black spored Agarics

Pluteus Grows on wood, the free gills becoming pink as the spores mature (p.118)

Lepista This is the Wood Blewit. The spores are pale pink (p.113)

Clitopilus prunulus The gills run down the stem (decurrent). They are white for a long time, then turn pink (p.112)

Entoloma and Leptonia The gills eventually show pink as the spores mature. Most Leptonias grow in grass (p.115)

Inocybe Smallish. Many have conical caps. The cap surface is usually covered with silky fibres. (p.148)

Gymnopilus Growing on wood (p.142)

Cortinarius A very large and varied genus. Some, especially the large ones, have sticky caps. All have rusty-brown spores (p.121)

Hebeloma Mostly sticky or slimy at first. The stem often has a granular surface (p.146)

Pholiota Usually growing in large clumps on wood. Some have sticky caps, others are very scaly (p.144)

Hypholoma fasiculare The Sulphur Tuft grows in large clumps on stumps and trees (p.158)

Gomphidius The gills run down the stem (decurrent). The caps are sticky. (p.189)

Paxillus involutus Very common. The cap is sticky when wet (p.142)

Psathyrella The most distinctive features are the brittle stem and flesh. Most have conical caps. They often grow in clumps (p.173)

Coprinus Ink Caps. The gills very quickly turn to a black liquid in many of the members of this genus (p.176)

Panaeolus The gills are mottled black and grey (p.180)

Agaricus The field and shop mushroom genus. Some have brown caps, some white (p.160)

Lacrymaria velutina Rather common (p.176)

11

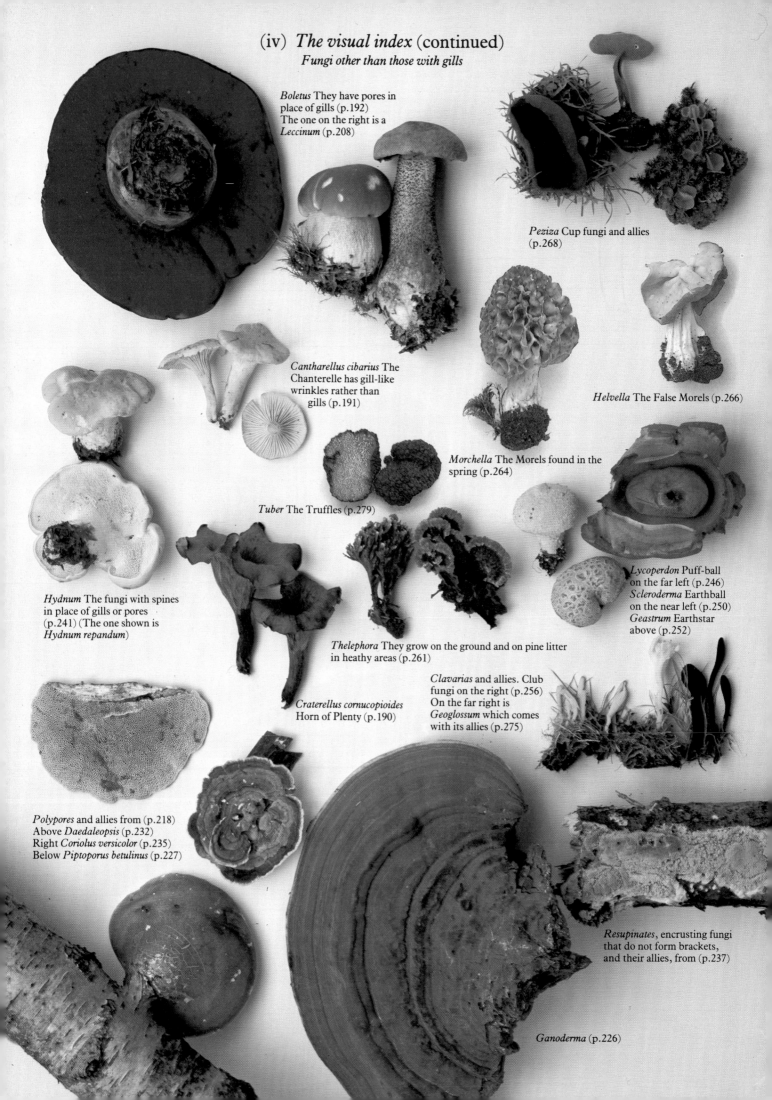

Boletus They have pores in place of gills (p.192) The one on the right is a *Leccinum* (p.208)

Peziza Cup fungi and allies (p.268)

Cantharellus cibarius The Chanterelle has gill-like wrinkles rather than gills (p.191)

Helvella The False Morels (p.266)

Morchella The Morels found in the spring (p.264)

Tuber The Truffles (p.279)

Lycoperdon Puff-ball on the far left (p.246) *Scleroderma* Earthball on the near left (p.250) *Geastrum* Earthstar above (p.252)

Hydnum The fungi with spines in place of gills or pores (p.241) (The one shown is *Hydnum repandum*)

Thelephora They grow on the ground and on pine litter in heathy areas (p.261)

Clavarias and allies. Club fungi on the right (p.256) On the far right is *Geoglossum* which comes with its allies (p.275)

Craterellus cornucopioides Horn of Plenty (p.190)

Polypores and allies from (p.218) Above *Daedaleopsis* (p.232) Right *Coriolus versicolor* (p.235) Below *Piptoporus betulinus* (p.227)

Resupinates, encrusting fungi that do not form brackets, and their allies, from (p.237)

Ganoderma (p.226)

(v) *The keys*

The gilled mushrooms (agarics) with central stems that are illustrated have been divided into four separate keys to genera: (A) white, cream and yellow spored, (B) pink spored, (C) ochre to brown spored, (D) purple-brown to black spored. The mushrooms that either have a stem which grows laterally from the cap or only a rudimentary stem are on pp.182–8. The spore colours in this group are mixed.

KEY A Mushrooms with gills, a central stem and spores white, cream or yellowish

1 With volva or hoop-like remains on stem base *Amanita* (pp.15–23)
1 Without volva 2

2 Stem with ring (a) *Lepiota* (most) and allies (pp.24–31)
 (b) Cap very slimy *Oudemansiella mucida* (p.33)
 (c) Usually in clumps *Armillaria mellea* (p.32)
 (d) *Tricholoma cingulatum* (p.34)
2 Stem without ring 3

3 Exudes milk when damaged
 (a) Large to average types *Lactarius* (pp.76–90)
 (b) Small with narrow stems *Mycena* (part) (p.71)
3 Not exuding milk 4

4 Cap and stem brittle, crumbly, average to large size *Russula* (pp.91–111)
4 Not brittle or crumbly 5

5 Growing on the remains of other mushrooms (a) *Asterophora* (p.76)
 (b) *Collybia tuberosa* (p.56)
5 Not growing on mushroom remains 6

6 Small (usually under 3cm across cap)
 (a) On pine cones *Pseudohiatula* (p.76) and *Baeospora* (p.69)
 (b) Gills decurrent *Omphalina* (p.69)
 (c) Caps conical, stems tall and narrow *Mycena* (pp.70–76)
 (d) Stems tough, cartilaginous *Marasmius* (pp.66–8)
 (e) *Lepiota* (part) (pp.29–30)
6 Larger (over 3cm across cap) 7

7 Gills decurrent
 (a) Gills thick, waxy *Hygrocybe* and *Hygrophorus* (pp.58–65)
 (b) Gills just shallow wrinkles *Cantharellus* group (pp.190–91)
 (c) Gills very blunt, forking *Hygrophoropsis aurantiaca* (p.66)
 (d) Gills thin, crowded *Clitocybe* and allies (pp.46–51)
7 Gills not decurrent 8

8 With deep tap root *Oudemansiella radicata* (p.33)
8 No tap root 9

9 Stems cartilaginous *Collybia* and allies (pp.54–8)
9 Stems not cartilaginous 10

10 Gills thick, waxy *Hygrocybe* (part) (p.60)
10 Gills not thick, waxy 11

11 Growing in clumps, stems fused at base (a) *Armillaria tabescens* (p.32)
 (b) *Flammulina velutipes* (p.58)
 (c) *Lyophyllum* (part) (p.42)
11 Not in clumps *Tricholoma* and allies (pp.34–46)
 also *Leucocortinarius bulbiger* (p.123)

KEY B Mushrooms with gills, a central stem and spores pink

1 With a volva at stem base *Volvariella* (p.112)
1 Without volva 2

2 Gills decurrent *Clitopilus* (p.112)
2 Gills not decurrent 3

3 Growing on wood (a) Cap cuticle thick and rubbery *Rhodotus* (p.187)
 (b) Small, blue-coloured *Leptonia euchroa* (p.117)
 (c) *Pluteus* (pp.118–20)
3 Not growing on wood 4

4 Mature gills salmon pink
 (a) Gills free *Pluteus* (pp.118–20)
 (b) Gills attached *Enteloma* and allies (pp.114–18)
4 Mature gills not pink *Lepista* (pp.113–14)

KEY C Mushrooms with gills, a central stem and spores ochre to rust brown

1 Spores dull ochre to brown, never rust-brown 2
1 Spores rust 3

2 Stem with a ring (a) Stem with tap root *Hebeloma radicosum* (p.147)
 (b) Without tap root *Agrocybe* (pp.169–70)
 (c) With sphagnum *Pholiota myosotis* (p.146)
2 Stem without a ring
 (a) Cap fibrous, silky or scaly, often conical *Inocybe* (pp.148–54)
 (b) Cap often sticky *Hebeloma* (pp.146–7)

3 Stems very tall and slender, cap conical (a) *Bolbitius vitellinus* (p.154)
 (b) *Conocybe* (p.155)
 (c) *Galerina* (part) (pp.156–7)
3 Stems shorter, more robust 4

4 Cap margin inrolled, gill decurrent *Paxillus involutus* (p.142)
4 Cap margin not inrolled, gills not decurrent 5

5 On wood, wood debris or burnt ground (a) *Galerina* (part) (p.156)
 (b) *Gymnopilus* (pp.142–4)
 (c) *Pholiota* (pp.144–6)
5 Not on wood, wood debris or burnt ground 6

6 Medium to large types (caps over 3cm across)
 (a) *Rozites caperatus* (p.141)
 (b) *Cortinarius* (most) (pp.121–41)
6 Small (cap usually under 3cm across) (c) *Naucoria* and allies (pp.157–8)
 (d) *Cortinarius* (a few) (pp.121–41)

KEY D Mushrooms with gills, a central stem and spores purple-brown to black

1 Cap turns to black slime (deliquesces)
 (a) *Coprinus* (most) (pp.176–81)
 (b) Weeping black slime *Lacrymaria* (p.176)
1 Not deliquescing 2

2 Cap and stem very brittle/fragile *Psathyrella* (p.172–5)
2 Not very brittle/fragile 3

3 Gills mottled, cap smooth *Panaeolus* (p.180–82)
3 Gills not mottled 4

4 Gills very decurrent *Gomphidius* and *Chroogomphus* (pp.189–90)
4 Not so 5

5 With a persistent ring, gills free *Agaricus* (pp.160–69)
5 Without persistent ring but some with veil remnants on the stem, gills attached
 (a) Spores blackish *Lacrymaria* and *Coprinus* (pp.176–81)
 (b) Spores purple brown *Hypholoma* (pp.158–60)
 also *Stropharia* and allies (pp.171–3)

Glossary

adnate (of gills) connected to stem by whole depth of gill, e.g. *Stropharia aeruginosa* (p.171)

adnexed (of gills) connected to stem by part of the depth of the gill

adpressed closely flattened onto surface

agaric general term for a fungus with gills

amyloid turning blue-black in iodine solutions such as Melzer's reagent (see Chemicals p.9)

appendiculate fringed with remains of the veil, e.g. *Lacrymaria velutina* (p.176)

Ascomycetes one of the major groups in fungi containing all those producing spores in asci which are liberated by pressure

ascospores reproductive cell of the Ascomycetes

ascus (plural **asci**) elongated cell in which ascospores are produced

basidia club-shaped cells on which spores are produced in Basidiomycetes

Basidiomycetes a major and very diverse group of fungi, including gill fungi, boletes, polypores, clavarias, jelly fungi and Gasteromycetes, characterized by the presence of basidia

basidiospore reproductive cell of the Basidiomycetes

binding hyphae much-branched, thick-walled hyphae without dividing cell walls which bind other hyphae together

bulb abrupt swelling at stem base

bulbous swollen into a bulb, e.g. *Cortinarius auroturbinatus* (p.123)

caespitose joined in tufts, e.g. *Hypholoma fasiculare* (p.158)

campanulate bell-shaped, e.g. *Conocybe lactea* (p.155)

capillitium mass of sterile thread-like fibres among the spores in the Gasteromycetes which may aid spore dispersal

capitate with a round head

cheilocystidia cystidia on the gill edge

chlamydospore a thick-walled, non-deciduous spore

chrysocystidia cystidia with granular contents which turn yellowish in alkali solutions

clamp connection a hyphal outgrowth connecting the two adjoining cells resulting from a cell division bypassing the dividing cell wall and apparently involved in the movement of nuclei

clavate club-like, e.g. *Clitocybe clavipes* (p.49)

coralloid much-branched, coral-like

cortina (adjective **cortinate**) web-like covering running between stem and cap edge enclosing the gills, e.g. *Cortinarius auroturbinatus* (p.123)

cortinal zone faint remnant of cortina on stem

crescentric crescent-like in form

cystidiole a sterile cell protruding beyond the spore-bearing surface

cystidium (plural **cystidia**) sterile cell, variable in shape, occurring between basidia in the spore-bearing surface, or in other parts of the fruit body

decurrent (of gills) running down the stem, e.g. *Clitocybe infundibuliformis* (p.49)

decurrent tooth (of gill) where only the narrow end portion of the gill runs down the stem

dendroid tree-like

dendrophyses irregularly-branched cystidia

dermatocystidia cystidia on the cap surface

dextrinoid turning reddish-brown with iodine solutions such as Melzer's (Chemicals, p.9)

dichotomously (branched) branching repeatedly in two

dimitic having two kinds of hyphae

emarginate (of gills) see **sinuate**

excentric off-centred

fibril a small fibre

fibrillose covered with small fibres

filiform thread-like

fimbriate fringed

flexuose, flexuous undulating

floccose cottony, covered with cottony tufts

free (of gills) not connected to stem, e.g. *Amanita muscaria* (p.15)

fugacious short-lived, fleeting

fusiform spindle-shaped, narrowing at both ends

fusoid somewhat spindle-shaped

Gasteromycetes a large, diverse group within the Basidiomycetes characterized by the basidiospores maturing within the fruit body; includes puff-balls, earth stars, stinkhorns and birds-nest fungi

generative hyphae thin-walled, branched hyphae with dividing cell walls, giving rise to other types of hyphae, e.g. binding hyphae

germ-pore a differentiated area in a spore wall which may give rise to a germination tube

glabrous smooth, hairless

gleba fleshy mycelial tissue which contains the spore-bearing cavities present in Gasteromycetes

gloeocystidia thin-walled cystidia with refractive, frequently granular contents

granulate covered with tiny particles

hyaline translucent or transparent, colourless

hygrophanous becoming darker coloured and appearing water-soaked when wet, drying paler

hymeniform resembling a hymenium but lacking functional basidia

hymenium spore-bearing surface

hypha (plural **hyphae**) a single filament, the basic unit forming the fungus (adjective **hyphal**)

immarginate without a distinct edge

infundibuliform funnel-shaped

innate inseparable, bedded in

intercalary between two cells

iodoform a crystalline compound of iodine, used as an antiseptic, with a distinctive smell (iodine)

lageniform shaped like a narrow-necked flask

lanceolate elongate and tapering towards both ends

marginate (bulb) having a well-defined edge, e.g. *Cortinarius amoenolens* (p.124)

milk a milky, usually white juice exuded by the gills of Lactarius species when cut or broken

monomitic having only one kind of hyphae

mucronate with a short, sharp point

mycelium (plural **mycelia**) vegetative stage of a fungus comprising a thread-like to felt-like mass

palmate having lobes radiating from a central point, like fingers on a hand

papillate having a small, nipple-like protuberance

paraphyses sterile hyphal filaments interspersed between the asci

partial veil see **veil**

pedicel a small stalk

pellicle a detachable skin-like cuticle

peridioles pea-shaped structures containing the spores

perithecia flask-shaped spore-producing chambers found in the Pyrenomycetes group of Ascomycetes

pleurocystidia cystidia on gill sides

pore (of polypores) the mouth of a tube

pruinose having a flour-like dusting

punctate minutely dotted or pitted

pyriform pear-shaped

recurved bent back

reflexed turned sharply back or up

resupinate lying flat on the substrate, with the spore-producing layer outwards

rhizoid root-like structure

rhizomorph cord-like structure comprising a mass of hyphae

ring remains of partial veil, only present in some Agarics (see **partial veil**)

ring zone faint mark where ring has been

saccate bag-like

sclerotium (plural **sclerotia**) firm, rounded mass of hyphae, often giving rise to a fruit body

scurfy surface covered with tiny flakes or scales

septate divided by cell walls

septum (plural **septa**) a dividing cell wall

sessile without a stem

seta (plural **setae**) a stiff hair or bristle

sinuate (of gills) = **emarginate** notched just before joining the stem, e.g. *Hebeloma crustuliniforme* (p.147)

sphaerocyst a globose cell

sphaeropedunculate a cystidium swollen spherically at the tip and tapered into an elongated stalk

spinulose finely spiny

spore general term for the reproductive unit of a fungus, usually consisting of a single cell which may germinate to produce a hypha from which a new mycelium arises (see **ascospore**, **basidiospore**)

spore print deposit of spores falling from a cap placed gills or pores downwards on a sheet of paper or glass

sporulating producing spores

squamule a small scale

stellate star-like

striate with fine lines

sub- (prefix) not quite, somewhat, e.g. subglobose, almost spherical

sub lente (literally under a lens) observed through a magnifying lens

sulcate grooved

tomentum thick matted covering of soft hairs (adjective **tomentose**)

trimitic having three kinds of hyphae

tuberculate with small wart-like nodules

tubes spore-producing layer in certain fungi, e.g. *Boletus pinicola* (p.194)

umbo a central hump on a cap like a shield boss

umbonate having an umbo

universal veil see **veil**

utriform bag- or bladder-like

veil protective tissue enclosing the developing fruit body; **universal veil** encloses the whole developing fruit body, **partial veil** (of agarics and certain boletes) joins the edge of the cap to the stem enclosing the developing spore-producing surface and in some genera later forming the ring or cortina (adjective **velar**)

ventricose inflated or swollen

vermiform worm-like

verrucose with small rounded warts

vesicle small bladder-like sac (adjective **vesicular**)

vesiculose formed of vesicles

vinaceous wine-coloured

volva cup-like bag enclosing stem base in some agarics, the remains of the universal veil

μ (mu) a micron, 1μ=0.001 millimetre (one-thousandth of a millimetre)

AMANITA *Look out for the volva at the base of the stem, this may be large and bag-like or only showing as a rim on the bulb. Always make sure to collect the whole stem from under the ground so the volva can be seen; some have rings on the stem, some don't. Some Amanitas have distinctive smells. Until you have had identifications double-checked do not eat any of them or you may die. Twenty-four in Britain.*

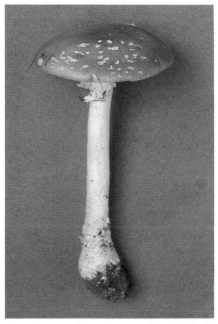

Amanita muscaria an orange specimen ½ life size

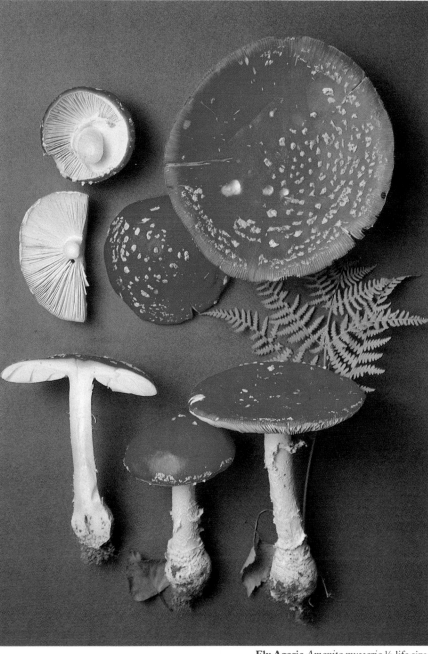

Fly Agaric *Amanita muscaria* ½ life size

Fly Agaric *Amanita muscaria* (L. ex Fr.) Hooker **Cap** 8–20cm across, globose or hemispherical at first then flattening, bright scarlet covered with distinctive white pyramidal warts which may be washed off by rain leaving the cap almost smooth and the colour faded. **Stem** 80–180×10–20mm, white, often covered in shaggy volval remnants as is the bulbous base, the white membranous ring attached to the stem apex sometimes becoming flushed yellow from the pigment washed below the cap cuticle. **Flesh** white, tinged red or yellow below the cap cuticle. Taste pleasant, smell faint. **Gills** free, white. Spore print white. Spores broadly ovate, nonamyloid, 9.5–10.5×7–8μ. Habitat with birch trees. Season late summer to late autumn. Common. **Poisonous**.

This is one of the easiest species to recognize and describe, and consequently its properties have been well documented for centuries. The common name Fly Agaric comes from the practice of breaking the cap into platefuls of milk, used since medieval times to stupefy flies. It is a strong hallucinogen and intoxicant and is used as such by the Lapps. In such cases the cap is dried and swallowed without chewing. The symptoms begin twenty minutes to two hours after ingestion. The central nervous system is affected and the muscles of the intoxicated person start to pull and twitch convulsively, followed by dizziness and a death-like sleep. During this stage the mushrooms are often vomited but nevertheless the drunkenness and stupor continue. While in this state of stupor, the person experiences vivid visions and on waking is usually filled with elation and is physically very active. This is due to the nerves being highly stimulated, the slightest effort of will producing exaggerated physical effects, e.g. the intoxicated person will make a gigantic leap to clear the smallest obstacle. The Lapps may have picked up the habit of eating the Fly Agaric through observing the effects of the fungus on reindeer, which are similarly affected. Indeed, they like it so much that all one has to do to round up a wandering herd is to scatter pieces of Fly Agaric on the ground. Another observation the Lapps made from the reindeer was that the intoxicating compounds in the fungus can be recycled by consuming the urine of an intoxicated person. The effects of consuming this species are exceedingly unpredictable; some people remain unaffected while others have similar, or different, symptoms to those above, and at least one death is attributed to *A. muscaria*. This unpredictability is due to the fungus containing different amounts of the toxins ibotenic acid and muscimol according to season, method of cooking and ingestion, as well as the subject's state of mind. Ibotenic acid is mostly concentrated in the coloured skin of the cap. This very unstable compound rapidly degrades on drying to form muscimol which is five to ten times more potent. Traditionally, where *A. muscaria* is used as an inebriant, it is the dried cap which is taken.

The Blusher *Amanita rubescens* ²/₃ life size

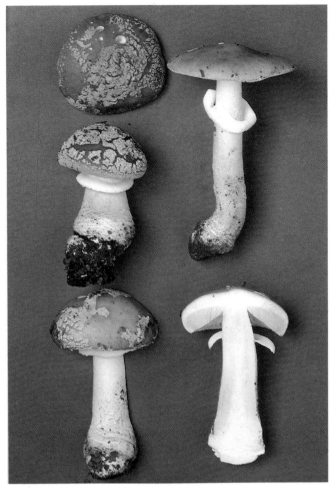

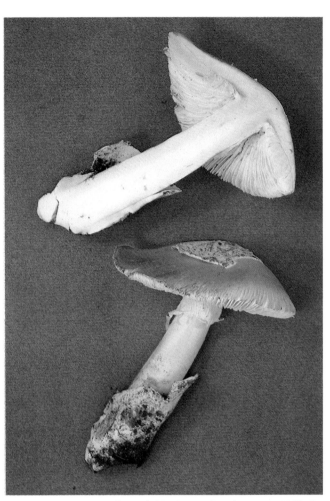

Amanita excelsa ½ life size

Caesar's Mushroom *Amanita caesarea* ½ life size

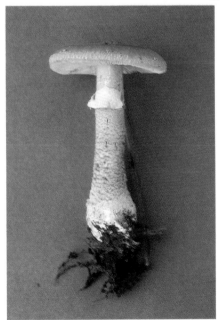

Amanita rubescens var. *annulosulphurea* ½ life size

Amanita rubescens var. *annulosulphurea* Gillet
Similar to *A. rubescens* but generally more slight.
The apex of the stem and the ring are tinged pale
sulphur-yellow. Habitat in woods and heaths.
Season autumn. Uncommon. **Edibility** as for *A. rubescens*.

The Blusher *Amanita rubescens* ([Pers.] Fr.) S.
F. Gray **Cap** 5–15cm across, rosy brown to flesh
colour, sometimes with a yellowish flush covered
with white or slightly reddish patches. **Stem** 60–
140×10–25mm, white, strongly flushed with cap
colour, white above the striate membranous
ring, becoming reddish near the bulbous base
which occasionally has scattered scaly patches of
volva. **Flesh** white, gradually becoming pink
when bruised or exposed to air, especially in the
stem. Taste mild at first then faintly acrid, smell
not distinctive. **Gills** free, white, becoming
spotted with red where damaged. Spore print
white. Spores ovate, amyloid, 8–9×5–5.5μ.
Habitat in coniferous and deciduous woodland.
Season summer to autumn. Very common.
Edible when cooked but poisonous if eaten raw;
the water it is cooked in should be discarded.

Amanita excelsa (Fr.) Kummer syn. *A. spissa*
(Fr.) Kummer **Cap** 6–10cm across, greyish or
brownish, variable, covered in whitish grey
hoary patches of volva, eventually losing these to
become bare and smooth. **Stem** 60–120×15–
25mm, white, lined above the large white ring
which also shows strong line marks on its upper
surface, covered in small scales below in a
concentric pattern towards the swollen base
which is deeply buried in the ground; the volva is
hardly perceivable on the swollen base. **Flesh**
white, firm; turning purple when treated with
sulphuric acid. Smell slight but unpleasant. **Gills**

with a slight decurrent tooth, crowded, white.
Spore print white. Spores broadly ellipsoid,
amyloid, 9–10×8–9μ. Habitat in deciduous or
coniferous woodland. Season summer to
autumn. Frequent. **Said to be edible** but best
avoided since it can easily be confused with the
poisonous *A. pantherina* (p.18). The two may be
separated on the difference of the velar
remnants, greyish in *A. excelsa*, white in *A.
pantherina*, and the presence of a distinct rim
around the stem base of *A. pantherina*.

Caesar's Mushroom *Amanita caesarea* (Scop. ex
Fr.) Quél. **Cap** 6–18cm across, ovoid or
hemispherical becoming expanded convex, clear
orange-red, fading or ageing more yellowish,
smooth and slightly viscid, finely lined at the
margin. **Stem** 50–120×15–25mm, yellow with a
large yellow pendulous ring which is often
striate, the basal bulb is encased in a large, white
bag-like volva. **Flesh** whitish, distinctly yellow
below the cap cuticle. Taste pleasant, smell faint
and delicate. **Gills** free and crowded, yellow.
Spore print white to yellowish. Spores elliptical,
nonamyloid, 10–14×6–11μ. Habitat not yet
found in Britain, this species favours open
deciduous woodland, especially with oaks, in
warm regions. Season summer to autumn.
Edible – excellent, this species has been a prized
esculent since Roman times and due to its
orange-red cap and yellow skin and gills it is not
easily confused with others.

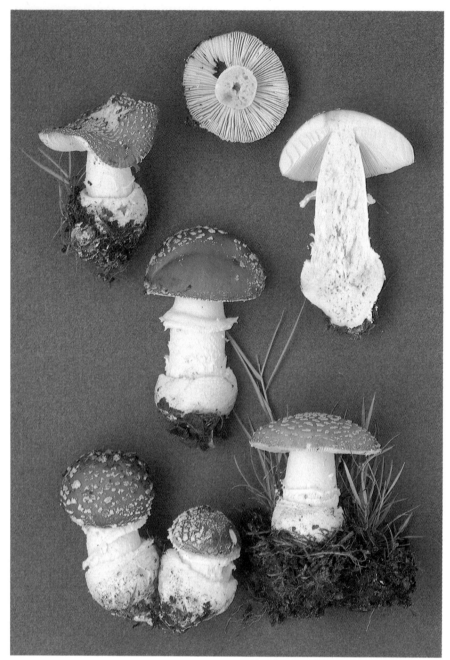

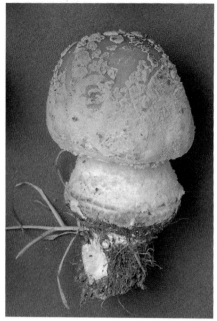

Amanita aspera life size

Panther Cap *Amanita pantherina* ½ life size

Panther Cap *Amanita pantherina* (DC. ex Fr.)
Secr. **Cap** 6–10cm across, ochraceous brown,
covered with small pure-white warty fragments
of the veil, finely striate at the margin. **Stem**
90–130×10–15mm, white with tattered,
pendulous ring which is not striate or grooved,
the stem base is bulbous and closely wrapped in
the white volva which forms a distinct free rim
around the base and one or two belt-like rings
just above. **Flesh** white, becoming hollow in the
stem. Taste and smell mild. **Gills** free, crowded
white. Spore print white. Spores broadly ovate,
nonamyloid, 8–12×6.7–7.5μ. Habitat in
coniferous or deciduous woodland especially
beech. Season summer to autumn. Uncommon.
Poisonous – may be deadly.

Amanita aspera (Fr.) S. F. Gray **Cap** 7–9cm
across, pale or dingy brown, the surface densely
covered with the remains of the universal veil
showing as pointed sulphur-yellow warts. **Stem**
80–100×20–30mm, pale buff with a large
membranous ring often embellished with light
sulphur veil remnants as is the bulbous stem base

with the remains of the volva. **Flesh** white,
discolouring brown where eaten by insects, etc.
Smell faint, not distinctive. **Gills** adnate or with a
slight decurrent tooth, white. Spore print white.
Spores broadly ovate, amyloid, 9×6–6.5μ.
Habitat in deciduous woods. Season autumn.
Rare. **Said to be edible** but not worthwhile.

Death Cap *Amanita phalloides* (Vaill. ex Fr.)
Secr. **Cap** 4–12cm across, convex then flattened,
smooth with faint radiating fibres often giving it a
streaked appearance, slightly shiny when wet,
variable in colour but usually greenish or
yellowish with an olivaceous flush, although
paler, almost white caps do occur. **Stem** 50–
130×10–18mm, thickening towards the large
basal bulb encased in a large white saccate volva,
white flushed with the cap colour and often
faintly banded, sometimes becoming hollow.
Flesh white with a faint yellowish flush below the
cap cuticle. Smell sickly sweet becoming
noticeably stronger after collection. **Gills** free,
crowded, white. Spore print white. Spores
broadly elliptical to subglobose, amyloid, 8–

10.5×7–8μ. Habitat in mixed deciduous
woodlands, especially with oak. Season late
summer to autumn. Occasional. **Deadly
poisonous**.
This is the most deadly fungus known and
despite years of detailed research into the toxins
it contains, no antidote exists against their effects
on the human body. Poisoning by *A. phalloides* is
characterized by a delay of between 6 and 24
hours in the onset of symptoms from the time of
ingestion during which time the cells of the liver
and kidneys are attacked.
However, if a gastroirritant has also been
consumed, e.g. as the result of eating a mixed
collection of mushrooms, the delay in gastric
upset may not occur and this vital diagnostic
evidence will be masked. The next stage is one of
prolonged and violent vomiting and diarrhoea
accompanied by severe abdominal pains, lasting
for a day or more. Typically this is followed by an
apparent recovery, when the victim may be
released from hospital or think his ordeal over.
Within a few days death results from kidney and
liver failure.
Although *A. phalloides* contains many poisonous
compounds it is believed that only the group
known as amatoxins are responsible for human
poisoning, the others (phallotoxins) being
rendered harmless by their being neutralized by
other compounds or not being absorbed from the
intestinal tract, being present in very low
concentrations or being so unstable as to be
destroyed by cooking or digestive juices. The
amatoxins however are fully active orally. The
main constituent of this group is α-amanitin
which through its effect on nuclear RNA in liver
cells causes the end of protein synthesis leading
to cell death. When filtered through the kidneys
it attacks the convoluted tubules and instead of
entering the urine it is reabsorbed into the
bloodstream and recirculated, causing repeated
liver and kidney damage. As with any hepatic
disease, treatment relies on the monitoring of
blood chemistries, urine output, etc. and the
maintenance of fluid and electrolyte balance. In
cases of amatoxin poisoning mortality is fifty to
ninety per cent and any chance of survival
depends on early recognition.

A. phalloides var. *alba* differs from the type in
being entirely white throughout. Like *A.
phalloides*, it is also deadly poisonous.

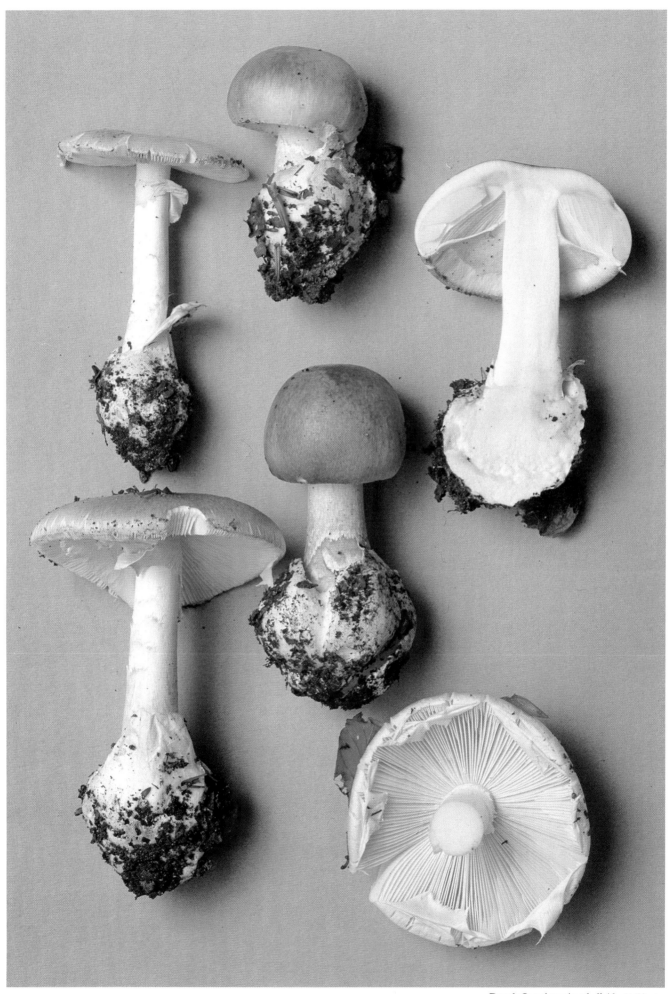

Death Cap *Amanita phalloides* ¾ life size

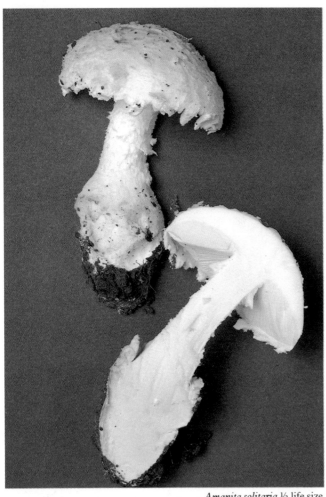

Amanita solitaria ½ life size

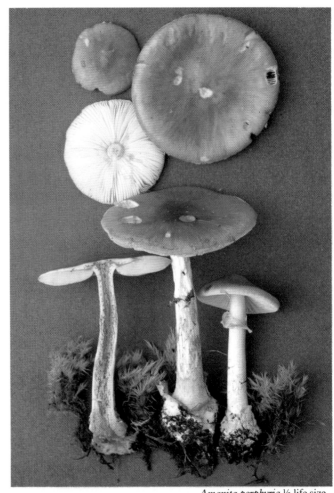

Amanita porphyria ½ life size

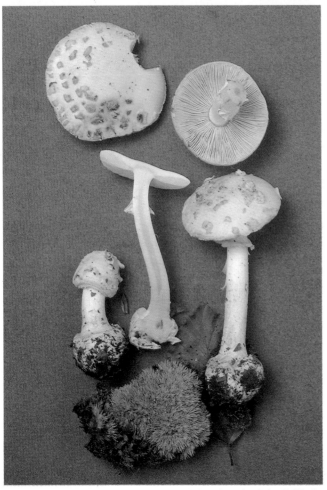

False Death Cap *Amanita citrina* ½ life size

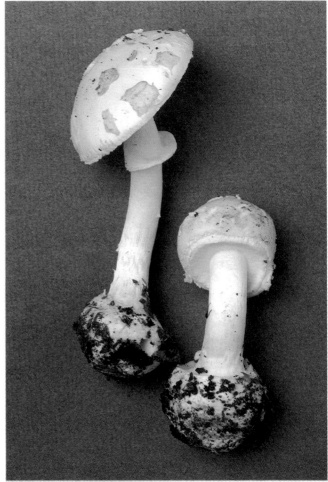

Amanita citrina var. *alba* ¾ life size

Amanita solitaria (Bull. ex Fr.) Secr. syn. *A. strobiliformis* (Vitt.) Quél. **Cap** 6–20cm across, white, covered with large thick flat greyish scales. **Stem** 60–100×8–14mm, shaggy with delicate mealy white scales and ending in a bulbous rooting base with belts of volval remains; the ring is white and of a delicate mealy texture. **Flesh** white, cream in stem base. Taste and smell faint and mild. **Gills** free, crowded, white. Spore print white. Spores broadly elliptical, amyloid, 10–12×8–10μ. Habitat near deciduous woodland, especially on calcareous soils. Season summer to autumn. Rare. **Edible** but easily confused with other deadly species.

Amanita porphyria (Alb. & Schw. ex Fr.) Secr. **Cap** 5–9cm across, convex becoming flattened, pale greyish-brown with vinaceous flush, smooth. **Stem** 100–130×10–15mm, whitish, ring thin and fragile, basal bulb encased in a short volva. **Flesh** whitish becoming brown. Taste unpleasant, smell slight. **Gills** free to adnexed, white. Spore print white. Spores globose, amyloid, 7.5–9.5μ diameter. Habitat in coniferous or mixed woods. Season late summer to autumn. Occasional. **Not edible.**

False Death Cap *Amanita citrina* (Schaeff.) S. F. Gray syn. *A. mappa* (Batsch ex Lasch) Quél. **Cap** 4–10cm across, ivory to pale lemon especially near the centre, covered in persistent coarse whitish patches which discolour ochre-brown. **Stem** 60–80×8–12mm, ivory white, tapering and longitudinally lined above the membranous ring, the large basal bulb encased in the remains of the volva which creates a trough around the stem. **Flesh** white, the stem becoming hollow in older specimens. Taste unpleasant, smelling strongly of raw potatoes. **Gills** adnexed, whitish. Spore print white. Spores almost spherical, amyloid, 9.5×7.5μ. Habitat in deciduous or coniferous woods, especially with beech. Season summer to late autumn. Frequent. **Edible** but of no interest as the strong taste and smell make it unpleasant, and best avoided due to possible confusion with the deadly *A. phalloides*.

Amanita citrina var. *alba* (Gillet) Gilbert This is a frequently occurring form of *A. citrina* which differs only in being white throughout. Less strongly smelling than *A. citrina*, but still disagreeable to taste, it is not poisonous but since it is easily confused with the deadly *Amanitas*, it is best avoided.

Destroying Angel *Amanita virosa* Secr. **Cap** 5–12cm across, conical at first then campanulate, sometimes with a slight umbo, later expanded but never totally smooth and slightly viscid, pure white. **Stem** 90–120×10–15mm, often slightly curved with a shaggy fibrous surface ending in a narrow bulb enclosed in a greyish-tinged bag-like volva; the white ring is fragile and often torn or incomplete. **Flesh** white, instantly yellow with KOH, separating this species from *A. verna*. Smell sickly sweet. **Gills** free, crowded, white. Spore print white. Spores globose, amyloid, 8–10μ in diameter. Habitat in mixed or deciduous woods. Season late summer to autumn. Uncommon. **Deadly poisonous** causing same symptoms as *A. phalloides* (p.18).

Spring Amanita *Amanita verna* (Bull. ex Fr.) Vitt. Also deadly poisonous, and similar to *A. virosa* is *A. verna*, differing from the former in the hemispherical cap shape of the young

specimens. The stem is without the fibrous scales of *A. virosa* but finely powdered instead. Spores broadly elliptical, amyloid, 8–11×7–9μ. Season autumn, but often appearing in spring giving rise to its common name. Very rare. **Deadly poisonous**. (Not illustrated.)

Amanita echinocephala (Vitt.) Quél. syn. *Aspidella echinocephala* (Vitt.) Gilbert **Cap** 6–20cm across, colour white with a greenish flush or it can vary from ivory to pale brown, the surface covered with pointed cream warts, less so with age. **Stem** 80–160×20–30mm swollen towards the pointed, deeply buried base, the lower half of the stem covered in the remains of the volva, the upper part white. **Flesh** white sometimes with a greenish tinge, bruising yellowish in the stem. Smell unpleasant. **Gills** free or with a decurrent tooth, white or tinged yellow-green. Spore print white or tinged yellow-green. Spores ellipsoid, amyloid, 9.5–11.5×6.5–8μ. Habitat on dry, calcareous soils. Season autumn. Rare. **Suspect** – should not be eaten.

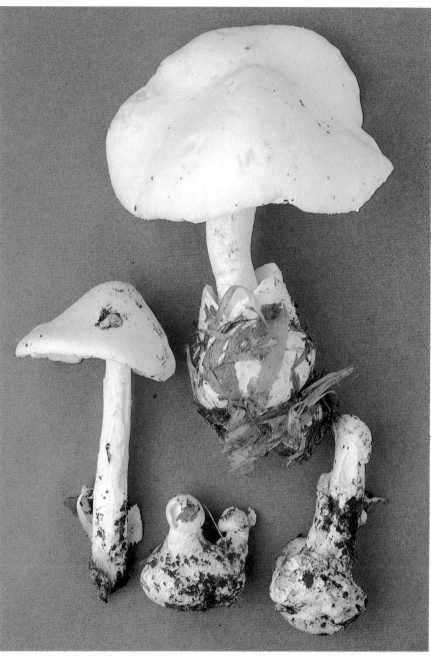

Destroying Angel *Amanita virosa* ¾ life size

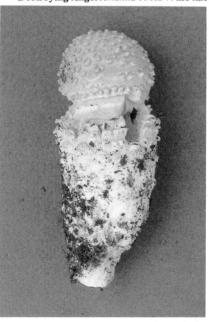

Amanita echinocephala ½ life size

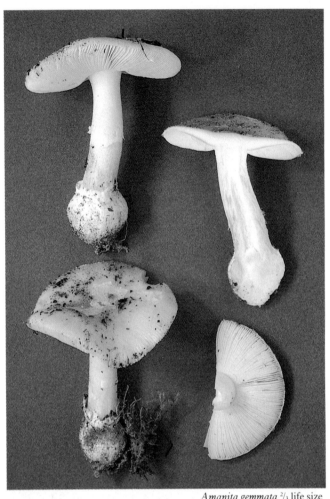

Amanita gemmata ²/₃ life size

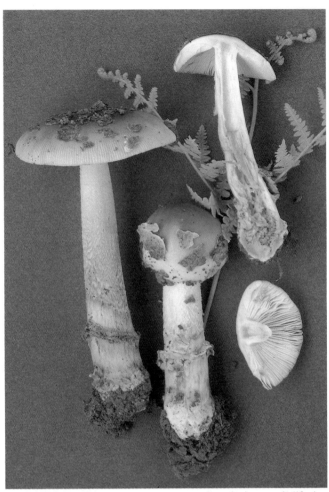

Amanita inaurata ²/₃ life size

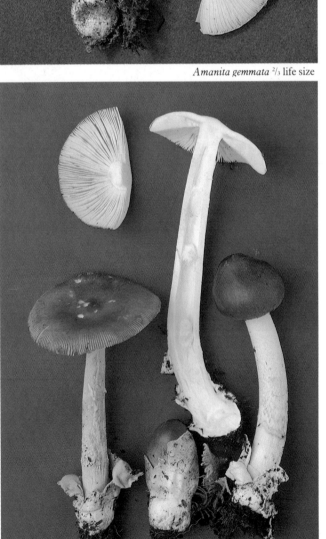

Grisette *Amanita vaginata* ½ life size

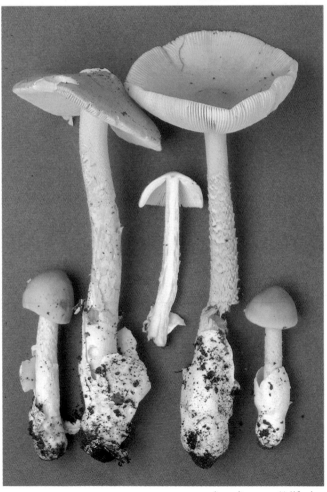

Amanita crocea ½ life size

Amanita gemmata (Fr.) Gillet syn. *A. junquillea* Quél. syn. *Amanitopsis adnata* (W. G. Smith) Sacc. **Cap** 5–7cm across, flattened convex, pale yellow with more ochre centre, covered in snow-white patches of veil remnants, margin striate. **Stem** 70–100×10–14mm, white with pale yellow flush, with a large basal bulb encased in a short thin volva. **Flesh** white, flushed pale yellow in the stem. Smell faint. **Gills** adnexed, white. Spore print white. Spores ovoid – subglobose, nonamyloid, 8.5–9×7–7.5µ. Habitat in coniferous woods. Season autumn. Very rare. **Deadly poisonous** causing symptoms as in *A. pantherina* poisoning (p.18).

Amanita inaurata Secr. syn. *Amanitopsis strangulata* Fr. **Cap** 7–12cm across, convex expanding to broadly bell-shaped, greyish-brown covered in large dingy grey warty patches of volva and distinctly grooved at the margin. **Stem** 75–130×15–20mm, pale grey-brown with distinctive white shaggy horizontal bands of veil tissue, the bulb encased in an easily broken volva soon falling away to show oblique ridges, no ring. **Flesh** white. Smell faint or none. **Gills** white. Spore print white. Spores globose, nonamyloid, 10.5–13µ diameter. Habitat in mixed woodland. Season autumn. Uncommon. **Edibility unknown** – best avoided since it is possibly poisonous.

Grisette *Amanita vaginata* (Bull. ex Fr.) Vitt. syn. *Amanitopsis vaginata* (Bull. ex Fr.) Roze **Cap** 5–9cm across, ovoid at first expanding to almost flat with umbo, typically grey-brown, more rarely darker or lighter, or even white (var. *alba*), distinctly lined at margin. **Stem** 130–200×15–20mm, tapering towards the apex, whitish flushed with cap colour, base enclosed in large bag-like volva tinged grey, no ring. **Flesh** white, becoming hollow in stem. Taste and smell not distinctive. **Gills** crowded, adnexed, white. Spore print white. Spores globose, nonamyloid, 9–12µ in diameter. Habitat in deciduous woods, or on heaths. Season summer to autumn. Frequent. **Edible** but best avoided due to possible confusion with the deadly *Amanitas*.

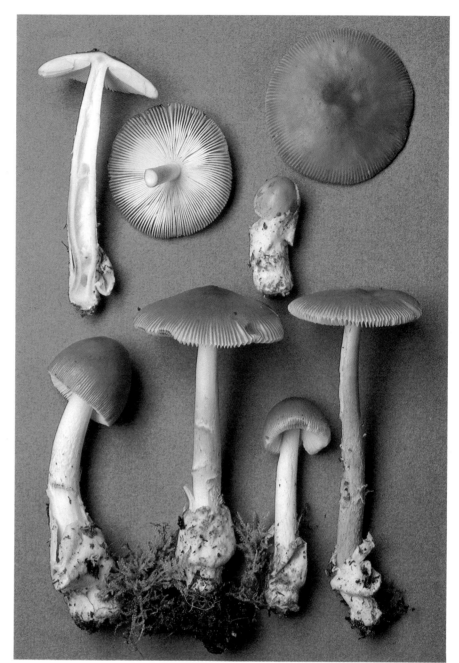

Tawny Grisette *Amanita fulva* ½ life size

Amanita crocea (Quél.) Kühn. & Romagn. syn. *A. vaginata* var. *crocea* Quél. syn. *Amanitopsis crocea* (Quél.) Gilbert **Cap** 4–10cm across, convex becoming flattened or turning up at margin, with a broad umbo, pale yellow orange or apricot at centre, paler towards the lined margin. **Stem** 100–150×10–20mm, gradually attenuated towards the apex, covered in silky or cottony tufts of the cap colour throughout the length, the non-bulbous base encased in a thick, persistent volva which is white on the outside and flushed with the cap colour on the interior surface, no ring. **Flesh** thin, white often pale orange below the cap cuticle. Smell sweet, taste sweet and nutty. **Gills** adnexed or free, cream. Spore print white. Spores subglobose, nonamyloid, 11–12.5×9–10µ. Habitat amongst broadleaved trees especially birch. Season late summer to autumn. Occasional. **Edible**.

Tawny Grisette *Amanita fulva* (Schaeff.) Secr. syn. *Amanitopsis vaginata* var. *fulva* (Schaeff.) Fr. **Cap** 4–9cm across, ovoid at first expanding to almost flat with low umbo, orange-brown with distinct grooved margin, smooth, dry. **Stem** 70–120×8–12mm, tapering towards apex, white tinged with cap colour encased in large bag-like similarly-coloured volva, no ring. **Flesh** white, becoming hollow in the stem. Taste and smell not distinctive. **Gills** free, white. Spore print white. Spores globose, nonamyloid, 9–11µ. Habitat mixed woodland. Season autumn. Common. **Edible**.

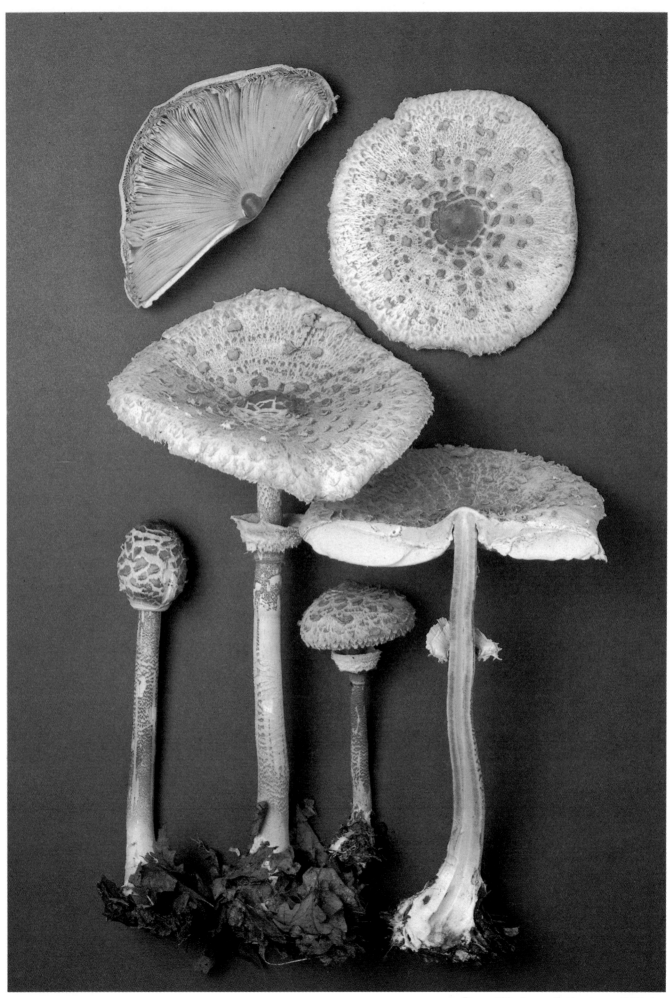

Parasol Mushroom *Lepiota procera* ½ life size

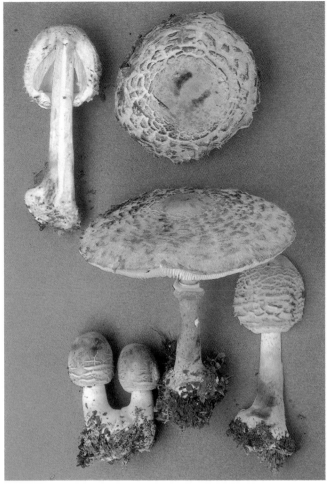

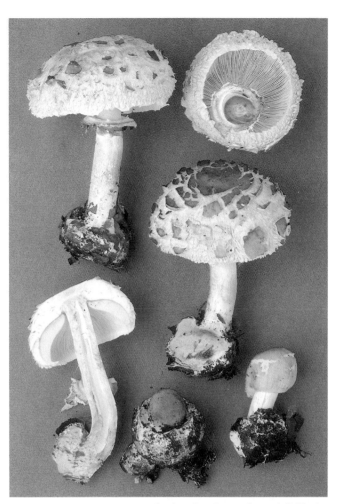

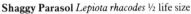

Shaggy Parasol *Lepiota rhacodes* ½ life size

Lepiota rhacodes var. *hortensis* ½ life size

LEPIOTA *Typically with rings; the large ones have a ring which is easily detachable and will move up and down the stem. The colour and type of scales on the cap are important. The gills are normally white or whitish and free from the stem. Smells are important in some cases, others have flesh that goes red or discolours when cut or bruised. Fifty-nine in Britain.*

Parasol Mushroom *Lepiota procera* (Scop. ex Fr.) S. F. Gray syn. *Macrolepiota procera* (Scop. ex Fr.) Sing. syn. *Leucocoprinus procerus* (Scop. ex Fr.) Pat. **Cap** 10–25cm across, button spherical or egg-shaped expanding flattened with a prominent umbo, pale buff or grey-brown covered in darker shaggy scales. **Stem** 150–300×8–15mm, 40mm at the bulb, white, with a grey-brown felty covering which becomes split into snake-like markings as the stem expands; ring large, double, white on upper surface, brown below, movable on the stem. **Flesh** thin, soft, white. Taste sweet, smell slight, indistinctive. **Gills** free, white. Spore print white. Spores ovate with a germ-pore, dextrinoid, 15–20×10–13μ. Habitat in open woods and pastures. Season summer and autumn. Uncommon. **Edible** – excellent.

Shaggy Parasol *Lepiota rhacodes* (Vitt.) Quél. **Cap** 5–15cm across, ovate then expanding to almost flat, disrupting into broad, pallid, often slightly reflexed scales on a fibrous background, giving the cap a shaggy, torn appearance. **Stem** 100–150×10–15mm, thickened towards the bulb which is usually oblique, whitish tinged dirty pinkish-brown, bruising reddish brown

when fresh; ring double, membranous, movable on the stem. **Flesh** white becoming orange to carmine red on cutting. Taste pleasant, smell strongly aromatic. **Gills** white, tinged reddish in older specimens, bruising reddish. Spore print white. Spores elliptic with germ-pore, dextrinoid, 10–12×6–7μ. Habitat woods and shrubberies of all kinds, often with conifers. Season summer to late autumn. Frequent. **Edible** but may cause gastric upsets in some people.

Lepiota rhacodes var. *hortensis* Pilat **Cap** 10–15cm across, subglobose at first, smooth and entirely reddish-brown, expanding to convex and disrupting into large angular scales, except at the centre, exposing the whitish fibrous subcutaneous layer. **Stem** 60–70×18–24mm, ending in a large subspherical bulb 40–60mm across, white discolouring brownish below the large, thick double ring. **Flesh** white, discolouring orange or reddish on cutting but less strongly so than the type. Taste and smell pleasant. **Gills** white to cream, eventually dirty buff or brown-spotted. Spore print white. Spores elliptic with germ-pore, dextrinoid, 10–13×7.5–9.5μ. Habitat on rich soil in gardens and compost heaps. Season summer to autumn. Frequent. **Edible** but may cause gastric upsets in some people.

Lepiota leucothites (Vitt.) Orton syn. *L'. naucina* (Fr.) Kummer **Cap** 5–8cm across, convex expanding to almost flattened, smooth and silky, whitish becoming flushed flesh-colour or pale cream-ochre. **Stem** 60–80×8–20mm,

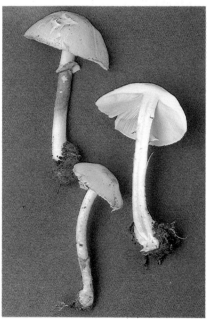

Lepiota leucothites ½ life size

concolorous with the cap; ring concolorous, narrow, free of the stem. **Flesh** thick and white in the cap, browning in the stem. Taste and smell not distinctive. **Gills** white becoming pale flesh-colour with age. Spore print white. Spores ovoid, dextrinoid, 7–9×4.5–5μ. Habitat in gardens or at roadsides. Season autumn. Rare. **Edible** but best avoided due to possible confusion with poisonous species.

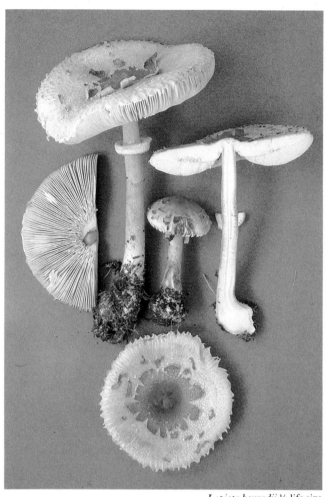

Lepiota konradii ½ life size

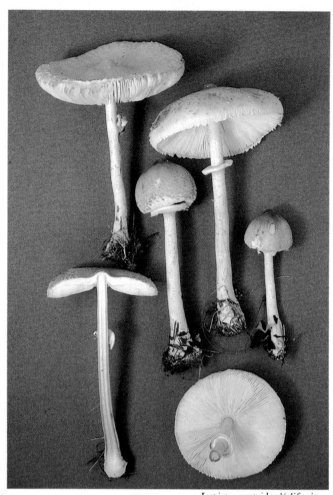

Lepiota mastoidea ½ life size

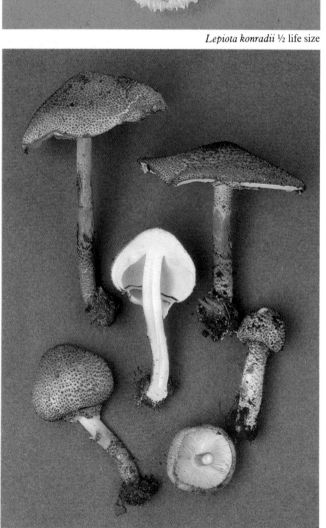

Lepiota hystrix ¾ life size

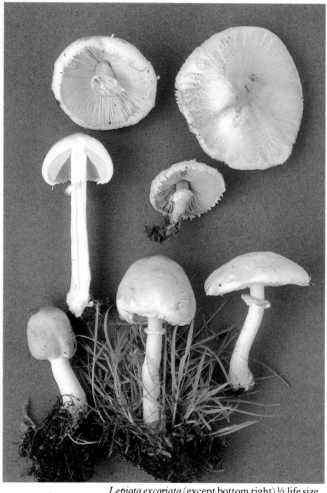

Lepiota excoriata (except bottom right) ½ life size

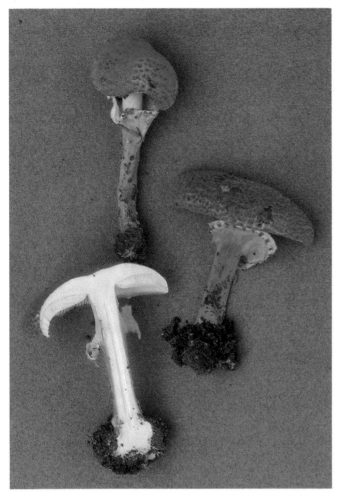

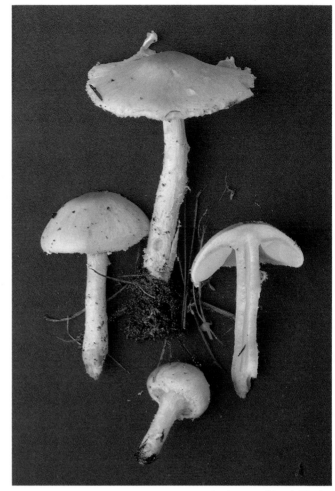

Lepiota friesii ½ life size

Lepiota oreadiformis life size

Lepiota konradii Huijsman ex. Orton syn. *L. gracilenta* (Krombh.) Quél. s. Rea syn. *L. excoriata* var. *konradii* Huijsman **Cap** 7–12cm across, ovate then slightly umbonate becoming expanded and even depressed, the brownish cuticle breaking up into large adnate scales exposing the white flesh beneath. **Stem** 100–150×8–12mm, bulbous, tapering upwards, whitish covered in small brownish scales. Smell pleasant. **Gills** white. Spore print white. Spores ovoid with an apical germ-pore, 13–17×8–10μ. Habitat pasture, heaths and open woodland. Season late summer to late autumn. Rare. **Edible.**

Lepiota mastoidea (Fr.) Kummer syn. *L. umbonata* (Schum.) Schroet. syn. *Macrolepiota mastoidea* (Fr.) Sing. **Cap** 8–12cm across, subglobose at first expanding flattened convex with a distinct acute umbo, white to cream-ochre covered in minute pale ochraceous granular scales. **Stem** 80–100×8–15mm, white with small, densely crowded, yellowish-brown granular scales, slightly swollen at the base; ring white and thick. **Flesh** thin, white. Taste and smell not distinctive. **Gills** white. Spore print white. Spores elliptic, 12–16×8–9.5μ. Habitat in open woodland. Season autumn. Uncommon. **Edible – good.**

Lepiota hystrix Lange syn. *L. hispida* (Lasch) Gillet **Cap** 4–6cm across, ovate then convex, surface disrupted into coarse pyramidal brownish-black scales, decreasing in size towards the overhanging margin and revealing the white subcutaneous layer. **Stem** 50–60×6–10mm, apex whitish and exuding reddish droplets (as does the cap margin) which become dark brown with age, lower side of ring and rest of stem covered in dark brown scales like the cap. **Flesh** whitish. Taste fungal, like puffballs, smell strong and reminiscent of elderflowers. **Gills** crowded, not forked, white with blackish edges (sub lente). Cheilocystidia thin-walled, clavate. Tips of scales on cap formed of brown sphaerocysts. Spore print white. Spores narrowly elliptic to subcylindric, dextrinoid, 6–7×2.5–3μ. Habitat deciduous woods. Season late summer. Rare. **Not edible.**

Lepiota excoriata (Schaeff ex. Fr.) Kummer syn. *Leucocoprinus excoriatus* (Schaeff. ex Fr.) Pat. **Cap** 6–10cm across, ovate at first then convex and slightly umbonate, covered in fine adpressed ochre-buff scales on a white ground. **Stem** 40–60×8–10mm, slightly thickened at the base, smooth, white; ring narrow and persistent. **Flesh** white. Smell none. **Gills** white to cream. Spore print white to pale ochraceous. Spores oval, 12–15×8–9μ. Habitat pastureland. Season late summer to late autumn. Rare. **Edible.** Unfortunately a specimen of *L. leucothites* has crept into this collection (bottom right).

Lepiota friesii (Lasch) Quél. syn. *L. acutesquamosa* var. *furcata* Kühn. **Cap** 5–10cm across, ovoid at first then obtusely conical or bell-shaped, dark brown at the centre elsewhere the surface breaking up into dark brown scales. **Stem** 30–50×5–10mm, pallid often with a few dark brown scales at the extreme base; ring whitish, cottony, often adhering to the cap margin. **Flesh** white. **Gills** free, crowded and forked near the stem, white. Cheilocystidia thin-walled, subglobose, hyaline, 8–23μ in diameter. Spore print white. Spores narrowly fusoid, dextrinoid, 6–8×3–4μ. Tips of the scales on the cap surface formed of brownish spherical cells. Habitat in deciduous woods. Season autumn. Occasional. **Edibility unknown.**

Lepiota oreadiformis Vel. syn. *L. laevigata* (Lange) Lange **Cap** 2–6cm across, flattened convex with a slight broad umbo, appearing smooth but minutely felty under a lens, light ochre-brown at the centre becoming pale towards the margin. **Stem** 30–45×8–12mm, white or whitish covered in pale cottony scales, ring zone indistinct. **Flesh** white becoming brown with age. Smell pleasant and sweet. **Gills** white. Spore print white. Spores ellipsoid-fusiform, dextrinoid, 11.5–13.5×4.5–5.5μ. Surface of cap formed of elongated, thin-walled, subhyaline, unicellular hairs with short clavate or ovate cells forming an almost hymeniform layer at their base. Habitat amongst grass in the open. Season late summer to autumn. Rare. **Edibility unknown.**

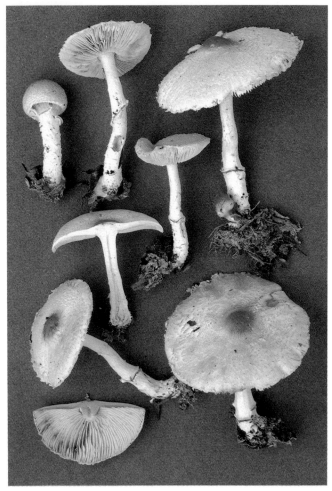

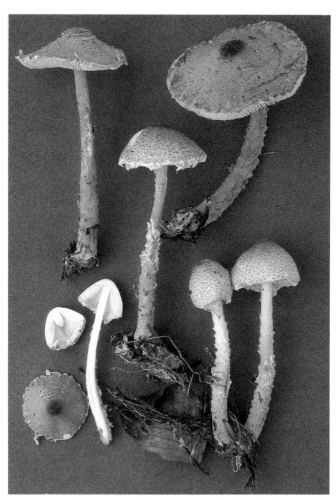

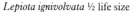

Lepiota ignivolvata ½ life size

Lepiota ventriosospora ²/₃ life size

Lepiota ignivolvata Bousset-Joss **Cap** 4–10cm across, convex then expanded and umbonate, centre reddish-brown, disrupting into tiny crowded ochraceous cream scales which become more dispersed towards the margin. **Stem** 60–120×6–15mm, slightly bulbous, with bright orange zone on the edge of the bulb which often becomes more obvious after collection; there is often a similar orange colour on the underside of the ring. **Flesh** white. Taste foul, smell strong and rank. **Gills** white to cream. Spore print white. Spores fusoid, 11–13×6μ. Habitat deciduous and coniferous woods. Season autumn. Rare. **Not edible.**

Lepiota ventriosospora Reid *L. metulaespora* (Berk. & Br.) Sacc. of some European authors **Cap** 4–8cm across, conico-convex expanding to almost flattened, ochraceous with yellow to brown scales, centre darker and smooth. **Stem** 30–40×4–8mm, concolorous with cap, covered in large yellowish cottony scales, especially towards the base. **Flesh** thin, whitish in cap, brown or reddish brown in the stem. **Gills** white. Cheilocystidia variable, ovate, clavate, or lageniform 9–15μ wide. Spore print white. Spores fusoid, dextrinoid, 14.5–17.5×4–5μ. Surface hairs comprising the scales on the cap elongated, thin-walled, unicellular, with rounded obtuse or slightly narrowed apex. Habitat deciduous woods. Season autumn. Uncommon. **Edibility unknown.**

Lepiota brunneo-incarnata Chodat & Martin syn. *L. helveola* Bres. s. Rea **Cap** 1.5–4cm across, convex then expanded and finally even slightly depressed, vinaceous-brown and felty when young later disrupting into scales exposing the whitish-pink ground, especially towards the margin. **Stem** 20–50×5–10mm, white above the short-lived ring, rosy pink below the brownish ring zone and covered in brown tufted scales. **Flesh** white, pinkish-brown in stem cuticle with age. Smell fruity. **Gills** white to cream. Cheilocystidia thin-walled, clavate. Spore print white. Spores elliptic to almond-shaped, 7–9.5×4–5μ. Habitat wood edges, usually on disturbed soil. Season autumn. Rare. **Poisonous** perhaps deadly.

Lepiota cristata Kummer **Cap** 2–5cm across, irregularly bell-shaped and umbonate, cuticle reddish-brown and soon broken up, except at centre, into small scales on a white silky background. **Stem** 20–35×3–4mm, white tinged flesh-colour; ring membranous and deciduous. **Flesh** thin, white. Taste pleasant, smell unpleasant, strongly fungusy. **Gills** white, becoming brownish with age. Spore print white. Spores bullet-shaped, dextrinoid, 6–7.5×3–3.5μ. Habitat in woods, garden refuse or in leaf litter. Season summer to autumn. Frequent. **Edibility suspect** – avoid.

Lepiota pseudohelveola Kühn. ex Hora **Cap** 1–2cm across, slightly umbonate, grey-brown to dirty brown breaking up into fine scales. **Stem** 25–40×2–5mm, white flushed pink-brown; upper surface of ring pinkish, lower brown and flaky. **Gills** brownish. Cheilocystidia thin-walled, fusoid-ventricose, hyaline. Spore print white. Spores ellipsoid, dextrinoid, 7–10×4–5μ. Habitat in deciduous woodland. Season autumn. Rare. **Edibility unknown.**

Lepiota felina (Pers. ex Fr.) Karst **Cap** 2–3cm across, slightly umbonate, the whole cap is dark brown to almost black when in bud, the cuticle breaks up into minute erect scales as the cap expands. **Stem** 30–50×2–4mm, fibrillose, whitish sprinkled with blackish scales towards the base; ring membranous, white on upper surface, dark grey-brown below. **Flesh** white, becoming tinged brownish. Smell strongly fungusy. **Gills** white. Cheilocystidia thin-walled, clavate to obtusely fusiform, hyaline, surface squamules formed of tufts of elongated hairs. Spore print white. Spores ovoid, 6.5–7.5×3.5–4μ. Habitat in coniferous woods. Season autumn. Uncommon. **Not edible.**

Lepiota castanea Quél. syn. *L. ignipes* Locquin **Cap** 2–4cm across, umbonate, bay to chestnut brown, soon breaking into small granular scales

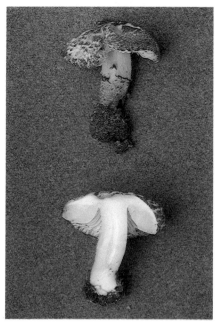

Lepiota brunneo-incarnata life size

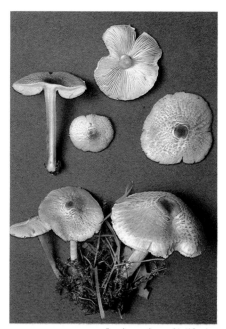

Lepiota cristata ²/₃ life size

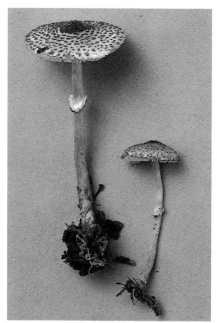

Lepiota pseudohelveola life size

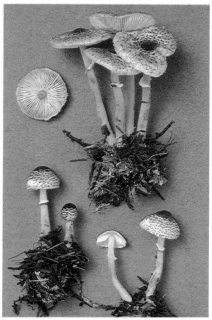

Lepiota felina ²/₃ life size

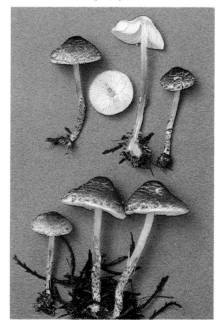

Lepiota castanea ²/₃ life size

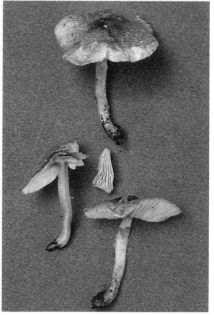

Lepiota fulvella ²/₃ life size

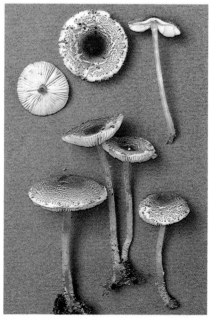

Lepiota subincarnata ¾ life size

which are formed of minute tufts of hairs. **Stem** 25–35×2–4mm, concolorous with cap and finely brown scaly below; ring zone inconspicuous. **Flesh** white in cap, brownish in stem. Smell strong and fungusy. **Gills** whitish, browning with age. Cheilocystidia numerous, thin-walled, subcylindric or clavate, hyaline, 30–47×5–8μ. Spore print white. Spores bullet-shaped, dextrinoid, 9–13×3.5–5μ. Hairs of cap scales thin-walled, elongated, obtuse, septate, brown. Habitat in deciduous and coniferous woods. Season autumn. Uncommon. **Edibility unknown**.

Lepiota fulvella Rea **Cap** 2–5cm across, umbonate, deep ochre to orange-brown with darker brown centre, almost smooth at first then covered in adpressed fibrils which do not disrupt into distinct scales. **Stem** 30–60×3–6mm, whitish at the apex, covered in brownish cottony velar remains below the ring zone. **Flesh** white in cap, brownish in stem. Smell strong and fungusy. **Gills** free, whitish sometimes with a yellow tinge. Spore print white. Spores bullet-shaped, dextrinoid, 8–9×3.5–4.5μ. Surface of cap formed of thin-walled, elongated, obtuse, brown hairs which when mounted in water can be seen to contain pigment granules in the 'sap' but these dissolve instantly in the presence of alkali. Habitat in damp woods, especially under hazel. Season autumn. Uncommon. **Edibility unknown**.

Lepiota subincarnata Lange syn. *L. fourquignoni* Quél. s. Lange **Cap** 1.5–2.5cm across, convex then flattened, tinted with rosy flesh colour and ornamented at the centre with small punctate scales of a brownish-fawn or red-brown tint formed of elongated non-septate hairs without a hymeniform layer at their base. **Stem** 20–40×2–3mm, whitish at first then reddish-brown ornamented with whitish cottony scales, ring zone indistinct. **Flesh** whitish with pinkish tint. Smell strongly acrid. **Gills** whitish. Spore print white. Spores oval, 5–7×3–4μ. Habitat deciduous and coniferous woods. Season late autumn. Uncommon. **Edibility unknown**.

29

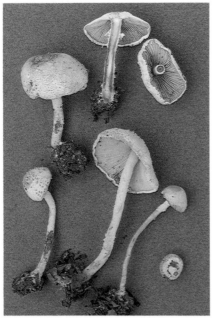

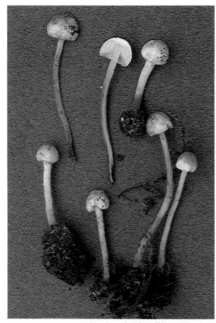

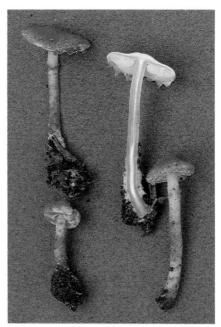

Lepiota adulterina life size

Lepiota bucknallii ¾ life size

Lepiota rosea ¾ life size

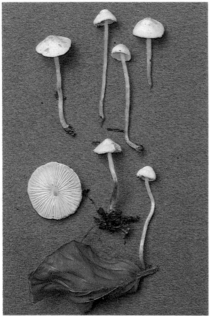

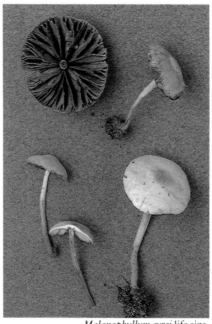

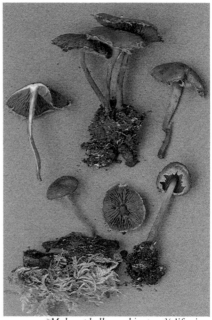

Lepiota sistrata life size

Melanophyllum eyrei life size

Melanophyllum echinatum ¾ life size

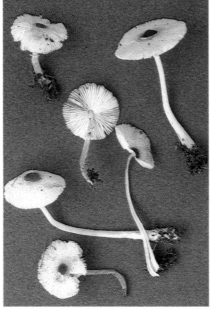

Leucocoprinus brebissonii ²/₃ life size

Lepiota adulterina Møll. **Cap** 1.5–2.5cm across, conico-convex, initially beige and scurfy with a few cottony warts, later disrupting into thick mealy ochraceous warts on a pale cream ground, velar remains adhering to the margin. **Stem** 30–40×2–4mm, whitish to pinkish with a scurfy beige covering below the ring zone. **Flesh** whitish in cap, vinaceous towards the base of the stem. **Gills** cream. Cheilocystidia inconspicuous, thin-walled, clavate with pointed apex. Spore print white. Spores narrowly elliptic to subcylindric, 4–6×2–2.5μ. Surface of cap covered with small, thin-walled globose cells 15–30μ in diameter. Habitat broad-leaved woods amongst scrub; ash, nettle, dog's mercury. Season late summer to autumn. Rare. **Suspect – avoid.**

Lepiota bucknallii (Berk. & Br.) Sacc. syn. *Cystoderma bucknallii* (Berk. & Br.) Sing. **Cap** 2–4cm across, umbonate, mealy, whitish with a tinge of lilac-violet when young. **Stem** 20–45×3–5mm, mealy, pale at the apex becoming purple-violet below at least on bruising. **Flesh** thin, whitish to lilac. Smell strongly of gas-tar. **Gills** free, cream. Cheilocystidia undifferentiated. Spore print white. Spores elongate ellipsoid, weakly dextrinoid, 7.5–10×3–3.5μ. Mealy surface of cap formed of thin-walled spherical cells. Habitat in damp deciduous woods. Season autumn. Uncommon. **Possibly poisonous.**

Leucocoprinus brebissonii (Godley apud Gillet) Locq. syn. *Lepiota brebissonii* Godley apud Gillet **Cap** 2–3cm across, delicate almost transparent, conical then flattened, white with uniform dark grey-brown disc, elsewhere ornamented with dark grey-brown scales becoming more dispersed toward the coarsely grooved margin. **Stem** 45–60×3–6mm, pure white with a small

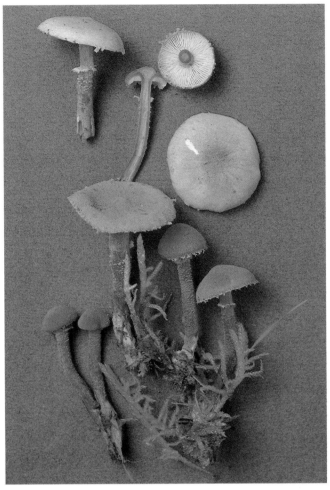

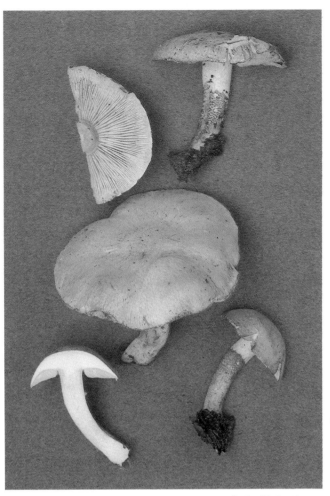

Cystoderma amianthinum ²/₃ life size

Drosella fracida ²/₃ life size

white ring, slightly thickened towards the base. **Flesh** thin, white. **Gills** crowded, pure white. Spore print white. Spores broadly elliptic or ovoid to almond-shaped with a germ-pore, 9–12.5×5.5–7μ. Habitat deciduous woods. Season autumn. Occasional. **Edibility unknown.**

Lepiota rosea Rea **Cap** 2–3cm across, convex then expanded, pink at first becoming brownish-pink with age, densely grainy-mealy, margin overhanging, appearing toothed. **Stem** 50–60×3–5mm, white at apex concolorous with cap below with floccose-granular scales at first; ring narrow, soon disappearing. **Flesh** white becoming tinged pinkish especially towards stem base. Smell faint and pleasant according to some authors, this collection however had a very strong unpleasant smell, like that of *L. cristata*. **Gills** white, later cream. Cheilocystidia scattered, thin-walled, hyaline, clavate or bottle-shaped. Spore print white. Spores elliptic, non-dextrinoid, 4.5–6×2.5–3.5μ. Mealy surface of cap formed of thin-walled, globose cells. Habitat damp ground in shady deciduous woods. Season autumn. Rare. **Edibility unknown.**

Lepiota sistrata (Fr.) Quél. syn. *L. seminuda* (Lasch) Kummer syn. *Cystoderma seminudum* (Lasch) Sing. **Cap** 0.5–1.5cm across, conico-convex with a distinct umbo, white with a flesh-colour tinge, mealy due to the surface being composed of thin-walled sphaerocysts. **Stem** 15–25×1–2mm, white tinged pinkish towards the base, finely mealy. **Flesh** thin, white in cap,

pinkish in lower stem. **Gills** white. Spore print white. Spores ellipsoid, 3–4×2–2.5μ. Habitat on pathsides or wood-edges. Season autumn. Common. **Edibility unknown.**

Melanophyllum eyrei (Massee) Sing. syn. *Lepiota eyrei* (Massee) Lange **Cap** 1–3cm across, convex to bell-shaped, granular, cream with ochre-brown centre, veil remnants adhering to margin. **Stem** 15–25×1–2mm, granular, concolorous with cap, often darkening towards the base. **Flesh** white in cap, cream to brownish in stem. **Gills** bluish-green. Spore print pale green. Spores oval, 4–5×2–2.5μ. Cap surface covered with thin-walled globose cells. Habitat amongst *Mercurialis* and moss in broad-leaved woods usually on alkaline soil. Rare. Season late summer to autumn. **Suspect** – avoid.

Melanophyllum echinatum (Roth ex Fr.) Sing. syn. *Lepiota echinata* (Roth ex Fr.) Quél. syn. *L. haematosperma* (Bull. ex Fr.) Quél. s. Fr. **Cap** 1–3cm across, conico-convex becoming bell-shaped and finally expanded, granulate-mealy all over, dirty grey-brown, margin shaggy with velar remains. **Stem** 20–40×1–3mm, vinaceous pink, covered in greyish-brown meal. **Flesh** thin, whitish in cap, vinaceous in stem darkening towards the base. Smell strong. **Gills** deep pink at first soon discolouring vinaceous or brownish-pink. Spore print pallid, dirty grey becoming reddish. Spores elliptic-subcylindric, 5–6×2.5–3.5μ. Mealy covering of cap formed of brown sphaerocysts. Habitat on burnt ground, or the

rich soil of flowerbeds or compost heaps. Season spring to summer. Rare. **Not edible.**

Cystoderma amianthinum ([Scop.] Fr.) Fayod syn. *Lepiota amianthina* ([Scop.] Fr.) Karst. **Cap** 2–5cm across, bell-shaped at first expanding to flattened convex, bright ochre-yellow with mealy surface often becoming indistinctly radially wrinkled with age. **Stem** 30–50×4–8mm, concolorous with cap and mealy-granular below the short-lived ring. **Flesh** thin, yellowish. **Gills** crowded, white at first becoming creamy yellow. Spore print white. Spores elliptic, amyloid, 5–7×3–4μ. Cap cuticle turns red-brown with KOH. Habitat on heaths, or in coniferous woodland. Season autumn. Occasional. **Edible** – not worthwhile.

Drosella fracida (Fr.) Sing. syn. *Lepiota irrorata* Quél. **Cap** 2.5–10cm across, convex, pale yellowish at first then straw-coloured, covered in dew-like drops when fresh which on drying often leave dark brown or blackish spots. **Stem** 30–40×7–10mm, whitish and smooth above the membranaceous ring covered in small yellow or brownish scales below, often exuding yellowish or orange-brown droplets. **Flesh** white. Smell unpleasant. **Gills** white then yellowish cream. Cheilo- and Pleurocystidia abundant, thin-walled, hyaline, clavate or fusiform, and very conspicuous. Spore print white. Spores ovoid, 4–5×4μ. Habitat pasture and open woodland. Season early summer to autumn. Rare. **Edibility unknown.**

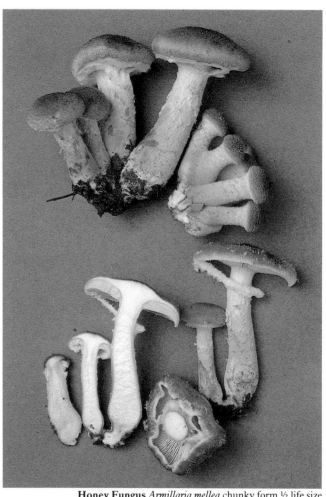

Honey Fungus *Armillaria mellea* chunky form ½ life size

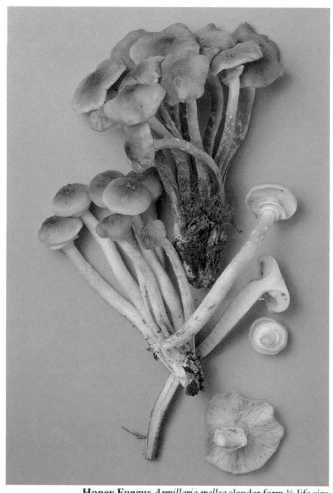

Honey Fungus *Armillaria mellea* slender form ½ life size

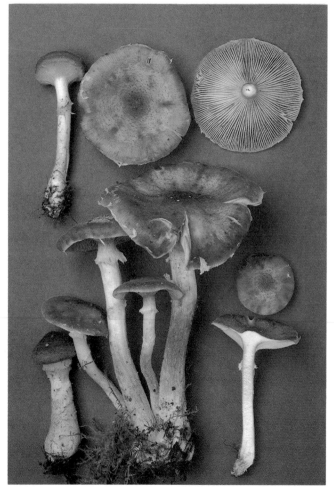

Armillaria polymyces ½ life size

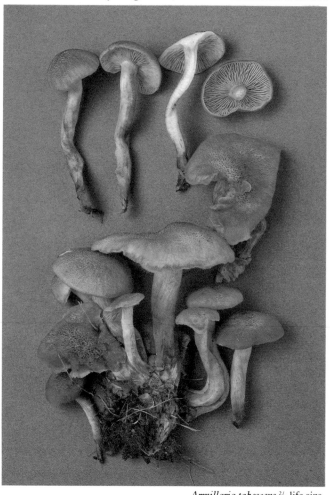

Armillaria tabescens ²/₃ life size

Rhizomorphs of A. mellea ⅔ life size

Honey Fungus or **Boot-lace Fungus** *Armillaria mellea* (Vahl. ex Fr.) Kummer syn. *Clitocybe mellea* (Vahl. ex Fr.) Ricken **Cap** 3–15cm across, very variable, convex then flattened and centrally depressed or wavy, ochre, tawny, to dark brown, often with an olivaceous tinge, covered in darker fibrillose scales especially at the centre. **Stem** 60–150×5–15mm, tapering towards the base or swollen, whitish becoming reddish-brown, initially with a thick whitish to yellow cottony ring. **Flesh** white. Taste astringent, smell strong. **Gills** white at first then yellowish becoming pinkish-brown and often darker spotted with age. Spore print pale cream. Spores elliptic, 8–9×5–6μ. Habitat in dense clusters on or around trunks or stumps of deciduous and coniferous trees. Season summer to early winter. Very common. **Edible** when cooked. The fungus spreads by long black cords called rhizomorphs resembling bootlaces which can be found beneath the bark of infected trees, on roots or in the soil where they can travel large distances to infect other trees. This is one of the most dangerous parasites of trees, causing an intensive white rot and ultimately death; there is no cure and the fungus is responsible for large losses of timber each year.

Some authors now recognize several species previously considered merely as forms of this variable fungus.

A. polymyces (Pers. ex S.F. Gray) Sing. is separated on the basis of the reddish-brown cap with darker brown scales towards the centre, and the white veil and ring.

Armillaria tabescens (Scop. ex Fr.) Emel syn. *Clitocybe tabescens* (Scop. ex Fr.) Bres. **Cap** 4–8cm across, convex then expanded and irregular, ochre brown with darker cottony scales. **Stem** 50–80×8–12mm, tapering towards the base, pale ochre-brown, without a ring. **Flesh** whitish. Taste astringent, smell strong. **Gills** whitish soon becoming pinkish brown. Spore print pale cream. Spores 8–10×5–7μ. Habitat in clusters on stumps or roots especially of oak. Season late summer to early autumn. Rare – readily distinguished from *A. mellea* by the absence of the ring. **Edible** when cooked.

Porcelain fungus or **Poached Egg Fungus** *Oudemansiella mucida* (Schrad. ex Fr.) Kühn. syn. *Armillaria mucida* (Schrad. ex Fr.) Kummer **Cap** 2–8cm across, convex then flattening, pale greyish when young becoming more white often with an ochraceous flush at the centre, semi-translucent, slimy. **Stem** 30–100×3–10mm, white striate above the membranous ring, slightly scaly below. **Flesh** thin, white. Cystidia thin-walled cylindric or utriform. Spore print white. Spores subglobose 13–18×12–15μ. Cap cuticle hymeniform, of erect club-shaped cells. Habitat on the trunks of beech, often high up and in large clusters. Season late summer to late autumn. Common. **Edible** after washing to remove gluten.

Rooting shank *Oudemansiella radicata* (Relh. ex Fr.) Sing. syn. *Collybia radicata* (Relh. ex Fr.) Quél. **Cap** 3–10cm across, bell-shaped to convex then flattened with a broad umbo, pallid or ochraceous to olive-brown, radially wrinkled, slimy. **Stem** 80–200×5–10mm, white at the apex, flushed with cap colour towards the thickened long-rooting base. **Flesh** thin, concolorous. **Gills** broad, white. Spore print white. Spores broadly elliptic, nonamyloid, 12–16×10–12μ. Habitat under or near deciduous trees, especially beech, attached to roots or buried wood. Season early summer to late autumn. Very common. **Edible** – not worthwhile.

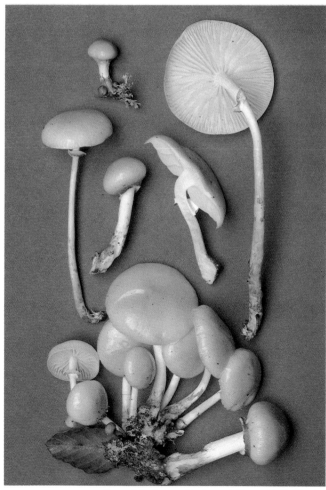

Porcelain fungus *Oudemansiella mucida* ½ life size

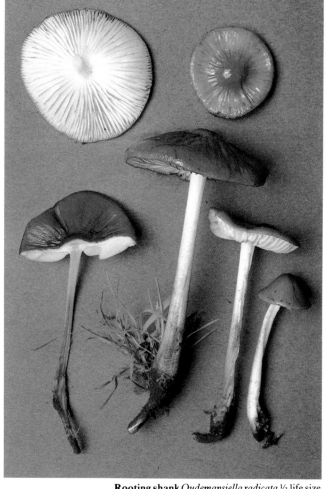

Rooting shank *Oudemansiella radicata* ½ life size

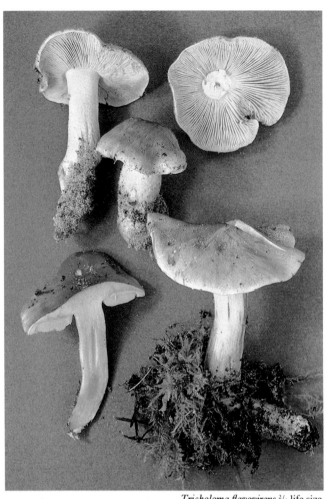

Tricholoma flavovirens ²/₃ life size

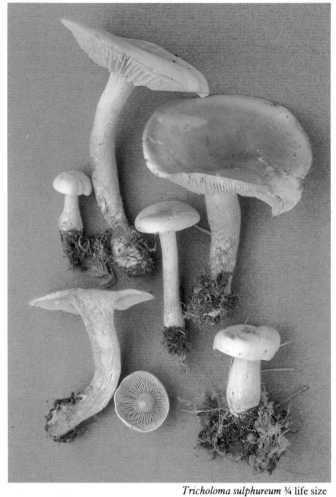

Tricholoma sulphureum ¾ life size

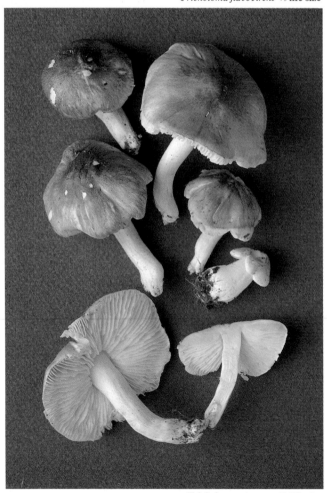

Tricholoma sejunctum ½ life size

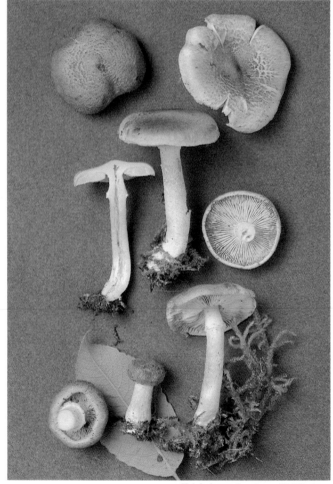

Tricholoma cingulatum ²/₃ life size

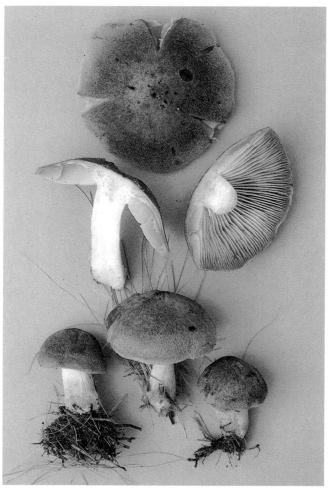

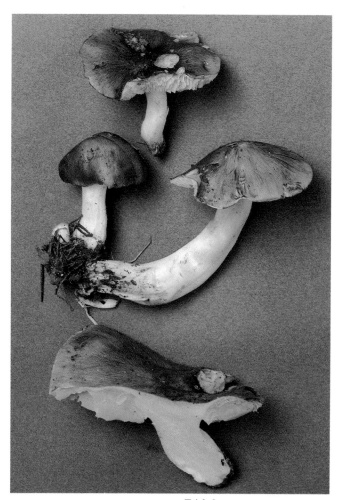

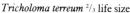

Tricholoma terreum ²/₃ life size

Tricholoma portentosum ½ life size

TRICHOLOMA *They have no ring (with one exception). Observe the quality of the cap surface, is it greasy, dry, scaly or hairy? Some have strong smells, often mealy; in some this can only be observed when cut or crushed. Fifty-three in Britain.*

Tricholoma flavovirens (Pers. ex Fr.) Lund. syn. *T. equestre* (L. ex Fr.) Kummer **Cap** 5–8cm across, expanded convex, bright yellow often with olive-brown or brown disc and either glabrous or with adpressed scales at centre. **Stem** 50–100×8–12mm, pale yellow with brownish flakes. **Flesh** whitish yellow. Taste slightly mushroomy, smell slight, not mealy. **Gills** bright sulphur or lemon yellow. Spore print white. Spores 6–8×3–5μ. Habitat coniferous woods, less frequently with deciduous trees. Season late summer to autumn. Rare – more common in Scotland. **Edible**.

Tricholoma sulphureum (Bull. ex Fr.) Kummer syn. *T. bufonium* (Pers. ex Fr.) Gillet **Cap** 3–8cm across, convex with an indistinct umbo, sulphur-yellow often tinged reddish-brown or olivaceous. **Stem** 25–40×6–10mm, sulphur-yellow covered in reddish-brown fibres. **Flesh** bright sulphur-yellow. Taste mealy, smell strongly of gas-tar. **Gills** bright sulphur-yellow. Spore print white. Spores 9–12×5–6μ. Habitat in deciduous woods, less frequently with conifers. Season autumn. Occasional. **Not edible**.

Tricholoma sejunctum (Sow. ex Fr.) Quél. **Cap** 4–10cm across, conico-convex then expanded, yellowish-green more brown or greyish-brown towards the centre, radially streaky, moist. **Stem** 50–80×10–30mm, white flushed yellowish.

Flesh white, yellowing below the cap cuticle in older specimens. Taste mealy. **Gills** whitish. Spore print white. Spores 5–7×4–5μ. Habitat deciduous woods. Season autumn. Uncommon. **Not edible** – nauseating.

Tricholoma cingulatum (Fr.) Jacobasch syn. *T. ramentacea* (Bull. ex Fr.) Kummer **Cap** 3.5–6cm across, expanded convex with a slight umbo, pale grey covered in fine grey-brown felt. **Stem** 50–80×8–12mm, whitish with a somewhat woolly ring. **Flesh** white. Taste and smell mealy. **Gills** emarginate, whitish. Spore print white. Spores 4–5.5×2.5–3.5μ. Habitat usually with willows. Season late summer to late autumn. Occasional. **Edible**.

Tricholoma terreum (Schaeff. ex Fr.) Kummer **Cap** 4–7cm across, convex with a low broad umbo, light to dark grey, downy to felty. **Stem** 30–80×10–15mm, white and silky smooth. **Flesh** whitish grey. Taste pleasant, not mealy, smell not distinctive. **Gills** emarginate, distant, whitish to grey. Spore print white. Spores 6–7×3.5–4.5μ. Habitat in woods, especially with conifers. Season late summer to late autumn. Uncommon. **Edible**.

Tricholoma portentosum (Fr.) Quél. **Cap** 5–10cm across, conical to bell-shaped, expanding with a broad umbo, light grey to grey-black covered in fine radiating innate streaks often with olivaceous or violaceous tints. **Stem** 40–100×10–20mm, white, often becoming flushed lemon-yellow. **Flesh** white. Taste and smell mealy. **Gills** white then lemon-yellow. Spore print white. Spores 5–6×3.5–5μ. Habitat with conifers. Season autumn. Occasional. **Edible**.

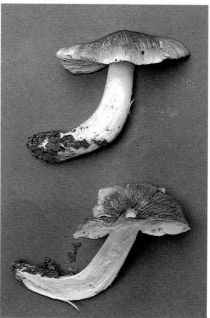

Tricholoma virgatum ²/₃ life size

Tricholoma virgatum (Fr. ex Fr.) Kummer **Cap** 3–7cm across, convex with a low broad umbo, brownish-black or greyish initially with violaceous tints, streaked with very fine black fibrils. **Stem** 50–90×10–18mm, white and smooth, often flushed grey. **Flesh** white to greyish. Taste bitter and peppery, smell musty. **Gills** greyish tinged flesh-colour, often browning at the edges. Spore print white. Spores 6.5–8×5–6μ. Habitat deciduous and coniferous woods. Season autumn. Uncommon. **Not edible**.

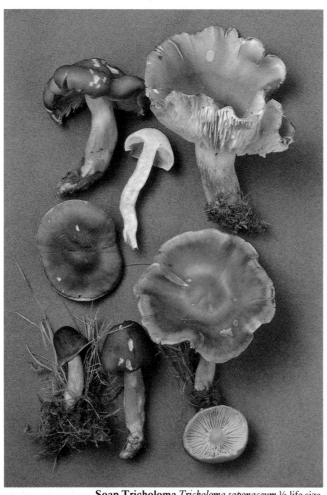

Soap Tricholoma *Tricholoma saponaceum* ½ life size

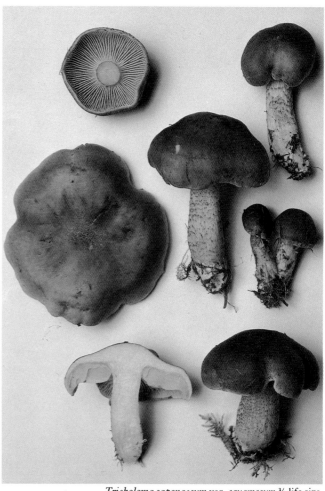

Tricholoma saponaceum var. *squamosum* ¾ life size

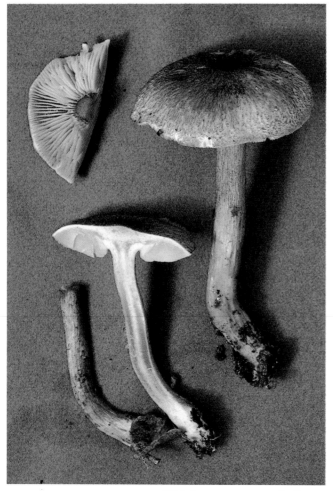

Tricholoma atrosquamosum ²/₃ life size

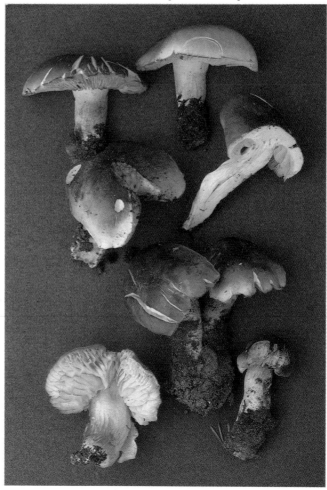

Tricholoma saponaceum showing rusty tints ²/₃ life size

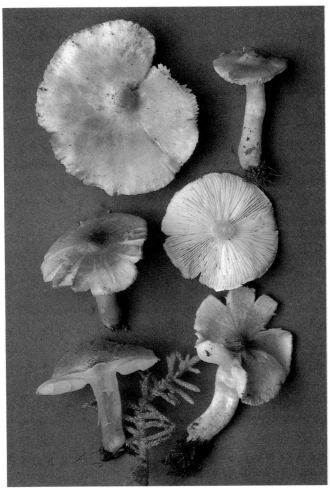

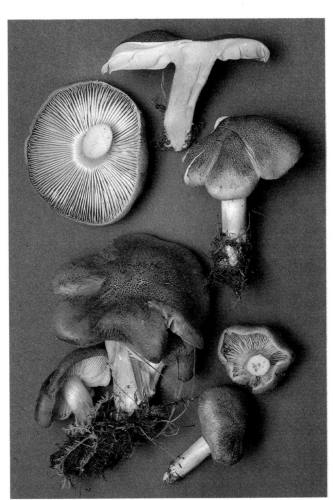

Tricholoma inocybeoides life size

Tricholoma argyraceum ¾ life size

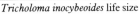

Soap Tricholoma *Tricholoma saponaceum* (Fr.) Kummer **Cap** 5–10cm across, convex at first then expanded with a broad umbo, grey-brown often with rusty or olivaceous tints, darker at the centre. **Stem** 50–100×10–30mm, white with reddish or olivaceous tints. **Flesh** white becoming more or less pink. Taste mushroomy, smell of soap. **Gills** rather distant, whitish sometimes with greenish tints or finally spotted reddish. Spore print white. Spores elliptical, 5–6×3.5–4μ. Habitat in troops in deciduous or coniferous woods. Season late summer to late autumn. Occasional. **Edible** – poor.

Tricholoma saponaceum var. *squamosum* (Cke.) Rea syn. *T. saponaceum* var. *ardosiacum* Bres. Differing from *T. saponaceum* in the dark brown, almost black, scales covering the stem.

Tricholoma atrosquamosum (Chev.) Sacc. syn. *T. terreum* var. *atrosquamosum* (Chev.) Massee **Cap** 4–12cm across, flattened convex with a slight umbo, grey or pale clay densely covered in blackish-grey pointed scales. **Stem** 30–80×10–20mm, paler than the cap, greyish with blackish scales. **Flesh** greyish. Taste slightly mealy, smell aromatic or peppery. **Gills** white to grey with black dotted edge. Spore print white. Spores 4.5–9×3–6μ. Habitat in coniferous and deciduous woods. Season autumn. Rare. **Edible.**

Tricholoma inocybeoides Pearson syn. *T. myomyces* var. *alboconicum* Lange **Cap** 1–4cm across, conical then expanded with an acute

conical umbo, pale grey at first then almost white with scattered minute grey-brown fibres. **Stem** 20–30×5–8mm, whitish often streaked yellowish or brown. **Flesh** whitish to grey-brown. Smell slight and unpleasant. **Gills** white, sometimes yellowing with age. Spore print white. Spores 4.5–6×2.5–3μ. Habitat in deciduous woods especially in open grassy spaces near birch. Season late spring to autumn. Rare. **Edibility unknown.**

Tricholoma argyraceum (Bull. ex St. Amans) Gillet syn. *T. sculpturatum* (Fr.) Quél. syn. *T. chrysites* (Fr.) Gillet **Cap** 4–8cm across, pale grey or grey-brown to almost white, the cuticle often breaking into felty scales leaving the cap even paler in colour, often tinged yellowish-brown at the centre. **Stem** 40–80×6–12mm, white often faintly flushed with the cap colour. **Flesh** white in cap, greyish in stem. Taste and smell mealy. **Gills** emarginate, white becoming spotted with yellow especially when old and beginning to decay. Spore print white. Spores 5–6×3–4μ. Habitat in pine or beech woods. Season early summer to late autumn. Occasional. **Edible.**

Tricholoma orirubens Quél. syn. *T. horribile* Rea **Cap** 4–8cm across, conical then expanded with an acute umbo, dark grey often paler at the margin, covered in black cottony or felty scales. **Stem** 40–80×10–15mm, white becoming flecked with red often marked green or blue at the base, arising from pale sulphur yellow mycelium. **Flesh** white, eventually reddening. Taste not distinctive, smell strongly of meal.

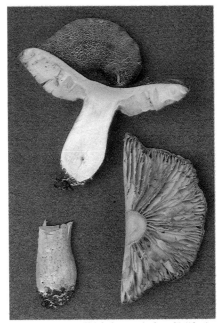

Tricholoma orirubens ⅔ life size

Gills white to greyish when young, then often turning pink and sometimes spotted. Spore print white. Spores broadly ovate to subglobose, 4–6.5×3–4.5μ. Habitat in deciduous, or less frequently, coniferous woods. Season autumn. Rare. **Edible.**

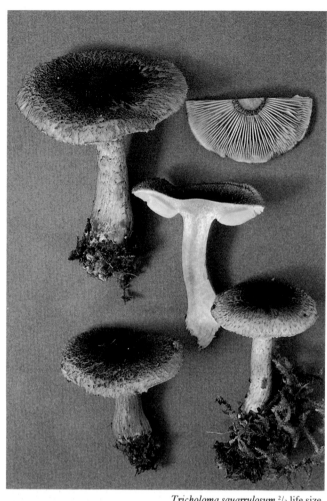

Tricholoma squarrulosum ²/₃ life size

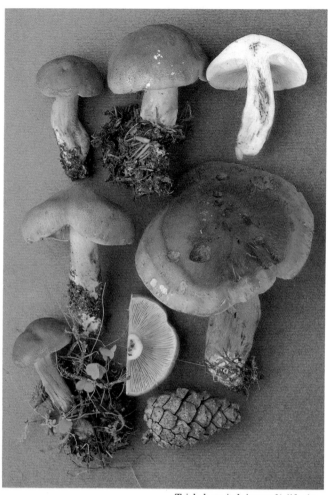

Tricholoma imbricatum ²/₃ life size

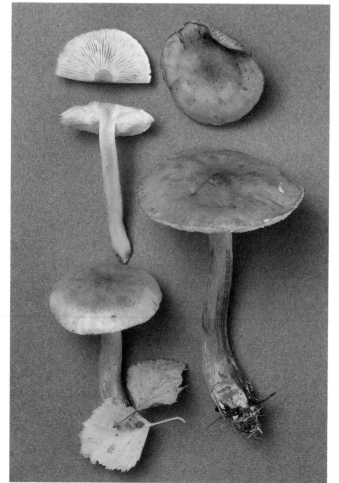

Tricholoma fulvum ²/₃ life size

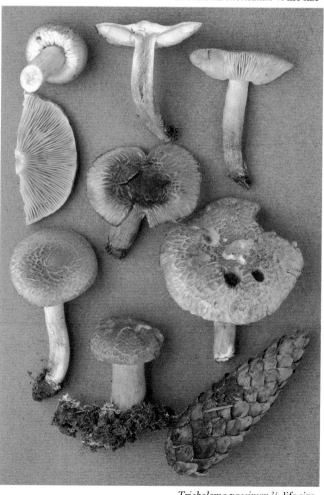

Tricholoma vaccinum ²/₃ life size

Tricholoma squarrulosum Bres. syn. *T. atrosquamosum* var. *squarrulosum* (Bres.) Pearson & Dennis **Cap** 4–5cm across, flattened convex, grey-brown, darker towards the centre, covered in blackish-brown scales. **Stem** 40–50×5–8mm, greyish covered in fine blackish-brown scales. **Flesh** whitish to grey. Smell mealy. **Gills** whitish grey often slightly flesh-coloured. Spore print white. Spores pip-shaped, 7–8×4–5μ. Habitat conifer woods. Season autumn. Rare. **Edible**.

Tricholoma imbricatum (Fr. ex Fr.) Kummer **Cap** 3–9cm across, conico-convex, smooth at first then minutely scaly, dull brown or reddish brown. **Stem** 35–45×10–12mm, whitish at apex, concolorous with cap below. **Flesh** white. Taste slightly bitter. **Gills** whitish becoming spotted reddish-brown. Spore print white. Spores 5–8.5×4–5.5μ. Habitat in coniferous woods, especially with pines. Season autumn. Occasional. **Edible** – not recommended.

Tricholoma fulvum (DC. ex Fr.) Sacc. syn. *T. flavobrunneum* (Fr. ex Pers.) Kummer **Cap** 4–8cm across, expanded convex with a slight umbo, brown to reddish-brown and finely streaky. **Stem** 30–70×8–14mm, concolorous with the cap, fibrous. **Flesh** whitish in cap, yellow in stem. Taste mild, smell mealy. **Gills** yellowish becoming spotted brownish with age. Spore print white. Spores elliptical, 5–7×3–4.5μ. Habitat in deciduous or mixed woods, usually with birches. Season autumn. Common. **Edible** – poor.

Tricholoma vaccinum (Pers. ex Fr.) Kummer **Cap** 4–7cm across, slightly umbonate, flesh-brown, darker towards the centre, disrupting into woolly scales. **Stem** 30–45×8–12mm, fibrous, paler than cap. **Flesh** pallid to rosy, often hollow in stem. Taste bitter, smell mealy. **Gills** white at first, later pallid flesh-colour. Spore print white. Spores ovate, 5–7×4–5μ. Habitat conifer woods. Season late summer to late autumn. Uncommon. **Edible** – poor.

Tricholoma ustale (Fr. ex Fr.) Kummer **Cap** 4–8cm across, convex then expanded, viscid in wet weather, chestnut brown, paler at margin, blackening with age. **Stem** 30–60×10–15mm, fibrous, reddish-brown, apex paler. **Flesh** whitish, sometimes reddening slightly. Taste slightly bitter, smell not distinctive. **Gills** white, becoming rust-spotted, edges blackening with age. Spore print white. Spores elliptic-ovate, 5.5–7×4–5μ. Habitat deciduous woods, especially beech. Season late summer to late autumn. Rare. **Poisonous**.

Tricholoma albobrunneum (Pers. ex Fr.) Kummer **Cap** 5–8cm across, conico-convex, reddish-brown and covered in fine innate radiating fibrils, greasy or viscid. **Stem** 60–80×10–15mm, whitish above the distinctive ring zone but reddish brown below remaining slightly scaly in the upper portion. **Flesh** white tinged brownish below the cap cuticle and towards the stem base. Smell faintly mealy. **Gills** white, reddish-brown with age. Spore print white. Spores broadly elliptical, 5×3–4μ. Habitat with conifers. Season autumn. Rare – found in Scottish pine woods. **Edible** – poor and indigestible.

Tricholoma ustaloides Romagn. **Cap** 4–9cm across, hemispherical to convex, chestnut brown, paler towards the inrolled margin, viscid.

Stem 60–100×8–15mm, white at the apex, rusty-brown and speckled towards the base; a fragile and very short-lived cortina is sometimes present near the top of the stem in young specimens. **Flesh** white. Taste and smell strongly of meal. **Gills** whitish becoming spotted with rust. Spore print white. Spores 6–7×4–5μ. Habitat deciduous woods. Season autumn. Occasional. **Not edible**.

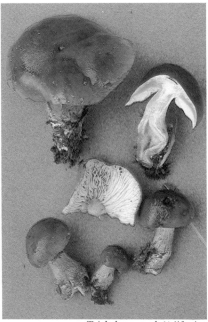

Tricholoma ustale ½ life size

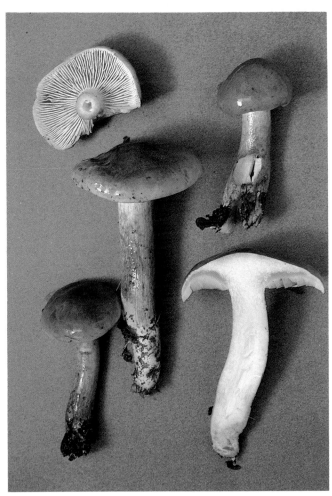

Tricholoma albobrunneum ²/₃ life size

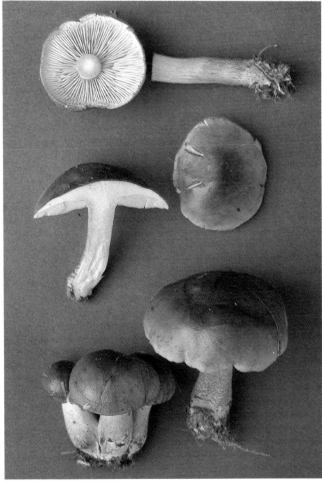

Tricholoma ustaloides ²/₃ life size

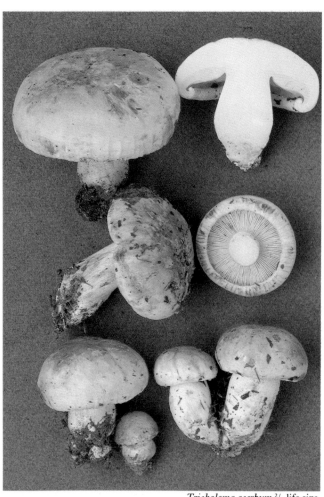

Tricholoma acerbum ²/₃ life size

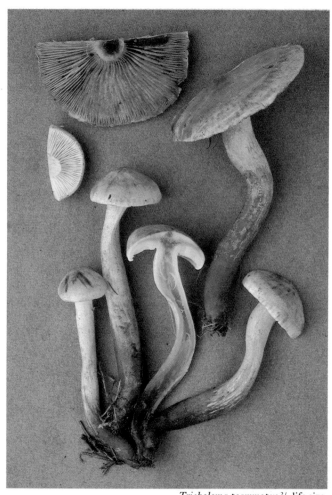

Tricholoma psammopus ²/₃ life size

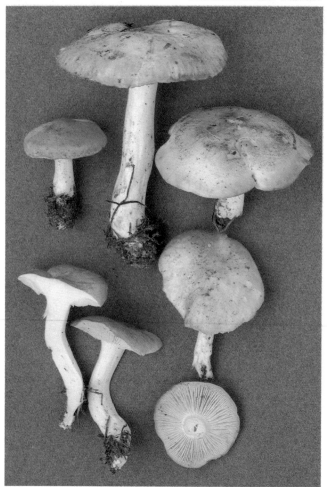

Tricholoma lascivum ²/₃ life size

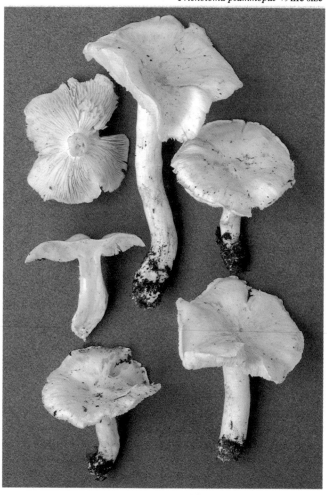

Tricholoma columbetta ²/₃ life size

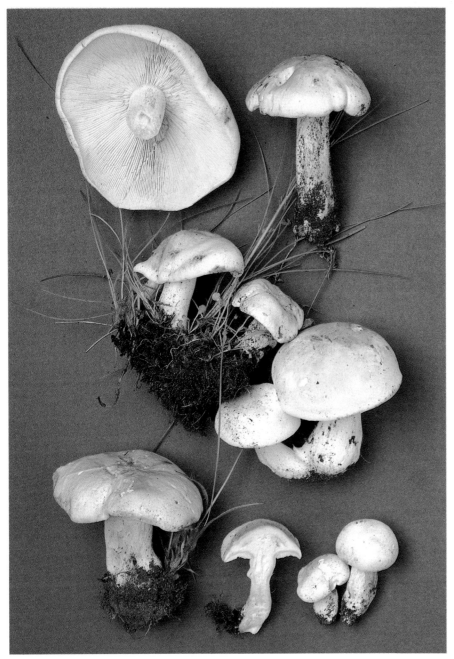

St George's Mushroom *Tricholoma gambosum* ²/₃ life size

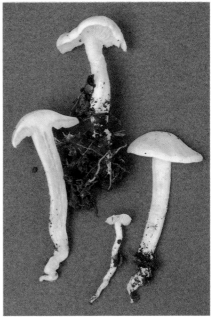

Tricholoma leucocephalum ½ life size

Tricholoma acerbum (Bull. ex Fr.) Quél. **Cap** 7–12cm across, convex, margin strongly incurved, and usually ribbed, yellowish-buff to tan. **Stem** 30–70×20–30mm, bulbous and often pointed at base, apex covered in densely crowded minute yellowish granular scales, becoming yellowish-buff below. **Flesh** thick, white. Taste peppery and bitter, but sometimes mild, smell fruity. **Gills** crowded, whitish to yellowish at first becoming spotted reddish-brown. Spore print white. Spores subglobose to ovate. 4–6×3–4μ. Habitat mixed woodland. Season autumn. Rare. **Slightly poisonous** although eaten in some places after parboiling; of poor quality.

Tricholoma psammopus (Kalchbr.) Quél. **Cap** 3–8cm across, convex then expanded, yellowish-brown to pale tan. **Stem** 40–80×10–15mm, apex whitish, becoming densely covered in minute reddish-brown cottony scales towards the base. **Flesh** yellowish-brown. Taste bitter, smell none. **Gills** white at first then straw-yellow becoming

rust-spotted. Spore print white. Spores 6–7×4–5μ. Habitat under larch. Season autumn. Uncommon. **Not edible.**

Tricholoma lascivum (Fr.) Gillet **Cap** 4–7cm across, convex then flattened and finally slightly depressed, dirty whitish to pallid tan, silky smooth. **Stem** 75–110×10–15mm, white discolouring pale brownish. **Flesh** white. Taste sweet and mealy, smell pleasant, sweet-scented. **Gills** crowded, whitish then cream. Spore print white. Spores elliptic, 6–7×3.5–4μ. Habitat deciduous woods. Season autumn. Uncommon. **Suspect – avoid.**

Tricholoma columbetta (Fr.) Kummer **Cap** 5–10cm across, convex then expanding, silky white sometimes with greenish, pinkish or violet-blue spots when old. **Stem** 40–100×10–20mm, rooting, white sometimes blue-green at base. **Flesh** white, firm. Taste none, smell not

distinctive. **Gills** white, crowded. Spore print white. Spores oval, 5.5–7×3.5–5μ. Habitat deciduous and coniferous woods. Season late summer to early autumn. Occasional. **Edible – good but somewhat fibrous.**

St George's Mushroom *Tricholoma gambosum* (Fr.) Kummer syn. *Calocybe gambosum* (Fr.) Sing. syn. *Lyophyllum georgii* (L. ex Fr.) Kühn. & Romagn. **Cap** 5–15cm across, subglobose then expanding, often irregularly wavy and sometimes cracking, margin inrolled, white. **Stem** 20–40×10–25mm, white. **Flesh** white, soft. Taste and smell mealy. **Gills** narrow, very crowded, whitish. Spore print white. Spores elliptical, 5–6×3–4μ. Habitat in grass on roadsides and wood edges or in pastureland. Season found traditionally on 23 April, St George's Day, whence it gets its name although more frequently maturing a week or so later. Occasional. **Edible – good.**

Tricholoma leucocephalum (Fr.) Quél. syn. *Lyophyllum leucocephalum* (Fr.) Sing. **Cap** 3–6cm across, convex, sometimes with an obtuse umbo, silky white occasionally tinged yellow at the centre, smooth. **Stem** 40–60×5–10mm, rooting at the tapering twisted base, white, smooth. **Flesh** white. Smell mealy. **Gills** crowded, white. Spore print white. Spores ovoid, distinctly warted, 7–10×4–6μ. Habitat broad-leaved woods. Season late summer to autumn although this collection was made on 8 July. Rare. **Edibility unknown.**

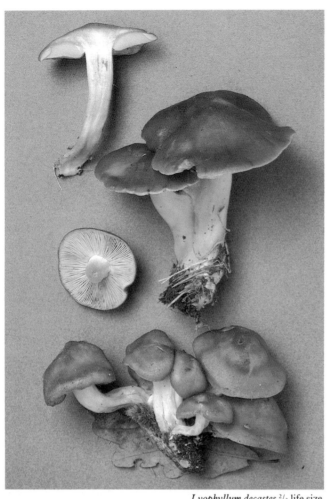

Lyophyllum decastes ²/₃ life size

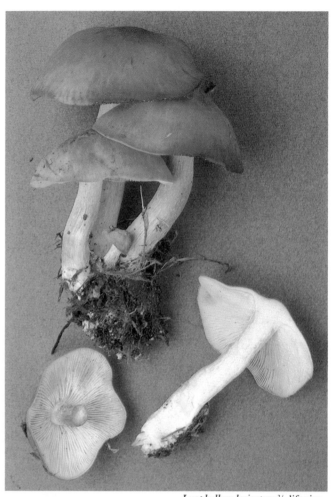

Lyophyllum loricatum ²/₃ life size

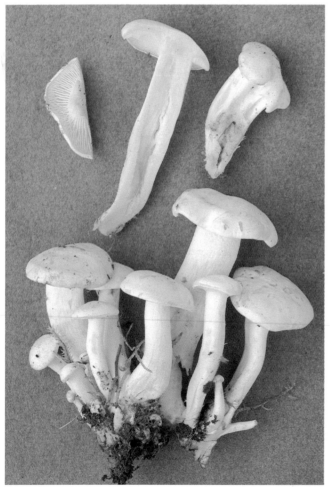

Lyophyllum connatum ²/₃ life size

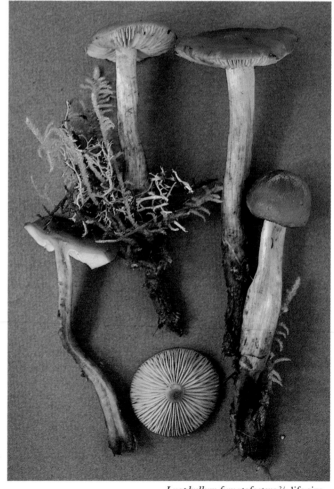

Lyophyllum fumatofoetens ²/₃ life size

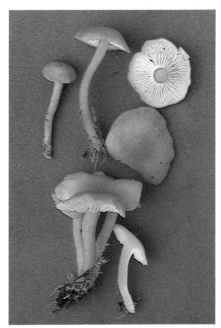

Calocybe carnea ¾ life size

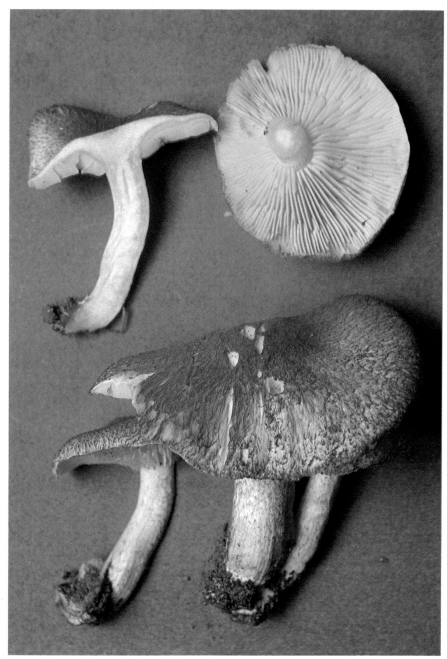

Plums and Custard *Tricholomopsis rutilans* ¾ life size

Lyophyllum decastes (Fr. ex Fr.) Sing. syn. *Clitocybe decastes* (Fr. ex Fr.) Kummer syn. *Tricholoma aggregatum* (Schaeff. ex Secr.) Gill. **Cap** 4–10cm across, convex then expanded, becoming wavy, grey-brown to brown, with silky or silvery streaks. **Stem** 30–60×10–20mm, tough, fibrous, often excentric, white at apex becoming brownish towards the base. **Flesh** whitish. Taste and smell not distinctive. **Gills** white to greyish. Spore print white. Spores subglobose, 5–7×5–6μ. Habitat in clusters on the ground in open woodland. Season summer to autumn. Occasional. **Edible – good.**

Lyophyllum loricatum (Fr.) Kühn. syn. *Tricholoma cartilagineum* (Bull. ex Fr.) Gillet **Cap** 5–12cm across, convex, later expanded and slightly depressed or umbonate, sepia to pale chestnut, cuticle cartilaginous. **Stem** 50–100×10–15mm, white to greyish-buff, apex white and floury, base somewhat rooting. **Flesh** white, firm. Taste sweet with a bitter aftertaste, smell slight or nutty. **Gills** white later straw-coloured. Spore print white. Spores globose, 6–7μ in diameter. Habitat deciduous and mixed woodland. Season summer to autumn. Rare. **Edible.**

Lyophyllum connatum (Schum. ex Fr.) Sing. syn. *Clitocybe connata* (Schum. ex Fr.) Gillet **Cap** 3–7cm across, pure white, margin often wavy. **Stem** 30–60×8–15mm, tapering towards the base, white. **Flesh** white. **Gills** slightly decurrent, white. Spore print white. Spores 6–7×3.5–4μ. Flesh and gills gradually turn violet with FeSO₄. Habitat in dense tufts amongst grass

in mixed woodland. Season autumn. Uncommon. **Edibility unknown.**

Lyophyllum fumatofoetens (Secr.) Schaeff. syn. *L. leucophaeatum* (Karst.) Karst. syn. *Collybia leucophaeatum* (Karst.) Karst. **Cap** 3–7cm across, convex then flattened, dark grey-brown sometimes with innate fibrils, often bruising black especially at margin. **Stem** 35–70×7–10mm, slightly rooting, whitish above, greying below, bruising blackish. **Flesh** grey-brown becoming black when cut. Smell fetid. **Gills** pallid bruising black. Spore print white. Spores oblong, very minutely ornamented, 6–9×2.5–4μ. Habitat with pines. Season autumn. Rare. **Edibility unknown.**

Calocybe carnea (Bull. ex Fr.) Kühn. syn. *Tricholoma carneum* (Bull. ex Fr.) Kummer syn. *Lyophyllum carneum* (Bull. ex Fr.) Kühn. & Romagn. **Cap** 1.5–4cm across, flattened convex, distinctive flesh-pink colour flushed brown at the centre. **Stem** 20–40×3–7mm, concolorous with

cap. **Flesh** whitish. Taste and smell not distinctive. **Gills** white. Spore print white. Spores elliptical, 4.5–5.5×2.5–3μ. Habitat in grassland, often in small clumps. Season late summer to autumn. Occasional. **Edible.**

Plums and Custard *Tricholomopsis rutilans* (Schaeff. ex Fr.) Sing. syn. *Tricholoma rutilans* (Schaeff. ex Fr.) Kummer **Cap** 4–12cm across, convex to bell-shaped when expanded often with a low broad umbo, yellow densely covered in reddish-purple downy tufts or scales, more densely covered at the centre. **Stem** 35–55×10–15mm, yellow covered in fine downy purplish scales like the cap but to a much lesser extent; no mycelial strands. **Flesh** pale yellow or cream. Taste watery, smell like rotten wood. **Gills** rich egg-yellow. Cheilocystidia thin-walled, voluminous, 20–30μ wide. Spore print white. Spores ellipsoid, 6–8.5×4–5μ. Habitat on and around conifer stumps. Season late summer to late autumn. Very common. **Considered edible** by some but not recommended.

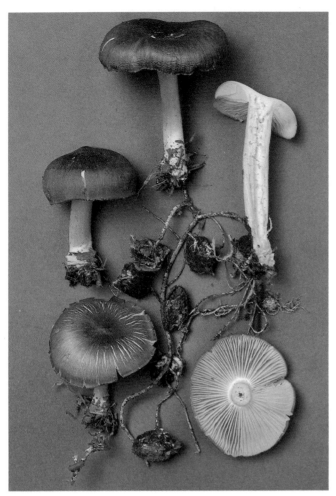

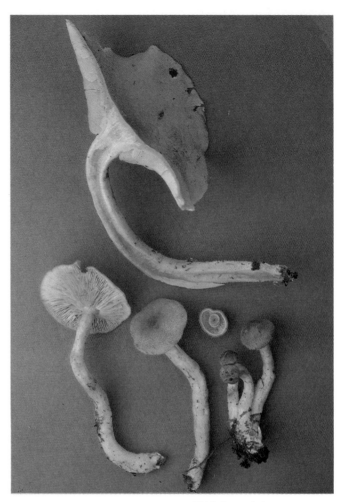

Tricholomopsis platyphylla ½ life size

Tricholomopsis decora ½ life size

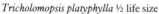

Tricholomopsis platyphylla (Pers. ex Fr.) Sing. syn. *Oudemansiella platyphylla* (Pers. ex Fr.) Moser syn. *Collybia platyphylla* (Pers. ex Fr.) Kummer **Cap** 4–10cm across, hemispherical soon expanded with depressed centre, dark grey-brown with an ochraceous tint, somewhat streaky surface sometimes disrupting in minute scurfy scales towards the margin. **Stem** 30–50 × 10–13mm, tough, whitish fibrillosely striate often flushed with cap colour, passing into long rooting mycelial strands. **Flesh** white. Taste bitter, smell not distinctive. **Gills** very broad, whitish cream. Cheilocystidia thin-walled, swollen pear-shaped, 50–60 × 15–25μ. Spore print white. Spores subglobose 6–8 × 6–7μ. Habitat attached to deciduous stumps or pieces of buried wood by the tough white mycelial strands. Season summer to autumn. Common. **Not edible.**

Tricholomopsis decora (Fr.) Sing. syn. *Tricholoma decorum* (Fr.) Quél. **Cap** 6–17cm across, convex at first becoming centrally depressed, deep golden yellow covered in tiny brownish-black fibrillose scales especially at the centre. **Stem** 80–180 × 5–15mm, yellow. **Flesh** deep yellow. Taste and smell not distinctive. **Gills** deep yellow. Cheilocystidia large, thin-walled, club-shaped, 20–30μ wide. Spores elliptic 6–8 × 4–5μ. Habitat on conifer stumps in northern regions. Season late summer to late autumn. Rare. **Edibility unknown.**

MELANOLEUCA *Look out for broad flat caps with a central umbo. The flesh of the stem may be dark. Nine in Britain.*

Melanoleuca cognata (Fr.) Konrad & Maubl. syn. *Tricholoma cognatum* (Fr.) Gillet **Cap** 4–10(12)cm across, expanded convex and umbonate, ochre-brown to grey-brown, shiny. **Stem** 60–120 × 10–15mm, swollen at the base, cream flushed ochre to grey-brown. **Flesh** whitish to cream. Taste sweetish, smell floury. **Gills** ochraceous cream. Cheilocystidia thin-walled, hyaline, lanceolate, sometimes encrusted with crystals at apex. Spore print ochraceous cream. Spores elliptic, minutely warted, amyloid 9–10 × 5.5–6μ. Habitat coniferous woods. Season spring and autumn. Occasional. **Edible.**

Melanoleuca grammopodia (Bull. ex Fr.) Pat., syn. *Tricholoma grammopodium* (Bull. ex Fr.) Quél. **Cap** 7–15cm across, bell-shaped then expanded, often becoming centrally depressed, light to dark grey-brown. **Stem** 50–120 × 10–15mm, swollen at the base, grey brown and longitudinally fibrillose. **Flesh** whitish. Smell mouldy, or of mice. **Gills** white becoming dirty cream with age. Cheilocystidia thin-walled, hyaline, with swollen base and long narrow neck. Spore print white. Spores elliptic, minutely warted, amyloid, 8.5–9.5 × 5–6μ. Habitat deciduous woods or meadows. Season autumn. Uncommon. **Edible.**

Melanoleuca melaleuca (Pers. ex Fr.) Murr. syn. *Tricholoma melaleucum* (Pers. ex Fr.) Kummer **Cap** 3–8cm, convex then flattened, often slightly depressed with a central boss, smooth, dark brown when moist drying buff. **Stem** 40–70 × 8–14mm, slightly bulbous, whitish covered in dark grey-brown longitudinal fibres. **Flesh** white in cap, flushed ochraceous to ochre-brown from stem base upwards. Taste and smell not distinctive. **Gills** crowded, sinuate, whitish to cream. Cheilocystidia thin-walled, hyaline, harpoon-shaped. Spore print cream. Spores elliptic, minutely ornamented, amyloid, 7–8.5 × 5–5.5μ. Habitat woods and pastures. Season late summer to late autumn. Common. **Edible** – not recommended.

Melanoleuca arcuata (Fr.) Sing. s. Bresinsky & Stangl. syn. *Tricholoma friesii* Bres. **Cap** 4–12cm, flattened convex, slightly umbonate or centrally depressed, reddish-brown to blackish-brown when moist drying grey-brown. **Stem** 30–60 × 5–13mm, bulbous, whitish and mealy at apex, grey-brown and smooth below. **Flesh** white or tinged ochraceous in cap, brown in stem becoming darker towards the base. Taste and smell not distinctive. **Gills** white. Cheilocystidia thin-walled, lanceolate. Spore print white. Spores elliptic, minutely ornamented, amyloid, 7–9 × 4.5–5.5μ. Habitat amongst grass in open woodland. Season autumn. Frequent. **Edibility unknown.**

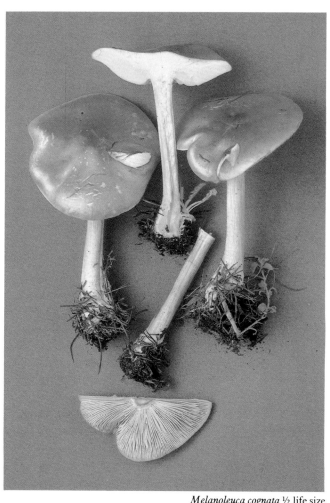

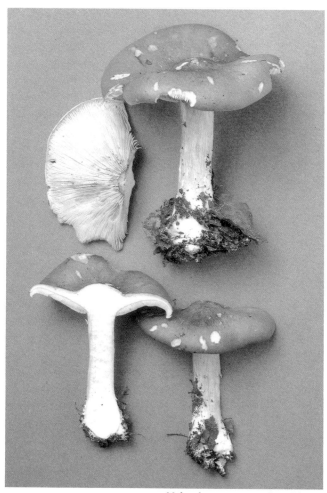

Melanoleuca cognata ½ life size

Melanoleuca grammopodia ⅓ life size

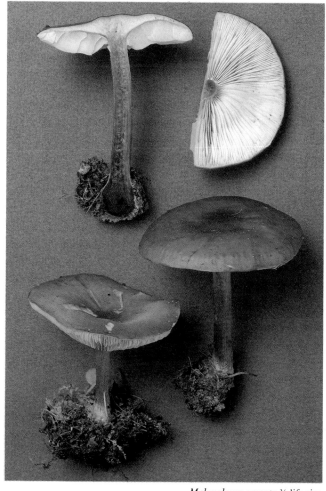

Melanoleuca melaleuca ¾ life size

Melanoleuca arcuata ¾ life size

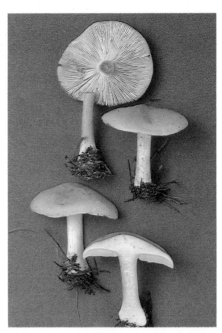

Melanoleuca strictipes ½ life size

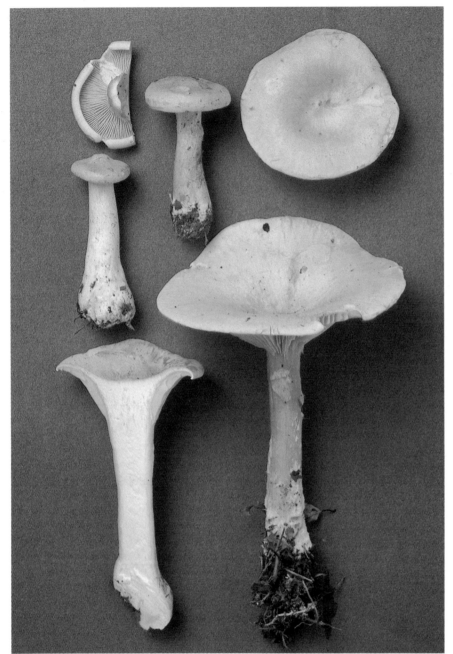

Clitocybe geotropa ½ life size

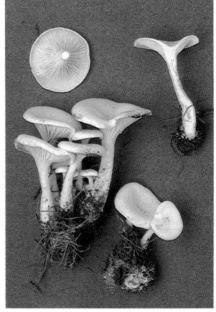

Clitocybe ericetorum ½ life size

CLITOCYBE *The gills are decurrent (running down the stem) often strongly so. The caps are often funnel-shaped with an umbo as well. Many have strong distinctive smells of meal or aniseed. Fifty-eight in Britain.*

Clitocybe geotropa (Bull. ex St. Amans.) Quél. syn. *C. maxima* ([Fl. Wett.] Fr.) Kummer **Cap** 4–20cm across, convex at first with a prominent broad umbo, becoming depressed, the margin remaining strongly incurved, pale yellowish buff when young later more flesh-coloured. **Stem** 50–150×20–30mm, swollen and slightly downy at the base, concolorous with the cap or paler. **Flesh** white. Smell faint and sweet. **Gills** decurrent, concolorous with cap. Spore print white. Spores subglobose, 6.5–7×5–6μ. Habitat in open deciduous or mixed woodland or grassy clearings, often in rings or troops. Season autumn. Occasional. **Edible – good.**

Melanoleuca strictipes (Karst.) Schaeff. syn. *M. evenosa* (Sacc.) Konrad & Maubl. **Cap** 4–10cm across, convex and slightly umbonate, white to cream or pallid, sometimes darker at the centre. **Stem** 80–140×8–12mm, swollen at the base or bulbous, concolorous with cap or paler, fibrous and often twisted. **Flesh** thick, white. Taste slight, smell strongly of meal. **Gills** white to cream sometimes slightly tinged pinkish. Cheilocystidia thin-walled, hyaline, lanceolate often encrusted with crystals at apex. Spore print white. Spores elliptic, minutely warted, amyloid, 8–9×4.5–5μ. Habitat amongst grass in open woodland or pasture. Season early summer to autumn. Rare. **Edible.**

Clitocybe ericetorum (Bull.) Quél. **Cap** 2–5cm across, flattened convex with a central depression becoming widely funnel-shaped, white then yellow-cream. **Stem** 30–40×3–5mm, concolorous with cap, downy. **Flesh** white.

Taste mild to slightly bitter, smell none. **Gills** decurrent, widely spaced, white then yellow-cream. Spore print white. Spores subglobose to ovate, 4–5×2–3μ. Habitat heathland, often amongst heather. Season summer. Rare. **Edibility unknown.**

Leucopaxillus giganteus (Sow. ex Fr.) Sing. syn. *Clitocybe gigantea* (Sow. ex Fr.) Quél. **Cap** 8–30cm across, flat at first soon deeply funnel-shaped, ivory finally flushed tan at the centre and often cracked or scaly, margin inrolled. **Stem** 40–70×25–35mm, whitish, tough. **Flesh** white. Taste and smell faint but pleasant. **Gills** decurrent, crowded and forked, creamy. Spore print white. Spores smooth, amyloid, 6.5–7×3–4μ. Habitat amongst grass in pastures, hedgerows or on roadsides, often in rings. Season late summer to late autumn. Uncommon. **Edible.**

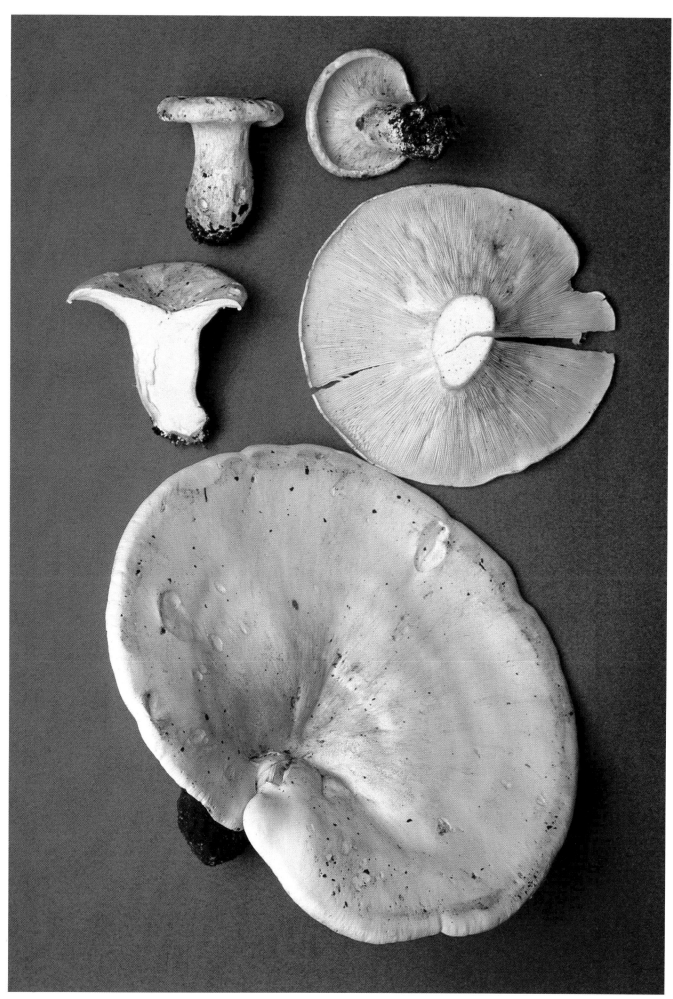

Leucopaxillus giganteus ½ life size

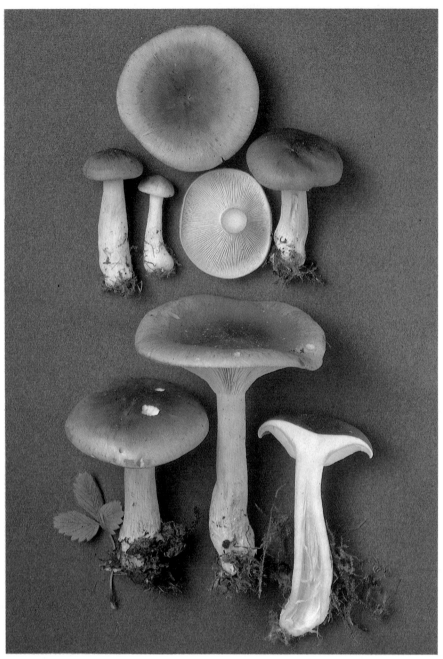

Clouded Agaric *Clitocybe nebularis* ½ life size

Clouded Agaric *Clitocybe nebularis* (Batsch. ex Fr.) Kummer **Cap** 5–20cm across, convex at first becoming flattened or occasionally slightly depressed in the centre, the margin remaining inrolled, cloudy grey sometimes tinged with buff, darker at the centre and often covered with a white bloom. **Stem** 50–100×15–25mm, swollen towards the base, paler than the cap, fibrous and easily broken. **Flesh** thick, white, becoming hollow in the stem. Smell strong and sweetish. **Gills** decurrent, crowded, whitish later with a yellow flush. Spore print cream. Spores ovoid-elliptical, 5.5–8×3.5–5μ. Habitat in deciduous or coniferous woods often in rings or troops. Season late summer to late autumn. Common. **Said to be edible** but known to cause gastric upsets in many people.

C. nebularis var. *alba* differs only in the milk-white cap and can be distinguished from other white fleshy Clitocybes by its relatively large spores.

Club Foot *Clitocybe clavipes* (Pers. ex Fr.) Kummer **Cap** 4–8cm across, flattened-convex with a slight umbo at first, later slightly depressed, grey-brown or with an olivaceous tint paling towards the white margin. **Stem** 30–70×10–15mm, greatly swollen at the base and tapering upwards from there, paler than the cap, covered in silky fibres. **Flesh** thick, white, becoming spongy and more yellow towards the stem base. Smell strong and sweet. **Gills** deeply decurrent, narrow, pale creamy yellow. Spore print white. Spores subglobose to elliptical, 4.5–5×3.5–4μ. Habitat in coniferous and deciduous woods especially with beech. Season late summer to late autumn. Frequent. **Not edible.**

Common Funnel Cap *Clitocybe infundibuliformis* (Schaeff. ex Weinm.) Quél. **Cap** 3–8cm across, funnel-shaped often with a wavy margin, pale pinkish buff to ochre, silky smooth. **Stem** 30–80×5–10mm, pale buff, tough and slightly swollen towards the base. **Flesh** whitish to buff. Smell faint and sweet. **Gills** decurrent, crowded, whitish. Spore print white. Spores pip-shaped, 6–7×3.5–4μ. Habitat in deciduous woodland or on heaths. Season summer to late autumn. Common. **Edible.**

Tawny Funnel Cap *Clitocybe flaccida* (Sow. ex Fr.) Kummer syn. *C. inversa* (Scop. ex Fr.) Quél. syn. *Lepista flaccida* (Sow. ex Fr.) Pat. **Cap** 5–9cm across, flattened-convex at first then broadly infundibuliform, pale ochraceous buff darkening to tawny with age. **Stem** 25–50×5–10mm, paler than the cap, woolly at the base. **Flesh** thin, pale cream to tan, stem becoming hollow. **Gills** deeply decurrent, narrow and crowded, whitish yellow. Spore print white. Spores subglobose, minutely roughened, 4–4.5×3.5–4μ. Habitat in leaf litter in deciduous or coniferous woods, often in clustered groups. Season summer to early winter. Frequent. **Edible** – poor.

Aniseed Toadstool or **Blue-green Clitocybe** *Clitocybe odora* (Bull. ex Fr.) Kummer syn. *C. viridis* (With. ex Fr.) Gillet **Cap** 3–8cm across, convex at first with a low broad umbo, later expanding and becoming irregular and wavy at the margin, blue-green, greyish or flushed greenish. **Stem** 30–60×5–10mm, flushed with cap colour, base covered in fine white down. **Flesh** whitish to pale tan. Taste and smell strongly of aniseed. **Gills** slightly decurrent, whitish tinged with cap colour. Spore print white. Spores ellipsoid, 6–7.5×3–4μ. Habitat in leaf litter of deciduous woods, especially beech. Season summer to late autumn. Frequent. **Edible** – due to its strong aromatic taste it is best used as a flavouring rather than a main dish.

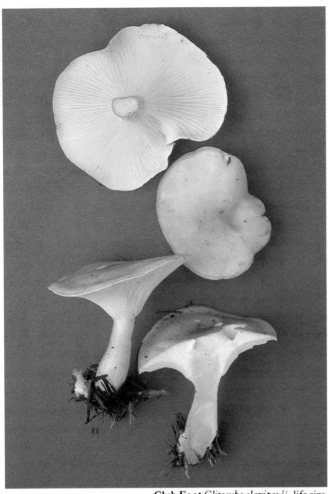

Club Foot *Clitocybe clavipes* ²/₃ life size

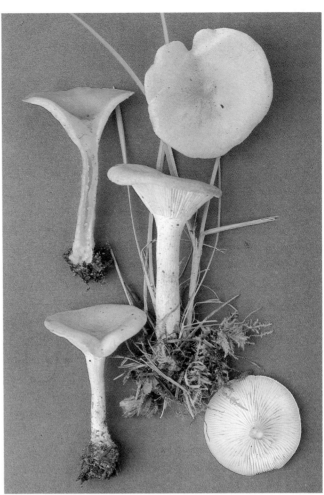

Common Funnel Cap *Clitocybe infundibuliformis* ²/₃ life size

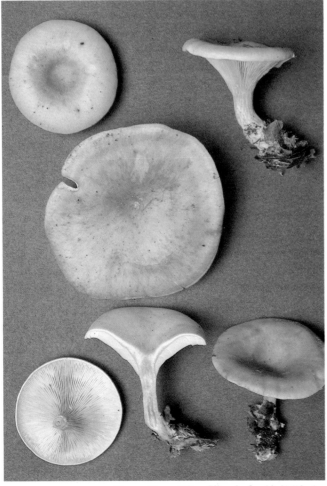

Tawny Funnel Cap *Clitocybe flaccida* ²/₃ life size

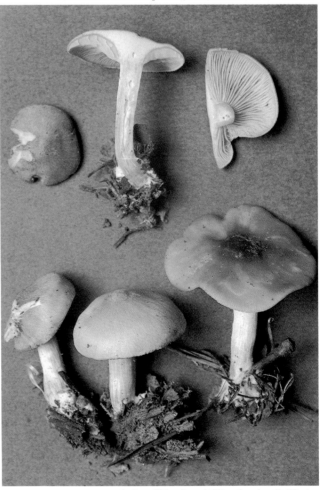

Aniseed Toadstool *Clitocybe odora* ²/₃ life size

49

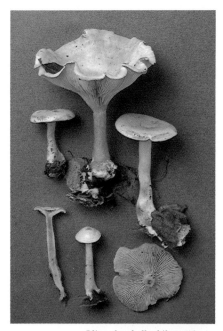

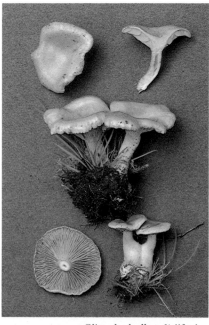

Clitocybe phyllophila ½ life size

Clitocybe dealbata ⅔ life size

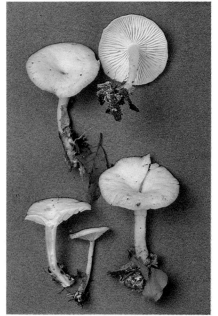

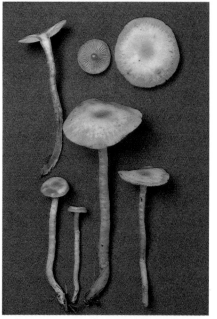

Clitocybe houghtonii ½ life size

Clitocybe fragrans ⅔ life size

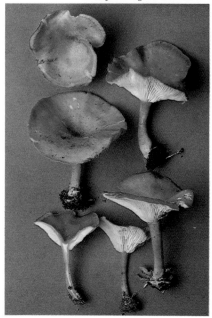

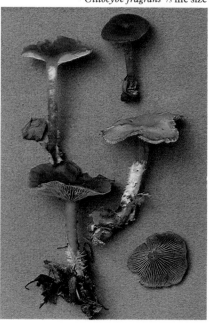

Clitocybe sinopicoides ⅔ life size

Clitocybe ditopus ⅔ life size

Clitocybe phyllophila (Fr.) Kummer **Cap** 3–10cm across, convex at first later irregularly funnel-shaped with a wavy margin, covered in a dull white bloom later flushed pale ochraceous or flesh-colour. **Stem** 40–65×8–15mm, concolorous with cap or light tan, swollen at the base which is covered in white down. **Flesh** whitish to tan. Smell sweetish. **Gills** decurrent, crowded, whitish to flesh-coloured. Spore print pale ochraceous-clay. Spores broadly ovate, 4–4.5×3–3.5μ. Habitat leaf litter in deciduous woods. Season autumn. **Edibility unknown.**

Clitocybe dealbata (Sow. ex Fr.) Kummer syn. *C. rivulosa* subsp. *dealbata* (Sow. ex Fr.) Konrad & Maubl. **Cap** 2–4cm across, flattened-convex becoming slightly depressed, buff dusted white. **Stem** 20–35×5–10mm, whitish, mealy at the apex. **Flesh** thin except for the centre of the cap, whitish. Smell faint, mealy. **Gills** adnate to decurrent, crowded, whitish or cream. Spore print white. Spores broadly ovate, 4–5.5×2–3μ. Habitat in lawns and pastureland often in troops or rings. Season summer to late autumn. Frequent. **Deadly poisonous.**

Clitocybe houghtonii (Berk. & Br.) Dennis syn. *Omphalia roseotincta* Pearson **Cap** 2–8cm across, initially convex becoming flattened and often deeply depressed at the centre, pale pinkish-buff when fresh drying almost white. **Stem** 30–80×3–8mm, concolorous with cap, often developing an apical ring-like swelling as the fungus dries. **Flesh** thin, white. Smell sweetish, reminiscent of crushed tomato leaves. **Gills** crowded, decurrent, pinkish-cream. Spore print white. Spores elliptic, nonamyloid, 5–6.5×3–4μ. Habitat gregarious in beech litter. Season late summer to late autumn. Rare. **Edibility unknown.**

Clitocybe fragrans (Sow. ex Fr.) Kummer **Cap** 1.5–4cm across, flattened-convex sometimes slightly depressed, hygrophanous, pale yellowish-brown when wet, whitish cream when dry with darker centre, finely lined at the margin. **Stem** 30–60×3–6mm, concolorous with cap. **Flesh** thin, whitish to buff. Smell of aniseed. **Gills** adnate to slightly decurrent, whitish buff. Spore print white. Spores ellipsoid, 7–8×3.5–4μ. Habitat amongst leaf litter, moss or grass beneath deciduous trees. Season late summer to early winter. Uncommon. **Edible** but best avoided due to possible confusion with poisonous species.

Clitocybe sinopicoides Peck. **Cap** 2–5cm across, tan to light chestnut, soon funnel-shaped and irregularly wavy towards the margin, more or less downy. **Stem** 20–35×3–12mm, concolorous with the cap, base covered in fine white down. **Flesh** thin, whitish to tan. Smell strong, mealy. **Gills** decurrent, white becoming tinged flesh-colour. Spore print white. Spores broadly elliptic, 6–8×3–4μ. Habitat in coniferous woods especially in burnt areas. Season spring. Rare. **Edibility unknown.**

Clitocybe ditopus (Fr. ex Fr.) Gillet syn. *C. ditopoda* Fr. **Cap** 2–4cm across, flattened-convex with depressed centre soon becoming infundibuliform, dark grey-brown drying paler, with a pale, almost white margin. **Stem** 25–40×4–8mm, grey-brown covered in long white cottony fibre towards the base. **Flesh** thin, brown, becoming hollow in the stem. Smell mealy. **Gills** adnate to slightly decurrent, rather crowded, dark grey. Spore print white. Spores subglobose, 3–3.5×2.5–3μ. Habitat in conifer woods. Season autumn. Uncommon. **Edibility unknown.**

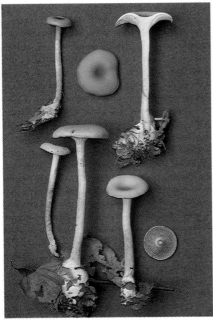

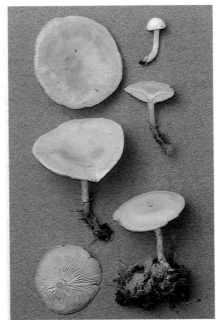

Clitocybe dicolor (Pers.) Lange **Cap** 3–5cm across, flattened-convex at first, soon deeply depressed, white when dry, pale tan-buff when moist with darker centre. **Stem** 30–60×4–8mm, tough, concolorous with cap, darkening below, with white silky fibres along its length. **Flesh** thin, tan-buff becoming hollow in stem. Smell none or faint, not mealy. **Gills** slightly decurrent, crowded, white to greyish. Spore print white. Spores ovate, 6–7×3.5–4μ. Habitat coniferous and deciduous woods. Season autumn. Occasional. **Edibility unknown.**

Clitocybe rivulosa (Pers. ex Fr.) Kummer **Cap** 2–5cm across, convex at first then flattened and depressed in the centre, the margin remaining slightly inrolled, powdered white often with concentric rings or markings where the flesh-coloured basic tint shows through. **Stem** 20–40×4–10mm, concolorous with cap, slightly woolly at the base. **Flesh** white to buff. Smell sweet. **Gills** decurrent, crowded, whitish to buff. Spore print white. Spores ovoid-ellipsoid, 4–5.5×2.5–3.5μ. Habitat in troops or rings in sandy soil amongst grass, often on path edges or roadsides. Season late summer to late autumn. Common. **Deadly poisonous.**

Clitocybe vibecina (Fr.) Quél. **Cap** 1.5–5cm across, flattened-convex becoming depressed in the centre, light grey-brown with faintly striate margin when moist, drying cream. **Stem** 30–50×3–8mm, paler than the cap, covered in fine white down towards the base in young specimens. **Flesh** thin, whitish to buff. Taste and smell of meal. **Gills** decurrent, pale grey-brown. Spore print white. Spores ellipsoid, 5.5–7×3.5–4μ. Habitat in coniferous or mixed woodland and heaths, often under bracken. Season autumn. Common. **Edible.**

Clitocybe hydrogramma (Bull. ex Fr.) Kummer syn. *Omphalia hydrogramma* (Bull. ex Fr.) Quél. **Cap** 2–5cm across, convex to depressed at first becoming funnel-shaped, hygrophanous, drying almost white. **Stem** 50–80×3–6mm, cartilaginous, concolorous with cap or paler, base downy. **Flesh** whitish, stem hollow. Smell strong, unpleasant. **Gills** deeply decurrent, rather widely spaced, pallid. Spore print white. Spores elliptic, 5–6.5×3–3.5μ. Surface of cap showing conspicuous inflated hyphal segments varying in shape from globose to fusoid up to 20μ wide. Habitat deciduous woods. Season autumn. Occasional. **Edibility unknown.**

Clitocybe asterospora (Lange) Moser apud Gams syn. *Omphalia asterospora* Lange **Cap** 1–2cm across, flattened convex or slightly depressed, brown to grey-brown and distinctly striate when moist, drying whitish. **Stem** 20–30×2–3mm, concolorous with cap. **Flesh** thin, pallid. Smell mealy. **Gills** slightly decurrent, lighter than cap. Spore print white. Spores subglobose with sparse blunt spines, 4–8μ in diameter. Habitat amongst moss near pines. Season winter to spring. Rare. **Edibility unknown.**

The Goblet *Cantharellula cyathiformis* (Bull. ex Fr.) Sing. syn. *Clitocybe cyathiformis* (Bull. ex Fr.) Kummer **Cap** 2–7cm across, funnel-shaped with a strongly inrolled margin, dark grey-brown to umber drying paler. **Stem** 40–80×5–10mm, paler than the cap with a silky white fibrous covering, swollen towards the downy base. **Flesh** thin, pallid. Taste mild, smell mushroomy. **Gills** more or less decurrent, pale grey becoming brownish with age. Spore print white. Spores ovoid, amyloid, 8–11×5–6μ. Habitat amongst grass, leaf litter, on very rotten logs or other debris in mixed woodland. Season late autumn to winter. Occasional. **Edible.**

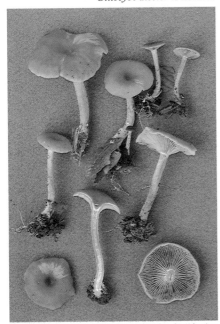

Clitocybe dicolor ½ life size

Clitocybe rivulosa ⅔ life size

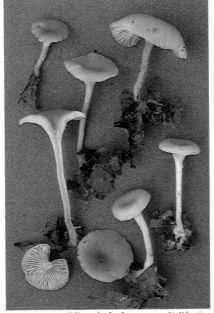

Clitocybe vibecina ⅔ life size

Clitocybe hydrogramma ⅔ life size

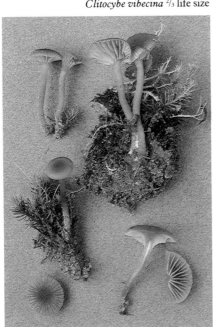

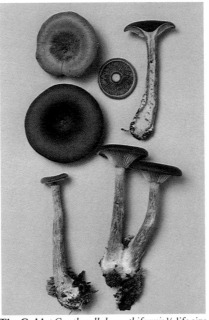

Clitocybe asterospora life size

The Goblet *Cantharellula cyathiformis* ⅓ life size

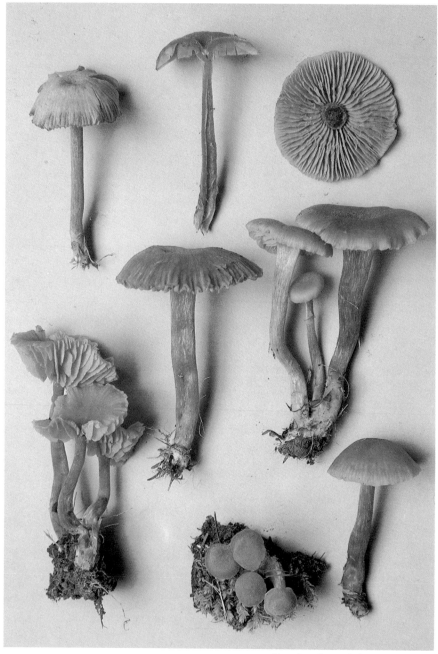

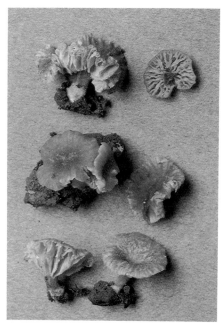

Laccaria tortilis life size

Deceiver *Laccaria laccata* ¾ life size

LACCARIA *The cap colours are very variable and you may keep picking up the common ones until you get used to them. Six in Britain.*

Deceiver *Laccaria laccata* (Scop. ex Fr.) Cke. syn. *Clitocybe laccata* (Scop. ex Fr.) Kummer **Cap** 1.5–6cm across, convex then flattened, often becoming finely wavy at the margin and centrally depressed, tawny to brick-red and striate at the margin when moist drying paler to ochre-yellow, surface often finely scurfy. **Stem** 50–100×6–10mm, concolorous with cap, tough and fibrous, often compressed or twisted. **Flesh** thin reddish-brown. Taste and smell not distinctive. **Gills** pinkish, dusted white with spores when mature. Spore print white. Spores globose, spiny, 7–10μ in diameter. Habitat in troops in woods or heaths. Season summer to early winter. Very common but very variable in appearance and therefore often difficult to recognize at first sight, hence the popular name 'Deceiver'. **Edible.**

Laccaria tortilis ([Bolt.] S. F.Gray) Cke. syn. *Omphalia tortilis* (Bolt.) S. F.Gray syn. *Clitocybe*

tortilis ([Bolt.] S. F. Gray) Gillet **Cap** 0.5–1.5cm across, flattened to centrally depressed, irregularly wavy at margin, pale pinkish-brown or more reddish and striate from margin to centre when moist, drying paler flesh-pink and scurfy. **Stem** 2–10×1–2mm, concolorous with cap, base covered in fine white down. **Flesh** thin, concolorous. Taste and smell not distinctive. **Gills** distant, pale pink. Spore print white. Spores globose, spiny, 11–14μ in diameter. Basidia two-spored. Habitat on bare soil in damp woods, often on banks of streams or ponds. Season autumn. Uncommon. **Edible.**

Amethyst deceiver *Laccaria amethystea* (Bull. ex Mérat) Murr. syn. *L. laccata* var. *amethystina* ([Huds.] Cke.) Rea **Cap** 1–6cm across, convex to flattened or centrally depressed, deep purplish-lilac when moist drying pale lilac-buff, surface slightly scurfy at centre especially with age. **Stem** 40–100×5–10mm, concolorous with stem, covered in whitish fibres below but mealy near the apex, base covered in lilac down, passing into the lilac mycelium. **Flesh** thin, tinged lilac, stem becoming hollow. Taste and smell not

distinctive. **Gills** often distant, concolorous with cap, becoming powdered white. Spore print white. Spores globose, spiny, 9–11μ in diameter. Habitat coniferous or deciduous woods, often with beech. Season late summer to early winter. Very common. **Edible.**

Laccaria bicolor (Maire) Orton syn. *L. proxima* var. *bicolor* (Maire) Kühn. & Romagn. **Cap** 2–4.5cm across, convex then flattened, often centrally depressed and incurved at the margin, ochraceous-tan drying pinkish to ochraceous-buff, surface scurfy. **Stem** 50–140×4–10mm, ochraceous-buff to rusty-tan, fibrillose, with distinctive lilac down covering the lower third. **Flesh** thin, whitish tinged pinkish to ochraceous. Taste and smell not distinctive. **Gills** pale lilac at first becoming clay-lilac and finally pallid. Spore print white. Spores broadly elliptic to subglobose, spiny, 7–9.5×6–7.5μ. Habitat in mixed birch and pine woods. Season late summer to autumn. Uncommon. **Edible –** not worthwhile.

Laccaria proxima (Boud.) Pat. syn. *L. laccata* var. *proxima* (Boud.) Maire **Cap** 2–7cm across, convex then more flattened and often centrally depressed, reddish-brown drying to almost ochraceous buff and scurfy. **Stem** 30–120×2–5mm, concolorous with cap, fibrillose, thicker towards the base which is covered in white down. **Flesh** thin, whitish tinged with cap colour. Taste and smell not distinctive. **Gills** pale pink. Spore print white. Spores broadly ovate, spiny, 7–9.5×6–7.5μ. Habitat in poor soil on heaths or in bogs. Season autumn. Occasional. **Edible.**

Laccaria purpureo-badia Reid **Cap** 2–5.5cm across, convex at first sometimes with a broad umbo soon becoming flattened and centrally depressed or wavy at the margin, dark purple-brown when moist drying paler and becoming distinctly scurfy. **Stem** 30–60×3–8mm, light vinaceous at the apex becoming dark purple-brown towards the base, covered in short fibres. **Flesh** thin, purplish-pink. Taste not distinctive, smell none. **Gills** pale pinkish at first becoming brownish. Spore print white. Spores ovate to broadly elliptic or subglobose, spiny, 7–10.5×6–8μ. Habitat in damp peaty ground near birch and alder. Season autumn. Rare. **Edibility unknown.**

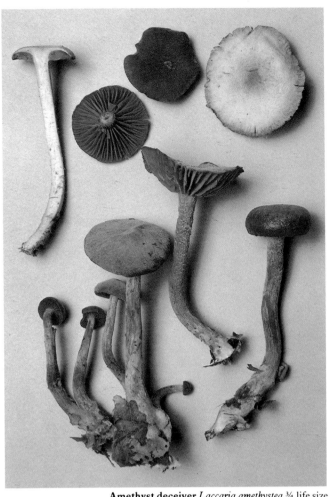

Amethyst deceiver *Laccaria amethystea* ¾ life size

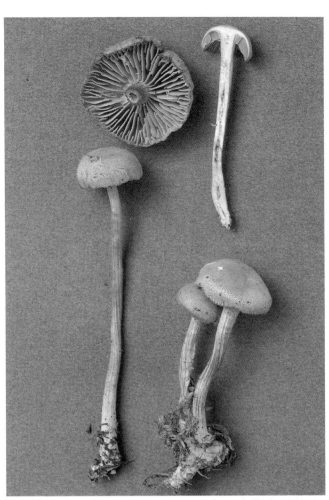

Laccaria bicolor ¾ life size

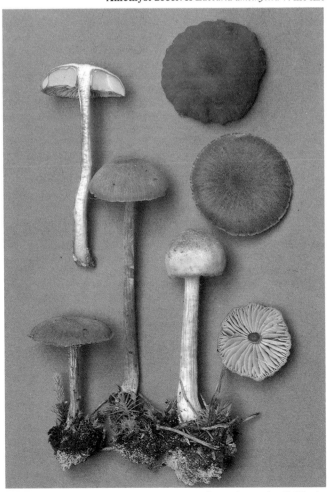

Laccaria proxima ⅔ life size

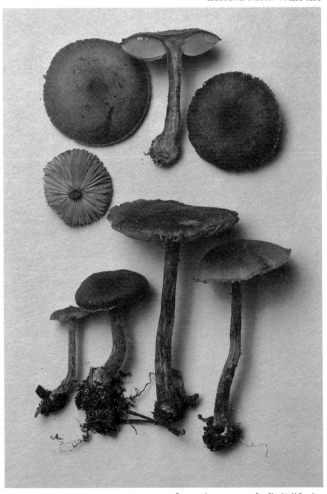

Laccaria purpureo-badia ¾ life size

53

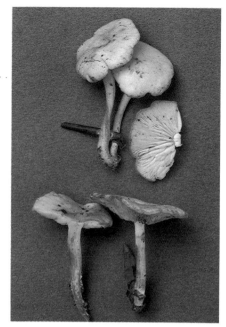

Collybia oreadoides ²/₃ life size

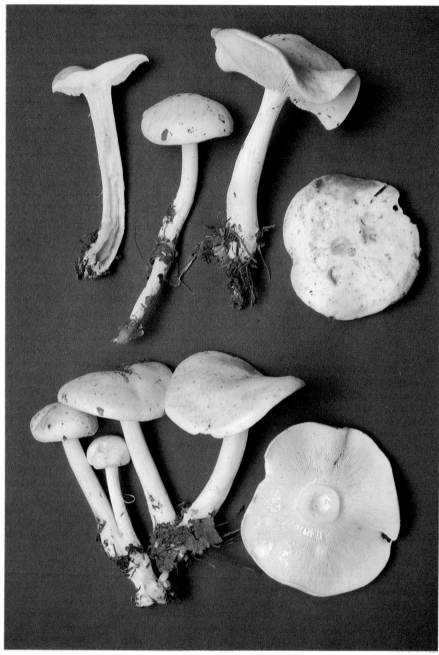

Spotted Tough-shank *Collybia maculata* ½ life size

COLLYBIA *The most distinctive feature is the tough fibrous stem, there is no ring or volva. The gills are often rather crowded, never decurrent. Some have strong smells. Thirty-six in Britain.*

Collybia oreadoides (Pass.) Orton syn. *Marasmius oreadoides* (Pass.) Fr. **Cap** 2–5cm across, convex then expanded irregularly, whitish to pinkish-buff discolouring rusty in patches with age. **Stem** 30–50×4–10mm, compressed, white. **Flesh** whitish-buff. Taste bitterish, smell pleasant. **Gills** white to cream. Spore print white. Spores cylindric to fusiform, 6–6.5×2.5–3μ. Habitat in tufts amongst leaf litter. Season autumn. Rare. **Edibility suspect** – avoid.

Spotted Tough-shank *Collybia maculata* (Alb. & Schw. ex Fr.) Kummer syn. *Rhodocollybia maculata* (Alb. & Schw. ex Fr.) Sing. **Cap** 4–10cm across, flattened convex, white at first soon becoming spotted tan-brown on bruising or ageing. **Stem** 50–100×8–12mm, similarly coloured to cap, sometimes rooting. **Flesh** white.

Taste bitter. **Gills** free, crowded, white becoming spotted with rusty brown. Spore print cream to pale pink. Spores globose, 4–6×3–5μ. Habitat in deciduous and especially coniferous woodland, and under bracken on heaths. Season summer to late autumn. Very common. **Not edible** due to its bitter taste and toughness.

Spindle Shank *Collybia fusipes* (Bull. ex Fr.) Quél. syn. *C. lancipes* (Fr.) Gillet **Cap** 3–7cm across, convex with broad umbo dark red-brown and slightly viscid when moist, drying smooth and pale tan. **Stem** 40–90×7–15mm, pale tan at apex, darker towards the swollen middle which tapers towards a thin stalk-like rooting base, the whole stem grooved and twisted along its length and often fused at the base to several others. **Flesh** whitish, tinged pale reddish-brown. Taste mild, smell slight. **Gills** free or attached to the stem by a small decurrent tooth, whitish then tinged with reddish-brown. Spore print white. Spores ellipsoid or pip-shaped, 4–6×2–3μ. Habitat in dense tufts at the base of deciduous

trees or stumps, especially beech and oak. Season spring to early winter. Occasional. **Not edible** due to its toughness.

Collybia dryophila (Bull. ex Fr.) Kummer syn. *C. aquosa* (Bull. ex Fr.) Kummer syn. *Marasmius dryophilus* var. *aquosus* (Bull. ex Fr.) Rea **Cap** 2–5cm across, convex becoming flattened and often wavy at margin, variable in colour from whitish or pale buff to light tan. **Stem** 20–40×2–4mm, flushed tan, darker towards the swollen base. **Flesh** thin, whitish, stem hollow. Taste and smell not distinctive. **Gills** free to adnexed, whitish to buff. Spore print white. Spores ellipsoid, 4.5–6.5×3μ. Cap cuticle of repent coralloid hyphae. Habitat in deciduous woods. Season late spring to late autumn. Very common. **Edible** – not worthwhile.

Clustered Tough-shank *Collybia confluens* (Pers. ex Fr.) Kummer syn. *Marasmius confluens* (Pers. ex Fr.) Karst. **Cap** 3–5cm across, convex, dingy flesh colour drying almost white, dry. **Stem** 30–60×2–5mm, compressed and tough, darker than cap and covered in fine white down. **Flesh** very thin, white, stem hollow. **Gills** narrow, very crowded, flushed with cap colour. Spore print white. Spores ellipsoid, 7–9×3–4μ. Habitat in dense tufts, often forming rings in the leaf litter of deciduous or mixed woods. Season summer to late autumn. Common. **Edible** – not recommended.

Collybia erythropus (Pers. ex Fr.) Kummer syn. *Marasmius erythropus* (Pers. ex Fr.) Fr. syn. *M. bresadolae* (Kühn. & Romagn.) **Cap** 1–3cm across, convex becoming flattened and often wavy at margin, pale tan when moist drying to pale buff or cream and wrinkled but remaining tan at the centre which is sometimes depressed. **Stem** 40–70×2–4mm, often compressed, dark red becoming paler towards the apex, the base covered in dark pink woolly hairs. **Flesh** white in the cap, reddish-brown in the stem. Smell mushroomy or slightly rancid. **Gills** free, white to pale buff. Spore print white. Spores pip-shaped, 6–8×3.5–4μ. Cap cuticle of repent coralloid hyphae. Habitat often in tufts, in leaf litter of deciduous woods. Season autumn. Rare. **Edible** – not worthwhile.

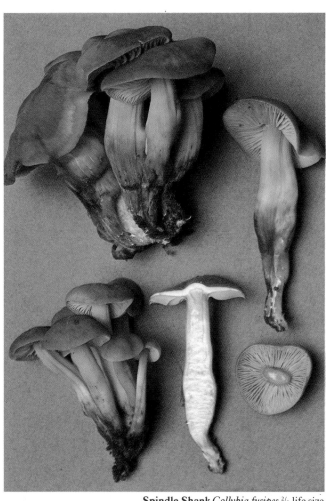

Spindle Shank *Collybia fusipes* ²/₃ life size

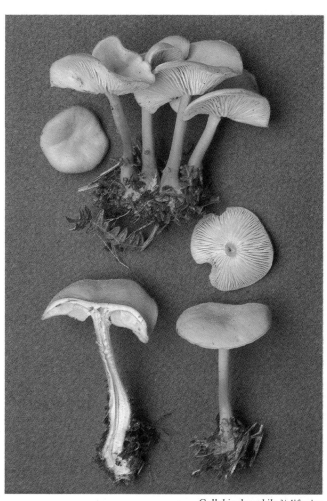

Collybia dryophila ¾ life size

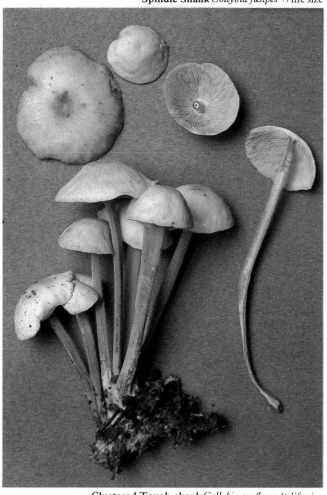

Clustered Tough-shank *Collybia confluens* ¾ life size

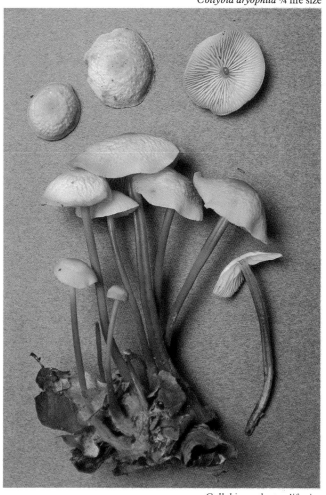

Collybia erythropus life size

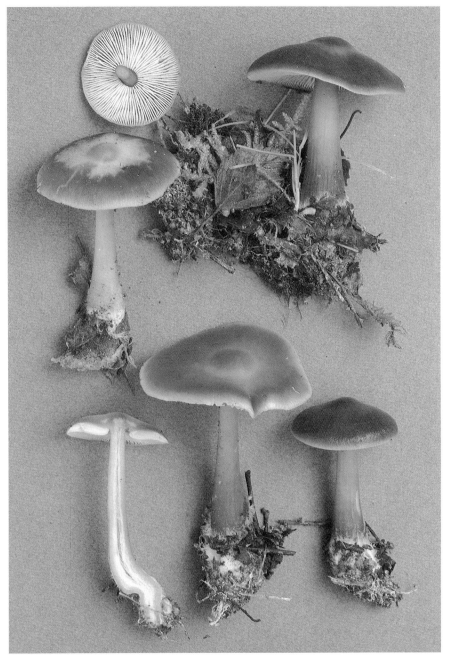

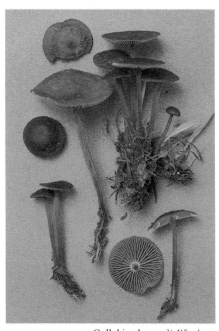

Collybia obscura ²/₃ life size

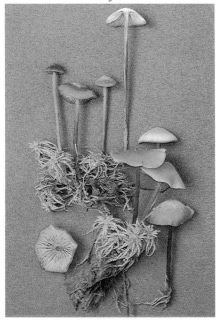

Butter Cap *Collybia butyracea* ¾ life size

Collybia palustris ²/₃ life size

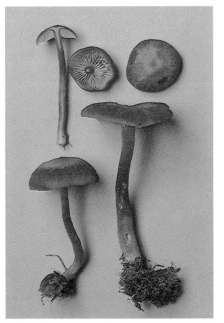

Collybia confusa ¾ life size

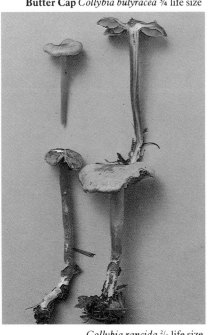

Collybia rancida ²/₃ life size

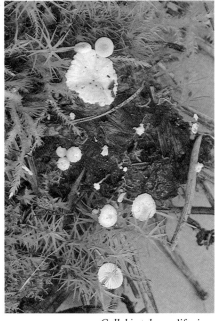

Collybia tuberosa life size

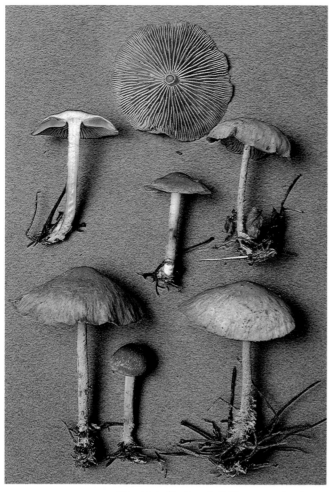

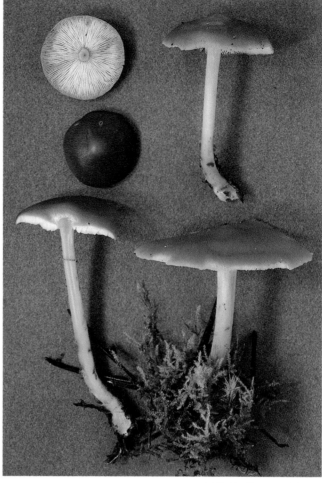

Wood Woolly-foot *Collybia peronata* ⅔ life size *Collybia distorta* ¾ life size

Butter Cap or **Greasy Tough-shank** *Collybia butyracea* (Bull. ex Fr.) Kummer **Cap** 3–7cm across, convex becoming flattened with a distinct umbo, dark reddish brown to dark ochraceous buff drying horn-brown to ivory, greasy to the touch. **Stem** 25–50×5–10mm, tough, slightly swollen towards the base which is covered in white woolly hairs, similarly coloured to cap. **Flesh** whitish buff, stem becoming hollow. Taste mushroomy, smell mushroomy or slightly rancid. **Gills** free, crowded, whitish. Spore print white or very pale pink. Spores ellipsoid, 6.5–8×3–3.5μ. Habitat in leaf litter in deciduous or coniferous woods. Season autumn to early winter. Occasional. **Edible** – not good. Easily recognized by the buttery feel of the cap.

Collybia obscura Favre syn. *Marasmius obscurus* Favre **Cap** 2–4cm across, convex then flattened or depressed, dark purple-brownish. **Stem** 30–70×2–4mm, concolorous with cap, sometimes blackish towards the base. **Flesh** thin, pinkish brown; microscopic examination of the flesh shows the presence of interhyphal dark brown pigment granules. **Gills** grey-brown to chocolate-brown. Cheilocystidia poorly differentiated, thin-walled, hyaline, worm-like, sometimes lobed at the blunt tips. Spore print white. Spores thin walled, elliptic tear-drop shaped, 6.5–7.5×3–4μ. Surface of cap formed of interwoven coralloid thin-walled brown hyphae encrusted with dark-brown granular pigment. Habitat in small tufts amongst grass. Season late autumn. Rare. **Edibility unknown**.

Collybia palustris (Peck) A. H. Smith syn. *C. leucomyosotis* (Cke. & W. G. Smith) Sacc. syn. *Lyophyllum palustre* (Peck.) Sing. **Cap** 1–2cm across, bell-shaped flattening when expanded, greyish-brown, striate almost to the paler centre, pallid when dry. **Stem** 20–30×2–3mm, pallid. **Flesh** pale buff. Smell mealy. **Gills** adnate or with a small decurrent tooth, pale buff. Spore print white. Spores ovoid, 5.5–8.5×4–5μ. Habitat often gregarious, in sphagnum. Season late spring to autumn. Occasional. **Edibility unknown**.

Collybia confusa Orton syn. *C. ozes* (Fr.) Karst. **Cap** 1–3cm across, convex becoming flattened, dark greyish-brown drying pale clay-brown. **Stem** 35–50×3–7mm, broader at base, concolorous with cap. **Flesh** thin, whitish, hollow in stem. **Gills** adnate, crowded, pale greyish. Spore print white. Spores ovoid 4.5–6.5×3–3.5μ. Habitat in coniferous woods, especially with spruce. Season autumn. Rare. **Edibility unknown**.

Collybia rancida (Fr.) Quél. syn. *Lyophyllum rancidum* (Fr.) Sing. **Cap** 1–4cm across, umbonate, leaden-grey with a whitish bloom at first, shiny when wet. **Stem** 40–80×3–7mm, concolorous with cap, the lower part covered in a dense white tomentum passing into the long rooting base. **Flesh** greyish. Taste and smell strongly of rancid meal. **Gills** free, crowded, grey. Spore print white. Spores ellipsoid 7–8×3–4.5μ. Habitat solitary in deciduous woodland. Season early autumn to early winter. Rare. **Not edible** due to rancid taste.

Collybia tuberosa (Bull. ex Fr.) Kummer **Cap** 0.3–1.3cm across, convex then flattening often becoming wavy and depressed at the centre which is tinged yellowish-green, the rest of the cap is pure white. **Stem** 15–25×1mm, white or pallid, arising from a reddish-brown sclerotium. **Flesh** very thin, whitish. Taste and smell not distinctive. **Gills** adnate, crowded, white. Spore print white. Spores ellipsoid to ovoid, 3–5×2–3μ. Habitat growing in large groups on decaying fungi, especially *Russula nigricans* and *Lactarius deliciosus*. Season autumn. Uncommon. **Not edible**.

Wood Woolly-foot *Collybia peronata* (Bolt. ex Fr.) Kummer syn. *Marasmius peronatus* (Bolt. ex Fr.) Fr. syn. *M. urens* (Bull. ex Fr.) Fr. **Cap** 3–6cm across, convex then flattened, often with a low, broad umbo, tan to darker brown, becoming wrinkled and leathery with age. **Stem** 30–60×3–6mm, yellowish covered in long dense white or yellowish woolly hairs at the base and lower stem. **Flesh** whitish tinged yellowish. Taste acrid. **Gills** adnexed to free, crowded, cream to yellowish brown or tan. Spore print white. Spores elongate pip-shaped, 7–9×3–4μ. Habitat in leaf litter of deciduous or occasionally coniferous woods. Season late summer to late autumn. Very common. **Not edible** due to the acrid taste.

Collybia distorta (Fr.) Quél. **Cap** 3–7cm across, convex becoming flattened with a low broad umbo, reddish brown. **Stem** 40–60×4–8mm, whitish flushed with cap colour, often grooved and twisted. **Flesh** pale tan. Taste and smell not distinctive. **Gills** crowded, adnate with a slightly uneven edge, whitish becoming stained reddish brown. Spore print white. Spores globose, 3–4.5μ diameter. Habitat in small tufts in coniferous woods. Season autumn. Occasional. **Edible** – not recommended.

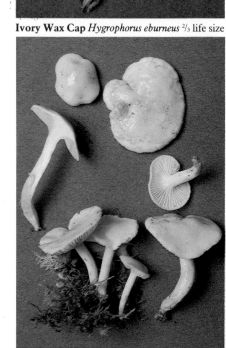

Ivory Wax Cap *Hygrophorus eburneus* ⅔ life size

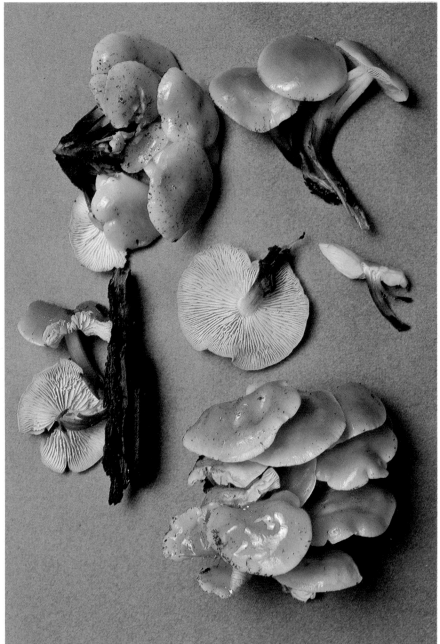

Velvet Shank *Flammulina velutipes* ⅔ life size

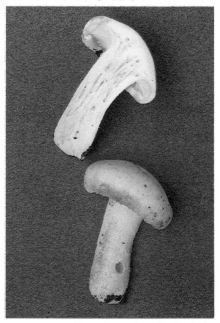

Goat Moth Wax Cap *Hygrophorus cossus* ⅔ size

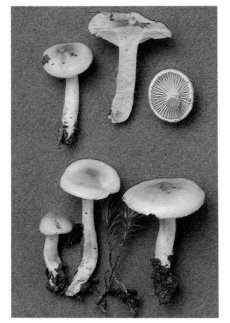

Hygrophorus leucophaeus ½ life size

Velvet Shank *Flammulina velutipes* (Curt. ex Fr.) Karst. syn. *Collybia velutipes* (Curt. ex Fr.) Kummer **Cap** 2–10cm across, convex at first then flattened, tan-yellow darkening towards the centre, smooth and slimy. **Stem** 30–10×4–8mm, tough and cartilaginous, yellowish at apex, dark brown and densely velvety below. **Flesh** thin, concolorous. Taste and smell pleasant. **Gills** pale yellow. Cheilo- and pleurocystidia present. Cap cuticle 'cellular' of irregular clavate elements with elongated narrow processes and conspicuous, fusiform, somewhat thick-walled dermatocystidia. Spore print white. Spores elliptic, 6.5–10×3–4μ. Habitat in clusters on decaying deciduous trees, especially elm. Season late autumn to spring; can survive being frozen solid and on thawing produces more spores. Common. **Edible**.

HYGROPHORUS *The caps are slimy or greasy and the gills are waxy to the touch. They grow in association with trees. Twenty-six in Britain.*

Hygrophorus chrysodon ½ life size

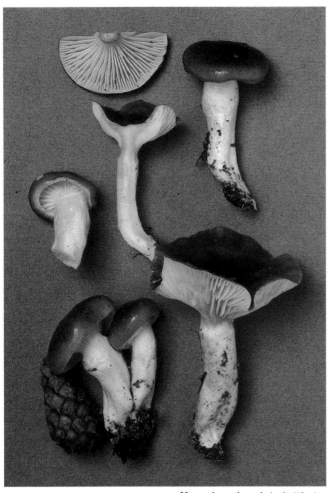

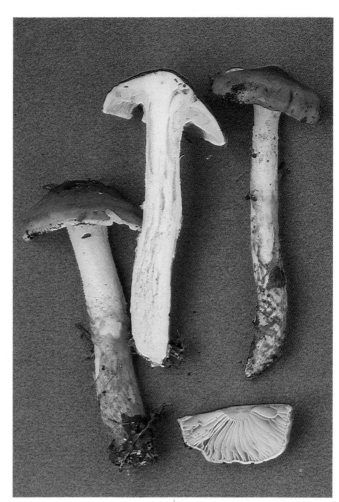

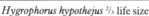
Hygrophorus hypothejus ²/₃ life size

Hygrophorus dichrous ²/₃ life size

Ivory Wax Cap *Hygrophorus eburneus* (Bull. ex Fr.) Fr. syn. *Limacium eburneum* (Bull. ex Fr.) Kummer **Cap** 3–7cm across, convex then becoming flattened, pure white, slimy. **Stem** 40–70×5–10mm, tapering towards the base, covered in mealy granules near the apex when young, white, slimy. **Flesh** thick at centre of cap, white. Taste and smell faint but pleasant. **Gills** decurrent, white. Spore print white. Spores broadly ellipsoid, 6–8×4–5μ. No reaction with KOH on cap. Habitat in leaf litter in woods, especially beech. Season autumn. Rare. **Edible** – not recommended.

Goat Moth Wax Cap *Hygrophorus cossus* (Sow. ex Berk.) Fr. syn. *Limacium eburneum* var. *cossus* (Sow. ex Berk.) Lange **Cap** 3–7cm across, convex becoming more flattened, white flushed buff especially near the centre, slimy. **Stem** 40–70×5–10mm, whitish, slimy. **Flesh** white. Taste and smell strong and unpleasant, said to resemble that of the larva of the Goat Moth whence it gets its name. **Gills** decurrent, whitish. Spore print white. Spores ovoid, 8–10×4–5μ. No reaction with KOH on cap. Habitat in mixed woodland, beechwood on chalk. Season autumn. Frequent. **Not edible**.

Hygrophorus chrysodon (Batsch ex Fr.) Fr. **Cap** 3–7cm across, convex then flat, whitish, viscid, covered at the margin in tiny cottony yellow scales. **Stem** 40–75×10–15mm, whitish covered in minute yellow scales. **Flesh** white, sometimes with a reddish tinge. Taste mild or slightly bitter, smell fungusy. **Gills** white with a yellowish tinge at the edge. Spore print white. Spores ellipsoid, 7–9×4–5.5μ. Habitat mixed deciduous wood, with oak and beech. Season autumn.

Uncommon. **Edible**. Typically less yellow than illustrated.

Hygrophorus leucophaeus ([Scop.] Fr.) Karst. syn. *Limacium leucophaeum* ([Scop.] Fr.) P.Henn. **Cap** 1.5–5cm across, convex, whitish buff with rusty brown at the prominent umbo, slightly viscid. **Stem** 30–70×4–7mm, whitish with a faint rust flush. **Flesh** thick at centre of cap, whitish. Taste and smell not distinctive. **Gills** decurrent, whitish buff. Spore print white. Spores ovoid-ellipsoid, 6.5–8×4μ. Habitat in deciduous woodland, especially beech. Season autumn. Occasional. **Edible**.

Hygrophorus hypothejus (Fr. ex Fr.) Fr. syn. *Limacium hypothejum* (Fr. ex Fr.) Kummer **Cap** 3–6cm across, hemispherical then flattening, sometimes with depressed centre, olive-brown with paler margin, slimy. **Stem** 40–70×7–14mm, whitish tinged yellow or orange, slimy below the ring-like zone. **Flesh** whitish to pale yellow bruising orange-red. **Gills** decurrent, pale yellow. Spore print white. Spores ellipsoid to ovoid, 7–9×4–5μ. Habitat in pinewoods. Season late autumn, often appearing after the first frosts. Common. **Edible** – not recommended.

Hygrophorus dichrous Kühn & Romagn. **Cap** 5–7cm across, convex with slight umbo, olive-brown with darker centre, slimy. **Stem** 50–80×10–18mm, white covered with thick, brownish gluten below the ring-like zone. **Flesh** thick, white. Smell odd. **Gills** adnate-decurrent, white. Spore print white. Spores broadly ovoid, 9–13×5–7.5μ. Habitat in deciduous woods. Season autumn. Uncommon. **Edible** – good.

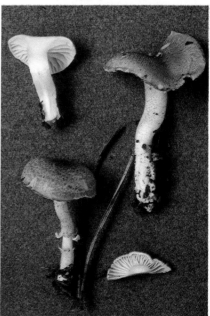
Hygrophorus pustulatus ²/₃ life size

Hygrophorus pustulatus (Pers. ex Fr.) Fr. syn. *Limacium pustulatum* (Pers. ex Fr.) Kummer **Cap** 2–5cm across, convex with depressed centre, grey-brown covered in darker granular scales especially at the centre. **Stem** 25–50×3–7mm, whitish flushed with cap colour covered in fine brownish tufts. **Flesh** white. Taste and smell not distinctive. **Gills** decurrent, white. Spore print white. Spores ovoid, 8.5–10×5–6μ. Habitat in Northern coniferous woods, especially with pine. Season autumn. Rare. **Edible**.

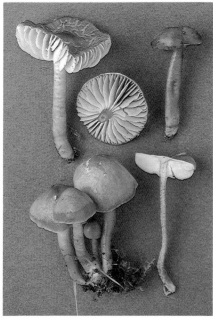

Hygrocybe unguinosa ²/₃ life size

Meadow Wax Cap *Hygrocybe pratensis* ¾ life size

HYGROCYBE *Small bright red, yellow, green or white; the greasy or slimy caps are often conical. The gills are waxy to the touch and often decurrent or nearly so. Some blacken with age. They are found on grass land. Sixty-three in Britain.*

Meadow Wax Cap *Hygrocybe pratensis* (Pers. ex Fr.) Fr. syn. *Camarophyllus pratensis* (Pers. ex Fr.) Kummer **Cap** 3–8cm across, convex then flattened with broad umbo, becoming distorted and often cracking with age, ochraceous or tawny-buff. **Stem** 20–50×10–15mm, paler than cap, tapering towards the base. **Flesh** thick at centre of cap, pale buff. Taste pleasant, smell mushroomy. **Gills** deeply decurrent, widely spaced, pale buff. Spore print white. Spores broadly ovoid to subglobose, 5–7×4.5–5μ. Habitat in pastureland. Season autumn. Frequent. **Edible** – good.

Hygrocybe unguinosa (Fr.) Karst. syn. *Hygrophorus unguinosus* (Fr.) Fr. **Cap** 2–4cm across, convex or bell-shaped, greyish brown, very shiny. **Stem** 40–60×3–6mm, concolorous with cap, slightly wavy and tapering towards the whitish base, very slimy. **Flesh** greyish. Taste mild, smell not distinctive. **Gills** adnate with a decurrent tooth, widely spaced but connected by veins, whitish. Spore print white. Spores broadly elliptical or oval, 7–8.5×4–5μ. Habitat in short grass in pastures or open woodland. Season late autumn. Rare. **Edibility unknown.**

Hygrocybe nitrata (Pers. ex Pers.) Wünsche syn. *Hygrophorus nitratus* (Pers. ex Pers.) Fr. **Cap** 1.5–8cm across, convex then expanded, light sepia to date-brown, often yellow-brown at margin when fresh, drying pallid. **Stem** 30–100×3–12mm, creamy pallid darkening towards the base. **Flesh**

whitish cream. Taste foul, soapy, smell nitrous. **Gills** whitish cream becoming tinged with cap colour. Spore print white. Spores 7–10×4.5–5.5μ. Habitat amongst grass. Season late summer. Rare. **Not edible**.

Hygrocybe ovina (Bull. ex Fr.) Kühn. syn. *Hygrophorus ovinus* (Bull. ex Fr.) Fr. **Cap** 2–8cm across, conico-convex, irregularly expanding and often broadly umbonate, dark sepia with yellowish-brown margin when fresh, drying pale sepia. **Stem** 30–60×6–20mm, often compressed, dark grey-brown. **Flesh** grey-brown. Taste strong and unpleasant, smell nitrous, or occasionally none. **Gills** dark sepia, discolouring bright reddish on bruising, as do cap and stem. Spore print white. Spores broadly elliptic to ovoid, 7–9×5–6.5μ. Habitat singly or in small tufts in grass. Season late summer. Rare. **Not edible**.

Blackening Wax Cap *Hygrocybe nigrescens* (Quél.) Kühn. syn. *H. pseudoconica* Lange syn. *Hygrophorus nigrescens* (Quél.) Quél. **Cap** 3.5–5.5cm across, bell-shaped or broadly conical often irregularly lobed, orange or scarlet blackening with age. **Stem** 30–70×6–10mm, yellow flushed scarlet with white base, becoming streaked black. **Flesh** yellowish in the cap, white in the stem, blackening on exposure to air. Taste mild, smell not distinctive. **Gills** adnexed or free, pale yellow. Spore print white. Spores ellipsoid, 8–11×5–6μ. Basidia four-spored. Habitat amongst grass in fields or woods. Season autumn. Occasional. **Edible**.

Conical Wax Cap *Hygrocybe conica* (Scop. ex Fr.) Kummer syn. *Hygrophorus conicus* (Scop. ex Fr.) Fr. **Cap** 2–5cm across, acutely conical and often irregularly lobed, yellow-orange sometimes flushed scarlet becoming black when bruised or with age. **Stem** 20–60×8–10mm, bright yellow and blackening. **Flesh** pale yellow, bruising black. Taste and smell none. **Gills** sinuate, pale yellow. Spore print white. Spores broadly ellipsoid, 7–9(10)×4–5(6)μ in four-spored form but 9–12×6–8μ in two-spored form. Habitat amongst grass in fields, lawns and roadsides. Season summer to late autumn. Frequent. **Edible** – not recommended.

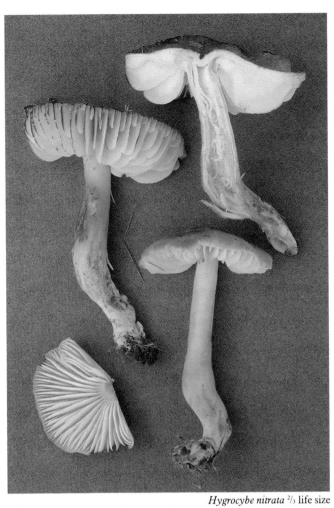

Hygrocybe nitrata ⅔ life size

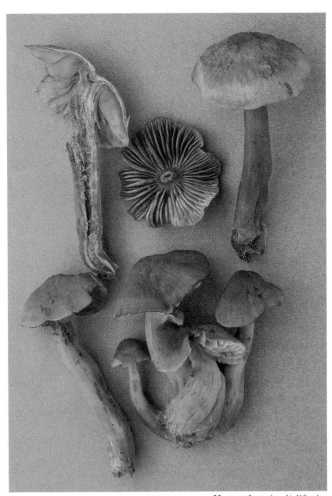

Hygrocybe ovina ⅔ life size

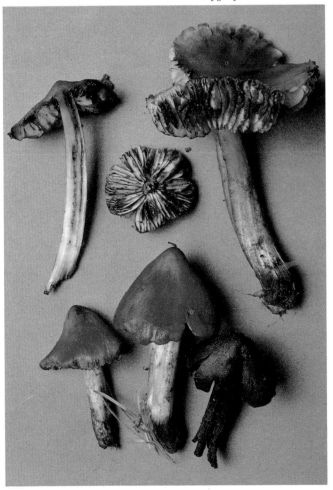

Blackening Wax Cap *Hygrocybe nigrescens* ¾ life size

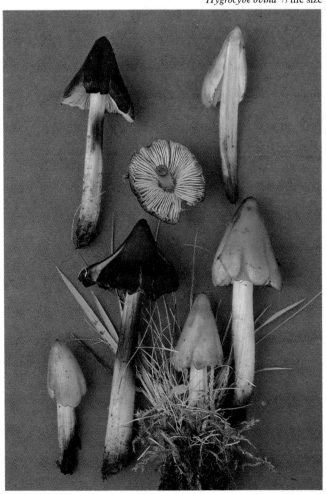

Conical Wax Cap *Hygrocybe conica* ¾ life size

61

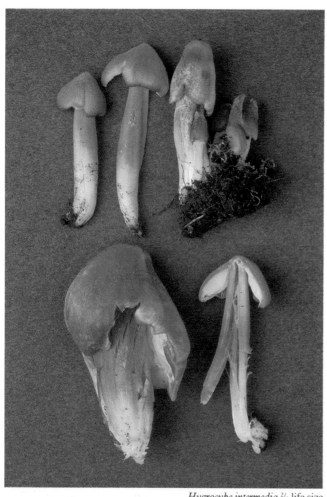

Hygrocybe intermedia ²/₃ life size

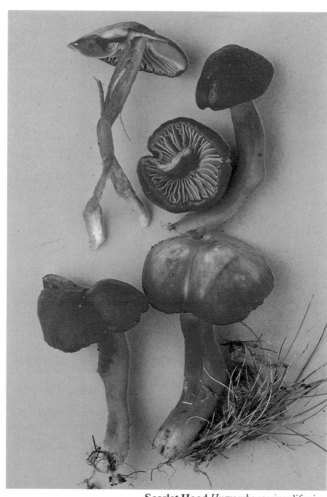

Scarlet Hood *Hygrocybe coccinea* life size

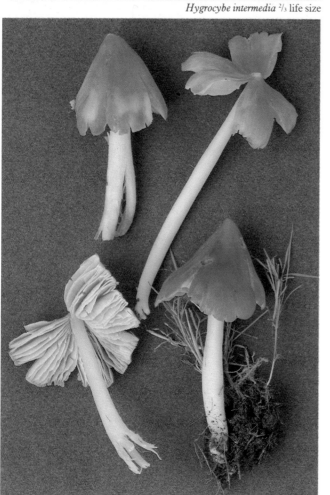

Hygrocybe calyptraeformis ²/₃ life size

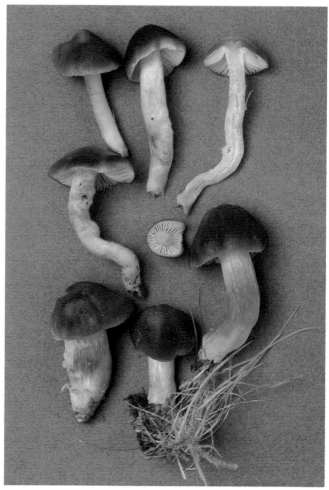

Crimson Wax Cap *Hygrocybe punicea* ²/₃ life size

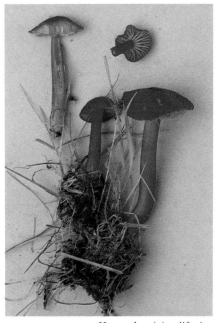

Hygrocybe miniata life size

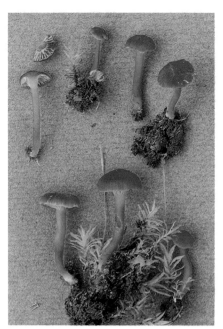

Hygrocybe cantharellus ²/₃ life size

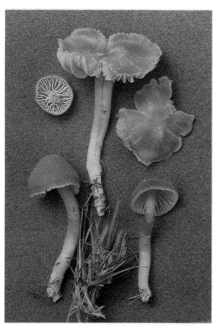

Hygrocybe strangulata ²/₃ life size

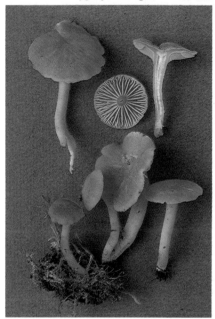

Hygrocybe marchii ²/₃ life size

Hygrocybe intermedia (Pass.) Fayod syn.
Hygrophorus intermedius Pass. **Cap** 2–7cm across,
conical, golden yellow or deep ochraceous,
covered in fine fibrils especially at the umbo.
Stem 60–90×9–18mm, robust, concolorous
with cap with yellowish-white base, dry and
fibrillose. **Flesh** yellowish. Smell mushroomy.
Gills whitish to pale yellow. Spore print white.
Spores ellipsoid, 8–11×5–6µ. Habitat in
grasslands. Season autumn. Rare. **Edible**.

Scarlet Hood *Hygrocybe coccinea* (Schaeff. ex
Fr.) Kummer syn. *Hygrophorus coccineus*
(Schaeff. ex Fr.) Fr. **Cap** 2–4cm across, bell-
shaped, scarlet blood-red, slimy at first. **Stem**
20–50×3–10mm, concolorous with cap but
yellow towards the base, often becoming
compressed. **Flesh** yellow-red, hollow in stem.
Taste and smell faint, not distinctive. **Gills**
adnate with a decurrent tooth, yellow when
young later blood red with yellowish edge. Spore
print white. Spores ellipsoid to almond-shaped,
often slightly constricted, 7–9.5×4–5µ. Habitat
amongst grass in fields. Season late summer to
autumn. Occasional. **Edible** – good.

Hygrocybe calyptraeformis (B. & Br.) Fayod syn.
Hygrophorus calyptraeformis (B. & Br.) Fr. **Cap** 3–
6cm across, acutely conical, expanding and
splitting radially, dusky-pink when moist drying
whitish-pink. **Stem** 60–120×8–10mm, white,
sometimes flushed pink at apex, brittle, often
splitting longitudinally. **Flesh** pink in cap, white
in stem. Taste mild, smell not distinctive. **Gills**
pale pink. Spore print white. Spores elliptic,
6–8×4.5–6µ. Habitat amongst grass in pastures
and heaths. Season autumn. Rare. **Edible** – not
recommended.

Crimson Wax Cap *Hygrocybe punicea* (Fr.)
Kummer syn. *Hygrophorus puniceus* (Fr.) Fr.
Cap 3–7cm across, irregularly bell-shaped and
often lobed, deep blood-red when fresh, soon
fading to orange-red, greasy. **Stem** 50–120×6–
20mm, yellow flushed with red, white towards

the pointed base, the surface covered in coarse
fibres. **Flesh** white at base and in centre of stem,
concolorous or yellow under the cuticle, stem
becoming hollow. Taste and smell not
distinctive. **Gills** adnexed, yellowish later
becoming flushed with cap colour. Spore print
white. Spores broadly elliptical, 9–12×5–6µ.
Habitat amongst short grass in fields and heaths.
Season autumn. Rare. **Edible**. Distinguished
from the more common *H. coccineus* by its larger
size and the base of the coarse stem being white.

Hygrocybe miniata (Fr.) Kummer syn.
Hygrophorus miniatus (Fr.) Fr. **Cap** 0.5–1.5cm
across, convex, bright scarlet, finely scurfy.
Stem 20–50×2–5mm, concolorous with cap or
more orange, smooth and shiny. **Flesh** thin,
orange-red. Taste and smell not distinctive. **Gills**
adnate, yellow to vermillion or orange-red with
paler yellow edge. Spore print white. Spores
ellipsoid to egg-shaped, 7.5–10×5–6µ. Habitat
in grassy clearings in woods or on heaths. Season
autumn. Uncommon. **Edible** but not
recommended. Distinguished from the other
small, bright red species in this genus by its dry
scurfy cap.

Hygrocybe cantharellus (Schw.) Murr. syn.
Hygrophorus cantharellus (Schw.) Fr. **Cap** 0.5–
4cm across, convex, slightly scurfy-scaly,
scarlet becoming vermillion and often yellowish at the
wavy margin. **Stem** 30–70×1–3mm, orange at
apex, concolorous with cap below. **Flesh** orange.
Gills deeply decurrent, pale yellowish becoming
deep egg-yellow. Spore print white. Spores
elliptic, 8–10×5–6µ. Habitat amongst damp
moss. Season autumn. Rare. **Edibility unknown**.

Hygrocybe strangulata Orton syn. *Hygrophorus
strangulatus* Orton **Cap** 0.5–3.5cm across,
convex, margin wavy when expanded and the
centre becoming depressed and scurfy scaly in
older specimens, scarlet-orange with bright
yellow striate margin, drying ochraceous. **Stem**
18–50×3–6mm, tapering downwards and often

becoming compressed, concolorous with cap,
paler towards the white base. **Flesh** orange.
Taste and smell none. **Gills** adnate or slightly
decurrent, pale yellow at first, later orange.
Spore print white. Spores ellipsoid, constricted
in some views, 7–9×4–5µ. Habitat on sandy soil
or heathland also in fields. Season autumn.
Uncommon. **Edibility unknown**.

Hygrocybe marchii (Bres.) Sing. syn. *Hygrophorus
marchii* Bres. **Cap** 1–4.5cm across, convex
becoming depressed at the centre, orange-scarlet
with yellowish margin and all over golden sheen.
Stem 30–60×3–6mm, rich golden-yellow. **Flesh**
yellowish, hollow in stem. Taste mild, smell
pleasant. **Gills** decurrent, golden-yellow. Spore
print white. Spores ellipsoid-ovoid, 6.5–8.5×4–
5µ. Habitat amongst grass in woods and fields.
Season autumn. Occasional. **Edibility unknown**.

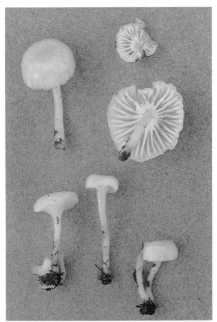

Hygrocybe vitellina life size

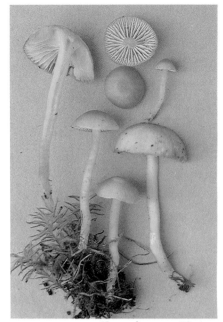

Hygrocybe ceracea life size

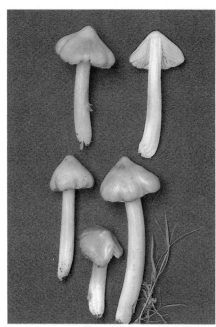

Hygrocybe konradii ½ life size

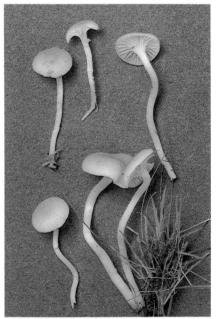

Hygrocybe russocoriacea ⅔ life size

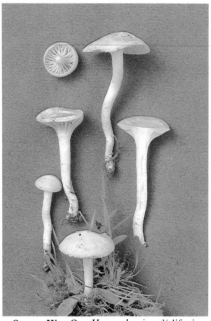

Snowy Wax Cap *Hygrocybe nivea* ¾ life size

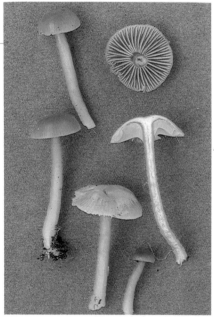

Hygrocybe laeta ⅔ life size

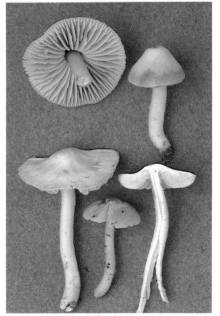

Parrot Wax Cap *Hygrocybe psittacina* ¾ life size

Hygrocybe vitellina (Fr.) Karst syn. *Hygrophorus vitellinus* Fr. **Cap** 1–2cm across, convex soon expanding and often slightly depressed, bright yellow, the margin often striate. **Stem** 10–35×1–3mm, concolorous with cap. **Flesh** thin, yellow. Taste none, smell delicate, slightly perfumed. **Gills** decurrent, bright yellow. Spore print white. Spores elliptic-ovoid, 6–8×4.5–5μ. Habitat amongst damp moss. Season late summer to autumn. Rare. **Edibility unknown**.

Hygrocybe ceracea (Wulf. ex Fr.) Kummer syn. *Hygrophorus ceraceus* (Wulf. ex Fr.) Fr. **Cap** 1–2.5cm across, convex then flattened, deep yellow to pale orange, greasy, faintly striate at margin. **Stem** 25–50×2–4mm, dry, concolorous with cap, narrowing towards the base which is sometimes covered in fine white down. **Flesh** thin, yellow, becoming hollow in the stem. Taste and smell not distinctive. **Gills** adnate-decurrent and connected by veins, yellow with a paler edge. Spore print white. Spores ellipsoid 5.5–7×3μ. Habitat in short grass in pastures and lawns. Season autumn. Occasional. **Edible**.

Hygrocybe konradii Haller syn. *Hygrophorus konradii* (Haller) Orton syn. *H. obrusseus* (Fr.) Fr. (of some authors) **Cap** 2–6cm across, conical and irregularly lobed with a prominent umbo, chrome yellow with richer colour at margin and sometimes at umbo. **Stem** 30–80×7–10mm, chrome yellow, white at stem base. **Flesh** white. Smell not distinctive. **Gills** pale yellow, deepening with age. Spore print white. Spores ovoid, 9–11×6.5–8μ. Habitat in grassland. Season summer. Uncommon. **Edibility unknown**.

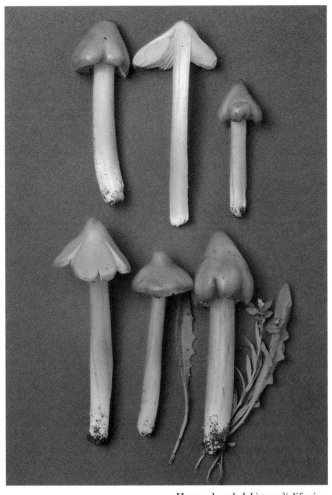

Hygrocybe subglobispora ⅔ life size

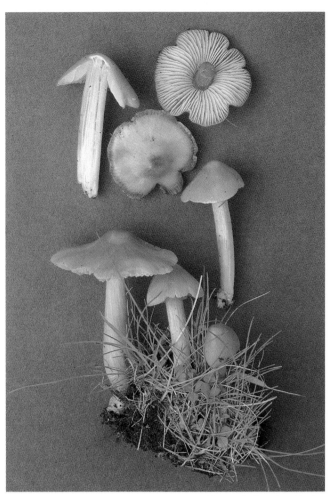

Hygrocybe langei ¾ life size

Hygrocybe russocoriacea Berk. & Miller syn. *Camarophyllus russo-coriaceus* (Berk. & Miller) Lange **Cap** 0.8–2cm across, white to yellow-ivory, convex, faintly striate. **Stem** 20–35×2–3mm, whitish, slightly wavy and tapering towards the base. **Flesh** thick at centre of cap, whitish or tinged ivory-yellow. Smell strongly of pencil sharpenings or sandalwood. **Gills** decurrent, widely spaced, white. Spore print white. Spores ellipsoid, 7.5–9×4–5μ. Habitat in short grass on lawns or heaths. Season autumn. Occasional. **Not edible.**

Snowy Wax Cap *Hygrocybe nivea* (Scop.) Fr. syn. *Camarophyllus virgineus* (Wulf. ex Fr.) Fr. (of certain authors) **Cap** 1–3cm across, convex becoming flattened and depressed, white becoming ivory or tinged ochraceous with age especially at centre, striate when moist. **Stem** 25–50×2–4mm, tapering towards the base, white. **Flesh** thick at centre of cap, whitish. Taste and smell not distinctive. **Gills** decurrent, widely spaced, whitish. Spore print white. Spores ellipsoid or pip-shaped, 7–9×4–5.5μ in four-spored forms but 10–12×5–6μ in two-spored forms. Habitat amongst short grass in pasture and open woodland. Season autumn. Common. **Edible – good.**

Hygrocybe laeta (Pers. ex Fr.) Kummer syn. *Hygrophorus laetus* (Pers. ex Fr.) Fr. syn. *Hygrophorus houghtonii* Berk. & Br. **Cap** 1–3cm across, convex, flesh to pale tawny-brown, slimy, faintly lined at the margin. **Stem** 30–70×2–

4mm, pale yellow tinged with cap colour, very slimy. **Flesh** thin, tawny in the cap, more yellowish in the stem which soon becomes hollow. Taste and smell not distinctive. **Gills** decurrent, widely spaced but connected by veins, whitish to flesh-coloured. Spore print white. Spores broadly ellipsoid, 5–7.5×4–5μ. Habitat on heaths usually amongst bracken. Season late autumn. Uncommon. **Edible – good.**

Parrot Wax Cap or **Parrot Toadstool** *Hygrocybe psittacina* (Schaeff. ex Fr.) Wünsche syn. *Hygrophorus psittacinus* (Schaeff. ex Fr.) Fr. **Cap** 1–3cm across, convex or bell-shaped, usually greenish at first then more yellowish often with a pinkish tinge at the broad umbo, often striate at the margin, covered in greenish gluten especially when young. **Stem** 20–40×2–5mm, greenish yellow with darker greenish blue apex, very slimy. **Flesh** white tinged with green and yellow. Smell mushroomy. **Gills** adnate, broad, yellowish near edge becoming more green towards the cap. Spore print white. Spores ellipsoid, 8–9.5×4–5.5μ. Habitat amongst grass on lawns or heaths. Season summer to late autumn. Occasional. **Edible** but not good due to its sliminess.

Hygrocybe subglobispora Orton syn. *H. amoena* f. *silvatica* Haller & Métrod **Cap** 2–7cm across, conical and irregularly lobed with a distinct umbo, bright chrome yellow flushed orange especially towards the margin, viscid when

moist, drying silky. **Stem** 30–90×7–12mm, concolorous with the cap paling to lemon above the white base which has a tendency to bruise brownish-black. **Flesh** white in the centre of cap and stem, yellow below the cap cuticle, the stem soon hollow. Smell none. **Gills** free, pale lemon, edge white. Spore print white. Spores broadly ovoid to subglobose, 8–12×6–10μ. Basidia either two- or four-spored. Habitat grassland and woods. Season early summer to autumn. Rare. **Edibility unknown.**

Hygrocybe langei Kühn. syn. *Hygrophorus langei* (Kühn.) Pearson syn. *H. rickenii* Maire **Cap** 3–6cm across, conical, slightly lobed with a prominent umbo, golden yellow often with touches of orange-red in places, striate at margin, sticky. **Stem** 30–50×7–12mm, concolorous with cap or paler, often with whitish stem base. **Flesh** yellow. Smell faint. **Gills** adnexed, pale yellow. Spore print white. Spores oblong-ellipsoid, 11–14×5.5–7.5μ. Habitat grassland. Season summer. Rare. **Edibility unknown.**

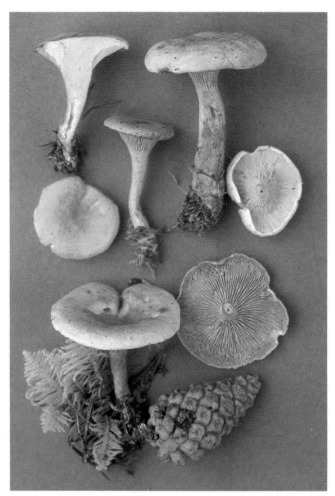

False Chanterelle *Hygrophoropsis aurantiaca* ²/₃ life size **Fairy Ring Champignon** *Marasmius oreades* life size

False Chanterelle *Hygrophoropsis aurantiaca*
([von Wulf.] Fr.) Maire apud Martin-Sans syn.
Cantharellus aurantiacus [von Wulf.] Fr. **Cap** 2–
8cm across, convex to shallowly funnel-shaped,
orange-yellow, finely downy, often remaining
incurved at the margin. **Stem** 30–50×5–10mm,
concolorous with the cap or darker, often
curved. **Flesh** tough, yellowish to orange. Taste
and smell mushroomy. **Gills** decurrent,
dichotomously forked and narrow, orange.
Spore print white. Spores elliptic, dextrinoid,
5.5–7×4–4.5μ. Habitat in coniferous woods and
heaths. Season autumn. Common. **Said to be
edible** but known to cause alarming symptoms
(hallucination) in some cases.

MARASMIUS *Usually small often tiny, they are
tough and leathery, if dried out they will revive on
wetting. The caps are generally not conical like the
Mycenas. Thirty in Britain.*

Fairy Ring Champignon *Marasmius oreades*
(Bolt. ex Fr.) Fr. **Cap** 2–5cm across, convex then
flattened with a large broad umbo, tan when
moist drying buff tinged with tan at the centre.
Stem 20–100×3–5mm, whitish to pale buff,
tough, rigid. **Flesh** thick at the centre of the cap,
whitish. Smell of fresh sawdust. **Gills** white then
ochre-cream, distant. Spore print white. Spores
pip-shaped, 8–10×5–6μ. Cuticular cells smooth,
subglobose. Habitat often forming rings in the
short grass of pasture or lawns. Season late spring
to late autumn. Common. **Edible** but since it can
be confused with the deadly *Clitocybe rivulosa*
(p.51) great care should be taken in collection.

Marasmius candidus [Bolt.] Fr. **Cap** 0.5–1.5cm
across, convex to flattened, membranous, white.

Stem 3–10×1–2mm, white. **Flesh** thin, white.
Gills broadly spaced, becoming irregular and wavy
or vein-like. Spore print white. Spores elongate
elliptical or spindle-shaped, 11.5–16.5×4–5.5μ.
Habitat on fallen branches or amongst leaf litter.
Season autumn. Rare. **Not edible.**

Marasmius wynnei Berk. & Br. syn. *M. globularis*
Fr. apud Quél. **Cap** 2–6cm across, hemispherical
to flattened convex, pallid or violet grey when
moist drying from centre to cream buff to clay
pink and slightly wrinkled, margin striate when
moist. **Stem** 20–100×2–5mm, buff near the apex,
reddish-brown to almost black towards the finely
white-powdered base. **Flesh** whitish in cap darker
in stem. **Gills** white at first then pallid or tinged
violet. Spore print white. Spores pip-shaped, 5–
7×3–3.5μ. Cuticular cells smooth and
subglobose. Habitat in clusters amongst leaf litter
in beech woods. Season autumn. Uncommon.
Not edible.

Marasmius undatus (Berk.) Fr. syn. *M. chordalis*
Fr. **Cap** 1–2cm across, convex, dirty white to
umber with a white bloom, becoming rust spotted
with age. **Stem** 50–100×1–2mm, white at apex,
reddish-brown towards the finely hairy base,
entirely covered in a fine white velvet. **Flesh** white
in cap, brownish in stem. **Gills** white to pale
yellowish becoming rust spotted. Cheilocystidia
and pleurocystidia thin-walled, fusiform. Spore
print white. Spores almond-shaped, 8–11×6–7μ.
Cuticular cells smooth and subglobose. Habitat on
rhizomes and dead stems of bracken. Season
autumn. Occasional. **Not edible.**

Horse-hair fungus *Marasmius androsaceus* (L. ex
Fr.) syn. *Androsaceus androsaceus* (L. ex Fr.) Rea

Cap 0.5–1cm across, convex often with the centre
depressed, membranous and radially wrinkled,
clay pink with red-brown centres. **Stem** 20–
60×1mm, black, hair-like, stiff and tough. **Flesh**
thin, white in cap, dark in stem. **Gills** distant, clay
pink. Spore print white. Spores pip-shaped, 6.5–
9×3–4μ. Cuticular cells irregular with minute
finger-like processes. Habitat on twigs, needles,
leaves and dead heather associated with black
horsehair-like mycelium. Season late spring to late
autumn. Common. **Not edible.**

Marasmius epiphyllus (Pers. ex Fr.) Fr. syn.
Androsaceus epiphyllus (Pers. ex Fr.) Pat. **Cap** 3–
10mm across, flattened, sometimes depressed,
white to creamy-white, membranous and radially
wrinkled. **Stem** 15–30×1mm, hair-like, whitish
near apex, reddish-brown below. **Gills** white, few,
broadly spaced, branched and vein-like. Spore
print white. Spores elongate elliptical, 10–11×3–
4μ. Cuticular cells smooth and subglobose.
Habitat on fallen twigs and leaf petioles. Season
autumn. Rare. **Not edible.**

Marasmius ramealis (Bull. ex Fr.) Fr. syn.
Marasmiellus ramealis (Bull. ex Fr.) Sing. **Cap**
3–10(15)mm across, convex then flattened or
centrally depressed, whitish pink often darker in
the centre, membranous and often wrinkled.
Stem 3–20×1mm, scurfy, concolorous with cap,
darkening towards the curved base. **Flesh** thin,
concolorous. **Gills** distant, white or pinkish.
Spore print white. Spores elongate, elliptical, 8.5–
10.5×3–4μ. Habitat on old stems. Season early
summer to autumn. Frequent. **Not edible.**

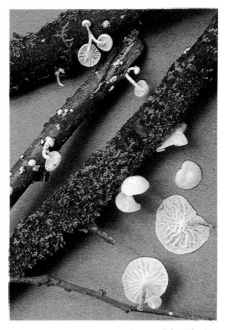

Marasmius candidus life size

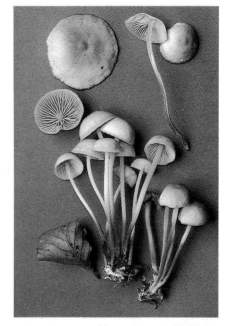

Marasmius wynnei ²/₃ life size

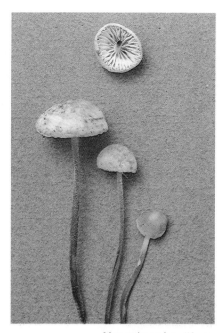

Marasmius undatus life size

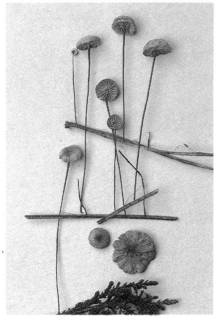

Horse-hair fungus *Marasmius androsaceus* life size

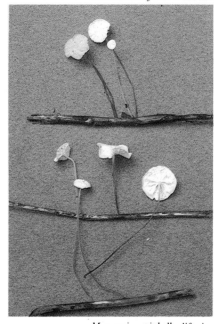

Marasmius epiphyllus life size

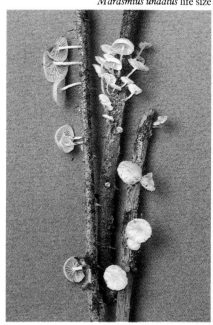

Marasmius ramealis ¾ life size

Marasmius rotula (Scop. ex Fr.) Fr. **Cap** 0.5–1.5cm across, convex, centrally flattened and ribbed like a parachute with the margin scalloped, whitish, sometimes dark brown in the depressed centre. **Stem** 20–70×1mm, white at apex dark brown below. **Flesh** white in cap, brown in stem. **Gills** whitish cream, attached to a collar free of the stem. Spore print white. Spores elongate elliptical, 7–10×3.5–5μ. Cuticular cells subglobose with tiny dense finger-like processes. Habitat gregarious on dead twigs and roots, less frequently on leaves. Season summer to winter. Common. **Not edible**.

Marasmius calopus (Pers. ex Fr.) Fr. **Cap** 0.5–1.5cm across, centrally depressed, whitish with rusty-brown tinge at centre, surface uneven. **Stem** 10–30×1–2mm, rusty-brown. **Flesh** thin, concolorous. **Gills** distant, white to cream. Cheilocystidia hair-like with irregular knobbly swellings. Spore print white. Spores tear-shaped, 7–8.5×3–4.5μ. Cap cuticle of irregularly branched hyphae. Habitat on leaf litter, dead grass and other debris. Season autumn. Uncommon. **Not edible**.

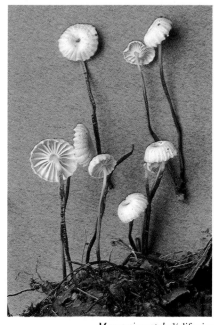

Marasmius rotula ¾ life size

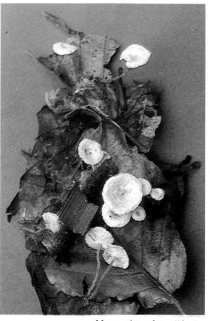

Marasmius calopus life size

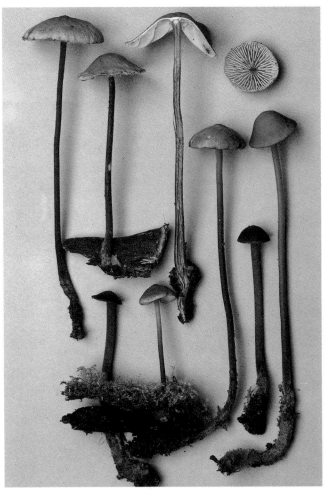

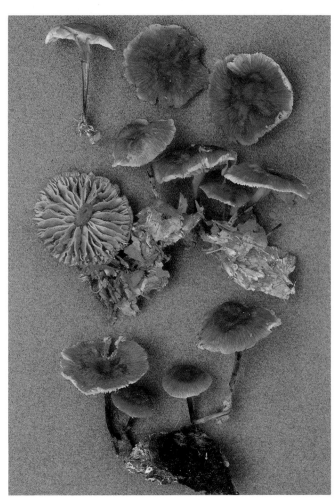

Marasmius alliaceus ¾ life size

Micromphale brassicolens life size

Marasmius alliaceus (Jacq. ex Fr.) Fr. **Cap** 1–4cm across, convex to broadly bell-shaped, whitish to pallid or clay-brown, often grooved or striate at margin. **Stem** 45–200×1–3mm, minutely velvety, clay-brown at apex becoming black below, base rooting. **Flesh** thin, whitish in cap, grey in stem. Smell strongly of garlic. **Gills** whitish to pallid. Spore print cream. Spores broadly elliptic, 7–11×6–8μ. Cuticular cells rounded and smooth. Habitat on leaf litter, buried twigs and other debris, usually beech, especially on chalk. Season late summer to late autumn. Uncommon. **Not edible**.

Micromphale brassicolens (Romagn.) Orton **Cap** 1–2cm across, convex then expanded and often centrally depressed, reddish-brown, faintly striate near the margin when moist, losing this when dry. **Stem** 15–20×1mm, pale flesh-brown at apex darkening to reddish-brown below and black towards the base. **Flesh** thin, whitish to pale brownish. Smell very unpleasant, strongly of rotting cabbage. **Gills** white at first, later tinged flesh-brown at the base. Spore print white. Spores 5–7×3–3.5μ. Habitat on beech litter. Season autumn. Rare. **Not edible**.

Micromphale foetidum ([Sow.] Fr.) Sing. syn. *Marasmius foetidus* (Sow.) Fr. **Cap** 1–3cm across, convex then expanded and slightly depressed at the centre, thin, membranous, pliant, dingy reddish-buff with darker centre and persistent radiating furrows. **Stem** 10–25×1–2mm, tough,

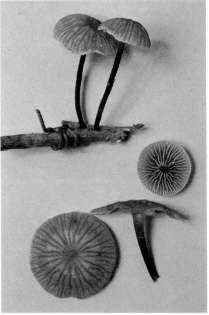

Micromphale foetidum ¾ life size

tapering towards the base, dark brown to black, velvety. **Flesh** very thin, concolorous. Smell fetid. **Gills** distant, connected by veins, clay-pink. Spore print white. Spores pip-shaped, 8–10×3–4μ. Habitat gregarious on fallen twigs of deciduous trees, especially hazel and beech. Season late summer to early winter. Uncommon. **Not edible**.

Myxomphalia maura (Fr.) Hora syn. *Omphalia maura* (Fr.) Gillet syn. *Mycena maura* (Fr.) Kühn. **Cap** 1–3cm across, hemispherical to convex with the centre depressed, dark grey-brown, drying paler and shiny. **Stem** 20–40×2–4mm, paler than cap or concolorous. **Flesh** white to greyish. Smell not distinctive. **Gills** adnate-decurrent, whitish to pale grey. Cheilo- and pleurocystidia thin-walled, hyaline, fusoid or cylindric. Spore print white. Spores broadly elliptic, amyloid, 5–6.5×3.5–4.5μ. Habitat on burnt ground in conifer woods. Season autumn. Uncommon. **Edibility unknown**.

Baeospora myosura (Fr. ex Fr.) Sprig. syn. *Collybia myosura* (Fr. ex Fr.) Quél. syn. *C. conigena* (Pers. ex Fr.) Kummer **Cap** 1–3cm across, convex to almost flat, pallid-tan to date-brown. **Stem** 30–50×1–2mm, pallid flushed with cap colour, elongated into a hairy 'root'. **Flesh** thin, brownish. Taste mild, smell mushroomy. **Gills** very crowded, whitish. Cheilocystidia thin-walled, fusoid. Spore print white. Spores elliptic, amyloid, 3–3.5×1.5–2μ.

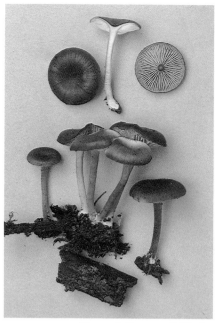

Myxomphalia maura ¾ life size

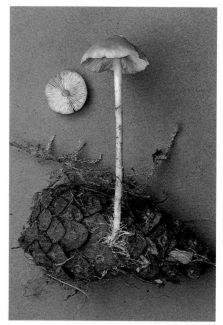

Baeospora myosura ¾ life size

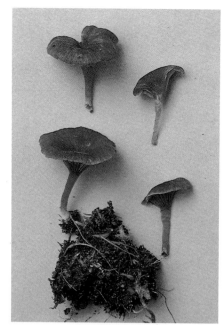

Omphalina griseopallida life size

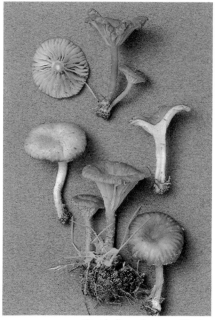

Omphalina ericetorum life size

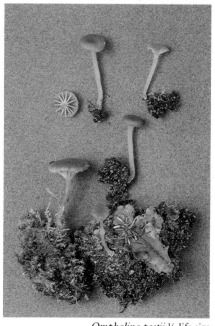

Omphalina postii ½ life size

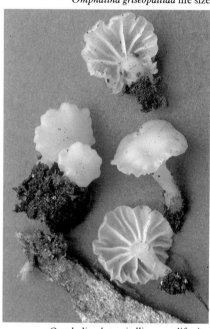

Omphalina luteovitellina over life size

Habitat rooting on partly buried pine cones and coniferous debris. Season autumn to late winter. Frequent. **Not edible.**

Omphalina griseopallida (Desm.) Quél. **Cap** 1–1.5cm across, convex with depressed centre, dark grey-brown drying pallid. **Stem** 10–12×2–3mm, concolorous, base covered in fine white down. **Flesh** thin, concolorous. **Gills** decurrent, concolorous with cap. Spore print white. Spores broadly elliptic, 9–12×5–6μ. Habitat amongst grass on open heathland. Season autumn. Uncommon. **Not edible.**

Omphalina ericetorum (Fr. ex Fr.) M. Lange syn. *O. umbellifera* (L. ex Fr.) Quél. **Cap** 0.5–2cm across, convex then centrally depressed to funnel-shaped, yellow-buff to yellow-brown sometimes with an olivaceous tinge, radially striate or grooved. **Stem** 10–20×2–4mm, more

or less cap colour often with darker brownish apex, base covered in white down. **Flesh** thin, whitish to ochre. **Gills** decurrent, pale yellowish-cream. Spore print white. Spores elliptic, 8–9.5×4.5–5.5μ. Habitat heathland, on peaty soil. Season late spring to late autumn. Frequent. **Not edible.**

Omphalina postii (Fr.) Sing. **Cap** 0.5–5cm across, convex then centrally depressed, bright orange, striate at the margin. **Stem** 20–80×1–3mm, pale yellow-orange. **Flesh** thin, concolorous. **Gills** decurrent, yellowish. Spore print white. Spores elliptic, 6–10×4–5.5μ. Habitat in damp places, amongst sphagnum, sometimes found on peat used for potting up plants. Season summer to autumn. Rare. **Not edible.**

Omphalina luteovitellina (Pilat & Nannf.) M. Lange syn. *O. flava* (Cke.) M. Lange **Cap** 7–15mm across, convex then flattened, margin wavy, bright yellow. **Stem** 10–20×2–4mm, concolorous or paler than cap. **Flesh** thin, concolorous. **Gills** strongly decurrent, thick and fleshy, few, pale yellowish. Spore print white. Spores elliptic, 6.5–9.5×3.5–4μ. Habitat on mountains, usually over 2500 feet, especially on peat covered with algal scum. Season autumn. Rare. **Not edible.**

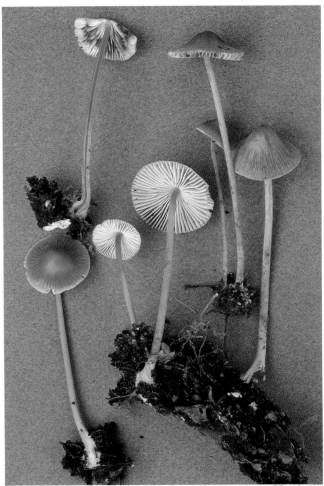

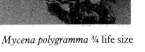

Mycena polygramma ¾ life size

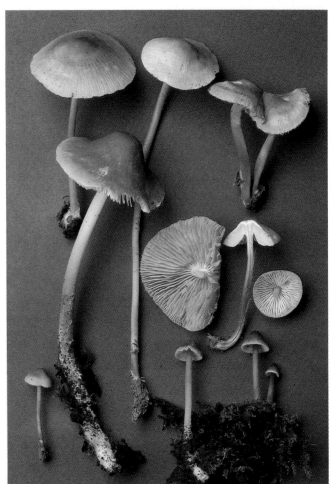

Bonnet Mycena *Mycena galericulata* ¾ life size

MYCENA *Small conical or bell-shaped caps on delicate long stems. Some exude a juice when the stem is broken. Note unusual smells. Check the gills to see if there is a dark edge. One hundred and two in Britain.*

Mycena polygramma (Bull. ex Fr.) S. F. Gray **Cap** 2–5cm across, conical then expanded and umbonate, dark grey to grey-brown, faintly grooved towards margin. **Stem** 60–100×2–4mm, silvery grey, striate, base rooting. **Flesh** thin, whitish with pallid line above gills. Taste mild to slightly acrid, smell pleasant. **Gills** whitish to grey or pinkish. Cheilocystidia thin-walled, hyaline, with swollen base and drawn-out pointed apex which may fork. Spore print white. Spores elliptic, amyloid, 9–10×6–7μ. Habitat on twigs or buried wood. Season summer to late autumn. Occasional. **Not edible.**

Bonnet Mycena *Mycena galericulata* (Scop. ex Fr.) S. F. Gray syn. *M. rugosa* (Fr.) Quél. **Cap** 2–6cm across, conical expanding to bell-shaped with broad umbo, brown or grey-brown with paler margin which is distinctly lined. **Stem** 20–100×3–8mm, concolorous with cap, paler near apex, hollow but tough, base covered in fine white fibrils and often rooting. **Flesh** thin, white. Taste mild, smell mealy when crushed, rancid. **Gills** adnate with decurrent tooth, white at first becoming flesh-pink. Cheilocystidia clavate covered with relatively long filiform processes. Spore print cream. Spores ellipsoid, amyloid, 9–12×6–8μ. Basidia often two-spored. Habitat in clusters on stumps and fallen branches of broad-leaved trees. Season all year. Common. **Edible – not worthwhile.**

Mycena galopus (Pers. ex Fr.) Kummer **Cap** 1–2cm across, conical or bell-shaped, grey-brown with umber centre, distinctly lined. **Stem** 50–100×2–3mm, grey, exuding white latex when broken, base covered in white cottony fibres. **Flesh** very thin, white. Taste mild, smell not distinctive. **Gills** adnate, white to grey. Cheilo- and pleurocystidia conspicuous, fusoid, thin-walled. Spores ellipsoid, amyloid, 11–13×5–6μ. Habitat amongst leaf litter in woods, hedgerows and on path sides. Season summer to autumn. Very common. **Edible** but not worthwhile.

Mycena galopus var. *candida* Lange syn. *M. galopus* var. *alba* Rea This variety differs from *M. galopus* only in the pure white colour throughout; it also exudes white latex.

Mycena leucogala (Cooke) Sacc. syn. *M. galopus* var. *nigra* Rea **Cap** 1–2cm across, bell-shaped, dark brown to almost black, deeply grooved from margin inwards. **Stem** 50–100×2–3mm, exuding a white latex when broken, concolorous with cap, with fine white down at base. **Flesh** very thin, greyish. Smell not distinctive. **Gills** adnate, grey. Cheilo- and pleurocystidia thin-walled, hyaline, fusoid. Spore print pale cream. Spores ellipsoid, amyloid, 11–13×5–6μ. Habitat in mixed woods. Season autumn. Uncommon. **Edible** but not worthwhile.

Mycena sanguinolenta (Alb. & Schw. ex Fr.) Kummer **Cap** 1–2cm across, conical to bell-shaped, brownish red with darker umbo, striate. **Stem** 45–80×1–2mm, concolorous with cap, exuding blood-red latex when broken. **Flesh** very thin, reddish. Taste mild, smell not distinctive. **Gills** adnate, whitish or tinged flesh-colour with reddish-brown edge. Cheilo- and

pleurocystidia thin-walled, fusoid with sharply pointed apex and brownish contents. Spore print white. Spores pip-shaped, amyloid 9–10×4–5μ. Habitat amongst grass in lawns, heaths and woodlands. Season summer. Very common. **Edible** but not worthwhile.

Mycena haematopus (Pers. ex Fr.) Kummer syn. *M. cruenta* (Fr.) Quél. **Cap** 2–4cm across, conical to bell-shaped, grey-brown with clay-pink tint, striate at margin when moist, drying light pink. **Stem** 40–100×2–3mm, grey-pink exuding a deep blood-red latex when broken, often fused together to form tufts. **Flesh** blood-red. Taste slightly bitter, smell not distinctive. **Gills** adnate, white becoming pale pink, often with darker edge. Cheilo- and pleurocystidia thin-walled with swollen base and an abrupt pointed apex. Spore print white. Spores ellipsoid, amyloid, 7–10×5–6μ. Habitat on old stumps. Season autumn. Occasional. **Edible.**

Mycena crocata (Schrad. ex Fr.) Kummer **Cap** 1–3cm across, conical expanding to bell-shaped with umbo, brownish-grey sometimes with olivaceous flush becoming stained orange-red by latex. **Stem** 40–80×2–3mm, lemon-white at apex saffron below exuding an orange latex when broken which gradually stains the stem, white woolliness at base. **Flesh** thin, saffron. Taste mild, smell none. **Gills** adnate, white staining orange-red. Cheilocystidia pyriform covered with scattered irregular short processes. Spore print white to pale buff. Spores ellipsoid, amyloid, 8–10×5–6μ. Habitat leaf litter of deciduous woods, especially beech. Season autumn. Uncommon. **Edible – not worthwhile.**

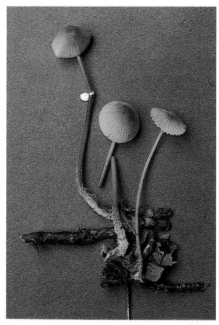

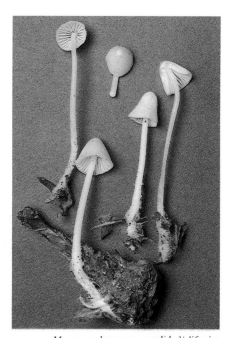

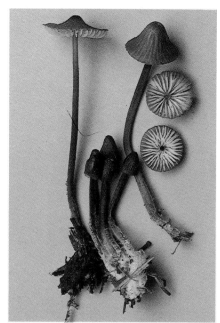

Mycena galopus ²/₃ life size

Mycena galopus var. *candida* ¾ life size

Mycena leucogala life size

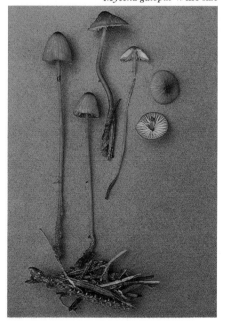

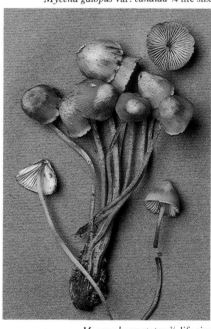

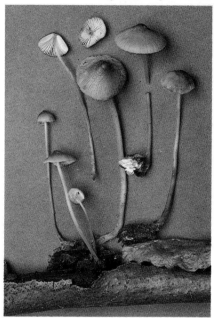

Mycena sanguinolenta ¾ life size

Mycena haematopus ²/₃ life size

Mycena crocata ½ life size

Mycena oortiana Hora syn. *M. arcangeliana* var. *oortiana* Kühn. **Cap** 1–5cm across, broadly conical, whitish to grey-brown with an olivaceous tint, striate. **Stem** 20–40×1–2mm, greyish, the colour fading with age, base covered in white down. **Flesh** white in cap, grey in stem. Taste mild, smell strongly iodoform. **Gills** crowded, adnexed, white at first later pinkish. Cheilocystidia abundant, thin-walled, clavate or ovate, hyaline, densely granulate-warted. Spore print whitish. Spores pip-shaped, amyloid, 7–8×4.5–5µ. Habitat on stumps and branches of deciduous trees. Season autumn. Uncommon. **Edibility unknown**.

Mycena alcalina (Fr.) Kummer **Cap** 1–3cm across, conical expanding to broadly bell-shaped, grey-brown, lined when moist. **Stem** 20–65×1–3mm, concolorous with cap, smooth. **Flesh** thin, whitish. Taste mild, smell of ammonia. **Gills** pale grey with whitish edge. Cheilocystidia fusoid, thin-walled. Spore print white. Spores cylindric-ellipsoid, amyloid, 8–12×4.5–6µ. Habitat on stumps, usually of conifers. Season autumn. Common. **Edible** but not worthwhile.

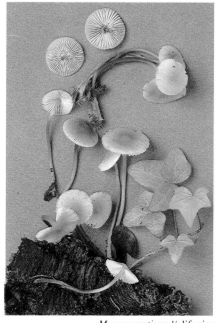

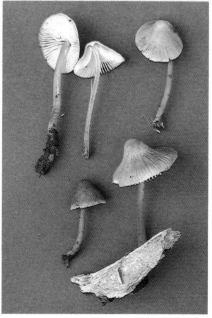

Mycena oortiana ½ life size

Mycena alcalina ¾ life size

71

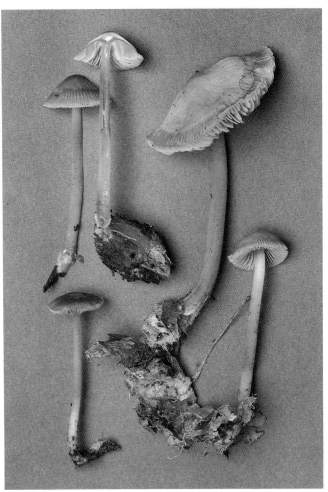

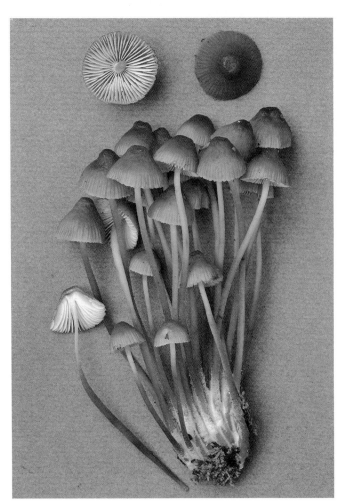

Mycena pura ¾ life size

Mycena inclinata ¾ life size

Mycena pura (Pers. ex Fr.) Kummer **Cap** 2–5cm across, rather variable in size, convex with a broad umbo, varying shades of lilac or pink, lined at margin when moist, paler when dry. **Stem** 50–100×4–10mm, rigid, flushed pink, base covered in fine white fibres, **Flesh** white. Taste mild, smell radishy. **Gills** adnate, pink. Cheilo- and pleurocystidia bottle-shaped. Spore print white. Spores subcylindric, amyloid, 6–8×3.5–4µ. Habitat in beech litter. Season summer to winter. Common. **Edible**.

Mycena inclinata (Fr.) Quél. **Cap** 2–3cm across, conical expanding to bell-shaped with prominent umbo, bay, darker and lined towards centre, margin slightly overhanging the gills giving a delicately scalloped appearance. **Stem** 50–100×2–4mm, whitish at apex deepening to dark red-brown towards the base which is covered in fine white down. **Flesh** thin, whitish. Taste mild, smell mealy or rancid. **Gills** adnate, whitish becoming flesh-pink. Cheilocystidia clavate, the apex covered with relatively long filiform irregular processes. Spore print white. Spores ovoid, amyloid, 8–9×6–7µ. Habitat in dense tufts on oak stumps. Season late summer to autumn. Frequent. **Not edible**.

Mycena aetites (Fr.) Quél. syn. *M. ammoniaca* (Fr.) Quél. s. Lange **Cap** 0.5–1.5cm across, conical to convex, pale to dark grey, grooved and having a lined appearance when moist, opaque when dry. **Stem** 30–45×0.5–1mm, concolorous with cap, lighter towards apex. **Flesh** thin,

whitish, greyish in stem. Taste mild, smell none or slightly ammoniacal. **Gills** adnate with a decurrent tooth, grey with whitish edge. Cheilocystidia fusoid, thin-walled. Spore print white. Spores elliptical, amyloid, 9–10×5–5.5µ. Habitat amongst short grass, or herbaceous debris. Season autumn. Rare. **Edible** but not worthwhile.

Mycena leptocephala (Pers. ex Fr.) Gillet syn. *M. ammoniaca* ([Fr.] Secr.) Quél. s. Pearson syn. *M. alcalina* var. *chlorinella* Lange **Cap** 1–1.5cm across, bell-shaped, smoky grey, striate when moist, opaque and grooved when dry. **Stem** 30–55×1–2mm, greyish with paler apex, base woolly white and slightly rooting. **Flesh** thin, whitish darkening towards the stem base. Taste mild, smelling strongly of ammonia or ozone. **Gills** pale grey with whitish edge. Cheilocystidia thin-walled, cylindric, fusoid often forked at apex. Spore print whitish. Spores ellipsoid to subcylindric, amyloid, 5–10×4–7µ. Habitat in short grass. Season autumn. Frequent. **Not edible**.

Mycena uracea Pearson **Cap** 1–3cm across, conical to convex, grooved with prominent umbo, grey-brown with darker, almost black, centre. **Stem** 20–40×2–3mm, grey-brown, base often with fine white hairs and rooting. **Flesh** thick at centre, whitish. Taste slightly radishy, smell none. **Gills** adnate with decurrent tooth, white then pinkish-grey. Cheilocystidia pyriform with warted apex. Spore print white.

Spores broadly ellipsoid, amyloid, 8–10×6–7.5µ. Habitat with heather, especially on burnt heaths. Season autumn. Occasional. **Not edible**.

Mycena pelianthina (Fr.) Quél. **Cap** 2–4cm across, bell-shaped with a broad umbo expanding to almost flat, brownish with violaceous tint drying pale buff. **Stem** 50–60×4–8mm, violaceous brown, fibrous at base. **Flesh** thin at margin, white. Taste mild, smell faintly radishy. **Gills** adnate, distant, violaceous with darker, sometimes uneven edge. Cheilo- and pleurocystidia thin-walled, cylindric to slightly fusoid. Spore print white. Spores ellipsoid, amyloid, 5–7×2.5–3µ. Habitat in beech litter. Season summer to autumn. Uncommon. **Edible** but not worthwhile.

Mycena sepia Lange syn. *M. vitrea* (Fr.) Quél. s. Kühn. syn. *M. filopes* (Bull. ex Fr.) Kummer s. Pearson **Cap** 0.5–1cm across, conical expanding to bell-shaped, dark grey-brown with sepia flush, whitish at margin. **Stem** 10–50×1–3mm, lighter than cap, base covered in fine white hairs and sometimes rooting. **Flesh** thin, pale greyish. Smell of iodoform especially when dried. **Gills** adnate with a decurrent tooth, pale grey with white edge. Cheilocystidia sac-like with granular warts. Spore print white. Spores ellipsoid, amyloid, 8.5–9×4.5µ. Basidia four-spored. Habitat in deciduous woods or with pine and spruce. Season autumn. Rare. **Not edible**.

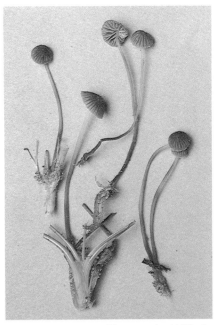

Mycena aetites ½ life size

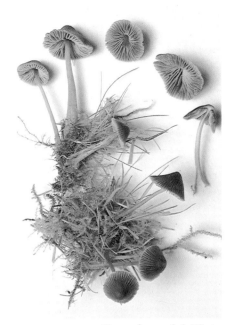

Mycena leptocephala life size

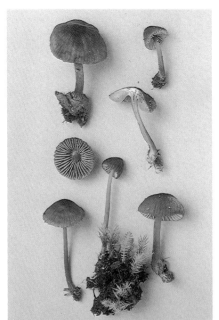

Mycena uracea ¾ life size

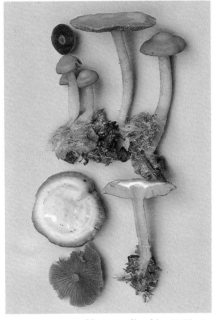

Mycena pelianthina ¾ life size

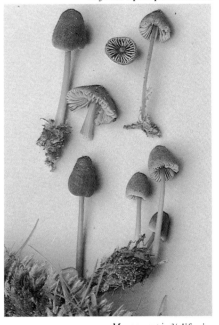

Mycena sepia ¾ life size

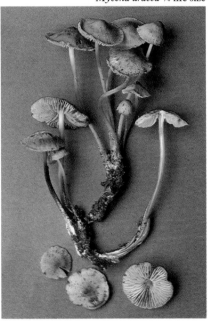

Mycena maculata ¾ life size

Mycena maculata Karst. syn. *M. parabolica* (Fr.) Quél. s. Bres. **Cap** 1–3cm across, convex expanding to bell-shaped with a distinct umbo, the margin becoming lined and upturned, grey-buff later stained rust. **Stem** 20–60×2–3mm, white at apex, grey-buff below, tinged rust with age, several stems fused together at the white downy base. **Flesh** very thin, whitish at first becoming tinged rust. Taste not distinctive, smell strongly mushroomy. **Gills** pale grey then tinged rust. Cheilocystidia pyriform, apex covered with relatively long filiform irregular processes. Spore print white. Spores ellipsoid, amyloid, 7–11×4–5μ. Habitat in small clusters on stumps or logs of beech. Season autumn. Rare. **Edible** but not worthwhile.

Mycena pearsoniana Dennis ex Sing. syn. *M. pseudopura* (Cooke) Sacc. **Cap** 1–2cm across, convex, flattening and turning up at margin, pale buff with violet tint, paler and lined at margin. **Stem** 30–50×2–3mm, pale flesh-coloured. **Flesh** thin at margin, brownish. Taste mild or slightly rancid, smell radishy. **Gills** horizontal, adnate with decurrent tooth, whitish flushed violet. Cheilocystidia numerous, thin-walled, cylindric with rounded apex. Spore print white. Spores pip-shaped, nonamyloid, 5–7×3.5–4.5μ. Habitat on spruce debris. Season summer to autumn. Rare. **Not edible**.

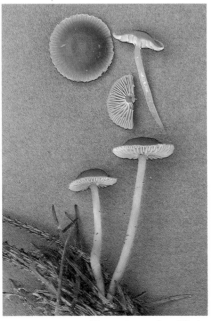

Mycena pearsoniana life size

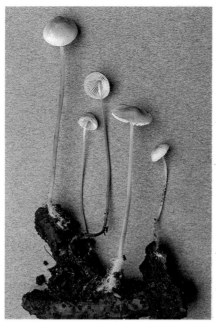

Mycena filopes ²/₃ life size

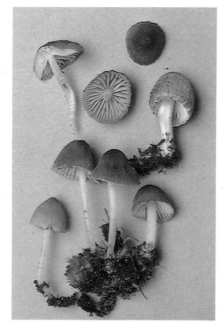

Mycena viscosa ¾ life size

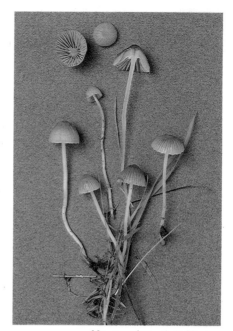

Mycena epipterygia ²/₃ life size

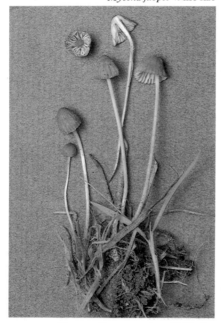

Mycena olivaceomarginata ¾ life size

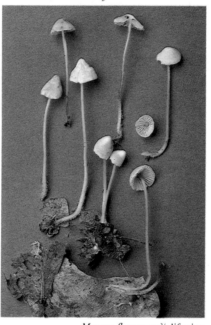

Mycena flavescens ²/₃ life size

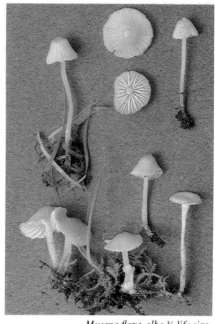

Mycena flavo-alba ¾ life size

Mycena filopes (Bull. ex Fr.) Kummer non s. Pearson syn. *M. vitilis* (Fr.) Quél. s. Kühn., Rick. **Cap** 1.5–2.5cm across, conico-convex becoming bell-shaped, grey-brown, paler and striate towards the margin. **Stem** 40–70×1–2mm, concolorous with cap or paler, whitish at apex, base covered in fine white hairs and rooting. **Flesh** thin, whitish. Smell iodoform. **Gills** crowded, whitish, greyish towards their base. Cheilocystidia sac-like with apical finger-like processes. Spore print white. Spores ellipsoid, often almond-shaped, amyloid, 7.5–10×4.2–7.2μ. Basidia generally two-spored. Habitat in mixed woodland, usually attached to buried twigs. Season autumn. Common. **Edibility unknown**.

Mycena viscosa (Secr.) Maire syn. *M. epipterygia* var. *viscosa* Ricken **Cap** 1–3cm across, ochraceous to brown sometimes flushed rust at the darker brown centre. **Stem** 10–30×3–7mm, viscid, bright lemon-yellow. **Flesh** yellowish-

white. Taste rancid, smell strongly mealy or rancid. **Gills** yellow to pale flesh, edge separable as an elastic filament as in *M. epipterygia*. Cheilocystidia club-shaped with apex covered in irregular short sometimes branched processes. Spore print white to cream. Spores ellipsoid or oval, amyloid, 8–10×4–5μ. Habitat on conifer stumps, especially pine and spruce. Season autumn. Occasional. **Not edible**.

Mycena epipterygia (Scop. ex Fr.) S. F. Gray **Cap** 1–2cm across, convex expanding to bell-shaped, fawn, especially at centre, with yellowish tinge, having a lined appearance when moist, margin often delicately toothed, covered with a viscid, easily removed skin. **Stem** 40–70×1–2mm, pale yellow and viscid. **Flesh** very thin. Taste mild, smell slight, not distinctive. **Gills** subdecurrent, pale pink, edge glutinous, can be removed by a needle when fresh. Cheilocystidia clavate covered with irregular knobbly sometimes branched processes. Spore print white to pale

buff. Spores ellipsoid, amyloid, 8–10×4.5–5μ. Habitat amongst grass or moss in woods or heaths. Season autumn. Common. **Edible** but not worthwhile.

Mycena olivaceomarginata Massee syn. *M. avenacea* (Fr.) Quél. **Cap** 1–2.5cm across, convex to bell-shaped, olive-brown with lined or grooved margin. **Stem** 50–70×2–3mm, concolorous with cap, lighter at apex, covered in fine white down at base. **Flesh** very thin, white to brown. Taste mild, smell radishy. **Gills** adnate, whitish with darker yellowish-brown or olive edge. Cheilocystidia comprising a mixture of thin-walled fusoid elements and more or less club-shaped bodies, the apex covered in short to elongate filiform processes. Spore print cream. Spores ellipsoid, amyloid, 9–12×5–6μ. Habitat on lawns or short grassland. Season autumn. Frequent. **Not edible**.

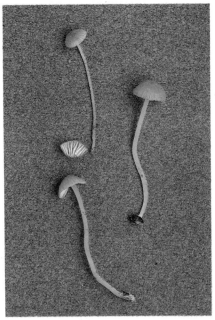

Mycena acicula life size

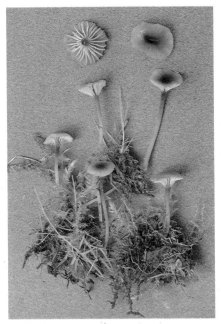

Mycena swartzii life size

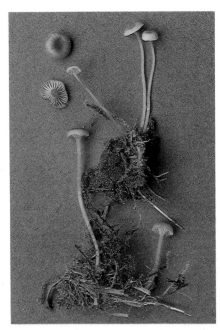

Mycena fibula life size

Mycena flavescens Vel. syn. *M. luteo-alba* var. *sulphureo-marginata* Lange **Cap** 0.5–1cm across, conical, yellowish grey, paler when dry. **Stem** 30–60×1–2mm, pale buff-grey, base covered in fine white down. **Flesh** thin, white. Taste mild, smell none. **Gills** adnate, whitish with yellow edge. Cheilocystidia 12–34μ wide, clavate, densely covered at apex with minute warts. Spore print whitish-yellow. Spores ellipsoid, amyloid, 8–10×4–5.5μ. Habitat in leaf litter under mixed broad-leaves often on sandy soil. Season autumn. Rare. **Edible** but not worthwhile.

Mycena flavo-alba (Fr.) Quél. syn. *Marasmiellus flavo-albus* (Fr.) Sing. **Cap** 1–2cm across, bell-shaped with prominent umbo, the margin becoming upturned and wavy as the cap expands, pale yellow with darker centre, distinctly lined when fresh. **Stem** 15–30×2–3mm, white to pale yellow, rigid. **Flesh** thin, white. Taste mild, smell radishy. **Gills** adnate, white. Cheilo- and pleurocystidia fusoid, thin-walled. Spore print pale yellow. Spores ellipsoid, nonamyloid, 6–8×3.5–4μ. Habitat on lawns. Season late summer to late autumn. Frequent. **Edible** but not worthwhile.

Mycena acicula (Schaeff. ex Fr.) Kummer syn. *Marasmiellus aciculus* (Schaeff. ex Fr.) Sing. **Cap** 2–10mm, hemispherical, bright orange becoming paler towards the margin, striate. **Stem** 20–50×1mm, bright yellow becoming paler towards the rooting, slightly hairy base. **Flesh** very thin, orange in cap. Taste mild, smell none. **Gills** ascending, pale yellow with whitish edge. Cheilo- and pleurocystidia not very prominent, thin-walled, hyaline, fusoid. Spore print white. Spores fusiform, nonamyloid, 9–12×3–4μ. Habitat on dead twigs and other woody fragments. Season summer to autumn. Occasional. **Not edible.**

Mycena swartzii (Fr. ex Fr.) A. H. Smith syn. *Omphalia fibula* var *swartzii* (Fr. ex Fr.) Karst **Cap** 0.5–1cm, convex then flattened, often

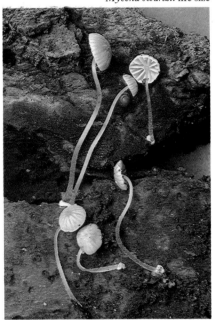

Mycena clavularis over life size

depressed at centre, ochraceous cream with dark brown centre. **Stem** 20–40×1–2mm, violet at apex, pallid below. **Flesh** thin, cream. Taste mild, smell slight, not distinctive. **Gills** decurrent, white or cream. Cheilo- and pleurocystidia thin-walled, fusoid. Spore print white. Spores narrowly ellipsoid, 4–5×2μ. Habitat in short grass or moss in damp places. Season late summer to early winter. Frequent. **Not edible.**

Mycena fibula (Bull. ex Fr.) Kühner syn. *Omphalia fibula* (Bull. ex Fr.) Kummer **Cap** 0.5–1cm across, convex then flattening with slightly depressed centre, yellow-orange, the centre more strongly coloured, having a lined appearance. **Stem** 20–40×1–2mm, pale orange, slightly downy towards the base. **Flesh** thin, orange. Taste mild, smell mushroomy. **Gills** strongly decurrent, white to pale yellow. Pleurocystidia prominent, fusoid, thin-walled. Spore print white. Spores narrowly elliptical, 4–5×2μ. Habitat in damp areas of short grass or moss. Season summer to autumn. Common. **Edible** but not worthwhile.

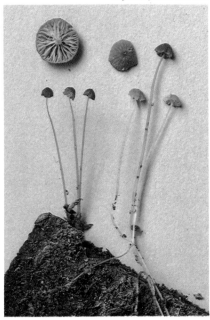

Mycena speirea life size

Mycena clavularis (Batsch. ex Fr.) Sacc. s. Kühner non Lange. **Cap** 3–6mm across, white to pale grey, having a lined appearance. **Stem** 13–25×1–2mm, whitish, with small white hairy disc at base. **Flesh** very thin, white. Smell none. **Gills** few, white. Cheilocystidia clavate with a few long apical filaments but fugacious. Spore print white. Spores globose or subglobose, amyloid, 8–10μ diameter. Habitat on bark. Season autumn. Rare. **Not edible.**

Mycena speirea (Fr.) Gillet syn. *Marasmiellus camptophyllus* (Berk.) Sing. syn. *Omphalia tenuistipes* Lange **Cap** 0.5–1.5cm across, convex, flattened or depressed at centre, often papillate, brown-grey, lined from margin to centre. **Stem** 30–60×1–1.5mm, pale brown or tinged yellowish-brown. **Flesh** very thin, whitish. Taste mild, smell none. **Gills** subdecurrent, whitish. Cheilocystidia thin-walled, hair-like, relatively undifferentiated. Spore print white. Spores pip-shaped, nonamyloid, 8–10×5–5.5μ. Habitat on wood and twigs. Season autumn. Rare. **Not edible.**

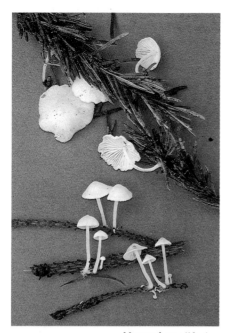

Mycena lactea life size

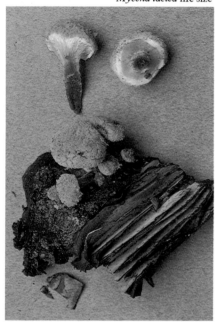

Asterophora lycoperdoides life size

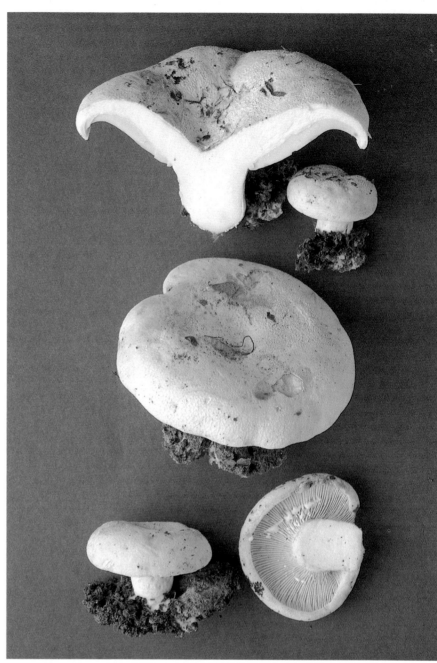

Fleecy Milk-cap *Lactarius vellereus* ½ life size

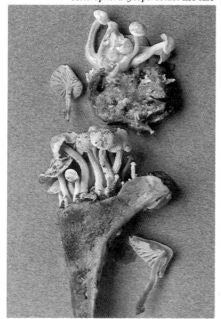

Asterophora parasitica ¾ life size

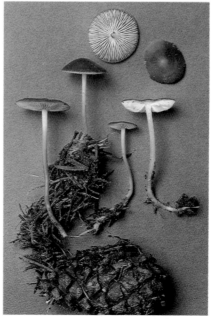

Pseudohiatula tenacella ⅔ life size

Mycena lactea (Pers. ex Fr.) Kummer **Cap** 1–1.5cm across, conical to bell-shaped, margin becoming wavy and irregular when expanded and lined when moist, chalk-white or with pale cream centre. **Stem** 10–50×2–3mm, white with white fibres at base. **Flesh** thin, white. Smell none. **Gills** adnate, white. Cheilocystidia small, thin-walled with the apex often subcapitate. Spore print white. Spores elongate-ellipsoid, nonamyloid, 9–11×3–4μ. Habitat in large groups amongst conifer needles and other debris. Season summer to autumn. Rare. **Edible** but not worthwhile.

Asterophora lycoperdoides (Bull. ex Mérat) S. F. Gray syn. *Nyctalis asterophora* Fr. **Cap** 0.5–1.5cm across, subglobose, covered in a clay-buff

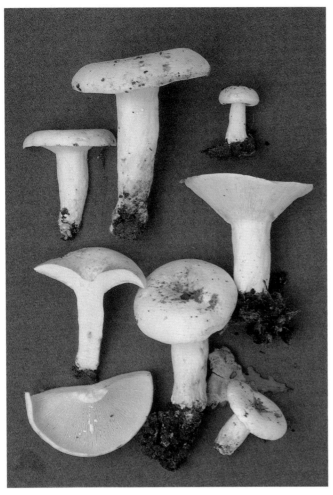

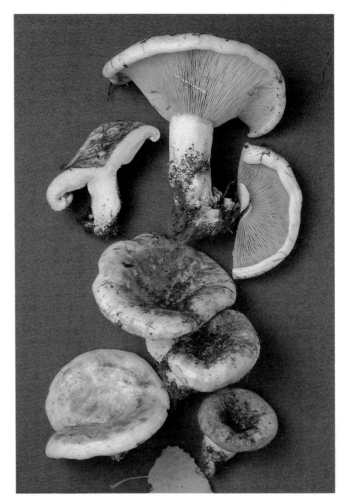

Peppery Milk-cap *Lactarius piperatus* ⅓ life size

Lactarius controversus ⅓ life size

mealy coating of chlamydospores. **Stem** 5–10×2–5mm, whitish. **Flesh** grey to dark brown. Chlamydospores clay-buff, subglobose covered in long blunt processes giving a star-shaped appearance, 13–16µ in diameter. Basidiospores (usually only on young gills) white, broadly elliptical, 5.5×3.5µ. Habitat on rotting *Russula nigricans*. Season summer to late autumn. Occasional – more common in wet periods. **Not edible.**

Asterophora parasitica (Bull. ex Fr.) Sing. syn. *Nyctalis parasitica* (Bull. ex Fr.) Fr. **Cap** 0.5–1.5cm, convex to bell-shaped at first then expanded, white with a greyish-lilac tinge, silky and very thin. **Stem** 10–30×1–3mm, often twisted, white often flushed brownish or lilaceous. **Flesh** thin, brown. Chlamydospores formed on the gills rather than the cap as in *A. lycoperdoides*, pale brown, thick-walled, ovate and smooth, 15×10µ. Basidiospores white, broadly ovate, 5–5.5×3–4µ. Habitat on old specimens of several species of Russula and certain Lactarius. Season summer to early winter. Occasional. **Not edible.**

Pseudohiatula tenacella (Pers. ex Fr.) Métrod syn. *Collybia tenacella* (Pers. ex Fr.) Kummer syn. *Marasmius tenacellus* (Pers. ex Fr.) Favre **Cap** 1–2.5cm across, convex then flattened and umbonate, brown often with a paler centre. **Stem** 40–80×1–3mm, tough, white at apex ochre-brown below with a very long rooting base. **Flesh** thin, concolorous. Taste bitter, smell not distinctive. **Gills** white. Pleuro- and

cheilocystidia thin-walled, hyaline, fusoid. Spore print white. Spores 6–7.5×2.5–3.5µ. Cap cuticle of globose cells with a stalked base. Habitat attached to buried pine cones by the long rooting system. Season spring. Frequent. **Not edible.**

LACTARIUS *Milk caps. They all exude droplets of milk from the gills or flesh when damaged; note the colour of the milk and whether it discolours after a time in the air, taste a drop of the milk on your tongue. It may be hot, bitter or mild. Note special smells. The flesh is granular like the Russulas and the cap and stem will break easily. Fifty-six in Britain.*

Fleecy Milk-cap *Lactarius vellereus* (Fr.) Fr. **Cap** 10–25cm across, convex and centrally depressed to widely funnel-shaped, margin incurved at first, white to cream becoming tinged yellowish-buff to pale reddish cinnamon in places, surface very shortly woolly. **Stem** 40–70×20–40mm, solid, concolorous with cap, shortly velvety. **Flesh** thick and firm. **Gills** decurrent, distant, narrow and brittle, pale ochraceous-cream. Milk white, abundant; taste mild. Spore print white (A). Spores elliptic with small warts connected by fine lines in an incomplete network, 7.5–9.5×6.5–8.5µ. Habitat deciduous woods. Season late summer to early winter. Common. **Not edible.**
L. vellereus var. *bertillonii* differs in the hot taste of the milk.

Peppery Milk-cap *Lactarius piperatus* (Scop. ex Fr.) S. F. Gray **Cap** 6–16cm across, convex with concave to widely funnel-shaped centre, creamy white, surface matt and glabrous. **Stem** 30–70×20–30mm, cylindrical or tapering towards the base, white. **Flesh** thick, white. **Gills** decurrent, crowded and narrow, white then creamy. Milk white; taste very hot and acrid. Spore print white (A). Spores elongate-elliptic, ornamented as *L. vellereus*, 6.5–9.5×5–7.5µ. Habitat deciduous woods. Season summer to early winter. Frequent. **Edible** but not recommended; used dried as seasoning or fresh after parboiling in some places, even then retaining an unpleasant taste and difficult to digest.
Easily distinguished from *L. vellereus* by its taller stature, glabrous cap and crowded gills.

Lactarius controversus (Fr. ex Fr.) Fr. **Cap** 8–15cm across, convex then concave to funnel-shaped, margin inrolled and downy at first, ivory to pale buff often with pale vinaceous tinges or indistinct blotches sometimes in concentric bands, glabrous, viscid when moist. **Stem** 30–75×20–40mm, solid, cylindrical or narrowing towards the base, concolorous with cap. **Flesh** white, thick. **Gills** decurrent, crowded and narrow, pale rosy buff. Milk white; taste slowly very hot. Spore print pinkish-cream (B). Spores oval with strong warts connected by thick ridges forming a fairly complete network, 6–7×5–6µ. Habitat near poplar or *Salix repens*. Season late summer to autumn. Uncommon. **Edible** – poor.

77

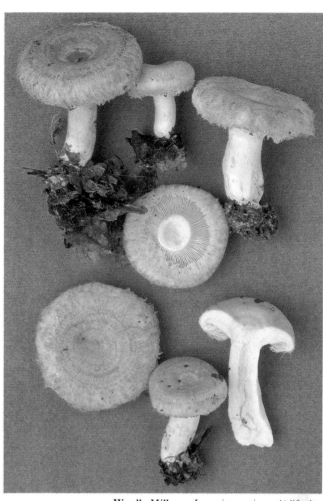

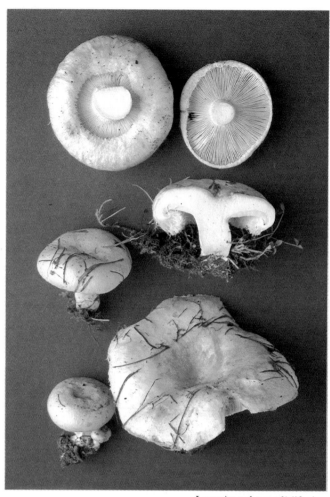

Woolly Milk-cap *Lactarius torminosus* ½ life size

Lactarius pubescens ⅔ life size

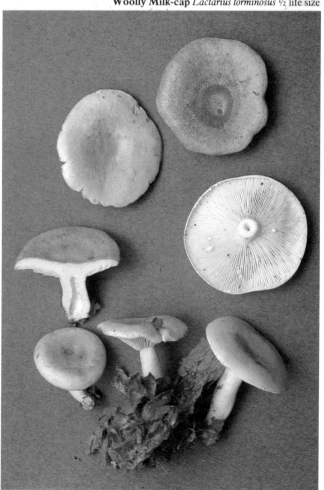

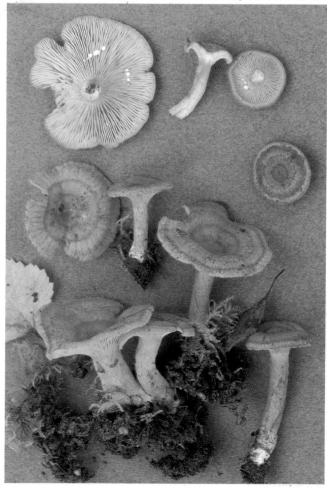

Lactarius chrysorrheus ⅔ life size

Lactarius spinosulus ¾ life size

Woolly Milk-cap *Lactarius torminosus* (Schaeff. ex Fr.) S. F. Gray **Cap** 4–12cm across, convex becoming funnel-shaped, margin inrolled and hairy, pale salmon buff to pale pink with deeper-coloured indistinct concentric bands. **Stem** 40–80×10–20mm, pale flesh-coloured to salmon, finely downy. **Flesh** white, soon hollow in stem. **Gills** slightly decurrent, narrow, pale flesh-coloured to pale salmon. Milk white; taste hot and acrid. Spore print yellowish-cream (C–D) with faint salmon tint. Spores oval with low warts connected by ridges forming a very incomplete network, 7.5–10×6–7.5μ. Habitat woods and heaths, usually with birch. Season late summer to early autumn. Frequent. **Poisonous.**

Lactarius pubescens (Fr. ex Krombh.) Fr. **Cap** 4–10cm across, convex then centrally depressed, margin inrolled and hairy, creamy white to rosy buff often with slightly darker areas, without concentric banding. **Stem** 30–60×10–23mm, concolorous with cap, often with a rosy-buff band at apex. **Flesh** thick, whitish. **Gills** slightly decurrent, crowded, whitish with a slight salmon tinge, darkening with age. Milk white; taste very hot. Spore print pale cream (C–D) with faint salmon tint. Spores elliptic with warts joined by ridges forming a well-developed, irregular network, 6.5–8.5×5.5–6.5μ. Habitat near birch on sandy soil. Season late summer to autumn. Uncommon. **Poisonous.**
Very similar to *L. torminosus* but paler and somewhat smaller.

Lactarius chrysorrheus Fr. **Cap** 3–8cm across, convex with a funnel-shaped depression, pale salmon to rosy or ochre-buff with darker rings of watery blotches or narrow concentric bands, smooth, margin hairless, incurved at first then straightening. **Stem** 30–80×9–20mm, cylindrical or with a slightly swollen base, whitish to pale buff, often flushed pinkish below. **Flesh** pallid to whitish becoming sulphur yellow from the milk, stem hollow. **Gills** decurrent, crowded, buff tinged pink. Milk white, abundant, becoming sulphur yellow in five to fifteen seconds; taste slowly bitterish and somewhat hot. Spore print creamy white (A+) with slight salmon tint. Spores oval with an incomplete network of ridges, 7–8.5×6–6.5μ. Habitat with oak. Season summer to autumn. Occasional. **Poisonous.**

Lactarius spinosulus Quél. **Cap** 2.5–6cm across, convex then funnel-shaped in centre, margin incurved at first then straight, pinkish-buff to vinaceous-lilac with darker flecks, fibrils or scattered pointed fibrillose scales, especially towards the margin. **Stem** 25–50×6–12mm, often irregularly dimpled or flattened, concolorous with cap or paler. **Flesh** white to vinaceous-buff. **Gills** decurrent, somewhat narrow and crowded, buff. Milk white; taste slowly moderately hot. Spore print pale ochre (D–E) with slight salmon tinge. Spores elliptic with thickish ridges running predominantly across the spores, 7–8.5×5.5–7.5μ. Habitat deciduous woods, especially with birch. Season late summer to autumn. Uncommon. **Not edible.**

Lactarius cilicioides (Fr.) Fr. **Cap** 10–20cm across, convex with a deep funnel-shaped central depression, pale yellowish buff to ochre-buff, with scattered ochre fibrils within its surface which become thicker and stronger coloured towards the margin, sometimes indistinctly banded towards the margin, hard and thick-fleshed, surface sticky, the fibrils forming a coarse fringe of matted hairs up to 1cm wide on the inrolled margin. **Stem** 40–80×20–45mm, narrowing downwards towards the base or cylindrical, hard and rigid, pale yellowish buff, sometimes with indistinct darker spots. **Flesh** pale yellow, a large cavity developing inside the stem. **Gills** decurrent, pale pinkish ochre-buff. Milk white, in a few seconds sulphur yellow; taste moderately hot and acrid. Spore print pale ochre (D–E) with slight salmon tinge. Spores broadly elliptic to subglobose with a fairly full network of both thick and thin ridges and an occasional isolated wart, 7.5–8.5×6μ. Habitat under birch. Season late summer to early autumn. Rare. **Suspect** – avoid.

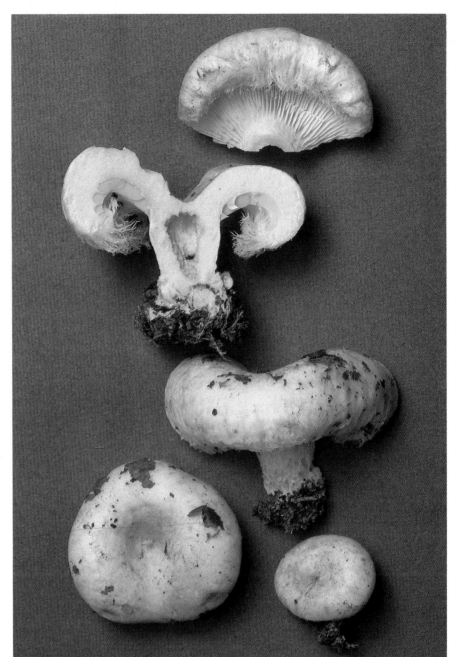

Lactarius cilicioides ½ life size

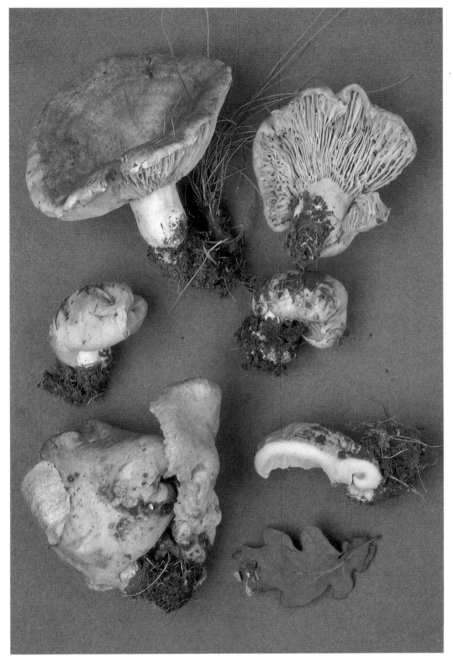

pinkish in places after fifteen minutes or so and eventually pale livid wine-coloured. **Gills** decurrent, saffron, fairly closely spaced, narrow, rather rigid and fairly easily breaking. Milk abundant, white; taste after a few seconds very hot, smell acrid-aromatic with a fruity element. Spore print deep cream to pale ochre (E–F). Spores elliptic, warts mainly joined in chains or crests in a partial network, 7–8.5×6–7μ. Habitat under broad-leaved trees, especially oak. Season late summer to autumn. Very rare. **Not edible.**

Lactarius zonarius (Bull. ex St. Amans) Fr. **Cap** 3.5–10cm across, convex with a central funnel-shaped depression, pale yellowish-buff at first with paler margin, later ochre-buff to reddish-ochre with several, indistinct, darker concentric bands, slightly sticky, margin inrolled and hairless. **Stem** 25–45×10–20mm, whitish to buff then ochre-buff, sometimes with indistinct spots. **Flesh** whitish, often hollow in stem. **Gills** decurrent, narrow and crowded, forked near the stem, yellowish-buff later ochre-buff. Milk white; taste very hot. Smell of geraniums. Spore print buff (E–F). Spores ovoid, warts mainly joined by ridges that tend to run across the spore, forming a partial network, 7–9.5×5–7.2μ. Habitat deciduous woods, especially with oak. Season late summer to autumn. Rare. **Not edible.**

Lactarius deterrimus Gröger Very similar to *L. deliciosus* and formerly not distinguished from it. It differs essentially in the flesh, where coloured by the milk, becoming purplish in ten minutes and dark dull wine-red in about thirty minutes after exposure, and by the milk being bitter. The cap colour is less reddish and more yellowish and the whole fungus is more liable to turn greenish. Habitat mainly under spruce but also pines. Frequent. Less good to eat than *L. deliciosus*.

Lactarius acerrimus ½ life size

Lactarius acerrimus Britz. **Cap** 8–15cm across, somewhat globose when young, later convex and eventually funnel- or crater-shaped, often strongly and rather irregularly waved or lobed, buff, often with an ochre or yellowish tint, paler at the margin, usually with several ill-defined ochre to tawny, concentric bands, very firm, slightly sticky when moist; margin inrolled at first, very soon hairless. **Stem** 20–60×20–40mm, short and thick, whitish, later mottled or entirely buff to pale ochre, frequently excentric to almost lateral. **Flesh** whitish, very firm, solid or with one or more small cavities in stem. **Gills** slightly decurrent, rosy buff, later tawny or cinnamon, well-spaced, the sides strongly reticulately wrinkled, the wrinkles often joining the gills and giving a pore-like appearance near the stem and the cap margin. Milk white; taste burning hot. Smell fruity, suggesting over-ripe pears. Spore print deep cream (D–E). Spores ovoid, with strong warts joined by thick ridges or thin lines to form a fairly well-developed but rather incomplete network, 10.5–13.5×8.5–10μ, unusually large for a Lactarius. Basidia two-spored. Habitat under broad-leaved trees especially oak. Season summer to early autumn. Rare. **Edibility unknown.**

Lactarius insulsus (Fr.) Fr. (*L. zonarius* of Romagnesi and others) **Cap** 5–12cm across, flattened convex at first, then with a central depression and eventually widely funnel-shaped with a somewhat irregular and broadly wavy margin, pale buff with yellowish centre and, often, numerous dull apricot or russet concentric bands; surface greasy rather than sticky, slightly lumpy-rough; margin incurved, later rounded, shortly hairy or hairless. **Stem** 30–70×1.5–3.5mm, whitish or the colour of the cap centre, with very slightly sunken yellowish to cinnamon or fawn spots and blotches, usually numerous, sometimes sparse or absent, usually with a large cavity. **Flesh** slightly creamy white, becoming

Saffron Milk-cap *Lactarius deliciosus* (L. ex Fr.) S. F. Gray **Cap** 3–10cm across, convex then shallowly funnel-shaped, with numerous small purplish-brick to salmon blotches arranged in narrow, concentric bands on a pale flesh or rosy buff background, becoming tinged greenish in places, slightly sticky, firm, brittle, margin incurved at first. **Stem** 30–60×15–20mm, pale buff or vinaceous to orangy or salmon, sometimes with darker, shallow, spot-like depressions, becoming green in places. **Flesh** pale yellowish, carrot in places from the milk (after one hour or so) fading and finally dull greyish green. **Gills** slightly decurrent, closely spaced, pale pinkish apricot to saffron, becoming carrot and slowly dull pistachio green on bruising. Milk carrot; taste mild or slightly bitter. Spore print pale ochre (F). Spores elliptic, with thin to thickish ridges forming a fairly full network, 7–9×6–7μ. Habitat under pines or spruce. Season summer to autumn. Uncommon in England, more frequent in Scotland. **Edible** and much esteemed on the Continent.

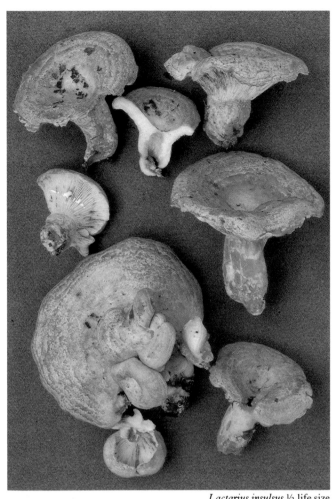

Lactarius insulsus ½ life size

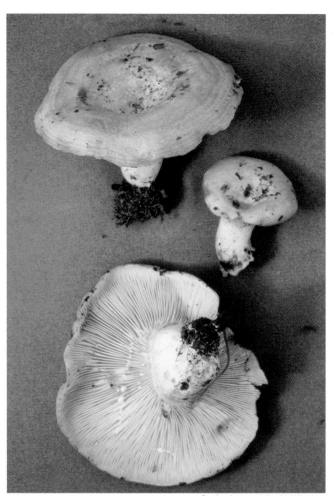

Lactarius zonarius ⅔ life size

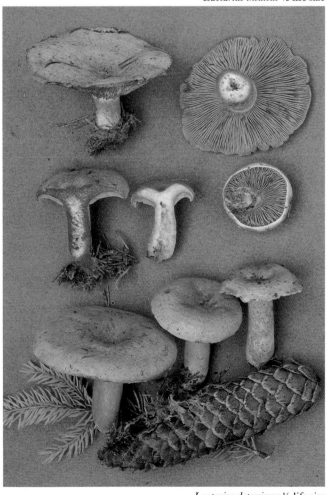

Lactarius deterrimus ½ life size

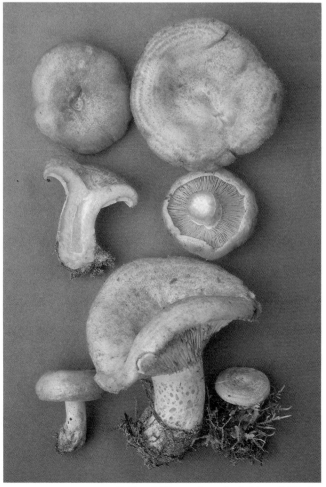

Saffron Milk-cap *Lactarius deliciosus* ½ life size

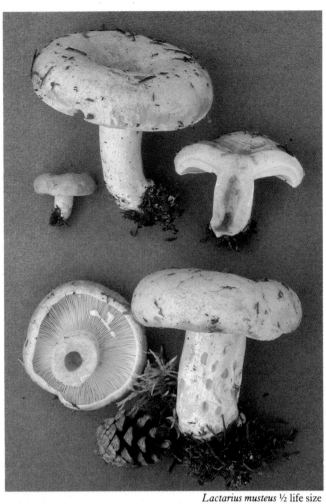

Lactarius musteus ½ life size

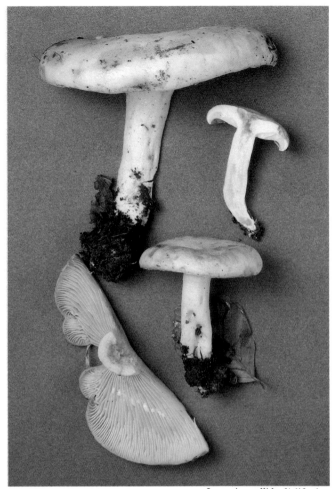

Lactarius pallidus ⅔ life size

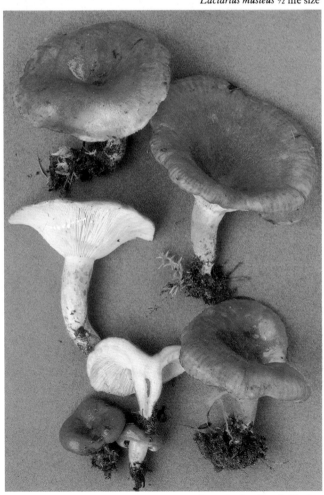

Lactarius hysginus ⅔ life size

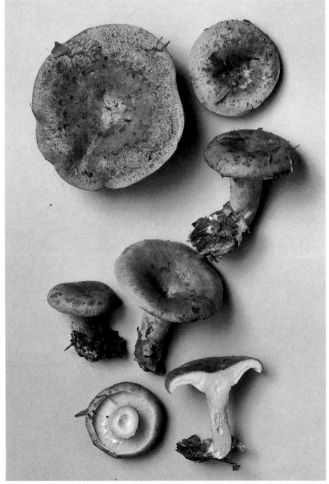

Slimy Milk-cap *Lactarius blennius* ½ life size

Lactarius musteus Fr. **Cap** 4–10cm across, at first flattened convex, soon with a depression, whitish to pale buff with a slight flesh tinge, in places with pale ochre tinges, very firm, thick-fleshed, surface sticky when moist; margin inrolled, later incurved, even and regular to somewhat irregular, slightly felty. **Stem** 30–80×10–35mm, concolorous with the cap, often with a broad band of pale rosy buff, with a watery appearance, below the gills, fairly hard; surface sticky when moist, smooth, with a network of fine, translucid veins, sometimes with scattered, oval, fawn spots, with a large cavity. **Gills** slightly decurrent, pale creamy with a slight rosy buff tinge, pale greyish olive after several hours where bruised, rather narrow, closely spaced, frequently forked near the stem. Milk white, becoming dull olive on the gills after several hours, abundant; taste mild but after a while very slightly hot. Spore print pale cream (C). Spores elliptic, warts joined by thin to thickish ridges which tend to run across the spore and form a loose partial network, 8–9×6.5–7μ. Habitat under pines. Season late summer to early autumn. Rare. Only known in Britain from the Cairngorms, Scotland. **Edible** if cooked.

Lactarius pallidus (Pers. ex Fr.) Fr. **Cap** 4–10cm across, flattened convex, later with a central, funnel-shaped depression, buff, often pale, dull or with a rosy tint to pale flesh-coloured or pale brownish, firm and fairly thick-fleshed, smooth, sticky, margin incurved at first. **Stem** 30–80×6–28mm, cylindrical or narrowed at base, whitish or concolorous with cap, smooth. **Flesh** white to buff. **Gills** moderately decurrent, pale rosy buff to yellowish buff, somewhat crowded. Milk white; taste from mild to quite hot. Spore print pale ochre (E–F) with slight salmon tinge. Spores elliptic with ridges of various thicknesses running mainly across the spore and with few cross-connections, 8–10×6–7μ. Habitat under beech. Season summer to autumn. Occasional. **Edible** when cooked.

Lactarius hysginus (Fr.) Fr. **Cap** 4–10cm across, at first flattened convex, then with a shallow depression or broadly funnel-shaped, reddish bay at first then becoming paler, especially towards the margin and here as pale as rosy buff, sometimes with purplish or flesh tinges, occasionally with indistinct, darker, concentric bands, surface sticky when moist, radially wrinkled; margin inrolled at first, regular to somewhat irregular. **Stem** 25–70×10–25mm, whitish, brownish buff or pale pinkish fawn, sometimes with more or less oval, pale dull brick blotches, cylindrical to spindle-shaped or variously misshapen, stuffed, later with a cavity, slightly longitudinally wrinkled, slightly sticky when moist. **Gills** slightly to moderately decurrent, at first pale dull golden yellow, later saffron, closely spaced, rather narrow. Milk abundant, white; taste acrid and very hot. Spore print deep cream (E) with a slight salmon tinge. Spores broadly elliptic, warts low but sometimes wide, joined by ridges, at times thick and tending to run across the spore, 6.5–7.5×5.5–6.5μ. Habitat under conifers. Season summer to autumn. Uncommon. **Not edible**.

Slimy Milk-cap *Lactarius blennius* (Fr. ex Fr.) Fr. **Cap** 4–10cm across, flattened convex, later centrally depressed, pale olive to greeny grey, pale greyish sepia or even dull greenish, with

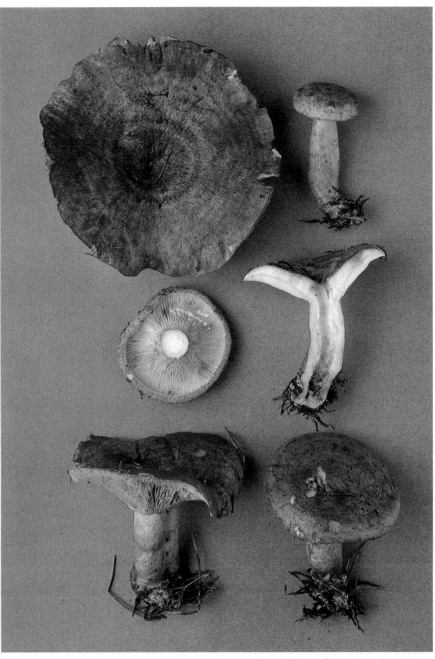

Ugly Milk-cap *Lactarius turpis* ½ life size

darker, drop-like blotches often grouped into concentric bands, very slimy when moist, margin incurved. **Stem** 40–50×10–17mm, paler than the cap, pale olive to pale grey or whitish, slimy. **Flesh** whitish. **Gills** slightly decurrent, white or whitish at first, later creamy to very pale buff, becoming brownish greyish when wounded. Milk white, drying grey; taste very hot and acrid. Spore print creamy (C) with a flesh-coloured tinge. Spores elliptic with low warts joined by ridges with a few cross connections, and tending to run across the spores, 7–8×5.5–6.5μ. Habitat broad-leaved woods, especially beech. Season late summer to late autumn. Very common. **Edible** if cooked but not recommended.

Ugly Milk-cap *Lactarius turpis* (Weinm.) Fr. syn. *L. plumbeus* (Bull. ex Fr.) S. F. Gray **Cap**

5–20cm across, convex then centrally depressed, dark olive-brown, umber or olive-blackish, margin paler, firm and thick-fleshed, sticky and slimy, shallowly felted at first and somewhat woolly at margin which is inrolled at first. **Stem** 40–80×10–25mm, cylindrical or narrowing towards base, concolorous with cap or paler, short and stout, surface often shallowly pitted, slimy. **Flesh** white discolouring brown in places, stem hollow. **Gills** decurrent, fairly narrow and crowded, cream to yellowish buff, pale sepia where wounded. Milk white, abundant; taste very hot and acrid. All parts purple-violet with ammonia or KOH. Spore print cream (B) with slight salmon tinge. Spores elliptic with ridges tending to run across the spore, forming a fairly well-developed network, 7.5–8.5×6–7μ. Habitat under birch especially in damp places. Season late summer to late autumn. Very common. **Not edible**.

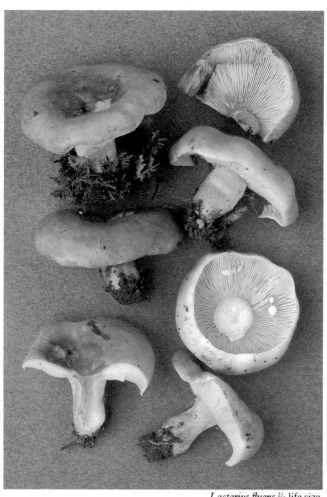

Lactarius fluens ²/₃ life size

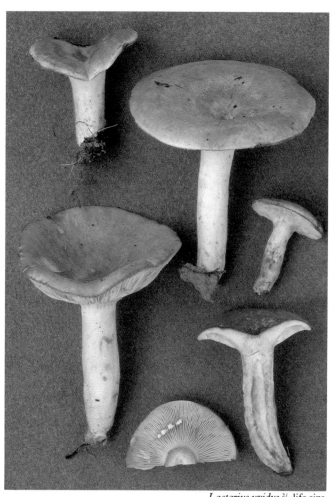

Lactarius uvidus ²/₃ life size

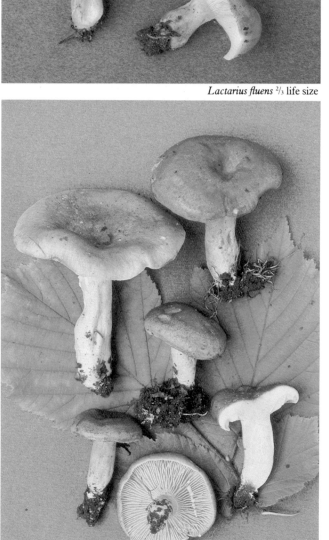

Lactarius pyrogalus ²/₃ life size

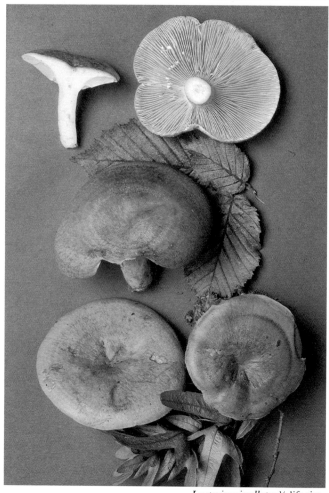

Lactarius circellatus ½ life size

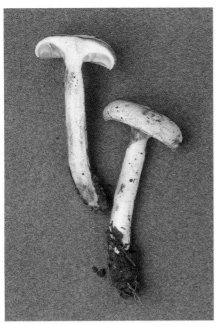

Lactarius flavidus ²⁄₃ life size

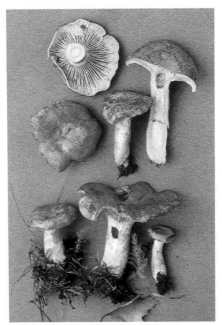

Coconut-scented Milk-cap
Lactarius glyciosmus ½ life size

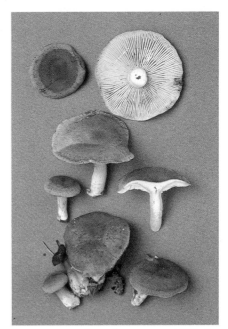

Lactarius mammosus ½ life size

Lactarius fluens Boudier **Cap** 4–13cm across (those in the photograph are rather small), at first shallow convex, soon flattening and developing a central depression, usually dull pale greenish olive to olive-green but sometimes from drab to greyish drab or slate grey, usually with several darker, concentric bands, surface sticky when moist, smooth, with fine translucid veining; margin incurved, sometimes much paler than rest of cap, from fairly even and regular to variously waved and lobed, hairless. **Stem** 25–70×10–20mm, paler than cap, whitish, pale olive buff to pale mouse or violaceous grey, often with ochre to rusty base, staining or bruising brownish, cylindrical, smooth. **Gills** adnexed to slightly decurrent even when young, with a creamy tint, later cream to buff, on bruising hazel to sepia but often only after several hours (this and their colour distinguishing from *L. blennius*), somewhat crowded, somewhat narrow. Milk white, drying greenish grey on gills; taste hot after a few seconds. Spore print deep cream (E) with a salmon tinge. Spores oval to elliptic, warts joined by relatively few, almost wing-like ridges tending to run across the spore and giving it a striped appearance, 6.5–8.5×5.2–6.5μ. Habitat under broad-leaved trees especially beech and hornbeam. Season late summer to autumn. Rare. **Edibility unknown.**

Lactarius circellatus Fr. **Cap** 5–10cm across, flattened convex, later shallowly funnel-shaped and often rather irregular, dull grey brown to pale umber, often slightly violet tinged, and with a slight silvery appearance when dry, with concentric lighter and darker bands always present, firm fleshed, slightly sticky when moist, margin slightly inrolled at first. **Stem** 30–60×8–20mm, cylindrical or spindle-shaped, whitish to concolorous with the cap. **Flesh** whitish, becoming hollow in stem. **Gills** adnexed to slightly decurrent, yellowish white at first, soon pale ochre, later dull yellowish ochre. Milk white, not changing colour with KOH; taste mild at first then hot. Spore print pale ochre (D) with slight salmon tinge. Spores broadly elliptic, with thickish ridges mostly running across the spore and with few cross-connections, 6–7×5–6.5μ. Habitat under hornbeams and frequent where these occur. Season summer to autumn. **Edibility unknown.**

Lactarius uvidus (Fr.) Fr. **Cap** 3–10cm across, flattened convex, later with a depression and often somewhat irregular margin, vinaceous buff, fawn, lilac or violet grey, occasionally with one or two indistinct darker bands, surface fairly smooth, sticky when moist; margin incurved. **Stem** 25–60×6–25mm, dirty whitish to pale dull buff, bruising fawn on the veining, with rusty stains towards the base, more or less cylindrical, smooth, with fine, translucid veining. Flesh pallid white, becoming dullish lilac in around thirty minutes after exposure, stem developing a cavity. **Gills** decurrent, pallid whitish, bruising dull lilac to livid vinaceous, fairly closely spaced, somewhat narrow. Milk white, becoming tinged lilac on gills; taste slightly bitter, not hot. Spore print cream (D). Spores oval, with strongish warts joined by thin to thick ridges to form only a partial network, 9–10.5×7.5–8.5μ. Habitat on acid soils in wet places under birch and willow. Season late summer to autumn. Uncommon – mainly found in Scotland. **Not edible.**

Lactarius pyrogalus (Bull. ex Fr.) Fr. **Cap** 5–10cm across, flattened convex to flat, later broadly funnel-shaped, dingy greyish fawn sometimes with yellowish tinge, not or only faintly concentrically banded, somewhat thin-fleshed, slightly sticky when moist. **Stem** 40–60×7–15mm, cylindrical to slightly swollen in the middle or at the base, whitish or concolorous with cap. **Flesh** whitish. **Gills** slightly decurrent, yellowish to flesh-coloured, later cinnamon-ochre. Milk white; taste very hot and acrid; a drop turns orange yellow on a glass slide with KOH. Spore print pale ochre (E–F). Spores broadly elliptic, warts mostly joined by thickish ridges in a fairly well-developed network, 7–8×5.5–6.5μ. Habitat under hazel. Season autumn. Frequent. **Suspect – avoid.**

Lactarius flavidus Boud. syn. *L. aspideus* var. *flavidus* (Boud.) Neuhoff. **Cap** 3–5cm across, flattened convex, later with a shallow depression, uniformly pale straw to pale ochre-yellow, becoming livid purple in fifteen to thirty minutes after bruising, surface smooth, sticky when moist; margin incurved, even, regular. **Stem** 25–60×6–20mm, concolorous with cap or paler and similarly colouring on bruising, solid, hollow when old; surface smooth, sticky. **Flesh** very

pale straw, becoming pale dull violet in around fifteen minutes after exposure. **Gills** adnexed to slightly decurrent, coloured as cap but slightly paler and similarly colouring on bruising, crowded, frequently forked near stem. Milk abundant, white; taste mild at first, then hot. Spore print pale cream (B). Spores elliptic; with low warts joined by ridges to form a partial network, 8.5–10×7.5–9μ. Habitat under oak or beech on lime soils. Season late summer to autumn. Rare. **Not edible.**

Coconut-scented Milk-cap *Lactarius glyciosmus* (Fr. ex Fr.) Fr. **Cap** 2–5.5cm across, convex, later with a shallow depression, sometimes with a central pimple, usually greyish lilac, sometimes dull buff, thin-fleshed, not sticky, margin incurved at first. **Stem** 25–65×4–12mm, cylindrical, narrowing upwards or slightly club-shaped, soft and easily broken, concolorous with cap but paler or yellowish. **Flesh** buff, sometimes becoming hollow in the stem. **Gills** decurrent, crowded, pale yellowish to pale flesh colour, later greyish lilac. Milk white; taste mild then a little hot and acrid. Smell suggestive of coconut. Spore print creamy white (A–B). Spores broadly elliptic, with small warts connected by thin ridges to form a somewhat incomplete network, 7–8.5×5.5–6.5μ. Habitat under broad-leaved trees, especially birch. Season late summer to autumn. Common. **Edible.**

Lactarius mammosus (Fr.) Fr. **Cap** 2.5–5.5cm across, convex, later flattening or with a depression, sometimes with a flat to pointed umbo, brownish, vinaceous-grey to umber or hazel, sometimes with one or more concentric bands, flesh moderately thick, firm, surface dry, of feathery adpressed fibres breaking up into small, low, fibrous scales, margin somewhat inrolled at first. **Stem** 15–35×5–11mm, whitish or tinged with the cap colour, bruising pale cinnamon brown. **Flesh** whitish to buff. **Gills** adnate to slightly decurrent, crowded, rosy buff, later darker with an orangy tinge. Milk white; taste mild, later hot or very hot. Smell of coconut. Spore print cream (C). Spores elliptic to oval, with a dense, fairly full network of ridges, 7.7–9×5–6μ. Habitat under pine. Season early autumn. Rare. **Edible.**

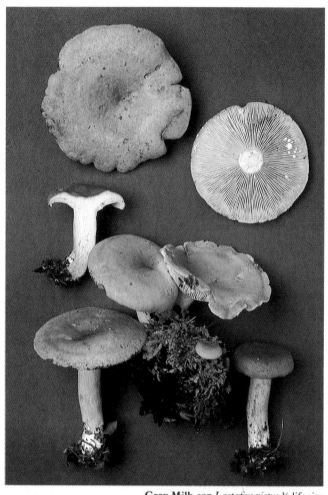

Grey Milk-cap *Lactarius vietus* ¾ life size

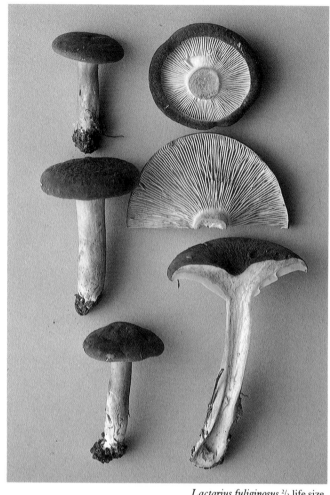

Lactarius fuliginosus ⅔ life size

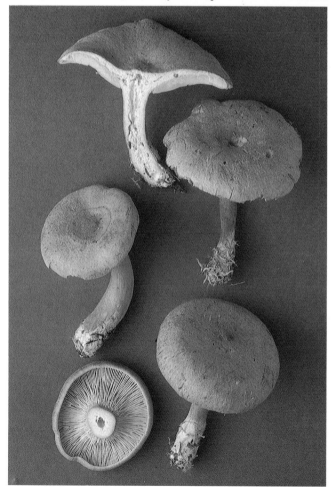

Lactarius helvus ½ life size

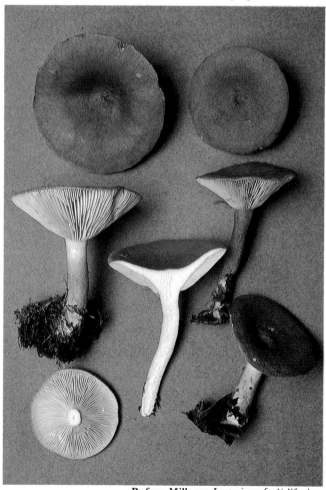

Rufous Milk-cap *Lactarius rufus* ½ life size

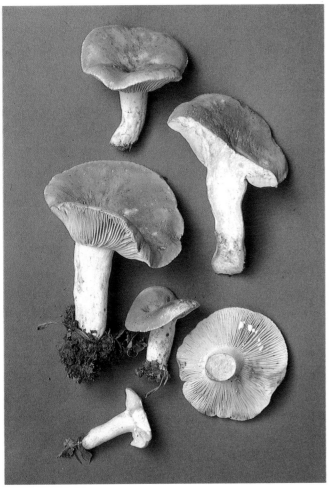

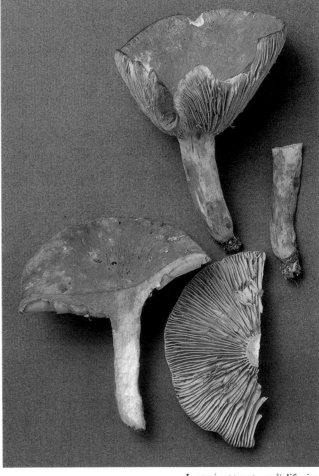

Lactarius azonites ²/₃ life size

Lactarius pterosporus ²/₃ life size

Grey Milk-cap *Lactarius vietus* (Fr.) Fr. **Cap** 2.5–7cm across, flattened convex, becoming widely funnel-shaped at times, sometimes with a broad to pointed umbo, violet- to flesh-tinted grey, or with pale yellowish-brownish tints, slimy or sticky when moist, margin incurved at first. **Stem** 25–80×5–13mm, cylindrical, sometimes narrowing downwards but at times with a club-shaped base, whitish or tinged greyish, rather weak and easily broken. **Flesh** whitish-buff, often hollow in stem. **Gills** slightly decurrent, crowded, whitish to dirty buff. Milk white, drying brownish or greenish smoke grey on the gills; taste acrid and hot. Smell not distinctive. Spore print creamy white (A–B) with slight salmon tinge. Spores elliptic, with a moderately developed network of ridges, 8–9.5×6.5–7.5μ. Habitat under birch in moist places. Season autumn. Frequent. **Not edible.**

Lactarius fuliginosus (Fr.) Fr. **Cap** 4.5–9cm across, flattened convex, later with a depression or shallowly funnel-shaped, dark dull umber, cigar brown or sepia, surface dry, appearing finely velvety, margin incurved at first. **Stem** 40–100×7–20mm, concolorous with cap or paler, surface as on cap. **Flesh** whitish becoming in places, or spotted with, salmon pink in two to three minutes after exposure; taste mild. **Gills** shortly decurrent, buffy ochre with a salmon tinge, salmon pink on bruising. Milk white, becoming pinkish but only in contact with the flesh; taste mild, later slightly bitter. Spore print pale ochre (F). Spores subglobose to broadly ovoid, with a fairly well-developed network of ridges up to 1.5μ tall, with finer ones between them, 7.8–9×7–8μ. Cap surface of upright, shortly cylindrical cells underlain by a cellular

layer. Habitat beech woods. Season summer to autumn. Uncommon. **Edible – poor.**

Lactarius helvus (Fr.) Fr. **Cap** 5–12cm across, flattened convex with a shallow depression, sometimes with a small umbo, yellowish to bricky cinnamon with numerous slightly darker flecks or small flattened scales, thin and firm-fleshed at first but becoming soft and easily broken, margin incurved at first. **Stem** 50–120×5–30mm, cylindrical to slightly club-shaped, reddish-ochre or cinnamon to darkish brick, often powdery or finely downy. **Flesh** whitish, becoming hollow in stem. **Gills** adnate to slightly decurrent, prolonged down the stem as short ridges, pale or buffy ochre. Milk clear; taste mild or slightly bitter. Smell almost none when fresh smelling very strongly of curry or stock cubes when dried and persisting for years. Spore print whitish with a slight salmon tinge (A–B). Spores elliptic with small warts mostly joined by slender ridges in a poorly developed network, 6.5–9×5.5–6.5μ. Habitat conifer woods on heaths and moors. Season summer to autumn. Uncommon. **Slightly poisonous** but sometimes dried and powdered to use as a condiment.

Rufous Milk-cap *Lactarius rufus* (Scop. ex Fr.) Fr. **Cap** 3–10cm across, convex, later flattening, finally with a central depression, the centre usually with a pointed umbo, red-brown, bay or dark brick, moderately thick-fleshed, breaking fairly easily, surface dry and matt, margin somewhat inrolled at first. **Stem** 40–80×5–20mm, concolorous with cap but paler. **Flesh** white, stem often hollow when old. **Gills** somewhat decurrent, brittle, yellowish at first,

later as cap but paler. Milk white; taste mild then after about a minute very hot and acrid. Spore print creamy whitish (B) with slight salmon tinge. Spores elliptic, warts occasionally isolated but mainly connected by thin ridges to form a rather incomplete network, 8–9.5×6.5–7.5μ. Habitat under pine. Season late spring to late autumn. Very common. **Not edible** although in some areas used as a seasoning after special treatment.

Lactarius azonites (Bull. ex St Amans) Fr. Very similar to *L. fuliginosus* but stem whitish and cap usually paler in colour and smaller. **Cap** 3–8cm across, greyish buff, greyish hazel, smoke grey or sometimes greyish sepia. **Stem** 30–70×5–15mm, white, later creamy to buffy smoke grey, bruising pale rose. **Flesh** white, colouring more widely and strongly than in *L. fuliginosus*, rose in two to five minutes, later orangy coral. **Gills** ivory white, then pale buffy golden yellow, crowded at first. Milk mild to somewhat hot in taste. Spores with warts around 0.7μ high, connected by an almost complete network of thick ridges, 8–9×7.5–8.5μ. Habitat under broad-leaved trees, especially oak. Season late summer to autumn. Uncommon. **Suspect – avoid.**

Lactarius pterosporus Romagn. Very similar to *L. azonites* and differing mainly in the spores (7–8×6.5–7μ) being ornamented by wings up to 2μ high together with a few small isolated warts; no connecting thin ridges between the wings. The taste of the milk is markedly hot instead of mild to somewhat hot and the gills are more crowded. Habitat under oak, beech or hornbeam. Uncommon. **Edibility unknown.**

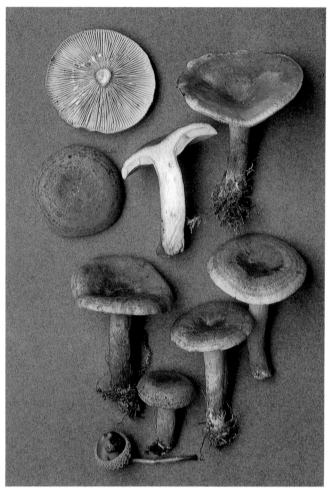

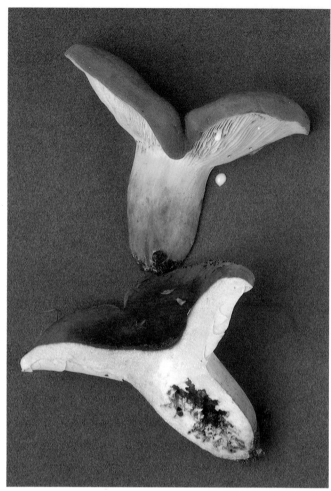

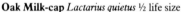

Oak Milk-cap *Lactarius quietus* ½ life size

Lactarius volemus ²/₃ life size

Oak Milk-cap *Lactarius quietus* (Fr.) Fr. **Cap** 3–8cm across, convex, later flattened or with a shallow depression, dull reddish brown with cinnamon tints, often with a few indistinct darker concentric bands or spotting, or dry and matt, not sticky when moist. **Stem** 40–90×10–15mm, coloured as cap or darker, more or less cylindrical, often lengthwise furrowed, matt. **Flesh** whitish buff, thick and firm in cap often hollow in stem. **Gills** slightly decurrent, brownish white, later pale reddish brown with a slight mauvy bloom. Milk white or slightly creamy; taste mild or slightly bitterish. Smell slightly oily or suggesting bugs. Spore print cream (C) with slight salmon tinge. Spores oval, warts mostly joined by ridges forming a well-developed network, 7.5–9×6.5–7.5μ. Habitat under oak. Season autumn. Very common. **Edible**.

Lactarius volemus Fr. **Cap** 5–11cm across, convex with a depression, coloured apricot to tawny, fleshy, firm, shortly velvety to smooth, not sticky. **Stem** 40–120×10–30mm, concolorous with cap, but usually paler, shortly velvety to smooth, solid. **Flesh** whitish, firm. **Gills** slightly decurrent, narrow, somewhat closely spaced, easily breaking, pale golden yellow, bruising brown. Gill cystidia abundant, with thick, wavy walls. Milk white, abundant; taste mild. Smell fishy. Spore print whitish (B). Spores spherical; ridges thick, a few thin, forming a complete network, 8–10×8–9.5μ. Cap surface cellular, cap and stem surfaces with spindle-shaped, tapering cystidia. Habitat under both coniferous

and broad-leaved trees. Season summer to autumn. Uncommon. **Edible – good**.

Lactarius hepaticus Plowright apud Boud. **Cap** 2.5–7cm across, convex, later flattened, sometimes with a central pimple, liver coloured to dull chestnut, surface dry and matt, margin often crimped or crisped with tiny lobes. **Stem** 30–70×4–8mm, reddish brown to brick-coloured. **Flesh** white tinged pinkish-buff, thin in cap stem becoming hollow. **Gills** slightly decurrent, pale buff, later deep buff to pale ochre with a mauvy bloom. Milk white, drying yellowish, a drop on a handkerchief turns sulphur yellow in one to two minutes; taste bitter and acrid, slowly slightly hot. Spore print cream (B). Spores broadly elliptic, with large warts, some isolated but mostly joined by thin to thickish ridges in a very incomplete network, 8–9×6–7μ. Habitat under pine. Season autumn. Common under pines in Southern Britain becoming rarer northwards. **Not edible**.

Lactarius mitissimus (Fr.) Fr. **Cap** 3–6cm across, convex, later flattened or with a depression, sometimes with a small umbo, bright brownish-orange or apricot, surface velvety-greasy to the touch but not sticky, margin incurved at first. **Stem** 30–70×6–12mm, concolorous with cap. **Flesh** white, firm, often hollow in stem with age. **Gills** adnate to slightly decurrent, palish ochre. Milk abundant, white; taste mild. Spore print cream (C) with a slight salmon tinge. Spores covered in warts mainly joined by thinnish ridges

to form a somewhat incomplete network, 8–9.5×6.5–7.5μ. Cap surface of more or less erect hyphae with rounded ends separated by jelly. Habitat deciduous and coniferous woods. Season autumn. Frequent. **Not edible**.

Lactarius brittanicus Reid **Cap** 3–8cm across, flattened convex soon shallowly depressed, often with an umbo, apricot to creamy orange often with brownish tones, especially towards the centre, surface smooth or puckered not sticky or velvety. **Stem** 30–80×8–18mm across, cylindrical to spindle-shaped, reddish-brown, darker below. **Flesh** white to buff, sometimes becoming hollow in stem. **Gills** decurrent, ochre-buff to pale cinnamon, bruising brownish. Milk white, drying pale yellowish on a handkerchief; taste mild or slightly hot. Spore print cream (D) with slight salmon tinge. Spores more or less globose with a few sparse more or less branched ridges, a fair proportion of the warts isolated, 6–8μ in diameter. Cap surface of a shallow layer or filamentous hyphae, the underlying hyphae with numerous, variously inflated cells. Habitat with beech. Season autumn. Occasional. **Edibility unknown**.

Lactarius subdulcis (Pers. ex Fr.) S. F. Gray **Cap** 3–7cm across, convex, later with a depression, sometimes with a small umbo, reddish brown, rusty or dark cinnamon, paling to buff, fairly rigid to flexible, surface matt, smooth to slightly wrinkled, margin incurved at first, sometimes slightly furrowed. **Stem** 30–70×6–13mm,

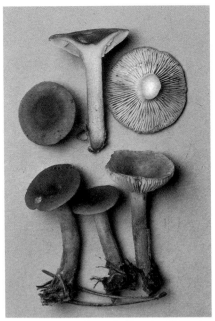

Lactarius hepaticus ½ life size

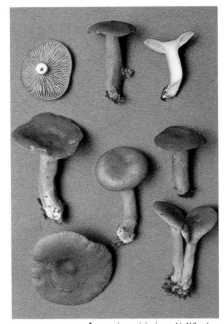

Lactarius mitissimus ½ life size

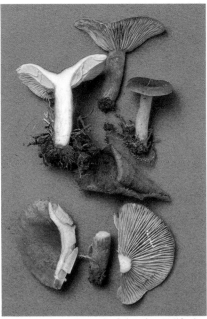

Lactarius brittanicus ½ life size

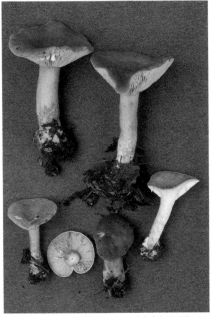

Lactarius subdulcis ⅓ life size

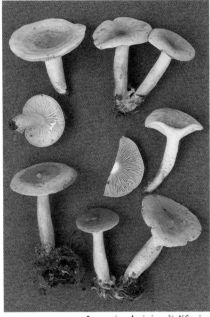

Lactarius decipiens ⅔ life size

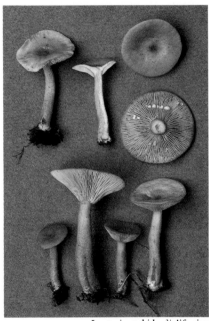

Lactarius tabidus ⅔ life size

cylindrical to slightly club-shaped, sometimes furrowed lengthwise, coloured as cap but paler above. **Flesh** white to buff, thin in cap. **Gills** adnate to slightly decurrent, whitish at first then rosy-buff with a slight vinaceous tinge. Milk white, plentiful, *not* turning yellow on a handkerchief; taste mild then slightly bitter. Spore print cream (C) with slight salmon tinge. Spores oval, with largish warts (1μ) joined by mainly thinnish ridges to form a well-developed network, 7.5–9.5×6.5–8μ. Cap surface of prostrate, filamentous hyphae with variously inflated cells. Habitat in broad-leaved woods especially beech. Season late summer to late autumn. Common. **Edible**.

Lactarius decipiens Quél. **Cap** 2–6cm across, flattened convex, later with a depression and often a small umbo, pale coloured, pinkish-buff or washleather coloured to pale dull cinnamon,

usually tinged with pinkish, lilac or flesh, the centre sometimes rather darker, thin-fleshed, surface dry, matt; margin entire, even and regular to somewhat uneven and irregular. **Stem** 20–80×3–10mm, the upper part coloured as the cap margin and the lower as the centre or tinged rusty, cylindrical to spindle-shaped, surface matt. **Flesh** buffy whitish, becoming yellowish in places in about thirty minutes after exposure. **Gills** decurrent, coloured as the cap margin but slightly darker, closely spaced, fairly narrow. Milk abundant, white, becoming pale straw in around ten minutes and drying yellow on the gills or on absorbent white tissue; taste mild, later bitter and hot, smell of geraniums. Spore print cream (C–D). Spores broadly elliptic, warts medium sized, mostly joined by thickish or thin ridges into an irregular, large-meshed network, 7.5–9×6.5–7.5μ. Cap surface filamentous. Habitat under hornbeam. Season summer to autumn. Rare. **Not edible**.

Lactarius tabidus Fr. syn. *L. thejogalus* (Bull. ex Fr.) S. F. Gray s. Moser **Cap** 2–4cm across, shallowly convex with a central depression, often with a pimple in the middle, dull ochre-buff to yellowish rusty or dull orange-ochre, somewhat fragile, surface matt, not sticky, often with small wrinkles. **Stem** 30–50×4–10mm, cylindrical or narrowing upwards, fairly rigid but easily broken, coloured as the cap above, more bricky below. **Flesh** whitish, thin in cap, becoming hollow in stem. **Gills** slightly decurrent, crowded, pale yellowish cinnamon with a rosy tinge. Milk white, rather scanty, a drop on a handkerchief turns slowly yellow; taste almost mild, but slightly hot and acrid. Spore print pale cream (B) with a slight salmon tinge. Spores elliptic, the warts mainly isolated and only a few joined by fine ridges, 7–9.5×6–7μ. Cap surfaces cellular. Habitat under deciduous trees especially birch and in moist places. Season late summer to late autumn. Common. **Not edible**.

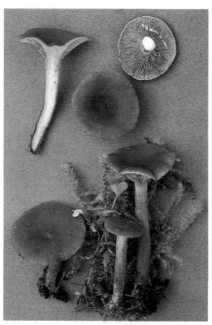

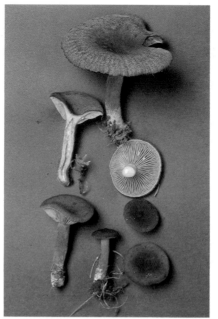

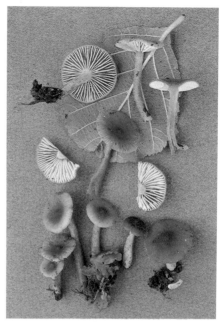

Curry-scented Milk-cap
Lactarius camphoratus ½ life size

Watery Milk-cap *Lactarius cimicarius* ½ life size

Lactarius obscuratus life size

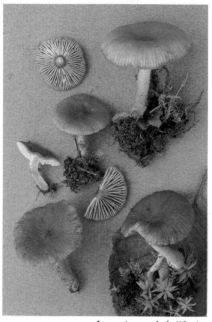

Lactarius cyathula life size

Curry-scented Milk-cap *Lactarius camphoratus* (Bull. ex Fr.) Fr. **Cap** 2.5–5cm across, convex, then with a depression and often with a small umbo, red-brown, bay or dark brick, sometimes with a violet tinge, surface smooth and matt, not sticky, margin slightly inrolled at first, often furrowed. **Stem** 30–50×4–7mm, cylindrical or narrowing downwards coloured as the cap or deeper. **Flesh** pale rusty brown. **Gills** decurrent, closely spaced, narrow, pale reddish brown. Milk rather watery but with whitish clouds; taste mild. Smell weakly of bugs when fresh, but a strong curry-like scent develops on drying. Spore print creamy (C). Spores subglobose with ornamentation of warts, mainly isolated but occasionally joined by ridges, 7.5–8.5×6.5–7.5μ. Habitat under pine but sometimes also in deciduous woods. Season summer to late autumn. Frequent. **Edible** – dried and powdered it is used in Germany as a flavouring.

Watery Milk-cap *Lactarius cimicarius* (Batsch. ex Secr.) Gillet **Cap** 3–7cm across, flattened convex with saucer- or narrow funnel-shaped centre, sometimes with a low umbo, umber or chestnut sometimes a little paler towards the margin, surface dry, matt, wrinkled and often granular or lumpy, margin remaining incurved for some time, usually more or less furrowed. **Stem** 20–65×7–12mm, concolorous with cap or more usually more reddish brown, or paler. **Flesh** cinnamon-buff, thin in cap, stem hollow. **Gills** moderately decurrent, saffron to bricky or orangy cinnamon. Milk watery with a few white clouds; taste mild. Smell of bugs, oily. Spore print creamy (C) with a slight salmon tinge. Spores covered with warts up to 1.3μ high, joined by usually strong almost wing-like ridges to form a more or less complete network, 6.5–9×6–8μ. Cap surface cellular; gill margin with globose, balloon or club-shaped cells. Habitat under oak and beech. Season summer to autumn. Occasional. **Not edible**.

Lactarius obscuratus (Lasch) Fr. syn. *L. obnubilus* (Lasch) Fr. Fruit body remarkably small and delicate for a Lactarius. **Cap** 6–16mm across, at first flat and slightly convex, later with a shallow depression, often with a small, somewhat pointed, umbo, dull cinnamon tinged, especially in the darker centre, with dull olivaceous tints or the centre hazel, later becoming somewhat brighter coloured and losing the olive tinge, very thin fleshed, translucid and striate at the margin due to the gills showing through, surface smooth or practically so. **Stem** 17–21×3–4mm, coloured like the cap margin, but a somewhat redder brown especially towards the base, cylindrical or slightly swollen at the base. **Gills** adnate to slightly decurrent, yellowish dull cream, slightly to somewhat closely spaced, thin, fairly broad. Milk white, unchanging; taste mild. Spore print whitish (A). Spores elliptic, warts joined by a well-developed network of ridges, 6–7.7×5–6.2μ. Superficial layer of cap cellular. Habitat in bogs under alder. Season early summer to late autumn. Occasional. **Not edible**.

Lactarius cyathula (Fr.) Fr. syn. *L. clethrophilus* Romagn. Very similar to *L. obscuratus* but cap brighter coloured and without olive tinges, tawny to russet or cinnamon, sometimes with darker centre, which is usually wrinkled and lumpy, and tending to be larger, 13–17mm across or even reaching 35mm. **Stem** 16–40×2–4mm, pale tawny. The gills are also more distinctly decurrent and are thicker and well spaced. Spores 6.5–7.5×5.2–6.5μ and similarly ornamented. Habitat and season as for *L. obscuratus* with which it is often found. Occasional. **Not edible**.

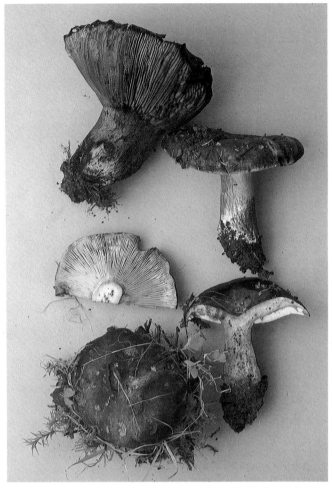

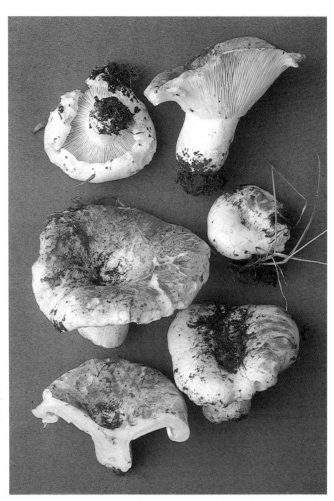

Russula albonigra ½ life size

Milk-white Russula *Russula delica* ½ life size

RUSSULA *Mostly bright red, purple, yellow or green caps, often flat or mildly convex. The flesh of the whole mushroom is granular and will break easily. The gills have a very neat geometric look and are brittle, they vary from white to egg-yolk yellow. Note the taste; they may be hot, bitter or mild. A few have interesting smells. Check the amount that the cap peels. To aid identification make a spore print overnight, then scrape together the spores to form a thick layer and note the colour. One hundred and twelve are listed as British by Ronnie Rayner in his key.*

Russula albonigra (Krombh.) Fr. syn. *R. anthracina* Romagn. **Cap** 7–12cm across, flattened convex, later with a depression or saucer shaped, dirty white, very soon blackish brown to black, firm, slightly sticky, soon dry, somewhat thin-fleshed, three-quarters peeling; margin inrolled. **Stem** 30–60×15–30mm, concolorous with cap. **Flesh** white, blackening on exposure to air, or on bruising. Taste mild to slightly hot, slightly bitter. **Gills** slightly decurrent, narrow, arc-shaped, somewhat closely spaced, interspersed with numerous shorter ones, whitish to buff. All parts blacken on bruising or with age. Spore print white (A). Spores ovoid-elliptic, with small warts up to 0.4μ high, joined by fine lines to form a fairly well-developed network, 7–9×7–8μ. Cap surface of prostrate hyphae, 2–6μ wide; cystidia absent. Habitat under conifers and broad-leaved trees. Season summer to autumn. Occasional. **Edible**.

Milk-white Russula *Russula delica* Fr. **Cap** 5–16cm across, convex, cup- or funnel-shaped, whitish, often tinged yellow brownish, matt, dry, thick-fleshed; margin strongly inrolled. **Stem** 20–60×20–40mm, white, often bluish at apex, hard. **Flesh** white, unchanging. Taste hot and acrid with a bitter tang; smell distinctive, slightly of bugs and reminiscent of certain Lactarius, sometimes fishy. **Gills** decurrent, whitish, often tinged bluish towards the stem, often forked or with cross-connections, interspersed with numerous short gills. Spore print white, to slightly creamy (A–B). Spores ovoid with warts 0.5–1.5μ high, often in chains or occasionally joined by fine lines not enclosing meshes, or sometimes more abundant and forming a network, 8–12×7–9μ. Cap cystidia worm-like to narrow cylindrical, hardly reacting to SV. Habitat under both broad-leaved and coniferous trees. Season autumn. Common. **Edible** – poor, unpleasant tasting.

Russula adusta (Pers. ex Fr.) Fr. Resembles *R. densifolia* but the taste is mild and the flesh only becomes slightly pinkish in the first half-hour after exposure, sometimes remaining so in the cap, but in the stem becoming pale smoky grey and not dark grey or blackish. **Cap** 5–17cm across, sticky when moist. **Stem** 40–110×10–30mm. Smell of old wine casks. The oval spores (7–9×6–8μ) have only very small warts, rarely exceeding 0.2–0.3μ high, which are joined by very fine lines to form a well-developed but

partial network with numerous small meshes. Cap hyphae narrow, 2–4μ wide. Habitat under pines. Season early summer to late autumn. Uncommon. **Edible** – poor.

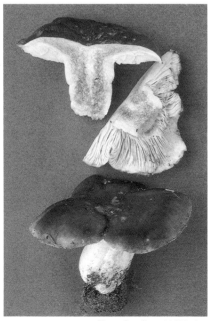

Russula adusta ⅓ life size

Blackening Russula *Russula nigricans* (Bull. ex Mérat) Fr. **Cap** 5–20cm across, convex, soon with a deep depression, dirty white, becoming brown and finally black, dry, fleshy, three-quarters peeling; margin incurved at first. **Stem** 30–80×10–40mm, white, then dull brown, finally black, hard. **Flesh** white, becoming greyish rose on exposure and finally grey to black. Taste slowly hot, smell fruity. **Gills** adnate, straw to olive, greyish rose on bruising, eventually black, very thick and widely spaced, brittle, with numerous shorter gills between them. Spore print white (A). Spores ovoid with small warts under 0.5μ high, mostly connected by fine lines to form a fairly well-developed, but partial network, $7–8×6–7\mu$. No cap cystidia. Habitat under broad-leaved trees and conifers. Season summer to late autumn. Very common. **Edible** but poor in taste.

Russula densifolia (Secr.) Gillet syn. *R. acrifolia* Romagn. **Cap** 3–12cm across, flattened convex at first, later with a depression, cup- or funnel-shaped, whitish or dull brown in the centre or all over, eventually blackish, sticky when moist, fleshy; margin incurved at first. **Stem** 25–80×6–30mm, white then dull brown to blackish, reddish on bruising, hard. **Flesh** white at first when cut, then tinged reddish and soon greyish as well, finally dark grey to brownish blackish. Taste hot or very hot, but sometimes almost mild, smell not distinctive. **Gills** slightly decurrent, white to pale cream, closely spaced, rather narrow and not thick, interspersed with shorter gills. Spore print whitish (A). Spores ovoid with small warts under 0.5μ high, joined by fine lines to form a well-developed network, $7–9×6–7\mu$. Cap hyphae cylindrical or narrowing towards the apex, $3–4\mu$ wide; cap cystidia few, narrow, not reacting to SV. Habitat under both broad-leaved trees and conifers. Season summer to autumn. Common. **Edible** – mediocre in taste.

Russula soroia (Fr.) Romell (*R. amoenolens* Romagn.) **Cap** 3–6cm across, convex, later flattening and with a depression, sepia to greyish sepia, rarely white, thinnish-fleshed, slightly sticky when moist, half-peeling; margin furrowed, with small, low warts. **Stem** 30–60×10–20mm, whitish, fairly firm to soft and fragile. **Flesh** white. Taste unpleasant, oily, slowly very hot; smell rancid or suggesting Camembert cheese. **Gills** adnexed, creamy to dirty whitish, edge browning. Spore print pale cream (B–D). Spores broadly elliptic with warts up to 0.7μ high, a few joined by fine lines, no network, $7–9×5–7\mu$. Cap cystidia narrow, tapering, poorly reacting to SV. Habitat under oak. Season summer to autumn. Occasional. **Not edible.**

Russula laurocerasi Melzer Very similar to *R. foetens* but rather smaller, the cap (4–8cm across) often a brighter ochre brown and less glutinous. It is distinguished by its more or less marked odour of bitter almonds. The globose spores (8–$9.5×8–8.5\mu$) are also very distinctive having more or less well-developed, sometimes branching, wings up to 2μ high connecting a large proportion of the warts. Habitat and season as *R. foetens*. Frequent. **Not edible.** The photograph is of the form separated as *R. fragrans* by Romagnesi.

Fetid Russula *Russula foetens* (Pers. ex Fr.) Fr. **Cap** 5–12cm across, globose at first, later convex, finally flattening, at times with a central depression, dull brownish ochre to honey-coloured, thick-fleshed, rigid, slimy or glutinous; margin furrowed and with small, low warts. **Stem** 50–120×15–40mm, whitish to buff, cylindrical or swollen in the middle, hard and rigid but easily breaking. **Flesh** white, irregular cavities forming in stem. Taste of gills very hot, of stem flesh almost mild, in addition bitter or oily, smell strongly oily or rancid. **Gills** adnexed, creamy, often brown spotted, thickish and well spaced. Spore print pale to medium cream (B–D). Spores somewhat globose with strong warts, up to 1.5μ high, isolated or an occasional fine line joining them, $8–10×7–9\mu$. Cap cystidia cylindrical, tapering or spindle-shaped, not reacting to SV. Habitat under broad-leaved trees or conifers. Season late summer to late autumn. Common. **Not edible.**

Blackening Russula *Russula nigricans* ½ life size

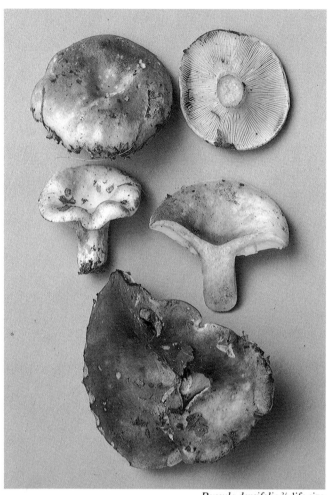

Russula densifolia ²/₃ life size

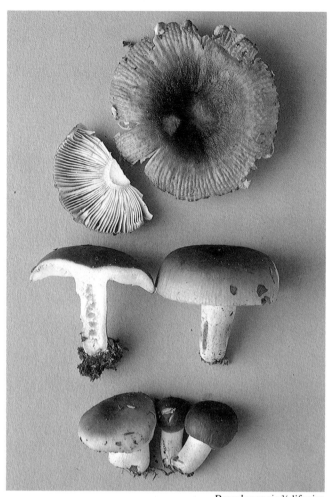

Russula sororia ¾ life size

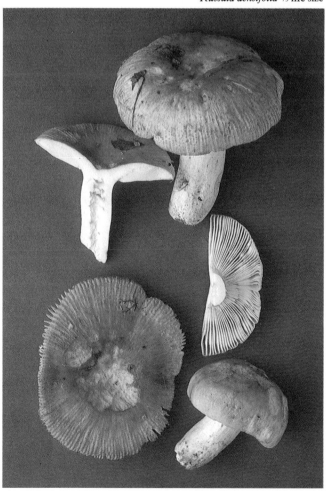

Russula laurocerasi ²/₃ life size

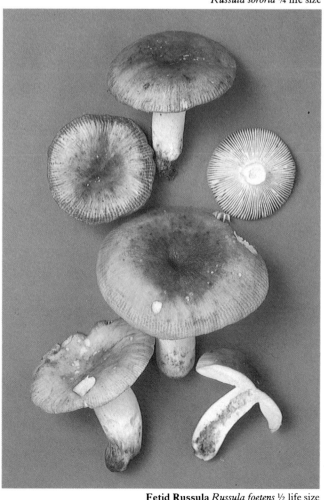

Fetid Russula *Russula foetens* ½ life size

93

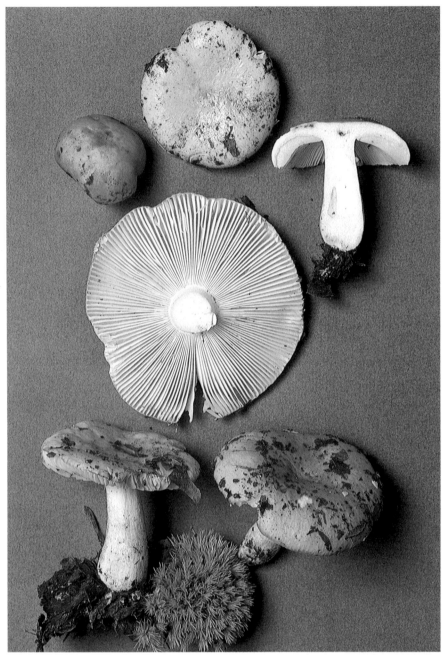

Common Yellow Russula *Russula ochroleuca* ²/₃ life size

smooth to slightly furrowed. **Stem** 20–60×10–20mm, coloured as cap but slightly paler, firm, cream if rubbed with iron salts. **Flesh** white. Taste very hot, smell of geraniums. **Gills** adnexed, coloured as stem. Spore print whitish to pale cream (A–C). Spores ovoid with warts up to 0.7μ high, mostly joined by fine lines to form a well-developed network, 7.5–9×6–7μ. Cap cystidia abundant, cylindrical to narrow club-shaped, strongly reacting with SV. Habitat under beech. Season late summer to late autumn. Very common. **Not edible**.

Russula virescens (Schaeff. ex Zantedschi) Fr. **Cap** 5–12cm across, globose, later convex, finally flattening and often wavy and lobed, verdigris to dull green, often ochre-buff to cream in places, half peeling; surface breaking up into small, flattened, angular, scurfy scales. **Stem** 40–90×20–40mm, whitish to pale cream, browning slightly, powdered above, firm. **Flesh** white. Taste mild. **Gills** almost free, cream, somewhat brittle, with veins connecting the bases. Spore print whitish to pale cream (A–B). Spores ellipsoid-ovoid to somewhat globose with warts 0.2–0.5μ high, fine lines absent to fairly numerous and forming a fairly well-developed network, 7–9×6–7μ. Cap cystidia none; gill cystidia few, not or hardly reacting with SV. Cap hyphae forming a loose, cellular layer of variously shaped or inflated cells, the terminal ones tapering. Habitat under broad-leaved trees, especially beech. Season summer to early autumn. Uncommon. **Edible**.

Russula violeipes Quél. **Cap** 4–8cm across, somewhat globose at first, then flattening and finally with a depression, straw, greenish-yellow (forma *citrina*) or olive tints, often in part, sometimes entirely, livid red, livid purple, lilac or wine-coloured, thick-fleshed, hard, powdered, hardly peeling. **Stem** 40–70×10–30mm, white, often tinged yellow, violet, purple or wine-coloured, firm, often powdered especially above. **Flesh** white. Taste mild, smell slight, when fresh of shrimps. **Gills** slightly decurrent, pale buffy straw, greasy to the touch. Spore print cream (C–D). Spores ovoid with warts 0.7–1μ high, joined by lines or ridges to form a fairly well-developed network, 6.5–9×6–8μ. No cap cystidia and very few on the gills and not reacting to SV. Gill margin fringed with tapering cells. Terminal cells of cap hyphae mostly tapering, supporting cells mostly inflated, sometimes balloon-shaped. Habitat under broad-leaved trees. Season summer to early autumn. Uncommon. **Edible**.

Common Yellow Russula *Russula ochroleuca* (Pers. ex Secr.) Fr. **Cap** 4–10cm across, convex then flattening and with a depression, ochre, yellow or sometimes greenish yellow, fleshy, two-thirds peeling; margin eventually furrowed. **Stem** 40–70×15–25mm, white, greying slightly with age especially when waterlogged. **Flesh** white. Taste from mild to moderately hot. **Gills** adnexed, creamy. Spore print whitish to pale cream (A–C). Spores broadly ovoid with warts up to 1.2μ high, joined by numerous fine lines forming a fairly well-developed network, 8–10×7–8μ. Cap surface cystidia absent, hyphae 2–3μ wide, often with yellow encrusting pigment. Habitat under broad-leaved trees and conifers. Season late summer to late autumn. Very common. **Edible**.

Russula farinipes Romell apud Britz. **Cap** 3–6cm across, convex, later often with a marked depression, yellowish to ochre-straw, thinnish but somewhat tough and elastic, hardly peeling; margin furrowed and slightly warty-lumpy. **Stem** 30–60×10–15mm, white or straw, hard, surface powdery towards the top. **Flesh** white, yellowish below cap cuticle. Taste very hot, smell fruity. **Gills** slightly decurrent, pale straw, rather narrow, often rather widely spaced. Spore print whitish (A). Spores ovoid with warts up to 0.7μ high, no lines, 6–8×5–7μ. Cap cystidia abundant, spindle-shaped, up to 5–9μ wide, reacting to SV. Habitat under broad-leaved trees. Season late summer to early autumn. Frequent. **Not edible**.

Geranium-scented Russula *Russula fellea (Fr.) Fr.* **Cap** 4–9cm across, convex, soon flattening, often with a broad umbo, straw-coloured to pale ochre-honey or buff, fairly fleshy, slightly sticky when moist, peeling at margin only, which is

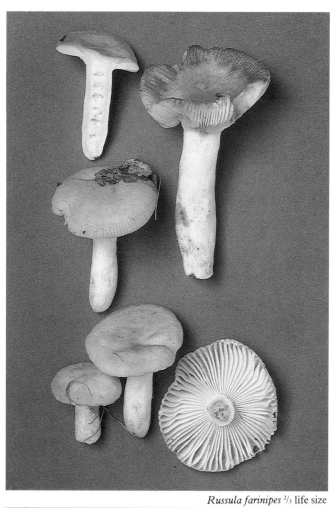

Russula farinipes ²/₃ life size

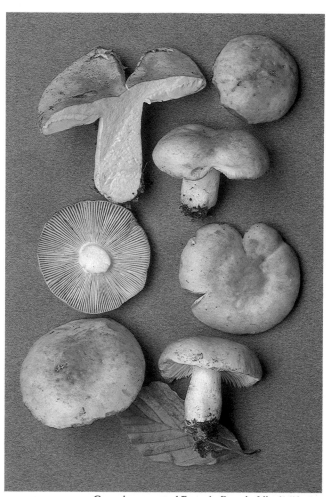

Geranium-scented Russula *Russula fellea* ²/₃ life size

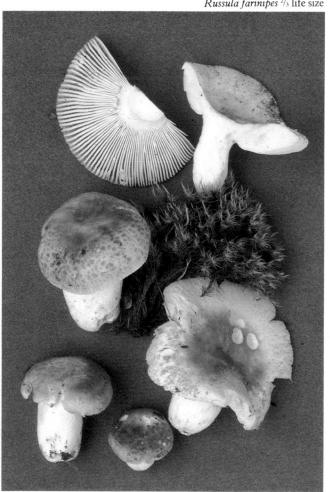

Russula virescens ½ life size

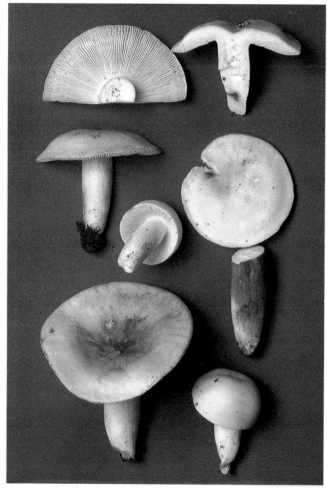

Russula violeipes ²/₃ life size

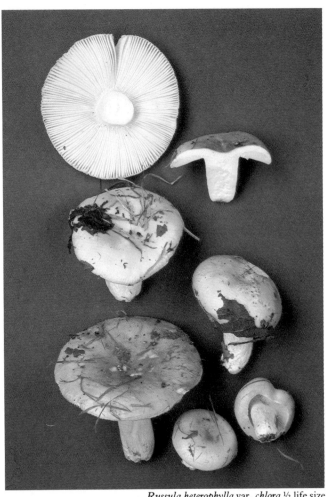

Russula heterophylla var. *chlora* ½ life size

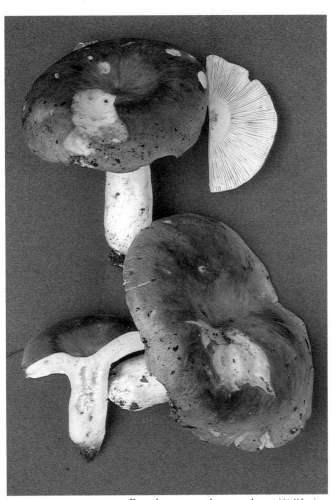

Russula cyanoxantha var. *peltereaui* ½ life size

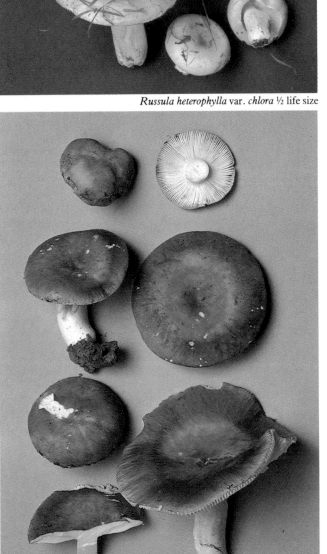

Russula ionochlora ⅔ life size

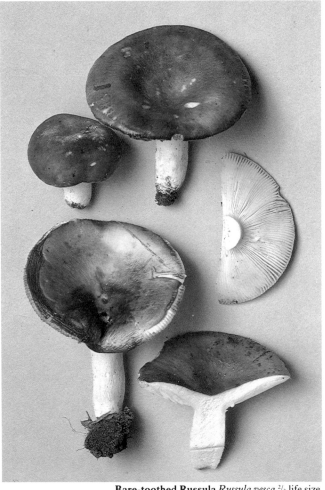

Bare-toothed Russula *Russula vesca* ⅔ life size

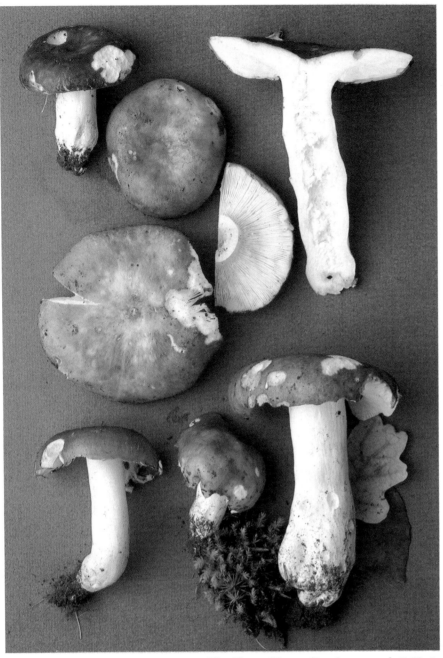

The Charcoal Burner *Russula cyanoxantha* ½ life size

Russula heterophylla (Fr.) Fr. **Cap** 5–10cm across, almost globose at first, later flattening and with a depression, various shades of green, brown or even ochre or (var. *chlora*) yellow, fairly firm, smooth or with radial branching veins. **Stem** 30–60×10–30mm, white, browning, firm, salmon when rubbed with an iron salt (this distinguishes it from *R. cyanoxantha* var. *peltereaui*). **Flesh** white. Taste mild. **Gills** slightly decurrent at first, later adnexed, white to very pale cream, very closely spaced, thin, from somewhat flexible with an oily feel to somewhat brittle. Spore print whitish (A). Spores almost globose to elliptic or pear-shaped, with warts 0.2–0.6μ high, mostly isolated, occasionally two to three joined together or connected by a line, 5–7×4–6μ (smallest in genus). Cap hyphae terminations tapering or sometimes prolonged into a narrow, thick-walled hair, supporting cells rectangular or inflated; cap cystidia club-shaped, cylindrical, spindle-shaped or tapering. Habitat

under broad-leaved trees. Season summer to early autumn. Occasional (var. *chlora* rare). **Edible**.

The Charcoal Burner *Russula cyanoxantha* (Schaeff. ex Secr.) Fr. **Cap** 5–15cm across, first globose, later flattening to depressed at the centre, sometimes one colour but usually a mixture, dullish lilac, purplish, wine-coloured, olive, greenish or brownish, sometimes entirely green (var. *peltereaui*), firm to hard, greasy when moist, with faint branching veins radiating from centre, half peeling. **Stem** 50–100×15–30mm, white, sometimes flushed purple, hard, giving no or a slightly greenish reaction when rubbed with iron salts *not* salmon as in most Russulas. **Flesh** white. Taste mild. **Gills** adnexed to slightly decurrent, whitish to very pale cream, rather narrow, oily to the touch and flexible, not brittle as in most Russulas, forked at times. Spore print

whitish (A). Spores broadly elliptic, with low, up to 0.6μ high warts; fine lines absent, 7–9×6–7μ. Cap cystidia scattered, small, short and narrow (2–4μ), cylindrical, teat-ended. Habitat under broad-leaved trees. Season summer to late autumn. Very common. **Edible** – good.

Russula ionochlora Romagn. **Cap** 4.5–7cm across, convex, later flattening, often with low bosses and somewhat irregularly waved, pale coloured, typically a mixture of dull bluish, yellowish to ochreous pale greens, often with greyish lilac to pale wine border, moderately fleshy, half peeling. **Stem** 30–70×12–20mm, white or faintly tinged violet, salmon if rubbed with iron salts. **Flesh** white. Taste distinctly hot when young, later mild. **Gills** almost free, pale cream. Spore print pale cream (B–C). Spores ovoid with warts up to 0.5μ high, isolated or occasionally in short chains, no fine lines, 6.5–7.5×4.7–6μ. Cap surface hyphae with terminal cell usually broadly cylindrical with rounded ends; supporting cells rectangular to somewhat inflated. Cap cystidia mostly club-shaped, not septate. Habitat under beech. Season summer to early autumn. Occasional. **Edible**.

Bare-toothed Russula *Russula vesca* Fr. **Cap** 5–10cm across, somewhat globose at first, later flattened convex, rather variable in colour, often with pastel tints, from dark or pale wine-coloured to buff, sometimes with olive or greenish tints, fleshy, firm, the skin half peeling, tending to retreat from the margin leaving the underlying flesh visible. **Stem** 30–100×15–25mm, white, rather hard, often with somewhat pointed base. **Flesh** white. Taste mild, nutty. **Gills** adnexed, whitish to very pale cream, rather closely spaced, narrow, forked, especially near stem. Gills and stem surface rapidly deep salmon when rubbed with an iron salt. Spore print whitish (A). Spores ovoid with small warts up to 0.5μ high, very occasionally with short lines attached or joining pairs, 6–8×5–6μ. Cap cystidia cylindrical or spindle-shaped, without septa, hardly reacting to SV. Cap hyphae with cylindrical or tapering terminal cells or sometimes a long, tapering, thickwalled hair; supporting cells rectangular. Habitat under broad-leaved trees. Season summer to autumn. Frequent. **Edible**.

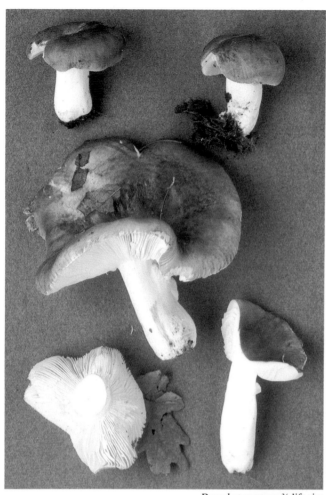

Russula parazurea ¾ life size

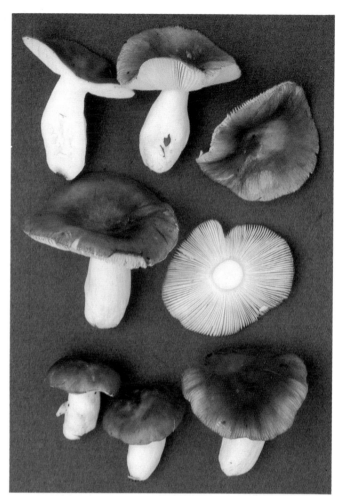

Russula grisea ⅔ life size

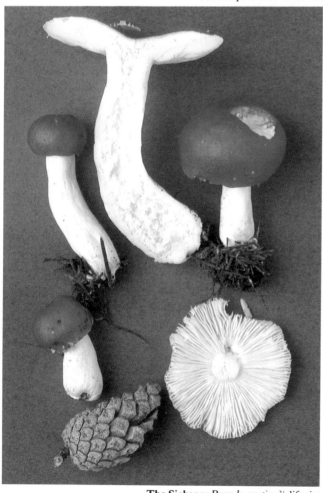

The Sickener *Russula emetica* ⅔ life size

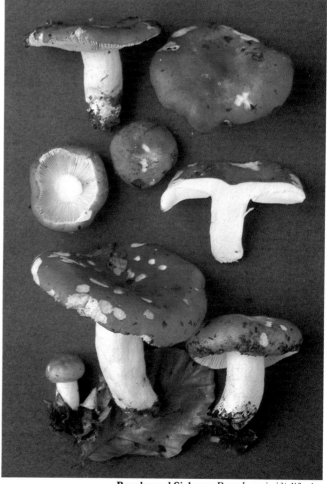

Beechwood Sickener *Russula mairei* ⅔ life size

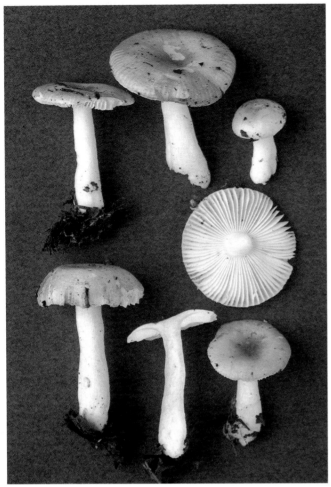

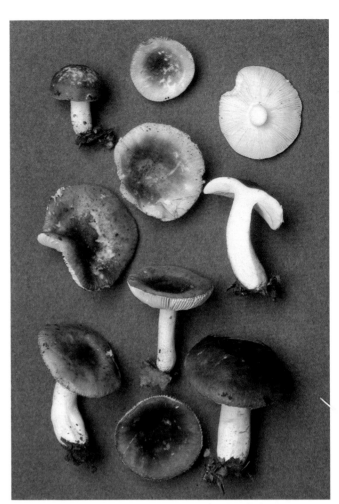

Russula betularum ¾ life size

Fragile Russula *Russula fragilis* ²/₃ life size

The Sickener or **Emetic Russula** *Russula emetica* (Schaeff. ex Fr.) S. F. Gray **Cap** 3–10cm across, convex, later flattening or with a shallow depression, scarlet, cherry or blood red, sometimes with ochre-tinted to white areas, somewhat thin-fleshed, fragile, shiny, sticky when moist; skin easily peeling to show pink to red coloured flesh beneath, margin often furrowed when old. **Stem** 40–90×7–20mm, white, cylindrical or more usually somewhat swollen towards the base, fragile. **Flesh** white, red immediately beneath cap cuticle. Taste very hot, smell slightly fruity. **Gills** adnexed to free, cream then pale straw. Spore print whitish (A). Spores broadly ovoid; with large warts, 1.2μ high, connected by fine lines to form a large-meshed, almost complete network, 9–11×7.5–8.5μ. Cap cystidia mostly narrowly club-shaped with 0–1 septa. Habitat under pines. Season summer to late autumn. Common. **Poisonous.**

Russula parazurea J. Schaeff. **Cap** 3–8cm across, convex then flattening, with greyish, dark colours, olive, violet-grey, greyish sepia or chestnut or tinged with dull green, wine or violet, firm, rather fleshy, sometimes greasy, usually matt, often as if powdered when dry, half to three quarters peeling. **Stem** 30–70×7–20mm, white. **Flesh** white. Taste mild or very slightly hot. **Gills** adnexed, pale buff, often forked. Spore print palish cream (C–D). Spores elliptic with warts up to 0.5μ high, some isolated but mostly joined by lines forming a moderately developed network, 5.7–8.5×5–6.5μ. Cap hyphae with the terminal cell usually tapering and the supporting cells rectangular. Cap cystidia cylindrical to narrow club-shaped, without septa, moderately reacting to SV.

Habitat under broad-leaved trees. Season early summer to autumn. Occasional. **Edible.**

Russula grisea (Pers. ex Secr.) Fr. Rather similar to *R. ionochlora* and only reliably distinguished by its microscopic characters. The cap colours are rather more dingy, being more dull brownish or greyish. Spores are slightly deeper coloured, cream (D) instead of pale cream (B), 6.5–8×5.5–6.5μ, elliptic; warts up to 0.9–1.2μ high, some joined in chains or by fine lines to form an incipient network and only rarely enclosing a mesh. Mainly distinguished by the terminal cells of the cap hyphae being long and narrow, cylindrical or tapering, and not short and broad as in *R. ionochlora*. Habitat mainly under beech. Season summer to early autumn. Apparently uncommon but perhaps because not easily recognized. **Edible.**

Beechwood Sickener *Russula mairei* Sing. **Cap** 3–9cm across, convex, later flattening, red or pink to entirely white, typically rather firm and thick-fleshed, one third peeling, underlying flesh pink. **Stem** 25–45×10–15mm, white, cylindrical, rarely club-shaped, usually hard. **Flesh** white. Taste hot, smell of coconut when young. **Gills** rounded, adnexed, white with greenish tinge, later cream, closely spaced at first. Spore print whitish (A). Spores ovoid with warts up to 0.5μ high, joined by thin lines to form a well-developed network with small meshes, 7–8×6–6.5μ. Cap cystidia mostly club-shaped with up to two septa, strongly reacting to SV. Habitat beech. Season autumn. Common. **Poisonous.**

Russula betularum Hora **Cap** 2–5cm across,

flattened convex, often with a central depression, deep rose or pink, but often paler and pale dull golden yellow to yellowish buff at the centre or even entirely so, sticky when moist, thin-fleshed, fragile, completely peeling; margin becoming furrowed and with small, low warts. **Stem** 25–65×5–10mm, cylindrical or narrow club-shaped, longer than the cap diameter, white, fragile. **Flesh** white, taste hot. **Gills** almost free, white, rather well-spaced; margin sometimes with small nicks. Spore print whitish (A). Spores ovoid with warts 0.5–0.7μ high, joined by fine lines to form a well-developed but incomplete network, 8–10×7.5–8μ. Cap cystidia cylindrical to strongly club-shaped, with 0–2 septa. Habitat under birch, often in damp places. Season summer to early autumn. Frequent. **Poisonous.**

Fragile Russula *Russula fragilis* (Pers. ex Fr.) Fr. **Cap** 2–5cm across, convex, then flattening or depressed, variable in colour, usually purplish or violet-tinted and rather pale, or purplish-red, purple-violet, olive-greenish, even lemon yellow, often with combinations of these, with a darker, paler or olive-tinted centre, thin-fleshed, usually delicate and fragile, three-quarters peeling. **Stem** 25–60×5–15mm, white, cylindrical to slightly club-shaped. **Flesh** white. Taste very hot, smell slightly fruity. **Gills** adnexed, white to very pale cream, with tiny nicks along their edges. Spore print whitish (A–B). Spores somewhat globose with warts up to 0.5μ high, joined by fine lines forming an almost complete network, 7.5–9×6–8μ. Cap cystidia cylindrical to club-shaped, with 0–2 septa, reacting strongly with SV. Habitat under broad-leaved trees or conifers. Season late summer to late autumn. Common. **Not edible.**

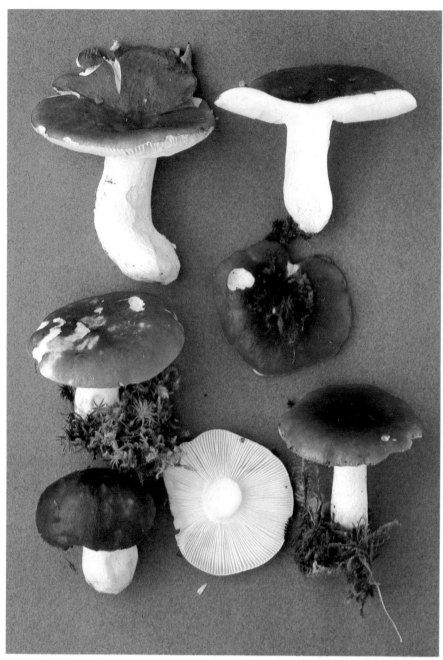

Blackish-purple Russula *Russula atropurpurea* ²/₃ life size

Blackish-purple Russula *Russula atropurpurea*
(Krombh.) Britz. **Cap** 4–10cm across, convex,
later flattening and with a slight depression,
usually deep purplish-red usually with a darker,
often almost black centre, at times variously
mottled with yellowish or brownish cream,
sticky when moist. **Stem** 30–60×10–20mm,
white, often becoming greyish with age, fairly
firm at first, later softer and easily broken. **Flesh**
white. Taste from almost mild to moderately hot,
smell slightly fruity, reminiscent of apples. **Gills**
adnexed, palish cream, closely spaced, fairly
broad. Spore print whitish (A–B). Spores ovoid,
with warts joined by fine ridges to form a well-
developed but not quite complete network, 7–
9×6–7μ. Cystidia on cap abundant, cylindrical
to somewhat club-shaped, without septa.
Habitat usually under oak or beech, less
commonly conifers. Season summer to late
autumn. Very common. **Edible** if cooked.

Russula nauseosa (Pers. ex Secr.) Fr. **Cap** 2–7cm
across, convex, later flattening and finally with a
shallow depression, wine coloured to red or often
pale, washed-out colours, greyish rose, pale
brownish, dull yellowish or tinged greenish,
thin-fleshed, fragile, easily peeling; margin often
shallowly warty and furrowed. **Stem** 20–75×5–
15mm, white, often tinged brownish or
yellowish, often narrow club-shaped, soft,
fragile. **Flesh** white, stem often hollow. Taste
mild or slightly hot. **Gills** almost free, saffron,
thin, connected by veins at their bases. Spore
print pale ochre to ochre (G–H). Spores ovoid to
elliptic, with warts up to 1.2μ high, isolated or
occasionally with fine lines attached, 7–11×6–
9μ. Cap cystidia abundant, mainly club-shaped,
with up to two septa. Habitat under conifers,
possibly only in Scotland. Season late spring to
early autumn. Rare. **Edible** – possibly best
avoided due to its hot taste.

Russula norvegica Reid. formerly misdetermined
in Britain as *R. alpina* **Cap** 13–27mm across,
hemispherical, later more or less flat, purple-
black at first, later violet, purple to wine purple,
or purplish red, as if powdered at first then sticky
when moist, half peeling. **Stem** 10–27×3–8mm,
white, cylindrical to club-shaped, becoming
furrowed or longitudinally wrinkled. **Flesh**
white. Taste burning hot. **Gills** rounded,
sinuate, white or whitish, fairly closely spaced;
margin entire. Spore print pale cream (B).
Spores ovoid-ellipsoidal; warts up to 0.7–1.0μ
high, mostly connected by fine lines which often
form a more or less complete network with many
small meshes, 7.5–11×5.5–7.5μ. Cap surface
with abundant dermatocystidia, strongly
reacting with SV, mostly club-shaped, often with
one, sometimes more septa. Habitat with dwarf
willow above the tree line on Scottish mountains.
Season summer to early autumn. Rare. **Not
edible**.

Russula aquosa Leclair **Cap** 3–7cm across,
flattened convex or with a depression, lilac-tinted
red to palish cherry red, often brownish in the
centre, frequently pale coloured, watery and
thin-fleshed, sticky when moist, very fragile, two
thirds to completely peeling; margin finally
furrowed and slightly warty-lumpy. **Stem** 40–
95×10–22mm, narrowing markedly towards the
apex, white, usually watery in appearance, often
tinged brown, yellow or grey, very fragile. **Flesh**
white. Taste very slightly hot, smell faint,
suggesting coconut, iodine or radish. **Gills**
almost free, well-spaced, dirty white. Spore print
slightly creamy white (A). Spores ovoid, with
warts up to 0.7μ high, joined by fine lines to form
a partial network, 7–8.5×6–7μ. Cap cystidia
narrow club-shaped, without septa. Habitat
damp places near water or in marshy places with
mosses. Season summer to autumn. Apparently
rare but possibly often overlooked. **Edibility
unknown** but of no culinary interest.

Russula aeruginea Lindblad ex Fr. **Cap** 4–9cm
across, convex then flattening or depressed,
grass-green, sometimes with yellowish or
brownish tinges, without any violaceous tints,
often with rusty spots, centre usually darker,
smooth or radially veined, peeling halfway;
margin often furrowed. **Stem** 40–80×7–20mm,
white, fairly firm. **Flesh** white. Taste mild to
slightly hot. **Gills** almost free, usually forking,
yellowish-buff. Spore print cream (D–E). Spores
elliptic, with rounded warts up to 0.6μ high,
some joined by fine lines to form a very
incomplete network with 0–2 meshes, 6–10×5–
7μ. Cap surface hyphae with rectangular, not
inflated, supporting cells; cystidia cylindrical to
spindle-shaped, without septa. Habitat under
birch. Season summer to early autumn.
Frequent. **Edible**.

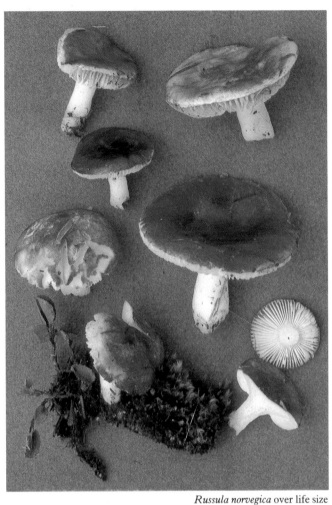

Russula norvegica over life size

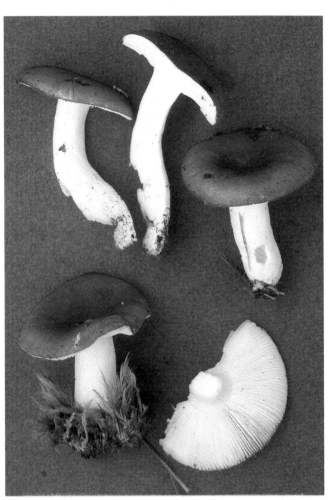

Russula aquosa ²/₃ life size

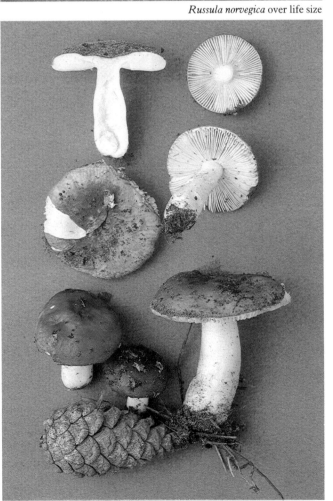

Russula nauseosa ²/₃ life size

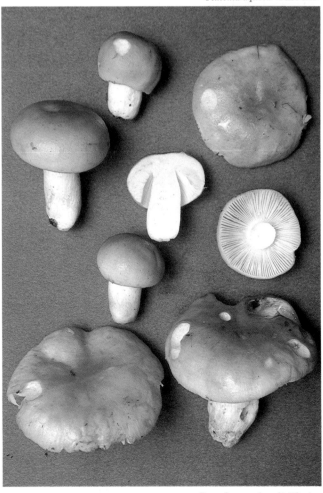

Russula aeruginea ²/₃ life size

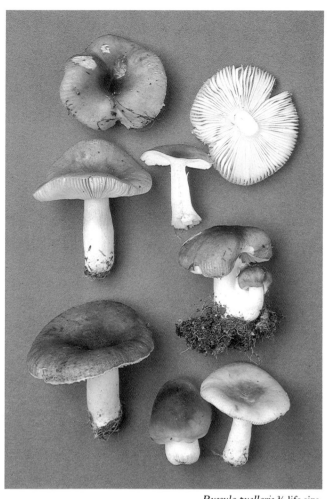

Russula puellaris ¾ life size

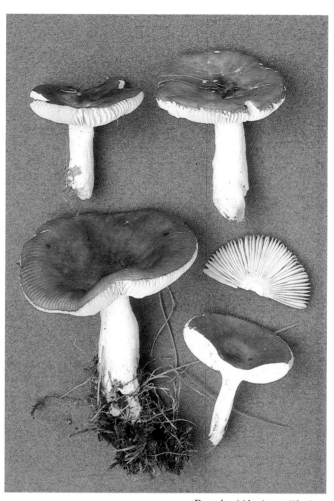

Russula nitida almost life size

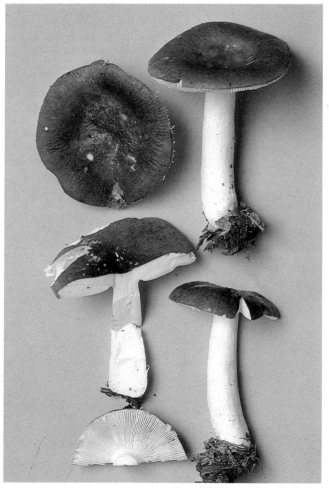

Russula brunneoviolacea ⅔ life size

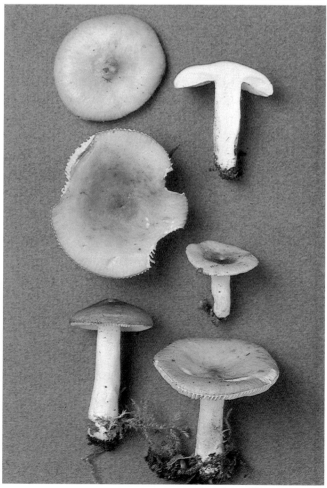

Russula gracillima ¾ life size

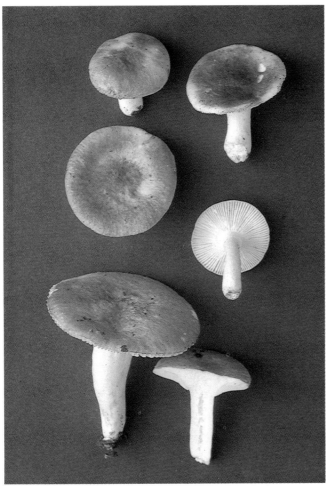

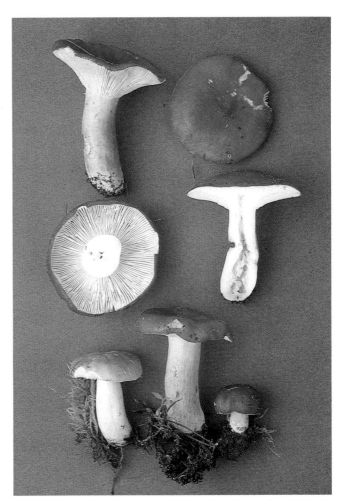

Russula luteotacta ²/₃ life size

Russula sanguinea ½ life size

Russula puellaris Fr. **Cap** 2.5–5cm across, convex then flattened and centrally depressed, dull purple, wine-coloured, dull red, bay or brick, or washed-out versions of these colours, often minutely spotted with darker colour, often darker in centre, thin-fleshed, sticky when moist, half to two-thirds peeling; margin furrowed. **Stem** 20–65×5–15mm, white, cylindrical or narrow club-shaped, easily broken. **Flesh** white. Taste mild. **Gills** adnexed-free, pale ochre. All parts becoming or bruising pale ochre. Spore print deepish cream (D–E). Spores ovoid with warts up to 1.2μ high, mostly isolated, fine lines absent or very few, 6.5–9×5.5–7μ. Cap cystidia numerous, mostly club-shaped, with 0–1 septa. Habitat under broad-leaved trees or conifers. Season summer to autumn. Occasional. **Edible.**

Russula nitida (Pers. ex Fr.) Fr. **Cap** 2–6cm across, convex then flattening or with a depression, variable in colour, various purplish to red hues, or often rather pale washed-out colours, greyish rose, wine, buff or greenish, the latter often in the centre with the margin reddish or purplish, thin-fleshed, fragile, peeling up to two-thirds; margin usually strongly furrowed. **Stem** 20–90×5–20mm, white or rose tinted, narrow club-shaped, fairly firm to fragile. **Flesh** white. Taste mild or very slightly hot. **Gills** adnexed to free, straw, fairly widely spaced and allowing the connecting veins at their bases to be seen easily. Spore print pale ochre (E–G). Spores ovoid with spines up to 0.7μ or more high, fine lines absent or nearly so, 8–11×6–9μ. Cap cystidia abundant, cylindrical or narrow club-shaped, with 0–1 septa, strongly reacting to

SV. Habitat with birch especially in damp places. Season summer to autumn. Common. **Edible.**

Russula brunneoviolacea Crawshay **Cap** 3–7cm across, flattened convex, later with a depression, livid violet, livid purple or dark wine-coloured, or browner, somewhat brittle, three-quarters peeling; margin becoming furrowed. **Stem** 30–60×7–15mm, white, with brown stains, cylindrical or narrow club-shaped, soft, brittle. **Flesh** white. Taste mild. **Gills** almost free, cream. Spore print cream (C–E). Spores ovoid with spines 1–2.2μ high, only a few connected by fine lines, 7–9×6–7.5μ. Cap surface hyphae tapering; cap cystidia cylindrical to club-shaped with 0–3 septa. Habitat under broad-leaved trees especially oak. Season summer to early autumn. Occasional. **Edible.**

Russula gracillima J. Schaeff **Cap** 2–6cm across, convex, then flattening, sometimes with an umbo, typically with dull greenish or olive centre and pink margin, but also completely these colours, or pale dull violet, thin-fleshed, fragile, one-third to a half peeling; margin eventually furrowed. **Stem** 35–70×5–10mm, white to greyish rose, soft, fragile. **Flesh** white. Taste slightly to moderately hot. **Gills** slightly decurrent, pale cream, thin. Spore print pale cream to cream (C–D). Spores ellipsoid-ovoid with warts up to 1μ high, with very few or no fine lines, 7–9×5–7μ. Cap cystidia cylindrical to slightly club-shaped, up to 10μ wide, with 0–1 septa. Habitat under birch. Season summer to late autumn. Uncommon. **Edibility unknown.**

Russula luteotacta Rea **Cap** 3–8cm across, flattened convex, later with a depression to shallowly funnel-shaped, red or pink, often with white areas, soon dry, matt, hardly peeling. **Stem** 30–70×5–15mm, white or tinted pink in places to completely red, club-shaped or narrowing upwards. **Flesh** white. Taste hot, smell slight, fragrant, sometimes suggesting coconut. **Gills** usually slightly but distinctly decurrent, pale cream, narrow. All parts bright yellow on bruising but often only after several hours. Spore print whitish (A). Spores with warts up to 0.7μ high, mostly isolated, very occasionally joined by fine lines, 7–9×6–7.5μ. Cap cystidia cylindrical, spindle-shaped or narrow club-shaped; cap surface hyphae cylindrical or tapering. Habitat under broad-leaved trees especially on wet clay. Season summer to autumn. Occasional. **Poisonous.**

Russula sanguinea (Bull. ex St. Amans) Fr. **Cap** 5–10cm across, convex, later flattening or saucer-shaped, blood to purplish-red or rose, often with whitish areas, fleshy, rigid or even hard, peeling at margin only; surface soon dry and matt, rough or veined. **Stem** 40–100×10–30mm, white, pink or red, firm. **Flesh** white. Taste slightly to moderately hot, also sometimes bitter. **Gills** adnate-decurrent, cream or pale ochre, narrow, forking or with cross-connections. Spore print pale to deep cream (C–F). Spores ovoid with warts up to 1μ high, with very few connecting lines, 7–10×6–8μ. Cap cystidia cylindrical to narrow club-shaped, often teat-ended, with 0–2 septa, somewhat poorly reacting to SV. Habitat under conifers. Season summer to autumn. Occasional. **Not edible.**

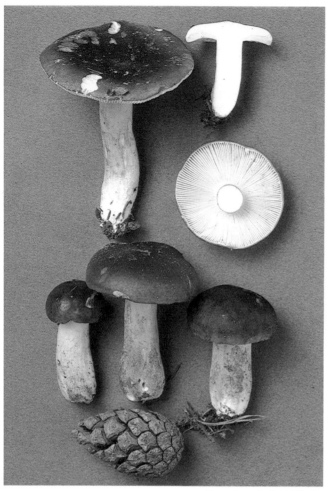

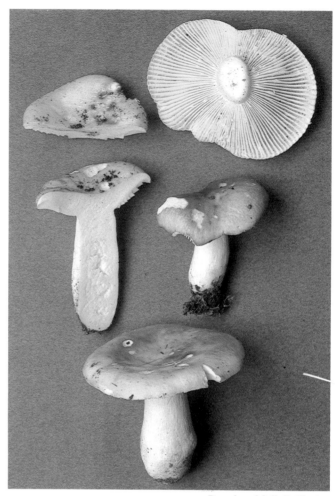

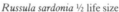

Russula sardonia ½ life size

Russula pulchella ⅔ life size

Russula sardonia Fr. **Cap** 4–10cm across, convex, later flattening and with a depression, violet-, purplish- or brownish-red, greenish or ochre to yellowish, hard, shortly peeling only. **Stem** 30–80×10–15mm, sometimes white but usually entirely pale lilac to greyish rose, firm; surface as if powdered. **Flesh** white. Taste very hot, smell slightly fruity. **Gills** adnexed to slightly decurrent, at first primrose, later pale golden yellow, narrow. Gills and flesh reacting rose with ammonia (distinguishes this species). Spore print cream (C–F). Spores ovoid with warts up to 0.5μ high, joined into ridges or by fine lines to form a rather poorly developed network, 7–9×6–8μ. Cap cystidia spindle-shaped or cylindrical, without septa, strongly reacting to SV. Habitat under pine. Season summer to autumn. Frequent. **Not edible**.

Russula pulchella Borszczow (*R. exalbicans* of some authors) **Cap** 5–9cm across, convex, later flattening or with a depression, centre greenish white or olive buff with rose, red or dull wine-coloured margin, or entirely any of these colours, firm, fleshy, slightly sticky when moist, half peeling. **Stem** 30–50×10–20mm, whitish, soon greyish, sometimes tinged pink. **Flesh** white. Taste moderately hot. **Gills** adnexed, pale cream. Spore print deep cream (E–F). Spores ellipsoid with warts up to 0.7μ high, some isolated, some joined into ridges or by lines to form a fairly poorly developed network, 8–10×6–7μ. Cap cystidia cylindrical, spindle-

shaped or narrow club-shaped, occasionally with a septum. Habitat under birch. Season early summer to autumn. Occasional. **Edible** – poor.

Russula erythropus Peltereau **Cap** 6–11cm across, convex, later with a depression, pale to dark blood colour, livid red or wine-coloured, sometimes with brown or olive tinges, fleshy, hard at first, peeling only at margin. **Stem** 40–80×14–30mm, typically rose, sometimes white, browning strongly with age or bruising, cylindrical or club-shaped, reacting dull green to rubbing with iron salts. **Flesh** white. Taste mild, smell of crabs. **Gills** adnexed, buff, connected by veins at their bases. Spore print deep cream to pale ochre (E or F). Spores ovoid with warts up to 0.5μ high and only a very few connecting fine lines present, 8–10×7–8μ. Cap cystidia few, cylindrical or spindle-shaped, not reacting to SV; cap surface hyphae with few or no inflations. Habitat under conifers. Season summer to late autumn. Frequent especially in the north and Scotland. **Edible**.

Russula xerampelina (Schaeff. ex Secr.) Fr. (*R. faginea* Romagn. in part) **Cap** 5–14 cm across, convex, later flattening and with a depression, colours very varied, often mixed, dull purples, reds, wine-coloured, cinnamon, straw, fawn, brick or dull brown, moderately firm, sometimes hard, soon dry and matt; margin eventually furrowed, one-quarter peeling at most. **Stem** 30–

110×10–30mm, white or tinted rose, staining honey to brownish ochre especially on bruising, firm to hard, reacting dull green when rubbed with iron salts. **Flesh** white. Taste mild, smell crab-like especially with age. **Gills** adnexed, pale to medium ochre, fairly broad and thick, connected by veins at their bases. Spore print deep cream to pale ochre (E–F). Spores ovoid with warts up to 1.2μ high, lines none or few, occasionally enclosing a mesh, 8–11×6.5–9μ. Cap cystidia infrequent, mostly narrow, not reacting to SV. Cap hyphae with terminal cells sometimes club-shaped, and these and the supporting cells inflated. Habitat under broad-leaved trees, especially beech and oak. Season late summer to late autumn. Common. **Edible**.

Divided by some authorities into a number of different species and varieties.

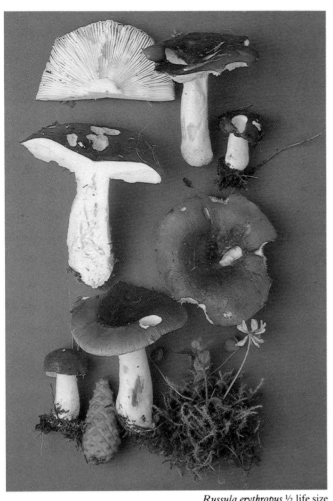

Russula erythropus ½ life size

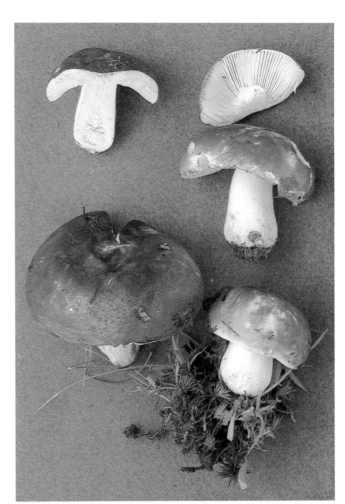

Russula xerampelina ½ life size

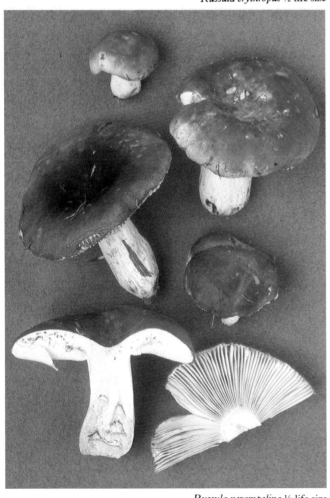

Russula xerampelina ½ life size

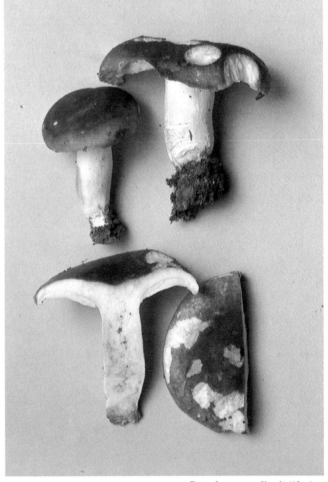

Russula xerampelina ⅔ life size

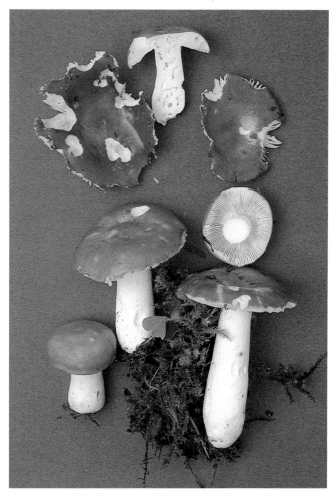

Russula velenovskyi ½ life size

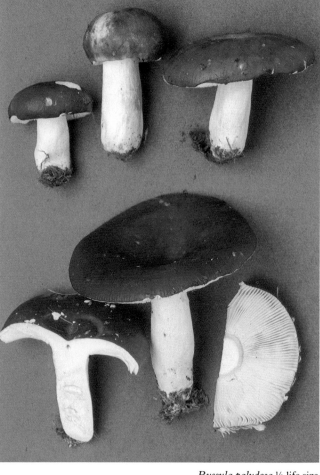

Russula paludosa ½ life size

Russula velenovskyi Melzer & Zvara. **Cap** 3–8cm across, almost globose at first, then flattening and with a depression, often with a low umbo, red, coral, brick, wine- or flesh-coloured, pale ochre or buff in places, fleshy, two-thirds peeling. **Stem** 30–60×10–15mm, white, often tinged pink especially near base, firm, powdered above. **Flesh** white. Taste mild. **Gills** almost free, cream. Spore print deep cream (E–F). Spores ovoid with warts up to 0.7μ high, with a very few thin lines, 6.5–9×5.5–7.5μ. Cap cystidia sparse, mostly cylindrical, sometimes with septa, occasionally narrow club-shaped, with sparse granules staining in fuchsin. Habitat under broad-leaved trees and pine. Season summer to autumn. Occasional. **Edible.**

Russula decolorans (Fr.) Fr. **Cap** 4.5–11cm across, subglobose at first then convex and flattening, finally with a depression, brownish red or orange, reddish sienna, tawny or cinnamon, staining black or brown, firm, sticky when moist, peeling at margin only; margin finally furrowed. **Stem** 45–100×10–25mm, white, greying strongly, firm, often with club-shaped base. **Flesh** thick, greying strongly on exposure. Taste mild. **Gills** adnexed, pale ochre, blackening, connected by veins at their bases. Spore print deep cream to pale ochre (E or F). Spores ovoid to elliptic with spines of various heights up to 1.5μ, mostly isolated but some connected by thin lines to form a very incomplete network with only 1–2 meshes, 9–14×7–12μ. Cap surface with numerous slightly club-shaped dermatocystidia with one or no septa. Habitat under conifers. Season summer to autumn. Uncommon – confined to the Highland region of Scotland. **Edible.**

Russula paludosa Britz. **Cap** 4–14cm across, convex, later flattening and with a depression, red, blood-red, scarlet red, bay, apricot or ochre, sometimes with paler areas, fleshy, firm, slightly sticky when moist, half to three-quarters peeling. **Stem** 40–150×10–32mm, white or tinged pink in part or entirely, cylindrical, narrow club-shaped or swollen in the middle. **Flesh** white. Taste mild. **Gills** adnexed, rather pale creamy golden yellow, connected by veins at their bases. Spore print deep cream (E–F). Spores ovoid or elliptic with warts up to 0.7–1.2μ high, joined by lines to form a somewhat incomplete network, 8–10.5×7–8μ. Cap cystidia sparse, cylindrical, without septa, with a few granules staining in fuchsin, moderately reacting to SV. Habitat conifers. Season early summer to early autumn. Uncommon in Scotland, rare elsewhere. **Edible.**

Russula lundelii Sing. **Cap** 8–15cm across, convex, later flattening or with a depression, orange scarlet, blood coloured, yellowish bay, reddish rust, brownish apricot or deep rosy wine-coloured, sometimes with ochre or yellowish areas, rather firm to almost hard, very fleshy, sticky when moist, one-third peeling. **Stem** 80–100×20–30mm, white, rarely tinted dull purplish, browning slightly on handling, hard. **Flesh** white. Taste bitter and more or less hot. **Gills** adnexed, deep saffron, connected by veins at their bases. Spore print ochre (H). Spores somewhat globose with warts up to 0.7–1μ high, isolated, no lines, 7–8×6.5–7μ. Cap cystidia sparse, cylindrical, reacting with SV. Habitat under birch. Season summer to early autumn. Uncommon – mainly Scottish, but also recorded from S. England. **Not edible.**

Russula maculata Quél. **Cap** 4–10cm across, convex, soon flattening and depressed, coral to pale pink, sometimes almost orange, often cream in part, especially the centre, frequently with rusty spots, peeling at the margin only, margin eventually furrowed. **Stem** 30–90×10–35mm, white, sometimes tinted pink, rusty spotted, browning. **Flesh** white. Taste sometimes hot, rarely mild, smell fragrant (cedarwood). **Gills** adnexed-free, palish ochre, forked, connected by veins at their bases. Spore print pale ochre to ochre (G–H). Spores subglobose to ovoid with warts up to 1.2μ high, isolated or mostly joined by lines to form a rather incomplete network, 8–10×7–9μ. Cap surface hyphae tapering, cylindrical or swollen at the tip. Cap cystidia abundant, cylindrical, spindle-shaped or slightly club-shaped, without septa, reacting with SV. Habitat with deciduous trees. Season summer to autumn. Uncommon. **Not edible.**

Russula polychroma Sing. ex Hora (*R. integra* of many authors.) **Cap** large, 5–15cm across, strongly convex, later flattening, blood coloured, livid red, pale to dark wine-coloured, umber or sepia, often with browner to buff centre, firm, fleshy, half-peeling, sticky when moist; margin finally furrowed. **Stem** 30–90×15–30mm, white, browning, firm. **Flesh** white. Taste mild. **Gills** almost free, saffron. Spore print ochre (G–H). Spores ovoid with isolated spines, no lines, 9–11×7–9.5μ. Cap hyphae finely tapering, some with granules staining in fuchsin. Cap cystidia numerous, cylindrical or narrow club-shaped, without septa, moderately reacting with SV. Habitat under conifers. Season late summer to autumn. Occasional in the Scottish Highlands. **Edible.**

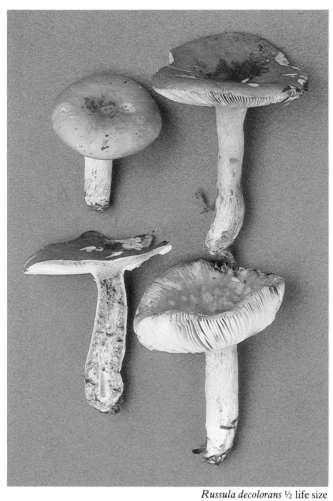

Russula decolorans ½ life size

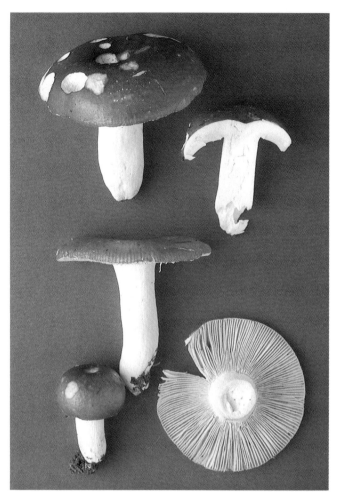

Russula lundelii ½ life size

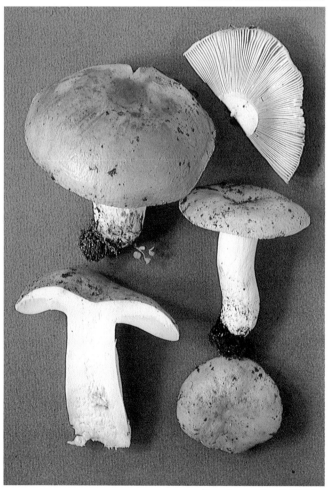

Russula maculata ⅔ life size

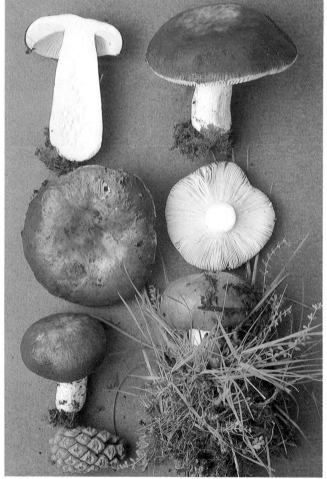

Russula polychroma ½ life size

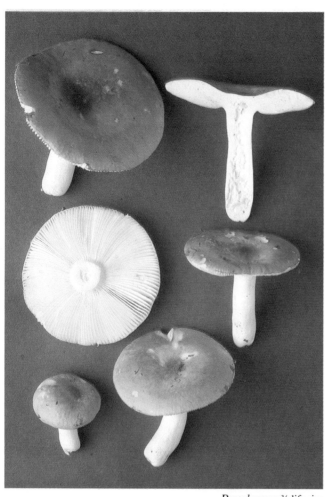

Russula rosea ¾ life size

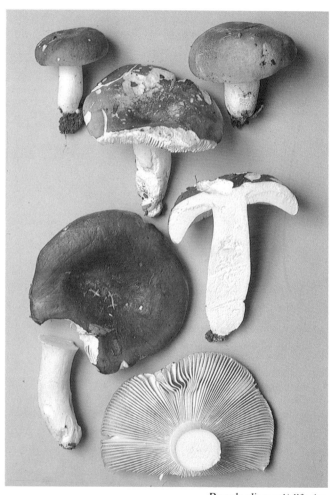

Russula olivacea ½ life size

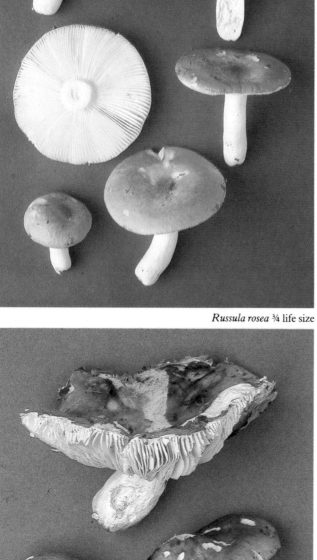

Russula alutacea ⅓ life size

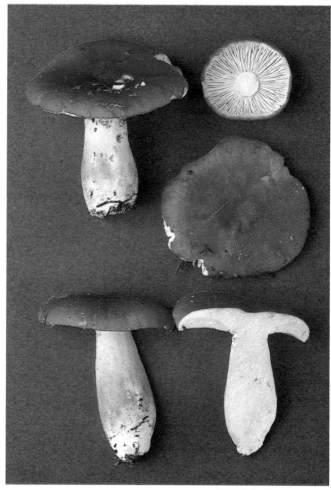

Russula lepida ½ life size

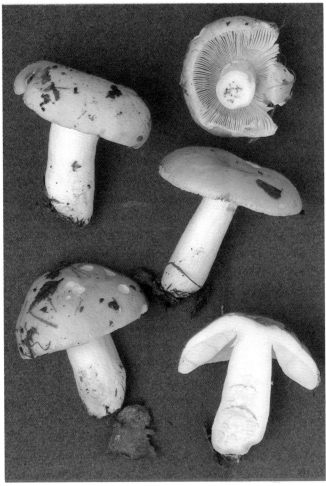

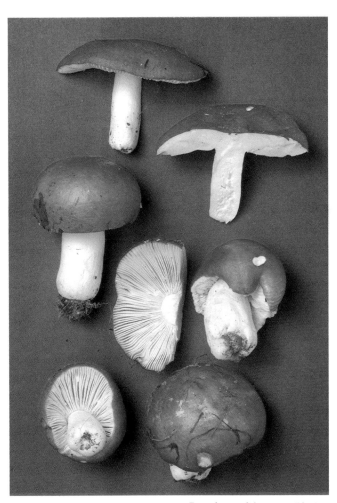

Yellow Swamp Russula *Russula claroflava* ²/₃ life size

Russula pseudointegra ½ life size

Russula olivacea (Schaeff. ex Secr.) Fr. **Cap** 6–16cm across, almost globose at first, later flattened or slightly depressed, often irregular, varying considerably in colour from straw, pale ochre, shades of olive or brown to dull purple or purplish-red, firm or hard, thick-fleshed, peeling up to one-third only; margin inrolled at first. **Stem** 50–100×15–40mm, white, usually tinged rose or entirely so, yellowing slightly or browning around base, fairly hard. **Flesh** white, taste mild, nutty. **Gills** adnexed, deep buffy straw, forking and with cross connections near stem. Spore print ochre (G–H). Spores ovoid with warts up to 1.5μ high, not or occasionally joined by lines, 8–11×7–9μ. Cap cystidia absent, hyphae with rectangular, barrel- or ampoule-shaped cells, the terminal one sometimes strongly inflated. Phenol solution turns stem livid purple. Habitat under beech. Season summer to autumn. Occasional. **Edible.**

Russula alutacea (Pers. ex Fr.) Fr. Similar to *R. olivacea* and sharing with it the livid purple reaction to phenol and the same type of microscopic structure of the cap surface. It differs mainly in the sporal ornamentation with rather lower warts (reaching 0.8μ high) which are often joined by ridges so as to form a partial network though with few or no meshes. **Cap** 7–13cm across, livid purple, vinaceous or purplish brown, the centre often paler or straw-coloured, buff, olive or greenish, these latter colours sometimes spreading over the entire surface. **Stem** 30–100×15–40mm, white, often tinted rose but usually at the base only (in *R. olivacea* the top or the whole stem may be affected.) Spores 8–10×6.5–8.5μ. Habitat in broad-leaved woods. Season early summer to early autumn. Occasional. **Edible.**

Russula rosea Fr. apud Quél. **Cap** 4–9cm across, convex, later flattening, red or pink, usually with cream centre or entirely so, moderately thick-fleshed, moderately firm, at most half peeling, dry, shiny or matt, sometimes powdered. **Stem** 40–70×10–20mm, white, fairly fragile to somewhat firm, powdered at first, especially above; surface carmine with SV, especially when dry (distinguishes this species). **Flesh** white. Taste mild. **Gills** nearly free, pale cream, abundantly forked especially near stem. Spore print pale cream (B). Spores ovoid with warts up to 0.5μ high, with few connecting lines, no network, 6–8×5–6.5μ. Cap cystidia absent, narrow hyphae with incrustations staining in fuchsin present. Habitat under broad-leaved trees. Season summer to early autumn. Frequent. **Edible.**

Russula lepida Fr. **Cap** 4–10cm across, convex, later flattening or slightly depressed, red, often paler and white or yellowish white in places or occasionally entirely, fleshy, hard; surface matt, dry, sometimes as if powdered, hardly peeling. **Stem** 30–70×15–35mm, white or flushed pink or red in part or entirely, often club-shaped or swollen slightly in the middle, powdered. **Flesh** white. Taste mild, of cedarwood pencils, sometimes bitter, smell slightly fruity with a suggestion of menthol. **Gills** almost free, pale cream. Spore print pale cream (B–C). Spores almost globose with warts up to 0.5μ high, joined by lines and ridges to form a well-developed network, 8–9×7–8μ. Cap cystidia frequent, cylindrical, tapering, spindle-shaped or narrow club-shaped, not reacting with SV; hyphae staining in fuchsin also present but granules that stain are rather sparse and scattered. Habitat with deciduous trees especially beech. Season

summer to early autumn. Frequent. **Not edible.**

Yellow Swamp Russula *Russula claroflava* Grove **Cap** 4–10cm across, convex, with a depression later, yellow to ochre yellow, fairly fleshy, slightly sticky, shining, less so when dry, peeling halfway; margin finally furrowed. **Stem** 40–100×10–20mm, white, soft but not fragile. **Flesh** white. Taste mild or slightly hot. **Gills** adnexed to almost free, palish ochre. All parts becoming dark grey on bruising or when old. Spore print pale ochre (F). Spores ovoid with warts up to 1μ high, joined by numerous fine lines to form a fairly well-developed network, 9–10×7.5–8μ. Cap surface without cystidia; numerous hyphae with encrustations staining in fuchsin present. Habitat under birch, especially on wet ground. Season autumn, sometimes late spring to early summer. Frequent. **Edible.**

Russula pseudointegra Arn and Goris. **Cap** 4–10cm across, convex, later flattening, scarlet red to coral, sometimes with cream or whitish areas, fleshy, slightly sticky at first, later dry, sometimes slightly powdered, one- to two-thirds peeling. **Stem** 30–70×15–30mm, white. **Flesh** white. Taste slightly bitter, eventually with a suggestion of hotness, smell slightly of geranium with a touch of menthol. **Gills** free, pale golden yellow to saffron. Spore print pale ochre (F–G). Spores subglobose with warts up to 0.7μ high, some isolated, mainly joined by fine lines forming a rather incomplete network, 7–9×6.5–8μ. Cap cystidia absent, long, rather wide, hyphae with incrustations staining in fuchsin abundant. Habitat under broad-leaved trees especially oak on clay soils. Season summer to autumn. Occasional. **Edible** but bitter.

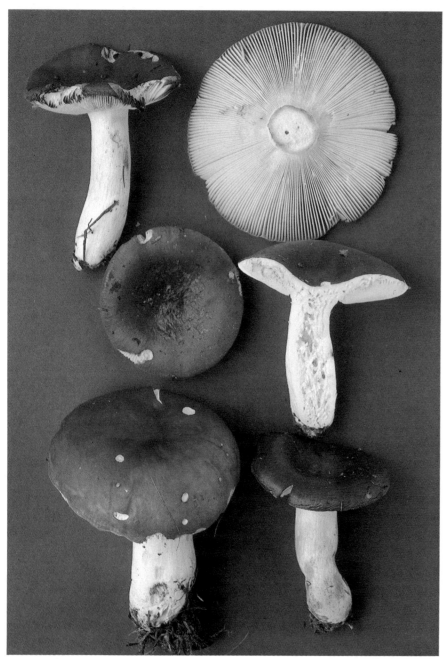

Russula obscura ½ life size

fawny, paling in places, fleshy, sticky or even glutinous when moist, drying matt and often powdered, one third peeling. **Stem** 30–70×10–25mm, white, rarely tinged rose, becoming dirty or brownish, cylindrical or narrow club-shaped. **Flesh** white. Taste mild, smell of iodoform at stem base. **Gills** adnexed, saffron, with connecting veins at their bases. Spore print pale ochre (G). Spores ovoid with warts up to 0.5µ high, mostly joined by fine lines or ridges to form a well-developed network, 7–9×6–8µ. Cap cystidia absent; hyphae with incrustations staining with fuchsin abundant. Habitat under conifers. Season early summer to autumn. Frequent in Scotland, rare in England. **Edible**.

Russula caerulea (Pers.) Fr. **Cap** 3–8cm across, almost conical at first, later with a pointed to broad umbo (rarely absent), livid violet, dark livid, dark wine-coloured or chestnut, hardly sticky when wet, fairly fleshy, one quarter to two thirds peeling; margin finally furrowed. **Stem** 40–90×10–20mm, white, narrow, club-shaped, firm. **Flesh** white. Taste mild but cap skin bitter. **Gills** adnexed to almost free, pale ochre, somewhat closely spaced at first. Spore print palish ochre (G). Spores ovoid, with warts or spines up to 1–1.2µ high, some isolated, others joined in chains or by a few fine lines to form at most a rather scanty network with 0–2 meshes, 8–10×7–9µ. Cap surface without cystidia, but scattered hyphae with sparse incrustations staining in fuchsin present. Habitat under pine and frequent where these occur. Season summer to autumn. Occasional. **Edible**.

Russula aurata (With.) Fr. **Cap** 4–9cm across, globose at first, then flattening and finally with a depression, scarlet red, brownish coral, blood-coloured or reddish orange, often partly or entirely golden yellow, fleshy, firm, half peeling, sticky when moist, smooth; margin often furrowed when mature. **Stem** 30–80×10–25mm, white to pale yellow to pale golden yellow, firm then soft, cylindrical to somewhat club-shaped, often somewhat irregular, smooth. **Gills** adnexed-free, pale ochre, broad, fairly widely spaced, connected by veins at their bases; edge often yellow. Taste mild. Spore print ochre (H). Spores globose-ovoid with conical warts up to 0.7–1.5µ high, with thin to thick connecting ridges which form a partial network enclosing a few meshes, 7.5–9×6–8µ. Cap hyphae tapering, cylindrical, spindle-shaped or slightly club-shaped, with shortish cells; both dermatocystidia and hyphae staining in fuchsin absent. Habitat under broad-leaved trees. Season summer to early autumn. Uncommon. **Edible**.

Russula obscura Romell **Cap** 5–14cm across, convex, soon flattening or with a depression, purplish-red to wine-coloured, centre often brownish, fleshy, up to two-thirds peeling; margin furrowed when old. **Stem** 60–120×10–35mm, white, occasionally tinted greyish rose. **Flesh** white becoming pink on exposure to the air and finally blackish. Taste mild. **Gills** adnexed, dull golden yellow, fairly widely spaced, with connecting veins at their bases. All parts greying or blackening. Spore print deep cream (E or F). Spores ovoid with small, isolated spines up to 0.5µ high, no fine lines, 8–11.5×6.5–9µ. Cap cystidia none, hyphae with incrustations staining in fuchsin present. Habitat under conifers. Season summer to autumn. Confined to the Scottish Highlands and uncommon there. **Edible**.

Russula lutea (Huds. ex Fr.) S. F. Gray **Cap** 2–7cm across, convex, later flattening or with a saucer-shaped depression, often entirely golden or egg-yolk yellow, but sometimes apricot, peach, flesh coloured or coral in part or entirely, thin-fleshed, rather fragile, three-quarters to almost totally peeling. **Stem** 20–60×5–15mm, white, cylindrical or club-shaped, soft, fragile. **Flesh** white. Taste mild, smell nil when young, later fruity and suggesting apricots. **Gills** deep saffron, strongly interlined. Spore print ochre (H). Spores ovoid-elliptic with warts up to 1µ high, mostly isolated, very occasionally joined by a line, 7.5–9×6–8µ. Cap cystidia absent; hyphae staining in fuchsin abundant, strongly encrusted, other hyphae often with club-shaped termination or with a round head (capitate). Habitat under broad-leaved trees. Season summer to early autumn. Frequent. **Edible**.

Russula turci Bres. **Cap** 3–10cm across, convex, soon flattening and with a depression, mauve, dark or dull purple, wine coloured, bay or dark

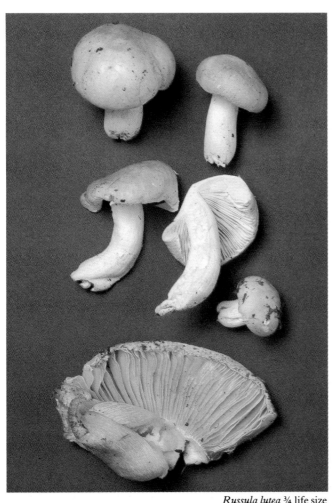

Russula lutea ¾ life size

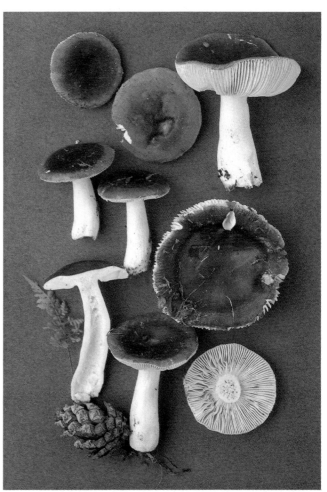

Russula turci ½ life size

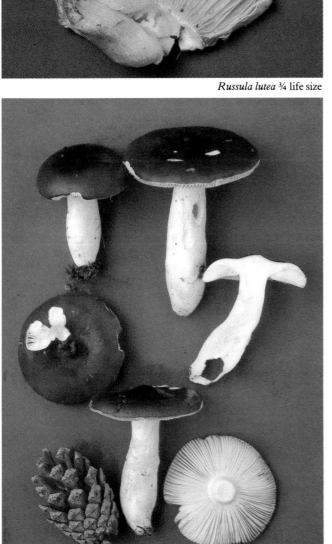

Russula caerulea ½ life size

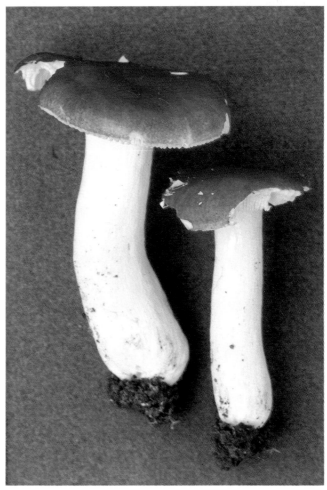

Russula aurata ¾ life size

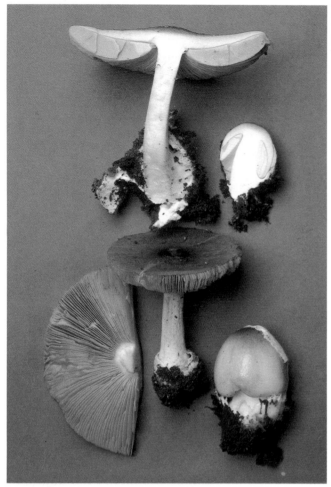

Volvariella speciosa ½ life size

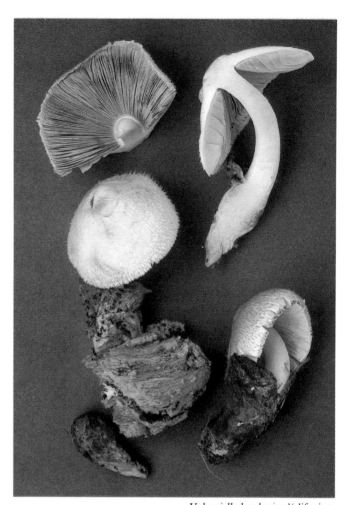

Volvariella bombycina ½ life size

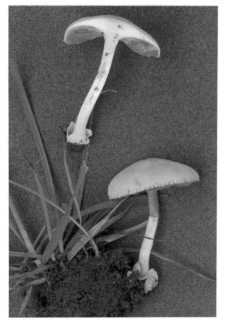

Volvariella parvula life size

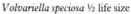

VOLVARIELLA *There is a volva at the base of the stem but no ring. The pink spores will discolour the gills pink as they mature. Some grow on wood, others on compost or rich soil. Nine in Britain.*

Volvariella speciosa (Fr. ex Fr.) Sing. syn. *Volvaria speciosa* (Fr. ex Fr.) Kummer **Cap** 5–10cm across, ovoid then convex to expanded, whitish with greyish-brown centre, viscid when moist. **Stem** 50–90×10–15mm, white, tapering upwards from the base which is enclosed in a whitish or somewhat greyish bag-like volva. **Flesh** white. Taste mild, smell earthy. **Gills** broad, crowded, white finally dark pink. Spore print pink. Spores broadly elliptic, 13–18×8–10μ. Habitat on well-manured ground, compost heaps and rotting straw. Season summer to autumn. Occasional. **Edible** but care should be taken in identification to avoid confusion with the deadly white-spored Amanitas; although the latter have rings, these may become detached.

Volvariella bombycina (Schaeff. ex Fr.) Sing. syn. *Volvaria bombycina* (Schaeff. ex Fr.) Kummer **Cap** 5–20cm across, ovate then bell-shaped, whitish covered in long fine yellowish silky, almost hair-like fibres. **Stem** 70–150×10–20mm, often curved, tapering upwards from the bulbous base; volva membranous, large and persistent, somewhat viscid, white at first discolouring dingy brown. **Flesh** white becoming faintly yellowish. Taste slight, smell pleasant, like that of bean sprouts. **Gills** crowded, white at first then flesh-pink. Spore print pink. Spores elliptic, 8.5–10×5–6μ. Habitat dead frondose trees, usually elm, often in knot-holes or hollow trunks. Season early summer to autumn. Rare. **Edible** – very good.

Volvariella parvula (Weins.) Orton syn. *Volvaria parvula* (Weins.) Kummer syn. *V. pusilla* (Pers. ex Fr.) Quél. **Cap** 1–3cm across, conical then bell-shaped becoming almost flat, whitish tinged yellow at the centre, slightly viscid at first drying silky. **Stem** 25–40×2–4mm, white, silky, base encased in the white, membranaceous, lobed volva. **Flesh** white. **Gills** white at first, later dark flesh-pink. Cheilocystidia thin-walled, broad, subcylindric to clavate. Spore print pink. Spores

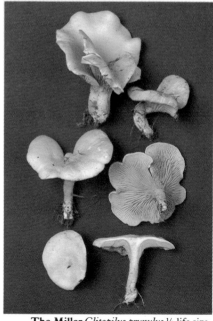

The Miller *Clitopilus prunulus* ⅓ life size

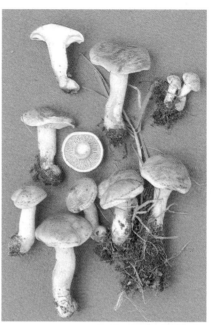

Lepista luscina ⅓ life size

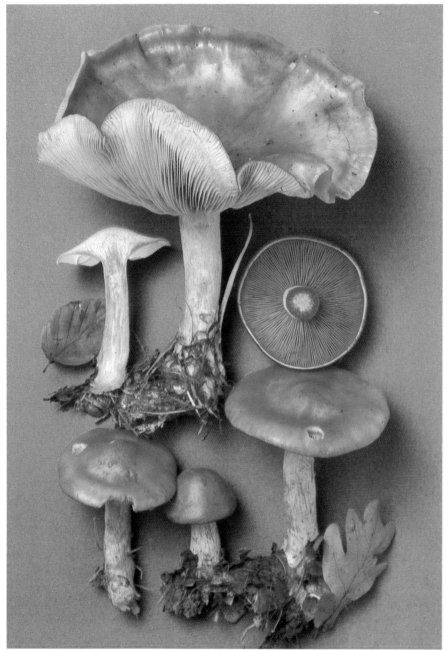

Wood Blewit *Lepista nuda* ⅔ life size

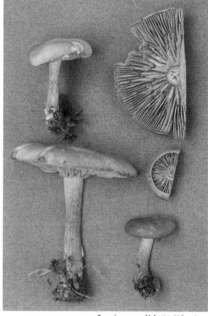

Lepista sordida ½ life size

elliptic, 5–7×3–5μ. Habitat amongst grass in pasture, gardens and open woodland. Season late spring to autumn. Rare. **Edible** – not worthwhile.

The Miller *Clitopilus prunulus* (Scop. ex Fr.) Kummer syn. *Paxillopsis prunulus* (Scop. ex Fr.) Lange **Cap** 3–12cm across, convex then irregularly depressed, lobed and wavy, white to pale cream or greyish, textured like kid leather. **Stem** 15–25×4–12mm, often off-centre, concolorous with cap. **Flesh** white, firm. Taste and smell strongly mealy. **Gills** decurrent, white then pink. Spore print pink. Spores elliptic and longitudinally ridged, 8–14×5–6μ. Habitat in grass in open woodland. Season summer to late autumn. Common. **Edible** – good.

LEPISTA *Similar to Tricholomas but with a pale pink spore print. Six in Britain.*

Wood Blewit *Lepista nuda* (Bull. ex Fr.) Cooke syn. *Tricholoma nudum* (Bull. ex Fr.) Kummer syn. *Rhodopaxillus nudus* (Bull. ex Fr.) Maire **Cap** 6–12cm across, flattened-convex becoming depressed and wavy, bluish lilac at first then more brownish, drying paler. **Stem** 50–90×15–25mm, often slightly bulbous at the base, bluish-lilac, fibrillose. **Flesh** thick, bluish-lilac. Taste and smell strongly perfumed. **Gills** crowded, bluish-lilac fading with age to almost buff. Spore print pale pink. Spores elliptic, minutely spiny, 6–8×4–5μ. Habitat in woodland, hedgerows and gardens. Season autumn to early winter. Common. **Edible** – excellent.

Lepista luscina (Fr. ex Fr.) Sing. syn. *Clitocybe luscina* (Fr. ex Fr.) Karst. syn. *Tricholoma panaeolum* (Fr.) Quél. **Cap** 3–10cm across, convex becoming flattened or depressed and wavy, grey-brown, often ornamented with darker concentric rings of spots, white and mealy

at margin. **Stem** 30–50×4–6mm, fibrous, apex white and mealy, greyish-brown below. **Flesh** thin, pallid. Taste sweet, mushroomy, smell of meal. **Gills** crowded, white then greyish. Spore print pale pinkish. Spores elliptic, minutely roughened, 5–7×3.5–4.5μ. Habitat in rings in grass. Season autumn. Rare. **Edible**.

Lepista sordida (Fr.) Sing. syn. *Tricholoma sordidum* (Fr.) Kummer **Cap** 3–8cm across, convex becoming flattened, depressed or slightly umbonate, often wavy, lilac to lilac-brown, fading with age. **Stem** 40–60×5–8mm, concolorous with cap, fibrous, often slightly thickened at base. **Flesh** greyish tinged with lilac. Taste mild, smell lilac scented. **Gills** lilac fading or becoming lilac-brown with age. Spore print pale, greyish-lilac. Spores elliptic, minutely roughened, 6–7×3.5–4μ. Habitat woodland, often around piles of rotting vegetation. Season summer to late autumn. Uncommon. **Edible**.

113

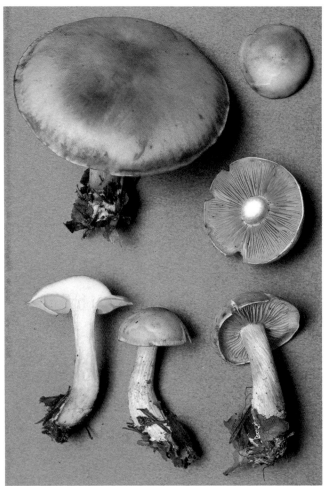

Lepista irina ²⁄₃ life size

Field Blewit *Lepista saeva* ½ life size

Lepista irina (Fr.) Bigelow syn. *Tricholoma irinum* (Fr.) Kummer syn. *Rhodopaxillus irinus* (Fr.) Métrod **Cap** 5–10cm across, hemispherical then flattened-convex, often wavy at the margin, clay-pink to reddish-brown. **Stem** 60–100×10–20mm, dirty white to pallid, covered in long fibres and often ochraceous near the base. **Flesh** thick, white. Taste and smell strongly perfumed. **Gills** emarginate, crowded, flesh-coloured becoming more reddish-brown or cinnamon. Spore print dirty pink. Spores very minutely spiny, 7–9×3.5–4μ. Habitat in open woodland. Season autumn. Rare. **Edible**.

Field Blewit or **Blue-leg** *Lepista saeva* (Fr.) Orton syn. *Tricholoma saevum* (Fr.) Gillet syn. *Rhodopaxillus saevus* (Fr.) Maire syn. *Tricholoma personatum* (Fr. ex Fr.) Kummer of British authors **Cap** 6–10cm across, convex then flattened or depressed, often wavy at the margin, pallid to dirty brown. **Stem** 30–60×15–25mm, often swollen at the base, bluish-lilac, fibrillose. **Flesh** thick, whitish to flesh-coloured. Taste and smell strongly perfumed. **Gills** crowded, whitish to flesh-coloured. Spore print pale pink. Spores elliptic, minutely spiny, 7–8×4–5μ. Habitat often in rings, in pastureland. Season autumn to early winter. Frequent. **Edible** – excellent.

Rhodocybe popinalis (Fr.) Sing. syn. *Clitocybe popinalis* (Fr.) Bres. **Cap** 2–6cm across, flat to centrally depressed, light to dark dirty grey-brown or brown, often cracking. **Stem** 15–

25×5–10mm, paler than the cap. **Flesh** pallid. Taste mealy then bitter, smell strongly mealy. **Gills** grey. Spore print pink. Spores subglobose, finely warted, 6.5–7×6μ. Habitat especially on sand dunes. Season late summer. Rare. **Edibility unknown**.

Entoloma saundersii (Fr.) Sacc. syn. *Rhodophyllus saundersii* (Fr.) Romagn. **Cap** 3–12cm across, bell-shaped becoming expanded-convex with a distinct umbo, pallid, ivory or yellowish-buff to pale grey-brown. **Stem** 20–50×10–24mm, white. **Flesh** white, firm. Taste mealy, smell mealy or slightly rancid. **Gills** dirty white becoming pale pink. Spore print pink. Spores obscurely angularly subglobose, 9–12×8–10μ. Habitat under trees and bushes belonging to the *Rosaceae*. Season late spring to summer. Uncommon. **Edible** though best avoided due to possible confusion with poisonous species.

Entoloma clypeatum (L. ex Fr.) Kummer syn. *Rhodophyllus clypeatus* (L. ex Fr.) Quél. **Cap** 3–10cm across, convex then flattened with a low broad umbo, grey-brown often flushed yellowish, with darker spots or radiating lines. **Stem** 30–50×8–15mm, white tinged with cap colour, covered in long silky fibres. **Flesh** white, firm. Taste and smell mealy. **Gills** pale grey at first then flesh pink. Spore print pink. Spores angularly subglobose, 8–11×7.5–9μ. Habitat under bushes belonging to the *Rosaceae*; rose, hawthorn, cherry, etc. Season spring to early

summer. Common. **Edibility suspect** – best avoided.

Entoloma sinuatum (Bull. ex Fr.) Kummer syn. *Rhodophyllus lividus* (Bull. ex St. Amans) Quél **Cap** 6–20cm across, convex then expanded,

Rhodocybe popinalis ²⁄₃ life size

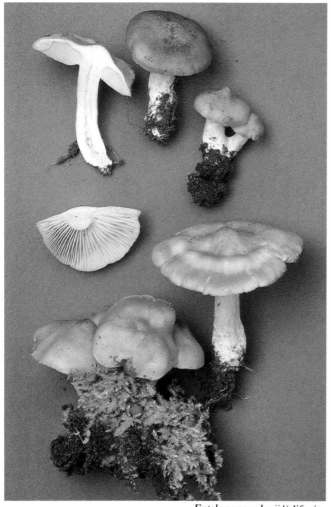

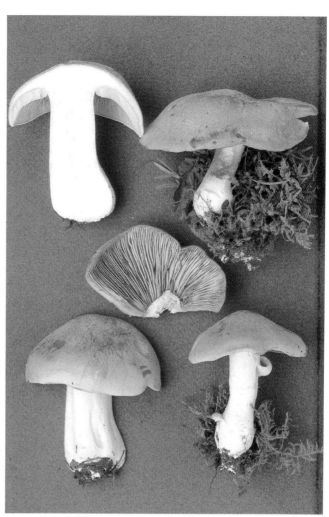

Entoloma saundersii ½ life size

Entoloma sinuatum ⅓ life size

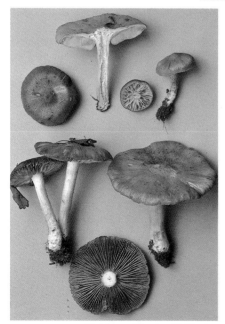

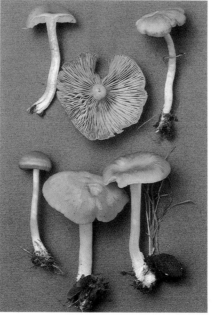

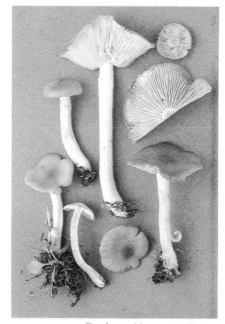

Entoloma clypeatum ⅓ life size

Entoloma rhodopolium ⅓ life size

Entoloma nidorosum ⅓ life size

ivory to dull grey-brown. **Stem** 60–100×10–30mm, white. **Flesh** firm, white. Smell mealy. **Gills** pale ochraceous when young, later flesh-coloured. Spore print pink. Spores angularly subglobose, 8–10×7–8.5μ. Habitat rich soil in open deciduous woodland or field edges. Season late summer to late autumn. Rare. **Poisonous**.

Entoloma rhodopolium (Fr.) Kummer syn. *Rhodophyllus rhodopolius* (Fr.) Quél **Cap** 3–7cm

across, convex with a slight umbo then expanded and often depressed, grey-brown to yellowish buff drying silky greyish. **Stem** 40–80×5–10mm, white to silky greyish. **Flesh** thin, white. Taste and smell slightly mealy. **Gills** whitish then flesh-pink. Spore print pink. Spores angularly subglobose, 8–10.5×7–8μ. Habitat in deciduous woods. Season summer to autumn. Frequent. **Poisonous** – causes gastric upsets.

Entoloma nidorosum (Fr.) Quél **Cap** 3–7cm across, convex then expanded and slightly umbonate or depressed, pale grey becoming paler with age, margin often wavy. **Stem** 50–100×3–15mm, white to whitish. **Flesh** white, watery. Smell strongly nitrous when first collected but soon fading. **Gills** whitish-pallid at first becoming flesh-pink. Spore print pink. Spores subglobose, angular, 7–9×6–8μ. Habitat damp deciduous woods. Season late summer to late autumn. Occasional. **Not edible**.

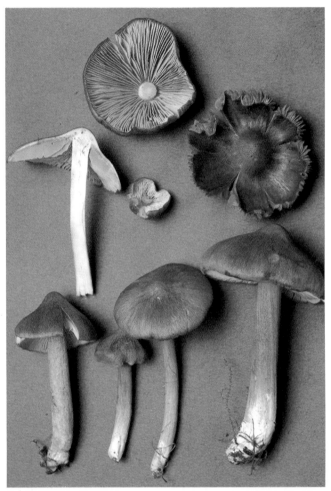

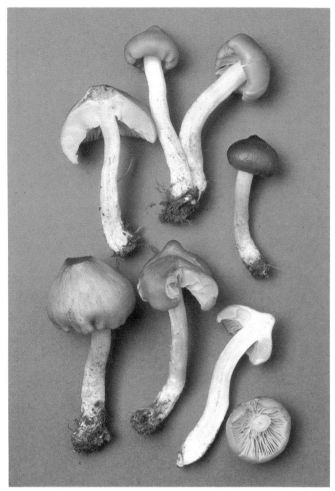

Entoloma porphyrophaeum ²/₃ life size

Entoloma aprile ½ life size

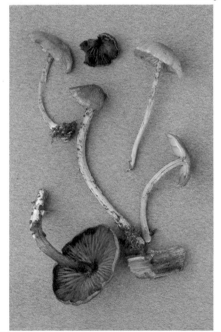

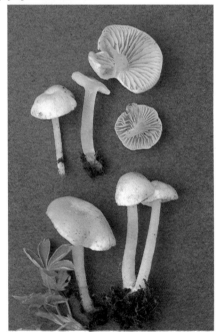

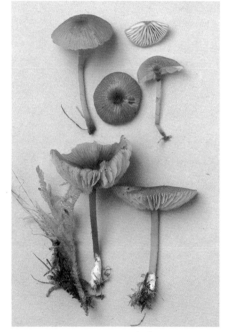

Leptonia euchroa life size

Leptonia sericella life size

Leptonia incana ¾ life size

Entoloma porphyrophaeum (Fr.) Karst. syn. *Rhodophyllus porphyrophaeus* (Fr.) Lange **Cap** 3–9cm across, convex to bell-shaped with a distinct umbo, dark grey-brown to date-brown often with a faint purplish-brown tinge at margin, covered in radiating fibres. **Stem** 40–80×5–10mm, purplish-grey-brown and fibrous, base covered in fine white down. **Flesh** thin, whitish. **Gills** rather distant, dirty white at first then dark flesh pink. Cystidia thin-walled, fusiform, often with capitate apex. Spore print pink. Spores angularly oblong, 10–13×5–7µ. Habitat in pasture and grassland. Season late spring to late autumn. Uncommon. **Edible** but best avoided due to possible confusion with poisonous species.

Entoloma aprile (Britz.) Sacc. syn. *Rhodophyllus aprilis* (Britz.) Romagn. **Cap** 3–6cm across, convex with a distinct umbo, dark brown when moist, drying paler grey-brown. **Stem** 30–70×5–10mm, whitish to pale grey-brown, striate. **Flesh** whitish-grey, firm, becoming hollow in stem. Taste and smell mealy. **Gills** whitish-grey, finally tinged pink. Spore print salmon pink. Spores angularly subglobose, 9–12×7.5–10µ. Habitat amongst bushes and deciduous trees. Season spring. Uncommon. **Suspect** – best avoided.

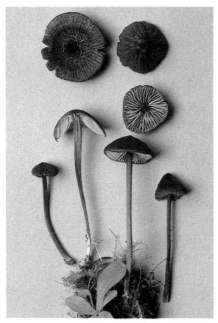

Leptonia lazulina ¾ life size

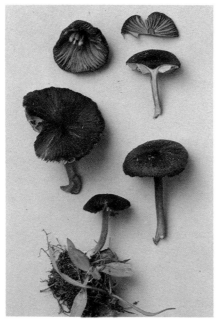

Leptonia serrulata ¾ life size

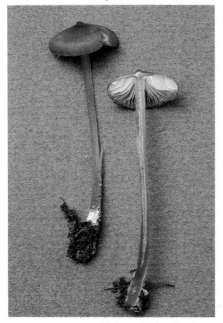

Nolanea hirtipes ²/₃ life size

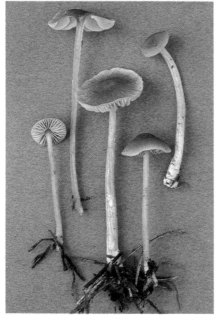

Nolanea cetrata ¾ life size

Leptonia euchroa (Pers. ex Fr.) Kummer **Cap** 1–4cm across, bell-shaped, beautifully violaceous, sometimes with a slight brownish tint at centre, silky-fibrous. **Stem** 20–60×2–4mm, concolorous with cap. **Flesh** bluish-pallid. Taste and smell not distinctive. **Gills** rich violaceous with a darker edge. Spore print pink. Spores angular, 9–11×5–7.5μ. Habitat on branches, stumps or fallen trunks of alder, hazel, beech or birch. Season late summer to autumn. Uncommon. **Edible.**

Leptonia serrulata (Pers. ex Fr.) Kummer syn. *Rhodophyllus serrulatus* (Pers. ex Fr.) Quél. **Cap** 1–3cm across, convex then expanded and finally depressed, blue-black becoming brownish with age, margin often slightly striate. **Stem** 15–20×1–2mm, blue-grey to blackish, typically with black dots at apex, base covered in white down. **Flesh** thin, bluish-white. **Gills** blue-grey with a blackish edge. Cystidia club-shaped with blue sap. Spore print pink. Spores angular-

elliptic, 10–12×6–8μ. Habitat grassland. Season summer to autumn. Occasional – more frequent in the North and West. **Poisonous.**

Leptonia incana (Fr.) Gillet syn. *Rhodophyllus incanus* (Fr.) Kühn. & Romagn. **Cap** 1–3cm across, convex, often becoming centrally depressed, expanding to almost flat, yellow-brown to olive-brown, darker brown at the centre, striate at the margin. **Stem** 20–40×1–3mm, yellowish green, bruising blue-green, base covered in white down. **Flesh** thin, greenish. Strong smell of mice. **Gills** greenish-white at first becoming pale flesh-colour. Spore print pink. Spores angularly oblong, 11–14×8–9μ. Habitat grassland and heaths, especially on chalk. Season late summer to late autumn. Uncommon. **Poisonous.**

Leptonia lazulina (Fr.) Quél. syn. *Rhodophyllus lazulinus* (Fr.) Quél. **Cap** 1–2cm across, convex,

blackish-blue, almost black at disc, covered in darker radiating fibres, margin striate. **Stem** 30–40×1–2mm, dark blue to blue-black or violet-blue. **Flesh** thin, dark blue. Smell strongly mushroomy. **Gills** at first deep bright blue or blue-grey becoming more pink with age. Spore print pink. Spores angularly oblong, 10–12×6.5–8μ. Habitat grassland and heaths. Season autumn. Occasional – more common in the North and West. **Poisonous.** The collection illustrated shows caps which are more conical than those found typically.

Leptonia sericella (Fr. ex Fr.) Barb. syn. *Entoloma sericellum* (Fr. ex Fr.) Kummer syn. *Rhodophyllus sericellus* (Fr. ex Fr.) Quél **Cap** 1–2cm across, conico-convex expanding to almost flat, sometimes depressed at the centre, pale ochre-buff drying whitish. **Stem** 15–25×2–4mm, concolorous with cap. **Flesh** thin, concolorous. Smell mushroomy. **Gills** white at first then pale pink. Spore print pink. Spores angularly oblong, 9–13×6–8.5μ. Habitat pastureland, open woodland and marshes. Season summer to autumn. Occasional. **Not edible.**

Nolanea hirtipes (Schum. ex Fr.) Kummer syn. *Rhodophyllus hirtipes* (Schum. ex Fr.) Quél. syn. *R. mammosus* var. *typicus* Kühn. & Romagn. **Cap** 2–5cm across, bell-shaped, dark sepia to dirty grey-brown drying pale ochre-tan, the prominent umbo darker brown. **Stem** 70–150×2–5mm, concolorous with cap or paler, covered in fine white down at the slightly thickened base. **Flesh** thin, greyish-brown. Smell distinctly of cucumber. **Gills** whitish at first becoming pale pinkish-brown. Cheilocystidia thin-walled, hair-like with obtuse apices. Spore print pink. Spores angular, 11–14×7–8μ. Habitat amongst grass or in mixed woodland. Season autumn. Occasional. **Not edible.**

Nolanea cetrata (Fr. ex Fr.) Kummer syn. *Rhodophyllus cetratus* (Fr. ex Fr.) Quél. **Cap** 1–3cm across, bell-shaped, ochre-brown to tan, striate. **Stem** 25–60×2–4mm, pale tan-buff covered in long whitish silky fibres. **Flesh** thin, dark brown in cap, paler in stem. Taste and smell not distinctive. **Gills** flesh-coloured to light tan. Spore print pink. Spores angular, 9–12×6.5–8μ. Basidia two-spored. Habitat under conifers, sometimes in sphagnum. Season autumn. Frequent. **Not edible.**

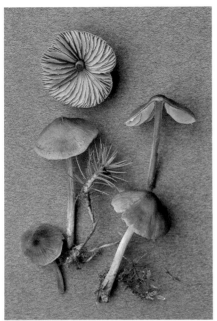

Nolanea staurospora ²/₃ life size

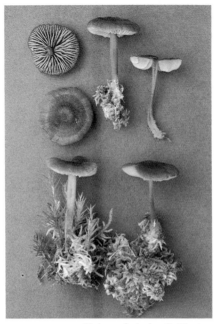

Nolanea farinolens ²/₃ life size

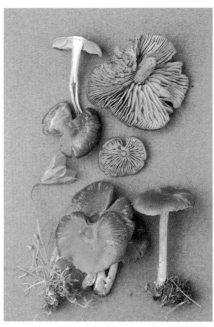

Nolanea lucida ²/₃ life size

Nolanea staurospora Bres. syn. *Rhodophyllus staurosporus* (Bres.) Lange **Cap** 1–3cm across, convex with an indistinct umbo, dark brown, reddish-brown or greyish, hygrophanous, drying pallid, striate when moist. **Stem** 20–60×1–3mm, paler than the cap, covered in long silky whitish fibrils. **Flesh** concolorous. Smell mealy. **Gills** whitish at first then pink. Spore print pink.Spores quadrangular to stellate, 9–10×7–9μ. Habitat in grassland and open woodland. Season autumn. Common. **Not edible**.

Nolanea farinolens Orton **Cap** 1.5–3cm across, varying in shape from convex or flattened-convex to slightly depressed, even umbonate, sepia to brownish-black, darkening towards the centre, drying pale buff or pallid, finely striate when moist. **Stem** 20–70×2–3mm, concolorous with cap or paler. **Flesh** concolorous. Taste strongly of meal, smell mealy when crushed. **Gills** whitish grey at first then becoming brownish-pink. Spore print pink. Spores subglobose to broadly elliptic, with rather rounded angles, 6.5–9×5.5–7μ. Cap cuticle tough and cartilaginous. Habitat in grass or soil in damp, shady woodland. Season summer to early autumn. Occasional. **Not edible**.

Nolanea lucida Orton **Cap** 1–4(5)cm across, conico-convex then flattened or bell-shaped with a broad umbo, sepia darkening towards the centre drying pallid or light sepia with conspicuous sheen, striate at margin when moist. **Stem** 20–60×2–5mm, more or less cartilaginous, pale greyish often flushed with sepia, base covered in fine white down. **Flesh** concolorous. Taste strongly of meal, smell mealy when crushed. **Gills** whitish at first becoming pink or brownish-pink. Spore print pink. Spores broadly elliptic to almost subglobose with well-marked angles, 7.5–10×5.5–7μ. Cap cuticle thin and fragile. Habitat amongst grass or moss in deciduous woods. Season summer to late autumn. Rare. **Not edible**.

PLUTEUS *Nearly all grow on wood or wood debris; the gills are free. You will be able to detect the gills turning pink (due to the pink spore deposit) in mature specimens. Thirty-four in Britain.*

Pluteus podospileus Sacc. & Cub. **Cap** 1.5–4cm across, convex then expanded and sometimes umbonate, umber to blackish-brown, covered in minute velvety scales. **Stem** 10–40×2–3mm, sometimes slightly bulbous, whitish then dingy brown due to the covering of minute brownish punctate scales. **Flesh** whitish in cap, greyish to pale brown in stem. Smell slight. **Gills** white at first then pinkish. Pleurocystidia thin-walled, hyaline, broadly vesiculose, clavate or cylindric. Spore print pink. Spores broadly ovate to subglobose, 4–7×3.5–5μ. Cap cuticle mixed, comprising sphaeropedunculate cells with projecting fusiform elements. Habitat on rotting deciduous wood. Season summer to autumn. Uncommon. **Edibility unknown**.

Pluteus cervinus (Schaeff. ex Fr.) Kummer **Cap** 4–12cm across, bell-shaped then convex to flattened, sepia to dark umber with radiating streaks. **Stem** 70–100×5–15mm, slightly swollen at the base, white becoming streaked with umber fibres. **Flesh** white. Taste and smell not distinctive. **Gills** white, later dull pink. Cystidia fusoid with thickened walls and crowned with several apical prongs. Spore print pink. Spores broadly elliptic, 7–8×5–6μ. Habitat on rotting stumps, trunks and sawdust of deciduous trees. Season early summer to late autumn, but also sporadically throughout the year. Very common. **Edible** – not worthwhile.

Pluteus umbrosus (Pers. ex Fr.) Kummer **Cap** 3–9cm across, convex, sepia covered in minute date brown velvety scales, more densely on the irregular ridges and near the centre. **Stem** 30–90×4–12mm, white covered in minute brown velvety scales. **Flesh** white. **Gills** whitish then pink with a conspicuous dark brown edge. Pleurocystidia thin walled, hyaline, bottle-shaped. Spore print pink. Spores subglobose, 6–7×4–5μ. Cap cuticle filamentous; the scales formed of slightly fusiform or elongated clavate elements. Habitat on rotting deciduous wood. Season autumn. Uncommon. **Edible**.

Pluteus salicinus (Pers. ex Fr.) Kummer **Cap** 2–5cm across, convex then flattened and slightly umbonate, bluish- or greenish-grey darker at the centre, faintly striate when moist. **Stem** 30–

50×2–6mm, white, sometimes becoming tinged with cap colour at the base. **Flesh** white with greyish tinge. **Gills** white then pink. Pleurocystidia fusiform with slightly thickened walls and an apical crown of hooked processes. Spore print pink. Spores elliptic, 8–9×6–7μ. Habitat on deciduous wood. Season spring to autumn. Frequent. **Edible**.

Pluteus semibulbosus (Lasch apud Fr.) Gillet s. Lange **Cap** 1.5–3cm across, bell-shaped to obtusely convex, white tinged pale flesh-colour when moist, radiately wrinkled and as if powdered with mica flakes. **Stem** 20–30×3–7mm, bulbous, white. **Flesh** white. **Gills** white at first, later pink. Pleurocystidia thin-walled, hyaline, bottle-shaped. Spore print pink. Spores broadly ovate to subglobose, 6–7×5–5.5μ. Cap cuticle of sphaeropedunculate cells. Habitat on rotting sawdust or wood of deciduous trees. Season autumn. Rare. **Edibility unknown**.

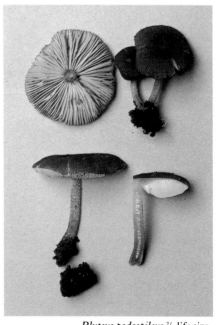

Pluteus podospileus ²/₃ life size

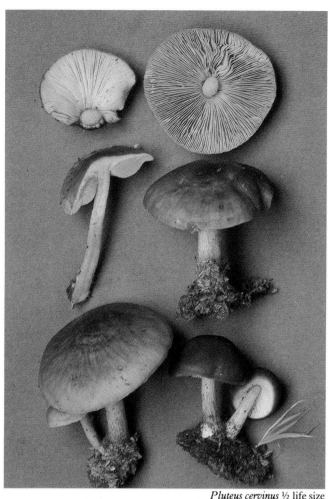

Pluteus cervinus ½ life size

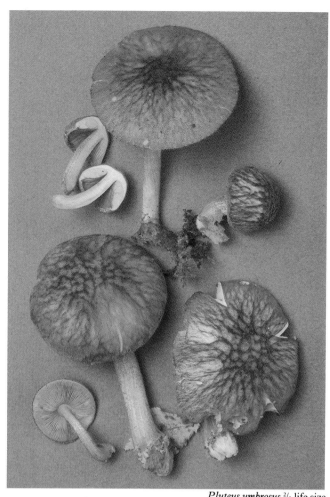

Pluteus umbrosus ⅔ life size

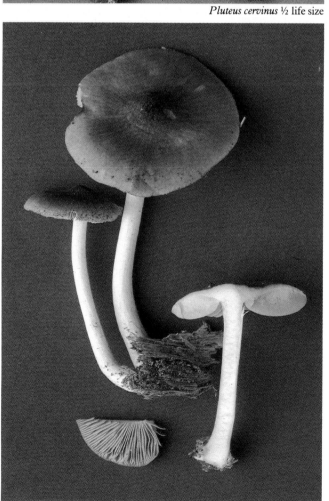

Pluteus salicinus life size

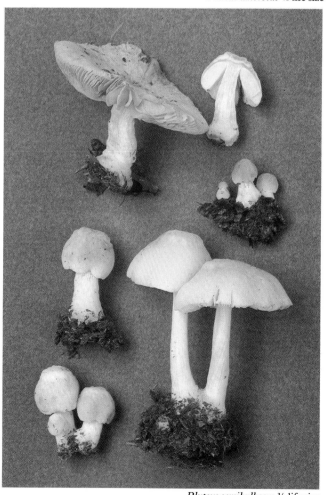

Pluteus semibulbosus ¾ life size

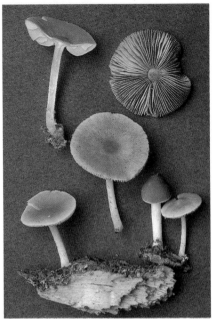

Pluteus luteovirens ²/₃ life size

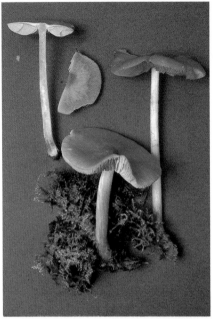

Pluteus leoninus ²/₃ life size

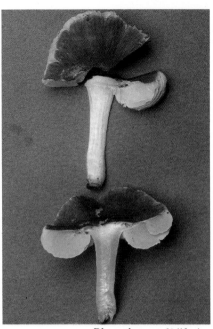

Pluteus lutescens ¾ life size

Pluteus luteovirens Rea **Cap** 2–4cm across, bell-shaped then flattened or umbonate, mustard yellow to olivaceous-ochre. **Stem** 20–60×2–5mm, white then cream. **Flesh** thin, yellowish in cap and stem base, elsewhere white. Taste and smell not distinctive. **Gills** white then pink, without yellow tints. Pleurocystidia thin-walled, hyaline, bottle-shaped. Spore print pink. Spores subglobose, 5–6×5µ. Cap cuticle of sphaeropedunculate cells with yellowish contents. Habitat on elm. Season autumn. Uncommon. **Edibility unknown**.

Pluteus leoninus (Schaeff. ex Fr.) Kummer s. Lange **Cap** 4–6cm across, convex to flattened and slightly umbonate, minutely velvety, deep yellow to bright golden, striate at the margin. **Stem** 50–75×3–10mm, whitish becoming flushed yellow from the base up. **Flesh** thin, whitish turning brownish in stem base. **Gills** pale pink, often edged with yellow. Pleurocystidia fusiform. Spore print pink. Spores subglobose, 6.5–7.5×5–6µ. Cap cuticle filamentous. Habitat on wood of deciduous trees. Season autumn. Rare. **Edibility unknown**.

Pluteus lutescens (Fr.) Bres. syn. *P. nanus* var. *lutescens* (Fr.) Karst **Cap** 1.5–5cm across, flattened convex or slightly umbonate, dark cinnamon-brown, margin paler to yellow and scarcely striate, cap surface often wrinkled towards the centre. **Stem** 15–70×2–6mm, bright lemon-yellow becoming chrome at base. **Flesh** thin, yellow. **Gills** chrome at first then yellowish pink. Pleurocystidia thin-walled, hyaline, broadly vesiculose, clavate, or cylindric. Spore print pink. Spores subglobose, 6.5×5.5µ. Cap cuticle of sphaeropedunculate cells. Habitat on the ground amongst wood chips or other rotting deciduous wood, especially beech. Season late spring to autumn. Uncommon. **Edible**.

Pluteolus aleuriatus (Fr. ex Fr.) Karst **Cap** 1.5–4cm across, flattened convex, lilaceous-grey, striate, viscid. **Stem** 25–40×2–3mm, white, often swollen at base. **Flesh** thin, whitish. **Gills** whitish at first then pink, finally cinnamon. Spore print rust. Spores narrowly elliptic, 9–10.5×4–5µ. Habitat on rotting sawdust,

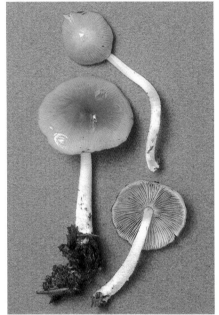

Pluteolus aleuriatus ²/₃ life size

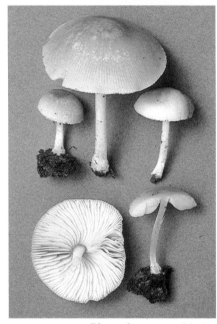

Pluteus depauperatus life size

branches and stumps of deciduous trees. Season autumn. Occasional. **Edibility unknown**.

Pluteus depauperatus Romagnesi **Cap** 2.5–3.5cm across, convex to flattened, with sulcate-striate margin, hygrophanous, disrupting into tiny ochre-buff scales near the centre, elsewhere pale pinkish-fawn, drying whitish. **Stem** 25–35×3–4mm, white becoming yellow tinged near the bulbous base. **Flesh** thin, whitish to yellowish or buff. Taste and smell faint, not distinctive. **Gills** pale pink-buff. Cheilo- and pleurocystidia thin-walled, hyaline, fusiform or lanceolate. Spore print pink. Spores broadly elliptic to subglobose, 7–8×5.5–6.5µ. Surface of cap formed of long thin-walled cylindric or clavate elements, 57–170×15–34(40)µ with bluntly rounded tips. Habitat on rotting wood or sawdust of beech. Season autumn. Uncommon. **Edibility unknown**.

CORTINARIUS *Have rust-coloured spores, and a cortina (a fine cobweb between the stem and cap edge). In addition there is a veil which covers the*

whole mushroom when it is minute, remnants of this veil can often be seen at the base of the stem and on the cap edge. It is essential to have immature specimens in any collection, as the distinctive violet, cream, olivaceous or other colours of the young gills are quickly turned red brown by the mature spores. The genus has been divided into seven subgenera. Two hundred and thirty listed as British.

CORTINARIUS *subgenus* MYXACIUM *Both cap and stem are sticky from the glutinous universal veil; this is easy to observe in buttons or in wet weather but in dry weather the gluten may dry out, however leaves and earth stuck to the cap and stem will point to it having been sticky. The cap cuticle often tastes bitter.*

Cortinarius (Myxacium) trivialis Lange syn. *M. collinitum* var. *repandum* Ricken **Cap** 3.5–11cm across, conico-convex then expanded and slightly umbonate, ochraceous tawny to bay brown, very viscid. **Stem** 50–120×10–20mm, viscid, apex whitish, concolorous with cap below and covered in whitish scales. **Flesh** pale

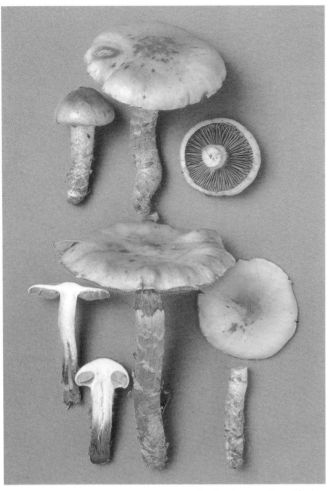

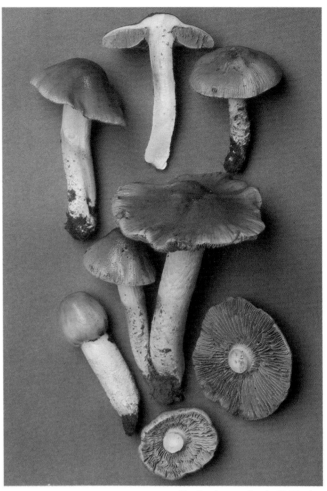

Cortinarius trivialis ½ life size

Cortinarius pseudosalor ½ life size

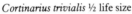

yellowish, brownish below the cap cuticle and in
the lower part of the stem. Taste mild, smell
none. **Gills** pale clay then ochre to rust. Spore
print rust. Spores almond-shaped, roughened.
10–13×6–7μ. Habitat in damp deciduous
woods, usually with alder or willow. Season
autumn. Rare. **Edibility unknown**.

Cortinarius (Myxacium) pseudosalor Lange syn.
C. mucifluoides (Henry) Henry **Cap** 3–8cm
across, conico-convex then expanded and often
umbonate, ochraceous buff to ochre-brown,
tinged tawny at centre, margin smooth or slightly
grooved, viscid when moist drying shiny. **Stem**
80–100×10–20mm, white covered in violaceous
slimy veil below cortinal zone. **Flesh** whitish to
pallid tinged yellowish especially below cap
cuticle. Taste mild, smell none. **Gills** clay then
ochraceous-rust. Cheilocystidia thin-walled,
hyaline, balloon-shaped. Spore print rust.
Spores almond-shaped, roughened, 12–14×7–
9μ. Habitat deciduous woods, especially beech
and also with conifers. Season autumn.
Common. **Edibility unknown**.

Cortinarius (Myxacium) collinitus (Sow. ex Fr.)
Fr. s. Lange **Cap** 2–10cm across, convex then
expanded with a low broad umbo, yellow-brown
to tawny or dark rust, often darker at centre,
glutinous drying shiny, margin incurved at first,
sometimes slightly grooved. **Stem** 50–120×7–
20mm, apex white to bluish, concolorous with
cap below cortinal zone and covered in bluish
bands of velar remains. **Flesh** whitish to
yellowish, sometimes tinged bluish in stem apex.
Taste mild, smell none. **Gills** pale violaceous or

clay at first, later rusty. Spore print rust. Spores
elliptic to almond- or lemon-shaped, rough, 12–
20×7–9μ. Habitat conifer woods, more rarely
deciduous. Season late summer. Occasional.
Edibility unknown.

Cortinarius (Myxacium) croceo-caeruleus (Pers. ex
Fr.) Fr. **Cap** 2–5cm across, convex then
expanded and often slightly depressed, bright
violaceous becoming pale ochraceous from

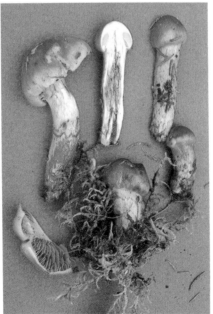

Cortinarius collinitus ⅓ life size

centre, sticky. **Stem** 40–60×5–12mm, spindle-
shaped tapering into a pointed base, white to
yellowish. **Flesh** white to yellowish, often tinged
violaceous below the cap cuticle. Taste bitter,
smell strong, unpleasant. **Gills** whitish, usually
with bluish tint at first, becoming ochraceous-
clay and finally cinnamon. Spore print rust.
Spores elliptic to almond-shaped, almost
smooth, 7.5–8.5×4.5–5.5μ. Habitat under
beech. Season autumn. Uncommon. **Edibility
unknown**.

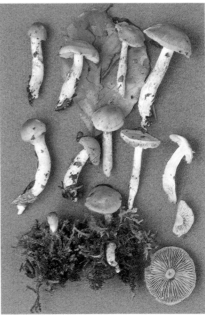

Cortinarius croceo-caeruleus ⅓ life size

121

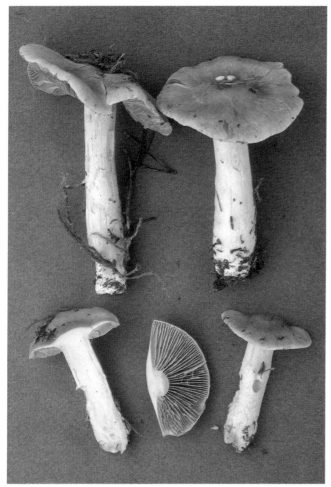

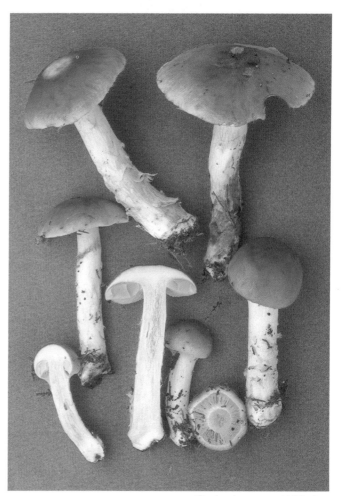

Cortinarius pinicola ½ life size

Cortinarius mucosus ½ life size

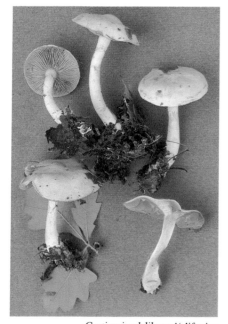

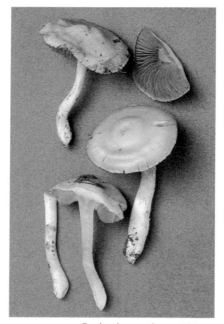

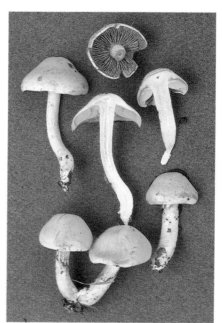

Cortinarius delibutus ⅓ life size

Cortinarius causticus ½ life size

Cortinarius ochroleucus ½ life size

Cortinarius (Myxacium) pinicola Orton **Cap** 3.5–10cm across, convex then expanded with a broad umbo, ochre-buff to tawny-ochraceous becoming paler towards the margin, glutinous when moist. **Stem** 15–150×8–16mm, whitish often tinged yellowish-buff, especially at the apex, silky white above the cortinal zone, covered in tiny white cottony scales from the veil below. **Flesh** whitish tinged yellowish-buff in stem, especially at base. Taste mild, smell none or honey-like. **Gills** whitish to pale clay, finally ochre-buff. Spore print rust. Spores lemon-shaped, rough, 13.5–16×7–8.5μ. Habitat under Scots pine. Season late summer to autumn. Rare. **Edibility unknown.**

Cortinarius (Myxacium) mucosus (Bull. ex Fr.) Kickx. **Cap** 4–10cm across, convex, tawny to chestnut, very glutinous, margin incurved at first, often striate. **Stem** 50–150×15–25mm, silky white, not disrupting into scales. **Flesh** whitish tinged tawny beneath cap cuticle. Taste mild, smell none. **Gills** whitish then pale ochraceous darkening to cinnamon. Spore print rust. Spores elongate lemon-shaped, rough, 14.5–17.5×6.5–7.5μ. Habitat conifer heaths, usually with pine. Season late summer. Rare. **Edibility unknown.**

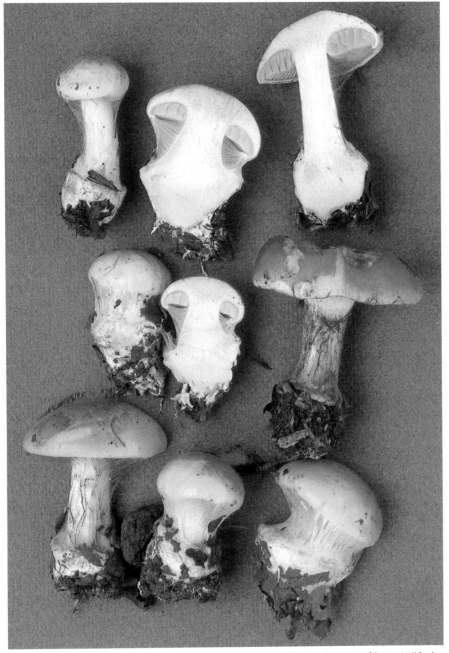

Cortinarius auroturbinatus ½ life size

rust. Spores elliptic, almost smooth, 7–8×4–5μ. Habitat deciduous woods, especially with oak. Season autumn. Rare. **Edibility unknown**.

CORTINARIUS *subgenus* PHLEGMACIUM
Only the cap is sticky, the stem is dry. Note the character of the stem base; bulbous, with a marginate bulb (that is, a bulb with a definite edge), rooting or whatever.

Cortinarius (Phlegmacium) auroturbinatus (Secr.) Lange syn. *C. elegantissimus* Henry **Cap** 4.5–12cm across, convex then expanded, margin incurved, sulphur-yellow soon discolouring rusty especially towards the centre, remaining sulphur-yellow at the margin. **Stem** 60–120×10–18mm (20–40mm wide at the more or less marginate bulb), yellow becoming tinged buff. **Flesh** white, sulphur-yellow in bulb. Taste mild, smell sickly sweet. **Gills** yellow then olivaceous, finally pale rust. Spore print rust. Spores lemon-shaped, very rough, 11.5–15×7–8.5μ. No reaction on flesh with NaOH but cap cuticle turns reddish-brown to purplish-black. Habitat beech woods on chalk. Season autumn. Occasional. **Edibility unknown**.

Leucocortinarius bulbiger (Alb. & Schw. ex Fr.) Sing. syn. *Armillaria bulbigera* (Alb. & Schw. ex Fr.) Kummer **Cap** 5–8cm across, convex, pale clay-brown, sometimes with debris of veil leaving brownish cobwebby patches, especially near the margin. **Stem** 50–100×10–12mm, base swollen into a large flattened bulb 25–30mm across, whitish, the remains of the cobwebby veil leaving a distinct ring zone. **Flesh** white, becoming pale clay in the stem. Taste and smell not distinctive. **Gills** white at first becoming cream to pale clay, never rust. Spore print white. Spores broadly elliptic, 7–9×4–5μ. Habitat with conifers. Season autumn. Rare. **Edibility unknown**.

Cortinarius (Myxacium) delibutus Fr. **Cap** 3–9cm across, convex then expanded and sometimes slightly umbonate, yellow with brighter centre or even tinged tawny-buff, very viscid. **Stem** 50–100×7–15mm, slightly swollen at base, white tinged yellow by the viscid veil from base up to cortinal zone, apex pale lilac, base covered in white down. **Flesh** whitish in stem, yellowish in cap, tinged violaceous throughout in young specimens and often persisting at stem apex. Taste mild, often with a bitter aftertaste, smell faintly of radish. **Gills** violaceous at first soon yellowish to clay or cinnamon. Spore print rust. Spores broadly ovate to subglobose, roughened, 7–8.5×6.5–7.5μ. Habitat deciduous woods, usually with beech or birch. Season autumn. Occasional. **Edibility unknown**.

Cortinarius (Myxacium) causticus Fr. **Cap** 3–8cm across, broadly umbonate, pale ochraceous flushed tawny at centre, drying paler and shiny,

viscid when moist. **Stem** 30–80×4–12mm, base often pointed, whitish often flushed ochraceous, slightly viscid below. **Flesh** lemon yellow to ochraceous, often white in cap. Taste: flesh mild, cap cuticle bitter; smell strong. **Gills** pale ochraceous at first becoming more buff to rusty cinnamon. Spore print rust. Spores elliptic, almost smooth, 6.5–7(8)×4–5μ. Habitat deciduous and coniferous woods, especially with oak and beech. Season autumn. Occasional. **Edibility unknown**.

Cortinarius (Myxacium) ochroleucus (Schaeff. ex Fr.) Fr. **Cap** 3–8cm across, convex then expanded and obtusely umbonate, whitish-pallid with more ochraceous disc, and a silky sheen which rubs off showing darker cap colour below. **Stem** 25–90×5–12mm, firm, tapering at base, white and silky. **Flesh** white to pallid. Taste bitter, smell none. **Gills** whitish then pallid-ochraceous, finally rusty-cinnamon. Spore print

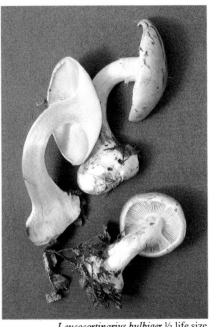

Leucocortinarius bulbiger ½ life size

123

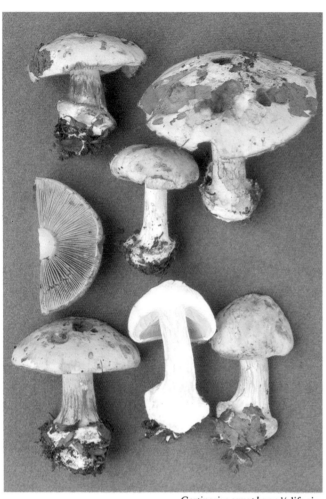

Cortinarius osmophorus ½ life size

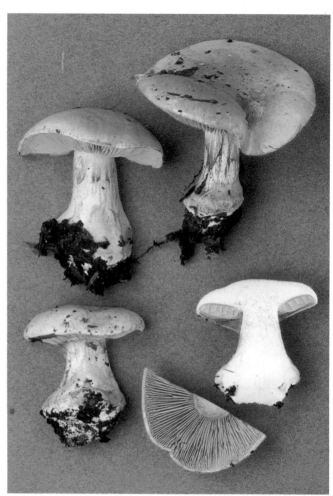

Cortinarius subfulgens ⅔ life size

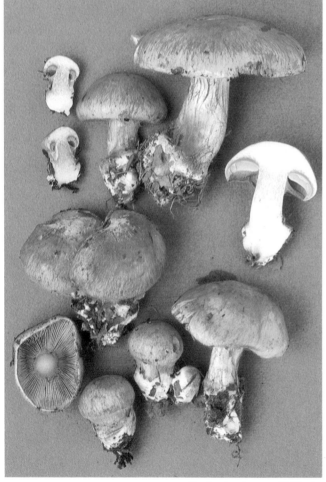

Cortinarius glaucopus ½ life size

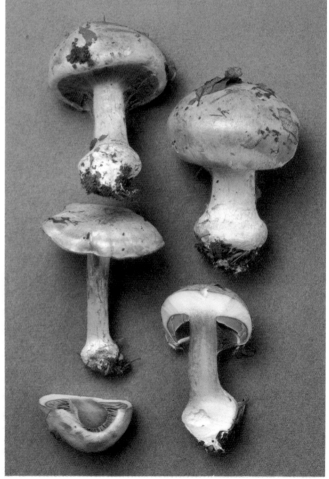

Cortinarius amoenolens ½ life size

Cortinarius (*Phlegmacium*) *osmophorus* Orton syn. *C. evosmus* Joachim apud Henry **Cap** 4–10cm across, convex with inrolled margin, ochraceous becoming tinged tawny with age. **Stem** 30–40×10–15mm, (20–30mm wide at marginate bulb), white discolouring pallid, finally rusty buff. **Flesh** whitish. Taste mild, smell very strong and heady, described as ranging from mock orange-blossom to metal polish, it may be detected in the field by its smell. **Gills** white then ochre-clay, finally cinnamon. Spore print rust. Spores lemon- to almond-shaped, rough, 9–10×5–6μ. Flesh turns slightly yellow with NaOH; cap cuticle turns reddish-brown. Habitat beech woods on chalk. Season autumn. Occasional. **Edibility unknown**.

Cortinarius (*Phlegmacium*) *subfulgens* Orton **Cap** 6–10cm across, convex then expanded, golden-yellow to orange-tawny, brighter yellow at the incurved margin. **Stem** 40–70×15–25mm (30–50mm at marginate bulb) yellowish-buff with paler apex, base tinged tawny; cortina yellowish. **Flesh** pale yellowish, darker at stem base. Taste mild, smell none. **Gills** yellow then rusty-ochre. Spore print rust. Spores slightly lemon-shaped, rough, 10–11.5×5.5–6μ. KOH turns cap cuticle and flesh of stem base blood-red. Habitat deciduous woods. Season autumn. Rare. **Edibility unknown**.

Cortinarius (*Phlegmacium*) *glaucopus* (Schff. ex Fr.) Fr. **Cap** 4–10cm across, convex, ochraceous-tawny covered in conspicuous darker innate fibrils, margin sometimes weakly greenish at first. **Stem** 50–10×10–25mm, (up to 35mm at the rounded marginate bulb), bluish-lilac at first, persisting at apex, becoming yellowish-white below. **Flesh** yellowish-white tinged bluish in upper stem. Taste mild, smell none or faintly mealy. **Gills** bluish-lilac becoming clay-cinnamon. Spore print rust. Spores elliptic to almond-shaped, finely roughened, 6.5–8.5×4.5–5μ. Habitat coniferous and mixed woods. Season autumn. Rare. **Edibility unknown**.

Cortinarius (*Phlegmacium*) *amoenolens* Henry ex Orton syn. *C. cyanopus* (Secr.) Fr. s. Lange **Cap** 3–13cm across, convex or obtuse, straw-yellow to ochre sometimes with an olivaceous or tawny flush, margin inrolled and often covered in remains of veil or cortina. **Stem** 45–140×10–22mm, bulb immarginate or rounded marginate (15–45mm across), violaceous at first fading to whitish, bulb covered in ochraceous patches of the veil; cortina whitish to violaceous. **Flesh** whitish in cap and bulb, intensely violaceous in stem, especially at apex. Taste: flesh mild, cap cuticle bitter; smell fruity, like plums. **Gills** deep violet when young then clay, never rusty. Spore print rust. Spores lemon-shaped and distinctly roughened, 9–12×5.5–7μ. Habitat beech woods, usually on chalk. Season autumn. Occasional. **Edibility unknown**.

Cortinarius (*Phlegmacium*) *subturbinatus* Henry syn. *C. sulphurinus* Quél s. Lange **Cap** 6–16cm across, convex to flattened-convex, margin remaining incurved for a long time, tawny-buff, often darker when old, paler at margin initially. **Stem** 35–100×7–20mm (18–45mm wide at marginate bulb), white discolouring yellowish especially from base. **Flesh** thick, very firm, white. Taste mild, smell fruity at first soon

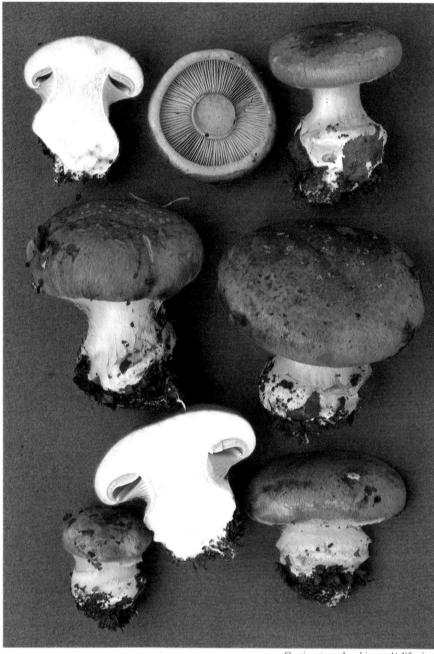

Cortinarius subturbinatus ½ life size

becoming more sour. **Gills** pale clay at first then ochraceous, finally rusty-buff. Spore print rust. Spores lemon- to almond-shaped, rough, 11.5–13×6–7.5μ. No reaction on flesh with NaOH; cap cuticle gradually dark brown. Habitat under beech on chalk. Season autumn. Occasional. **Edibility unknown**.

Cortinarius (*Phlegmacium*) *splendens* Henry **Cap** 3–6(8)cm across, convex then expanded and often wavy at the margin, bright sulphur yellow often with tawny centre or spotting. **Stem** 25–60×7–12mm, 15–25mm at the distinctly marginate bulb, sulphur yellow becoming tinged rust especially towards the base, arising from sulphur yellow mycelium; cortina sulphur yellow. **Flesh** bright sulphur yellow. Taste mild, smell none. **Gills** bright sulphur yellow then rusty. Spore print rust. Spores almond-shaped and roughened, 10–11(14)×5–6.5μ. NaOH turns cap cuticle dark red to reddish brown. Habitat beech woods on chalk. Season autumn. Uncommon. **Edibility unknown**.

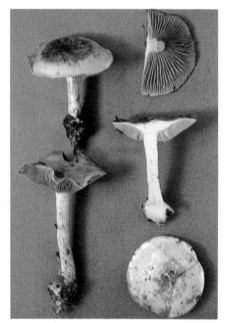

Cortinarius splendens ½ life size

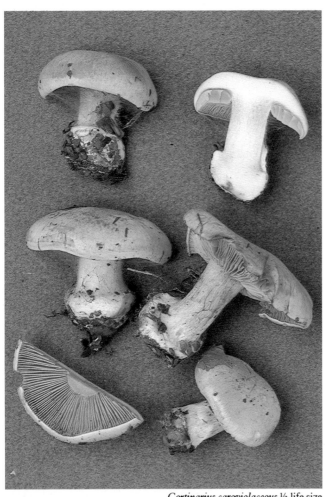

Cortinarius caroviolaceous ½ life size

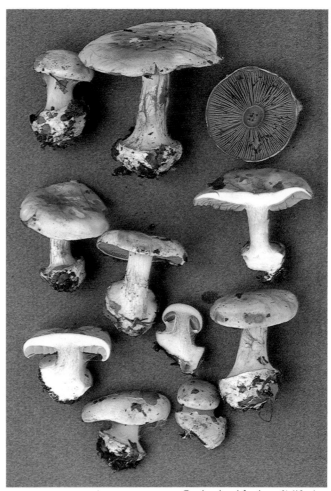

Cortinarius rickenianus ²/₃ life size

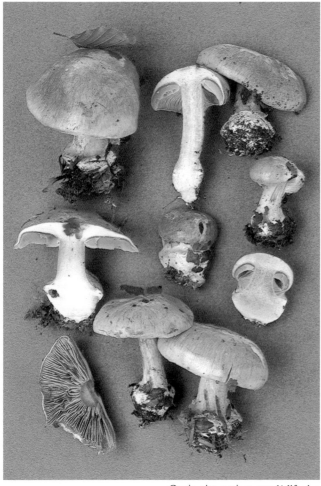

Cortinarius caesiocyaneus ½ life size

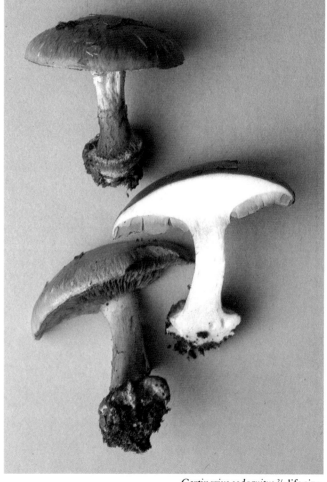

Cortinarius sodagnitus ²/₃ life size

Cortinarius (Phlegmacium) caroviolaceus Orton **Cap** 4–12cm across, convex then expanded, white initially, soon pale ochre-buff, paler at the incurved margin, viscid, often with adpressed white scales of velar remnants. **Stem** 50–80×10–15mm (20–40mm at marginate bulb) white then yellowish, apex rarely tinged bluish at first. **Flesh** white then pallid or yellowish, sometimes tinged violaceous in stem apex. Taste mild, smell strong, unpleasant. **Gills** white then pale clay, finally ochre- to rusty-buff. Spore print rust. Spores almond- to lemon-shaped, rough, 9–11×5.5–7μ. Habitat beech woods on chalk. Season autumn. Rare. **Edibility unknown**.

Cortinarius (Phlegmacium) rickenianus Maire **Cap** 4–6cm across, ochraceous-cream often with violaceous tinges. **Stem** 20–40×10–15mm, (20–30mm wide at marginate bulb), cream with remnants of the violaceous veil. **Flesh** white to cream with violaceous in stem apex when young. Taste and smell not distinctive. **Gills** violet at first becoming violaceous clay. Spore print rust. Spores ovoid, roughened, 9–11×5–6μ. No reaction on flesh with NaOH; cap cuticle turns bright rose red. Habitat amongst scrub near deciduous trees. Season autumn. Rare. **Edibility unknown**.

Cortinarius (Phlegmacium) caesiocyaneus Britz. **Cap** 3–8cm across, convex then expanded, margin incurved at first, greyish-blue to blue-violaceous discolouring ochraceous from centre or in patches. **Stem** 25–70×10–20mm, (20–40mm wide at marginate bulb), blue-violaceous discolouring yellowish from stem base; cortina bluish. **Flesh** buff to dark brown with NaOH; no reaction in cap cuticle. Taste mild, smell strong, unpleasant and musty. **Gills** blue-violaceous then ochraceous to clay-buff, finally rusty. Spore print rust. Spores elliptic to almond-shaped, rough, 8.5–10×5–6μ. Habitat beech woods on chalk. Season autumn. Occasional. **Edibility unknown**.

Cortinarius (Phlegmacium) sodagnitus Henry **Cap** 3–10cm across, convex, bright violaceous at first discolouring ochraceous to buff from centre outwards, fading to silvery; lilac at the margin with age. **Stem** 25–100×5–18mm, 12–30mm at the distinctly marginate bulb, violaceous like the cap at first discolouring ochraceous from the base up except for a persistent narrow violet zone at the apex; cortina violaceous. **Flesh** whitish with violaceous flush in stem apex and ochraceous tinge in bulb. Taste bitter in the cap cuticle, flesh mild, smell faint, mushroomy. **Gills** violet then clay-pink to umber; edge remaining violaceous a long time. Spore print rust. Spores almond-shaped, rough, 10–12×5.5–6.5μ. NaOH turns cap cuticle bright red. Habitat beech woods, usually on chalk. Season autumn. Occasional. **Edibility unknown**.

Cortinarius (Phlegmacium) rufo-olivaceus (Pers. ex Fr.) Fr. **Cap** 6–10cm across, convex to broadly umbonate, reddish-copper with paler margin, shiny when dry, margin incurved and violet at first. **Stem** 50–90×12–20mm (20–40mm wide at marginate bulb), whitish to violaceous at first or more rarely greenish-yellow, becoming tinged with cap colour from base up. **Flesh** whitish, tinged violaceous beneath cap cuticle, slightly reddish-purple in stem base. Taste bitter, smell slight. **Gills** greenish to lemon-yellow at first then olivaceous-rusty, finally dark rust, in one variety the very young gills can be violet. Spore print rust. Spores almond-shaped, rough, 11–13×6.5–7.5μ. Habitat deciduous woods, especially with beech on chalk. Season autumn. Uncommon. **Edibility unknown**.

Cortinarius (Phlegmacium) xanthocephalus Orton **Cap** 2–6cm across, convex then expanded and broadly umbonate, ochraceous- to lemon-yellow, sometimes streaked or spotted olive-brown, margin incurved. **Stem** 25–70×4–8mm, base pointed, whitish discolouring ochraceous from base up, apex more or less lilac, cortina short-lived and inconspicuous. **Flesh** whitish to ochraceous-buff, often tinged lilaceous in stem apex. Taste mild, smell none. **Gills** lilac at first, becoming clay-brown and finally cinnamon. Spore print rust. Spores subglobose, rough, 7.5–9×6–7μ. Habitat deciduous or coniferous woods. Season autumn. Rare. **Edibility unknown**.

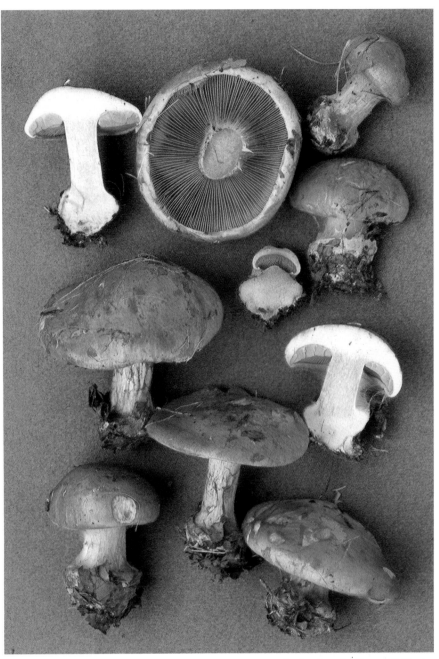

Cortinarius rufo-olivaceus ½ life size

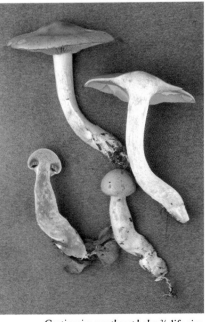

Cortinarius xanthocephalus ⅔ life size

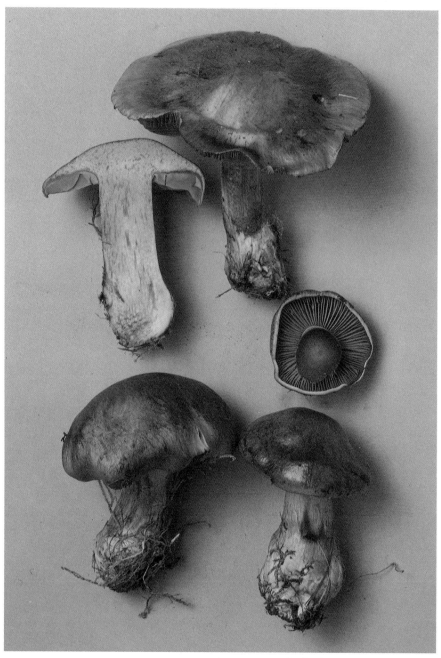

Cortinarius purpurascens ½ life size

Habitat deciduous woods, usually with beech and oak. Season autumn. Occasional. **Edibility unknown**.

Cortinarius (Phlegmacium) olidus Lange **Cap** 5–10cm across, convex then flattened to broadly umbonate, dull ochre often tinged tawny at the centre which often breaks up into small flattened scales. **Stem** 50–80×10–15mm, base swollen to bulbous (15–25mm across) whitish above, yellowish below and covered in scattered ochraceous scales; cortina whitish-yellow. **Flesh** white. Taste mild, smell strong and unpleasant. **Gills** whitish to pale buff then tinged ochraceous. Spore print rust. Spores almond-shaped, 9.5–12×5–6.5µ. NaOH turns cap cuticle brownish. Habitat deciduous or less frequently coniferous woods. Season autumn. Rare. **Edibility unknown**.

Cortinarius (Phlegmacium) balteato-cumatilis Henry **Cap** 5–15cm across, convex, margin remaining incurved for a long time, pinkish-brown often tinged tawny and with violaceous margin. **Stem** 50–70×18–30mm, swollen at base, whitish becoming tinged violaceous or rust and with fugacious patches of violaceous veil near base. **Flesh** hard, whitish with violaceous tinges below cuticle. Taste mild, smell strong and rank. **Gills** pale clay sometimes with a violaceous tint, becoming clay or ochraceous. Spore print rust. Spores elliptic to almond-shaped, minutely roughened, 9.5–13×6–6.5µ. No reaction with NaOH on flesh; ammonia turns flesh yellowish-tan. Habitat beech woods. Season autumn. Rare. **Edibility unknown**.

Cortinarius (Phlegmacium) melliolens Schaeff. **Cap** 4–10cm across, convex to bell-shaped, bright ochraceous to tawny-buff, covered in white silky fibres when young. **Stem** 50–80×10–15mm, swollen into a more or less marginate bulb, whitish becoming tinged ochraceous to tawny, base covered in white down, cortina white. **Flesh** whitish, tinged yellowish especially at stem base. Taste mild, smell honey-like. **Gills** whitish then clay becoming rusty-cinnamon. Spore print rust. Spores elliptic to almond-shaped, almost smooth, 8–9×4.5–6µ. Habitat deciduous and coniferous woods. Season late summer to autumn. Rare. **Edibility unknown**.

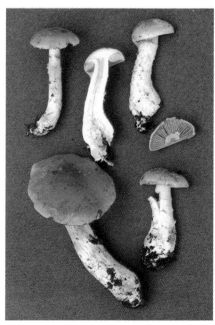

Cortinarius fraudulosus ⅓ life size

Cortinarius (Phlegmacium) purpurascens [Fr.] Fr. syn. *P. purpurascens* ([Fr.] Fr.) Ricken syn. *P. porphyropus* ([Alb. & Schw.] Fr.) Wünsche s. Ricken **Cap** 5–15cm across, hemispherical then expanded and often broadly umbonate, margin becoming wavy, tawny-buff to dark umber often violet-tinged and streaked or spotted. **Stem** 50–120×15–25mm, with a marginate or immarginate bulb 20–30mm across, violaceous sometimes discolouring pallid near the base; cortina purplish. **Flesh** violaceous becoming deep purple when bruised or cut. Taste mild, smell none or very faint but pleasant. **Gills** purplish-violet then clay-buff to cinnamon, violaceous tinge often persisting, becoming deep purple when bruised. Spore print rust. Spores almond-shaped to elliptic, rough, 8.5–10×4.5–6µ. Habitat deciduous and coniferous woods. Season autumn. Occasional. **Edibility unknown**.

Cortinarius (Phlegmacium) fraudulosus Britz. **Cap** 2.5–6cm across, convex then expanded, slightly umbonate, pink-buff to tan-buff becoming

darker at the centre, margin initially silky white from the veil, slightly greasy, not viscid. **Stem** 25–80×10–15mm, swollen to 25mm at the cottony base, pure white, discolouring pallid. **Flesh** white tinged pallid in stem. Taste mild, smell faint but pleasant. **Gills** white at first then ochre-clay. Spore print rust. Spores elliptic to almond-shaped, rough, 11–15.5×6.5–8µ. No reaction with NaOH. Habitat beech woods. Season autumn. Rare. **Edibility unknown**.

Cortinarius (Phlegmacium) largus Fr. **Cap** 3–12cm across, lilac to violaceous becoming buff to ochre- or reddish-brown from the centre. **Stem** 50–100×10–20mm, slightly swollen to bulbous, violaceous at first then whitish to pallid, cortinal zone near apex, base covered in white down. **Flesh** lilac to violaceous, becoming white in stem and centre of cap when cut. Taste mild, sweetish, smell none or slightly fruity when fresh. **Gills** lilac at first then clay-buff, finally rusty-clay. Spore print rust. Spores almond- to lemon-shaped, finely roughened, 11–13×5.5–6.5µ.

Cortinarius largus ½ life size

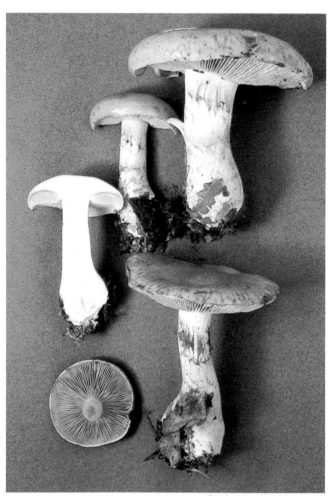

Cortinarius olidus ⅔ life size

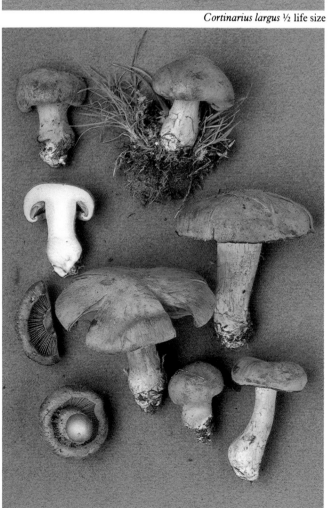

Cortinarius balteato-cumatilis ½ life size

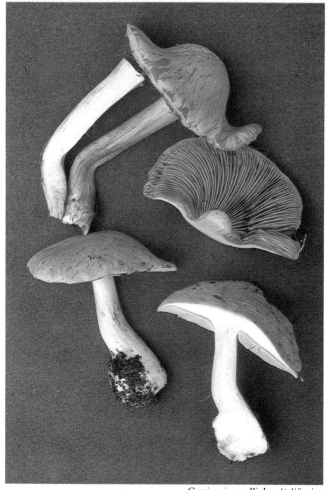

Cortinarius melliolens ½ life size

129

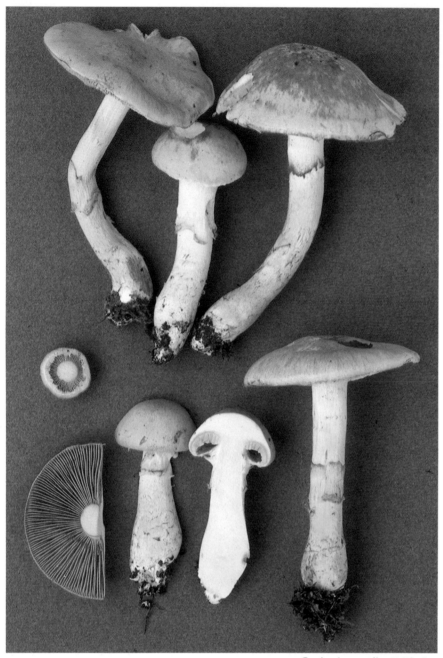

Cortinarius crocolitus ½ life size

Cortinarius (Sericeocybe) malachius (Fr. ex Fr.) Fr. s. Kühn. & Romagn. **Cap** 4–11cm across, convex then expanded, violaceous-clay at first then pale clay-buff to ochraceous, discolouring tawny ochre, densely covered by the whitish silky veil at first. **Stem** 40–140×10–20mm, swollen to bulbous, pale violaceous at first persisting at apex, elsewhere becoming dirty white to ochraceous, base with white or violet down; cortina white or pale violaceous. **Flesh** violaceous at first, stem apex remaining so, elsewhere whitish pallid. Taste and smell faint, pleasant. **Gills** violaceous at first soon clay then rusty. Spore print rust. Spores elliptic, finely roughened, 7.5–9(10)×4.5–5.5μ. Habitat conifer woods. Season autumn. Common. **Edibility unknown.**

Cortinarius (Sericeocybe) alboviolaceus (Pers. ex Fr.) Fr. **Cap** 3–9cm across, convex to bell-shaped then expanded and umbonate, margin often splitting with age, bluish-white to pale violaceous discolouring pallid to ochraceous, covered in pale bluish-violet or whitish silky veil at first. **Stem** 80–100×10–18mm, swollen towards the base, concolorous with cap, apex deep violaceous discolouring pallid to ochraceous from base up; cortina white. **Flesh** pale violaceous, deeper in stem apex, later pallid in stem base. Taste of radish, smell faint, pleasant. **Gills** violaceous at first then tinged clay, finally rusty. Spore print rust. Spores elliptic, minutely rough, 8–10×5–6μ. Habitat deciduous woods. Season autumn. Uncommon. **Edibility unknown.**

Cortinarius (Sericeocybe) pearsonii Orton syn. *C. malachius* (Fr. ex Fr.) Fr. s. Pearson **Cap** 4–15cm across, convex then expanded and slightly umbonate, margin becoming wavy and sometimes cracked, pale ochraceous buff becoming darker reddish-buff, covered in white silky veil which breaks up into small flattened scales. **Stem** 100–150×10–25mm, swollen towards the base, pale lavender at first then pale cream becoming streaked reddish brown from the base up with a few shaggy ring zones formed by the remnants of the veil and cortina. **Flesh** pale lilac at first discolouring ochre-buff with age especially in the stem base. Taste and smell pleasant. **Gills** pale lilac at first soon becoming cinnamon, later rusty. Spore print rust. Spores elliptic to almond-shaped, smooth, 6–8×3–4μ. Habitat mixed woods on sandy soil. Season autumn. Occasional. **Edibility unknown.**

Cortinarius (Phlegmacium) crocolitus Quél. syn. *C. triumphans* Fr. s. Lange **Cap** 5–12cm across, convex, yellow tinged tawny at centre, margin remaining pale yellow. **Stem** 70–170×10–25mm, base slightly swollen or pointed, whitish above, yellow below and covered in bands of ochraceous tawny scales, remnants of the veil, cortina white. **Flesh** cream, often with yellowish tints. Taste mild, smell none or faint. **Gills** cream to pallid at first often tinged lilaceous, later clay-cinnamon to rusty-buff. Spore print rust. Spores almond-shaped, 10–12.5×5.5–7μ. Habitat damp deciduous woods, usually with birch. Season autumn. Uncommon. **Edibility unknown.**

Cortinarius (Phlegmacium) infractus (Pers. ex Fr.) Fr. syn. *C. infractus* Fr. **Cap** 3–10cm across, convex then umbonate or depressed, often wavy at the margin, chestnut to olive-brown, often paler at the centre. **Stem** 30–80×6–25mm, more or less swollen below, whitish tinged olive-brown at base, apex sometimes violaceous; cortina abundant, pale grey. **Flesh** whitish to ochre-buff, often tinged violaceous especially in stem apex. Taste bitter, smell none or faintly of radish. **Gills** olive-brown at first, finally umber. Spore print rust. Spores subglobose and roughened, 7–10×5–7μ. AgNO₃ turns flesh black immediately. Habitat deciduous and coniferous woods. Season autumn. Occasional. **Edibility unknown.**

Cortinarius (Phlegmacium) nemorensis (Fr.) Lange **Cap** 4–10cm across, convex, violaceous to buff, hazel or date-brown, margin violaceous at first, fibrillose, often becoming dry and cracked at centre. **Stem** 40–80×10–30mm, base slightly swollen, often pointed, violaceous discolouring pallid; cortina pale violaceous. **Flesh** whitish, at first tinged violaceous throughout. Taste mild, smell faint or strong, earthy to rank. **Gills** pale violaceous then clay to cinnamon. Spore print rust. Spores almond-shaped, 9–12×5–7μ. KOH and Ammonia turn flesh deep chrome. Habitat deciduous or coniferous woods, usually with beech. Season autumn. Occasional. **Edibility unknown.**

CORTINARIUS *subgenus* SERICEOCYBE *Caps often silky, shiny or shaggy with veil remnants, not changing colour when wet. Stems typically swollen or bulbous. Many have violet colours in the young gills and flesh. Some have strong smells.*

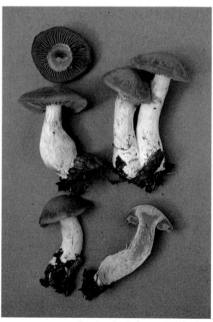

Cortinarius infractus ⅓ life size

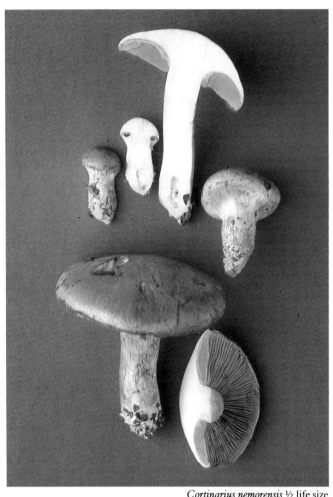

Cortinarius nemorensis ½ life size

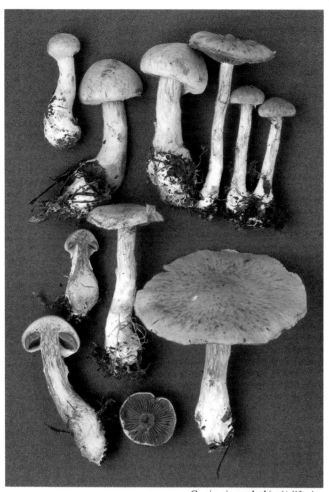

Cortinarius malachius ½ life size

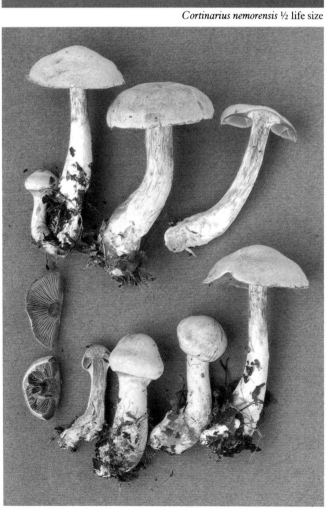

Cortinarius alboviolaceus ½ life size

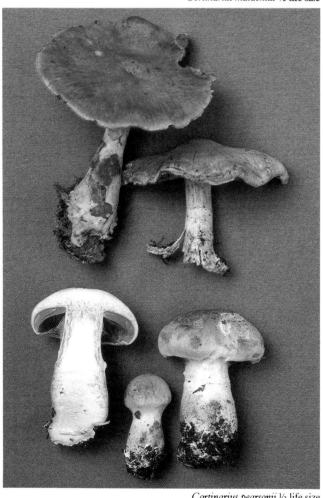

Cortinarius pearsonii ½ life size

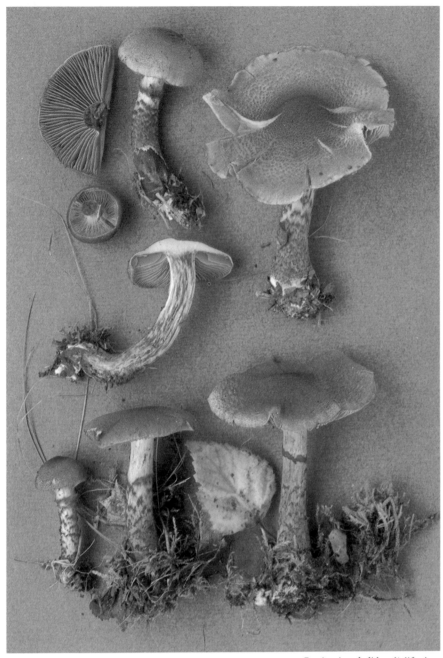

Cortinarius pholideus ²/₃ life size

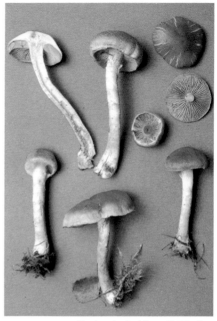

Cortinarius lepidopus ⅓ life size

Cortinarius (Sericeocybe) azureovelatus Orton **Cap** 4–8cm across, convex then expanded and often broadly umbonate, pale bluish-clay at first then ochre-buff darkening with age, margin remaining incurved and bluish for some time often with remains of the whitish to yellowish veil. **Stem** 50–100×10–18mm (15–30mm wide at the swollen to bulbous base), tinged violaceous when young, whitish with yellowish patches of veil and a well-defined ring zone. **Flesh** whitish, tinged with violaceous in stem apex when young and yellowish in stem base in older specimens. Taste pleasant, smell pleasant becoming stronger and sickly-sweet when cut. **Gills** violaceous at first then clay buff, finally tinged rust. Spore print rust. Spores subglobose, minutely roughened, 8–10×7–8μ. Habitat deciduous woods. Season late summer to early autumn. Rare. **Edibility unknown**.

Cortinarius (Sericeocybe) traganus (Fr.) Fr. **Cap** 4–12cm across, convex then expanded, pale lilaceous soon becoming pale ochraceous to rusty-pallid from the centre out, finely silky-

Cortinarius (Sericeocybe) pholideus (Fr. ex Fr.) Fr. **Cap** 3–10cm across, convex then expanded, sometimes centrally depressed or wavy at the margin, ochraceous-buff to light date-brown darker towards the centre, covered in small sepia fibrillose scales. **Stem** 50–120×8–15mm, dirty ochraceous darkening towards the base, flushed violaceous at apex at first, conspicuously dark brown fibrillose scaly below the distinct ring zone; cortina pale brown. **Flesh** pallid to ochraceous buff, darker towards stem base. Smell faint, pleasant. **Gills** pale violaceous at first, soon clay buff to pale rust brown. Spore print rust. Spores broadly elliptic, rough, 6.5–8.5×5–6μ. Habitat deciduous woods, usually with birch. Season autumn. Rare. **Edibility unknown**.

Cortinarius (Sericeocybe) humicolus (Quél.) Maire **Cap** 1–5cm across, conico-convex then expanded and umbonate, chrome- to ochre-yellow, densely covered with small rusty fibrous scales. **Stem** 30–70×3–10mm, tapering at base, concolorous with cap, fibrillose at apex, covered in scales like the cap below. **Flesh** white in cap,

yellow-buff in stem becoming rusty at the base. Taste sweet, smell pleasant and slightly scented. **Gills** whitish at first then ochraceous, finally rusty-ochre. Spore print rust. Spores elliptic, finely roughened, 8–10.5×5–6μ. Habitat beech woods. Season autumn. Rare. **Edibility unknown**.

Cortinarius (Sericeocybe) lepidopus Cke. syn. *C. anomalus* f. *lepidopus* (Cke.) Kühn. & Romagn. **Cap** 2.5–7cm across, convex then expanded, dingy ochraceous flushed reddish-brown later umber to date-brown, sometimes tinged violaceous near margin especially when young. **Stem** 50–80×4–12mm, slightly thickened at base, tinged violaceous at apex, whitish-ochre below, covered in bands of yellowish scales from the veil. **Flesh** whitish, tinged violaceous at stem apex and ochraceous in stem base. Smell faint, pleasant. **Gills** violaceous then tinged clay finally ochre-rust. Spore print rust. Spores broadly ovate to subglobose, minutely roughened, 6.5–8.5×5.5–7μ. Habitat deciduous and coniferous woods especially with birch and pine. Season autumn. Occasional. **Edibility unknown**.

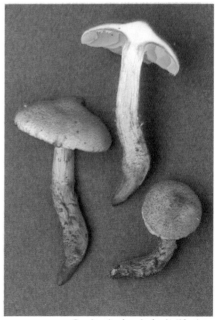

Cortinarius humicolus ²/₃ life size

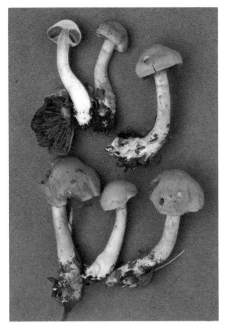

Cortinarius azureovelatus ⅓ life size

scaly at first with velar remnants adhering to margin, later silky smooth. **Stem** 60–120×10–20mm (15–30mm at base), clavate-bulbous, lilaceous becoming white to ochraceous then rusty from base up, covered in patches of the lilaceous veil which discolour ochraceous; cortina lilaceous. **Flesh** yellowish buff in cap, marbled tawny in stem. Taste slightly bitter, smell often strongly sickly sweet. **Gills** pale ochre buff at first, later tawny to rusty. Spore print rust. Spores elliptic, rough, 8–10×5–6μ. Habitat pine woods. Season late summer to autumn. Rare but not infrequent in native Scottish pine woods. **Edibility unknown.**

CORTINARIUS *subgenus* CORTINARIUS *Only two large, completely violet mushrooms in Professor Moser's key.*

Cortinarius (Cortinarius) violaceus (L. ex Fr.) Fr. **Cap** 3.5–15cm across, convex, margin incurved, dark violaceous to blue-black, covered in fine downy scales. **Stem** 60–120×10–20mm (20–40mm at base), swollen to bulbous at base, dark blue-violaceous, covered in woolly fibrils. **Flesh** violaceous, more strongly so below cap cuticle and in stem. Taste mild, smell slight, of cedar wood. **Gills** dark violet becoming purplish brown. Spore print rust. Spores elliptic to almond-shaped, rough, 12–15×7–8.5μ. Habitat deciduous woods, especially oak, birch and beech, also occasionally with conifers. Season autumn. Rare. **Edible.**

CORTINARIUS *subgenus* LEPROCYBE *This group contains the olivaceous, yellowish and orangy-red mushrooms. Note the veil colour at the base of the stem. There are deadly poisonous mushrooms in this group.*

Cortinarius (Leprocybe) saniosus Fr. s. Moser, Lange **Cap** 1–2.5cm across, bell-shaped expanding with an acute umbo, tawny-ochre to cinnamon covered in radiating yellowish fibrils. **Stem** 30–60×3–4mm, pale ochre-buff, lighter at apex, covered in ochraceous cottony fibres; cortina yellow. **Flesh** concolorous, pale buff in cap. Smell strong. **Gills** ochraceous then cinnamon. Spore print rust. Spores almond-shaped, 8–9×5–6μ. Habitat in damp places, often near poplar and willow. Season autumn. Rare. **Edibility unknown.**

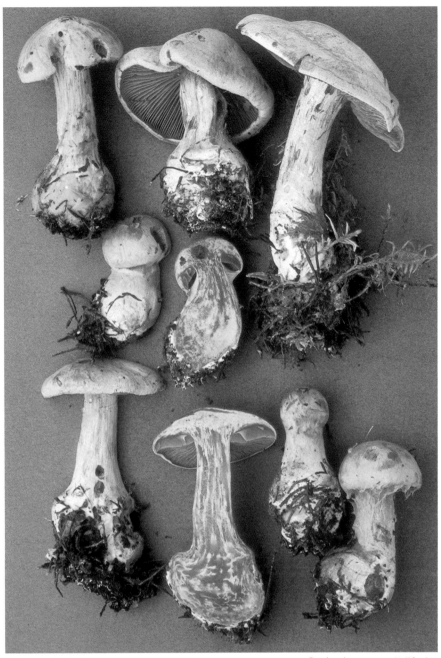

Cortinarius traganus ½ life size

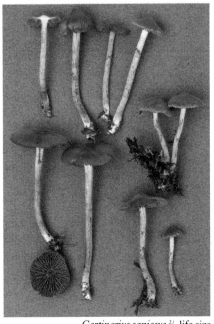

Cortinarius saniosus ⅔ life size

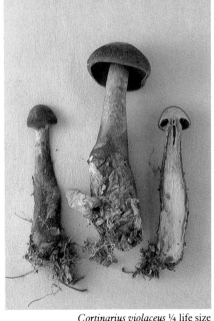

Cortinarius violaceus ¼ life size

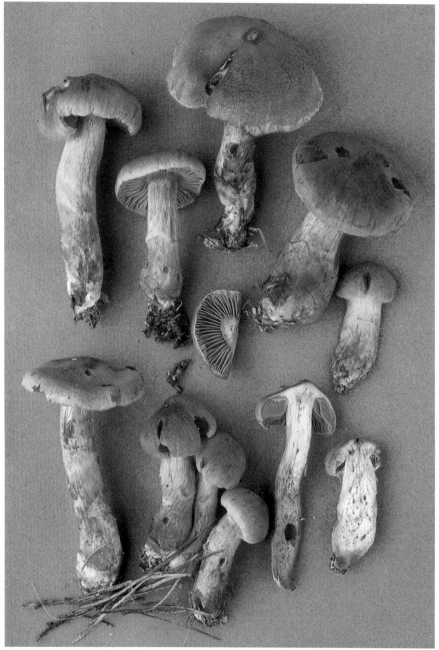

Cortinarius speciosissimus ²/₃ life size

finally deep red or red-brown. Smell none or faint and pleasant. **Gills** pale yellowish-cream, later pallid cinnamon. Spore print rusty cinnamon. Spores broadly ovate to subglobose, punctate rough, 6–7.5×4.5–5.5μ. Habitat deciduous woods, especially beech. Season late summer to late autumn. Uncommon. **Poisonous**.

Cortinarius (Leprocybe) orellanus Fr. **Cap** 3–7cm across, convex then expanded and broadly umbonate, tawny-ochre darkening with age, covered in fine downy scales. **Stem** 30–90×4–12mm, apex yellow, tawny below darkening towards the tapering base. **Flesh** yellowish-tawny, sometimes reddish in cap. Smell strongly of radish. **Gills** ochre at first then tawny, finally tinged rust. Spore print rust. Spores elliptic, 9–12×5–7μ. Habitat deciduous woods. Season autumn. Rare. **Deadly poisonous** (not illustrated).

Cortinarius (Leprocybe) callisteus (Fr. ex Fr.) Fr. **Cap** 2.5–9cm across, convex then expanded and slightly depressed or umbonate, bright tawny orange, darker at centre. **Stem** 50–120×8–20mm, yellow-orange above becoming rusty-tawny towards the base, covered in scattered patches of yellow velar remains; cortina yellow. **Flesh** yellow to golden, often tawny below cap cuticle and stem base. Smell faint, like raw potato. **Gills** yellow soon golden, finally rusty-tawny. Spore print rust. Spores broadly ovate to subglobose, rough, 6.5–8×5.5–7μ. Habitat coniferous woods, usually with pine. Season autumn. Occasional in Scotland, elsewhere rare. **Edibility unknown**.

Cortinarius (Leprocybe) gentilis (Fr.) Fr. s. s. Cke. **Cap** 1–3cm across, distinctly umbonate, tawny-brown, becoming rust-yellow to yellow-brown, finely downy. **Stem** 50–100×3–8mm, concolorous with cap, covered in pale yellow patches of velar remains. **Flesh** yellow to yellow-brown. Taste mild, smell radish-like when cut. **Gills** rust-yellow, occasionally olive-brown, later rust-brown. Spore print rust. Spores elliptic, 7.5–9×5.5–6.5μ. Habitat acid pine woods. Season late summer to autumn. Rare. **Suspect – avoid**.

Cortinarius (Leprocybe) betuletorum (Mos.) Mos. doubtfully separable from *C. raphnoides* (Pers.) Fr. **Cap** 3–6cm across, conico-convex then bell-shaped or expanded and broadly umbonate, umber to grey brown with an olivaceous tinge. **Stem** 40–80×8–12mm (up to 20mm at base), often swollen at base, pale buff with remnants of the pallid to olive-brown veil below. **Flesh** light brownish, becoming hollow in stem. Taste and smell slightly radishy sometimes. **Gills** pale ochre at first later rust. Spore print rust. Spores 7–7.5×5.5–6μ. Habitat deciduous woods, usually with birch. Season late summer to early autumn. Frequent. **Edibility unknown**.

Cortinarius (Leprocybe) speciosissimus Kühn. & Romagn. **Cap** 2.5–8cm across, convex to conico-convex then expanded and umbonate, tawny to tawny-date, margin paler, covered in fine adpressed fibrous scales, disc soon smooth. **Stem** 50–110×5–15mm (20mm at base), slightly thickened at base or bulbous, silky fibrous, concolorous with cap or paler, lower part covered in yellow patches of velar remnants. **Flesh** pale yellowish tinged tawny below cap cuticle and towards stem base. Taste not distinctive, smell slight, faintly of radish. **Gills** pale ochre at first becoming tawny to deep rust. Spore print rust. Spores broadly elliptic to subglobose, rough, 9–12×6.5–8.5μ. Habitat damp conifer woods, often in moss. Season autumn. Rare. **Deadly poisonous**. In 1979 three people camping in the north of Scotland included specimens of *C. speciosissimus* in a dish in mistake for the edible Chanterelle. Nearly two weeks later they were admitted to hospital with severe renal failure caused by the orellanin complex of toxins present in *C. speciosissimus*. As is common in cases of orellanin poisoning, one of the three recovered while the others suffered irreparable damage to their kidneys and had to be kept on dialysis treatment until suitable kidney donors could be found. In the last few years *C. speciosissimus* has been responsible for many deaths in Central Europe. Although it has only recently been recorded from Britain, it may previously have been overlooked.

Cortinarius (Leprocybe) bolaris (Pers. ex Fr.) Fr. **Cap** 3–5cm across, convex, covered in tiny adpressed pinkish to brick-red scales on a paler white, yellowish or reddish ground. **Stem** 25–40×12–20mm, whitish at the apex, covered in tiny fibrous reddish scales below, and bruising reddish or red-brown like cap; arising from orange-red mycelium. **Flesh** white in cap, ochraceous or yellowish in stem, becoming sulphur-yellow especially in stem base when cut,

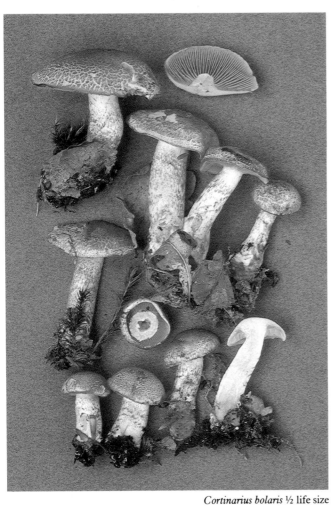

Cortinarius bolaris ½ life size

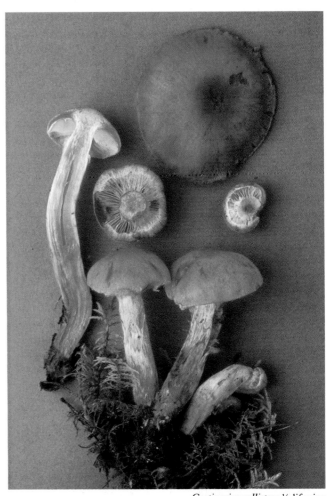

Cortinarius callisteus ½ life size

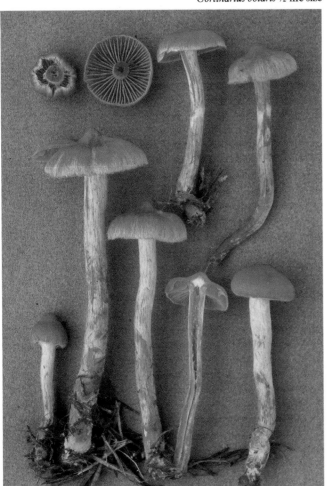

Cortinarius gentilis life size

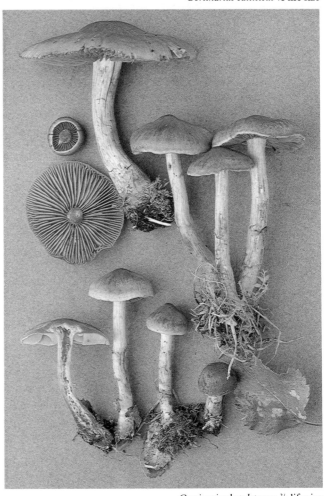

Cortinarius betuletorum ²/₃ life size

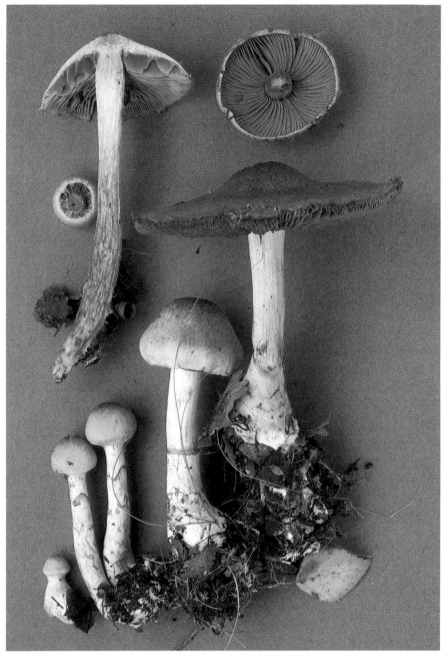

Cortinarius armillatus ⅔ life size

flesh purplish-pink. Habitat mixed woods. Season autumn. Rare. **Edibility unknown**.

Cortinarius (Telamonia) torvus (Bull. ex Fr.) Fr. **Cap** 3–10cm across, convex then flattened, clay-brown, covered in darker innate radiating fibrils. **Stem** 40–60×10–15mm, slightly swollen at base, clay-buff flushed violaceous above the membranous sheathing ring. **Flesh** buff flushed violaceous in upper stem. Taste slightly bitter or stinging, smell heavy and sweet. **Gills** lilac-clay at first later light brown to rust. Spore print rust. Spores elliptic, minutely rough, 8–10×5–6.5μ. Habitat deciduous woods, especially beech. Season autumn. Uncommon. **Edibility unknown**.

Cortinarius (Telamonia) bulliardii (Fr.) Fr. **Cap** 4–8cm across, convex then expanded, deep red-brown to chestnut drying ochre-buff. **Stem** 50–100×10–15mm, whitish near apex becoming rust towards the base and covered in reddish fibres. **Flesh** whitish, sometimes reddish at stem base. Taste and smell not distinctive. **Gills** violaceous at first, soon rusty. Spore print rust. Spores elliptic, rough, 8–10×5–6μ. Habitat deciduous wood, especially beech. Season autumn. Rare. **Edibility unknown**.

Cortinarius (Telamonia) bulbosus Fr. s. Rick. **Cap** 3–7cm across, broadly bell-shaped, hygrophanous, reddish-brown to dark chestnut drying brick-red. **Stem** 30–70×10–15mm, bulbous, pale brown becoming white-covered, base sheathed in white cottony veil forming a distinct ring. **Flesh** concolorous when moist, drying whitish. Smell faintly of radish. **Gills** pale brownish soon cinnamon to rust. Spore print rust. Spores elliptic, rough, 7–8×4.5–5μ. Habitat coniferous and deciduous woods. Season autumn. Rare. **Edibility unknown**.

CORTINARIUS *subgenus* TELAMONIA *This large group contains most of the small brown Cortinarius species. The simplest characteristic is that the majority of them are hygrophanous, (the cap and flesh darken when wet). Look for young gill colours, the colours of the veil and interesting or remarkable smells.*

Cortinarius (Telamonia) armillatus (Fr.) Fr. **Cap** 4–12cm across, hemispherical to bell-shaped then expanded and often upturned at the margin with age, rusty brown often darker at the centre, disrupting into fibrous scales with age. **Stem** 60–150×10–30mm, swollen at the base, remains of veil forming one or two orange-red belts; cortina reddish-white. **Flesh** pallid, darker in the stem. Taste bitter, smell faintly of radish. **Gills** pallid cinnamon at first then dark rust. Spore print rust. Spores broadly elliptic to almond-shaped, 7–12×(5)6–7μ. Habitat woods and heather, usually with birch. Season autumn. Occasional. **Edibility unknown**.

Cortinarius (Telamonia) firmus Fr. **Cap** 4–10cm across, convex then expanding and obtusely umbonate, becoming irregularly twisted, light tan buff to deep rust. **Stem** 30–90×10–20mm (15–25mm at base), swollen towards the base, white discolouring ochraceous cream. **Flesh** white to pale buff. Taste not distinctive, smell strong, somewhat rancid. **Gills** ochre at first later ochre-rust. Spore print rust. Spores elliptic, rough, 7–8×4–5μ. Habitat coniferous and deciduous woods. Season late summer. Rare. **Edibility unknown**.

Cortinarius (Telamonia) pseudoprivignus R. Hy. s. Kühn. & Romagn. **Cap** 2–6cm across, conical to convex then expanded and often umbonate, ochraceous buff. **Stem** 30–50×8–20mm, swollen into a large pointed bulb, more or less colour of cap, very fibrous; cortina white. **Flesh** buff, tinged ochre in stem base. Smell astringent. **Gills** pale orange, later cinnamon. Spore print rust. Spores 8.5–10×4.5–5.5μ. AgNO₃ turns

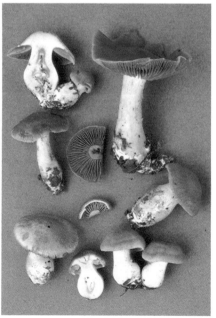

Cortinarius firmus ½ life size

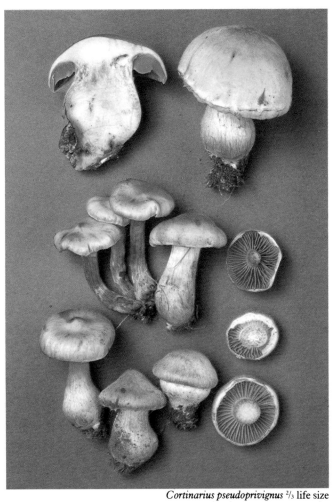

Cortinarius pseudoprivignus ²/₃ life size

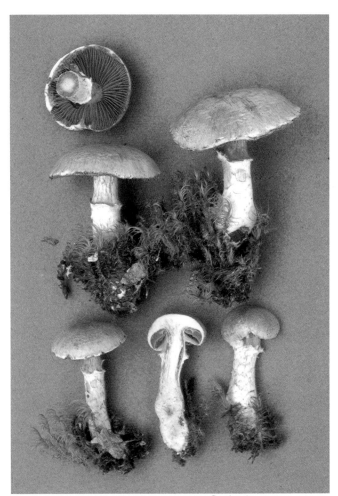

Cortinarius torvus ⅓ life size

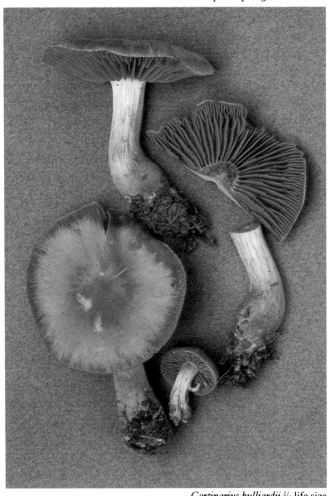

Cortinarius bulliardii ²/₃ life size

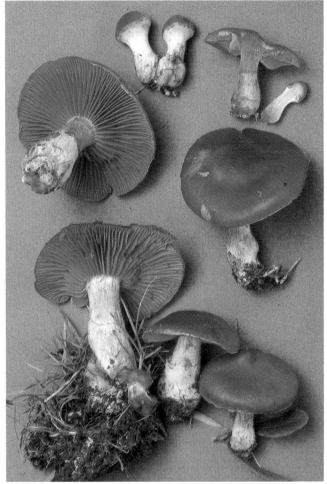

Cortinarius bulbosus ²/₃ life size

137

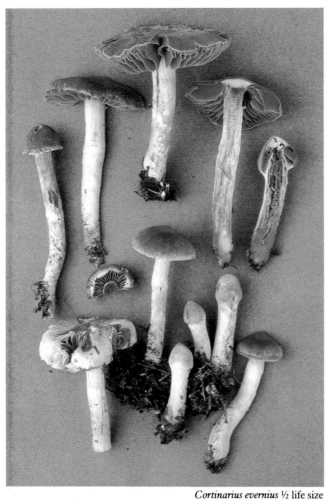

Cortinarius evernius ½ life size

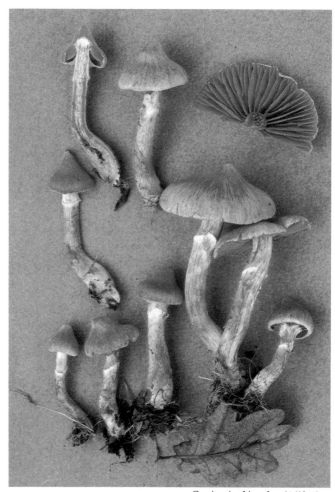

Cortinarius hinnuleus ¾ life size

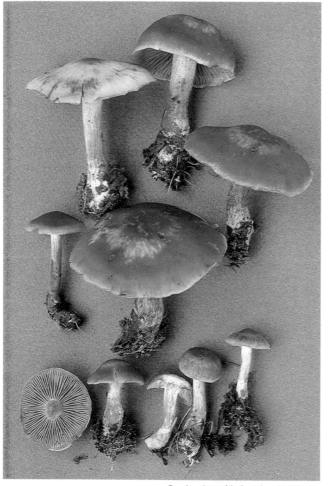

Cortinarius subbalaustinus ⅔ life size

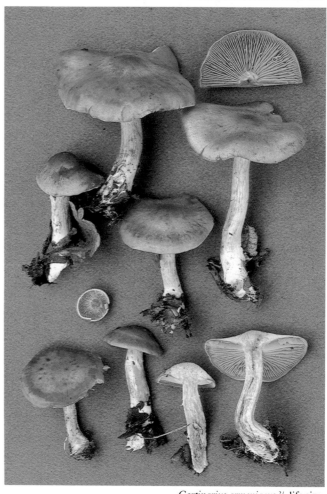

Cortinarius armeniacus ⅔ life size

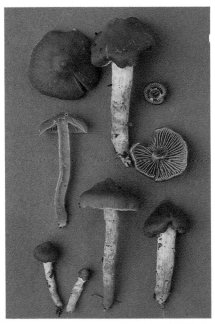

Cortinarius obtusus ½ life size

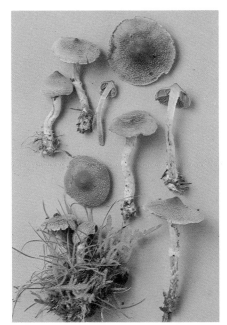

Cortinarius paleaceus ½ life size

Cortinarius (Telamonia) evernius Fr. **Cap** 3–9cm across, conical to bell-shaped then expanded and obtusely umbonate, very hygrophanous, purplish umber-brown when damp drying reddish-ochre, becoming pale tawny beige with age. **Stem** 70–150×10–15mm, violaceous covered in whitish bands of velar remains. **Flesh** concolorous. Taste and smell not distinctive. **Gills** violaceous at first then pale clay, finally cinnamon. Spore print rust. Spores elliptic, 8.5–10×5–6μ. Habitat conifer woods. Season autumn. Rare. **Edibility unknown**.

Cortinarius (Telamonia) hinnuleus (Sow.) Fr. **Cap** 2.5–6cm across, convex to bell-shaped then expanded and umbonate, dark ochre brown when moist drying paler and more ochraceous, margin pallid when young and covered in the whitish cobwebby veil. **Stem** 30–100×5–12mm, paler than cap, covered below in white silky velar remains, often forming a distinct white ring-like zone; cortina white. **Flesh** whitish tinged with cap colour, often flushed violaceous in stem apex when young. Taste mild with a slightly bitter aftertaste, smell slight, sometimes faintly of radish. **Gills** tinged violaceous at first, ochraceous then tawny. Spore print rust. Spores narrowly elliptic, minutely roughened, 7–8(9)×4–4.75μ. Habitat with poplar and willow. Season autumn. Occasional. **Edibility unknown**.

Cortinarius (Telamonia) subbalaustinus Henry syn. *C. balaustinus* s.s. Lange **Cap** 4–8cm across, convex then expanded, often slightly domed, hygrophanous, tan when moist drying yellow-brown. **Stem** 40–70×5–10mm, slightly swollen at base, brownish covered in white silky fibrils especially at the base. **Flesh** light yellowish-brown. Taste and smell not distinctive. **Gills** ochre at first, later ochre-cinnamon. Spore print rust. Spores ovoid to pip-shaped, rough, 7.5–9×4.5–5.5μ. Habitat usually with birch. Season autumn. Uncommon. **Edibility unknown**.

Cortinarius (Telamonia) armeniacus (Schaeff. ex Fr.) Fr. **Cap** 3–7cm across, conical to bell-shaped becoming flattened convex to broadly umbonate, apricot, yellow-brown or orange-cinnamon. **Stem** 40–80×8–14mm, usually swollen near the base, fibrillose, whitish discolouring ochre-rust. **Flesh** whitish to ochre-buff, stem becoming hollow. Taste mild, cuticle often slightly bitter, smell faintly of radish or iodoform. **Gills** pallid at first then pale ochre becoming bright ochre-cinnamon with age. Spore print rust. Spores elliptic to ovoid, finely warted, 7.5–9.5×5–5.5μ. Habitat with conifers, especially spruce. Season autumn. Occasional. **Edible** – not worthwhile.

Cortinarius (Telamonia) obtusus Fr. **Cap** 1–4cm across, conical to bell-shaped, then expanded and umbonate, reddish-brown and striate when moist drying ochre to light tan, sometimes splitting at the margin. **Stem** 40–80×4–10mm, often spindle-shaped towards the base, ochre-tan covered in white fibres; cortina white. **Flesh** ochre-tan. Smell strongly of radish. **Gills** ochre-cinnamon then cinnamon-brown. Spore print rust. Spores elliptic, 6–8.5×4.5–5.5μ. Habitat conifer woods, especially pine. Season spring to autumn. Occasional. **Edibility unknown**.

Cortinarius (Telamonia) paleaceus (Weinm.) Fr. **Cap** 1–3cm across, conical then expanded and umbonate, dark brown when moist, especially at the centre, drying pale fawn, covered in minute white fibrous scales. **Stem** 30–70×2–6mm, brownish, covered at first with the white cottony veil which forms a distinct but short-lived ring and cottony scales below. **Flesh** pallid. Smell of pelargonium. **Gills** pallid at first later cinnamon. Spore print rust. Spores broadly elliptic, 6.5–9×4–6μ. Habitat damp places on deciduous heathland. Season autumn. Uncommon. **Edibility unknown**.

CORTINARIUS *subgenus* DERMOCYBE *This group of Cortinarius can be recognized by their slender stems. The caps are strongly coloured greenish, yellow or red.*

Cortinarius (Dermocybe) croceofolius Peck. **Cap** 1.5–3cm across, convex then expanded and umbonate, yellow-buff to ochre-brown usually with darker centre, later tawny or rusty. **Stem** 25–80×2–5mm, bright chrome at first discolouring tawny from base up, the apex remaining yellow; cortina yellow. **Flesh** chrome yellow. Taste slightly radishy or bitter, smell none. **Gills** chrome-yellow at first soon becoming tawny and finally rust. Spore print rust. Spores elliptic, more or less roughened, 6.5–7.5×4.5–5μ. Habitat coniferous woods. Season autumn. Occasional. **Edibility unknown**.

Cortinarius (Dermocybe) cinnamomeobadius Hry. **Cap** 1–6cm across, convex then expanded and umbonate, rusty ochraceous-buff to chestnut, margin remaining yellowish for a long time. **Stem** 30–80×3–8mm, chrome-yellow, often tinged olivaceous above gills. Taste mild, smell faint, radishy. **Gills** chrome to deep golden, then ochre buff to rusty or amber. Spore print rust. Spores elliptic, almost smooth, 6.5–8.6(9)×4.5–5μ. Habitat coniferous and deciduous woods. Season autumn. Rare. **Edibility unknown**.

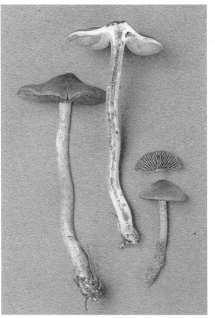

Cortinarius croceofolius ¾ life size

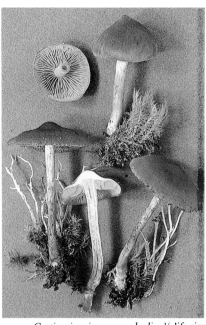

Cortinarius cinnamomeobadius ½ life size

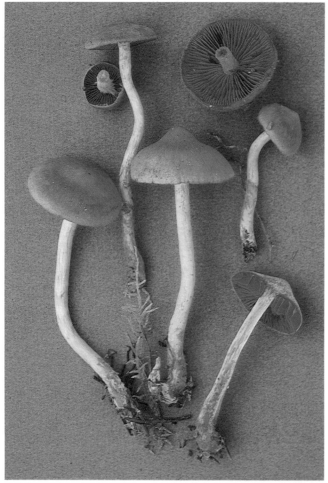

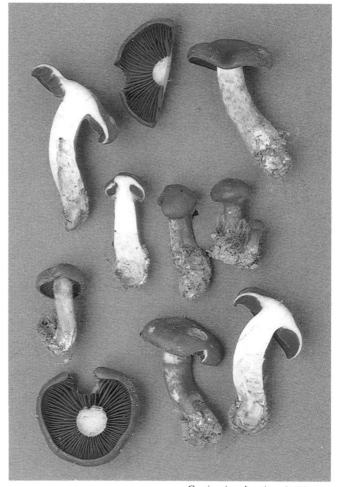

Cortinarius semisanguineus ⅔ life size

Cortinarius phoeniceus ⅔ life size

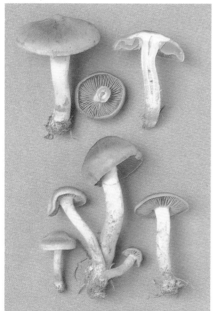

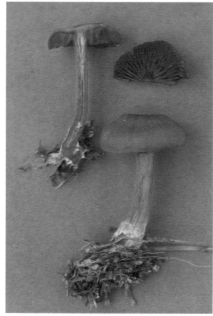

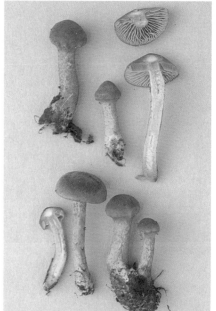

Cortinarius cinnamomeus ½ life size

Cortinarius sanguineus ⅔ life size

Cortinarius uliginosus ½ life size

Cortinarius (Dermocybe) semisanguineus (Fr.) Gillet **Cap** 2–6cm across, convex then expanded and umbonate, ochre- to olive-buff, often darker or tinged reddish at the centre, covered in fine fibres disrupting into minute scales near the margin. **Stem** 20–100×4–12mm, ochraceous to olivaceous, paler at the apex, sparsely covered in olivaceous fibres below, base sometimes covered in pinkish to reddish down. **Flesh** ochraceous in stem, olivaceous in cap. Taste slightly bitter, smell of radish. **Gills** blood-red. Spore print rust. Spores elliptic, 6–8×4–5μ. Habitat mixed

conifer and birch woods. Season autumn. Frequent. **Edibility unknown**.

Cortinarius (Dermocybe) phoeniceus (Bull.) Maire **Cap** 2.5–6cm across, convex then expanded, often irregularly lobed, ochraceous red-brown to chestnut with metallic copper-red sheen when dry, silky or with a few adpressed tawny scales near the centre. **Stem** 25–90×5–12mm, slightly tapered at base when mature, yellowish covered in adpressed tawny or red fibrils, often forming

concentric bands of scales below cortinal zone, base covered in pinkish or yellowish down. **Flesh** whitish to yellowish with reddish tinge below cap cuticle and sometimes in stem apex and base. Taste none or slightly bitter, smell none or slight, pleasant. **Gills** blood-red later tinged rust-red. Spore print rust. Spores almond- to pip-shaped, minutely roughened, 6–7(8)×3.8–4.5μ. Habitat conifer and beech woods. Season autumn. Rare. **Edibility unknown**.

Rozites caperatus (Pers. ex Fr.) Karst. syn.
Pholiota caperata (Pers. ex Fr.) Kummer syn.
Cortinarius caperatus (Pers. ex Fr.) Fr. **Cap** 5–
10cm across, convex then expanded and
umbonate, ochre-buff to ochre-brown, covered
in silky white cobwebby fibrils, more densely at
the centre. **Stem** 40–70×10–15mm, slightly
swollen at the base or bulbous, whitish; ring
whitish, narrow, spreading. **Flesh** whitish
tinged ochre. Taste and smell mild and pleasant.
Gills pale clay. Spore print ochre-brown. Spores

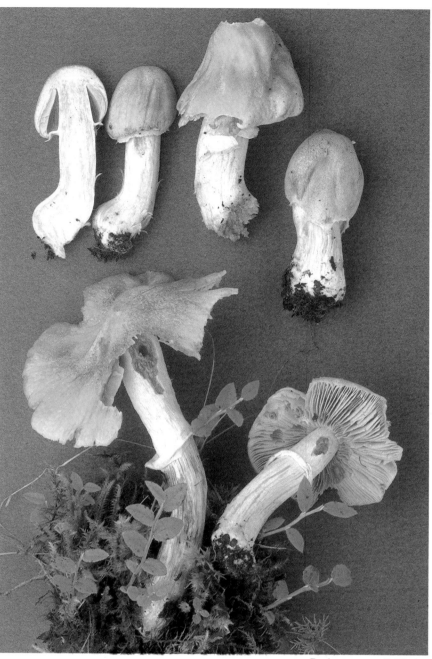

Rozites caperatus ²/₃ life size

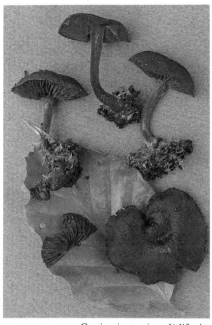

Cortinarius puniceus ¾ life size

elliptic, finely warted, 10–13×8–9μ. Habitat on
damp acid soils, usually in open situations
amongst conifers and heather. Season autumn.
Confined to the Highlands of Scotland; virtually
unknown in the South of England. Rare. **Edible**.

Cortinarius (Dermocybe) cinnamomeus (L. ex Fr.)
Fr. s. Fr. **Cap** 1.5–6cm across, convex then
expanded and often umbonate, olive-yellow to
olive-buff with reddish-brown tinge at centre,
soon bright red-brown to coppery, covered in
radiating fibrils. **Stem** 25–100×3–10mm,
lemon- to chrome-yellow becoming ringed in
tawny fibrous scales below from the veil; cortina
yellowish. **Flesh** lemon- to chrome-yellow tinged
olivaceous above the gills. Taste bitter and
radishy, smell faintly of radish. **Gills** deep
lemon- to chrome-yellow at first then deep
golden to tawny or bright golden-red. Spore
print rust. Spores elliptic, almost smooth to
minutely roughened, 9.5–8×4–5μ. Habitat with
conifers and birch. Season autumn. Uncommon.
Edibility unknown.

Cortinarius (Dermocybe) sanguineus (Wulf. ex Fr.)
Fr. **Cap** 2–5cm across, flattened convex, carmine
to dark blood-red, covered in radiating silky
fibrils (sub lente). **Stem** 30–60×3–8mm, slightly
thickened at base, concolorous with cap or
darker, base with pinkish or yellowish down;
cortina red. **Flesh** concolorous, deep reddish-
purple over gills and in stem cuticle. Smell faint,
pleasant. **Gills** concolorous with cap or darker,
finally rusty-tinged. Spore print rust. Spores
elliptic, minutely roughened, 7–9×4–6μ.
Habitat coniferous woods. Season autumn.
Occasional. **Edibility unknown**.

Cortinarius ((Dermocybe) uliginosus Berk. syn. *C.
queletii* Bataille syn. *C. concinnus* Karst. **Cap** 1.5–
5cm across, convex (often conical when young),
then expanded and usually umbonate, bright
tawny-orange to tawny-brick, margin paler or
more yellowish, covered in fine yellowish fibrils
especially near margin. **Stem** 25–65×3–10mm,
more or less thickened at base, concolorous with
cap or paler, more yellowish at apex and at base,

apex covered in yellow tufts of fibres, below in
rusty fibres; cortina yellow. **Flesh** bright lemon-
to sulphur-yellow, tinged tawny in cap. Smell of
radish. **Gills** bright lemon-yellow, then ochre- to
tawny-buff. Spore print rust. Spores elliptic,
minutely rough, 8–11×5–6μ. Habitat in damp
woods, usually with alders or willow. Season
autumn. Rare. **Edibility unknown**.

Cortinarius (Dermocybe) puniceus Orton **Cap** 1.5–
4cm across, convex then expanded and often
obtusely umbonate, purplish blood-red or with a
chestnut tone especially at the centre, more
ochraceous reddish at the margin, covered in
radiating silky fibres. **Stem** 35–70×3–9mm,
slightly thickened at base, concolorous with cap
or paler, base covered in pinkish or ochraceous
down; cortina ochraceous to golden-brown.
Flesh deep purplish blood-red finally deep rusty-
chestnut. Spore print rust. Spores elliptic,
almost smooth, 6.5–8.5×4–5μ. Habitat
deciduous woods. Season autumn. Rare.
Edibility unknown.

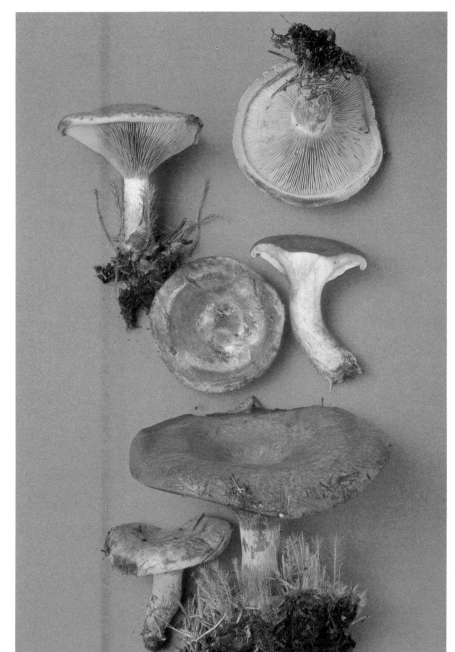

Brown Roll-rim *Paxillus involutus* (Fr.) Fr. **Cap**
5–12cm across, ochraceous or fulvous with
olivaceous flush at first becoming more rusty-
brown and finally hazel or snuff brown, viscid at
centre when wet, downy throughout particularly
at margin which remains inrolled, becoming
smooth later. **Stem** up to 75×8–12mm,
concolorous with cap becoming stained chestnut
especially with age or on bruising. **Flesh** pale
ochre in cap, fulvous in stem base, darkening on
cutting. Taste acidic, smell fungusy. **Gills**
decurrent, crowded, pale ochre then sienna,
bruising vinaceous or chestnut. Spore print
sienna. Spores ellipsoid, 8–10×5–6μ. Habitat in
broad-leaved woodland, especially with birch on
acid heathland. Season late summer to late
autumn. Very common. **Poisonous** – possibly
deadly.

Paxillus panuoides (Fr.) Fr. syn. *Tapinia
panuoides* (Fr.) Karst. **Cap** 1–6cm across,
ochraceous to buff or fulvous, downy and often
with lilac tomentum especially toward the point
of attachment. **Stem** up to 10mm, entirely absent
or rudimentary and lateral. **Flesh** ochraceous.
Taste and smell not distinctive. **Gills** decurrent,
crowded, branched and wavy, pale buff bruising
darker. Spore print ochraceous rust. Spores
ellipsoid, 4–5.5×3–4μ. Habitat on conifer
debris, causing the infected wood to become soft
and discolour bright yellow. Season late summer
to late autumn. Uncommon. **Not edible.**

Gymnopilus hybridus (Fr. ex Fr.) Sing. syn.
Flammula hybrida (Fr. ex Fr.) Gillet **Cap** 2–8cm
across, convex then expanded, pale ochraceous
at first then bright rusty-orange but remaining
pale at the inrolled margin. **Stem** 25–50×4–
8mm, ochraceous at first with a white cortinate
zone, later becoming rusty towards the base
which is covered in white down. **Flesh**
ochraceous in cap becoming more rusty in stem
or hollow. Taste bitter, smell scented. **Gills**
ochre yellow. Cheilocystidia skittle-shaped.
Spore print rust. Spores almond-shaped, warted,
7–9×3.5–4.5μ. Habitat on conifer stumps and
debris. Season late summer. Frequent. **Edibility
unknown.**

Brown Roll-rim *Paxillus involutus* ²⁄₃ life size

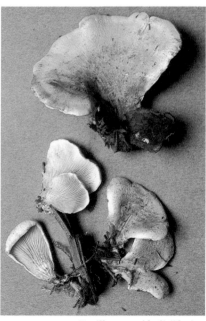

Paxillus panuoides ²⁄₃ life size

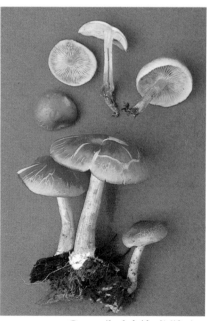

Gymnopilus hybridus ²⁄₃ life size

Paxillus atrotomentosus (Fr.) Fr. **Cap** 12–28cm across, snuff-brown or sepia with sienna patches, depressed in the centre, margin inrolled, slightly downy. **Stem** 30–90×20–50mm, sometimes lateral, rooting, covered in a fine olivaceous buff down which becomes more coarse, velvety and dark brown with age. **Flesh** cream, ochre or buff in stem. Taste and smell not distinctive. **Gills** crowded, joining to give a vein-like network near the stem. Spore print sienna. Spores ellipsoid, 5–6.5×3–4.5μ. Habitat tufted on stumps of conifers. Season late summer to autumn. Occasional. **Not edible.**

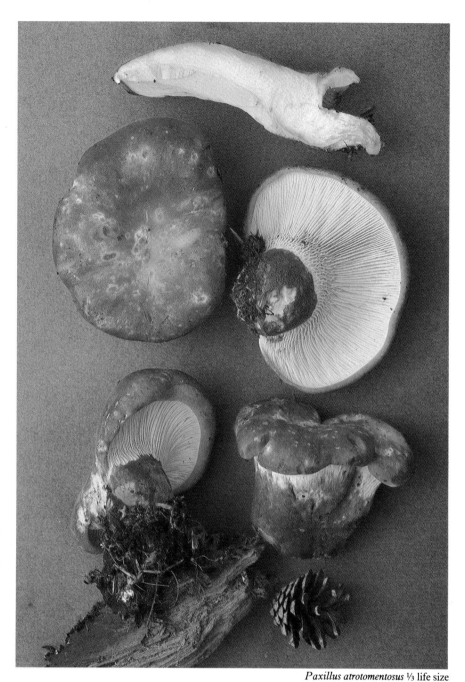

Paxillus atrotomentosus ⅓ life size

Gymnopilus penetrans (Fr. ex Fr.) Murr. syn. *Flammula penetrans* (Fr. ex Fr.) Quél. **Cap** 3–8cm across, convex then flattened and often wavy at the margin, golden to tawny, smooth. **Stem** 40–70×5–10mm, yellow above, brownish below, covered in whitish fibres, base covered in white down. **Flesh** yellowish, tawny in stem. Taste bitter, smell not distinctive. **Gills** gold becoming spotted tawny with age. Cheilocystidia thin-walled, hyaline, skittle-shaped. Spore print rust. Spores almond-shaped, warted, 8–9×4–5μ. Habitat on conifer debris. Season late summer to late autumn. Common. **Not edible.**

Gymnopilus fulgens (Favre & Maire) Sing. syn. *Naucoria cerodes* (Fr.) Kummer s. Lange **Cap** 0.5–2cm across, convex then expanded, tan or cinnamon when moist drying more ochre. **Stem** 5–20×1–3mm, tan, becoming dark brown. **Flesh** thin, concolorous. Taste mild, smell strong. **Gills** ochre to cinnamon. Spore print rust-brown. Spores broadly elliptic, 8–11×5–7μ. Habitat swampy heathland, often amongst sphagnum. Season autumn. Rare. **Edibility unknown.**

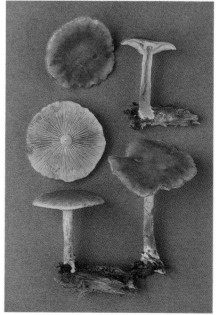

Gymnopilus penetrans ½ life size

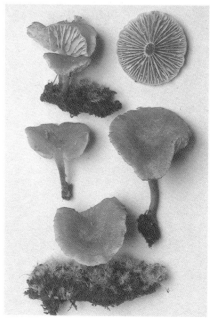

Gymnopilus fulgens life size

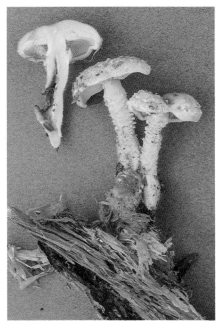

Pholiota flammans ½ life size

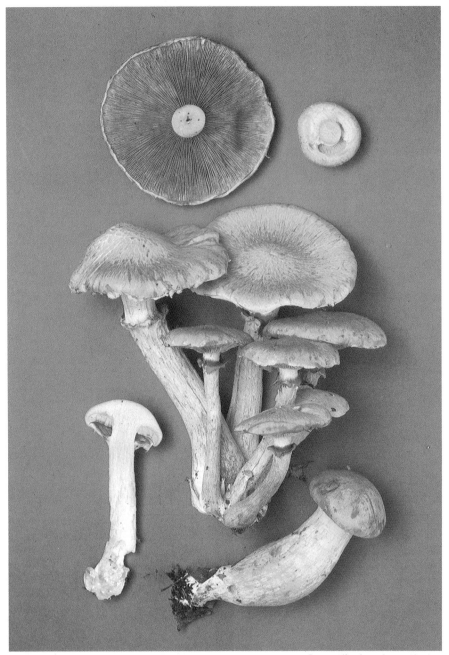

Gymnopilus junonius ½ life size

Gymnopilus junonius (Fr.) Orton syn. *G. spectabilis* var. *junonius* (Fr.) Kühn. & Romagn. syn. *Pholiota spectabilis* (Fr.) Kummer **Cap** 5–15cm across, convex then expanded, rich golden tawny covered in small fibrous adpressed scales. **Stem** 50–120×15–35mm, usually swollen in the lower part but narrowed again at base, chrome to ochre-buff, fibrous; ring membranous, yellowish becoming rusty from the spores, soon collapsing. **Flesh** pale yellowish. Taste bitter, smell not distinctive. **Gills** yellow then rusty-brown. Cheilocystidia thin-walled, hyaline, skittle-shaped. Spore print rust. Spores elliptic to almond-shaped, roughened, 8–10×5–6μ. Habitat in dense clusters at the base of deciduous trees or on stumps or logs. Season late summer to early winter. Common. **Not edible.**

Pholiota adiposa (Fr.) Kummer syn. *Dryophila sciposa* (Fr.) Quél. **Cap** 5–12cm across, golden-yellow, viscid, covered in gelatinous rusty-brown upturned scales especially towards the centre. **Stem** 20–50×5–10mm, often curved or distorted due to growing in clusters, yellow, smooth above the inconspicuous torn ring, covered in bands of viscid brownish recurved scales below. **Flesh** tough, pale yellow in cap darkening to brownish in the stem. Smell scented. **Gills** yellow at first later rusty-brown. Pleurocystidia thin-walled, lanceolate with an acute mucronate apex. Spore print rusty-brown. Spores oval, smooth, 5–6.5×3–3.5μ. Habitat in dense clusters at the foot of beech trees or stumps. Season late summer to autumn. Uncommon. **Not edible.**

Pholiota ochrochlora (Fr.) Orton **Cap** 2–5cm across, convex then expanded or slightly depressed, initially slightly viscid but soon dry, pale straw-coloured or tinged greenish at the margin, covered in straw-yellow to olivaceous pointed scales especially at the centre, margin with velar remnants at first. **Stem** 25–50×4–8mm, apex whitish, straw-yellow below darkening to rust at the base, covered in reflexed straw-coloured or greenish scales below the indistinct ring zone. **Flesh** whitish to yellowish in cap becoming brownish in stem base. Taste mild, smell none. **Gills** whitish-yellow becoming

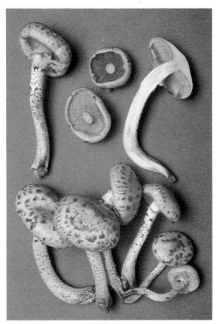

Pholiota adiposa ⅓ life size

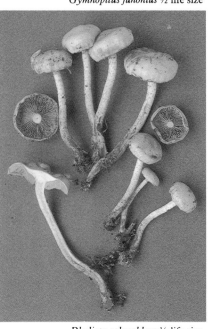

Pholiota ochrochlora ½ life size

ochre or tinged olivaceous, finally cinnamon. Spore print rust-brown. Spores elliptic to ovoid, 6–8×4–5μ. Habitat in small clusters on wood. Season autumn. Occasional. **Edibility unknown**.

Pholiota flammans (Fr.) Kummer **Cap** 2–8cm across, convex then expanded, tawny yellow covered in recurved lemon- to sulphur-yellow scales, margin incurved. **Stem** 40–80×4–10mm, bright yellow with concolorous cottony ring near the apex, densely covered in concolorous scales below. **Flesh** pale yellow. **Gills** pale yellow darkening to rusty yellow with age. Pleurocystidia lanceolate with pointed apex, staining deeply in cotton blue in lactic acid. Spore print rusty. Spores elliptic, 4–4.5×2–2.5μ. Habitat singly or in tufts on conifer stumps or fallen trunks. Season late summer to autumn. Rare, more frequent in the Scottish Highlands. **Not edible**.

Shaggy Pholiota *Pholiota squarrosa* (Müller ex Fr.) Kummer syn. *Dryophila squarrosa* (Müller ex Fr.) Quél. **Cap** 3–10(15)cm across, convex becoming flattened, the margin remaining inrolled, pale straw-yellow densely covered in coarse red-brown, upturned scales, not viscid. **Stem** 50–120×10–15mm, smooth and pale yellow above torn membranous ring, covered in red-brown recurved scales below and darkening at the base. **Flesh** tough, pale yellowish becoming red-brown in stem base. Taste and smell radishy. **Gills** crowded, pale yellow at first later cinnamon. Pleurocystidia clavate with mucronate apex. Spore print rust brown. Spores oval, smooth, 5.5–9×3.5–5μ. Habitat in dense clusters at the base of deciduous and very occasionally coniferous trees. Season autumn. Occasional. **Not edible**.

Pholiota tuberculosa (Schaeff. ex Fr.) Kummer syn. *Dryophila tuberculosa* (Schaeff. ex Fr.) Quél. **Cap** 2–5cm across, subglobose becoming convex to flattened, sulphur yellow to orange covered in small rusty flattened scales. **Stem** 30–60×3–10mm, yellow and smooth above the shortlived ring, flaky below and becoming brownish towards the swollen base. **Flesh** yellow, becoming reddish-brown on cutting. Taste bitter, smell slight and mushroomy. **Gills** pale yellow becoming spotted rusty-brown. Cheilocystidia thin-walled, hyaline, cylindric-clavate or capitate. Spore print rusty-brown. Spores kidney-shaped, smooth, 6.5–9×4–5μ. Habitat on fallen twigs, branches and sawdust. Season summer. Occasional. **Edibility unknown**.

Pholiota alnicola (Fr.) Sing. syn. *Flammula alnicola* (Fr.) Kummer syn. *Dryophila alnicola* (Fr.) Quél. **Cap** 2–6(11)cm across, convex to flattened, smooth and greasy, bright lemon-yellow at first becoming flushed olivaceous at the margin, remains of veil often adhering to the margin. **Stem** 20–80×5–10mm, pale lemon-yellow above the remains of the veil becoming rusty-brown towards the base, not viscid. **Flesh** yellow in cap, rusty towards the stem base. Taste mild to slightly bitter, smell pleasant and sweet. **Gills** pale yellow at first becoming cinnamon. Cheilocystidia thin-walled, hyaline, hair-like, clavate. Spore print rusty brown. Spores oval, smooth, 8.5–11.5×5–5.5μ. Habitat solitary or in small clusters on deciduous wood, especially alder, willow and birch. Season autumn. Uncommon. **Edible** – not worthwhile.

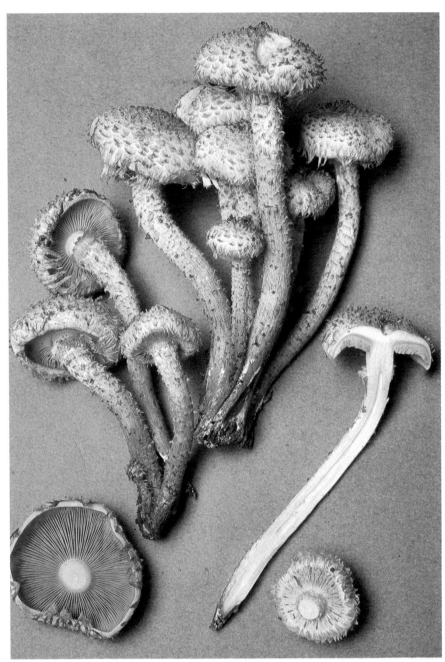

Shaggy Pholiota *Pholiota squarrosa* ½ life size

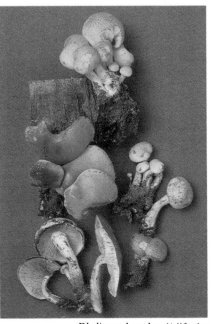

Pholiota tuberculosa ½ life size

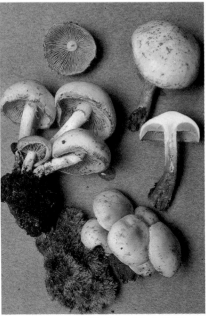

Pholiota alnicola ⅓ life size

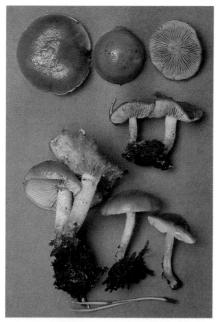

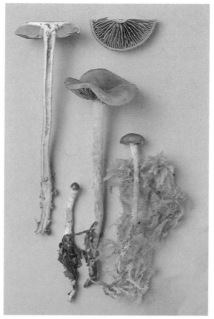

Charcoal Pholiota *Pholiota carbonaria* ½ life size

Pholiota myosotis ¾ life size

Charcoal Pholiota *Pholiota carbonaria* (Fr. ex Fr.) Sing. syn. *Flammula carbonaria* (Fr. ex Fr.) Kummer syn. *Dryophila carbonaria* (Fr. ex Fr.) Quél. **Cap** 2–5cm across, shallowly convex becoming flattened and wavy, smooth, ochre-brown to tan but lighter at the margin, viscid drying shiny. **Stem** 35–70×4–8mm, pale yellowish above the ring zone, covered in fine cottony fibres and darkening reddish-brown towards the base. **Flesh** pale yellow except for the rusty-brown stem base. Taste and smell not distinctive. **Gills** at first pale clay later cinnamon, finally olive-brown. Pleurocystidia thin-walled, hyaline, fusiform and projecting conspicuously beyond the basidia; cheilocystidia similar. Spore print brown. Spores oval, smooth, 6.5–8×3.5–4.5μ. Habitat on burnt ground often in large numbers. Season autumn and sporadically throughout the year. Common. **Not edible**.

Pholiota myosotis (Fr. ex Fr.) Sing. syn. *Naucoria myosotis* (Fr. ex Fr.) Kummer syn. *Flammula myosotis* (Fr. ex Fr.) Sing. **Cap** 1.5–3cm across, convex becoming flattened or irregularly wavy, smooth, olive-brown, viscid. **Stem** 70–110×2–5mm, elongated and fragile, rooting, dirty yellowish at apex, concolorous with cap below. **Flesh** whitish with yellow tinge, becoming hollow in stem. Smell slightly mealy. **Gills** dingy clay- to olive-brown with a paler edge. Cheilocystidia, thin-walled, hyaline, bottle-shaped; pleurocystidia clavate with mucronate apex, staining deeply in aniline blue in lactic acid. Spore print snuff brown. Spores almond-shaped, smooth, 14.5–19×7–9μ. Habitat in moist peaty ground usually in sphagnum. Season autumn. Occasional. **Edibility unknown**.

HEBELOMA *There are a few that are very common, the pale brown caps may be smooth or a bit slimy. The stems are fibrous often with a granular surface. Note the smell which may only be apparent on cutting or bruising. The gills like Inocybe go dull fawn-coloured as they mature. Seventeen in Britain.*

Hebeloma sinapizans (Paulet ex Fr.) Gillet **Cap** 4–12(20)cm across, convex then flattened and often wavy or upturned at the margin, ochre-brown or tan paling to cream or buff at the margin, greasy at first. **Stem** 50–120×10–20mm, swollen at the base, white covered in brownish scales forming a pattern of bands around the stem. **Flesh** whitish, becoming hollow in the stem often with a piece of the cap flesh hanging down into the stem cavity. Smell of radish. **Gills** pale clay-buff later with a cinnamon flush. Cheilocystidia thin-walled, hyaline, with a slightly swollen body and a narrower neck. Spore print rust. Spores almond-shaped, warted, 10–14.5×6–8μ. Habitat in deciduous and mixed woods. Season autumn. Uncommon. **Poisonous**.

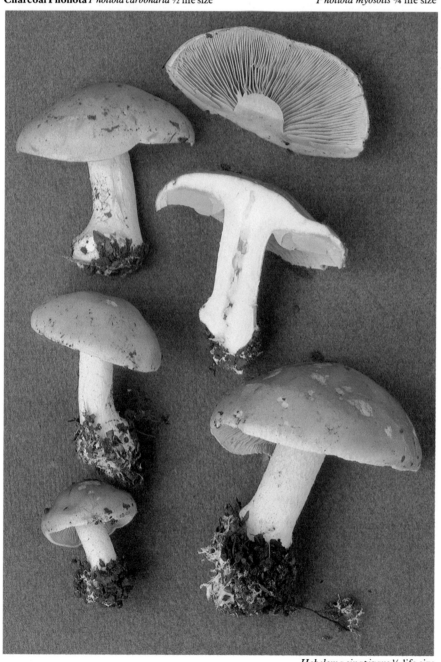

Hebeloma sinapizans ½ life size

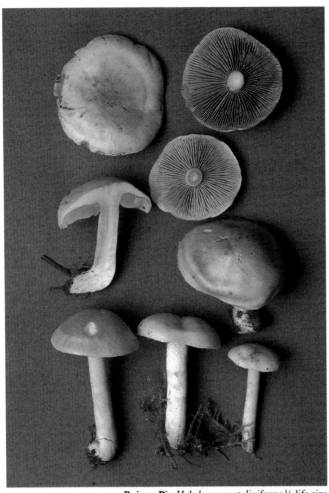

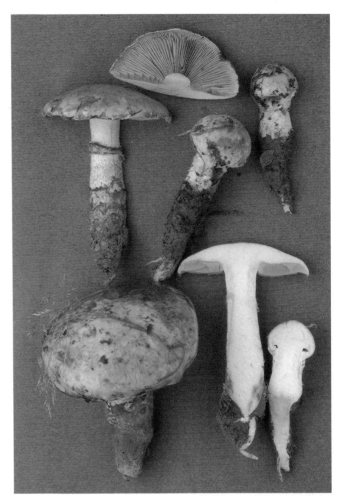

Poison Pie *Hebeloma crustuliniforme* ½ life size

Hebeloma radicosum ½ life size

Poison Pie *Hebeloma crustuliniforme* (Bull. ex St. Amans) Quél. **Cap** 4–10cm across, convex then expanded and often obtusely umbonate, the margin remaining inrolled for a long time and often lobed, buff to pale ochre-tan, darker at the centre, slightly greasy to viscid when moist. **Stem** 40–70×10–20mm, whitish, mealy, especially towards the apex. **Flesh** thick, white. Taste bitter, smell strongly of radish. **Gills** pale clay-brown exuding watery droplets in moist conditions, spotted when dry. Cheilocystidia thin-walled, hyaline, elongated club-shaped. Spore print rust. Spores almond-shaped, warted, 10–12×5.5–6.5μ. Habitat in open mixed woodland. Season late summer to late autumn. Common. **Poisonous**.

Hebeloma radicosum (Bull. ex Fr.) Ricken syn. *Pholiota radicosa* (Bull. ex Fr.) Kummer **Cap** 6–9cm across, convex, cream to pale yellowish-brown, glutinous in wet weather. **Stem** 50–80×10–15mm, tapering into a long 'tap-root', white and mealy above the ring, covered in brownish fibrous scales below. **Flesh** white. Taste sweet, smell of almonds. **Gills** pallid at first darkening slightly with age. Cheilocystidia thin-walled, hyaline, subcylindric to slightly clavate. Spore print dull brown. Spores almond-shaped, minutely warted, 9–10×5–6μ. Habitat deciduous woods, usually with oak or beech. Season autumn. Rare. **Edible** – poor.

Hebeloma mesophaeum (Pers.) Quél **Cap** 2–4.5cm across, convex then expanded, yellowish-brown, darker tan to date-brown at the centre, viscid when moist, margin covered in white fibrous remains of veil in young specimens. **Stem** 40–

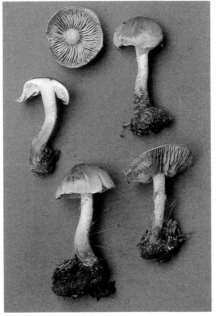

Hebeloma mesophaeum ½ life size

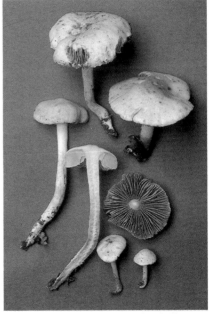

Hebeloma sacchariolens ½ life size

70×4mm, whitish above, with a poorly developed fibrillose ring zone, brownish towards the base. **Flesh** white in cap, brownish towards stem base. Taste bitter, smell strongly of radish. **Gills** clay-brown. Cheilocystidia thin-walled, hyaline, elongate-cylindric with obtuse apex, base often slightly enlarged. Spore print rusty-clay. Spores elliptic, very minutely punctate, 8–10×5–6μ. Habitat damp woodland, often on burnt ground. Season late summer to early winter. Occasional. **Edibility unknown** – best avoided.

Hebeloma sacchariolens Quél. **Cap** 2–7cm across, convex then flattened, sometimes with an indistinct umbo, ochre buff at the centre paling to buff at the margin, greasy. **Stem** 40–80×5–12mm, whitish apex mealy, silky-fibrous below. **Flesh** white. Taste bitter, smell sweet and flowery. **Gills** clay-brown then rusty. Cheilocystidia thin-walled, hyaline, cylindric. Spore print deep rust. Spores almond-shaped, warted, 12–17×7–9μ. Habitat damp woodland. Season autumn. Occasional. **Edibility unknown** – best avoided.

147

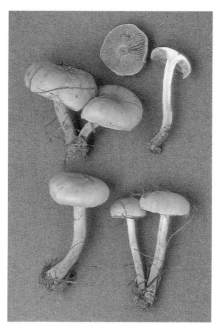

Hebeloma strophosum ½ life size

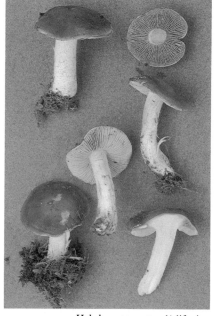

Hebeloma truncatum ½ life size

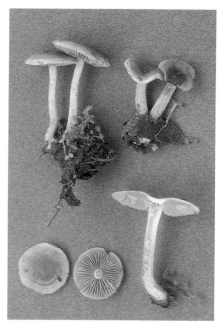

Hebeloma pusillum ¾ life size

Hebeloma strophosum (Fr.) Sacc. **Cap** 3–4cm across, convex, clay-brown. **Stem** 25–35×3–5mm, apex white, dirty ochre-clay below, woolly-fibrous. **Flesh** white, ochre-buff in stem. Taste bitter, smell slightly radishy. **Gills** pale buff then clay-brown with distinct flesh-coloured tint. Spore print clay-brown. Spores 7.5–9×4.5–6μ. Habitat woods. Season summer. Occasional. **Edibility unknown**.

Hebeloma truncatum (Schaeff. ex Fr.) Kummer **Cap** 4–6cm across, convex, dark tan to cocoa-brown, greasy. **Stem** 50–80×5–10mm, white. **Flesh** white. Taste bitter, smell faintly of radish. **Gills** white at first, later milky coffee. Cheilocystidia thin-walled, hyaline, clavate with apex about 6μ wide. Spore print brown. Spores almond-shaped, virtually smooth, 7–11×4.5–5.5μ. Habitat grassy coniferous woods. Season autumn. Rare. **Edibility unknown**.

Hebeloma pusillum Lange **Cap** 1–2.5cm across, conico-convex then expanded, often with a small umbo, pallid tan darkening to rufous or date brown at the centre, slightly viscid. **Stem** 20–40×2–3mm, mealy, white discolouring

brownish towards the base. **Flesh** thin, pallid. Taste bitter, smell of radish. **Gills** pallid then clay-brown. Spore print clay-brown. Spores almond-shaped, finely warted, 10–14×5.5–7μ. Habitat under willow. Season summer to autumn. Rare. **Edibility unknown**.

INOCYBE *Small dull coloured mushrooms with conical or umbonate caps. Note the presence or absence of a bulb at the stem base. Examine the cap surface for texture. The flesh may discolour when old or cut or bruised. Many have interesting smells. Most Inocybes cannot be determined without examining the spores under a microscope. Avoid eating any Inocybes, at least one is deadly poisonous. Eighty-seven in Britain.*

Inocybe godeyi Gillet **Cap** 2–5cm across, conical then expanded, cream then ochraceous to tan, bruising bright red, often becoming entirely so, smooth and silky becoming radially fissured with age. **Stem** 40–60×3–8mm, ending in a distinctly marginate bulb, whitish then reddening, mealy to the base. **Flesh** white, gradually reddening when cut. Taste acrid, smell strong, unpleasant. **Gills** whitish at first then cinnamon. Cheilo- and

pleurocystidia fusoid or bottle-shaped with thickened walls and apical encrustation. Spore print snuff brown. Spores almond-shaped, smooth, 9–11.5×5.5–7μ. Habitat deciduous woods, especially with beech on chalk. Season autumn. Uncommon. **Poisonous**.

Inocybe jurana Pat. **Cap** 2–6cm across, conical to bell-shaped, buff with radiating darker brown fibres radiating from the centre, soon flushed reddish brown or sometimes vinaceous-purple; note, the black patches on the caps are mould. **Stem** 20–60×4–10mm, white soon reddish, base slightly swollen. **Flesh** white becoming flushed pink in cap and stem base. Taste mild or mealy, smell strongly mealy. **Gills** adnate or free, white at first then tinged clay, edge white. Cheilocystidia thin-walled, clavate, without apical encrustation. Spore print snuff-brown. Spores smooth, bean-shaped, 10–15×5–7μ. Habitat deciduous or mixed woods especially beechwoods on chalk. Season autumn. Uncommon. **Not edible**.

Inocybe calamistrata (Fr.) Gillet **Cap** 1–5cm across, convex to bell-shaped, dark brown, covered in erect pointed scales. **Stem** 30–70×5–

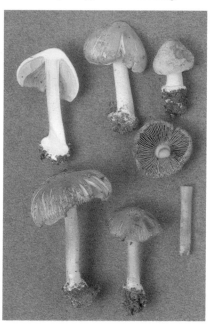

Inocybe godeyi ⅔ life size

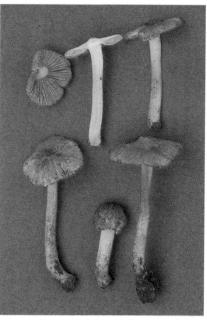

Inocybe jurana ½ life size

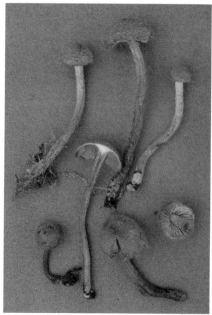

Inocybe calamistrata ½ life size

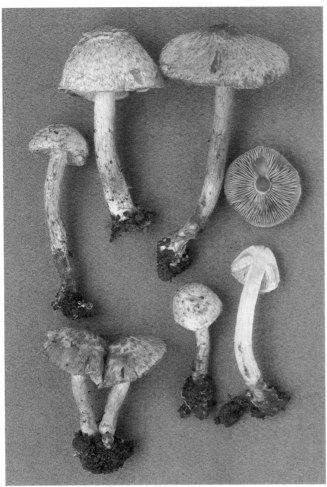

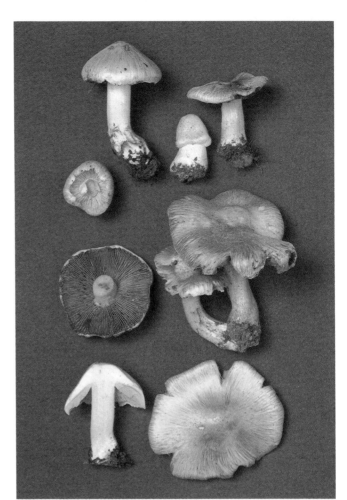

Inocybe bongardii ¾ life size

Red-staining Inocybe *Inocybe patouillardii* ⅔ life size

10mm, concolorous with cap, apex paler, covered in recurved brown scales, base with bluish-green down. **Flesh** white becoming reddish, bluish-green at stem base. Taste mild, smell fishy or acidic. **Gills** whitish later rusty-brown. Cheilocystidia thin-walled, vesicular or clavate lacking apical encrustation. Pleurocystidia absent. Spore print snuff-brown. Spores bean-shaped, smooth, 9.5–11.5×5–6.5μ. Habitat coniferous or mixed woods. Season summer. Rare. **Edibility unknown**.

Inocybe bongardii (Weinm.) Quél **Cap** 3–6cm across, conico-convex then bell-shaped, pale cinnamon with pink flush, densely covered with slightly darker scales. **Stem** 50–100×5–10mm, silky, whitish but bruising red, finally entirely brownish. **Flesh** white becoming pinkish-buff. Taste mild, smell fruity, like ripe pears. **Gills** pale olive-grey becoming olive-cinnamon, edge white. Cheilocystidia thin-walled, cylindric to clavate. Spore print snuff-brown. Spores bean-shaped, smooth, 10–12×6–7μ. Habitat coniferous and deciduous woods. Season autumn. Uncommon. **Poisonous**.

Red-staining Inocybe *Inocybe patouillardii* Bres. **Cap** 2.5–8cm across, conical or bell-shaped often with low, broad umbo, margin becoming lobed or split, ivory covered in red or brown-staining radial fibres. **Stem** 30–100×10–20mm, white staining red, sometimes with a marginate bulb. **Flesh** white, unchanging. Taste mild, smell faint when young, rank in older specimens. **Gills** adnate, rose-pink at first then cream, finally olive-brown, bruising red. Cheilocystidia thin-walled, subcylindric without apical encrustation. Spore print dull brown. Spores smooth, bean-shaped, 10–13×5.5–7μ. Habitat pathsides in deciduous woods, usually beech, on chalky soils. Season

spring to autumn. Occasional. **Deadly poisonous**.

Inocybe cookei Bres. **Cap** 2–5cm across, conical or bell-shaped then flattened with a prominent umbo, margin cracking, ochre, covered in long fibrous fibres. **Stem** 30–60×4–8mm, whitish with ochre flush, bulb marginate. **Flesh** whitish then straw-yellow. Taste mild, smell slight. **Gills** adnexed, whitish then pale cinnamon. Cheilocystidia thin-walled, pyriform and non-encrusted. Spore print snuff-brown. Spores smooth, bean-shaped, 7–8×4–5μ. Habitat mixed woods. Season summer to late autumn. Occasional. **Poisonous**.

Inocybe corydalina Quél. **Cap** 2–6cm across, bell-shaped, then flattened, margin cracking, dingy white covered in long brown fibres, radiating umbo flushed olivaceous. **Stem** 30–60×5–10mm, whitish tinged brown, slightly swollen at base and there sometimes blue green. **Flesh** white, yellowish with age. Taste mild, smell strong of breadpaste. **Gills** adnexed, pale clay with white edge. Cystidia thick-walled, fusoid, encrusted. Spore print snuff-brown. Spores smooth, ellipsoid, 8–10×5–6.5μ. Habitat beechwoods on chalk. Season autumn. Rare. **Not edible**.

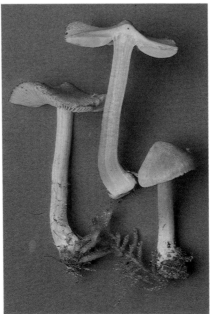

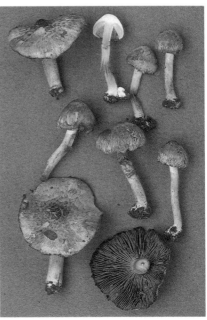

Inocybe cookei ⅔ life size

Inocybe corydalina ½ life size

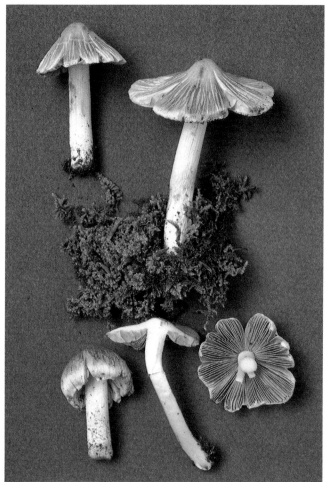

Inocybe fastigiata ²/₃ life size

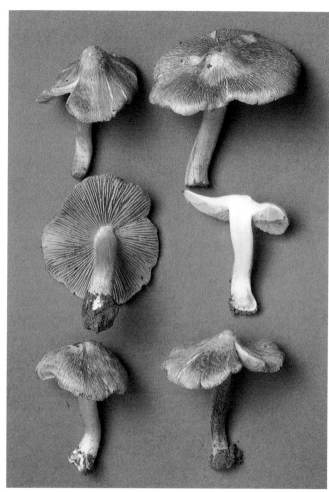

Inocybe maculata life size

Inocybe fastigiata (Schaeff. ex Fr.) Quél. syn *I. pseudofastigiata* Rea **Cap** 2–10cm across, conical or bell-shaped with prominent umbo, splitting radially on expanding, straw-yellow or buff covered in long silky fibres. **Stem** 30–90×4–12mm, white at apex, pale buff below, no bulb. **Flesh** white, unchanging. Taste mild with bitter aftertaste, smell slight, mealy. **Gills** adnexed or adnate, yellowish-clay with white edge. Cheilocystidia thin-walled, cylindric, non-encrusted. Spore print snuff-brown. Spores smooth, bean-shaped 9–12×4.5–7μ. Habitat in deciduous woodland especially beechwoods. Season early summer to late autumn. Common. **Poisonous.**

Inocybe maculata Boud **Cap** 2–8cm across, conical to bell-shaped, covered in long chestnut fibres and initially with a veil of dense white down which persists on the prominent umbo, often radially split or cracked. **Stem** 30–80×5–12mm, white becoming flushed brown, sometimes slightly smoother at the base. **Flesh** white. Taste mild, smell strong and fruity. **Gills** adnate pale greyish buff, edge white. Cheilocystidia thin-walled, clavate without apical encrustation. Spore print snuff-brown. Spores smooth, bean-shaped 9–11×4.5–5.5μ. Habitat in beechwoods on chalk. Season autumn. Occasional. **Poisonous.**

Inocybe dulcamara (Alb. & Schw. ex Pers.) Kummer s. Lange **Cap** 1–4cm across, convex becoming almost flat, greenish ochraceous to tawny, with a white cortina when young. **Stem** 25–40×3–8mm, concolorous with cap, sometimes with an indistinct cottony ring. The cortina makes it possible to confuse this fungus with *Cortinarius*, however the spore colour makes it recognizable as an *Inocybe*. **Flesh** buff or ochraceous. Taste sweet, smell slight. **Gills** adnate, yellow-buff at first then brown. Cheilocystidia thin-walled, clavate or pyriform sometimes in short chains. Spore print snuff-brown. Spores smooth, bean-shaped, 7.5–10.5×5–5.5μ. Habitat on sandy pathsides or dunes. Season autumn. Uncommon. **Not edible.**

Inocybe geophylla (Sow. ex Fr.) Kummer **Cap** 1.5–3.5cm across, conical, soon expanding, with prominent umbo, smooth and silky, white with yellowish tinge. **Stem** 10–60×3–6mm, white, silky fibrillose. **Flesh** white, unchanging. Taste mild, smell earthy or mealy. **Gills** crowded, adnexed, cream at first darkening to clay. Cystidia thick-walled, fusoid with apical encrustation. Spore print snuff-brown. Spores smooth, almond-shaped, 8–10.5×5–6μ. Habitat on pathsides in deciduous, mixed and coniferous woods. Season early summer to late autumn. Common. **Poisonous.**

Inocybe geophylla var. *lilacina* Gillet **Cap** as *I. geophylla* except for the striking lilac colour, often with ochraceous flush at umbo. **Stem** lilac with ochraceous base. **Flesh** violaceous. Taste acrid, smell strongly earthy or mealy. **Gills** clay-coloured. Cystidia as in var. *geophylla*. Spore print snuff-brown. Spores smooth, slightly almond-shaped, 7–10×5.5–6μ. Habitat in woods of all kinds. Season summer to autumn. Frequent. **Poisonous.**

Inocybe cincinnata (Fr.) Quél **Cap** 1–2cm across, bell-shaped then expanding with a broad umbo, reddish-brown, densely covered in minute erect scales. **Stem** 20–30×2–4mm, pallid tinged violaceous at apex, thinly covered in brownish cottony tufts towards the base. **Flesh** whitish, flushed violet in cap and stem apex. Taste slightly bitter, smell mealy. **Gills** pallid with a brown edge, then rusty-brown. Cheilo- and pleurocystidia fusoid, bottle-shaped, encrusted apically with crystals and with thickened walls which are yellowish in ammonia. Spore print rust brown. Spores obliquely ovate, smooth, 7.5–9.5×4.5–6μ. Habitat damp deciduous and coniferous woods. Season summer. Occasional. **Suspect** – avoid.

Inocybe griseolilacina Lange **Cap** 1.5–2.5cm across, conico-convex at first then expanded and umbonate, ochre-brown with violet tinges when young, particularly at the centre, covered in small shaggy scales. **Stem** 30–70×2–4mm, pale lilac when young later brown, densely covered in white cottony fibres, slightly swollen at the base. **Flesh** lilac when young becoming dirty white or brownish with age. Taste mild, smell strongly

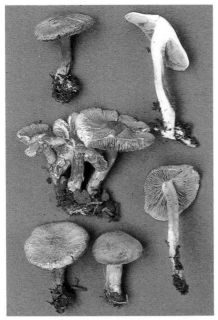

Inocybe dulcamara ¾ life size

Inocybe geophylla var. *lilacina* ¾ life size

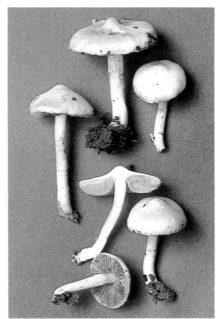

Inocybe geophylla ¾ life size

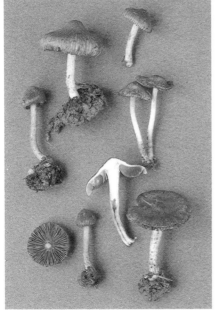

Inocybe cincinnata life size

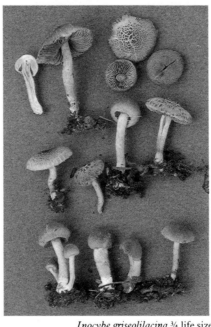

Inocybe griseolilacina ¾ life size

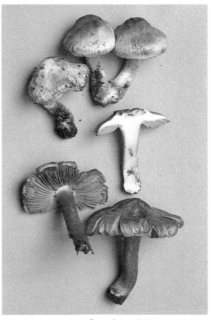

Inocybe pyriodora ½ life size

mealy. **Gills** adnate, white at first then snuff-brown. Cheilo- and pleurocystidia thick-walled, fusoid with apical encrustation, hyaline. Spore print snuff-brown. Spores ellipsoid to almond-shaped, 8.5–11×5–6μ. Habitat deciduous woods and roadsides. Season autumn. Uncommon. **Not edible**.

Inocybe pyriodora (Pers. ex Fr.) Kummer syn. *I. incarnata* Bres. **Cap** 3–7cm across, bell-shaped, the margin often becoming split, ochraceous brown with reddish tints. **Stem** 40–80×6–12mm, whitish becoming flushed the colour of the cap, the apex remaining white. **Flesh** white becoming pinkish or buff. Taste mild, smell of over-ripe pears. **Gills** adnate, whitish at first becoming clay pink with a white edge. Cystidia fusoid, not very numerous, with thin or only slightly thickened wall with apical encrustation. Spore print snuff-brown. Spores smooth, almond-shaped, 8–11.5×5–7μ. Habitat all kinds of woodland. Season autumn. Occasional. **Edibility suspect**.

Inocybe hirtella Bres. **Cap** 1–3cm across, convex to bell-shaped, straw-yellow to gold, disrupting into small, adpressed scales. **Stem** 20–45×2–4mm, base slightly bulbous, mealy, white tinged with flesh-colour. **Flesh** white in cap, pale brownish in stem. Taste mild, smell of almonds but often difficult to detect unless specimens have been enclosed in a small container. **Gills** whitish-straw at first then olive-brown. Cheilo- and pleurocystidia thick-walled, apically encrusted with crystals and varying in shape from narrowly to broadly fusoid. Spore print brown. Spores smooth, almond-shaped, 8–12×5–7μ. Basidia usually two-spored. Habitat deciduous or mixed woods, especially with hazel. Season autumn. Occasional, probably often overlooked or confused with other species. **Not edible**.

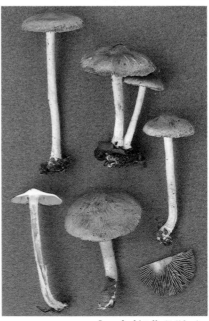

Inocybe hirtella ¾ life size

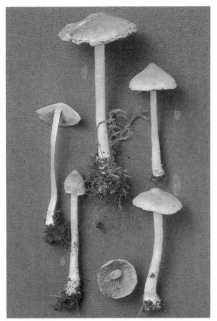

Inocybe eutheles ¾ life size

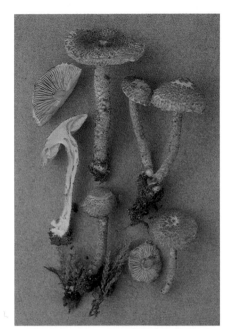

Inocybe hystrix ¾ life size

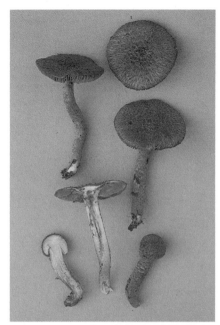

Inocybe longicystis ¾ life size

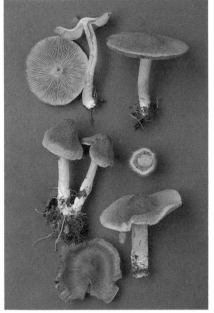

Inocybe flocculosa ⅔ life size

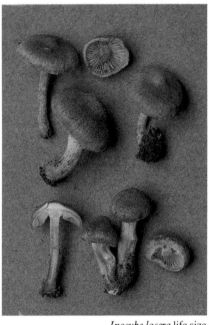

Inocybe lacera life size

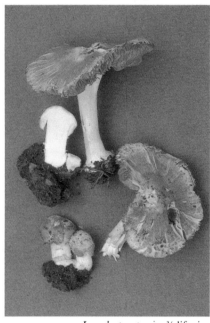

Inocybe praetervisa ¾ life size

Inocybe eutheles (Berk. & Br.) Quél **Cap** 2–4cm across, bell-shaped with prominent umbo, pale buff and broken up into coarse fibrous scales, paler at margin. **Stem** 40–70×5–10mm, white flushed flesh-colour, slightly swollen at the base, pruinose throughout. **Flesh** white, unchanging. Taste mild, smell earthy. **Gills** adnate, pale clay with white edge. Cystidia thick-walled elongate-fusoid with apical encrustation, pale yellowish. Spore print snuff-brown. Spores smooth, almond-shaped, 8.5–10×4–5μ. Habitat with conifers. Season autumn. Frequent. **Not edible.**

Inocybe hystrix (Fr.) Karst. **Cap** 2–4cm across, convex or with a low broad umbo, covered in dark brown pointed, erect scales on a pale background. **Stem** 40–80×5–8mm, sometimes slightly thickened towards the base, covered in dark brown recurved scales except for the paler apex. **Flesh** whitish pallid. Taste mild, smell slight. **Gills** adnate, whitish at first then pale clay with a white edge. Pleuro- and cheilocystidia thick-walled, apically encrusted, fusoid. Spore

print snuff-brown. Spores almond-shaped, smooth, 9–11.5×4.5–6.5μ. Habitat deciduous woods, especially beech. Season autumn. Rare – mostly northern in distribution. **Poisonous.**

Inocybe longicystis Atk. **Cap** 2–4cm across, convex at first becoming flattened, cinnamon to darker brown, covered in shaggy fibrous erect scales especially in the centre. **Stem** 40–70×5–7mm, brown with cottony fibres giving it a coarse shaggy appearance. **Flesh** white. Smell slight. **Gills** broad, adnexed to adnate, cinnamon. Cystidia thin-walled, cylindric, sometimes with subapical constriction, present on gill edge and gill face. Spore print snuff-brown. Spores oblong with knobby surface, 8–10×5–6μ. Habitat amongst moss in mixed woods of pine and birch. Season autumn. Occasional. **Not edible.**

Inocybe flocculosa (Berk.) Sacc. syn. *I. gausapata* Kühn. **Cap** 2–4cm across, bell-shaped with a prominent broad umbo, pale cinnamon brown

with cream or grey down, margin paler and joined to the stem by a whitish cortina. **Stem** 30–50×5–10mm, white becoming flushed fawn with white base, apex pruinose. **Flesh** white, reddening slightly in the stem. Taste mild, smell mealy or fruity. **Gills** adnexed, crowded, pale fawn at first later cinnamon. Cystidia thick-walled, fusoid, with apical encrustation. Spore print snuff-brown. Spores smooth, almond-shaped, 8–11×4.5–5.5μ. Habitat in broad-leaved or mixed woods. Season autumn. Occasional. **Poisonous.**

Inocybe lacera (Fr.) Kummer **Cap** 1–3cm across, convex with slight umbo, snuff-brown, fibrillose, sometimes splitting from the margin inwards. **Stem** 20–30×3–6mm, whitish near apex, brownish towards the slightly bulbous base, fibrillose. **Flesh** white. Taste mild, smell mealy. **Gills** adnexed, white at first, soon clay-buff with white edge. Cystidia thick-walled, fusoid, with apical encrustation. Spore print snuff-brown. Spores smooth, subcylindric, 11–

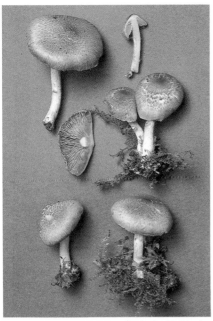

Inocybe tigrina ²/₃ life size

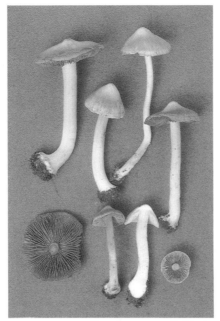

Inocybe grammata ²/₃ life size

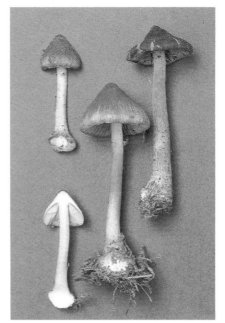

Inocybe napipes ²/₃ life size

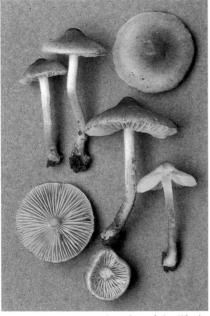

Inocybe umbrina life size

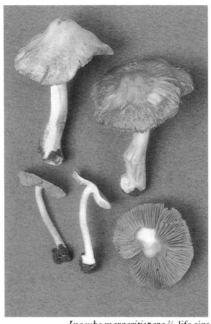

Inocybe margaritispora ²/₃ life size

15×4.5–6μ, making this species easily recognizable microscopically. Habitat on sandy soils especially with pines. Season autumn. Occasional. **Not edible**.

Inocybe praetervisa Quél **Cap** 3–5cm across, bell-shaped then expanded, dirty yellowish-brown, fibrous, splitting radially. **Stem** 50–60×3–8mm, with submarginate bulb, white then pale straw, entirely finely mealy. **Flesh** white discolouring yellowish in stem. Taste mild, smell faintly of meal. **Gills** whitish at first later clay-brown. Cheilo- and pleurocystidia fusoid with thickened hyaline or pale yellowish walls and apical encrustation. Spore print clay-brown. Spores oblong with numerous distinct angular knobs, 10–12×7–9μ. Habitat mixed woods, often under beech. Season late summer to late autumn. Uncommon. **Edibility suspect** – avoid.

Inocybe tigrina Heim **Cap** 2–5cm across, conical, almost flat when expanded, covered in chestnut

brown fibres which radiate from the centre as if combed on a pale background. **Stem** 30–60×3–6mm, white becoming flushed with cap colour. **Flesh** white unchanging. **Gills** adnate, white at first then clay-pink. Cystidia thick-walled, yellowish in ammonia, with apical encrustation. Spore print snuff-brown. Spores 8–11×4.5–5.5μ. Habitat in deciduous or mixed woodland. Season autumn. Rare. **Edibility unknown**.

Inocybe grammata Quél. **Cap** 1.5–4cm across, conical to bell-shaped with an acute whitish umbo, elsewhere honey-coloured often with a pink flush and covered in fine white radiating fibrils. **Stem** 40–75×3–10mm, with a large marginate bulb, white becoming flushed pinkish especially at apex, finely mealy to base. **Flesh** white in the centre of the cap, elsewhere pale flesh-coloured. Taste mild, smell strong and pleasant. **Gills** white then pallid becoming cinnamon. Cheilo- and pleurocystidia variable in shape from fusoid to ovoid with thickened hyaline walls and apical encrustation. Spore

print snuff-brown. Spores oblong with 8–12 indistinct knobs giving a wavy outline, 7–9×5–5.5μ. Habitat amongst grass in open mixed woodland. Season summer. Uncommon. **Edibility unknown** – best avoided.

Inocybe napipes Lange syn. *Astrosporina napipes* (Lange) Pearson **Cap** 2–5cm across, conical to bell-shaped with pointed umbo, chestnut brown to umber, covered in radial fibres. **Stem** 30–60×5–7mm, whitish at apex and at base of bulb, stem tinged with cap colour. **Flesh** whitish buff in cap and bulb, darker in stem. Taste mild, smell slight, not distinctive. **Gills** adnexed, whitish then dingy brown. Cystidia thick-walled, ventricose, with apical encrustation. Spore print snuff-brown. Spores oblong with several prominent knobs, 9–10×6μ. Habitat in damp deciduous and mixed woods. Season summer to late autumn. Frequent. **Poisonous**.

Inocybe umbrina Bres. syn. *Astrosporina umbrina* (Bres.) Rea **Cap** 1.5–4cm across, bell-shaped with prominent umbo, umber or chestnut brown initially covered by a greyish veil. **Stem** 30–50×3–5mm, whitish at apex and bulb, concolorous with cap below. **Flesh** whitish turning brown in stem. Taste mild, smell not distinctive. **Gills** adnate, pale clay. Cystidia thick-walled, fusoid with apical encrustation. Spore print snuff-brown. Spores oblong with slight protuberances, 7–8×5–6μ. Habitat in coniferous and deciduous woods. Occasional. **Not edible**.

Inocybe margaritispora (Berk. apud Cke.) Sacc. **Cap** 3–6cm across, bell-shaped, surface disrupting into rather dispersed yellowish-brown scales on a whitish background. **Stem** 40–100×4–10mm, rather tall and straight with a slightly flattened bulb, whitish becoming flushed yellowish-brown, finely mealy at apex. **Flesh** white. Smell fruity. **Gills** whitish at first then clay-brown. Cheilo- and pleurocystidia bottle-shaped, with thickened walls especially towards the apex which is encrusted with crystals. Spore print brown. Spores almost star-shaped with 5–6 prominent knobs, 8.5–11×6–7.5μ. Habitat hazel copses. Season summer. Rare. **Edibility unknown** – best avoided.

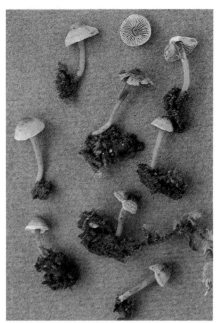

Inocybe petiginosa ¾ life size

Inocybe petiginosa (Fr. ex Fr.) Gillet **Cap** 0.5–1.5cm across, convex to obtusely umbonate, initally covered in small whitish scales which are soon lost leaving the surface silky-fibrous, margin white, disc brown. **Stem** 15–40×1–2mm, mealy, cream to reddish-brown. **Flesh** thick at disc, whitish in cap, reddish-brown in stem. Taste mild, smell none. **Gills** cream at first later brown with an olivaceous tint, edge hairy (sub lente). Cystidia thick-walled, fusoid, becoming yellow in ammonia. Spore print snuff brown. Spores ovoid with several blunt knobs, 6.5–8.5×4–6μ. Habitat deciduous woods, especially beech. Season autumn. Uncommon. **Edibility unknown**.

Bolbitius vitellinus (Pers. ex Fr.) Fr. **Cap** 1–4cm across, acorn-shaped then bell-shaped, finally expanding to almost flat, very thin and almost transparent, chrome yellow at first fading to grey-brown at the margin, somewhat viscid when young drying shiny with age, deeply grooved at the margin. **Stem** 30–100×2–4mm, very delicate, whitish-yellow with a fine mealy powdering, base downy. **Flesh** thin and membranous above the gills, stem hollow. **Gills** crowded, pale yellow at first, later cinnamon or rusty. Spore print rust brown. Spores smooth, elliptic, 11–15×6–9μ. Habitat on rotting straw, manured grassland or wood chips. Season summer to late autumn. Frequent. **Not edible**.

Conocybe plumbeitincta (Atk.) Sing. syn. *Galera siliginea* (Fr. ex Fr.) Quél. s. Rea, Kühn. **Cap** 1–2cm across, bell-shaped, pale grey-brown, smooth. **Stem** 40–60×2–3mm, pallid becoming darker towards the base, no ring. **Flesh** concolorous, thin. Taste and smell not distinctive. **Gills** adnate, pale ochraceous-buff. Spore print ochraceous-brown. Spores broadly ellipsoid, 9–16×5–9.5μ. Cheilocystidia skittle-shaped, head 3.2–5μ in diameter. Habitat in earth at roadsides, in gardens or fields. Season autumn. Rare. **Edibility suspect**.

Conocybe rickenii (Schaeff.) Kühn. syn. *Galera rickenii* Schaeff. **Cap** 1–2.5cm across, conical to bell-shaped, cream tinged ochre-brown or more grey-brown at the centre, almost never striate. **Stem** 40–70×1–2mm, whitish cream darkening to dirty brown with age. **Flesh** thin, grey-brown in cap, cream to ochre-brown in the stem, darkening towards the base. Taste and smell not distinctive. **Gills** ochraceous-cream at first darkening to rusty-ochre. Spore print brown. Spores elliptic to oval, 10–20×6–12μ. Basidia two-spored. Cap cuticle cellular. Habitat on rich soil, compost heaps or dung. Season autumn. Occasional. **Edibility unknown**.

Conocybe percincta Orton **Cap** 1–3.5cm across, conico-convex then expanding and often umbonate, pale yellow with darker ochre centre becoming darker yellow-brown. **Stem** 25–45×2–5mm, pale yellowish, silky above ring, finely cottony below, often darkening towards the base; ring prominent, later movable and often slipping down the stem. **Flesh** yellowish darkening to brown towards the stem base. Smell slightly acidic or mealy. **Gills** pale clay at first becoming dirty ochre, finally rusty-clay. Cheilocystidia obtuse, cylindric-clavate, utriform or lageniform. Spore print rust. Spores elliptic to almond-shaped, with germ pore, 10–12×5–6μ. Basidia two-spored. Habitat on bare soil or rotting straw. Season late autumn. Occasional. **Edibility unknown**.

Conocybe filaris (Fr.) Kühn. syn. *Pholiota filaris* (Fr.) Lange syn. *P. togularis* var. *filaris* (Fr.) Lange **Cap** 0.5–1.5cm across, bell-shaped, tan to yellowish-cream with faint lines at the margin when fresh. **Stem** 30–50×1–3mm, white at first discolouring yellowish to brownish especially towards the base; the distinct membranous striate ring is white at first but soon coloured golden-rust by the spores. **Flesh** concolorous with cap. Taste and smell not distinctive. **Gills** adnate, pale ochraceous tan. Spore print rust brown. Spores ellipsoid, 6–10×4–5μ. Cystidia lageniform, sometimes slightly capitate or with flexuous neck. Habitat amongst grass, usually solitary. Season autumn. Rare. **Not edible**.

Conocybe tenera (Schaeff. ex Fr.) Kühn. **Cap** 1–4cm across, bluntly conical at first expanding bell-shaped, ochre brown or cinnamon drying more yellowish. **Stem** 50–100×4–7mm, whitish flushed with cap colour, fragile, the surface having a finely powdered appearance. **Flesh** thin, concolorous with cap, soon hollow in the stem. Smell mushroomy. **Gills** adnate, crowded, whitish at first then cinnamon. Spore print bright yellow-brown. Spores ovoid, 8.5–14.5×5–8μ. Cheilocystidia skittle-shaped, head 2.5–5μ in diameter. Habitat amongst grass in woods and fields. Season late spring to early winter. Occasional. **Not edible**.

Conocybe lactea (Lange) Métrod syn. *Galera lactea* Lange **Cap** 1–2.5cm across, conical to narrowly bell-shaped, whitish to yellowish-cream, not hygrophanous or striate. **Stem** 30–110×1–2mm, ending in a rounded bulb, white, powdery near apex. **Flesh** thin. **Gills** cinnamon. Cheilocystidia thin-walled, skittle-shaped with swollen body, narrow neck and distinct head 4.5–5.7μ wide. Spores elliptic, with a germ-pore, 11.5–15×7–10μ. Basidia four-spored. Habitat on lawns, roadsides, sawdust and sand-dunes. Season late summer to late autumn. Uncommon. **Edibility unknown**.

Conocybe ochracea (Kühn.) Sing. syn. *C. siliginea* var. *ochracea* Kühn. **Cap** 1–2cm across, bell-shaped, ochre to tawny brown, drying paler, striate from margin to halfway to centre. **Stem** 30–60×2–3mm, pale at the apex, concolorous with cap below, towards the base covered in fine white fibres. **Flesh** pale ochraceous buff. **Gills** adnexed or free, clay-buff at first later ochraceous. Spore print ochraceous. Spores 8.5–11.5×5–7μ. Cheilocystidia skittle-shaped, head 3–5μ in diameter. Habitat in lawns. Season summer. Common. **Edibility suspect**.

Conocybe subovalis (Kühn.) Kühn. & Romagn. syn. *Galera tenera* (Schaeff. ex Fr.) Quél. s. Lange syn. *G. tenera* var. *subovalis* Kühn. **Cap** 1.5–3.5cm across, convex to bell-shaped, dull ochre, flushed with cinnamon, drying pale ochraceous cream, smooth. **Stem** 60–100×1–2mm, ochraceous cinnamon, minutely powdered whitish towards the base which ends in a small, distinct, more or less marginate bulb. **Flesh** very thin ochraceous cream in cap, cinnamon in stem. **Gills** free, rather crowded, ochraceous buff becoming more cinnamon. Spore print pale rust brown. Spores oval, 11–14×6–8μ. Cheilocystidia skittle-shaped, head usually 5–6.5μ in diameter. Habitat in pastures. Season autumn. Rare. **Edibility suspect**.

Conocybe pseudopilosella (Kühn.) Kühn. & Romagn. syn. *C. pubescens* var. *pseudopilosella* Kühn. **Cap** 0.5–1.2cm across, remaining conical to bell-shaped and not expanding, ochraceous drying paler almost cream. **Stem** 40–80×1–2mm, fragile, pale at apex, concolorous with cap below, darkening towards the base. **Flesh** very thin, ochraceous, soon hollow in the stem. **Gills** adnate, ochraceous cinnamon. Spore print ochraceous-brown. Spores 13–14.5×7–8.5μ. Cheilocystidia skittle-shaped, head 2.5–4.5μ in diameter. Habitat amongst grass in woods and in lawns. Season autumn. Uncommon. **Edibility suspect**.

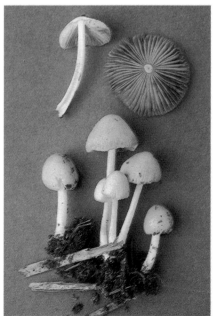

Bolbitius vitellinus ¾ life size

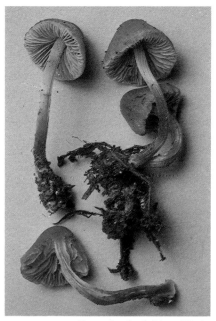

Conocybe plumbeitincta life size

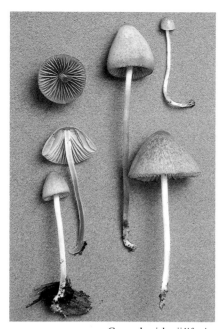

Conocybe rickenii life size

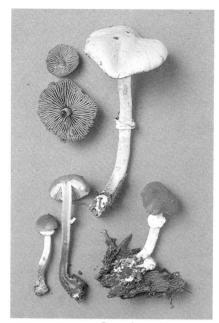

Conocybe percincta life size

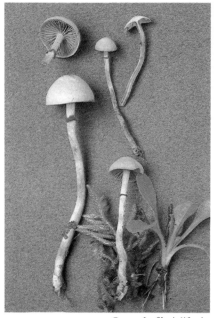

Conocybe filaris life size

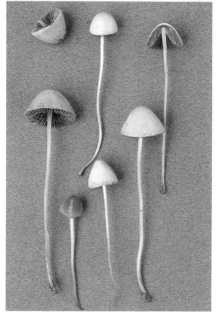

Conocybe tenera ²/₃ life size

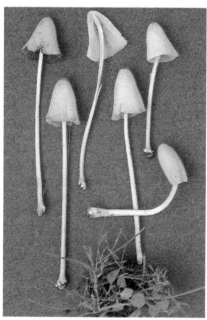

Conocybe lactea ²/₃ life size

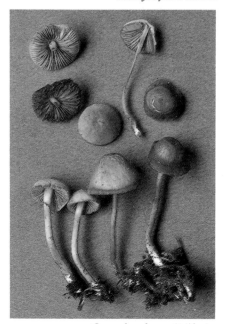

Conocybe ochracea ¾ life size

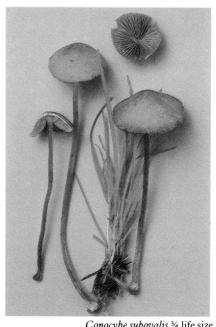

Conocybe subovalis ¾ life size

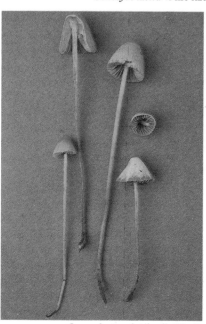

Conocybe pseudopilosella life size

155

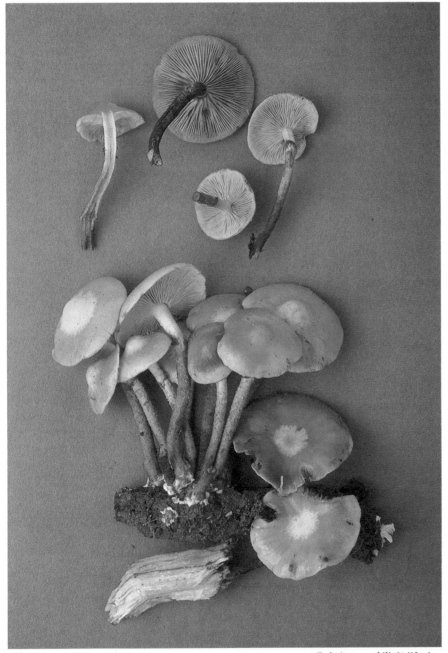

Galerina mutabilis (Schaeff. ex Fr.) Orton syn. *Pholiota mutabilis* (Schaeff. ex Fr.) Kummer syn. *Kuehneromyces mutabilis* (Schaeff. ex Fr.) Sing. & Smith **Cap** 3–6cm across, convex then expanded and usually umbonate, bright orange-cinnamon when moist drying pale ochraceous from the centre and often appearing distinctly two-coloured. **Stem** 30–80×5–10mm, whitish above becoming darker tan to blackish towards the base, scaly below the ring. **Flesh** white tinged brownish. Taste and smell not distinctive. **Gills** pallid at first later cinnamon. Spore print deep ochre. Spores ovoid to slightly almond-shaped, with germ-pore, 6–7.5×4–5μ. Habitat in dense clusters on stumps or trunks of deciduous trees. Season spring to early winter. Common. **Edible** – good.

Galerina mniophila (Lasch) Kühn. syn. *Galera mniophila* (Lasch) Gillet **Cap** 1–1.5cm across, bell-shaped, dirty yellowish-brown and distinctly striate when moist, drying pallid clay. **Stem** 40–80×2mm, whitish at apex in young specimens, pale yellowish-brown below. **Flesh** concolorous. Smell mealy. **Gills** pale ochraceous then dingy yellowish-brown. Cheilocystidia thin-walled, hyaline, with swollen base and long obtuse neck. Spore print ochre. Spores almond-shaped, faintly ornamented, 9.5–13×5.5–7μ. Habitat amongst moss in damp woods. Season autumn. Occasional. **Edibility unknown**.

Galerina mycenopsis (Fr. ex Fr.) Kühn. syn. *Galera mycenopsis* (Fr. ex Fr.) Quél. **Cap** 0.5–2cm across, hemispherical then broadly bell-shaped, bright ochre-brown and distinctly striate when moist drying pale yellow. **Stem** 30–60×1–2mm, ochraceous with white silky fibres when young. **Flesh** yellowish. Taste and smell not distinctive. **Gills** yellowish, paler than cap. Spore print ochraceous. Spores elliptic, smooth, 9–13×5–6.5μ. Habitat amongst moss. Season late summer to late autumn. Rare. **Edibility unknown**.

Galerina cinctula Orton **Cap** 0.5–1.5cm across, conico-convex becoming expanded and often umbonate, ochraceous tan and striate when moist, drying yellow from centre. **Stem** 10–25×1–2mm, ochraceous, covered below in white silky fibrils. **Flesh** thin, concolorous. Taste and smell mealy. **Gills** pale yellow at first then rusty-ochre. Cheilocystidia skittle-shaped. Spore print rust. Spores almond-shaped, 10–13×5–6μ. Basidia two-spored. Habitat pine woods, often amongst moss. Season summer to autumn. Rare. **Edibility unknown**.

Galerina phillipsii sp. nov. **Cap** 8–18mm across, conico-convex then expanded and acutely umbonate, hygrophanous, dark olive-brown when moist drying rusty-brown and striate. **Stem** 20–40×2–3mm, concolorous with cap except for the paler apex. **Flesh** concolorous with cap and stem. Smell not distinctive. **Gills** olive-brown to rust. Cheilocystidia thin-walled, subcylindric to bottle-shaped, 30–50×5–8μ, sometimes swollen to 10μ at the base. Spore print brown. Spores almond-shaped, ornamented, 9–12×4.5–5(6)μ. Habitat amongst moss on marshy firesite. Season late spring. Rare. **Edibility unknown**.
Latin description by Reid in *Bulletin of the British Mycological Society* Vol. 15, II.

Galerina mutabilis ¾ life size

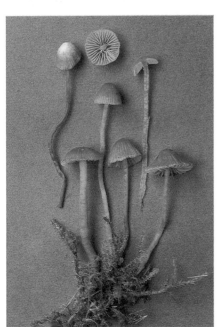

Galerina mniophila life size

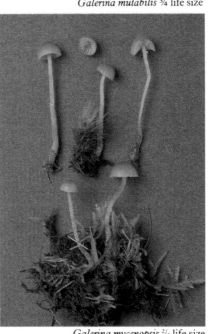

Galerina mycenopsis ⅔ life size

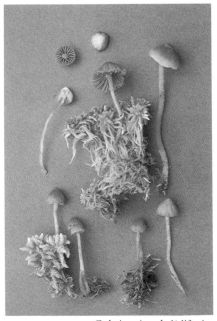

Galerina cinctula ¾ life size

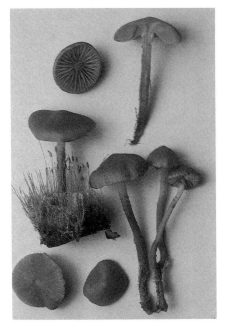

Galerina phillipsii life size

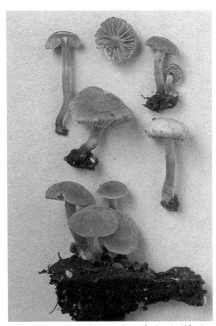

Naucoria scolecina ¾ life size

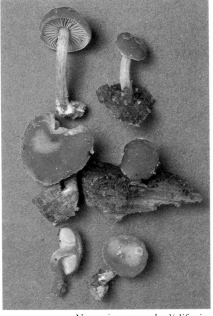

Naucoria centunculus ¾ life size

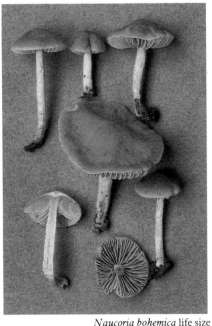

Naucoria bohemica life size

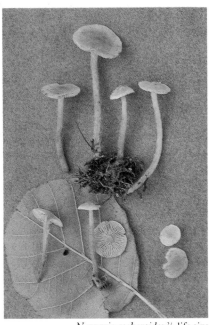

Naucoria escharoides ⅔ life size

NAUCORIA *Small mushrooms most of which grow in association with alder trees. The gills are fawn to rust brown. Twenty-one in Britain.*

Naucoria escharoides (Fr. ex Fr.) Kummer syn. *Alnicola escharoides* (Fr. ex Fr.) Kummer **Cap** 0.7–4cm across, pale yellowish buff when moist drying even paler, not striate. **Stem** 15–40×1–4mm, concolorous with cap, more yellowish towards the apex. **Flesh** thin, brown to buff. Taste radishy or sometimes bitter, smell sweet. **Gills** ochraceous to ochre-brown. Cheilocystidia densely crowded, thin-walled, with swollen base and long narrow neck with acute apex. Spore print brown. Spores brown, almond-shaped and rough, (9)10–13×5–6.5μ. Habitat in damp ground under alders. Season autumn. Frequent. **Not edible**.

Naucoria scolecina (Fr.) Quél. **Cap** 0.5–3cm across, umber to date-brown drying pale ochraceous tan, striate near the margin when

moist. **Stem** 30–50×2–5mm, concolorous with cap, slightly white silky fibrillose, darkening towards the base. **Flesh** brown to tan. Taste mild, smell not distinctive. **Gills** brownish to tan. Cheilocystidia thin-walled, with swollen base and narrow neck terminating in acute apex. Spore print brown. Spores brown, almond-shaped and rough, (9)10–14×5–6.5μ. Habitat under alders. Season autumn. Uncommon. **Not edible**.

Naucoria centunculus (Fr.) Kummer **Cap** 4–25mm across, shallowly convex, velvety pruinose under a lens, tan-brown usually with an olivaceous tinge. **Stem** 6–30×1–3mm, light olive-brown. **Flesh** olive-brown. Smell acidic. **Gills** pale tan-buff often tinged olivaceous. Cheilocystidia and dermatocystidia rather elongated cylindric flexuose often with a swollen apex 6–14μ wide. Spore print brown. Spores brown, bean-shaped, smooth, 6.5–10×4–5.5μ. Habitat on deciduous stumps or logs. Season autumn. Occasional. **Not edible**.

Naucoria bohemica Vel. syn. *Alnicola bohemica* (Vel.) Sing. **Cap** 1–4cm across, date-brown or deep reddish-brown drying paler tan, faintly striate near the margin. **Stem** 30–70×2–5mm, white silky fibrillose becoming tan from the base upwards. **Flesh** thin, pale tan-buff. Taste and smell not distinctive. **Gills** pale tan. Cheilocystidia thin-walled, narrowly cylindric to somewhat flexuose, often slightly enlarged at the obtuse apex. Spore print brown. Spores brown, broadly lemon-shaped and rough, 11–14×6.5–8μ. Basidia two-spored. Cap cuticle cellular but covered by a layer of filamentous hyphae. Habitat with willows and alders. Season autumn. Uncommon. **Not edible**.

157

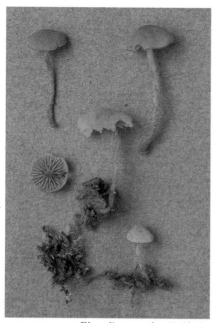

Flocculina granulosa ¾ life size

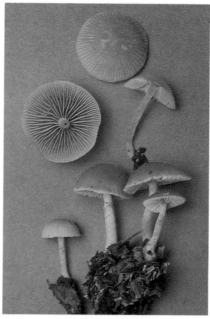

Tubaria furfuracea ¾ life size

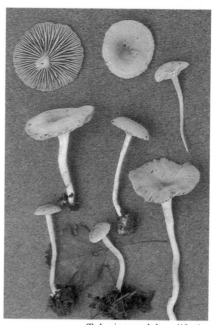

Tubaria autochthona life size

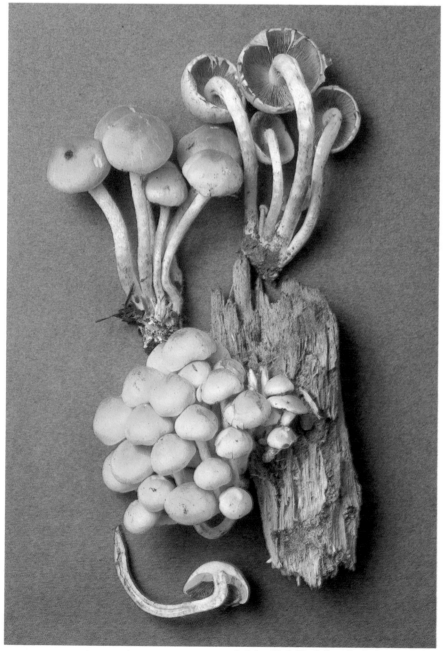

Sulphur Tuft *Hypholoma fasciculare* ½ life size

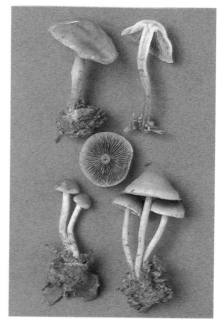

Hypholoma marginatum ½ life size

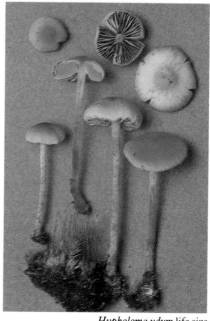

Hypholoma udum life size

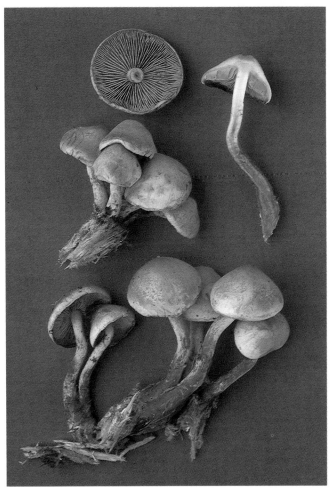

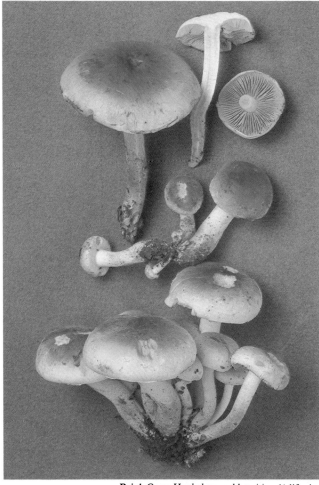

Hypholoma capnoides ½ life size

Brick Caps *Hypholoma sublateritium* ½ life size

Flocculina granulosa (Lange) Orton syn.
Naucoria granulosa Lange **Cap** 5–15mm across,
convex, ochre- to reddish-brown, drying buff,
granular-floccose to minutely papillate-scaly.
Stem 10–20×1–2mm, apex ochre, more brown
below, fibrillose-tomentose and floccose-scaly.
Flesh concolorous. **Gills** ochre-brown.
Cheilocystidia cylindric flexuose. Spore print
rusty-brown. Spores almond-shaped, 8–
9.5×4.5–5μ. Habitat mixed woods. Season
autumn. Occasional. **Not edible.**

Tubaria furfuracea (Pers. ex Fr.) Gillet **Cap** 1–
4cm across, convex then flattened or centrally
depressed, cinnamon to tan and striate from
margin inwards when moist drying pale buff and
slightly scurfy. **Stem** 20–50×2–4mm, more or
less concolorous with the cap, base covered in
white down. **Flesh** concolorous. Taste and smell
not distinctive. **Gills** broad, distant, adnate to
slightly decurrent, cinnamon. Cheilocystidia
thin-walled, hyaline, cylindric to clavate. Spore
print pale ochre. Spores elliptic with rounded
apex, 7–9×4.5–5μ. Habitat on twigs and woody
debris. Season all year, usually autumn to early
winter. Common. **Not edible.**

Tubaria autochthona (Berk. & Br.) Sacc. **Cap**
0.5–2cm across, convex, then flattened, later
centrally depressed, minutely felty, ochre-buff,
margin striate. **Stem** 15–30×1–2mm, whitish,
thickened upwards and often wavy. **Flesh**
whitish. Taste and smell not distinctive. **Gills**
pale lemon becoming tinged ochraceous. Spore
print ochraceous. Spores elliptical, very
minutely roughened, 4.5–7.5×2.5–5μ. Habitat
hawthorn. Season summer to autumn.
Occasional. **Edibility unknown.**

Sulphur Tuft *Hypholoma fasciculare* (Huds. ex

Fr.) Kummer syn. *Geophila fascicularis* (Huds.
ex Fr.) Quél. syn. *Naematoloma fasciculare*
(Huds. ex Fr.) Karst. **Cap** 2–7cm across, convex
or slightly umbonate, remains of the pale yellow
veil often adhering to the margin, bright
sulphur-yellow tinged orange-tan towards the
centre. **Stem** 40–100×5–10mm, often curved,
sulphur at the apex becoming dirty brownish
towards the base with a faint ring zone often
made more obvious by trapped purple-brown
spores. **Flesh** sulphur-yellow, more brownish
towards the stem base. Taste very bitter, smell
mushroomy. **Gills** sulphur-yellow becoming
olivaceous, finally dark brown. Spore print
purplish-brown. Cheilocystidia thin-walled,
cylindric, hair-like. Pleurocystidia broadly
clavate with beak-like apex. Spores oval, with
pore 6–7×4–4.5μ. Habitat in dense clusters on
stumps of deciduous and coniferous trees.
Season all year. Very common. **Not edible.**

Hypholoma marginatum (Pers. ex Fr.) Schroet.
apud Cohn **Cap** 1.5–4cm across, bell-shaped,
dull tan with paler buff margin. **Stem** 30–70×2–
5mm, brownish, covered in white silky fibres
producing a silvery effect, becoming brownish
on handling. **Flesh** whitish in cap becoming
brownish towards the stem base. Taste very
bitter, smell mushroomy. **Gills** pale yellowish
when young soon olivaceous brown.
Cheilocystidia thin-walled, hyaline, hair-like or
bottle-shaped. Pleurocystidia clavate with long
beak-like apex. Spore print dark brown. Spores
elliptic with a distinct pore, 7–9.5×4–5μ.
Habitat under conifers. Season autumn.
Occasional. **Edibility unknown.**

Hypholoma udum (Pers. ex Fr.) Kühn. **Cap** 1–
2cm across, convex to bell-shaped becoming
expanded, dull ochre flushed tan towards the

centre, drying paler ochre, slightly viscid. **Stem**
30–100×2–3mm, pale yellowish at apex,
becoming dark reddish-brown in stem. Smell
mushroomy. **Gills** pale olivaceous at first, later
dark brown. Cheilocystidia thin-walled, hyaline,
hair-like. Pleurocystidia clavate with beak-like
apex. Spore print dark brown. Spores elliptic to
fusiform, slightly ornamented, 13–15×6–6.5μ.
Habitat in peaty, boggy ground. Season autumn.
Uncommon. **Edibility unknown.**

Hypholoma capnoides (Fr. ex Fr.) Kummer **Cap**
2–6cm across, convex with an indistinct umbo,
pale ochraceous flushed tan in the centre, margin
buff. **Stem** 40–100×5–10mm, ochraceous buff
flushed tan from base up, with white cortinal
zone. **Flesh** yellowish. Taste sweetish, smell not
distinctive. **Gills** whitish at first then greyish-
lilac. Cheilocystidia thin-walled, cylindric, hair-
like. Pleurocystidia broadly clavate with beak-
like apex. Spore print dark brown. Spores
ellipsoid-ovate with a distinct pore, 7–8×4–5μ.
Habitat conifer stumps. Season spring to late
autumn. Uncommon. **Edible.**

Brick Caps *Hypholoma sublateritium* (Fr.) Quél.
Cap 3–10cm across, convex, brick red to
reddish-brown at centre on ochraceous ground
often with fibrillose remnants of veil towards
margin. **Stem** 50–180×5–12mm, pale yellow
near the apex becoming ochre brown towards the
base, and with a cortinal zone near the apex.
Flesh pale yellowish, reddish-brown towards stem
base. Taste bitter, smell mushroomy. **Gills** pale
yellowish becoming olive-brown. Cheilocystidia
thin-walled, hair-like. Pleurocystidia clavate
with beak-like apex. Spore print purplish-
brown. Spores elliptic with an indistinct pore,
6–7×3–4.5μ. Habitat stumps of deciduous
trees. Season autumn. Occasional. **Not edible.**

159

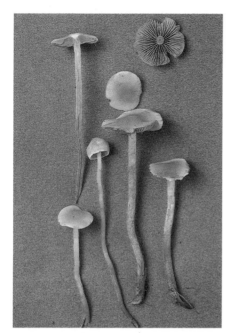

Hypholoma elongatum ¾ life size

Hypholoma elongatum (Pers. ex Fr.) Ricken syn.
Psilocybe elongata (Pers. ex Fr.) Lange **Cap** 1–
2cm across, convex to bell-shaped then flattened,
pale honey-yellow to olivaceous when moist
drying ochre-buff. **Stem** 50–100×1–3mm,
elongated, concolorous with cap, paler at apex,
base covered in white down. **Flesh** thin, whitish
yellow. Taste and smell mushroomy. **Gills** pallid
then pinkish. Spore print dark brown. Spores
elliptic, with pore, 9.5–11.5×6–6.5μ. Habitat
usually amongst sphagnum and polytrichum
moss, also on bare peat. Season autumn.
Frequent. **Edibility unknown.**

AGARICUS *(previously* PSALLIOTA*) The shop
and field mushrooms are members of this genus.
Many species discolour when bruised or cut, either
yellow, red or slightly pinkish. The young gills are
pink or, in some species, white at first. Some species
have an aniseed smell. Most are edible but those
bruising bright yellow should be carefully checked.
Forty in Britain.*

Agaricus silvaticus Schaeff. ex Secr. **Cap** 5–10cm
across, convex, covered in ochre to brown fibrils
breaking up into small adpressed scales. **Stem**
50–80×10–12mm, whitish sometimes with
brownish fibrous scales below the dirty brown
ring. **Flesh** white, reddening on cutting when
fresh, later turning brownish. Taste and smell
not distinctive. **Gills** pale at first then reddish,
later dark brown. Cheilocystidia thin-walled,
clavate. Spore print brown. Spores ovoid, 4.5–
6×3–3.5μ. Habitat coniferous woods. Season
summer to autumn. Rare. **Edible** – good.

A. haemorrhoidarius (formerly a subspecies of *A.
silvaticus*) is distinguished by its different
habitat; it grows in deciduous woods.

Agaricus langei (Møller) Møller syn. *Psalliota
langei* Møller **Cap** 4–12cm across, convex,
densely covered in fine rust brown fibrous scales.
Stem 30–120×15–30mm, whitish with pink
tinge and slightly mealy beneath the white
pendulous ring. **Flesh** white gradually becoming
bright red on cutting. Taste and smell pleasant
and mushroomy. **Gills** pale fawny-pink at first
becoming darker with age. Cheilocystidia
numerous, thin-walled, tufted, ovate to broadly-
clavate, hyaline or brownish, 20–50×10–30μ.
Spore print purple-brown. Spores elliptic, 7–
9×3.5–5μ. Habitat in coniferous or mixed

woods. Season late summer to autumn.
Occasional. **Edible** – good.

Agaricus bernardii (Quél.) Sacc. syn. *A.
campestris* subsp. *bernardii* (Quél.) Konrad &
Maubl. **Cap** 5–15cm across, hemispherical then
flattened convex and often depressed, whitish to
light brown, bruising reddish on handling,
surface soon disrupting into coarse brownish
scales. **Stem** 50–70×20–40mm, whitish,
narrowing slightly at the greyish-brown base;
ring sheathing, whitish and narrow. **Flesh** white
becoming reddish orange on cutting. Taste
slightly unpleasant, smell fishy. **Gills** pale grey
then flesh-coloured becoming dark brown.
Cheilocystidia thin-walled, elongate, cylindric,
clavate or fusiform. Spore print dark brown.
Spores broadly ovoid, 5.5–7×5–5.5μ. Habitat
on sand dunes and meadows near the sea, also on
roadsides inland, possibly due to the practice of
salting the roads in icy weather. Season autumn.
Uncommon. **Edible.**

Agaricus vaporarius (Vitt.) Mos. syn. *Psalliota
vaporaria* (Vitt.) Møller & Schaeff. **Cap** 10–15cm
across, subglobose at first expanding to flattened

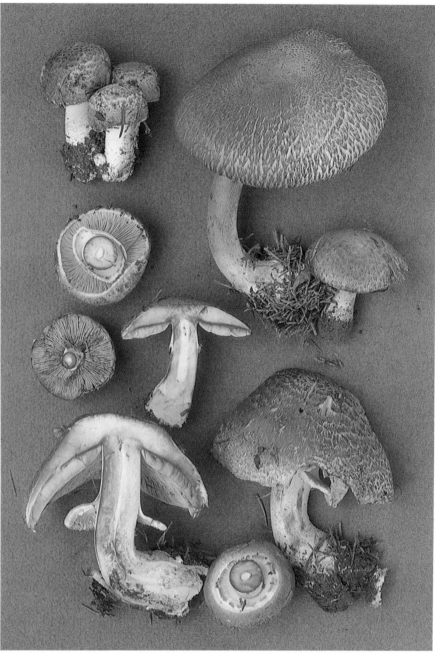

Agaricus silvaticus ⅔ life size

convex, dirty brown soon breaking up into large
scales. **Stem** 60–120×25–50mm, tapering at the
base which is deeply buried in the soil, white and
smooth although initially with brown fibrous
scales; ring thick and white, pendulous. **Flesh**
white, reddening only slightly on cutting. Taste
nutty, smell mushroomy. **Gills** pale pink at first
later chocolate brown. Cheilocystidia numerous,
thin-walled, clavate, hyaline, 18–28×4–10μ.
Spore print brown. Spores subglobose, 6–
7×4.5–6μ. Habitat gardens and deciduous
woods often developing below ground and
pushing up through the soil as it expands. Season
autumn. Rare. **Edible.**

Agaricus porphyrocephalus Møller syn. *Psalliota
porphyrea* Møller **Cap** 3–8cm across,
hemispherical to flat, brown, with darker
radiating fibrils. **Stem** 30–40×10–20mm, white,
slightly tapering towards the base or sometimes
slightly swollen and bulbous; ring thin and
white. **Flesh** white to pale flesh-coloured. Taste
and smell mushroomy. **Gills** pink at first, later
chocolate brown. Cheilocystidia absent. Spore
print brown. Spores 5–7×3–4.5μ. Habitat lawns
or pastures. Season autumn. Rare. **Edible.**

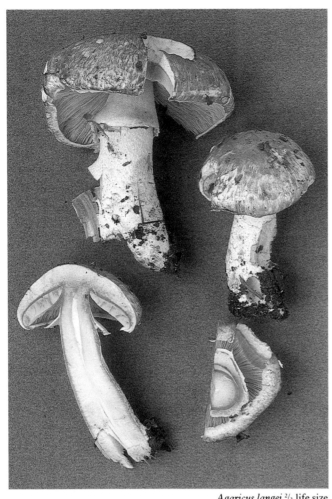

Agaricus langei ²/₃ life size

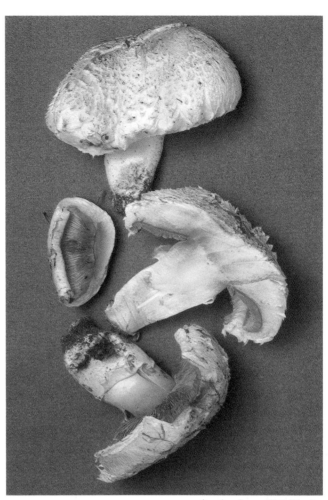

Agaricus bernardii ½ life size

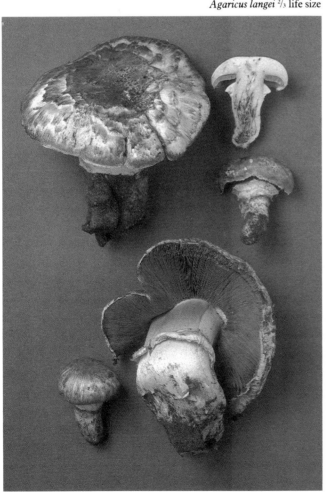

Agaricus vaporarius ½ life size

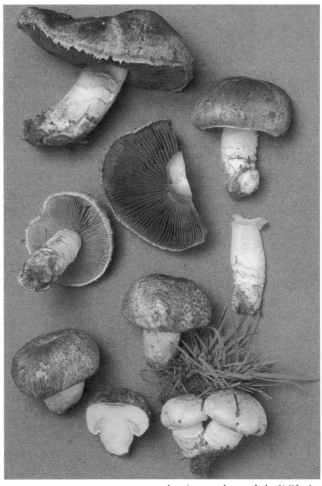

Agaricus porphyrocephalus ¾ life size

161

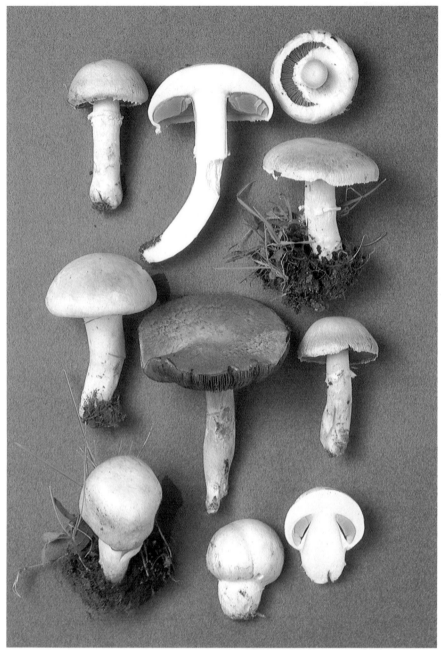

Field Mushroom *Agaricus campestris* L. ex Fr. syn. *Psalliota campestris* (L. ex Fr.) Quél. **Cap** 3–10cm across, domed and remaining so a long time before expanding fully, white sometimes creamy yellow, scaly or smooth. **Stem** 30–100×10–15(20)mm, white sometimes yellowing slightly towards the tapered base; ring thin and white, short-lived, often little more than a torn frill. **Flesh** white, bruising faintly pink especially above the gills. Taste and smell pleasant and mushroomy. **Gills** deep pink even in unopened 'buttons', finally darkening to brown. Cheilocystidia lacking. Spore print brown. Spores ovoid, 7–8×4–5μ. Habitat in pastureland. Season late summer to autumn. Frequent. **Edible** – excellent.

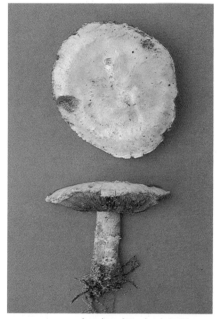

Field **Mushroom** *Agaricus campestris* ½ life size

Agaricus devoniensis ½ life size

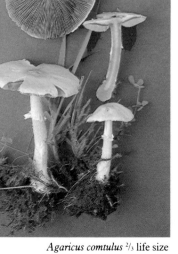

Agaricus semotus ½ life size

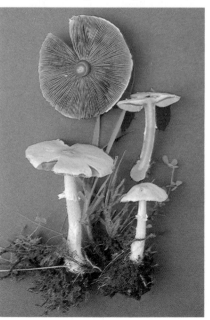

Agaricus comtulus ⅔ life size

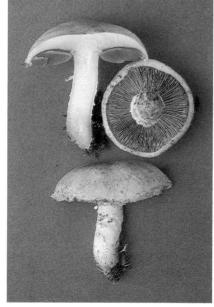

Agaricus litoralis ½ life size

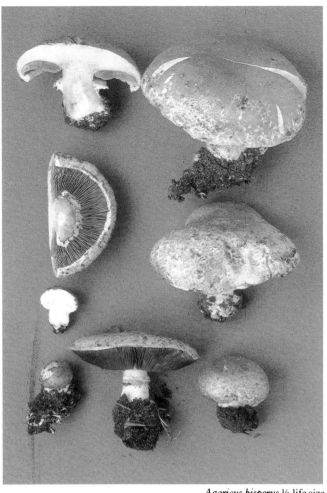

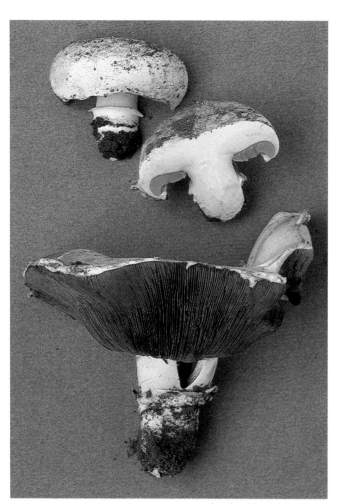

Agaricus bisporus ½ life size

Agaricus bitorquis ¾ life size

Agaricus devoniensis Orton syn. *Psalliota arenicola* Wakef. & Pearson **Cap** 3–15cm across, convex to flattened-convex, whitish and silky tinted pinkish or violaceous. **Stem** 30–40×10–15mm, white covered in scaly remnants of the veil, bruising reddish; ring sheathing, white and short-lived. **Flesh** white, tinted pink above the gills and in the lower stem. Taste and smell mushroomy but not distinctive. **Gills** free, greyish pink darkening with age. Cheilocystidia thin-walled, tufted, clavate, hyaline or brownish, 36–50×10–13μ. Spore print dark brown. Spores subglobose, 6.5–7×5–5.5μ. Habitat on sand dunes, only noticeable after the expanded cap has pushed up through the sand. Season late summer to autumn. Rare. **Edible.**

Agaricus semotus Fr. syn. *A. comtulus* var. *amethystinus* (Quél.) Konrad & Maubl. syn. *Psalliota amethystina* (Quél.) Lange **Cap** 2–5cm across, obtusely ovoid expanding flattened-convex, white at first soon covered in small lilaceous scales at the centre with vinaceous fibres radiating out towards the white margin, finally yellowing to a dirty brownish. **Stem** 30–60×4–8mm, white but yellowing at the bulbous base; ring double, pendulous. **Flesh** white, staining yellow in stem base. Taste and smell not distinctive. **Gills** very pale at first then pinkish, finally grey-brown. Cheilocystidia numerous, thin-walled, ovate to broadly clavate, hyaline or brownish, 12–26×4–14μ. Spore print brown. Spores elliptic, 4.5–5×2.5–3μ. Habitat in clearings and on the edges of deciduous and

coniferous woods. Season summer to autumn. Rare. **Poisonous** to some people; best avoided.

Agaricus comtulus Fr. syn. *Psalliota comtula* (Fr.) Quél. **Cap** 2–4cm across, convex expanding flat, white to ochraceous-cream. **Stem** 30–50×4–6mm, white or creamy, not bruising yellow; ring white and membranous. **Flesh** white but yellowing slightly in the stem base. Taste almondy, smell faintly of almonds or aniseed. **Gills** flesh-pink at first, darkening with age. Spore print brown. Spores ovate, 4.5–5.5×3–3.5μ. Habitat in pastureland. Season late summer to autumn. Occasional. **Edible.**

Agaricus litoralis (Wakef. & Pearson) Konrad & Maubl. syn. *Psalliota litoralis* Wakef. & Pearson **Cap** 5–8cm across, convex, pale buff at first becoming more tawny with age, covered in fibrous scales, margin overhanging and slightly shaggy. **Stem** 30–40×15–20mm, white becoming tawny near the base; ring white, sheathing, flaky. **Flesh** thick, white in cap becoming tawny at the stem base. Smell not distinctive. **Gills** very crowded, free, pale pink-buff at first darkening to chocolate brown. Spore print brown. Spores ellipsoid, 6–8×4.5–5μ. Habitat in short grass near the sea. Season late summer to autumn. Rare. **Edibility unknown.**

Agaricus bisporus (Lange) Pilát **Cap** 5–10cm across, hemispherical expanding convex,

greyish-brown to umber covered in brown radiating fibres and often slightly scaly with age. **Stem** 35–55×8–14mm, white, often flaky below the membranous sheathing ring. **Flesh** white bruising faintly red. Taste and smell mushroomy. **Gills** dirty pinkish darkening with age. Cheilocystidia thin-walled, elongate-clavate, 17–44×7–14μ. Spore print brown. Spores ovate to subglobose, 4–7.5×4–5.5μ. Basidia two-spored, separating this species from the rest of this genus which all have four-spored basidia. Habitat on manure heaps, garden waste and roadsides, not in grass. Season late spring to autumn. Occasional. **Edible.** This species is believed to be the wild 'parent' of many of the cultivated crop varieties, all of which have two-spored basidia.

Agaricus bitorquis (Quél.) Sacc. syn. *A. edulis* (Witt.) Møller & Schaeff. syn. *A. campestris* subsp. *bitorquis* (Quél.) Konrad & Maubl. syn. *Psalliota rodmanii* (Peck) Kauffm. **Cap** 4–10cm across, convex soon flattened, white with faintly ochraceous flakes. **Stem** 30–60×15–20mm, white with two separate sheathing rings, the lower thinner and resembling a volva. **Flesh** white, tinged faintly pink on cutting. Taste mushroomy, smell pleasant. **Gills** dirty pink at first, soon clay, finally dark chocolate brown. Cheilocystidia thin-walled, clavate. Spore print brown. Spores subglobose, 4–6.5×4–5μ. Habitat in gardens and at roadsides, sometimes found growing through asphalt. Season late spring to autumn. Occasional. **Edible – good.**

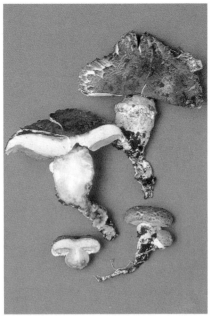

Agaricus lanipes ⅓ life size

Agaricus bresadolianus ½ life size

Agaricus lanipes (Møll. & Schaeff.) Sing. **Cap** 5–10cm across, convex at first then depressed at the centre and undulate, chocolate brown and breaking up into broad, flattened scales especially towards the margin. **Stem** 40–60×20–35mm, squat, narrowing at the apex, swollen towards the slightly bulbous base which tapers into a whitish root-like mycelial strand 1–10mm thick, white above the ring, brownish and slightly scaly below, bruising rust; ring white on upper surface, brownish below. **Flesh** white becoming reddish on cutting especially at the stem apex and orange at the base. Taste sweet and mushroomy, smell mushroomy. **Gills** free, crowded, pale pink at first later dark brown. Cheilocystidia thin-walled, tufted, clavate, hyaline, 16–28×8–14μ. Spore print dark brown. Spores elliptic, 5.5–6.5×3.5–4μ. Habitat in deciduous woods and manured fields. Season summer to late autumn. Rare. **Edible** – delicious.

Agaricus bresadolianus Bohus syn. *A. campestris* var. *radicatus* Vitt. **Cap** 5–10cm across, convex becoming expanded and slightly depressed at the centre, margin finally wavy, whitish to buff covered in buff to grey-brown fibrils, more densely so towards the centre. **Stem** 30–70×8–16mm, slightly swollen towards the rooting base, white flushed yellowish-buff especially at the base; ring white and narrow, short-lived, leaving an indistinct ring zone in older specimens. **Flesh** whitish, bruising faintly brown beneath the cap cuticle. Taste and smell slight and pleasant. **Gills** crowded, pale pink, finally blackish-brown. Cheilocystidia absent. Spore print dark brown. Spores elliptical to ovate, 6–7×4–4.5μ. Habitat amongst grass in open deciduous woodland or gardens. Season summer. Very rare. **Edibility unknown**.

The Prince *Agaricus augustus* Fr. syn. *Psalliota augusta* (Fr.) Quél. **Cap** 10–20cm across, obtusely ovoid at first expanding convex, yellowish-brown covered in chestnut-brown fibrous scales. **Stem** 100–200×20–40mm, whitish with small scales below the ring which discolour brownish with age, bruising yellowish; ring white, large and pendulous. **Flesh** thick and white, becoming tinged reddish with age. Taste mushroomy, smell strongly of bitter almonds. **Gills** free, white at first then brown. Cheilocystidia formed of chains of bladder-shaped elements. Spore print purple brown. Spores ellipsoid, 7–10×4.5–5.5μ. Habitat in coniferous and deciduous woods. Season late summer to autumn. Uncommon. **Edible** – good.

Agaricus macrosporus (Møller & Schaeff.) Pilát syn. *Psalliota arvensis* subsp. *macrospora* Møller & Schaeff. **Cap** 8–25(50)cm across, convex, whitish splitting into large ochraceous scales or patches and the margin becoming toothed with age. **Stem** 50–100×25–35mm, frequently with a fusiform rooting base, whitish cream covered in easily removable floccules; ring thick and scaly on the underside. **Flesh** firm and whitish, sometimes reddening in the stem on cutting. Taste mushroomy, smell faint of crushed almonds when young, rapidly smelling more ammoniacal. **Gills** whitish-grey at first, finally dark brown. Cheilocystidia numerous, ovate, 8–31×6–16μ. Spore print brown. Spores ellipsoid, 8–12×5.5–6.5μ. Habitat in rings in pastureland. Season summer to autumn. Occasional. **Edible** – good.

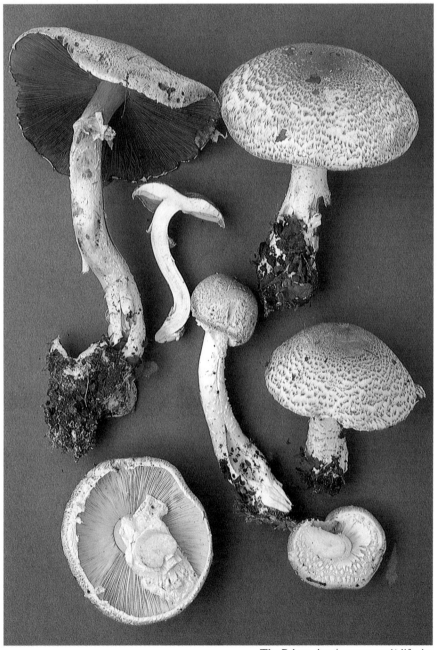

The Prince *Agaricus augustus* ½ life size

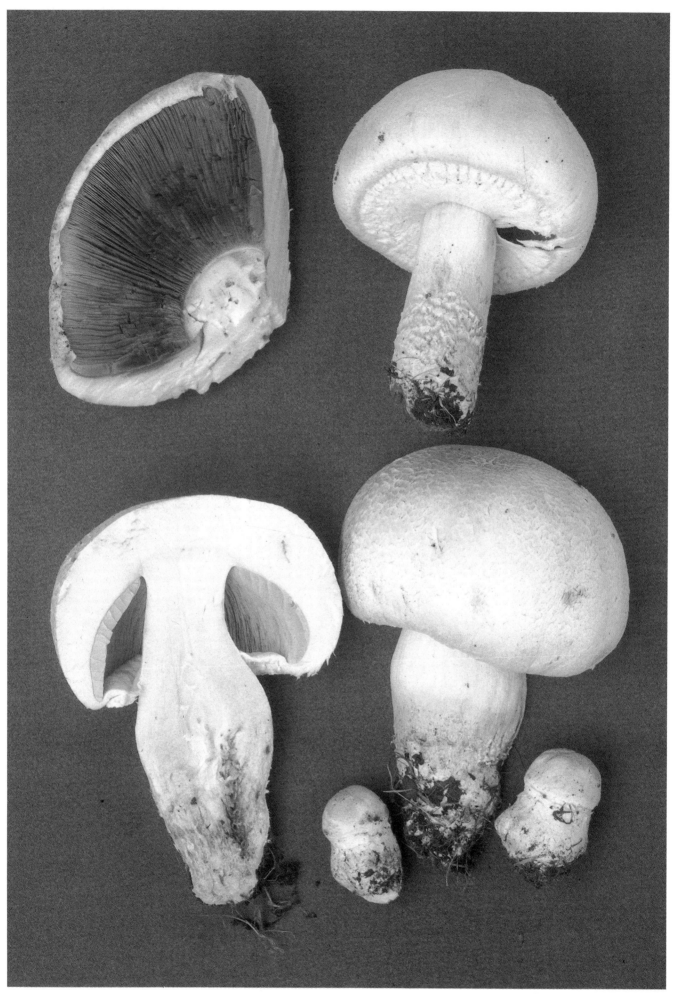

Agaricus macrosporus ²/₃ life size

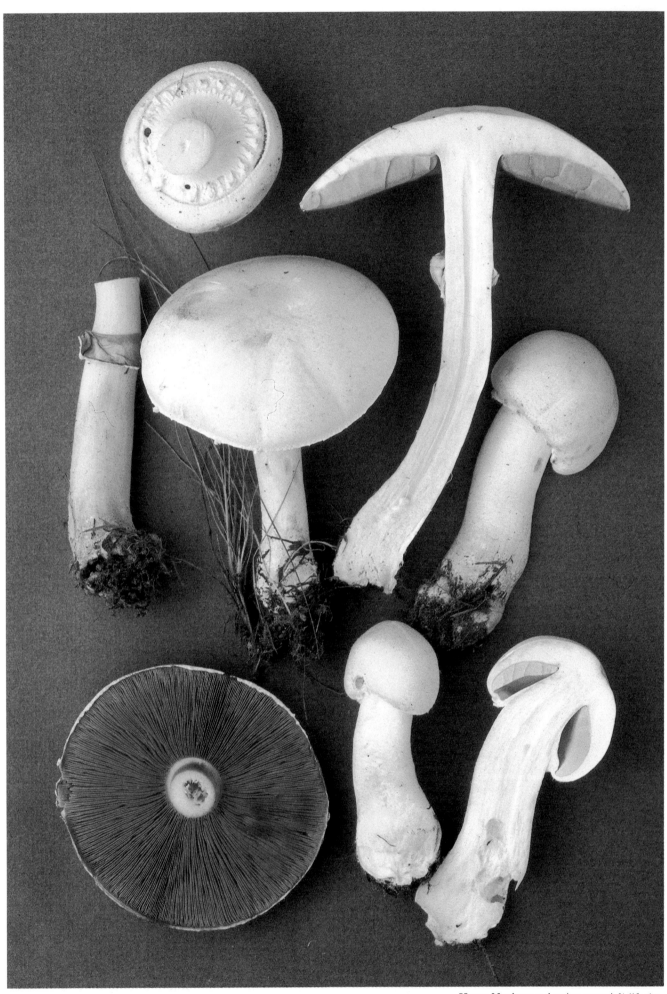

Horse Mushroom *Agaricus arvensis* ²/₃ life size

Horse Mushroom *Agaricus arvensis* Schaeff. ex
Secr. s. Lange non Cooke syn. *Psalliota arvensis*
(Schaeff. ex Secr.) Kummer **Cap** 8–20cm across,
ovate at first expanding convex, creamy white
yellowing slightly with age or on bruising. **Stem**
80–100×20–30mm, often slightly clavate at the
base, concolorous with the cap, the ring is
formed of a double membrane, the lower
splitting into a star-shape around the stem. **Flesh**
white, thick and firm in the cap, pithy in the stem
which tends to become hollow. Taste
mushroomy, smell of aniseed. **Gills** free, white at
first then flesh-pink, finally chocolate brown
with age. Cheilocystidia thin-walled, ovate
balloon-shaped 11–26×9–18(21)μ. Spore print
dark purple-brown. Spores ellipsoid, 7–8×4.5–
5μ. Habitat amongst grass in pasture or thickets
often in rings. Season autumn. Frequent. **Edible**
– excellent.

Yellow Stainer *Agaricus xanthodermus* Genevier
syn. *Psalliota xanthoderma* (Genevier) Richon &
Roze **Cap** 5–15cm across, subspherical with the
top flattened later expanded convex, white at first
later often with tiny indistinct greyish-brown
scales and bruising bright chrome-yellow,
especially towards the margin. **Stem** 50–
150×10–20mm, white, bulbous at the base; ring
white with a thickened edge which can cause it to
appear double. **Flesh** white, staining chrome-
yellow in the stem base. Taste slightly
unpleasant, smell slightly of ink. **Gills** white at
first then pale pink, finally grey-brown.
Cheilocystidia thin-walled, subglobose or ovate,
hyaline, 10–20×8–14μ. Spore print purple-
brown. Spores ellipsoid, 5–6.5×3–4μ. Habitat
in woods, meadows and gardens. Season summer
to autumn. Occasional. **Poisonous**. The
symptoms are sweating, flushing and severe
stomach cramps, but only some people are
affected.

Agaricus pilatianus Bohus syn. *A. xanthodermus*
var. *pilatianus* Bohus **Cap** 6–12cm across,
obtusely convex, white at first becoming smoky-
or greyish-brown, bruising yellow when young.
Stem 40–80×15–30mm, cylindrical, slightly
clavate or tapering at the base, white becoming
tinged ochraceous to brownish; ring white,
double. **Flesh** white, staining yellow in the stem
base. Taste strong and unpleasant, smell
unpleasant, strongly of carbolic. **Gills** white at
first then pink, finally chocolate brown.
Cheilocystidia clavate to broadly clavate, 22–
30×11–13.5μ. Spore print brown. Spores
broadly ovate, 5.5–6.5×4.3–5.3μ. Habitat in
short grass in gardens or on lawns. Season
autumn. Rare. **Poisonous**.

Agaricus excellens (Møller) Møller syn. *Psalliota
excellens* Møller **Cap** 10–15cm across, convex,
white and silky, yellowing slightly at the centre
especially with age, densely covered in minute
fibrous scales of the same colour. **Stem** 100–
140×20–35mm, white; ring thick and white, the
underside scaly. **Flesh** thick, white, becoming
more or less pink on cutting. Taste sweet and
mushroomy, smell slightly of aniseed. **Gills** pale
grey-pink. Cheilocystidia thin-walled, globose or
ovate to broadly clavate, hyaline, 10–38×5–16μ.
Spore print brown. Spores elliptic, 9–12×5–7μ.
Habitat amongst grass in open woodland,
especially spruce. Season autumn. Rare. **Edible**.

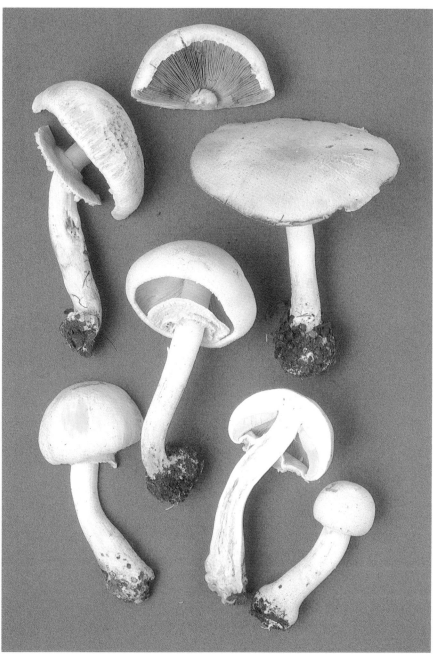

Yellow Stainer *Agaricus xanthodermus* ²/₃ life size

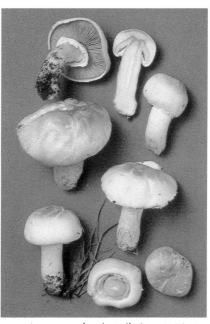

Agaricus pilatianus ⅓ life size

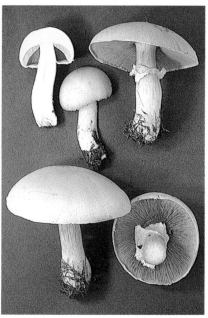

Agaricus excellens ⅓ life size

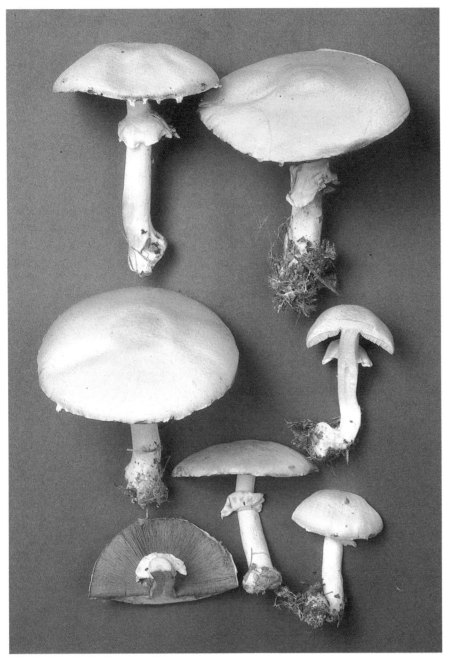

Wood Mushroom *Agaricus silvicola* ²/₃ life size

Agaricus placomyces Peck syn. *Psalliota meleagris* Schaeff. **Cap** 5–9cm across, ovoid at first becoming expanded, densely covered with tiny grey-brown scales, especially towards the centre, on a whitish ground. **Stem** 60–90×10–12mm, bulbous, whitish, initially covered in conspicuous flakes below the large membranous ring. **Flesh** white, discolouring faintly yellowish and later pale brown. Cap, stem and flesh bruise yellow. Taste and smell strong and unpleasant. **Gills** remaining light pink for a long time, at length blackish-brown. Cheilocystidia thin-walled, hyaline, globose or pear-shaped. Spore print brown. Spores elliptic, 4–6×3–4µ. Habitat woodland. Season summer. Uncommon. **Suspect** – avoid.

Agrocybe erebia (Fr.) Kühn. syn. *Pholiota erebia* (Fr.) Gillet **Cap** 3–6cm across, convex becoming flattened with a broad umbo, the margin wavy in older specimens, dull clay-brown when dry, darker and slightly viscid when moist. **Stem** 60–80×8–12mm, whitish at first gradually darkening brown from base upwards, with whitish grooved ring. **Flesh** pale brownish. **Gills** pale at first then dark umber brown. Spore print very dark brown. Spores ellipsoid, 10–13×5–6µ. Cap cuticle cellular. Habitat on bare soil or in leaf litter in deciduous woods. Season autumn. Frequent. **Not edible** – easily confused with poisonous species.

Agrocybe praecox (Pers. ex Fr.) Fayod syn. *Pholiota praecox* (Pers. ex Fr.) Kummer **Cap** 3–6cm across, convex, ochraceous-cream or light tan, drying almost whitish with darker margin. **Stem** 40–60×4–8mm, cream, with ring. **Flesh** whitish cream becoming brown in stem with age. Smell mealy. **Gills** adnate, pale reddish-brown at first darkening with age. Spore print cigar brown. Spores ovoid-ellipsoid, 9–10×5–5.5µ. Cap cuticle cellular. Habitat amongst grass, usually in shady places, e.g copses. Season late spring to late autumn. Uncommon. **Edible**.

Wood Mushroom *Agaricus silvicola* (Vitt.) Peck **Cap** 5–10cm across, convex, cream, readily bruising ochraceous and becoming more yellow with age. **Stem** 50–80×10–15mm, concolorous with the cap, base usually bulbous; ring large and pendulous, upper surface white, lower drab. **Flesh** thin, white. Taste mushroomy, smell of aniseed. **Gills** free, pale greyish-pink at first later chocolate brown. Cheilocystidia numerous, thin-walled, oval to subglobose, hyaline, 10–20×7–20µ. Spore print purple-brown. Spores ellipsoid 5–6×3–4µ. Habitat in coniferous and deciduous woods. Season autumn. Occasional. **Edible** – good.

Agrocybe semiorbicularis (Bull. ex St. Amans) Fayod syn. *Naucoria semiorbicularis* (Bull. ex St. Amans) Quél. **Cap** 1–2cm across, hemispherical to flattened convex, ochraceous to tan. **Stem** 25–40×2–3mm, pallid flushed with cap colour. **Flesh** ochraceous darkening to tan towards stem base. Smell mealy. **Gills** adnate, very broad, pale ochraceous at first gradually becoming dark cinnamon with age. Spore print cigar brown. Spores ovoid, 11–13×7.5–8µ. Habitat amongst grass on lawns, roadsides and sand-dunes. Season late summer to autumn. Occasional. **Edible**.

Agaricus abruptibulbus Peck **Cap** 8–12cm across, convex, often with a slight umbo, whitish bruising yellowish. **Stem** 80–120×10–30mm at the characteristic, abruptly marginate bulb, coloured as cap; ring large, white and pendulous, with cog-wheel ornamentation on lower side. **Flesh** white, becoming yellowish to brownish when cut. Smell of aniseed. **Gills** pallid at first then clay brown. Cheilocystidia thin-walled, oval or globose. Spore print brown. Spores elliptic, 6–8×4–5µ. Habitat with spruce. Season late summer to late autumn. Occasional. **Edible**.

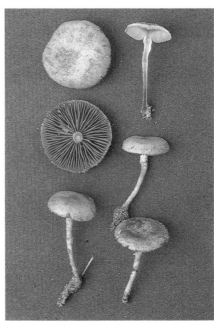

Agrocybe semiorbicularis ¾ life size

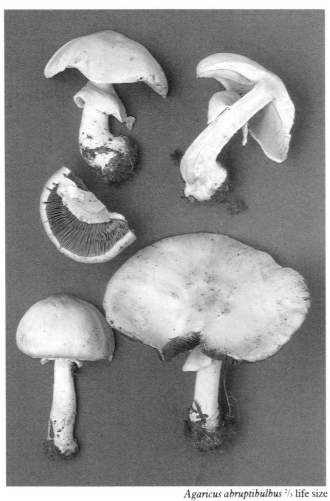

Agaricus abruptibulbus ²/₃ life size

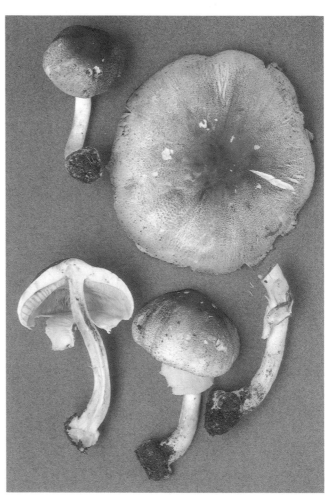

Agaricus placomyces ²/₃ life size

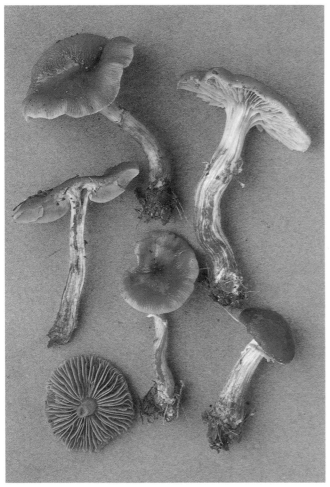

Agrocybe erebia ²/₃ life size

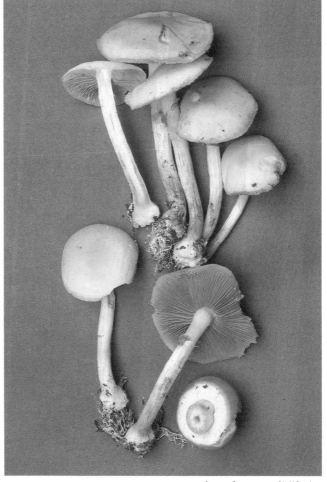

Agrocybe praecox ²/₃ life size

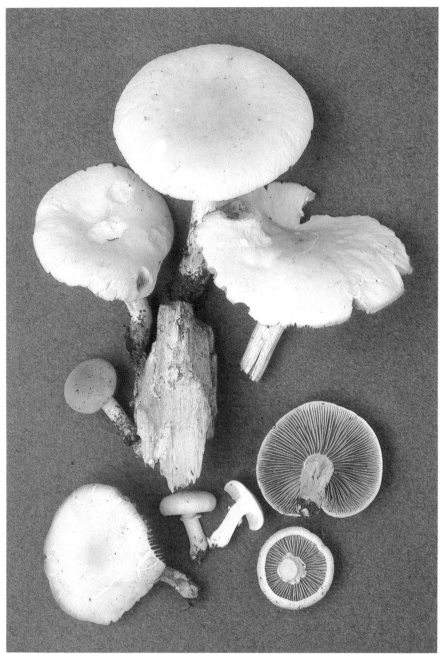

Agrocybe cylindracea ⅔ life size

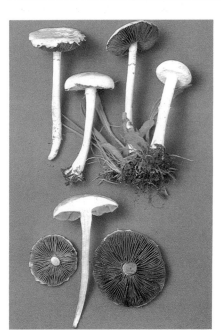

Agrocybe dura ½ life size

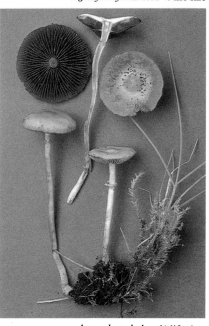

Agrocybe paludosa ¾ life size

Agrocybe cylindracea (DC. ex Fr.) Maire syn. *Pholiota aegerita* (Brig.) Quél. **Cap** 4–10cm across, hemispherical convex becoming flattened and sometimes cracked at centre and often wavy near the margin, pale buff to almost white with rust flush at centre when young becoming darker brown with age. **Stem** 50–100×10–15mm, cream at first, darker brown with age, with persistent ring which soon becomes dusted brown by the spores. **Flesh** white in the cap and stem, brown in the stem base. Taste nutty, smell of old wine casks. **Gills** adnate or slightly decurrent, cream at first then tobacco brown due to the spores. Spore print tobacco brown. Spores ovoid-ellipsoid, 8.5–10.5×5–6μ. Cap cuticle cellular. Habitat in tufts especially willows and poplars. Season all year round. Rare. **Edible**.

Agrocybe dura (Bolt. ex Fr.) Sing. syn. *Pholiota dura* (Bolt. ex Fr.) Kummer **Cap** 3–7cm across, convex expanding to almost flat, ivory white to yellowish cream. **Stem** 50–80×3–7mm, whitish with cottony ring near apex. **Flesh** thick, firm, whitish. Taste slightly bitter, smell mushroomy. **Gills** adnate, pale at first then darker clay. Spore print light cigar brown. Spores ovoid-ellipsoid, 12–13×6–7.5μ. Cap cuticle cellular. Habitat singly in grass at roadsides or in meadows. Season spring to late summer. Occasional. **Edible**– poor.

Agrocybe paludosa (Lange) Kühn. & Romagn. syn. *Pholiota praecox* var. *paludosa* Lange **Cap** 1.5–3cm across, convex then flattened with broad umbo, dirty cream to pale tan, especially at the centre. **Stem** 40–70×2–3mm, cream flushed with cap colour, ring near apex, rather broad and fragile. **Flesh** thin, whitish in cap, brownish in stem. Smell of meal. **Gills** adnate, pale at first then darker brown. Spore print light cigar-brown. Spores ovoid-ellipsoid, 9–10×5–5.5μ. Cap cuticle cellular. Habitat in marshy meadows. Season late spring to summer. Rare. **Not edible**.

Verdigris Agaric *Stropharia aeruginosa* (Curt. ex Fr.) Quél. **Cap** 2–8cm across, convex to bell-shaped then flattened and slightly umbonate, blue to blue-green from the gluten and flecked with white scales, becoming pale yellowish as this is lost. **Stem** 40–100×4–12mm, whitish to blue, apex smooth, covered in small whitish scales below the spreading membranous ring. **Flesh** whitish-blue. Smell none. **Gills** white then clay brown, often with a white edge. Cheilocystidia obtuse, clavate-capitate or lageniform capitate; lanceolate chrysocystidia found on gill face and only rarely on gill-edge. Spore print brownish-purple. Spores elliptic, 7–10×5μ. Habitat woods, heaths and pastures. Season late spring to late autumn. Common. **Poisonous.**

Stropharia merdaria (Fr.) Quél. syn. *Psilocybe merdaria* (Fr.) Ricken **Cap** 2–5cm across, obtusely bell-shaped then flattened convex, ochraceous, more cinnamon when moist, viscid. **Stem** 50–75×4–6mm, dry, whitish flushed straw-yellow, base covered in white down. **Flesh** white, becoming brownish in stem when old. Smell none. **Gills** pallid then purplish-brown. Cheilocystidia thin-walled, hyaline, lageniform. Spore print brown-black. Spores broadly elliptical and often somewhat angular, with germ-pore, 10–16×8–9μ. Habitat on horse dung. Season late summer to autumn. Uncommon. **Edibility unknown.**

Dung Roundhead *Stropharia semiglobata* (Batsch. ex Fr.) Quél. **Cap** 1–3cm across, hemispherical, light yellow, viscid. **Stem** 60–100×2–3mm, yellowish, apex paler, viscid below the ring; ring incomplete, often represented by zone of blackish fibrils. **Flesh** thin, pallid. **Gills** purplish-brown becoming black-spotted. Spore print dark purplish-brown. Spores elliptic, 15–17×9–10μ. Habitat on dung. Season spring to late autumn. Common. **Not edible.**

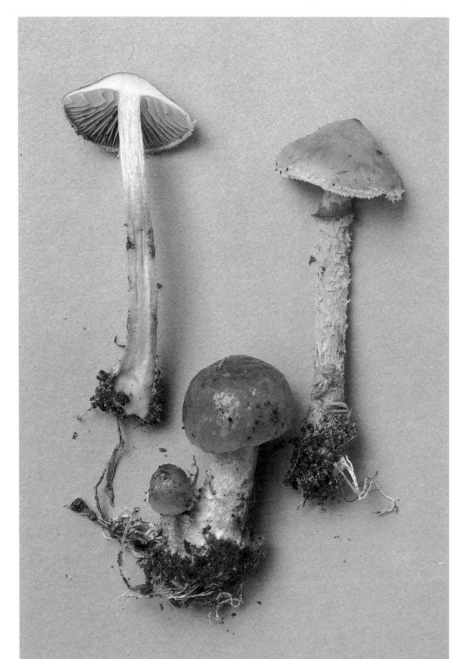

Verdigris Agaric *Stropharia aeruginosa* ¾ life size

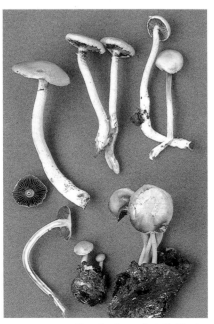

Stropharia merdaria ²/₃ life size

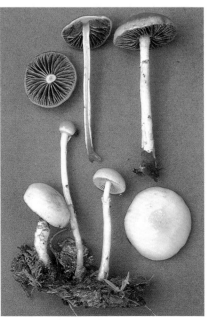

Dung Roundhead *Stropharia semiglobata* ½ size

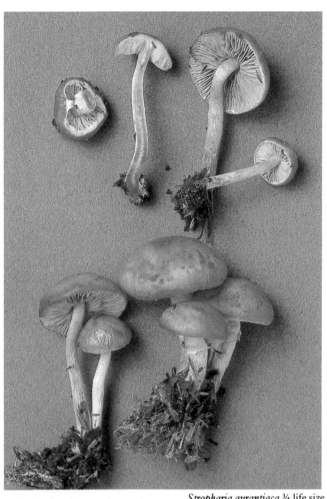

Stropharia aurantiaca ¾ life size

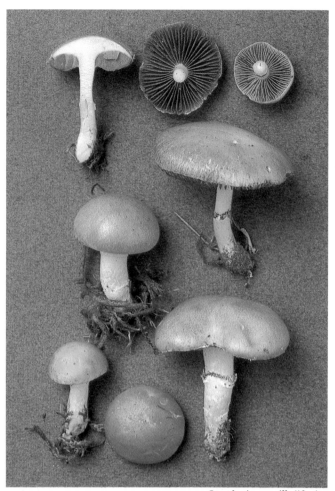

Stropharia coronilla life size

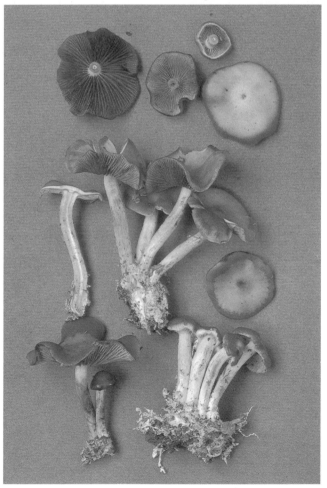

Psilocybe cyanescens ²/₃ life size

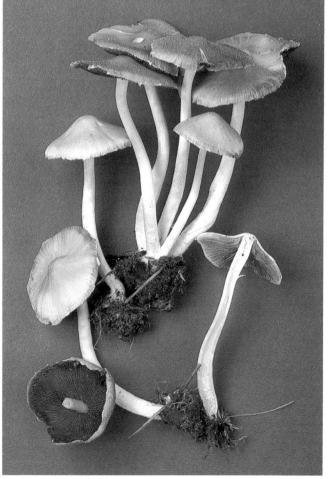

Psathyrella candolleana ²/₃ life size

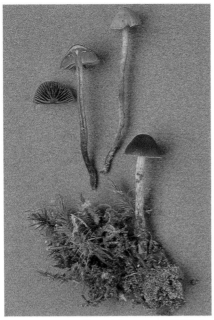

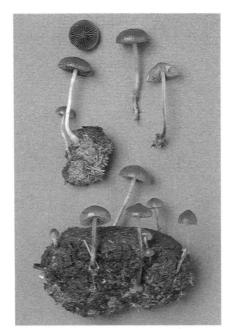

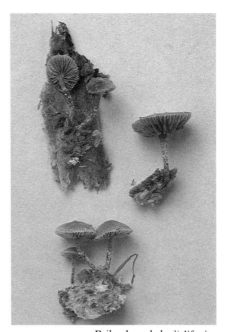

Deconica muscorum ⅔ life size

Deconica coprophila ½ life size

Psilocybe crobulus ⅔ life size

Stropharia aurantiaca (Cke.) Orton **Cap** 1.5–
5.5cm across, convex then expanded, orange-red
with paler patches when dry, viscid when moist,
margin often with whitish velar remnants. **Stem**
20–100×2–10mm, slightly thickened at base,
whitish becoming streaked ochraceous or
orange-red below. **Flesh** pale buff to
concolorous. **Gills** whitish at first then
olivaceous-clay. Pleurocystidia thin-walled,
lanceolate with a sharp-pointed apex and
yellowish contents. Cheilocystidia variable in
shape, mostly thin-walled and lageniform often
with flexuous necks, sometimes irregularly
cylindric or clavate with a swollen or even
capitate apex. Spore print dark purplish-brown.
Spores elliptic, 11–13×6–7.5μ. Habitat on
rotting sawdust, usually in parks or gardens.
Season autumn. Rare. **Edibility unknown.**

Stropharia coronilla (Bull. ex Fr.) Quél. syn. *S.
obturata* (Fr.) Quél. **Cap** 2–4cm across, convex
then flattened, light yellow, slightly viscid or
greasy. **Stem** 25–40×6–8mm, white tapering
towards base; ring white, but often accentuated
by trapped deposit of dark spores. **Flesh** thick,
white. **Gills** white then clay-brown.
Pleurocystidia broadly lanceolate with acutely
pointed apex, staining deeply in aniline blue in
lactic acid. Spore print purple-brown. Spores
elliptic with indistinct pore, 7–9×4–6μ. Habitat
lawns and pasture. Season autumn. Common.
Edible – not worthwhile.

Psilocybe cyanescens Wakefield **Cap** 2–4cm
across, convex then expanded and irregularly
wavy, hygrophanous, reddish buff drying
ochraceous cream, developing blue-green tints
when handled. **Stem** 25–50×5–8mm, white,
bruising strongly blue to blue-green; cortinate
ring forming indistinct ring zone. **Flesh** whitish,
tinged bluish in places. Smell mealy. **Gills** pale
ochre-clay at first becoming dark brown.
Chrysocystidia lacking. Cheilocystidia thin-
walled, lageniform. Spore print dark purplish-
brown. Spores elliptic to almond-shaped, 9–
12×5–7μ. Habitat on rotting sawdust and other
herbaceous debris. Season late autumn to early
winter. Rare. **Hallucinogenic.**

PSATHYRELLA *The stem is brittle and usually
has a mottled white silvery appearance. Fifty-seven
in Britain.*

Psathyrella candolleana (Fr.) Maire **Cap** 2–6cm
across, bell-shaped becoming flattened, pale
ochraceous-brown when moist drying almost
white or flushed with brown, margin often
appearing toothed with remnants of veil. **Stem**
40–80×4–8mm, white, hollow, fragile. **Flesh**
thin, white. Taste and smell not distinctive. **Gills**
greyish lilac darkening to chocolate brown.
Cheilocystidia thin-walled, hyaline, finger-
shaped or cylindric. Spore print dark brown.
Spores elliptical or ovate, 6–8×3.5–4.5μ.
Habitat on or near deciduous trees, stumps or cut
timbers. Season spring to late autumn.
Frequent. **Edibility unknown.**

Deconica muscorum Orton syn. *Psilocybe bullacea*
(Bull. ex Fr.) Kummer s. Lange **Cap** 0.5–2cm
across, hemispherical to broadly convex,
chestnut brown covered with a detachable viscid
layer, drying ochraceous. **Stem** 15–30×2–3mm,
paler than the cap, covered in white cottony
fibres. **Flesh** concolorous. Taste and smell none.
Gills broad, whitish at first later tan to umber.
Spore print violaceous brown. Spores almond-
shaped, 7–9×5–6μ. Habitat amongst moss or
lichens. Season spring. Rare. **Not edible.**

Deconica coprophila (Bull. ex Fr.) Karst syn.
Psilocybe coprophila (Bull. ex Fr.) Kummer syn.
Stropharia coprophila (Bull. ex Fr.) Lange **Cap**
0.5–2.5cm across, hemispherical to broadly bell-
shaped, often with an umbo, tan to reddish-
pallid, covered with a detachable viscid layer.
Stem 25–40×1–3mm, pallid flushed with cap
colour, covered in fine cottony tufts below. **Flesh**
thin, concolorous. Taste mealy. **Gills** crowded,
broad, pale grey-brown darkening with age.
Spore print violaceous. Spores lemon-shaped,
12–14×6.5–8μ. Habitat on dung. Season late
summer to late autumn. Rare. **Not edible.**

Psilocybe crobulus (Fr.) Kühn. & Romagn. **Cap**
0.5–1cm across, convex then flattened, with
separable viscid pellicle, pallid-brown with small
adpressed whitish scales from the veil at first,
persisting at margin, which is faintly or not at all
striate. **Stem** 5–12×1mm, concolorous with cap
or darker, with whitish shaggy fibrous scales.
Flesh pallid. **Gills** pallid clay becoming dull
rust. Spore print cigar-brown. Spores elliptic to
lens-shaped, 6–7.5×3.5–4.5μ. Habitat on twigs,
grass stems and other herbaceous debris. Season

autumn. Occasional. **Hallucinogenic.**

Liberty Cap *Psilocybe semilanceata* (Fr. ex Secr.)
Kummer **Cap** 0.5–1.5cm across, elongate
conical with a distinct sharply pointed umbo,
puckered at margin, hygrophanous, yellowish-
brown with olivaceous tinge drying ochre-buff,
covered with a viscid pellicle. **Stem** 25–75×1–
2mm, white to cream, sometimes with a bluish
tinge at the stem base. **Flesh** cream to pallid.
Gills pale clay at first, finally dark purple-brown.
Spore print dark purplish-brown. Spores
elliptic, 11.5–14.5×7–9μ. Habitat lawns,
pasture and roadsides. Season late summer to
late autumn. Frequent. **Hallucinogenic.**

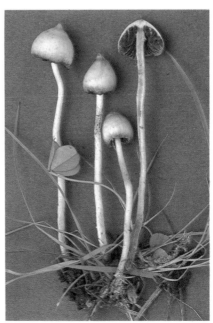

Liberty Cap *Psilocybe semilanceata* life size

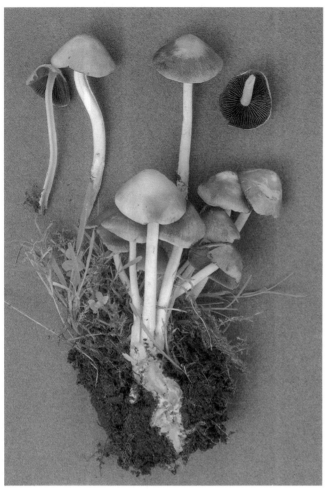

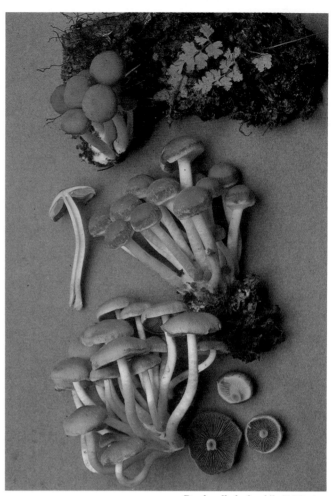

Psathyrella multipedata ²/₃ life size *Psathyrella hydrophila* ²/₃ life size

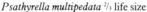

Psathyrella multipedata (Peck) Smith Fruit bodies growing in very dense tufts of up to seventy individuals arising from a common base. **Cap** 1–3cm across, conical-convex, dingy clay-brown drying or ageing cream, striate. **Stem** 70–120×2–4mm, whitish. **Flesh** thin, whitish. Taste and smell not distinctive. **Gills** dark purplish-brown. Cystidia thin-walled, narrowly fusoid with somewhat swollen base. Spore print dark brown. Spores elliptic, 6.5–10×3.5–4.5μ. Habitat amongst grass in open deciduous woodland and roadsides. Season summer. Rare. **Edibility unknown**.

Psathyrella hydrophila (Bull. ex Mérat) Maire syn. *Hypholoma hydrophilum* (Bull. ex Mérat) Quél. **Cap** 2–3cm across, convex becoming flattened, tan to dark chestnut or date-brown drying paler often with a tan flush at the centre, margin appendiculate with remnants of the fibrillose veil. **Stem** 40–100×5–10mm, white flushed with cap colour below, fragile. **Flesh** thin, whitish. Taste bitter, smell not distinctive. **Gills** crowded, clay-brown becoming chocolate brown with age. Cystidia thin-walled, hyaline, fusiform. Spore print dark brown. Spores elliptic, 4.5–7×3–4μ. Habitat in dense tufts in damp deciduous woodland. Season late spring to late autumn. Common. **Edible** – bitter and not worthwhile.

Psathyrella pennata (Fr.) Pearson & Dennis syn. *Drosophila pennata* (Fr.) Kühn. & Romagn. **Cap** 1–2.5cm across, broadly bell-shaped, grey-brown to reddish-brown becoming ochre, covered in whitish cottony fibrils or scales especially towards the margin. **Stem** 25–50×2–4mm, whitish. **Flesh** thin, brownish in cap, whitish to ochraceous in stem. Taste and smell not distinctive. **Gills** pallid to purplish-grey. Cheilo-and pleurocystidia thin-walled, hyaline, acutely fusiform. Spore print dark purplish-brown. Spores pip-shaped, 8–9×4–4.5μ. Habitat on fire sites. Season early summer to autumn. Common. **Edibility unknown**.

Psathyrella obtusata (Fr.) Smith syn. *Drosophila obtusata* (Fr.) Kühn. & Romagn. **Cap** 1–3cm across, hemispherical then flattened convex, dark date-brown when moist drying pale ochre-buff often with a tan flush at the centre. **Stem** 30–70×2–4mm, white and silky, fragile. **Flesh** thin, whitish, hollow in stem. **Gills** pinkish brown then chocolate brown. Cystidia thin-walled, hyaline, obtusely fusoid. Spore print dark brown. Spores oblong, 7.5–10×4.5–5.5μ. Habitat on the ground in woods. Season spring to late autumn. Common. **Edibility unknown**.

Psathyrella squamosa (Karst.) Moser apud Gams syn. *Drosophila squamosa* (Karst.) Kühn & Romagn. **Cap** 2.5–3.5cm across, ovoid at first becoming conical to expanded bell-shaped, ochre-brown when moist with a broad marginal zone covered in whitish silky fibrils, drying ochre-cream, dingy brown with age. **Stem** 35–50×3–5mm, white, flaky. **Flesh** ochre-brown, hollow in stem. Taste and smell not distinctive. **Gills** white then ochre-brown finally violet-brown. Cheilo- and pleurocystidia fusoid with slightly thickened yellowish walls when examined in KOH solution. Spore print purplish brown. Spores elliptic with germ-pore, 8.5–9.5×4.5–5μ. Habitat beech woods. Season autumn. Occasional. **Edibility unknown**.

Psathyrella marcescibilis (Britz.) Sing. syn. *Hypholoma marcescibilis* (Britz.) Sacc. **Cap** 1.5–4(8)cm across, conical to bell-shaped, grey-brown when moist drying whitish clay, margin appendiculate with whitish remnants of veil. **Gills** white then ochre-brown finally violet-brown. **Stem** 30–100×2–5mm, white, fragile. **Flesh** thin, white, hollow in stem. Taste and smell not distinctive. **Gills** almost free, grey becoming tinged purplish then blackish. Pleurocystidia lacking; cheilocystidia thin-walled, with swollen base and short broad obtuse neck. Spore print dark brown. Spores elliptic with germ pore, 12–16×6–7μ. Habitat deciduous woodland especially on chalk. Season spring to autumn. Uncommon. **Edibility unknown**.

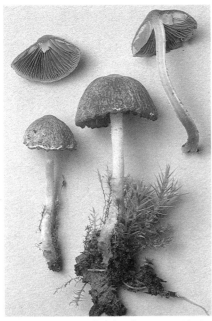

Psathyrella pennata life size

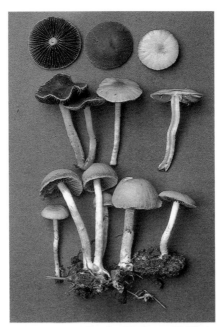

Psathyrella obtusata ²/₃ life size

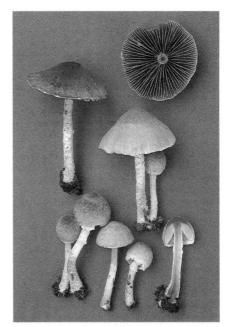

Psathyrella squamosa ²/₃ life size

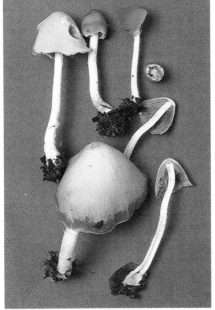

Psathyrella marcescibilis ²/₃ life size

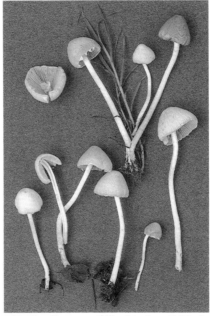

Psathyrella marcescibilis white form ½ life size

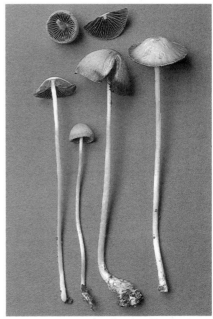

Psathyrella microrhiza ²/₃ life size

Psathyrella microrhiza (Lasch) Konrad & Maubl. syn. *Psathyra microrhiza* (Lasch) Kummer **Cap** 1–3cm across, bell-shaped, ochraceous to reddish brown when moist drying pale greyish. **Stem** 40–100×2–3mm, white, fragile, with rooting base covered in whitish hairs. **Flesh** very thin, whitish. Taste and smell not distinctive. **Gills** pallid soon darkening to brownish-black with pinkish edge. Cheilo- and pleurocystidia thin-walled, hyaline, obtusely fusiform. Spore print dark brown. Spores broadly elliptic with germ-pore, 10–14×6–7μ. Habitat on bare soil in gardens, hedgerows or woodland. Season autumn. Common. **Edibility unknown**.

Psathyrella pellucidipes (Romagn.) Galland syn. *Drosophila pellucidipes* Romagn. **Cap** 1–2cm across, convex to bell-shaped, hygrophanous, dark tan drying light yellow-brown, striate. **Stem** 50–70×2–3mm, rooting, whitish to pale brown. **Flesh** thin, brown in cap, paler in stem. **Gills** broadly adnate, grey, edge white. Spore print black. Spores elliptic to almond-shaped, 11.5–13.5×6.5–7μ. Habitat sandy soil. Season spring to autumn. Rare. **Edibility unknown**.

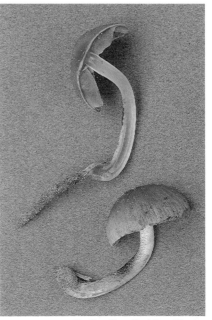

Psathyrella pellucidipes life size

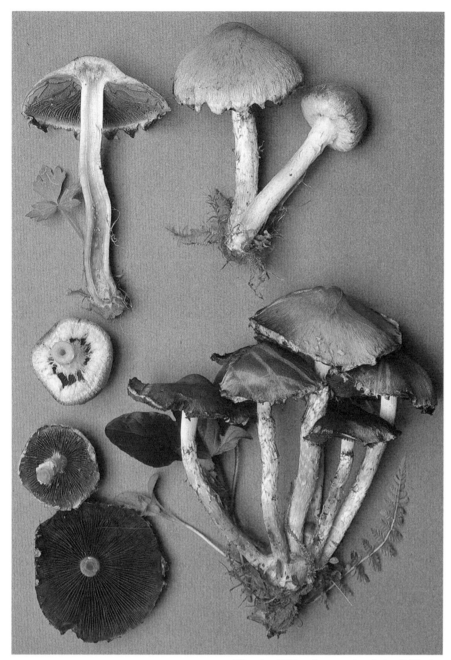

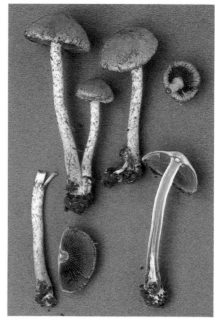

Lacrymaria pyrotricha ⅓ life size

Weeping Widow *Lacrymaria velutina* ½ life size

Coprinus macrocephalus (Berk.) Berk. **Cap** 1–3 cm high, cylindrical to conical at first expanding to broadly bell-shaped or flat, white then grey often buff at centre, covered in coarse fibres which break up into buff-coloured scales. **Stem** 40–190×2–7mm, translucent white. Smell none. **Gills** white soon becoming black. Spore print violaceous black. Spores ellipsoid, 11–14×7.5–8.5μ. Habitat on dung-heaps and rotting straw. Season all year round. Uncommon. **Edibility unknown**.

Shaggy Ink Cap or **Lawyer's Wig** *Coprinus comatus* (Müll. ex Fr.) S. F. Gray **Cap** 5–15cm high, cylindrical, white with buff centre, the cuticle breaking up into large white shaggy, brownish-tipped scales. **Stem** 100–370×10–25mm, swollen, sometimes rooting at the base, white; ring white and loose often falling to base of stem. Smell faint and pleasant. **Gills** white then pink or vinaceous, finally black and deliquescing from margin upwards. Spore print brownish black. Spores almond-shaped, 10–13×6.5–8μ. Habitat in grass by roadsides, on rubbish heaps or lawns, particularly on recently disturbed soil. Season late summer to autumn. Common. **Edible** – good while gills still white.

Weeping Widow *Lacrymaria velutina* (Pers. ex Fr.) Konrad & Maubl. syn. *Hypholoma velutinum* (Pers. ex Fr.) Kummer **Cap** 1.5–10cm across, convex with a broad umbo becoming more flattened, ochre-brown to tan at first, covered in woolly fibrils but then smooth, veil remnants often adhering to the margin giving a fringed cottony appearance. **Stem** 40–80×5–10mm, whitish at the apex becoming flushed with cap colour towards the base, covered in small fibrous scales below the cottony fibrillose ring zone which is often made more prominent by the almost black spores which are trapped in it. **Flesh** ochraceous to brownish. Taste slightly bitter. **Gills** crowded, mottled, dark purplish-brown with white edge, 'weeping' when moist. Cheilocystidia thin-walled, clavate, with rounded head. Spore print black. Spores lemon-shaped, warted, with truncate germ-pore, 8–11×5–6μ. Habitat amongst tufted grass on woodland paths and roadsides. Season late spring to late autumn. Common. **Edible** – but bitter.

Lacrymaria pyrotricha (Holms. ex Fr.) Konr. & Maubl. syn. *Psathyrella pyrotricha* (Holms. ex Fr.) Moser apud Gams. Similar to *L. velutina*. **Cap** 4–8cm across, bright orange, as is the veil. Spores 10–12×5.5–7μ.

COPRINUS *The Ink Caps. The gills are crowded and parallel sided and in most species they quickly auto-digest (deliquesce) which results in the dripping black inky fluid from which the genus gets its common name. The spores ripen from the edge of the gill inwards towards the flesh of the cap and the deliquescing which takes place after they ripen allows the spores on the inner parts of the gills room to fall as they in turn ripen. The young fungus may be covered by a thick woolly veil that leaves felty scales on the cap, or by a powdery veil which also may remain in the cap especially in dry weather. Thirdly there are Coprinus that have no veil. Many have strong radial grooves on the cap. Smells are important for identifying some species. They grow on the ground, on wood and on dung.*

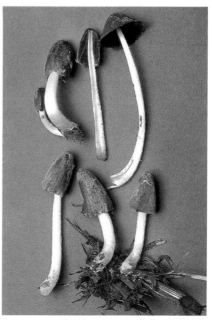

Coprinus macrocephalus ⅔ life size

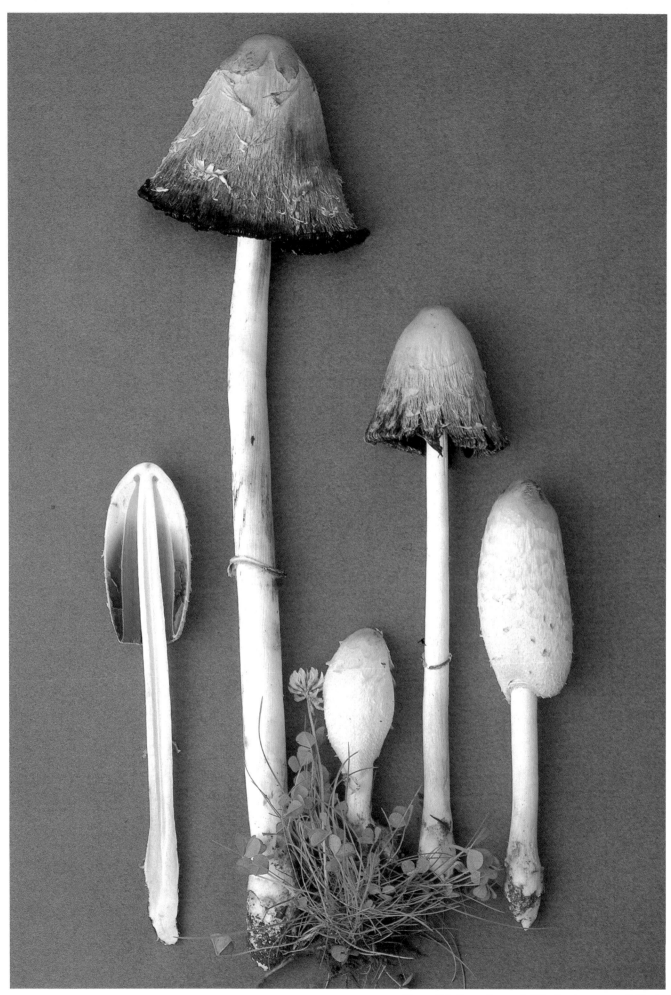

Shaggy Ink Cap or **Lawyer's Wig** *Coprinus comatus* ²/₃ life size

177

Magpie Fungus *Coprinus picaceus* ½ life size

Common Ink Cap *Coprinus atramentarius* ½ life size

Magpie Fungus *Coprinus picaceus* (Bull. ex Fr.) S. F. Gray **Cap** 5–8cm high, cylindrical-ovate to conical, broadly bell-shaped when expanded, white then sepia-grey finally black covered in white to clay-pink patches of veil remnant. **Stem** 90–300×6–15mm, with woolly bulbous base, white. Smell unpleasant. **Gills** white then clay-pink, finally black and deliquescing. Spore print black. Spores ellipsoid, 13–17×10–12μ. Habitat on alkaline soil, usually in beech woods. Season late summer to autumn. Uncommon. Said to be **poisonous** but eaten by some with no ill-effect.

Common Ink Cap *Coprinus atramentarius* (Bull. ex Fr.) Fr. **Cap** 3–7cm high, ovoid at first, broadly conical when expanded, margin irregularly puckered initially then splitting, remnants of veil seen as minute sepia scales, especially near the centre. **Stem** 70–170×9–15mm, whitish, smooth with ring-like zone left by veil near base. Smell faint and pleasant. **Gills** crowded, white at first then black and soon deliquescing. Spore print date-brown. Spores ellipsoid or almond-shaped, 8–11×5–6μ. Habitat in tufts, terrestrial but associated with buried wood. Season spring to late autumn. Common. **Edible** but causing alarming symptoms (nausea, palpitations) when taken in conjunction with alcohol, indeed it has been given to alcoholics to cause these symptoms and eventually cure their habit. Good black drawing ink used to be made from the deliquesced caps by boiling the black 'ink' with a little water and cloves.

Coprinus lagopides Karst. **Cap** 2–6cm high, cylindrical to conical, expanding with margin gradually enrolling, white to grey, at first covered in a conspicuous whitish to greyish fibrillose veil remnants, later less so and striate from margin inwards. **Stem** 30–110×3–12mm, white, initially with white down then smooth in places, base white and woolly. Smell none. **Gills** soon dark vinaceous then black. Spore print violaceous black. Spores ellipsoid to subglobose, 6–9×5–7μ. Habitat on burnt soil or charred wood and so differing markedly in habitat from the superficially similar *C. lagopus*. Season late autumn. Frequent. **Edibility unknown.**

Coprinus lagopus (Fr.) Fr. **Cap** 2–4cm high, cylindrical-ovoid or conical, almost flat when expanded, greyish covered with whitish to greyish fibrillose veil remnants. **Stem** 65–130×2–3mm, swollen at base, white, covered in down as the cap at first then smooth. Smell none. **Gills** white, rapidly turning black. Spore print violaceous black. Spores ellipsoid, 11–13.5×6–7μ. Habitat on soil or in leaf litter in shady woods, less frequently in fields. Season summer to autumn. Occasional. **Edible** – but not worthwhile.

Coprinus narcoticus (Batsch. ex Fr.) Fr. **Cap** 1–1.5cm high, cylindric-ovoid becoming flat, the margin becoming split and rolled back, pale grey covered in coarse white granular meal becoming buff and warty towards the centre. **Stem** 15–

65×2–8mm, sometimes rooting at the base. Smell strongly of tar-gas. **Gills** white rapidly becoming black. Spore print black. Spores ellipsoid to almond-shaped, 11–13.5×5.5–7μ, remains of perispore often visible. Mealy covering of cap formed of thin-walled globose cells ornamented with granular warts. Habitat on dung or manured soil. Season autumn. Rare. **Edibility unknown.**

Coprinus pachyspermus Orton **Cap** 1–3cm high, ellipsoid, sometimes with pointed apex, expanding to broadly conical and splitting at the margin, grey or creamy, covered in coarse mealy flocculose scales. **Stem** 30–110×2–4mm, fragile, white, sometimes with the remains of the mealy veil around the base. Smell none. **Gills** cream then black. Spore print black. Spores ellipsoid to ovoid, 15–17×12.5–14μ. Basidia two-spored. Mealy covering of cap formed of smooth, thin-walled globose cells. Habitat on cow dung. Season summer. Rare. **Edibility unknown.**

Coprinus niveus (Pers. ex Fr.) Fr. **Cap** 1.5–3cm high, ovoid to conical at first, bell-shaped when expanded with split or rolled-back margin, white covered in chalk-white meal. **Stem** 30–90×4–7mm, white, slightly thickened at the cottony base. Smell none. **Gills** white, rapidly greying and finally black. Spore print black. Spores ellipsoid or slightly almond-shaped, 15–19×11–13μ. Mealy covering of cap consisting of thin-walled, smooth globose calls. Habitat on cow or

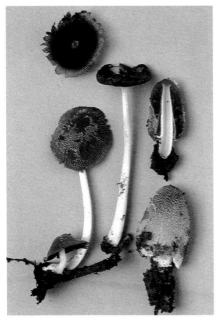

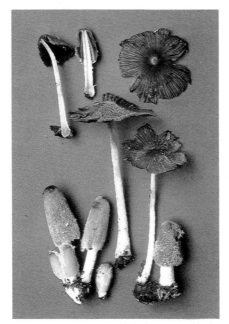

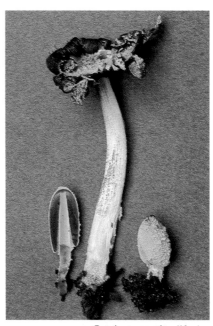

Coprinus lagopides ²/₃ life size

Coprinus lagopus ¾ life size

Coprinus narcoticus life size

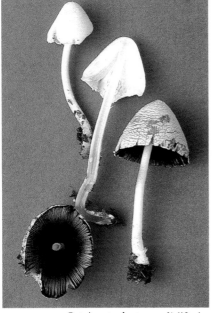

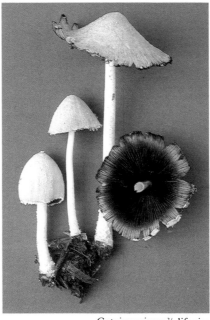

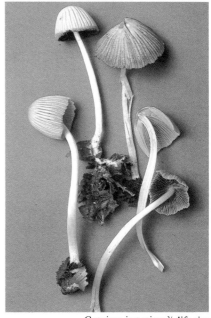

Coprinus pachyspermus ²/₃ life size

Coprinus niveus ²/₃ life size

Coprinus impatiens ²/₃ life size

horse dung. Season summer to autumn. Occasional. **Edibility unknown**.

Coprinus impatiens (Fr.) Quél. syn. *Psathyrella impatiens* (Fr.) Kühner **Cap** 1–3cm high, ellipsoid at first then broadly convex, finally flat, pale buff with cinnamon centre drying whitish, strongly grooved to centre. **Stem** 70–100×2–4mm, white. Smell none. **Gills** pale clay-buff then greying, hardly deliquescing. Spore print dark umber. Spores ellipsoid, 9–12×5–6μ. Dermatocystidia 70–120×8–14μ, thin-walled, lageniform with a rather acute apex. Habitat in leaf litter or soil in broad-leaved woods, especially beech-woods on chalk. Season autumn to winter. Occasional. **Edibility unknown**.

Coprinus congregatus (Bull. ex St Amans) Fr. **Cap** 0.5–2cm high, cylindric-ellipsoid expanding to broadly convex, ochraceous buff with darker centre becoming grey from margin inwards. **Stem** 20–80×1–4mm, white, sometimes rooting. Smell slight, pleasant. **Gills** cream then brown-vinaceous, finally black and deliquescing. Spore print black. Spores ellipsoid, 12–14×6–7μ. Dermatocystidia 48–106×7.5–17μ, thin-walled, subcylindric with swollen base to somewhat lageniform. Habitat caespitose, on dung, compost or rotting straw. Season summer. Rare. **Edibility unknown**.

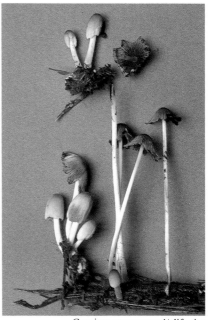

Coprinus congregatus ½ life size

179

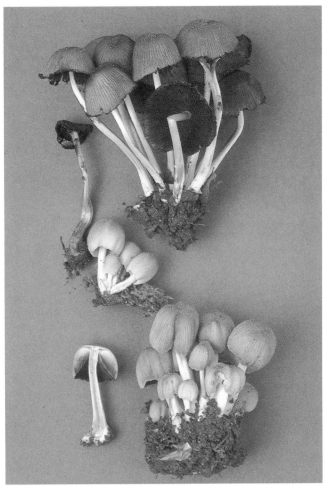

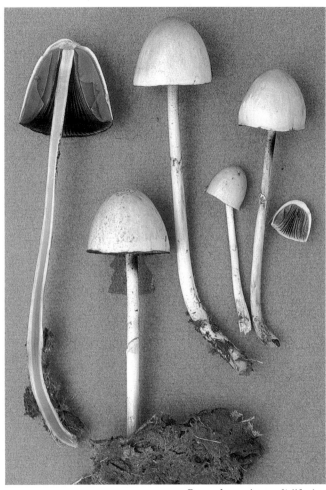

Glistening Ink Cap *Coprinus micaceus* ¾ life size

Panaeolus semiovatus ⅔ life size

Glistening Ink Cap *Coprinus micaceus* (Bull. ex Fr.) Fr. **Cap** 1–4cm high, ovoid expanding to bell-shaped, the margin becoming split and sometimes rolled back, grooved from margin almost to centre, ochraceous becoming cinnamon towards the centre, cuticle covered with white powdery veil, especially when young. **Stem** 40–100×2–5mm, white discolouring buff in lower part. Smell none. **Gills** white becoming date-brown and finally black. Spore print date-brown. Spores mitriform, 7–10×4.5–6μ. Velar remnants on cap formed of globose hyaline or brownish thin- or thick-walled cells which are often verrucose. Habitat caespitose on or around broad-leaved stumps or on buried wood. Season late spring to early winter. Common. **Edible**.

Panaeolus The black spores ripen unevenly on the gill surface causing the gills to have a mottled appearance.

Panaeolus semiovatus (Sow. ex Fr.) Lund. syn. *Anellaria separata* (L. ex Fr.) Karst. syn. *P. separatus* (L. ex Fr.) Gillet **Cap** 2–6cm across, ovate-bell-shaped, never expanding, clay white tinged yellowish towards centre, viscid, drying shiny, velar remnants often adhering to margin. **Stem** 50–100×4–8mm, slightly thickened at base, whitish; ring white and membranaceous, persistent. **Flesh** whitish, yellowish in stem. **Gills** broad, whitish, soon brown-black, often with a white edge. Pleurocystidia in form of broad lanceolate chrysocystidia with pointed apices. Spore print black. Spores pip-shaped, 16–20×10–12μ. Habitat on dung. Season spring to early winter. Occasional. **Not edible**.

Coprinus domesticus (Bolt. ex Fr.) S. F. Gray **Cap** 1–3cm high, ovoid at first expanding convex or bell-shaped, splitting at margin, pale buff with darker tawny centre powdered at first with whitish or buff remains of veil, later smooth and becoming grooved from the margin inwards. **Stem** 40–155×2–10mm, swollen at base, white tinged buff towards the ridged base, often arising from a rust-coloured mat of mycelium. Smell none. **Gills** white at first rapidly purplish date then black. Spore print dark brown. Spores cylindric ellipsoid, 7.5–10×4–5μ. Remnants of veil on cap formed of chains of globose or ellipsoid cells which are hyaline or golden brown, thin- to thick-walled and often verrucose. Habitat on dead wood of broad-leaved trees. Season late spring to summer. Uncommon. **Not edible**.

Coprinus silvaticus Peck. syn. *Coprinellus tardus* Karst. **Cap** 1–3cm high, ovoid expanding to conical-convex, cream buff with darker sienna or cinnamon centre, often becoming grey, grooved from margin inwards. **Stem** 40–85×3–6mm, white, the lower part discolouring pale buff, fragile. Smell none. **Gills** crowded white then grey-umber, finally black. Spore print black. Spores almond-shaped possibly ornamented with low warts and ridges, 11–15×8–10μ. Dermatocystidia 90–180×16–25μ, lageniform. Habitat on soil attached to buried wood. Season autumn. Rare. **Edibility unknown**.

Coprinus plicatilis (Fr.) Fr. **Cap** 0.5–1.5cm high, cylindric-ovoid expanding to shallowly convex or flat with depressed centre, buff with cinnamon centre, soon deeply grooved and greying from margin inwards. **Stem** 30–70×1–2mm, white

Coprinus domesticus ⅔ life size

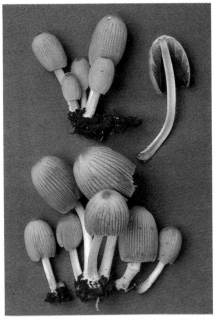

Coprinus silvaticus ¾ life size

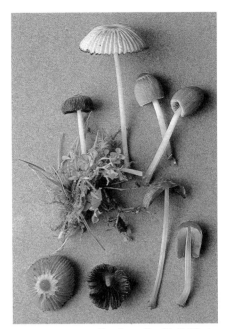

Coprinus plicatilis ¾ life size

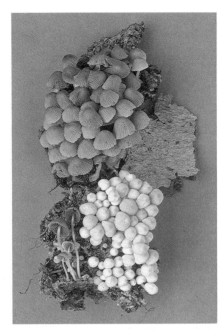

Fairies' Bonnets *Coprinus disseminatus* ½ life size

discolouring buff from the base upwards. Smell none. **Gills** clay pink then grey, finally black, hardly deliquescing. Spore print black. Spores ellipsoid to almond-shaped, 10–13×8.5–10.5μ. Habitat in grass on lawns at pathsides. Season spring to late autumn. Common. **Edible** – not worthwhile.

Fairies' Bonnets or **Trooping Crumble Cap**
Coprinus disseminatus (Pers. ex Fr.) S. F. Gray syn. *Psathyrella disseminata* (Pers. ex Fr.) Quél. **Cap** 0.5–1.5cm high, ovoid at first expanding to convex or bell-shaped, pale buff with buff or fulvous centre, deeply grooved, fragile. **Stem** 15–40×1–3mm, white with buff tinge near the base which is covered in white down. Smell none. **Gills** white then umber, finally black but not deliquescing. Spore print date brown or umber. Spores ellipsoid to almond-shaped, 7–9.5×4–5μ. Dermatocystidia 75–200×20–30μ, thin-walled, blunt cylindric with swollen base. Habitat in large groups (often of hundreds) on stumps of broad-leaved trees or on soil nearby.

Season late spring to late autumn. Frequent. **Edible** but not worth considering due to its small size.

Panaeolus speciosus Orton **Cap** 2–7cm across, conical to convex, buff or dull brown at first becoming more greyish with darker olivaceous-brown zone near the margin, tinged ochraceous or tawny at the centre, drying greyish or buff, cracking. **Stem** 70–175×2–5mm, whitish tinged tawny or greyish-pink, base dusted white. **Flesh** concolorous with cap, hollow in stem. Smell faint, mushroomy. **Gills** adnate, clay-buff becoming mottled blackish. Spore print blackish. Spores angular lemon-shaped, 14–20×8–10×10–12μ. Habitat on horse or sheep dung. Season late summer to autumn. Uncommon. **Edibility unknown.**

Panaeolus rickenii Hora **Cap** 1–2cm across, convex to conical with prominent umbo, dark brown and striate at margin when moist drying

pale buff or tan, flushed tan towards centre. **Stem** 50–100×2–3m, pinkish brown or tan with paler apex. **Flesh** thin, tan. Taste not distinctive, smell mushroomy. **Gills** adnate, grey soon becoming black. Spore print black. Spores lemon-shaped, 13–16×9.5–11μ. Habitat in damp pastureland. Season summer to autumn. Frequent. **Not edible.**

Bell-shaped Mottlegill *Panaeolus campanulatus* (Bull. ex Fr.) Quél **Cap** 2–4cm across, hemispherical, pale buff at margin, reddish-brown towards centre which is slightly viscid in wet weather. **Stem** 70–100×2–3mm, grey or grey-brown. **Flesh** buff. Smell faint, not distinctive. **Gills** adnate grey soon becoming black. Spore print black. Spores lemon-shaped, 12–14×7–8μ. Habitat in pastureland, especially on horse dung. Season late summer to autumn. Uncommon. **Not edible.**

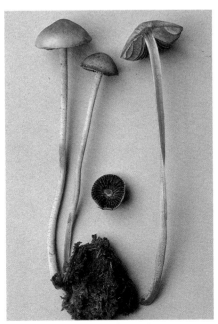

Panaeolus speciosus ½ life size

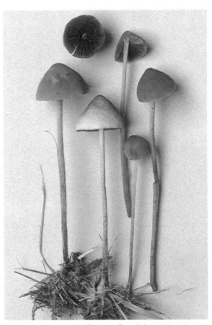

Panaeolus rickenii ⅔ life size

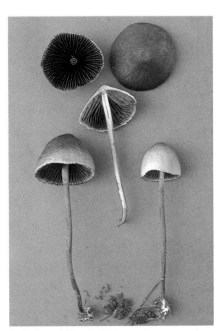

Bell-shaped Mottlegill *Panaeolus campanulatus* ½ life size

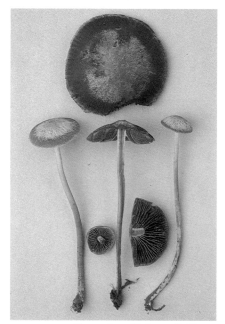

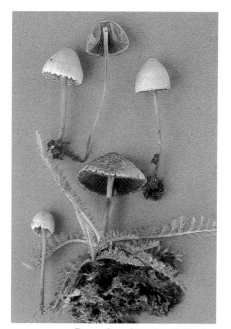

Panaeolus subbalteatus ²/₃ life size

Panaeolus sphinctrinus ²/₃ life size

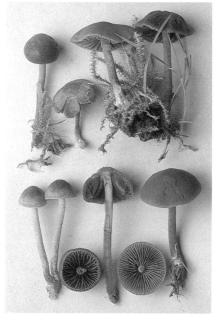

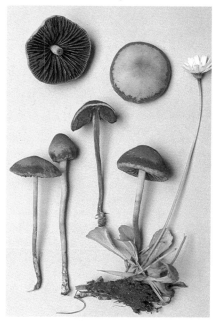

Panaeolus ater ²/₃ life size

Panaeolina foenisecii ¾ life size

Panaeolina foenisecii (Pers. ex Fr.) Maire syn. *Psilocybe foenisecii* (Pers. ex Fr.) Quél. syn *Panaeolus foenisecii* (Pers. ex Fr.) Schroeter **Cap** 1–2cm across, bell-shaped to convex, dark dull-brown drying out pale clay brown from the rust-coloured centre outwards to the margin which often remains darker. **Stem** 40–70×2–3mm, paler than cap. **Flesh** buff to pale brown. Smell not distinctive. **Gills** adnate, pale brown when young soon becoming mottled darker. Spore print brownish black. Spores lemon-shaped, rough, with germ-pore, 12–15×7–8.5μ. Habitat in grassland and on lawns and roadsides. Season summer to autumn. Common. **Not edible.**

Pleurotus lignatilis (Pers. ex Fr.) Kummer **Cap** 1.5–5cm across, slightly depressed, creamy white. **Stem** 5–20×4–8mm, central or slightly excentric, whitish discolouring ochraceous. **Flesh** white. **Gills** crowded, white then ochraceous-cream. Spore print white. Spores oval, 4.5×2.5μ. Habitat on dead deciduous wood, especially inside the hollow trunks of beech and elm. Season autumn. Uncommon. **Edibility unknown.**

Oyster Mushroom *Pleurotus ostreatus* (Jacq. ex Fr.) Kummer **Cap** 6–14cm across, shell-shaped, convex at first then flattening or slightly depressed and often wavy and lobed at the margin or splitting, variable in colour; flesh-brown or deep blue-grey later more grey-brown. **Stem** 20–30×10–20cm, excentric to lateral, or absent, white with a woolly base. **Flesh** white. Taste and smell pleasant. **Gills** decurrent, white at first then with a yellowish tinge. Spore print lilac. Spores subcylindric, 7.5–11×3–4μ. Habitat often in large clusters on stumps and fallen or standing trunks, usually of deciduous trees, especially beech. Season all year. Common. **Edible.**

Panaeolus subbalteatus (Berk. & Br.) Sacc. **Cap** 2–6cm across, convex at first expanding to almost flat with a broad umbo, dark reddish-brown when moist drying buff to pale tan from centre outwards leaving a darker zone at margin. **Stem** 60–90×3–5mm, buff or pale brown with paler apex. **Flesh** thin, brownish. Taste not distinctive, smell mushroomy. **Gills** adnate, pale tan at first rapidly blackening. Spore print black. Spores lemon-shaped, 12–14×7.5–8.5μ. Habitat in manured places especially gardens or compost heaps. Season early summer to autumn. Rare. **Not edible.**

Panaeolus sphinctrinus (Fr.) Quél. syn. *P. campanulatus* var. *sphinctrinus* (Fr.) Quél. **Cap** 2–4cm across, broadly conical to bell-shaped sometimes with a slight umbo, dark grey to almost black when moist drying out pale grey with dark ochre centre, margin overhanging gills forming pale delicate teeth. **Stem** 60–120×2–3mm, grey, paler at apex. **Flesh** thin, pale grey.

Gills adnate, grey soon becoming black, edge white. Spore print black. Spores lemon-shaped, 14–18×10–12μ. Habitat in pastureland, on or near dung. Season late spring to autumn. Common. **Not edible.**

Panaeolus ater (Lange) Kühn. & Romagn. syn. *P. fimicola* (Fr.) Quél. s. Ricken. **Cap** 1.5–4.5cm across, hemispherical with slight umbo, dark brown when moist drying buff or tan from margin inwards. **Stem** 20–80×2–5mm, buff or tan to darker brown, paler at apex, base covered in fine white down. **Flesh** thin, brown. Taste mushroomy, smell none. **Gills** adnate, grey at first soon becoming mottled black then finally totally black. Spore print black. Spores lemon-shaped, 10–14×7–8μ. Habitat on lawns or in short grass under trees. Season spring to autumn. Frequent. **Not edible.**

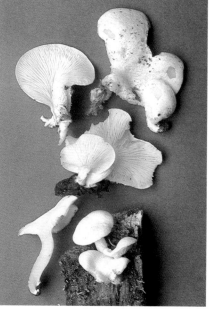

Pleurotus lignatilis ²/₃ life size

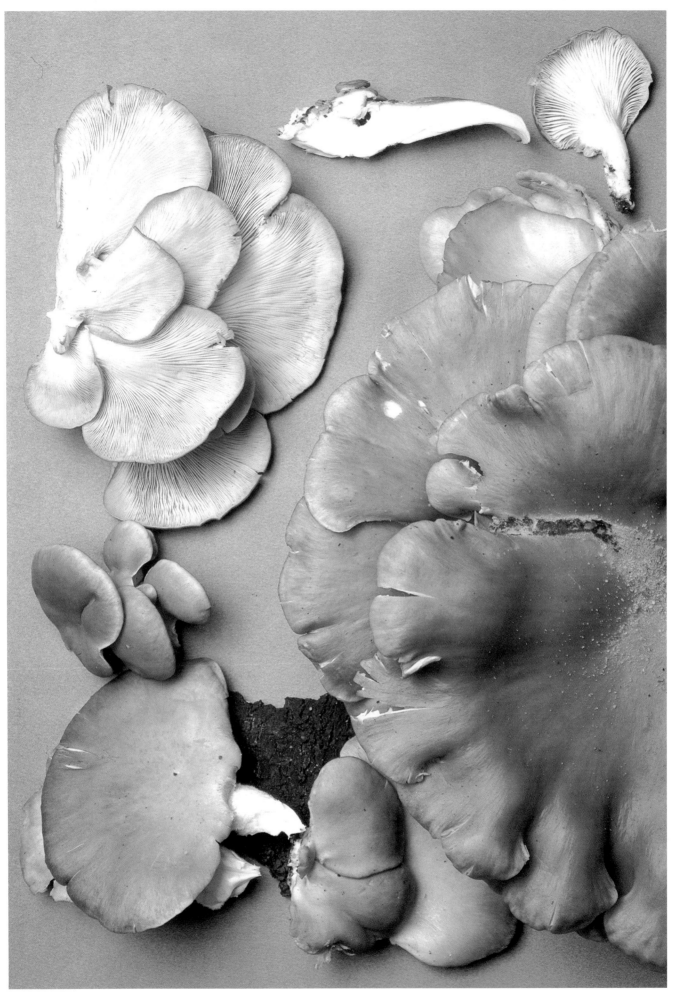

Oyster Mushroom *Pleurotus ostreatus* life size

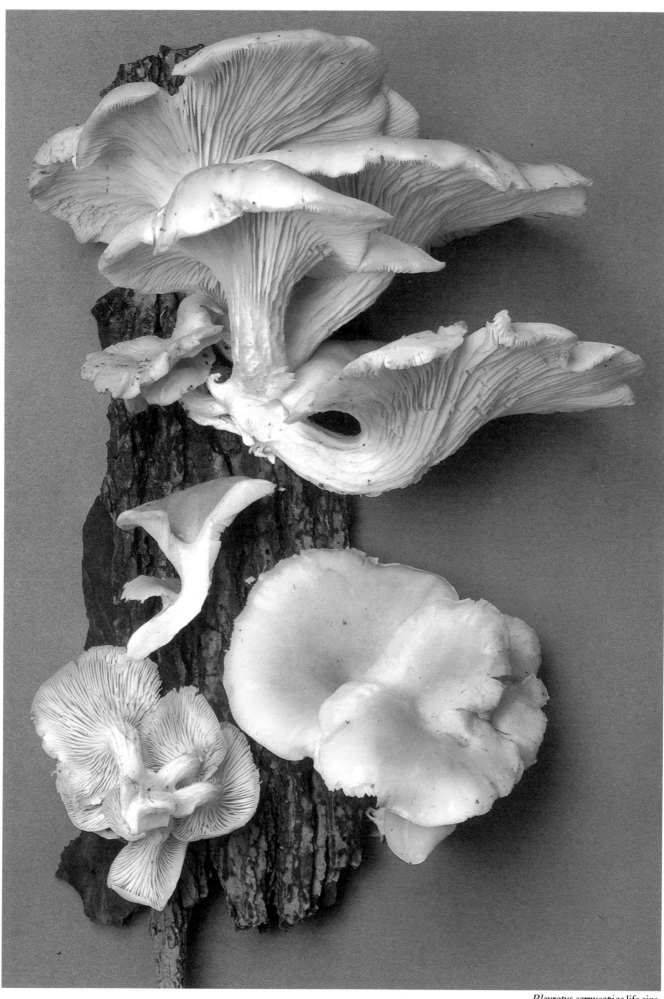

Pleurotus cornucopiae life size

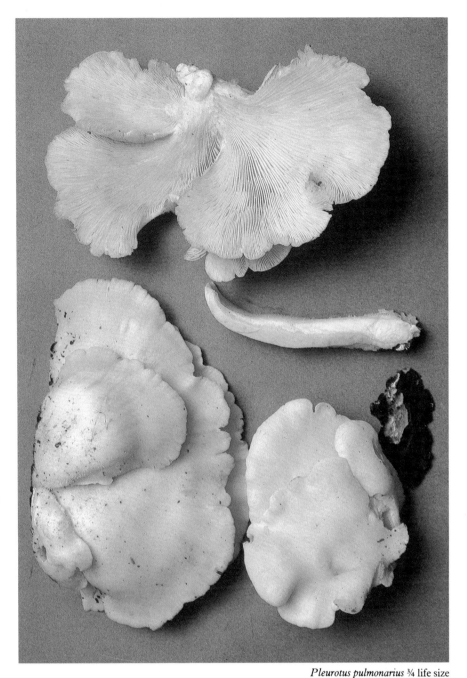

Pleurotus cornucopiae (Paul. ex Pers.) Rolland syn. *P. sapidus* (Schulz. apud Kalchbr.) Sacc. **Cap** 5–12cm across, convex then depressed to funnel-shaped, often becoming wavy or cracked at the margin, cream at first and covered in a whitish bloom then smooth and tinged ochraceous, finally ochre-brown. **Stem** 20–50×10–25mm, frequently excentric, usually several fused into a common base, whitish becoming tinged with cap colour. **Flesh** white. Taste pleasant, smell of flour or ammonia. **Gills** deeply decurrent, white to pale flesh. Spore print pale lilac. Spores subcylindric, 8–11×3.5–5μ. Habitat in dense clusters on the cut stumps of deciduous trees, usually elm or oak. Season spring to autumn. Occasional. **Edible**.

Pleurotus pulmonarius (Fr.) Quél **Cap** 2–10cm across, fan- or shell-shaped in overlapping groups, white to cream. **Stem** very short, lateral. **Flesh** white. Smell of flour or ammonia. **Gills** crowded, white then ochraceous-cream. Spore print white. Spores cylindric, 7.5–11×3–4μ. Habitat in clusters on deciduous trees. Season autumn. Uncommon. **Edible**.

Pleurotus acerosus (Fr.) Konrad & Maubl. **Cap** 1–3cm across, somewhat kidney-shaped, often lobed, dark grey-brown when moist drying pale grey, margin downy, white. **Stem** 5–10×5–10mm, lateral, white. **Flesh** thin, pallid. **Gills** adnate to decurrent, greyish. Spore print white. Spores pip-shaped, 7–8×3–4μ. Habitat on rotting wood or rich humus on the ground amongst moss. Season late summer to early winter. Uncommon. **Edibility unknown**.

Pleurotus eryngii (D.C. ex Fr.) Quél **Cap** 3–10cm across, convex then centrally depressed, margin remaining downturned, slightly velvety at first remaining so at margin but elsewhere soon smooth, dirty whitish at first then brownish. **Stem** 30–100×10–30mm, usually slightly excentric, whitish. **Flesh** white. Taste and smell pleasant. **Gills** decurrent, greyish. Spore print white. Spores narrowly elliptic, 10–14×4–5μ. Habitat on roots and decaying remains of umbellifers, especially *Eryngium* and *Heracleum*. Season spring to autumn. Not yet found in Britain. **Edible**.

Pleurotus pulmonarius ¾ life size

Pleurotus acerosus ⅔ life size

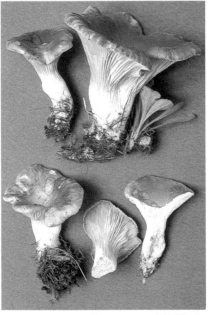

Pleurotus eryngii ½ life size

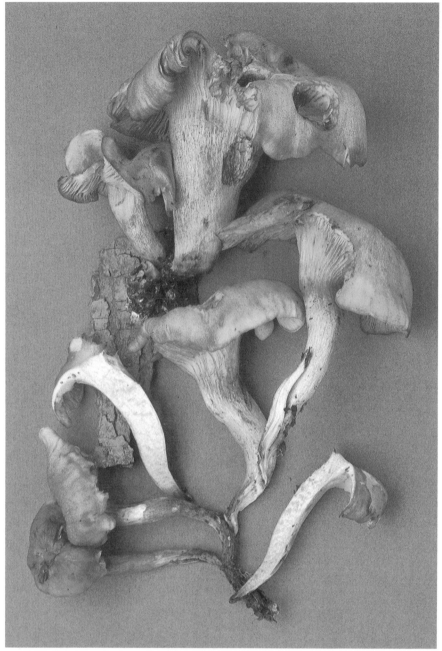

lobed with age, but fruit bodies often much distorted by mutual pressure. **Flesh** white. **Gills** ivory white. Spores subglobose, 5–6μ. Habitat rotting wood, frequently on partly buried moss-covered branches forming dense clusters. Season autumn. Restricted to coniferous woodland in the Scottish highlands where it is not uncommon. **Edibility unknown**.

Panus torulosus (Pers. ex Fr.) Fr. syn. *Pleurotus conchatus* (Bull. ex Fr.) Pilát **Cap** 4–8cm across, slightly concave to funnel-shaped, often wavy at the margin, ochre to reddish-brown, tinged lilac when young, becoming cracked and scaly with age. **Stem** 10–20×10–20mm, excentric or lateral, tapering towards the base, concolorous with cap, covered in a lilac bloom when young. **Flesh** whitish. Taste and smell not distinctive. **Gills** deeply decurrent, ochraceous, but distinctly flesh-coloured or lilac when young. Spore print white. Spores oblong-elliptical, non-amyloid, 5–6×3–3.5μ. Habitat on stumps and branches of deciduous trees. Season late spring to autumn. Occasional. **Not edible**.

Split-gill *Schizophyllum commune* Fr. **Cap** 1–4cm across, fan-shaped, often lobed or fused with others, sessile or on a short stem-like base, densely covered in greyish-white down with a purplish tinge. **Gills** radiating from the point of attachment, splitting lengthwise and rolling back covering the space between the gills, and protecting the hymenium from desiccation. Spore print white. Spores cylindric, 6×3μ. Habitat on dead wood of deciduous trees and also on cut timber. Season all year. Uncommon – more frequent in south-east England. **Not edible**.

Hohenbuehelia geogenia (DC. ex Fr.) Sing. syn. *Pleurotus geogenius* (DC. ex Fr.) Gillet syn. *Geopetalum geogenium* (DC. ex Fr.) Kühn. & Romagn. **Cap** 3–16cm across, tongue-, spatula- or funnel-shaped but split down one side, margin incurved at first then wavy and lobed, ochre-buff to hazel brown, with a somewhat gelatinous skin and covered towards the stem with white down. **Stem** 5–10×5–10mm, excentric, whitish, tough. **Flesh** whitish, tough. Taste and smell mealy. **Gills** decurrent, white at first, later creamy-yellow. Pleurocystidia thick-walled, lanceolate and apically encrusted. Spore print white. Spores elliptic, 7–7.5×3.5–4μ. Habitat on stumps or decaying wood of deciduous trees. Season autumn. Rare. **Edible**.

Rhodotus palmatus (Bull. ex Fr.) Maire syn. *Pleurotus palmatus* (Bull. ex Fr.) Quél. **Cap** 5–10cm across, convex then flattened, horizontal, clear pink at first later peach to apricot-coloured, distinctly wrinkled, margin inrolled; pellicle gelatinous, thick and tough, entirely separable. **Stem** 30–70×10–15mm, white to pinkish, covered in white fibrils, curved. **Flesh** whitish tinged pink to orange. Taste bitter, smell pleasant. **Gills** paler than the cap, interconnected. Spore print pinkish. Spores subglobose, finely warted, 5–7μ in diameter. Habitat on elm logs or beams. Season early autumn to winter. At one time rare, but due to the abundance of dead elms now becoming quite frequent. **Not edible**.

Omphalotus olearius ²/₃ life size

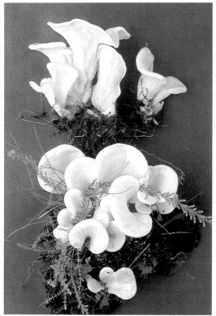

Pleurotellus porrigens ⅓ life size

Omphalotus olearius (DC. ex Fr.) Sing. syn. *Clitocybe olearia* (Fr. ex DC.) Maire **Cap** 5–10cm across, strongly depressed to funnel-shaped, bright orange. **Stem** 40–140×7–28mm, wavy and tapering towards the base, paler than cap. **Flesh** yellowish, darkening towards the stem base. Taste not distinctive, smell strong and unpleasant. **Gills** decurrent, golden to orange. Spore print white. Spores subglobose, 5–7×4.5–6.5μ. Habitat on the roots or at the base of trunks of certain trees; oak and chestnut in Britain, frequently on olive in Europe. Season autumn. Very rare. **Poisonous**.
This fungus may be seen to glow in the dark, the phosphorescence coming from the gills when the spores are mature.

Pleurotellus porrigens (Pers. ex Fr.) Kühn. & Romagn. syn. *Pleurotus porrigens* (Pers. ex Fr.) Kummer **Cap** 2–10cm across, white, sessile, tongue-shaped, the margin becoming wavy and

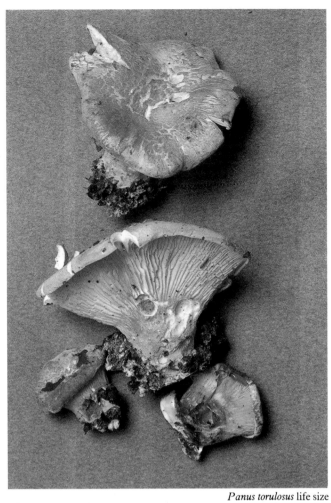

Panus torulosus life size

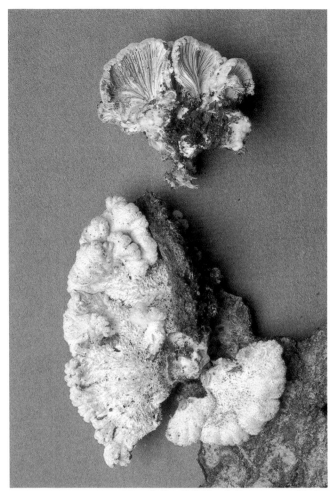

Split-gill *Schizophyllum commune* life size

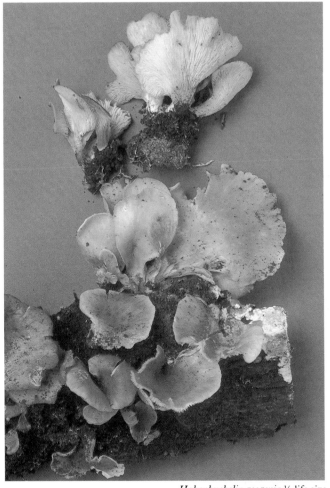

Hohenbuehelia geogenia ½ life size

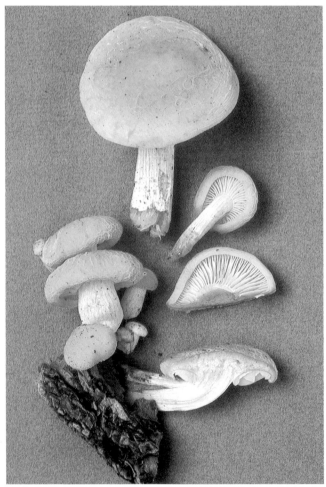

Rhodotus palmatus ⅔ life size

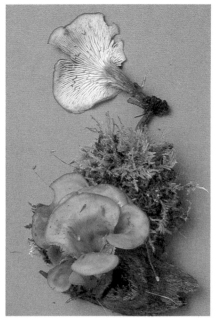

Lentinellus cochleatus ⅔ life size

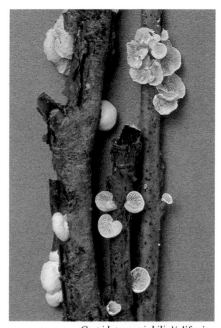

Crepidotus variabilis ½ life size

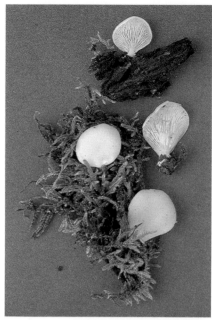

Crepidotus applanatus ½ life size

Lentinellus cochleatus (Pers. ex Fr.) Karst. syn.
Lentinus cochleatus (Pers. ex Fr.) Fr. **Cap** 2–6cm
across, irregularly funnel-shaped, flesh-colour to
reddish-brown. **Stem** 20–50×8–15mm, central
or lateral, often rooting, reddish-brown
darkening towards the base. **Flesh** pinkish,
tough. Taste mild, smell of aniseed. **Gills**
decurrent, pale flesh-coloured. Spore print
white. Spores subglobose, amyloid, 4.5–5×3.5–
4μ. Habitat tufted on stumps of deciduous trees.
Season late summer to late autumn. Uncommon.
Edible.

Crepidotus variabilis (Pers. ex Fr.) Kummer syn.
Claudopus variabilis (Pers. ex Fr.) Gillet **Cap**
0.5–2cm across, kidney-shaped, white and felty-
hairy, often lobed. **Stem** absent or rudimentary.
Gills whitish at first becoming ochraceous flesh-
coloured. Spore print clay-pink. Spores elliptic,
minutely spiny-warty, 5–7×3–3.5μ. Habitat on

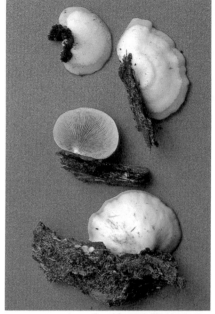

Crepidotus mollis ¾ life size

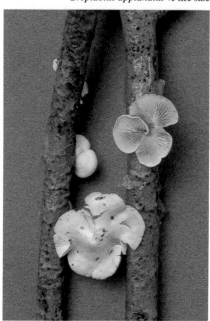

Crepidotus luteolus ¾ life size

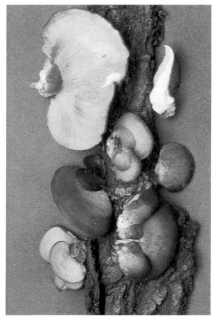

Panellus serotinus ½ life size

Panellus mitis ½ life size

Panellus stipticus ¾ life size

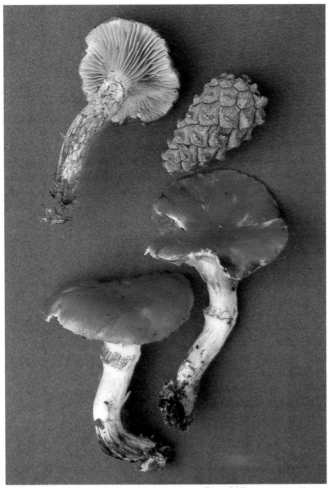

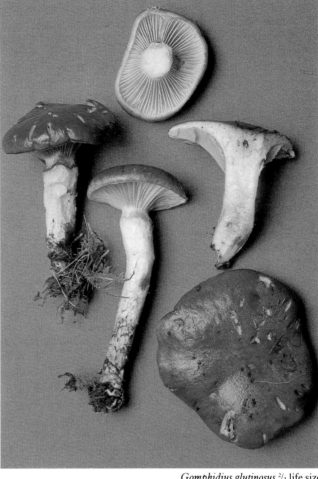

Gomphidius roseus ¾ life size

Gomphidius glutinosus ²/₃ life size

fallen twigs, old straw, dead grass or other vegetable debris. Season autumn to early winter. Common. **Not edible**.

Crepidotus applanatus (Pers. ex Pers.) Kummer **Cap** 1–4cm across, shell- or kidney-shaped, creamy white, sometimes striate towards the margin. **Stem** short and rudimentary, white. **Gills** horizontal, white at first becoming pale cinnamon. Spore print snuff-brown. Spores globose, minutely spiny, (4)5–6μ in diameter. Habitat on decaying wood. Season autumn. Rare. **Not edible**.

Crepidotus mollis (Schaeff. ex Fr.) Kummer syn. *C. caloSepis* (Fr.) Karst **Cap** 1.5–6cm across, bell- or kidney-shaped, bracket-like and often densely tiered, ochre brown, margin grey-brown and striate when moist drying creamy-ochre, to almost white, surface with a gelatinous covering. **Stem** absent or rudimentary. **Gills** crowded, pallid becoming cinnamon. Spore print snuff-brown. Spores broadly elliptic, smooth, 7–9×5–7μ. Habitat on decaying trunks of frondose trees. Season summer to late autumn. Occasional. **Edibility unknown** – best avoided.

Crepidotus luteolus (Lamb.) Sacc. syn. *C. pubescens* Bres. s. Lange syn. *Claudopus terricola* (Britz.) Sacc. **Cap** 1–2.5cm across, kidney-shaped, sulphur-yellow at first becoming white; stem absent or rudimentary, at first sulphur-yellow becoming white. **Gills** white at first then flesh-coloured or more rusty. Spore print clay-pink. Spores brown, narrowly elliptic, 7.5–10(11)×3.5–5μ. Habitat on twigs of deciduous

trees, often ash. Season autumn. Uncommon. **Not edible**.

Panellus serotinus (Schrad. ex Fr.) Kühn. syn. *Pleurotus serotinus* (Schrad. ex Fr.) Kummer **Cap** 3–7(15)cm across, kidney-shaped, ochre to olive-green, tacky in wet weather. **Stem** 10–25×8–15mm, lateral or rudimentary, yellowish covered in minute brownish scurfy scales. **Flesh** white with a gelatinous layer below the cap cuticle. **Gills** pale yellow to orange-yellow, fading with age. Pleuro- and cheilocystidia thin-walled, vesiculose-clavate, with yellowish contents. Spore print white. Spores curved cylindrical, amyloid 4–5.5×1–2μ. Habitat on fallen trunks and branches. Season autumn to early winter. Uncommon. **Not edible**.

Panellus mitis (Pers. ex Fr.) Sing. syn. *Pleurotus mitis* (Pers. ex Fr.) Quél. **Cap** 0.5–1.5cm across, fan-shaped, horizontal, white becoming clay-pink, pellicle separable. **Stem** 5–10×3–5mm, lateral, flattened, whitish covered in white mealy granules. **Flesh** white. Taste mild. **Gills** crowded, with gelatinous edge, white to cream. Spore print white. Spores cylindrical, amyloid, 3.5–5×1–1.5μ. Habitat coniferous twigs. Season early autumn to early winter. Rare. **Not edible**.

Panellus stipticus (Bull. ex Fr.) Karst. syn. *Panus stipticus* (Bull. ex Fr.) Fr. **Cap** 1–3cm across, kidney-shaped, pale ochre-brown to cinnamon, minutely scurfy. **Stem** 5–20×2–5mm, lateral, tapering towards the base, concolorous with cap or paler. **Flesh** whitish to pale yellowish. Taste

bitter. **Gills** pale cinnamon. Spore print white. Spores elliptic, amyloid, 3–6×2–3μ. Habitat often in crowded tiers on dead branches or stumps, especially of oak. Season all year. Uncommon. **Not edible**.

Gomphidius roseus (Fr.) Karst. **Cap** up to 5cm across, coral becoming more brick with age, convex at first then flattened, very viscid. **Stem** 25–45×4–10mm, whitish flushed with pink or vinaceous tint, the white glutinous veil leaving an indistinct ring zone. **Flesh** dirty white tinted coral, occasionally dirty yellow in stem base. Taste and smell not distinctive. **Gills** deeply decurrent, greyish, finally mouse-grey with olivaceous tinge. Spore print fuscous black. Spores subfusiform 15.5–17.5(20)×5–5.5μ. Habitat with conifers, especially pines. Season autumn. Uncommon. **Edible** but not recommended.

Gomphidius glutinosus (Fr.) Fr. syn. *Gomphus glutinosus* (Fr.) Kummer **Cap** 5–12cm across, greyish violet, glutinous. **Stem** 35–100×10–20mm, whitish above, grey-brown below, sometimes lemon-chrome at the base, glutinous with a glutinous veil connecting stem and cap margin which leaves a gelatinous blackening zone near the stem apex. **Flesh** whitish flushing vinaceous in the cap, strongly lemon-chrome towards the stem base. Taste and smell not distinctive. **Gills** decurrent, distant, whitish then vinaceous grey, darkening with age. Spore print sepia. Spores subfusiform, 17–20×5.5–6μ. Habitat with conifers. Season autumn. Rare. **Edible** but not recommended.

189

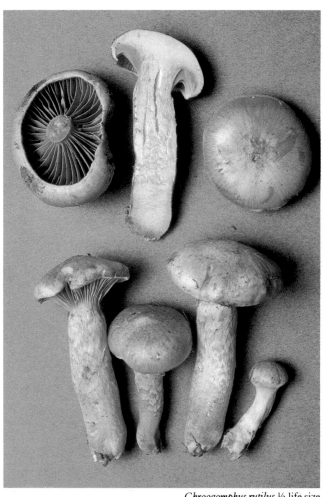

Chroogomphus rutilus ½ life size

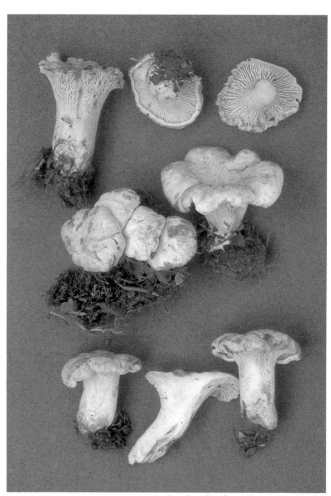

Cantharellus ferruginascens ½ life size

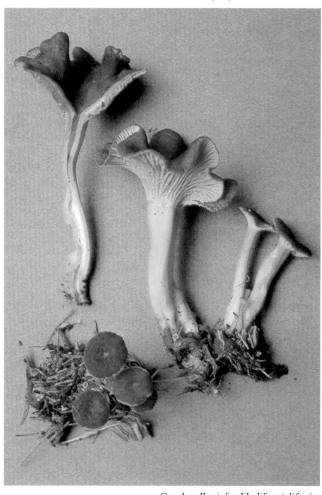

Cantharellus infundibuliformis life size

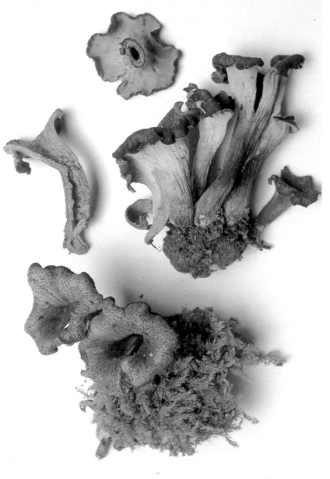

Horn of Plenty *Craterellus cornucopioides* ½ life size

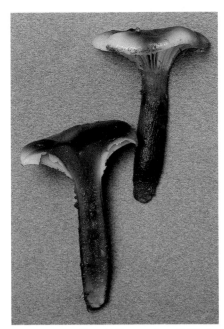

Gomphidius maculatus ¾ life size

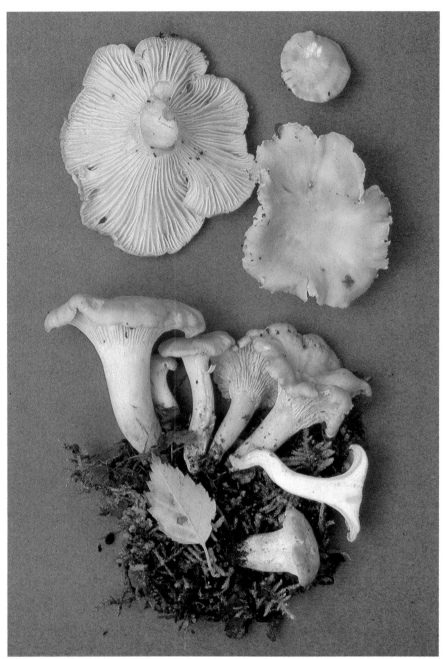

Chanterelle *Cantharellus cibarius* ²⁄₃ life size

Chroogomphus rutilus (Fr.) Miller syn.
Gomphidius viscidus Fr. **Cap** 3–15cm across,
brick-colour flushed vinaceous, viscid drying
shiny, convex, umbonate. **Stem** 60–120×2–
8mm, vinaceous at apex, yellow-buff below,
chrome at stem base, slightly viscid with cottony
veil which leaves irregular zones on the stem.
Flesh vinaceous in cap and stem, deep chrome in
stem base. Taste and smell somewhat astringent.
Gills deeply decurrent, dull olivaceous buff
becoming dirty purplish. Spore print fuscous
black to sepia. Spores subfusiform, 15–22×5.5–
7μ. Habitat with conifers, usually pines. Season
autumn. Common. **Edible** but not
recommended.

Cantharellus ferruginascens Orton **Cap** 2–6cm
across, convex then expanded-depressed,
irregularly lobed and wavy at the upturned
margin, ochraceous-buff bruising rusty
ochraceous. **Stem** 20–40×5–20mm, robust,
tapering towards the base, yellowish-cream,
bruising like the cap. **Flesh** whitish to yellowish-
cream. Taste mild, smell faint and pleasant.
Gills decurrent, narrow, forked, interveined and
fusing into one another, pale yellowish cream
darkening with age. Spore print pale creamy-
yellowish. Spores broadly elliptic, 7.5–10×5–
6μ. Habitat gregarious, in mixed woodland on
chalk soils. Season late summer to early autumn.
Rare. **Edible**.

Cantharellus infundibuliformis (Scop.) Fr. syn. *C.
tubaeformis* Fr. **Cap** 2–5cm across, convex with
depressed centre, becoming funnel-shaped with
an irregular wavy margin, dark dingy brown.
Stem 50–80×4–9mm, hollow dirty yellow, often
grooved or flattened. **Flesh** thin and tough,
yellowish. Taste bitter, smell aromatic. **Gills**
narrow, irregularly branched and vein-like,
yellowish at first then grey, decurrent. Spore
print yellowish. Spores 9–12×6.5–8μ. Habitat
on acid soils in deciduous or coniferous woods.
Season autumn. Occasional. **Edible**.
Also edible is *C. infundibuliformis* var. *lutescens*
which differs in the fruit body being entirely
yellowish.

Horn of Plenty *Craterellus cornucopioides* (L. ex
Fr.) Pers. syn. *Cantharellus cornucopioides* L. ex
Fr. **Cap** 2–8cm across, deeply tubular with flared
mouth, becoming irregularly crisped and wavy at
the margin, thin and leathery, dark brown to
black and scurfy scaly when moist drying paler
and greyish brown. Spore-bearing or outer
surface ashy grey, smooth in young specimens
becoming somewhat undulating with age. Spores
white, elliptic, 10–11×6–7μ. Habitat gregarious
or clustered amongst leaf litter of deciduous
woods. Season late summer to late autumn.
Occasional but locally abundant. **Edible – good**.

Gomphidius maculatus Fr. **Cap** 3–6cm across,
whitish or greyish and blotched with black in
older specimens, glutinous. **Stem** 45–75×10–
20mm, whitish becoming streaked sepia, base
yellowish, dry at apex. **Flesh** white in cap
reddening throughout with a vinaceous tint in
stem base, blackening with age in places. Taste
and smell not distinctive. **Gills** distant,
decurrent, whitish becoming vinaceous grey,
darkening with age. Spore print fuscous black.
Spores subfusiform, 17–23×6–8μ. Habitat with
larch. Season late summer to autumn.
Uncommon. **Edible** but not recommended.

Chanterelle *Cantharellus cibarius* Fr. **Cap** 3–
10cm across, at first flattened with an irregular
incurved margin later becoming wavy and lobed
and depressed at the centre, pale to deep egg-
yellow fading with age. **Stem** 30–80×5–15mm,
solid, concolorous with cap or paler, tapering
towards the base. **Flesh** yellowish. Taste watery
at first then slightly peppery, smell faint,
fragrant (of apricots). **Gills** narrow, vein-like,
irregularly forked and decurrent, egg-yellow.
Spore print ochraceous. Spores elliptical, 8–
10×4.5–5.5μ. Habitat in all kinds of woodland,
but usually associated with frondose trees in
Britain. Season summer to late autumn.
Occasional. **Edible – excellent**.

Pseudocraterellus sinuosus ¼ life size

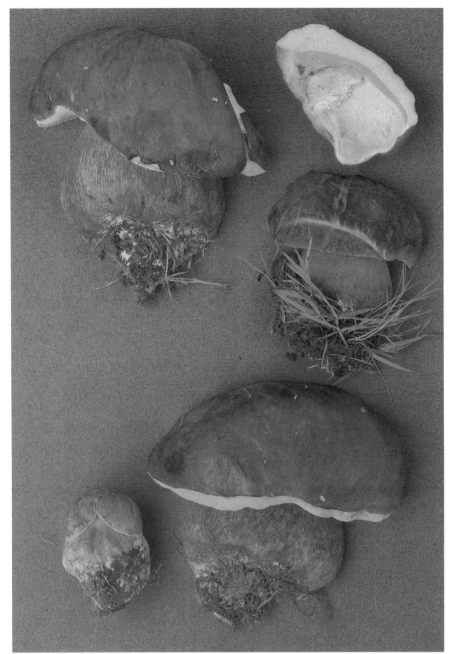

Boletus aereus ½ life size

BOLETUS *The caps are normally dry or slightly viscid in wet weather but never glutinous. Many species have the stem marked with a network (reticulation) others have small coloured dot markings; there is no ring. The tubes can easily be separated from the cap. The majority are edible and good to eat but care must be taken with any species with red or orange pores. Except for one species they all grow on the ground in association with trees. Dr Watling lists thirty-six in the British Fungus Flora.*

Boletus aereus Bull. ex Fr. **Cap** 7–16cm, dark cigar brown, bay to dark sepia, often dark brick-coloured near the margin, minutely cracking making the surface roughly textured, slightly downy at first then smooth. **Stem** 60–80×11–12mm, robust, covered with network which is brown near apex, clay pink or buff around the middle and rusty below. **Flesh** white, unchanging or becoming dirty vinaceous when bruised. Taste pleasant, smell strong and earthy. Tubes white to cream, finally sulphur-yellow. **Pores** similarly coloured but bruising vinaceous on handling and often flushed rust with age. Spores olivaceous snuff-brown, subfusiform, 13.5–15.5×4–5.5μ. Habitat with broad-leaved trees, especially beech and oak. Season summer to autumn. Rare. **Edible** – excellent.

Pseudocraterellus sinuosus (Fr.) Reid **Cap** 1–5cm across, irregularly funnel-shaped with a wavy and lobed margin, greyish-brown, fibrous. **Stem** 5–10cm long, tapering towards the base, greyish below, paler and more creamy above where it is covered by the spore-bearing surface which is irregularly wrinkled and folded, giving the appearance of vein-like 'gills'. Smell fruity. Spores white, ovoid, 8–10×5–7μ. Habitat in clusters amongst the leaf litter of deciduous woods. Season autumn. Rare. **Edible** – good.

Cep or **Penny Bun** *Boletus edulis* Bull. ex Fr. **Cap** 8–20(30)cm, brown often with a whitish bloom at first gradually lost on expanding leaving a white line at the margin, smooth and dry initially becoming greasy, in wet weather slightly viscid and polished. **Stem** 30–230×30–70(110)mm, robust, pallid with white net. **Flesh** white, unchanging, flushed dirty straw-colour or vinaceous in cap. Taste and smell pleasant. Tubes white becoming grey-yellow. **Pores** small and round, similarly coloured. Spore print olivaceous snuff-brown. Spores subfusiform, 14–17×4.5–5.5μ. Habitat coniferous, broad-leaved or mixed woodland. Season summer to late autumn. Common. **Edible** – excellent. This fungus is perhaps the most important edible species, it can often be found on sale in continental markets. Commercially it is dried and used as flavouring for soups.

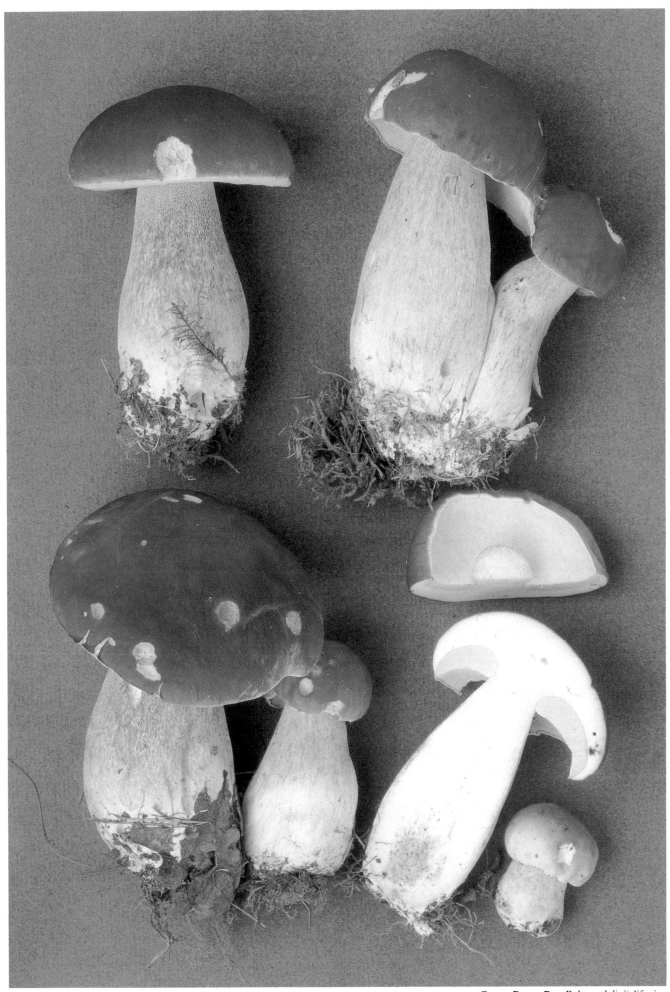

Cep or **Penny Bun** *Boletus edulis* ²/₃ life size

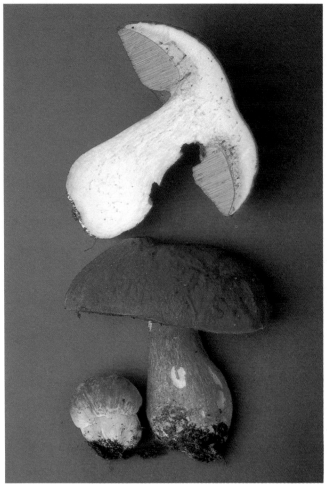

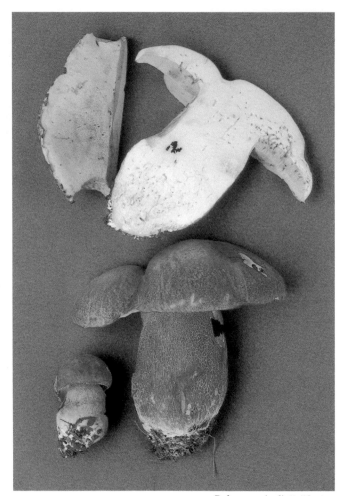

Boletus pinicola ⅓ life size

Boletus aestivalis ⅓ life size

Boletus pinicola (Vitt.) Venturi syn. *B. edulis* var *pinicola* Vitt. **Cap** 8–20cm, red brown or chestnut, with a white margin, smooth and greasy at first then dry and slightly downy. **Stem** robust, becoming wider and darker brown below, covered in a fine whitish or cinnamon net which bruises red. **Flesh** whitish, becoming deep vinaceous below cuticle when cut. Taste and smell pleasant. Tubes whitish, then greenish yellow. **Pores** small, white, then greenish yellow, finally olivaceous. Spore print olivaceous snuff-brown. Spores subfusiform, 13–17×4–5μ. Habitat in coniferous woods. Season late spring until as late as November. Rare. **Edible**.

Boletus aestivalis Fr. syn. *B. reticulatus* Boud. **Cap** 7–20cm, pale straw-colour to pale snuff-brown, dry, soon becoming rough and cracking into small scales, particularly at centre. **Stem** 60–150×20–50mm, robust, covered in a dense white network. **Flesh** white throughout, sometimes with slight yellowish tinges. Smell and taste strong but pleasant. Tubes white then greenish-yellow. **Pores** small, round, similarly coloured. Spore print olivaceous snuff-brown. Spores subfusiform, 13–15×4.5–5.5μ. Habitat with beech and oak. Season early summer to autumn. Rare. **Edible** – excellent.

Peppery Boletus *Boletus piperatus* Bull. ex Fr. syn. *Suillus piperatus* (Fr.) Kuntze **Cap** 3–7cm, cinnamon to sienna, at first slightly viscid then dry, smooth and shiny. **Stem** 40–75×5–20mm, concolorous with cap, slender, tapering towards

base, where it is a distinctive lemon-chrome. **Flesh** flushed red above tubes and under cuticle, intensely lemon-chrome in stem base. Taste peppery, smell not distinctive. Tubes cinnamon then rust-coloured, not bruising, decurrent or subdecurrent. **Pores** angular, rich rust-coloured at maturity. Spore print snuff-brown flushed

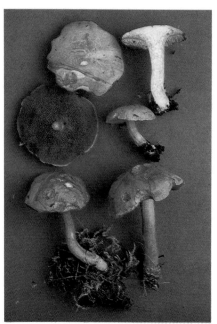

Peppery Boletus *Boletus piperatus* ⅓ life size

ochraceous cinnamon. Spores subfusiform to ellipsoid, 8–11×3–4μ. Habitat variable, particularly in birch scrub or mixed pine and birch on sandy soil. Season late summer to autumn. Occasional. **Edible** – peppery flavoured.

Boletus appendiculatus Schaeff. ex Fr. syn. *B. edulis* f. *appendiculatus* Fr. **Cap** 8–14cm, ochraceous with distinct bay to rusty flush particularly near the centre where irregular cracking may occur. **Stem** 110–125×34–37mm, lemon-yellow at apex darker below often with red patches, with a fine cream to pale lemon-yellow net. **Flesh** white to pale yellow, turning blue on cutting at apex of stem and often ochraceous rust at base. Taste pleasant, smell like puffballs. Tubes lemon-yellow bruising faintly greenish blue. **Pores** initially lemon-yellow becoming slightly rusty and expanding with age. Spore print olivaceous snuff-brown. Spores subfusiform, 12–15×3.5–4.5μ. Habitat with broad-leaved trees, associated with oak in the South of England. Season late summer to early autumn. Rare, more frequent in the South of England. **Edible** – excellent.

194

Boletus appendiculatus life size

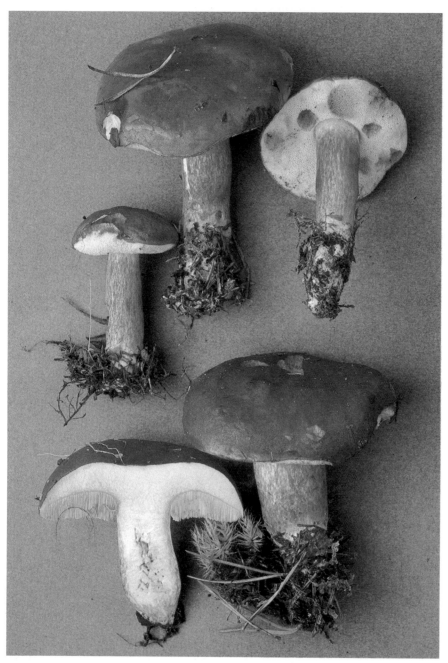

Bay Boletus *Boletus badius* ²⁄₃ life size

Bay Boletus *Boletus badius* Fr. syn. *Xerocomus badius* (Fr.) Kühn. **Cap** 4–14cm, bay to dark brick-colour later flushed ochraceous brown, downy when young, soon becoming smooth and polished, slightly viscid in wet weather. **Stem** 45–125×8–40mm, concolorous with cap or paler, surface slightly cottony. **Flesh** white to lemon-yellow on cutting becoming faintly blue particularly in stem apex and above tubes, vinaceous in cap. Taste and smell mild and mushroomy. Tubes cream to lemon-yellow, bruising bluish green. **Pores** large, readily bruising blue-green. Spore print olivaceous snuff-brown. Spores subfusiform, 13–15×4.5–5.5μ. Habitat in mixed woods. Season autumn. Common throughout British Isles. **Edible** – very good and usually free of maggots.

Boletus albidus Rocques syn. *B. radicans* Pers. ex Fr. s. Kall. **Cap** 8–16cm, dingy white to clay buff with ochraceous tints and smokey-grey margin, downy at first becoming smooth or cracking into small scales at centre, more ochraceous with age. **Stem** 50–80×30–40mm, robust, swollen towards the rooting base, sometimes flushed reddish, lemon-yellow at apex, spotted rusty to dirty ochraceous near base, net straw-coloured and distinct near apex, disappearing below. **Flesh** yellow then rapidly white in cap when cut; reacting similarly in stem but becoming pale blue especially in apex and rapidly fading. Taste unpleasant or bitter, smell spicy. Tubes lemon-yellow becoming blue on cutting or bruising. **Pores** small, round, lemon-yellow bruising blue. Spore print olivaceous snuff-brown. Spores subfusiform, 12–16×4.5–6μ. Habitat with broad-leaved trees, particularly oak and beech. Season summer to autumn. Rare. **Not edible** due to its bitterness.

Boletus fragrans Vitt. **Cap** 5–12cm across, convex then expanded, umber to date-brown, velvety at first becoming smooth. **Stem** 70–90×30–50mm, spindle-shaped, apex yellow becoming flushed red below, whitish above base in young specimens, extreme base black. **Flesh** lemon-yellow flushed red below cap cuticle, blueing only after several hours. Taste and smell pleasant. Tubes lemon-yellow sometimes with olivaceous flush. **Pores** lemon-yellow at first, later chrome-yellow, bruising faintly bluish. Spores elliptic, 9–16×4.5–6.5μ. Habitat deciduous woods. Season autumn. Very rare. **Edible**.

Boletus impolitus Fr. syn. *Xerocomus impolitus* (Fr.) Quél **Cap** 5–15cm, clay coloured, sometimes with tawny or olive tints with a pale grey hoariness at first, dry, slightly velvety, then smooth. **Stem** 60–100×30–50mm, robust, straw-coloured at apex, darker brown towards the base. **Flesh** pale lemon-yellow with deeper yellow region above the pores, becoming faintly pink or very rarely faintly blue after some time on cutting. Taste mild, smell of iodoform in stem base. Tubes lemon-yellow then lemon-chrome. **Pores** small, similarly coloured. Spore print olivaceous snuff-brown. Spores subfusiform, 10–14×4.5–5.5μ. Habitat on rides in broad-leaved woods, particularly oak and often on clay soils. Season early summer to autumn. Rare. **Edible**. (Two forms illustrated.)

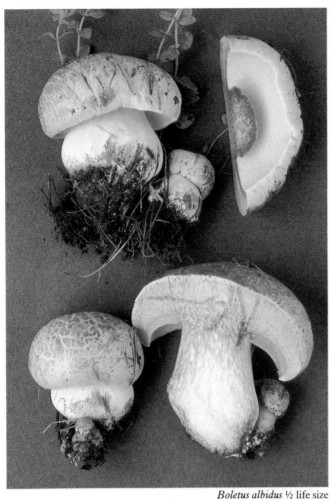

Boletus albidus ½ life size

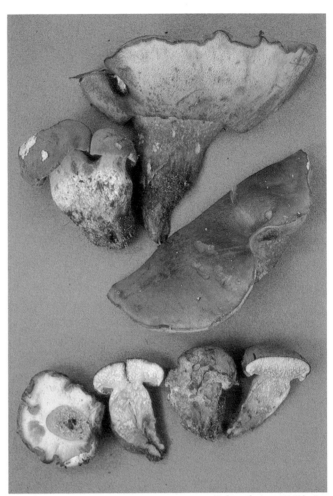

Boletus fragrans ½ life size

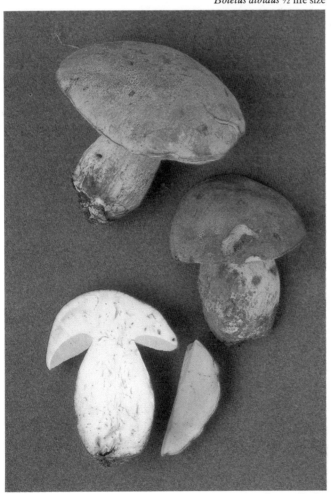

Boletus impolitus ⅓ life size

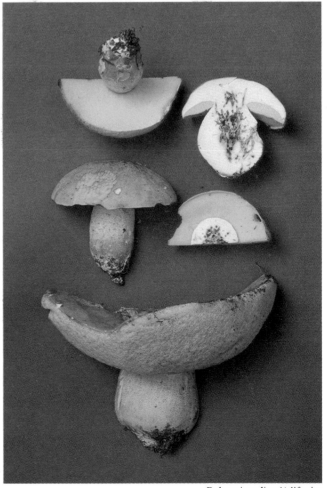

Boletus impolitus ⅓ life size

197

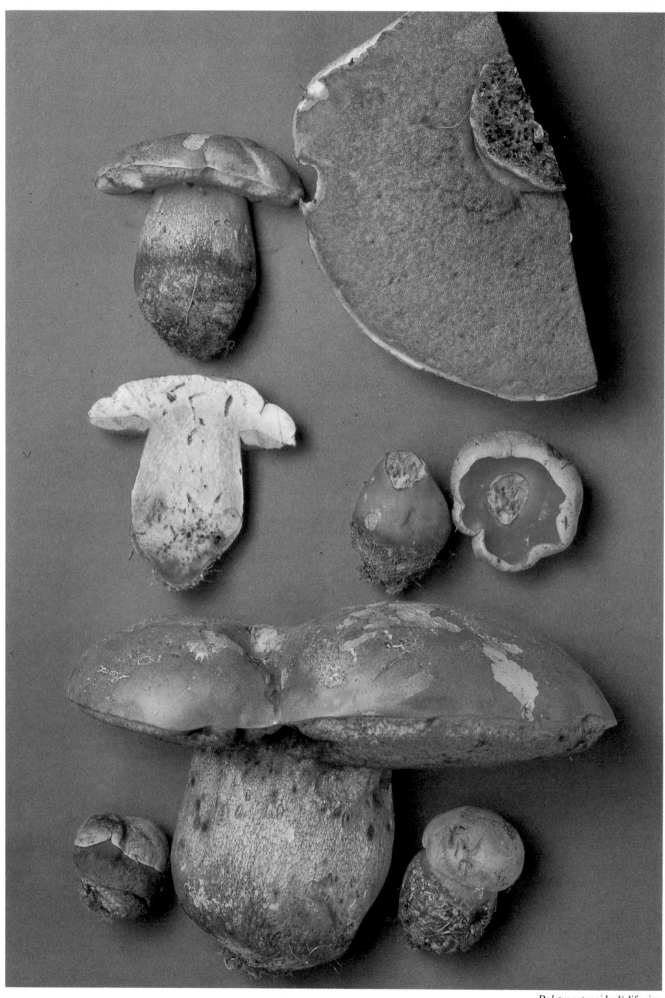

Boletus satanoides ¾ life size

Boletus satanoides Smotlacha syn. *B. splendidus* Martin subsp. *splendidus* **Cap** 5–14cm, initially whitish or milky coffee-coloured then grey olivaceous with a flush of red becoming more intense with age, particularly at the margin, bruising blue only after rough handling. **Stem** 80–160×20–40mm, orange above the red central zone, lower half lemon-yellow or coral, with an orange net at apex which is gradually lost towards the base, bruising blue. **Flesh** white to pale lemon, discolouring blue-green and red in the base of the stem when cut. Taste unpleasant, smell spicy. Tubes lemon-chrome bruising blue. **Pores** small, orange red becoming darker red with age, lighter at margin. Spore print olivaceous snuff-brown. Spores subfusiform, 10.5–12.5×4.5–5μ. Habitat with oaks. Season summer. Rare. **Poisonous.**

Boletus luridus Schaeff. ex Fr. **Cap** 6–14cm, snuff brown or olive brown with rusty or bay tints, slightly downy at first then becoming smooth and polished, bruising dark brownish or blue-black. **Stem** 80–140×10–30mm yellowish red with orange-red net, bruising blue. **Flesh** lemon-yellow in cap soon becoming greenish-blue to dark blue on cutting with a persistent red line above tubes, lemon in stem and blackish-red in stem base. Taste and smell not distinctive. Tubes yellowish-green, blue on cutting. **Pores** small, orange-red, more yellow at margin, bruising dark blue. Spore print olivaceous snuff-brown. Spore subfusiform to broadly ellipsoid, 11–15×4.5–6.5μ. Habitat in broad-leaved woods, particularly with oak or beech and on calcareous soils. Season summer to autumn. Occasional. **Edible** when cooked, but has been known to cause gastric upsets. (Two forms illustrated.)

Boletus pulverulentus Opat. **Cap** 4–9cm, drab, snuff-brown or milky coffee often variously flushed red, olive or purplish, initially downy then smooth, rapidly bruising blue to almost black on handling. **Stem** 50–65×8–14mm, lemon-chrome or lemon-yellow at apex, elsewhere brownish becoming streaked blood-red, punctate, bruising dark blue and finally black. **Flesh** lemon-yellow turning blue immediately on cutting. Taste and smell pleasant. Tubes bright lemon-yellow bruising dark blue. **Pores** dark sulphur-yellow, bruising dark blue. Spore print olivaceous snuff-brown. Spores subfusiform, 10–14×3.5–6.5μ. Habitat in grassy rides of broad-leaved woods, particularly with oak. Season autumn. Rare. **Edible** – good.

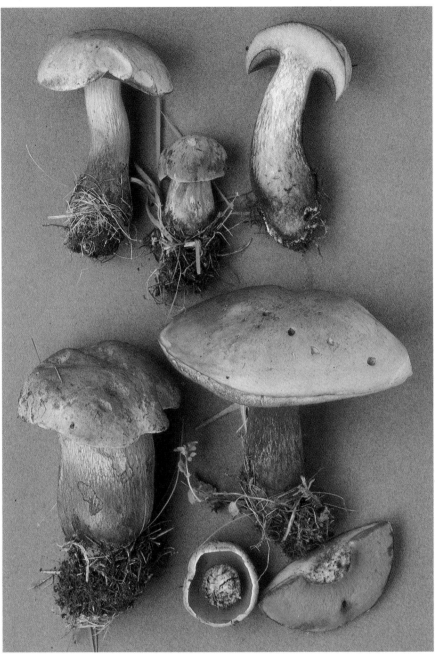

Boletus luridus ½ life size

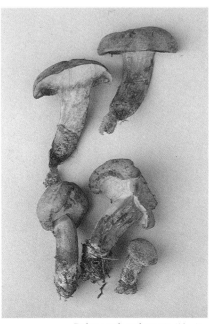

Boletus pulverulentus ⅓ life size

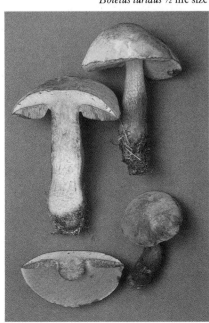

Boletus luridus ¼ life size

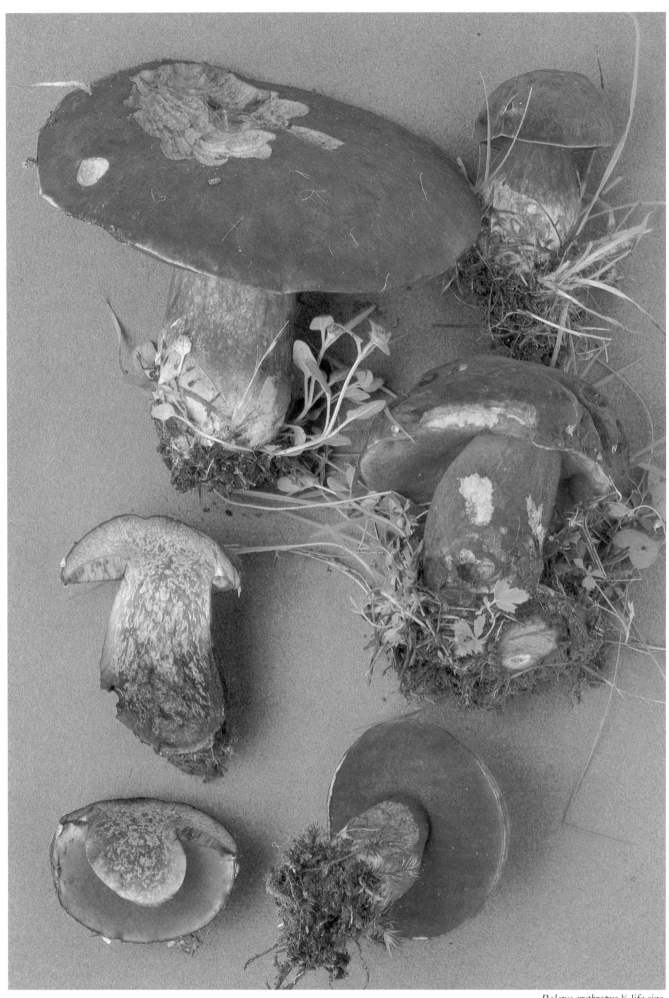

Boletus erythropus ¾ life size

Boletus erythropus (Fr. ex Fr.) Secr. **Cap** 8–20cm, bay to snuff-brown with olivaceous tints, tending to yellowish ochre towards the margin, slightly velvety at first, soon becoming smooth and sometimes slightly viscid when wet, bruising blue-black. **Stem** 45–145×20–50mm, robust, yellowish densely covered in red dots. **Flesh** yellow, immediately dark blue on cutting. Taste and smell not distinctive. Tubes lemon-yellow then greenish, becoming dark blue on cutting. **Pores** small, round, orange-red becoming rusty with age, readily bruising dark blue to black. Spore print olivaceous snuff-brown. Spores subfusiform 12–15×4–6μ. Habitat in coniferous, broad-leaved and mixed woodland. Season late summer to autumn. Common. **Edible** only when cooked, can cause gastric upsets.

Boletus queletii Schulzer **Cap** 5–15cm, red-brown to brick colour, minutely pruinose at first particularly towards the margin, becoming more polished, bruising bluish-black on handling. **Stem** 70–100×25–45mm, yellow flushed with coral from apex to middle and minutely dotted with red or orange, more red towards the base. **Flesh** lemon-yellow in cap immediately turning blue on cutting sometimes with a red line above tubes, base of stem blackish purple. Taste and smell not distinctive. Tubes dirty ochre becoming bluish olivaceous on cutting. **Pores** initially peach becoming more orange then rusty, with a pale zone at margin, bruising dark blue. Spore print olivaceous snuff-brown. Spores subfusiform, 12–14×5.5–6.5μ. Habitat with broad-leaved trees, especially beech and oak in South-east England. Season autumn. Rare. **Edible**.

Boletus purpureus Pers. **Cap** 7–20cm, whitish or buff to pinky ochre, slightly velvety, sometimes cracking at centre, easily bruising and marking dark blue. **Stem** 60–90×18–55mm, lemon-yellow flushed reddish towards base, with a red net, bruising dark violet to blackish. **Flesh** lemon flushed greenish yellow rapidly turning deep blue on cutting then black, stem base blood-red then beetroot. Taste indistinct, smell fruity. Tubes lemon-yellow then greenish-yellow, bruising blue. **Pores** small, orange then flushed red becoming olivaceous buff with age. Spore print olivaceous brown. Spores subfusiform 10.5–13.5×4–5.5μ. Habitat mixed and broad-leaved woods and birch scrub. Season summer to autumn. Rare. **Poisonous**.

Boletus rhodoxanthus (Krombh.) Kall. **Cap** 6–20cm across, convex, whitish-pink, more pink at margin, discolouring yellowish with age, covered in pinkish-grey slime but appearing reddish pink where this has been removed in handling. **Stem** 50–150×20–50mm, with a purple-red net on an orange-yellow ground, net becoming indistinct at the olive-grey base. **Flesh** lemon-yellow turning light blue in the cap on cutting, eventually fading to yellow. Taste sweet, smell strong, fungusy. Tubes yellow, blueing slightly on cutting. **Pores** golden-yellow at first becoming bright blood red. Spores olive-brown, 10–16×4–5.5μ. Habitat beech and oak woods. Season autumn. Very rare. **Poisonous**.

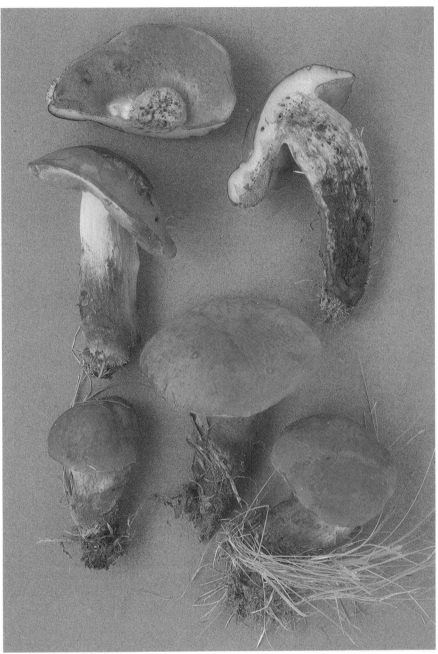

Boletus queletii ½ life size

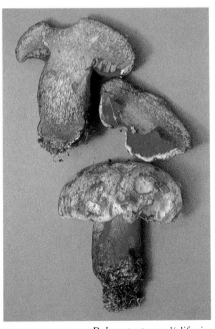

Boletus purpureus ¼ life size

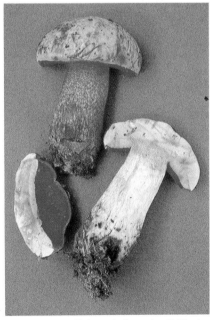

Boletus rhodoxanthus ¼ life size

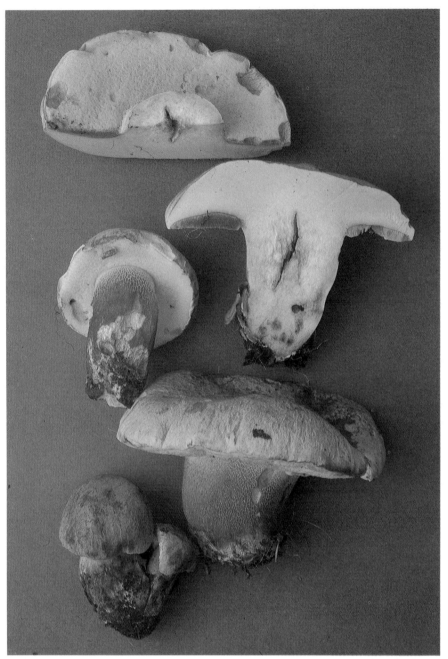

Boletus calopus ²/₃ life size

B. subtomentosus L. ex Fr. differs in the stem having no network and the cap cuticle turning purplish-date with ammonia.

Boletus porosporus (Imler) Watling syn. *Xerocomus porosporus* Imler **Cap** up to 8cm, dark olive brown then sepia to cigar-brown although at first with yellow down which darkens on bruising, later cracking to show yellowish flesh particularly at centre. **Stem** 90–100×20–30mm, apex lemon-chrome sometimes with brown to blood-red zone, slightly ribbed with olivaceous brown, darkening when bruised. **Flesh** pale lemon yellow to buff in cap, stem apex lemon-chrome, stem base dark brick or vinaceous, finally becoming blue after cutting particularly above the tubes. Taste and smell not distinctive. Tubes lemon-yellow finally olivaceous, bruising blue. **Pores** compound, angular, lemon-yellow darkening with age, bruising blue. Spore print olivaceous snuff-brown. Spores subfusiform, 13–15×4.5–5.5μ, with a distinct truncate pore making this species unique among European boletes. Habitat mixed deciduous woods, particularly where oak is present. Season autumn. Rare. **Edible** but not recommended.

Boletus leonis Reid **Cap** 3–5cm, bright sienna or ochre becoming buff, surface covered in irregularly downy patches particularly at the centre, elsewhere smooth. **Stem** 30–75×90–135mm, with rooting base, cream at apex, more ochraceous below. **Flesh** cream, with lemon-yellow tinge towards stem base. Taste and smell not distinctive. Tubes greenish yellow or lemon yellow. **Pores** lemon chrome unchanging. Spore print ochraceous citrine. Spores subfusiform to ellipsoid, 9–13×4.5–5.5μ. Habitat in parkland with oak. Season autumn. Rare. **Edibility unknown**.

Satan's or **Devil's Boletus** *Boletus satanas* Lenz **Cap** 8–25cm, almost white with buff or sepia flush frequently with faint red flush at margin, becoming flushed ochre with age, slightly downy then smooth with minute cracks particularly at centre, bruising brown with handling. **Stem** 60–90×50–110mm, often markedly swollen at base, saffron orange to lemon-chrome at apex, red with ochre flush at base, covered with a red net. **Flesh** pale straw-coloured to saffron in cap, white or pale lemon in stem gradually becoming pale sky blue on cutting with rusty patches in stem and dirty buff fading to greenish blue or blotched with red at stem base. Taste and smell unpleasant. Tubes yellowish green then dark olivaceous, blue on cutting. **Pores** small, round, blood-red but orange towards the margin, finally tinged orange, bruising greenish. Spore print olivaceous snuff-brown. Spores subfusiform, 11–14×4.5–6μ. Habitat with broad-leaved trees, especially beech and oak, usually on calcareous soils. Season summer. Very rare. **Poisonous** – possibly deadly.
Unfortunately the least successful photograph in the book.

Boletus calopus Fr. syn. *B. pachypus* Fr. **Cap** 5–14cm, smoke-grey or flushed olivaceous, slightly downy at first then smooth, sometimes slightly cracked or scaly at centre with age. **Stem** 70–90×35–40(50)mm, robust, lemon-yellow at apex, elsewhere red although frequently brown at base, covered with a white or straw-coloured network. **Flesh** pale straw-coloured to pale lemon-yellow becoming whitish immediately on cutting then flushed blue especially in stem apex and over the tubes, sometimes patchily red at base of stem. Taste bitter, smell strong. Tubes dirty sulphur-yellow, bruising bluish-green. **Pores** similarly coloured, also bruising bluish-green. Spore print olivaceous snuff-brown. Spores subfusiform, 12–16×4.5–5.5μ. Habitat in mixed woodland, particularly with beech or oak. Season late summer to autumn. Occasional. **Not edible.**

Boletus lanatus Fr. **Cap** 4–10cm, very velvety, fulvous to pale sepia, darkening where rubbed or bruised. **Stem** up to 80×10–15(20)mm, pale at apex and yellow towards middle with a wide, coarse, irregular network of dark brick-coloured veins, paler again towards the base. **Flesh** white in cap with a date-brown line beneath the cuticle, rust above tubes and flushed lemon-yellow in base of stem, hardly blueing or not at all on cutting; cap surface immediately yellowish- or bluish- green when treated with ammonia solution then fading. Taste and smell not distinctive. Tubes lemon-chrome blueing on exposure to air. **Pores** large, angular, similarly coloured, bruising blue on handling then fading. Spore print olivaceous snuff-brown. Spores subfusiform-ellipsoid, 9–11.5×3.5–4.5μ. Habitat in broad-leaved and mixed woods, particularly with birch. Season autumn. Rare. **Edibility unknown**.

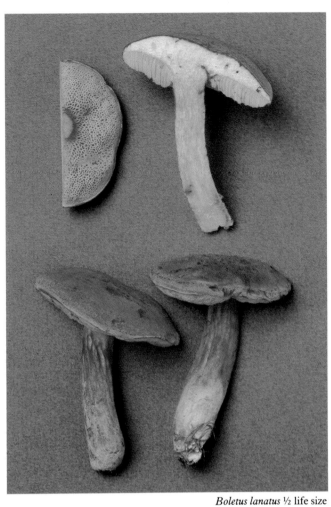

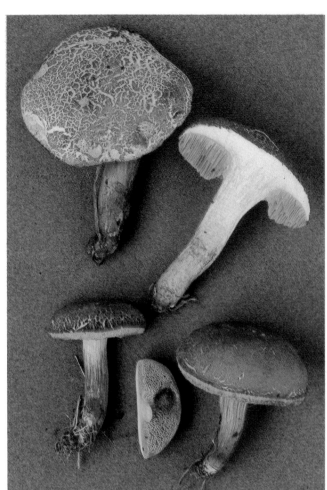

Boletus lanatus ½ life size

Boletus porosporus ⅔ life size

Boletus leonis ¾ life size

Satan's Boletus *Boletus satanas* ⅓ life size

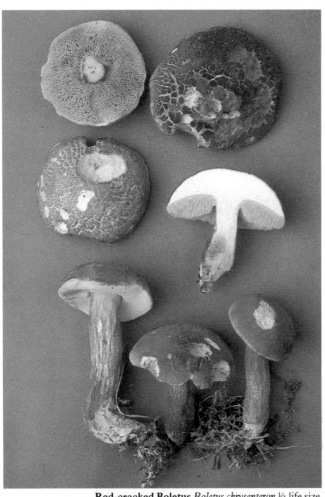

Red-cracked Boletus *Boletus chrysenteron* ½ life size

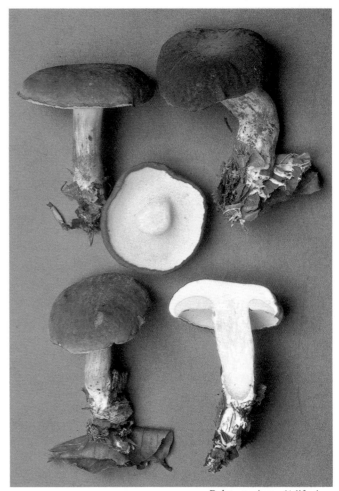

Boletus pruinatus ½ life size

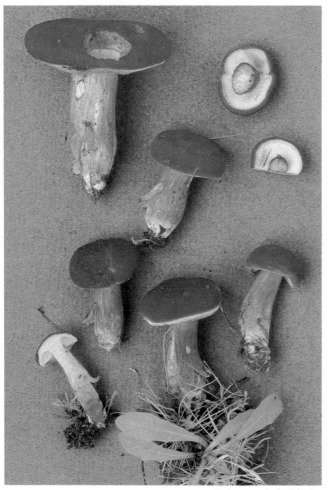

Boletus versicolor life size

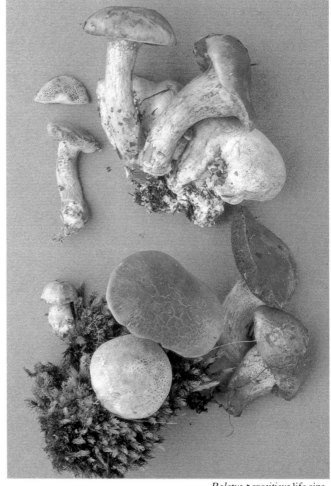

Boletus parasiticus life size

Red-cracked Boletus *Boletus chrysenteron* Bull.
ex St. Amans syn. *Xerocomus chrysenteron* (Bull.
ex St. Amans) Quél. **Cap** 4–11cm, dingy brown
to pale sepia or buff with olivaceous flush, or with
a pinkish red flush particularly late in the season,
slightly velvety at first then smooth, later
cracking irregularly to show coral flesh, making
this an easily recognizable species. **Stem** 40–
80×10–15mm, lemon-yellow at apex, red from
middle downwards becoming more buff towards
base. **Flesh** cream or lemon-yellow in cap, brown
to reddish-buff in stem, usually pale red just
below cap, turning slightly blue above the tubes
and in base of stem but only slowly. Taste and
smell slight but not distinctive. Tubes sulphur or
lemon yellow, becoming greenish with age.
Pores large, angular, similarly coloured and
sometimes bruising greenish. Spore print
olivaceous snuff-brown. Spores subfusiform,
12–15×3.5–5μ. Habitat with broad-leaved
trees. Season autumn. Very common. **Edible** but
mushy when cooked.

Boletus pruinatus Fr. & Hök **Cap** 4–10cm, dark
red-brown or chestnut when young becoming
lighter and more pink with age, with a hoary
bloom which is destroyed by handling. **Stem**
90–100×20–30mm lemon-yellow or yellow-
chrome at apex, irregularly covered with fine
blood-red dots, base more red and arising from
apricot-coloured mycelium. **Flesh** lemon-
chrome throughout with darker brown base,
slowly turning blue-green on cutting. Taste and
smell not distinctive. Tubes lemon-yellow,
becoming bluish with age. **Pores** small, similarly
coloured. Spore print olivaceous snuff-brown.
Spores subfusiform, 11.5–14×4.5–5.5μ.
Habitat mixed broad-leaved woods, especially
when beech is present. Season summer and
autumn. Rare. **Edible**.

Boletus versicolor Rostk. **Cap** 3–6cm, red, scarlet
or vinaceous, with a faint olivaceous flush near
margin or disc. **Stem** slender and often very
long, up to 75mm, lemon-yellow or lemon-
chrome at apex, red elsewhere becoming rusty
towards the base. **Flesh** dirty buff or straw-
coloured in cap, lemon-yellow in stem apex,
vinaceous or blood-red below and brownish at
the base, blueing slowly over tubes. Taste and
smell not distinct. Tubes lemon-yellow with
greenish flush when older. **Pores** large, angular,
similarly coloured, bruising blue. Spore print
olivaceous snuff-brown. Spores subfusiform,
11–14×4.5–5.5μ. Habitat with broad-leaved
trees in grass. Season autumn. Rare. **Edible** but
not good.

Boletus parasiticus Bull. ex Fr. syn. *Xerocomus
parasiticus* (Fr.) Quél. **Cap** 2–4cm, olivaceous
straw-colour to sienna, slightly downy. **Stem** up
to 40×10mm concolorous with cap often curved
around or beneath host, tapering towards base.
Flesh pale lemon-yellow, unchanging, flushed
rust near stem base. Taste and smell not
distinctive. Tubes lemon-yellow to ochraceous
or even rust-coloured, adnate to subdecurrent.
Pores lemon yellow becoming rust. Spore print
olivaceous snuff-brown. Spores elongate, 11–
21×3.5–5μ. Habitat unique, on *Scleroderma
citrinum*, and therefore easily recognized. Season
autumn. Rare. **Edible**.

Bitter Bolete *Tylopilus felleus* (Fr.) Karst. syn
Boletus felleus Fr. **Cap** 6–12cm, fulvous to snuff-
brown, slightly downy at first, smooth with age.
Stem 70–100×20–30 (60 at base) creamy ochre,
lighter at apex, covered in a coarse snuff-

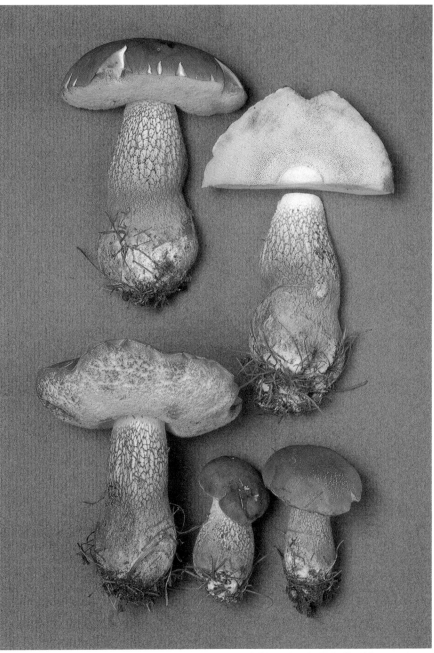

Bitter Bolete *Tylopilus felleus* ½ life size

brown network. **Flesh** soft, white to cream, clay-
pink beneath cap cuticle. Taste very bitter, like
bile, smell slightly unpleasant. Tubes slightly
salmon or coral. **Pores** similarly coloured,
bruising brownish. Spore print clay-pink to
vinaceous. Spores subfusoid, 11–15×4–5μ.
Habitat coniferous and deciduous woodland.
Season late summer to autumn. Occasional. **Not
edible** due to bitter taste.

Aureoboletus cramesinus (Secr.) Watling syn.
Boletus cramesinus Secr. **Cap** 2.5–5cm,
ochraceous peach to dirty pink, viscid. **Stem**
50–80×5–10mm, more or less rooting,
narrowing towards the pointed base, smooth and
viscid, yellow at apex flushed reddish buff or
pink towards the base. **Flesh** whitish often
pinkish under cap disc and lemon-yellow over
the tubes. Taste and smell pleasant. Tubes
lemon-chrome then golden-yellow, unchanging
on bruising. **Pores** similarly coloured. Spore
print ochraceous buff. Spores subfusiform, 11–
15×4.5–5.5μ. Habitat in broad-leaved woods,
occasionally on old bonfire sites. Season late
summer to autumn. Rare. **Edible**.

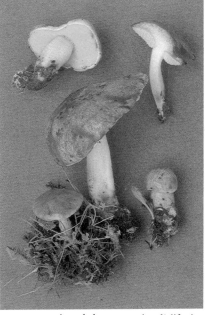

Aureoboletus cramesinus ⅔ life size

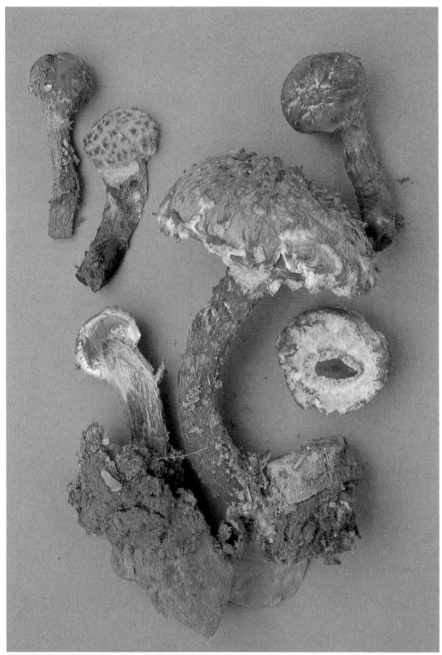

Strobilomyces floccopus ²/₃ life size

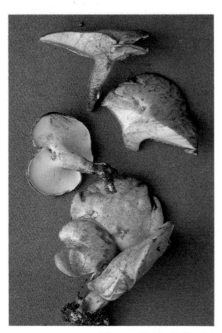

Uloporus lividus ⅓ life size

70×10–20mm, concolorous with cap or paler later flushed vinaceous brown. **Flesh** whitish-lemon in cap, becoming blue above the tubes and in the stem apex, rusty towards the stem base. Taste and smell not distinctive. Tubes bright sulphur-yellow, bruising greenish-blue then fading to brown. **Pores** large, angular, similarly coloured bruising dark blue-grey. Spore print olivaceous brown. Spores ellipsoid to ovoid, 4.5–6×3–4μ. Habitat solitary or often joined at the stem to several others into tufts; with alders. Season autumn. Rare. **Edible**.

Gyroporus castaneus (Bull. ex Fr.) Quél. syn. *Boletus castaneus* Fr. **Cap** 3–10cm, cinnamon to rusty tawny becoming darker with age, slightly downy at first, later smooth. **Stem** 35–95×11–30mm becoming hollow, concolorous with cap but often paler at apex. **Flesh** firm, white, unchanging. Taste mild and nutty-sweetish; smell slight. Tubes white then straw-coloured, darkening with age. **Pores** virtually free, similarly coloured, not bruising when handled. Spore print pale straw-colour. Spores ellipsoid 8–11×4.5–6μ. Habitat usually associated with oak. Season summer to autumn. Rare. **Edible** – excellent.

Gyroporus cyanescens (Bull. ex Fr.) Quél. syn. *Boletus cyanescens* Fr. **Cap** 6–12cm, pale ochre, buff or dingy white becoming more ochre with age bruising blue or rusty, coarsely velvety, margin often shaggy. **Stem** 50–100×20–85mm, becoming hollow, pale yellow at apex gradually becoming concolorous with cap below, often cracking to give ring-like zones. **Flesh** firm, white, instantly blue-green on cutting. Taste and smell not distinctive. Tubes white then pale yellow flushed sulphur or greenish yellow with age. **Pores** virtually free, similarly coloured, bruising blue. Spore print pale straw-colour. Spores ellipsoid, 9–11×4.5–6μ. Habitat often with birch or spruce and on heaths. Season summer to late autumn. Rare. **Edible** – good.

Boletinus cavipes (Opat.) Kalchbr. syn. *Boletus cavipes* Opat. **Cap** 3–8cm across, convex or slightly umbonate then expanding often becoming irregular or lobed at the margin, entirely golden yellow or more often rusty-tawny to umber, suede-like or even felty scaly. **Stem** 40–80×10–20mm, lemon yellow with an indistinct net above the white cottony ring, darker and covered in brownish fibrils below. **Flesh** whitish, tinged yellow in cap and sometimes pinkish in stem. Taste and smell pleasant. Tubes short, yellowish then flushed olivaceous. **Pores** large, angular, concolorous with tubes. Spore print olivaceous. Spores subcylindric to fusiform, 7–10×3–4μ. Habitat with larch. Season late summer. Rare. **Edible** – poor.

Porphyrellus pseudoscaber (Secr.) Sing. syn. *Boletus porphyrosporus* Fr. & Hök **Cap** 5–15cm, sepia to snuff-brown with paler margin, velvety at first becoming smooth and bruising darker on handling. **Stem** 40–150×10–35mm, concolorous with cap becoming more olivaceous towards the base, sometimes with lilaceous flush, initially velvety then smooth. **Flesh** buff to straw-coloured becoming vinaceous then grey-olivaceous on cutting with a touch of blue-green above the tubes and in the stem apex. Taste and smell sour and unpleasant. Tubes vinaceous buff, bruising bluish green. **Pores** similarly coloured and changing, ochraceous or sienna around mouth. Spore print pale brown-vinaceous. Spores subfusiform, 12–16×5–6.5μ. Habitat with broad-leaved trees and conifers. Season late summer and autumn. Rare. **Edible** – not good.

Strobilomyces floccopus (Vahl. ex Fr.) Karst. syn *Boletus floccopus* Vahl. ex Fr. syn. *Boletus strobilaceus* Fr. **Cap** 5–12cm, smoke-grey with white patches, soon becoming mouse-grey or cigar-brown to olivaceous black covered with large, thick, concolorous wart-like scales some of which overhang the margin giving the cap a ragged appearance. **Stem** 80–120×10–20mm, white to mouse-grey above, concolorous with cap below and covered in large scales. **Flesh** firm, white gradually vinaceous to coral then brown on cutting. Taste and smell not distinctive. Tubes white to grey, coral then red on bruising. **Pores** large, angular, similarly coloured. Spore print violaceous black. Spores subglobose to broadly ellipsoid with reticulate ornamentation, 10–12×8.5–11μ. Habitat broad-leaved or coniferous woods. Season early autumn. Rare. **Edible** when young but not worth eating.

Uloporus lividus Fr. Quél. syn. *Boletus lividus* Fr. syn. *Gyrodon lividus* Fr. (Sacc.) **Cap** 4–10cm, straw-coloured or pale buff often with a tinge of rust, viscid at first becoming dry. **Stem** 30–

Gyroporus castaneus ½ life size

Gyroporus cyanescens ½ life size

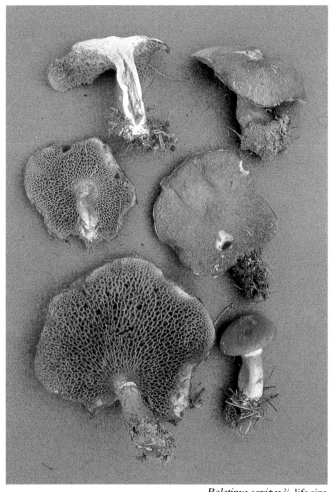

Boletinus cavipes ⅔ life size

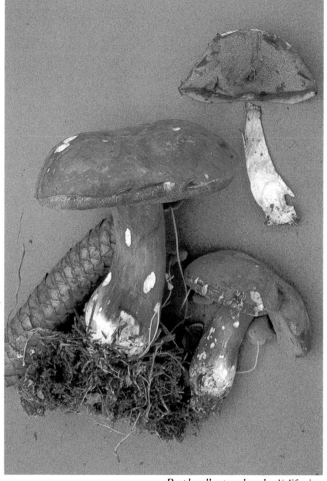

Porphyrellus pseudoscaber ½ life size

207

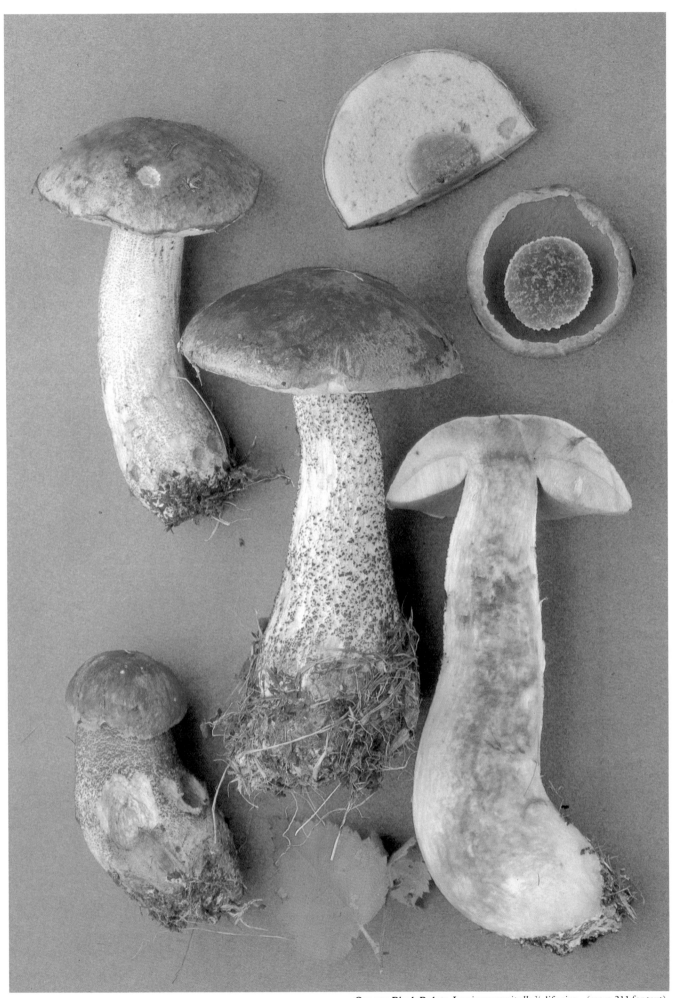

Orange Birch Bolete *Leccinum versipelle* ²/₃ life size – (see p.211 for text)

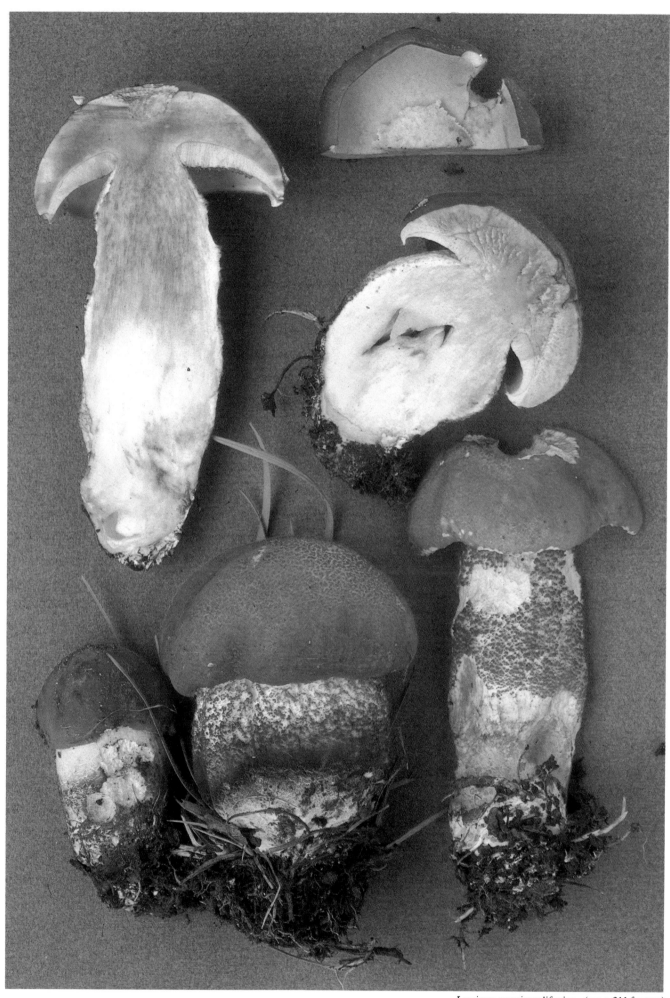

Leccinum quercinum life size – (see p.211 for text)

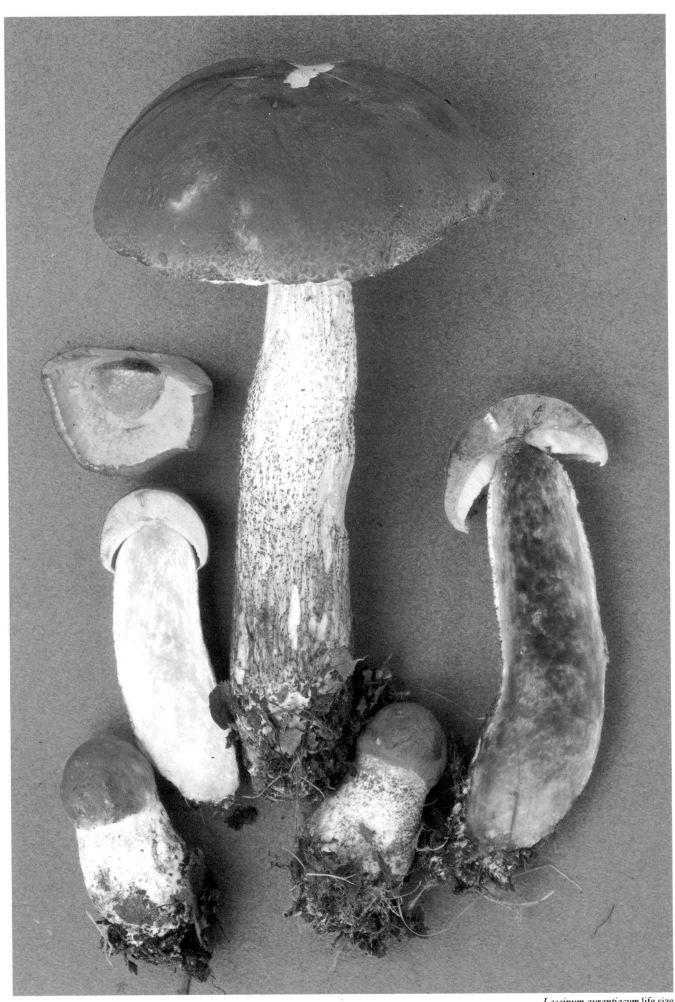

Leccinum aurantiacum life size

LECCINUM *The caps are dry; sometimes the cuticle overhangs the edge of the cap. The stems are tall and covered with woolly scales which usually discolour darker with age. Cut one or two of each collection in half and bruise the flesh with the knife, leave for three to twenty minutes and observe any discolouration; this test is important for identification. Dr Watling lists thirteen in the British Fungus Flora.*

Orange Birch Bolete *Leccinum versipelle* (Fr. & Hök) Snell. syn. *L. testaceoscabrum* (Secr.) Sing. syn. *Boletus versipellis* Fr. & Hök **Cap** 8–20cm, tawny orange, slightly downy at first becoming smooth, dry to very slightly viscid, the margin overhanging the pores. **Stem** up to 200×15–40mm, white or greyish covered with woolly brownish-black scales. **Flesh** white then dark vinaceous, but blue-green in stem base, finally blackish. Taste and smell pleasant. Tubes white to buff, vinaceous on cutting. **Pores** small, mouse-grey at first later ochraceous, bruising vinaceous. Spore print ochraceous snuff-brown. Spores subfusiform, 12.5–15×4–5μ. Habitat with birch in scrub or open woodland. Season summer to autumn. Common. **Edible** – good. *Illustrated on p.208.*

Leccinum quercinum (Pilát) Green and Watling **Cap** 6–15cm, chestnut to date-brown, fibrillose scaly, becoming smooth and more rusty, margin overhanging the pores. **Stem** 110–180×20–35mm, pale brown to buff at apex with whitish scales becoming pale brown, stem whitish to buff towards base with whitish scales becoming rusty or purplish date, darkening on handling. **Flesh** white to cream rapidly pink or vinaceous in cap, more grey in the stem sometimes with a slight green flush in the base. Taste and smell pleasant. Tubes white to pale buff becoming vinaceous or cigar-brown. **Pores** small, similarly coloured. Spore print snuff-brown. Spores subfusiform, 12–15×3.5–5μ. Habitat with oak. Season late summer to autumn. Rare. **Edible**. *Illustrated on p.209.*

Leccinum aurantiacum (Fr.) Gray syn. *Boletus aurantiacus* **Cap** 8–16cm across, orange to apricot, brown, smooth or slightly downy-fibrillose, cuticle overhanging tubes as an irregular skirt up to 3mm deep. **Stem** 80–140×18–48mm, initially covered in white scales which gradually turn rusty then dark brown. **Flesh** cream turning vinaceous in cap and stem base and sepia elsewhere. Taste and smell pleasant. Tubes white, vinaceous on exposure to air. **Pores** very small, white or cream bruising vinaceous. Spore print ochraceous buff. Spores subfusiform, 14–16.5×4–5μ. Habitat with aspens. Season late summer to autumn. Rare. **Edible**.

Yellow-Cracking Bolete *Leccinum crocipodium* (Letellier) Watling syn. *Boletus crocipodius* Letellier syn. *Leccinum nigrescens* (Rich. & Roze) Sing. **Cap** 4–11cm across, cinnamon to fulvous with yellow or olivaceous tinge, downy and soon conspicuously cracked, margin slightly overhanging tubes. **Stem** 60–120×18–24mm, lemon-yellow at apex, covered in yellow scales which become buff to cinnamon and finally

mouse-grey, darkening on handling. **Flesh** pale yellow then rapidly brick-colour, vinaceous or greyish and finally black throughout. Taste and smell not distinctive. Tubes lemon-yellow becoming flushed ochre or sienna. **Pores** minute, similarly coloured, bruising darker. Spore print ochre with olivaceous flush. Spores ellipsoid-subfusiform, 12–17.5×4.5–6μ. Habitat with oaks. Season late summer to early autumn. Rare. **Edible**.

Leccinum roseofractum Watling **Cap** 7–13cm across, umber to brownish-black, greasy at first then dry and splitting into small scales at centre. **Stem** 80×25mm, white with mouse-grey scales which gradually darken towards the base. **Flesh** white gradually turning coral then vinaceous on cutting. Taste and smell not distinctive. Tubes white becoming flushed slightly ochraceous. **Pores** similarly coloured. Spore print ochraceous snuff-brown. Spores subfusiform, 15.5–17.5×5–5.5μ. Habitat with birch. Season autumn. Occasional. **Edible** – not worthwhile.

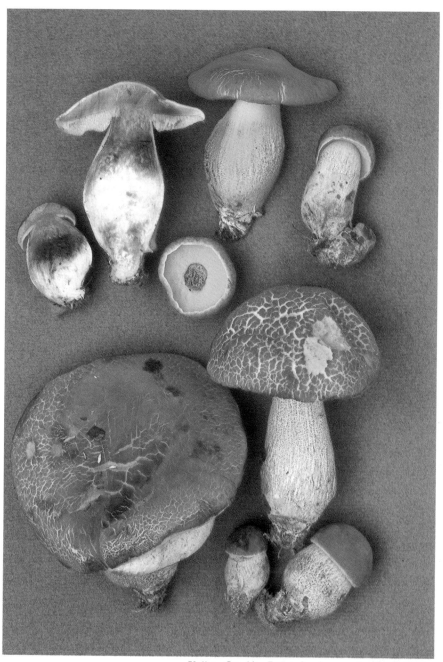

Yellow-Cracking Bolete *Leccinum crocipodium* ²⁄₃ life size

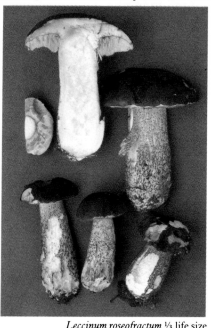

Leccinum roseofractum ¹⁄₃ life size

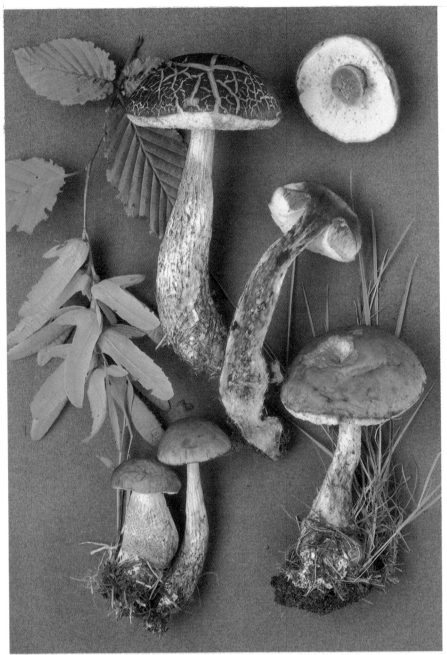

Leccinum carpini ½ life size

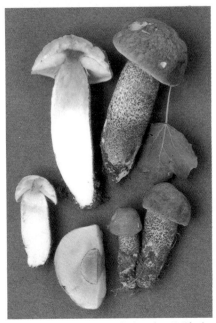

Leccinum duriusculum ⅓ life size

Leccinum duriusculum (Schulz.) Sing. syn. *Boletus duriusculus* Schulz. **Cap** 6–15cm, light cinnamon-buff, slightly downy to somewhat stippled, becoming smoother with age, cuticle overhanging tubes. **Stem** 80–140×20–35mm, white at apex, buff towards the base, ornamented with black or brown-black scales, often tinged blue-green near the base. **Flesh** firm, white, pink or peach in the cap, vinaceous grey in the stem apex and with touches of blue-green fading brownish in the stem base, finally blotched blackish throughout. Taste and smell not distinctive. Tubes whitish then pale yellowish. **Pores** small, round, whitish bruising olive brown. Spore print snuff-brown. Spores subfusiform, 14.5–16×4.5–6μ. Habitat with aspens. Season summer to late autumn. Rare. **Edible**.

Leccinum variicolor Watling syn. *L. oxydabile* (Sing.) Sing. p.p. **Cap** 5–10cm, stippled mouse-grey to dark brown, initially felty and dry, later smooth and slightly viscid. **Stem** 125–180×20–25mm, white, with mouse-grey scales but bruising greenish yellow on handling. **Flesh** pink in the cap, intensely blue-green in stem base. Taste and smell pleasant. Tubes white or pale cream. **Pores** small, similarly coloured, bruising pink or vinaceous. Spore print snuff-brown with cinnamon flush. Spores subfusiform, 14–20×5–6μ. Habitat with birch. Season summer to autumn. Occasional. **Edible**.

Leccinum oxydabile (Sing.) Sing. syn. *Krombholzia oxydabilis* Sing. **Cap** 7–14cm, buff to ochraceous with darker disc, slightly downy or smooth with irregular small scales. **Stem** 60–100×20–35mm, apex covered in brown scales which gradually become darker below. **Flesh** firm, white flushing coral in cap, pale yellow-greenish in stem. Taste and smell not distinctive. Tubes white becoming buff. **Pores** small, similarly coloured, bruising dark ochraceous. Spore print ochraceous snuff-brown. Spores subfusiform, 18–19×6–6.5μ. Habitat under spruce with scrub birch. Season summer to autumn. Rare. **Edible** – not worthwhile.

Brown Birch Bolete *Leccinum scabrum* (Fr.) S. F. Gray syn. *Boletus scaber* Fr. **Cap** 5–15cm, hazel, fulvous or snuff-brown, dry but tacky in wet weather. **Stem** 70–200×20–30mm, white to grey covered with brownish-black scales becoming darker towards the base. **Flesh** white, very soft, watery, unchanging or flushing pale pink. Taste and smell pleasant. Tubes white becoming dirty ochraceous. **Pores** small, white then dingy, bruising ochraceous. Spore print snuff-brown. Spores subfusiform, 14–20×5–6μ. Habitat with birch. Season summer to autumn. Common. **Edible** – not worthwhile.

Leccinum carpini (R. Schulz) Moser ex Reid syn. *Boletus carpini* (R. Schulz) Pearson **Cap** 3–9cm, pale buff, snuff-brown or tawny olive, slightly wrinkled and often cracked. **Stem** 80–90×8–11mm, punctate with pale buff scales at apex and darker brown scales below, blackening on handling. **Flesh** in stem white to straw-coloured and in the stem base immediately blue spotted but rose or vinaceous in the cap and stem apex, rapidly blackening throughout. Tubes white or cream, rapidly coral or vinaceous on cutting, then blackening. **Pores** small, white at first then yellowish buff, blackening on handling. Spore print ochraceous snuff-brown. Spores subfusiform, 15–19×5–6μ. Surface of cap composed of erect chains of globose to barrel-shaped segments. Habitat with hazel or hornbeam, occasionally with oak. Season summer. Rare. **Edible** – not worthwhile.

Leccinum holopus (Rostk.) Watling syn. *Boletus holopus* Rostk. **Cap** 4–7(10)cm, dirty white to pale buff becoming darker and flushed greenish with age, smooth, viscid when fresh. **Stem** 80–110×8–15(30)mm, white or pale buff, covered with white scales discolouring cinnamon with age. **Flesh** soft, white, blue green in stem base, often pink elsewhere or unchanging. Taste and smell pleasant. Tubes white to clay-buff. **Pores** white to buff, flushed cinnamon with age or on bruising. Spore print cinnamon-ochraceous buff. Spores subfusiform, 17.5–20×5.5–6.5μ. Habitat amongst sphagnum under birches. Season autumn. Rare. **Edible** – not worthwhile.

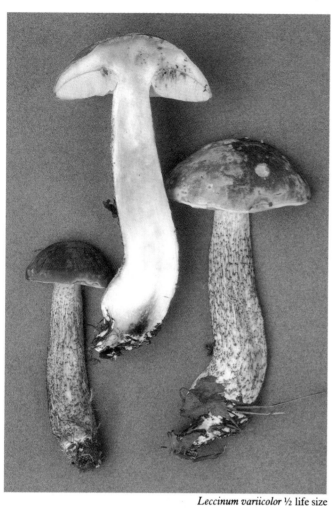

Leccinum variicolor ½ life size

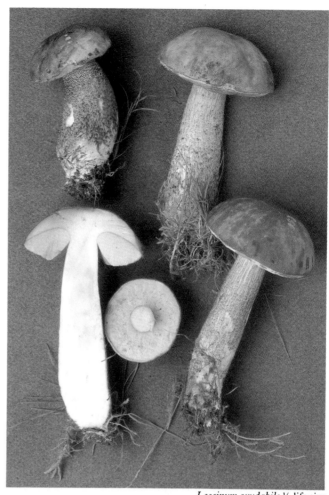

Leccinum oxydabile ½ life size

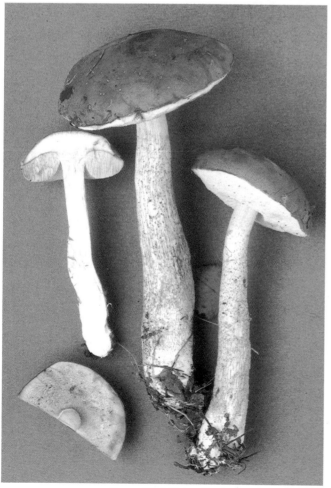

Brown Birch Bolete *Leccinum scabrum* ½ life size

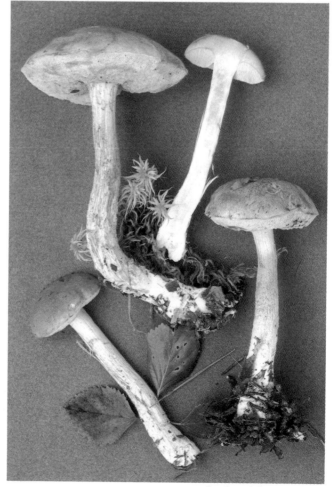

Leccinum holopus ½ life size

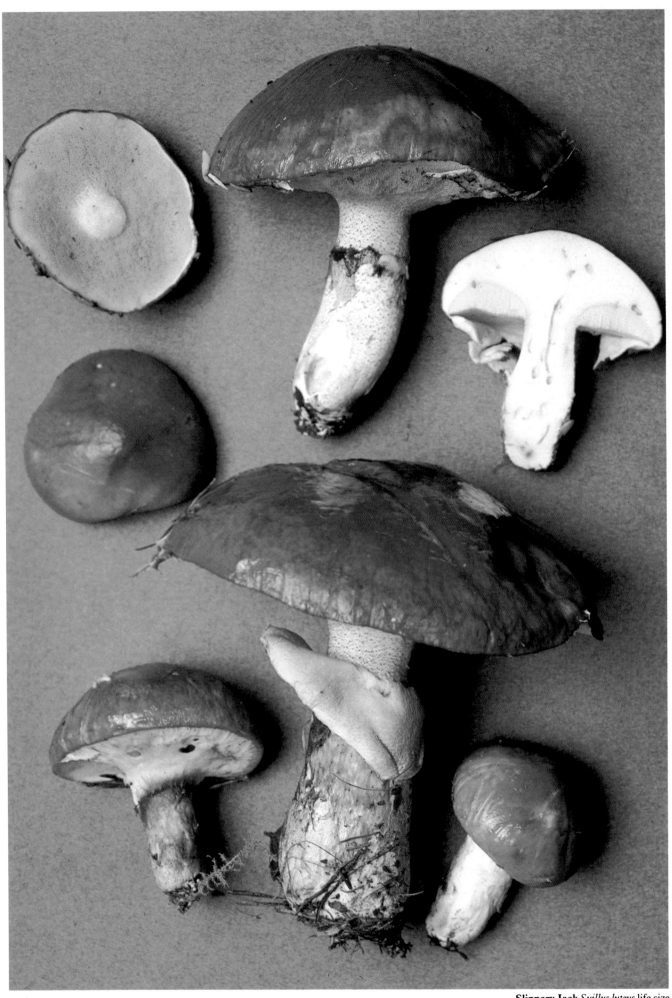

Slippery Jack *Suillus luteus* life size

SUILLUS *Most have distinctly glutinous caps. The stems of many of the species have rings, others have small spots on the surface but none have reticulations as in Boletus. They are all terrestrial and grow in association with conifers. Dr Watling lists ten in the British Fungus Flora.*

Slippery Jack *Suillus luteus* (Fr.) S. F. Gray syn. *Boletus luteus* Fr. **Cap** 5–10cm, chestnut to sepia covered in brown gluten, becoming more rust-coloured with age, shiny on drying. **Stem** 50–100×20–30mm, pale straw-coloured at apex rapidly discoloured with darkening glandular dots, with a large white to cream ring which darkens to sepia, white below becoming vinaceous brown with age. **Flesh** white, often vinaceous at base of stem. Taste and smell not distinctive. Tubes lemon-yellow to straw-colour. **Pores** round, similarly coloured, becoming flushed sienna. Spore print clay to ochraceous. Spores subfusiform to elongate ellipsoid, 7–10×3–3.5μ. Habitat with conifers, usually Scots pine. Season autumn. Common. **Edible.**

Suillus bovinus (Fr.) O. Kuntze syn. *Boletus bovinus* Fr. **Cap** 3–10cm, clay-pink with cinnamon or ochraceous flush, with a distinct white margin, viscid with pale sticky covering. **Stem** 40–60×5–8mm, sienna-yellow, arising from pink mycelium. **Flesh** whitish or yellowed gradually becoming clay pink particularly in cap or the stem base, rusty-coloured in stem. Taste sweet, pleasant, smell fruity. Tubes grey vinaceous. **Pores** large, angular, compound, olivaceous buff at first then ochre, finally clay-buff with ochraceous flush. Spore print olivaceous snuff-brown. Spores ellipsoid subfusiform, 8–10×3–4μ. Habitat in coniferous woods, especially with Scots pine. Season late autumn. Common. **Edible.**

Suillus fluryi Huijsman **Cap** 3–10cm, reddish buff overlaid with network of purplish-brown streaks. **Stem** 15–30×25–100mm, with pointed base, yellowish covered in purplish-brown flecks. **Flesh** light yellow with vinaceous flush immediately below the cuticle and also in the stem base. Taste indistinct, smell fungusy. Tubes lemon-yellow, unchanging. **Pores** small, irregular, initially pale yellow then yellowish-cinnamon. Spore print ochraceous. Spores subcylindric, 7.8–11×3.3–4.3μ. Habitat coniferous woodland. Season autumn. Not yet found in Britain. **Edibility unknown.**

Suillus flavidus (Fr.) Sing. syn. *Boletus flavidus* Fr. **Cap** 2–6cm across, umbonate, straw-yellow to pale ochre, viscid. **Stem** 50–75×5–8mm, straw-yellow above the gelatinous, tawny ring, dull yellow to buff below. **Flesh** pale yellow becoming vinaceous when cut. Taste and smell not distinctive. Tubes decurrent, deep yellow. **Pores** large, angular, concolorous with tubes. Spore print ochraceous snuff-brown. Spores subfusiform-elliptic, 8–10×3.5–4.5μ. Habitat wet mossy areas, usually with Scots pine and often in sphagnum. Season late summer. Rare and more or less confined to the Scottish Highlands. **Edible.**

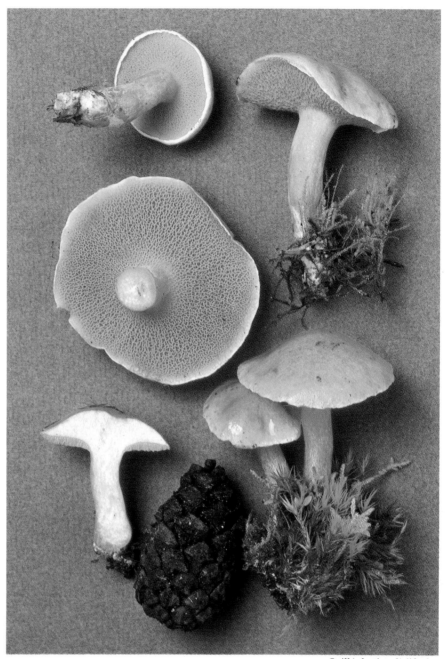

Suillus bovinus ⅔ life size

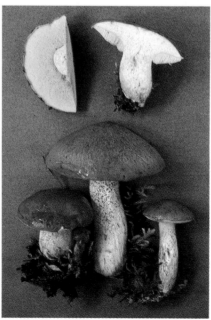

Suillus fluryi ⅓ life size

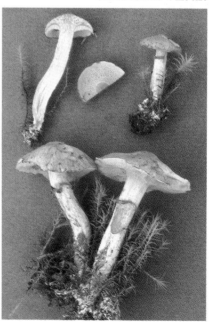

Suillus flavidus ½ life size

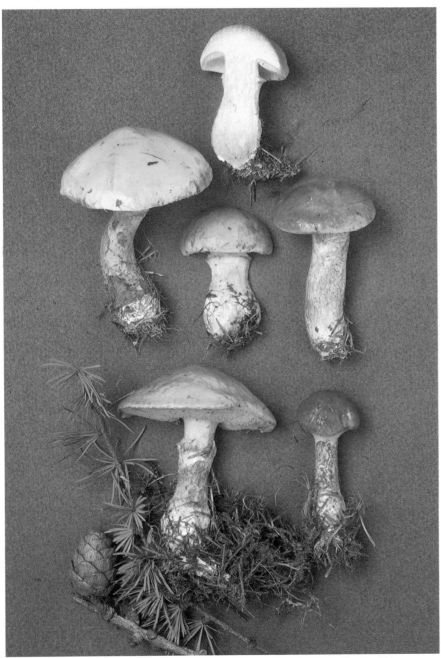

Larch Bolete *Suillus grevillei* ½ life size

olivaceous tint at first becoming more cinnamon. Spore print snuff-brown. Spores subfusoid-elongate to ellipsoid, 9–11×3–4µ. Habitat with conifers. Season late summer. Occasional. **Edible**.

Suillus tridentinus (Bres.) Sing. syn. *Boletus tridentinus* Bres. **Cap** 5–12cm across, orange or reddish-brown with darker adpressed indistinct scales, covered in apricot gluten. **Stem** 40–75×12–20mm, white to yellow at apex, dotted brownish to vinaceous below, with a rust-coloured net and a white to yellowish ring. **Flesh** pale lemon-yellow with faint pinkish tinge in cap which gradually deepens on exposure to air. Taste and smell pleasant. Tubes 1–5mm long, subdecurrent, yellow to orange, finally rust. **Pores** often compound, angular, yellow-orange becoming deep orange to rust-coloured with age. Spore print dark straw-yellow with a sienna tint. Spores elliptic, 10–13×4–5µ. Habitat with larch. Season autumn. Rare, more frequent in Southern England. **Edibility unknown**.

Suillus aeruginascens (Secr.) Snell syn. *Boletus viscidus* L. ex Fr. **Cap** 3–9cm, pallid, livid white or buff often flushed olivaceous buff or sometimes finally hazel, viscid and usually wrinkled. **Stem** 50–90×10–16mm, white to pale straw-colour flushed yellowish green with greyish net above the whitish to olivaceous buff ring, buff to ochraceous and viscid below. **Flesh** cream flushed olivaceous at base, becoming very slightly bluish-green on cutting particularly in the stem. Taste and smell not distinctive. Tubes more or less decurrent, dirty white tinged sulphur-yellow or buff, flushed vinaceous at maturity. **Pores** large, angular, similarly coloured bruising dirty greenish on handling. Spore print snuff-brown with vinaceous flush. Spores ellipsoid–subfusiform, 10–12×4–5.5µ. Habitat with larch. Season late summer to late autumn. Rare. **Edible** but mediocre.

Larch Bolete *Suillus grevillei* (Klotsch) Sing. syn. *Boletus elegans* Schum. ex Fr. **Cap** 3–10cm, yellow to chrome becoming flushed rust, viscid with pale lemon gluten, shiny when dry. **Stem** 50–70×15–20mm, yellow above the whitish ring and punctate or occasionally netted, flushed cinnamon below. **Flesh** pale yellow in cap, darker lemon-chrome in the stem. Taste and smell not distinctive. Tubes pale yellow. **Pores** small, angular, lemon-yellow becoming flushed sienna, bruising rust. Spore print ochre to sienna. Spores subfusiform-ellipsoid, 8–11×3–4µ. Habitat with larch. Season late summer to autumn. Very common. **Edible**.

Suillus granulatus (Fr.) O. Kuntze. syn. *Boletus granulatus* Fr. **Cap** 3–9cm, rusty brown to yellowish, viscid, shiny when dry. **Stem** 35–80×7–10mm, lemon-yellow flushed vinaceous to coral towards the base, the upper region covered in white or pale yellow granules which exude pale

milky droplets. **Flesh** lemon-yellow, lemon-chrome in stem, paler in cap. Taste and smell slight but pleasant. Tubes buff to pale yellow, unchanging. **Pores** small, similarly coloured, exuding pale milky droplets. Spore print ochraceous sienna. Spores subfusiform-ellipsoid, 8–10×2.5–3.5µ. Habitat with conifers. Season late autumn. Common. **Edible**.

Suillus variegatus (Fr.) O. Kuntze syn. *Boletus variegatus* Fr. **Cap** 6–13cm, rusty tawny or ochraceous to olivaceous, speckled with darker, small, flattened scales, initially slightly downy becoming slightly greasy with age, tacky in wet weather. **Stem** 50–90×15–20mm, ochre, more yellow towards apex, flushed rust-colour below. **Flesh** pale lemon in cap, more deeply coloured in stem base, sometimes tinged with blue throughout or above the tubes. Taste slight, smell strongly fungusy. Tubes dark buff. **Pores** subangular and compound, ochre with

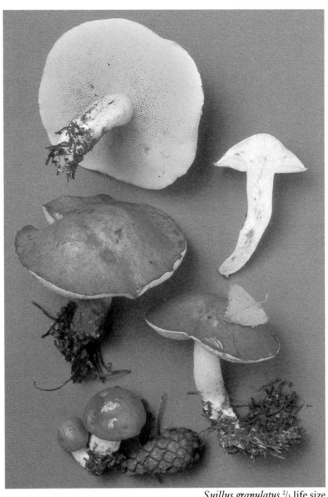

Suillus granulatus ²/₃ life size

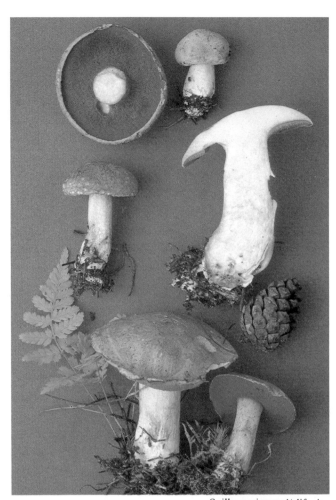

Suillus variegatus ½ life size

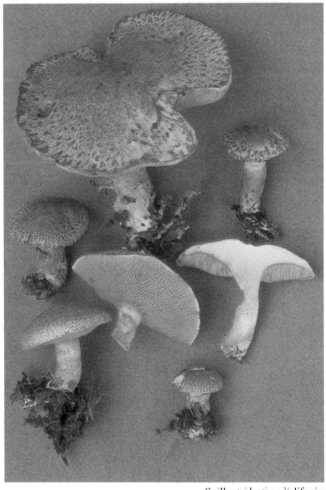

Suillus tridentinus ²/₃ life size

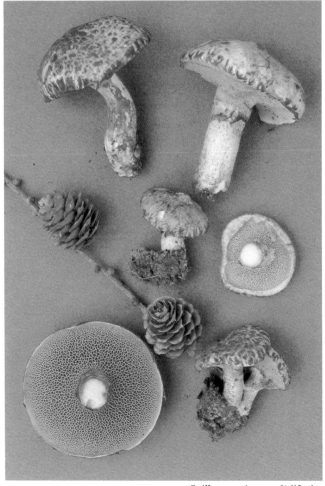

Suillus aeruginascens ²/₃ life size

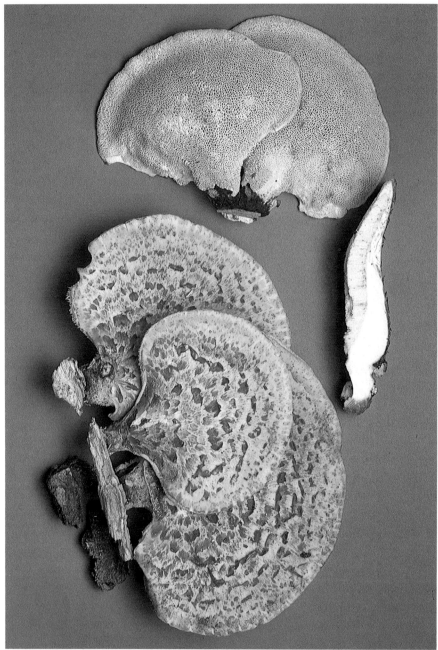

Dryad's Saddle *Polyporus squamosus* ⅓ life size

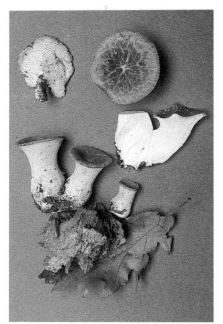

Polyporus squamosus young specimens ⅓ size

Polyporus badius (Pers. ex S. F. Gray) Schur. syn. *P. picipes* Fr. **Cap** 5–20cm across, infundibuliform, often lopsided and lobed, viscid when fresh drying smooth and shiny, pallid grey-brown at first then chestnut, darker at the centre, very thin. **Stem** 20–35×5–15mm, usually excentric, black at least at the base. Taste bitter. Tubes 0.5–2.5mm long, white later cream, decurrent down the stem. **Pores** 4–7 per mm, circular, white to cream. Spores white, elongate-ellipsoid, 5–9×3–4μ. Hyphal structure dimitic with generative and binding hyphae; generative hyphae lacking clamps. Habitat on dead or living deciduous trees. Season spring to autumn, annual. Occasional. **Not edible**.

Polyporus varius Pers. ex Fr. **Cap** 1–10cm across, infundibuliform, or irregularly kidney-shaped, depressed above the point of attachment to the stem, wavy and often lobed at the margin, ochre-brown with fine radial lines becoming tobacco-brown with age. **Stem** 5–30×5–15mm, lateral or off-centre, the basal part brown-black. **Flesh** white when fresh, drying corky and cream-coloured, tough and leathery. Taste slightly bitter, smell faint and mushroomy. Tubes 0.5–2.5mm long, decurrent down the stem, white to cream. **Pores** 4–7 per mm, circular, white becoming ochraceous-brown. Spores white, ellipsoid to fusiform, 5–9×3–4μ. Hyphal structure dimitic with generative and binding hyphae; generative hyphae with clamp connections. Habitat on dead or dying deciduous trees. Season late spring to autumn, annual. Occasional. **Not edible**.

Polyporus ciliatus Fr. ex Fr. **Cap** 1–12cm across, convex and centrally depressed, often wavy and rolled under at the margin, grey-brown, rusty or tobacco brown, surface glabrous or minutely bristly, especially at the margin. **Stem** 20–40×2–7mm, usually central, often curved and thickened at the base, yellow-brown or tawny. **Flesh** white, leathery. Tubes 0.5–2mm long, slightly decurrent, whitish at first later pallid or tan. **Pores** 4–6 per mm, circular, white to cream. Spores white, subcylindric, 5–6×1.5–2.5μ. Hyphal structure dimitic with generative and binding hyphae; generative hyphae with clamp-connections. Habitat dead wood of deciduous trees, usually on logs and fallen branches. Season early spring to summer, annual. Occasional. **Not edible**.

P. brumalis Pers. ex Fr., previously thought to be more common then *P. ciliatus*, is readily distinguished by having larger circular pores which elongate with age.

Dryad's Saddle or **Scaly Polypore** *Polyporus squamosus* Huds. ex Fr. **Bracket** 5–60cm across, 0.5–5cm thick, initially circular or fan-shaped, ochraceous-cream covered in concentric dark brown fibrillose scales. **Stem** 30–100×20–60mm, lateral or occasionally off-centre, blackish towards the base. **Flesh** 1–3cm thick, succulent when fresh, drying corky, white. Smell strongly of meal. Tubes 5–10mm long, decurrent down the stem, white to creamy. **Pores** 1–3×0.5–1.5mm, irregular and angular, whitish to ochraceous-cream. Spores white, oblong-ellipsoid, 10–15×4–5μ. Hyphal structure dimitic with generative and binding hyphae; generative hyphae with clamp-connections. Habitat parasitic on deciduous trees, especially elm, beech and sycamore, causing intensive white rot. Season spring to summer, annual. Common. **Edible**.

Coltricia perennis (L. ex Fr.) Murr. syn. *Polystictus perennis* (L. ex Fr.) Quél. **Cap** 2–8cm across, centre depressed, upper surface finely velvety becoming smooth with age, more or less zoned maroon, rusty-brown, ochraceous and pale grey. **Stem** 15–35×2–10mm, usually central but occasionally fused to neighbouring fruit-bodies, rusty-brown and slightly velvety. **Flesh** brown. Taste and smell not distinctive. Tubes 0.5–3mm long, decurrent, umber. **Pores** 2–3 per mm, irregularly angular, cinnamon brown, covered at first by a whitish bloom. Spores ochraceous, ellipsoid, 6–9×4–5μ. Hyphal structure monomitic; generative hyphae thin-walled, brown, and devoid of clamp-connections. Habitat on pathsides in woods and heaths, usually on sandy soil. Season all year, annual. Occasional. **Not edible**.

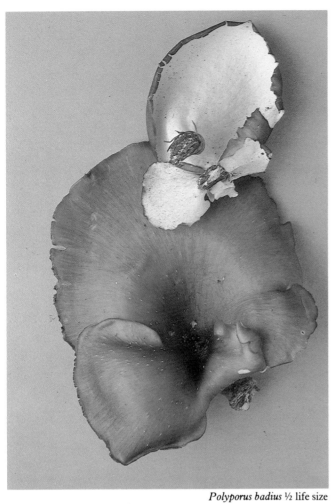

Polyporus badius ½ life size

Polyporus varius ⅔ life size

Polyporus ciliatus life size

Coltricia perennis ½ life size

Polyporus floccipes ½ life size

or central, pallid, covered at the base in bundles of stiff white cottony hairs. **Flesh** white. Tubes very short, decurrent far down the stem, pallid to ochraceous-cream. **Pores** 2–2.5×1–1.5mm, polygonal or longitudinal, ochraceous-cream. Spores hyaline, ellipsoid-cylindric, 9–14×4–5.5μ. Hyphal structure dimitic with generative and binding hyphae; generative hyphae with clamp-connections. Habitat on fallen twigs of deciduous trees. Season spring. Uncommon. **Not edible.**

Grifola umbellata (Pers. ex Fr.) syn. *Polyporus umbellatus* Pers. ex Fr. **Fruit Body** up to 50cm in diameter consisting of a thick fleshy base from which repeated branching occurs, the ultimate branchlets ending in small umbrella-like caps, each 1–4cm across and centrally depressed with a thin, wavy margin, covered in fibrils or small fibrous scales, initially grey-brown becoming ochraceous with age. **Stem** thin, flushed with cap colour, merging at the bottom into the common trunk-like base. **Flesh** thin in cap, white. Taste pleasant but with acrid aftertaste, smell pleasant when fresh. Tubes 1–1.5mm long, decurrent on to the stem, straw-yellow. **Pores** 1 per mm, angular, whitish to straw-yellow. Spores cylindric-ellipsoid, 7–10×3–4μ. Habitat on the ground arising from a subterranean sclerotium associated with roots of deciduous trees, especially oak. Season summer to autumn. Very rare. **Edible.**

Grifola frondosa (Dicks. ex Fr.) S. F. Gray **Fruit Body** 15–40cm diameter, subglobose, consisting of a central repeatedly branched stem, each branch ending in a flattened tongue-shaped cap;

Polyporus floccipes Rostk. syn. *P. squamosus* f. *coronatus* (Rostk.) Pilát syn. *P. lentus* Berk. **Cap** 2–10(15)cm across, semicircular or circular, depressed above the point of attachment to the stem, yellow-cream to light cinnamon covered in hairy scales with darkening tips, thick and fleshy. **Stem** 5–60×5–15mm, lateral, off-centre

each cap 4–10cm across, 0.5–1cm thick, leathery and wavy at the margin, upper surface usually wrinkled, grey or olivaceous drying brownish. **Stem** cream or pale greyish. **Flesh** white. Taste pleasant when young and fresh, soon acrid, smell reminiscent of mice. Tubes 2–3mm long on the underside of each cap, and decurrent far down the stem, whitish. **Pores** two per mm, subcircular to slightly angular, larger and more irregular on the stem. Spores ellipsoid, 5.5–7×3.5–4.5μ. Hyphal structure monomitic; generative hyphae with clamp connections. Habitat parasitic on deciduous trees especially oak and beech fruiting at the extreme base of the trunk. Season autumn. Uncommon. **Edible.**

Giant Polypore *Meripilus giganteus* (Pers. ex Fr.) Karst. syn. *Polyporus giganteus* Pers. ex Fr. syn. *Grifola gigantea* (Pers. ex Fr.) Pilát **Fruit body** 50–80cm across, rosette-like, consisting of numerous flattened fan-shaped caps around a common base. Each cap 10–30cm across, 1–2cm thick, covered in very fine brown scales on the upper surface which is radially grooved and concentrically zoned light and darker brown; attached to the common base by a short stem. **Flesh** white, soft and fibrous. Taste slightly sour, smell pleasant. Tubes 4–6mm long, whitish. **Pores** 3–4 per mm, subcircular, whitish, often late in forming, bruising blackish. Spores hyaline, broadly ovate to subglobose, 5.5–6.5×4.5–5μ. Hyphal structure monomitic; generative hyphae lacking clamps. Habitat at the base of deciduous trees or stumps or some distance from them arising from the roots usually on beech but sometimes also on oak. Season autumn, annual. Frequent. **Not edible** due to the sour taste and fibrous texture.

Grifola umbellata ⅓ life size

Grifola frondosa ⅓ life size

Giant Polypore *Meripilus giganteus* ²/₃ life size

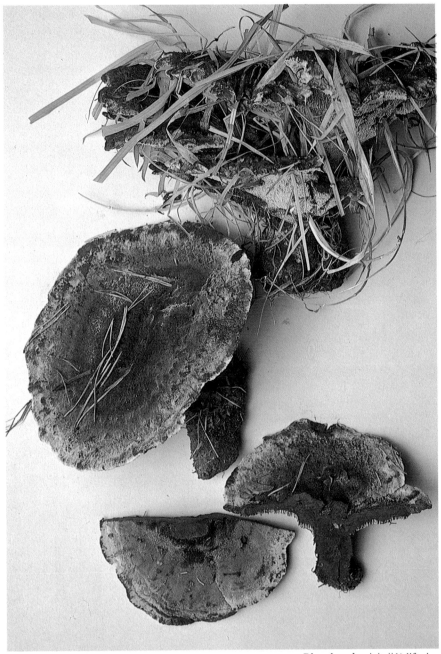

Phaeolus schweinitzii (Fr.) Pat. syn. *Polyporus schweinitzii* Fr. **Fruit body** sometimes forming amorphous cushions, more often subcircular, 10–30cm across with a short thick stalk, soft and spongy when fresh drying fragile and light; upper surface concave, rough, hairy, concentrically grooved at first, dark sulphur-yellow becoming rusty or dark brown and finally blackish with age. **Stem** brown, very short and thick, merging into the cap and covered in tubes. **Flesh** rusty brown, fibrous. Tubes 3–6mm long, decurrent, concolorous with the upper surface. **Pores** 0.3–2.5mm across, circular, angular or irregular, yellow, olivaceous or tinged rust, finally maroon brown, often glistening in the light. Spores whitish tinged yellowish, ovate to elliptic, 5.5–7.5×3.5–4μ. Hyphal structure monomitic; generative hyphae lacking clamps. Habitat parasitic on conifers, usually arising from the roots. Season autumn. Occasional. **Not edible**.

Cinnabar Polypore *Pycnoporus cinnabarinus* (Jacq. ex Fr.) Karst. syn. *Polyporus cinnabarina* Jacq. ex Fr. syn. *Trametes cinnabarinus* (Jacq. ex Fr.) Fr. **Fruit body** 3–11cm across, 2–8cm wide, 0.5–1.5cm thick, semicircular or fan-shaped, leathery becoming corky when dried; upper surface covered in fine soft hairs when young, later smooth and slightly wrinkled, bright red or orange-red becoming less bright with age. Tubes 2–6mm long, pale orange. **Pores** 2–3 per mm, circular or angular, cinnabar- or saffron-red. Spores white, oblong-ellipsoid, 4.5–6×2–2.5μ. Hyphal structure trimitic. Habitat on dead deciduous trees, especially cherry, beech and birch. Season autumn. Very rare. **Not edible**.

Podoscypha multizonata (B. & Br.) Pat. syn. *Thelephora multizonata* B. & Br. **Fruit body** 5–20cm across, rosette-like, comprising numerous thin, leathery, erect lobes which are flesh-coloured to rich brown zoned with darker bands, arising from a stout common base. **Flesh** tough and leathery. Spore-bearing surface pale brown to greyish. Spores white, broadly elliptic to subglobose, 4.5–6.5×4–5μ. Gloeocystidia present in the hymenium as elongated, undulating worm-like bodies with swollen base and refractive contents. Hyphal structure dimitic, generative hyphae with clamp-connections. Habitat on the ground in deciduous woods. Season early autumn to early winter. Rare. **Not edible**.

Sulphur Polypore or Chicken of the Woods *Laetiporus sulphureus* (Bull. ex Fr.) Murr. syn. *Polyporus sulphureus* Bull. ex Fr. **Bracket** 10–40cm across, fan-shaped or irregularly semicircular, thick and fleshy, usually in large tiered groups; upper surface uneven, lumpy, and wrinkled, suede-like, lemon-yellow or yellow-orange drying pallid or straw-coloured; margin obtuse. **Flesh** at first succulent and exuding a yellowish juice when squeezed, but white and crumbly with age. Taste pleasant and slightly sourish, smell strong and fungusy. Tubes 1.5–3mm long, sulphur-yellow. **Pores** 1–3 per mm, circular or ovoid, sulphur-yellow. Spores white, ellipsoid to broadly ovate, 5–7×3.5–4.5μ. Hyphal structure dimitic with generative and binding hyphae; generative hyphae without clamp-connections. Habitat deciduous trees, usually oak but common also on yew, cherry, sweet chestnut and willow. Season late spring to autumn, annual. Common. **Edible** when young and fresh, considered a delicacy in Germany and North America.

Phaeolus schweinitzii ⅓ life size

Cinnabar Polypore *Pycnoporus cinnabarinus*
⅔ life size

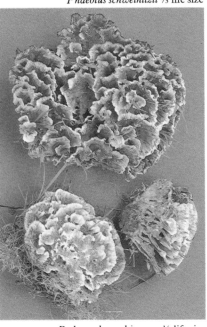

Podoscypha multizonata ⅓ life size

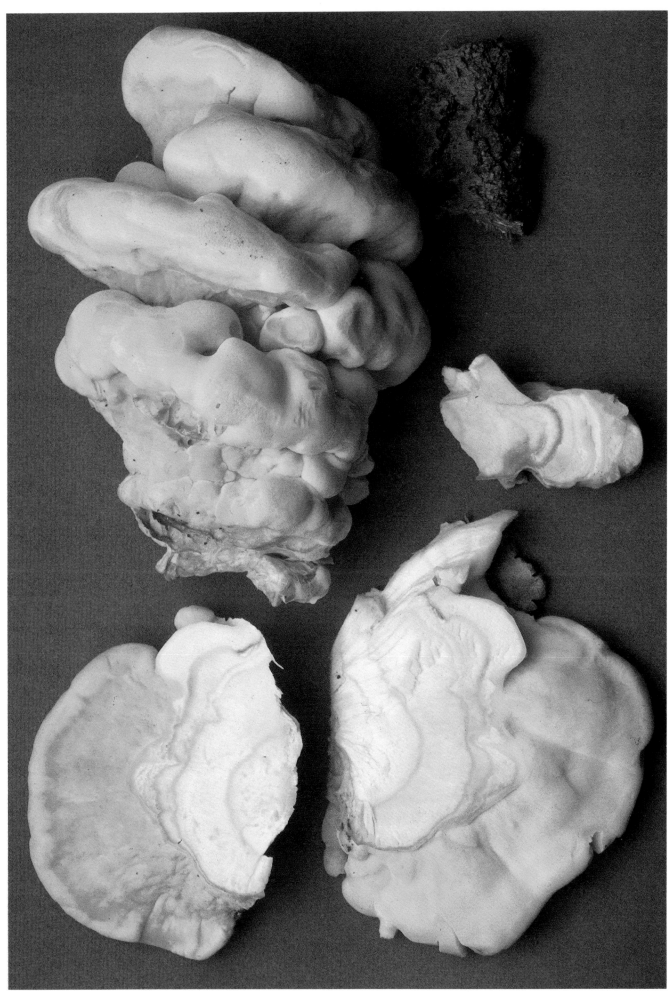

Sulphur Polypore *Laetiporus sulphureus* ²/₃ life size

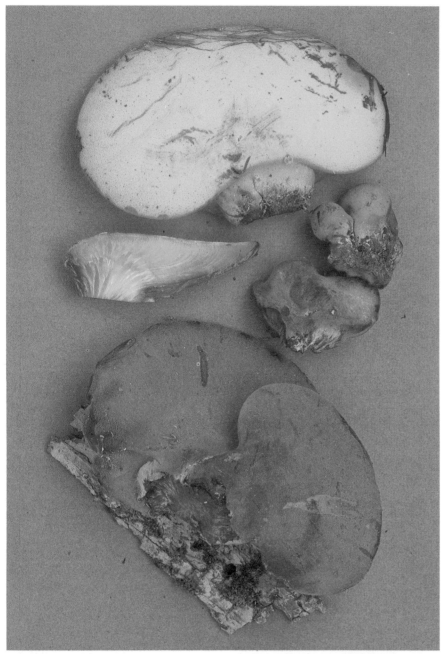

Beefsteak Fungus or **Ox-tongue** *Fistulina hepatica* Schaeff. ex Fr. **Bracket** 10–25cm across, 2–6cm thick, usually single, tongue-shaped sometimes on a short rudimentary stem; upper surface moist to tacky, rough with rudimentary pores especially towards margin, pinkish to orange-red and finally purple-brown. **Flesh** thick and succulent, mottled dark flesh-pink with lighter veining with blood-like sap, like raw meat. Taste sourish, smell pleasant. Tubes 10–15mm long, whitish or yellowish, arising free from each other but adhering at maturity. **Pores** 3 per mm, circular, whitish at first bruising reddish-brown. Spores pallid-ochraceous, ovate, 4.5–6×3–4μ. Habitat parasitic on chestnut and oak, usually found on the lower part of the trunk. Season late summer to autumn, annual. Common. **Edible.** Causes brown rot of wood and therefore has a certain economic value; the infected oak timber is of a darker richer colour than normal and this 'brown oak' is much in demand by the furniture industry.

Hapalopilus nidulans (Fr.) Karst. syn. *Polyporus nidulans* Fr. syn. *P. rutilans* Pers. ex Fr. **Bracket** 5–10cm across, 2–4cm wide, 1–4cm thick, fan-shaped; upper surface downy at first becoming smooth, ochraceous to cinnamon. **Flesh** cinnamon becoming paler towards the cuticle. Smell sweetish. Tubes up to 10mm long, ochraceous. **Pores** 2–4 per mm, angular, ochraceous to cinnamon-brown. Spores ellipsoid to cylindrical, 3.5–5×2–3μ. Hyphal system monomitic; generative hyphae thin- to thick-walled with clamp-connections. KOH stains all parts bright violaceous. Habitat on dead deciduous wood. Season annual, summer to autumn. Uncommon. **Not edible.**

Heteroporus biennis (Bull. ex Fr.) Laz. syn. *Abortiporus biennis* (Bull. ex Fr.) Sing. syn. *Daedalea biennis* Bull. ex Fr. **Fruit body** variable, irregularly top-shaped, or rosette-like, or fused together into amorphous masses, 3–9cm across, 0.5–1.5cm thick, flattened to concave, surface downy to felty, whitish soon becoming pinkish. Tubes 2–6mm long, decurrent. **Pores** 1–2 per mm, angular and irregular, becoming maze-like, whitish bruising reddish. Spores elliptic-ovate to subglobose, 4–7×3.5–4.5μ. Long undulating worm-like refractive gloeocystidia present in the hymenium. In addition to the normal basidiospores the fungus also produces similarly shaped chlamydospores in the flesh and hymenium. Habitat on the ground from roots or wood chips of deciduous trees. Season autumn, annual. Occasional. **Not edible.**

Ganoderma lucidum (Curt. ex Fr.) Karst. **Fruit body** stalked. **Bracket** 10–25cm in diameter, 2–3cm thick, fan- or kidney-shaped, laterally attached, concentrically grooved and zoned ochraceous to orange brown, later purple-brown to blackish, and like the stem conspicuously glossy as if varnished. **Stem** up to 250×10–30mm, dark brown, glossy. Tubes 0.5–2cm long. **Pores** 4–5 per mm, circular, whitish then cream, finally tobacco brown, darkening on bruising when fresh. Spores rusty, ellipsoid-ovate with truncate end, 7–13×6–8μ. Habitat on roots of deciduous trees. Season all year. Rare. **Not edible.**

Beefsteak Fungus *Fistulina hepatica* ½ life size

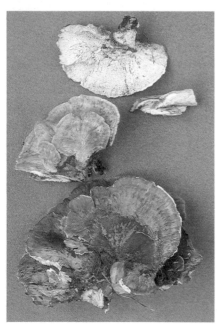

Heteroporus biennis ½ life size

Hapalopilus nidulans ⅓ life size

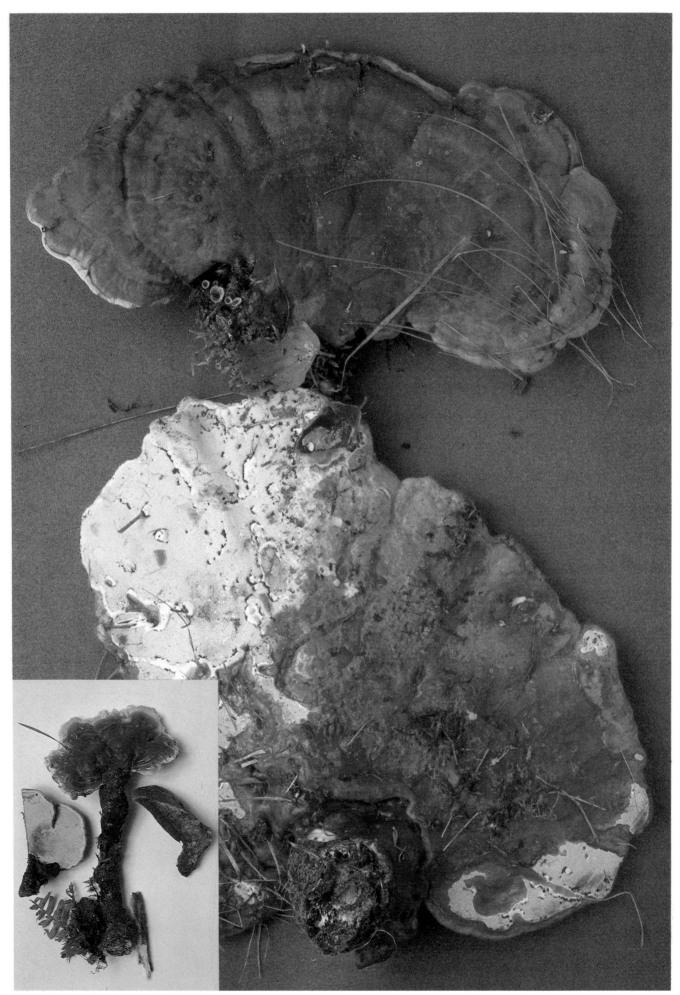

Ganoderma lucidum ½ life size

Ganoderma lucidum (British form) ½ life size

Lacquered Bracket *Ganoderma resinaceum* ¼ life size

Artist's Fungus *Ganoderma applanatum* ¼ life size

Ganoderma adspersum ⅓ life size

Root Fomes *Heterobasidion annosum* ¼ life size

Lacquered Bracket *Ganoderma resinaceum*
Boud. ex Pat. syn. *Fomes resinaceus* (Boud.)
Sacc. **Bracket** 10–45cm across and up to 10cm
thick behind, semicircular, sessile, or on a thick
rudimentary stem; upper surface concentrically
grooved, strikingly glossy as if varnished, red-
brown or maroon to almost black, margin obtuse
and cream-coloured. **Flesh** soft, pale wood-
coloured. Tubes 5–20mm long, rusty-brown.
Pores 2–2.5 per mm, circular, pale greyish
bruising brown. Spores brown, ellipsoid-ovate
and truncate at one end, 9–11×5–7μ. Hyphal
structure trimitic; generative hyphae with
clamp-connections. Habitat on stumps of oak.
Season all year. Rare. **Not edible.**

Artist's Fungus *Ganoderma applanatum* (Pers. ex
Wallr.) Pat. **Bracket** 10–60cm across, 5–30cm
wide, 2–8cm thick, more or less flat,
semicircular, hard, corky and glabrous, margin
acute; upper surface knobbly and concentrically
grooved, covered with a hard wrinkled crust,
often pallid, grey-brown, umber or cocoa-
coloured. **Flesh** cinnamon brown, thinner than
the tube layer. Taste bitter, smell mushroomy.
Tubes 7–25mm long in each annual layer,
brown. **Pores** 4–5 per mm, circular, white,
bruising brown. Spores brown ornamented,
ovoid-ellipsoid, truncate at one end, 6.5–
8.5×4.5–6μ, mostly 8×5.5μ. Hyphal structure
trimitic; generative hyphae with clamp-
connections but these may be very difficult to
demonstrate. Habitat on the trunks of deciduous
trees, especially beech, where it causes an
intensive white rot. Season all year, perennial.
Uncommon but until recently much confused
with *G. adspersum*. **Not edible.**

Ganoderma adspersum (Schulz.) Donk. **Bracket**
7–60cm across, 5–25cm wide, 3–30cm thick,
upper surface with a thick dark brown hard
knobbly crust which is concentrically ridged,
margin thick and obtuse, white in the growing
season. **Flesh** dark brown, thicker than the tube-
layer. Tubes stratified, reddish-brown. **Pores** 3–
4 per mm, circular, white to pale yellow-ochre,
discolouring when handled. Spores brown,
ovate, truncate at one end, 8–13×5.5–9μ,

Birch Polypore *Piptoporus betulinus* ²⁄₃ life size

Heterobasidion annosum (young specimen)
¼ life size

mostly about 10×6.5μ. Hyphal structure
trimitic; generative hyphae with clamp-
connections but these often difficult to
demonstrate. Habitat parasitic on deciduous
trees, usually found on the lower part of the
trunks; the cocoa-like spore deposit is often very
dense on top of the cap and on the wood above it.
Season all year, perennial. Common. **Not edible.**

Root Fomes *Heterobasidion annosum* (Fr.) Bref.
syn. *Fomes annosus* (Fr.) Cke. **Fruit body**
variable in shape, frequently forming large
resupinate patches or irregular knobbly brackets
5–30cm across, 3–15cm wide, 1–2cm thick;
upper surface uneven and lumpy covered in a
light brown crust which darkens with age;
margin thin, acute, white. **Flesh** whitish to pale
wood-coloured. Smell strongly fungusy. Tubes
2–5mm long in each annual layer. **Pores** 2–4 per
mm, varying from circular to angular or
irregularly elongated, white browning with age.
Spores white, ovate, 4.5–6×3.5–4.5μ. Hyphal
structure dimitic; generative hyphae without

clamp connections. Habitat parasitic on the roots
of coniferous trees causing intensive rot and
ultimately death of the infected tree; occasionally
also infecting deciduous trees. Season all year,
perennial. Common causing serious economical
losses of conifers. **Not edible.**

Birch Polypore or **Razor-strop Fungus**
Piptoporus betulinus (Bull. ex Fr.) Karst. syn.
Polyporus betulinus Bull. ex Fr. **Bracket** 10–20cm
across, 2–6cm thick, subglobose at first,
expanding to hoof-shaped often with a
rudimentary stem, margin thick and rounded;
upper surface with a thin separable skin, smooth,
whitish when young darkening to fleshy grey-
brown with age. **Flesh** white, rubbery. Taste
slightly bitter, smell strong and pleasant. Tubes
1.5–5mm long, white. **Pores** 3–4 per mm,
circular, white at first, later pale grey-brown.
Spores cylindric to bean-shaped, 4.5–6×1.3–
1.5μ. Habitat on birch. Season all year, annual,
although fruit bodies remain intact from one year
into the next. Very common. **Not edible.**

227

concentrically ridged and zoned rusty-brown to almost black; margin acute. **Flesh** pale brownish, succulent. Smell pleasant. Tubes 6–10mm long, brown. **Pores** 2–3 per mm, angular, creamy white later ochre-brown. Spores white, subcylindric, 5–6×2–2.5μ. Hyphal structure dimitic; generative hyphae with clamp-connections. Habitat on dead coniferous and deciduous trees. Season autumn to winter, annual. Uncommon. **Not edible**.

Pseudotrametes gibbosa (Pers. ex Pers.) Bond. & Sing. syn. *Trametes gibbosa* (Pers. ex Pers.) Fr. **Bracket** 5–20cm across, 8–12cm wide, 1–8cm thick, semicircular often with a hump, single or in groups, upper surface downy or minutely velvety at first later smooth, greyish-white sometimes flushed cinnamon or yellowish (or greenish due to the growth of algae amongst the surface hairs), margin thick when young becoming acute. **Flesh** white, corky. Tubes 3–15mm long, whitish to yellow. **Pores** 1–2 per mm, elongated, slot-like, grey-white then creamy. Spores white, subcylindric, 4–5×2–2.5μ. Hyphal structure trimitic. Habitat on dead deciduous trees, especially beech. Season all year (sporulating in late spring). Frequent. **Not edible**.

Phellinus igniarius (L. ex Fr.) Quél. syn. *Fomes igniarius* (L. ex Fr.) Gill. **Bracket** 10–40cm across, 2–8cm wide, 5–20cm thick, hoof-shaped, very hard and woody; concentrically ridged, rusty brown when young later grey and finally black with the surface becoming cracked; margin obtuse, long-remaining rusty brown and velvety. **Flesh** rusty brown, hard. Taste sour or bitter, smell fungusy. Tubes 3–5mm long in each annual layer, rusty-brown. **Pores** 4–6 per mm, circular, rusty-cinnamon to maroon. Spores white, more or less globose, 4.5×6.5×4–5μ. Setae thick-walled, very dark brown, fusoid with acute apex. Habitat parasitic on deciduous trees, especially willow, causing intensive white rot. Season sporulating from spring to late autumn, perennial. Uncommon. **Not edible**.

Fomitopsis pinicola (Sow. ex Fr.) Karst. syn. *Polyporus marginatus* (Pers.) Fr. **Fruit body** 10–30cm across, 15–60cm wide, 5–20cm thick, hoof-shaped, pallid becoming straw-yellow and later reddish-brown, exuding clear droplets when fresh, glossy as if varnished, older parts covered in a hard resinous skin. **Flesh** corky to woody, white to straw-yellow. Tubes each layer 2–8mm long, cream to straw-yellow. **Pores** 3–4 per mm, circular, whitish bruising or ageing cream, straw-yellow to apricot-coloured. Habitat on conifers, less frequently on deciduous trees. Season all year, perennial. Common in Europe although not yet recorded from Britain. **Not edible**.

Hoof Fungus or **Tinder Fungus** *Fomes fomentarius* (L. ex Fr.) Kickx **Bracket** 5–45cm across, 3–25cm wide, 2–25cm thick, hoof-shaped, hard and woody, usually discrete but several fruit bodies may occur on the same trunk; upper surface with a hard horny crust, concentrically grooved and zoned grey. **Flesh** hard, fibrous, cinnamon-brown. Taste acrid, smell slightly fruity. Tubes 2–7mm long in each layer, rusty-brown. **Pores** 2–3 per mm, circular, light grey-brown darkening when handled. Spores lemon-yellow, oblong-ellipsoid, 15–20×5–7μ. Hyphal structure trimitic; generative hyphae with clamp-connections. Habitat usually on birch in Scotland and Northern England, but also on beech. The few records from Southern England are mostly on beech and sycamore. Season sporulating in spring to early summer, perennial. Uncommon. **Not edible**.

Rigidoporus ulmarius ⅓ life size

Rigidoporus ulmarius (Sow. ex Fr.) Imazeki syn. *Fomes ulmarius* (Sow. ex Fr.) Gill. **Bracket** 12–50cm across, 6–15cm wide, 4–8cm thick, bracket-shaped, hard and woody, surface knobbly; concentrically ridged, white to ochraceous becoming dirty-brown in older specimens. Tubes 1–5mm long in each layer, pinkish to orange when young, browning with age, each layer separated by a thin contrasting band of white flesh. **Pores** 5–8 per mm, red-orange fading to clay-pink or buff with age. Spores pale yellow, globose, 6–7.5μ in diameter. Hyphal structure monomitic; generative hyphae lacking clamps. Habitat at the base of trunks of deciduous trees, usually elm. Season all year, perennial. Common. **Not edible**.

Ischnoderma resinosum (Fr.) Karst. syn. *Polyporus resinosus* Fr. syn. *Polyporus benzoinus* (Wahl.) Fr. **Bracket** 5–30cm across, 3–15cm wide, 1–3cm thick, single or in small tiers; upper surface very uneven and wrinkled, velvety, saturated in a rusty resin when young,

Ischnoderma resinosum ¼ life size

Pseudotrametes gibbosa ½ life size

Phellinus igniarius ⅓ life size

Fomitopsis pinicola ⅓ life size

Hoof Fungus *Fomes fomentarius* ½ life size

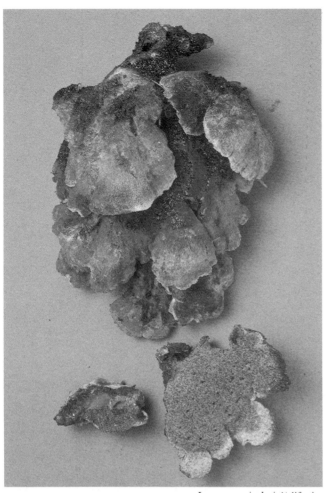

Inonotus cuticularis ⅓ life size

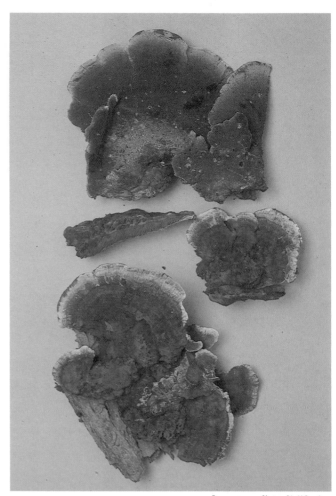

Inonotus radiatus ⅔ life size

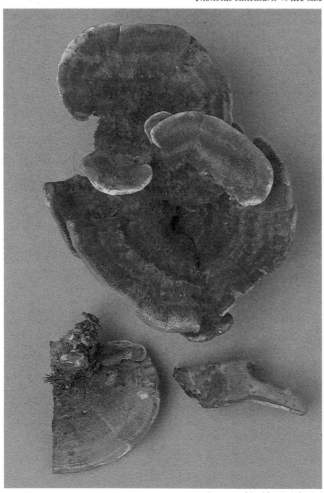

Inonotus hispidus ½ life size

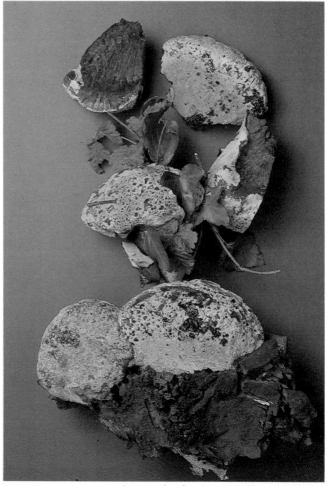

Inonotus dryadeus (young specimen) ⅓ life size

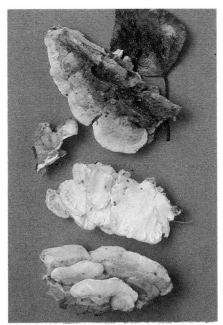

Inonotus cuticularis (Bull. ex Fr.) Karst. **Bracket** 5–20cm across, 3–10cm wide, 0.5–2.5cm thick, single or in overlapping tiers, soft and fleshy when young, later corky and fibrous; upper surface velvety becoming smooth, zoned, apricot at first then rusty, finally umber or tobacco-coloured. **Flesh** rusty brown, fibrous. Tubes 3–10mm long, rusty. **Pores** 2–4 per mm, circular at first becoming irregular, yellow-brown then rusty or cinnamon, glancing in the light. Spores brown, ovoid-ellipsoid, 5.5–8×4–6μ. Hyphal structure dimitic; generative hyphae without clamp-connections. Setae in tubes dark brown, fusiform, with acute apex projecting beyond the basidia; similar seta-like structures are found on the cap-surface but these are dark brown, branched and anchor-shaped. Habitat on deciduous trees, especially oak and beech. Season autumn, annual. Uncommon. **Not edible**.

Inonotus radiatus (Sow. ex Fr.) Karst. **Bracket** 2–9cm across, 1–6cm wide, 1–2cm thick, in tiers, woody; upper surface becoming glabrous, uneven and radially wrinkled, apricot at first then rusty, finally almost black, margin paler, thin and acute. **Flesh** rusty brown, woody. Taste bitter, smell faint and sweet. Tubes 3–8mm long, rusty-brown. **Pores** 3–4 per mm, circular or angular, glancing silvery in the light. Spores yellowish, ellipsoid, 4.5–6×3–4.5μ. Hyphal structure monomitic; generative hyphae lacking clamps. Setae in tubes, thick-walled, dark brown, fusiform with curved pointed apex. Habitat parasitic on alder and occasionally certain other deciduous trees. Season all year, annual but often persisting in old blackened state throughout the year. Frequent. **Not edible**.

Inonotus hispidus (Bull. ex Fr.) Karst. **Bracket** 6–25cm across, 4–12cm wide, 2–10cm thick, fan-shaped, usually single but occasionally fusing with others into overlapping groups, surface felty-hairy varying from ochraceous to tobacco-brown, finally blackish and bristly. Tubes 10–20(50)mm long. **Pores** 2–3 per mm, circular to angular, pale ochraceous at first, later brown and glancing in the light. Spores rust, subglobose, 9–12×4–10μ. Habitat usually on ash but commonly on other trees such as elm, apple and walnut. Season summer but persisting on the tree in blackened state throughout the year, annual. Frequent. **Not edible**.

Oxyporus populinus (Schum. ex Fr.) Donk syn. *Fomes populinus* (Schum. ex Fr.) Karst. syn. *Fomes connatus* (Weinm.) Gill. **Bracket** 3–6cm across, 2–3cm wide, 1–4cm thick, in tiers; upper surface uneven, whitish grey to pale grey-buff often with an ochraceous tint, frequently green tinged due to being overgrown by algae or moss. **Flesh** white. Smell slightly fungusy. Tubes 2–4mm long in each layer, whitish at first then straw-yellow. **Pores** 4–7 per mm, circular or slightly angular, whitish. Cystidia in tubes thin-walled, hyaline, clavate or fusoid with encrusted apex. Spores white, subglobose, 3.5–4.5×3–4μ. Hyphal structure monomitic; generative hyphae without clamp-connections. Habitat on trunks of deciduous trees. Season all year. Occasional. **Not edible**.

Inonotus dryadeus (Pers. ex Fr.) Murr. syn. *Polyporus dryadeus* Pers. ex Fr. **Bracket** 10–65cm across, 5–25cm wide, 2–12cm thick, or sometimes forming large, irregular cushions, corky; upper surface uneven, white-grey becoming brownish, finally very dark, margin broadly rounded and paler, exuding drops of yellowish liquid. **Flesh** rusty brown, fibrous. Tubes 5–20mm long, rusty-brown. **Pores** 3–4 per mm, circular then angular, white-grey becoming rusty. Spores white to yellowish, subglobose, 7–9×6.5–7.5μ. Hyphal structure monomitic; generative hyphae lacking clamp-connections. Setae in the tubes dark brown with swollen base and hooked pointed tips. Habitat parasitic on various species of oak, found at the base of trunks. Season all year. Uncommon. **Not edible**.

Oxyporus populinus ½ life size

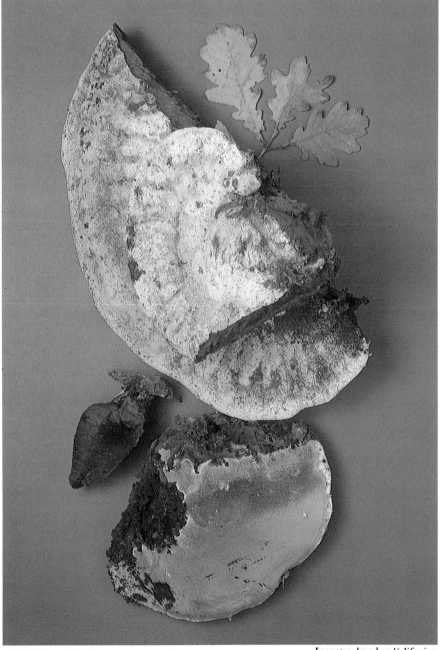

Inonotus dryadeus ⅓ life size

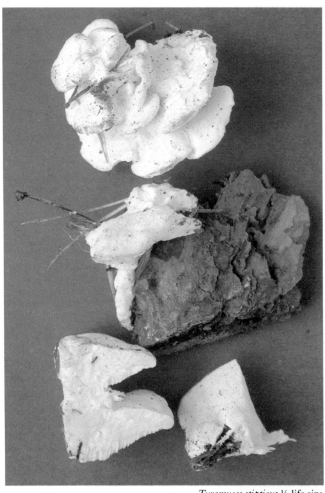

Tyromyces stipticus ½ life size

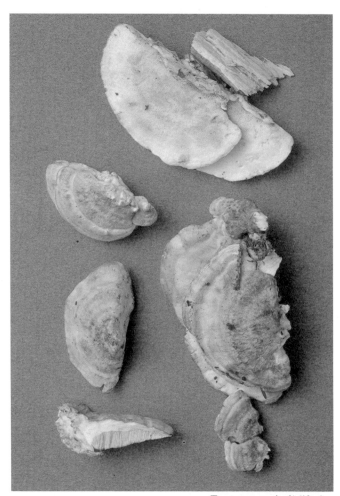

Tyromyces caesius ⅔ life size

Blushing Bracket *Daedaleopsis confragosa* ⅔ life size

Lenzites betulina ⅔ life size

Tyromyces albellus ⅓ life size

Tyromyces stipticus (Pers. ex Fr.) Kotl. & Pouz. syn. *Polyporus stipticus* Pers. ex Fr. **Bracket** 1–8cm across, 1–6.5cm wide, 0.5–3.5cm thick, semicircular or kidney-shaped, single or in small overlapping groups; upper surface uneven, milk-white. Taste bitter and stinging. Tubes 0.3–0.7mm long, white exuding whitish droplets in humid weather, which dry cream. **Pores** 1–5mm across, circular becoming more elongate, white to cream. Spores white, oblong-ellipsoid, 3.5–4.5×1.5–2.5μ. Hyphal structure monomitic; generative hyphae with clamp connections. Habitat usually on dead conifers, less frequently on living trees. Season all year. Frequent. **Not edible**.

Tyromyces caesius (Schrad. ex Fr.) Murr. syn. *Polyporus caesius* Schrad. ex Fr. **Bracket** 1–6cm across, 1–4cm wide, 0.3–1cm thick, single or in overlapping groups, semicircular; upper surface covered in fine long hairs, whitish, grey-blue with age or where handled. Tubes 0.5–4.5mm long, white later grey-blue. **Pores** 3–4 per mm, circular, white at first more grey or grey-blue with age. Spores white with grey-blue tint, sausage-shaped, amyloid, 4–5×0.7–1.0μ. Hyphal structure monomitic; generative hyphae appearing glassy in KOH, and with clamp-connections. Habitat on dead conifers, especially spruce. Season all year, annual. Occasional. **Not edible**.

Blushing Bracket *Daedaleopsis confragosa* (Bolt. ex Fr.) Schroet. syn. *Trametes rubescens* (A. & S.) Fr. **Bracket** 8–22cm across, 4–10cm wide, 1.5–5cm thick, corky, single or tiered, margin thin and acute; upper surface radially wrinkled and concentrically ridged, reddish-brown. **Flesh** white then pinkish, finally pale brownish. Taste slightly bitter, smell none. Tubes 5–15mm long, cream-coloured. **Pores** large, usually somewhat elongate or slot-like, whitish readily bruising pink to red on handling when fresh, staining violet with ammonia. Spores white, cylindric 8–11×2–3μ. Hyphal structure trimitic. Habitat on deciduous trees, especially willow. Season all year. Frequent. **Not edible**.

Lenzites betulina (L. ex Fr.) Fr. **Bracket** 3–8cm across, 2–4cm wide, 0.3–1.5cm thick, semicircular or fan-shaped, often in overlapping groups, tough and leathery; upper surface uneven, concentrically grooved and zoned, whitish, grey, tan and brown, covered in fine hairs in which algae may grow giving the surface a green tinge. **Flesh** white, cottony. **Gills** forked and fused together in places, straw-yellow to buff-grey. Spores white, subcylindric, 5–6×1.5–3μ. Hyphal structure trimitic. Habitat on deciduous trees, also on cut timber. Season all year. Uncommon. **Not edible**.

Tyromyces albellus (Peck.) Boud. & Sing. syn. *Polyporus albellus* Peck. **Bracket** 3–10cm across, 2–8cm wide, 1–3.5cm thick, fan-shaped to subcircular, succulent; upper surface suede-like and white at first later yellowing. **Flesh** white, soft and watery at first drying hard and chalky. Tubes 3–7mm long, white yellowing with age. **Pores** 3–4 per mm, circular to elongate, whitish. Spores hyaline, subcylindric, to sausage-shaped, 4–6×1.5–2μ. Hyphal structure dimitic with clamp-bearing generative hyphae and coralloid binding hyphae. Habitat on dead conifers or frondose trees. Season late summer to early winter. Uncommon. **Not edible**.

Maze-gill *Daedalea quercina* L. ex Fr. syn. *Trametes quercina* (L. ex Fr.) Pilát **Bracket** 4–20cm across, 3–8cm wide, 1.5–5cm thick, hard and corky, singly or occasionally in shelved groups; upper surface uneven, creamy or ochraceous tinged with grey, drying pallid or umber. **Flesh** pale wood-coloured. Smell faintly acrid or fungusy. Tubes 10–30mm long, ochraceous-cream coloured. **Pores** large, irregular and maze-like, often elongate resembling gills. Spores ellipsoid, 6–7.5×3–3.5μ. Hyphal structure trimitic. Habitat on dead deciduous wood, virtually restricted to oak in this country. Season from spring onwards. Common. **Not edible**.

Maze-gill *Daedalea quercina* ⅔ life size

Spongipellis spumeus ½ life size

Gloeophyllum sepiarium ⅔ life size

Incrustoporia semipileata ½ life size

Datronia mollis ⅔ life size

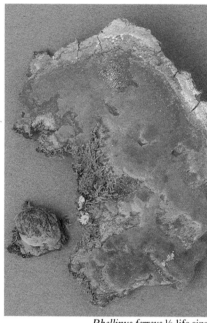

Phellinus ferreus ½ life size

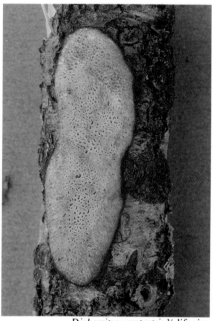

Dichomitus campestris ¾ life size

Spongipellis spumeus (Sow. ex Fr.) Pat. syn. *Polyporus spumeus* Sow. ex Fr. **Bracket** 5–20(30)cm across, 3–10cm wide, 2–6cm thick, fan-shaped, usually single; upper surface felty, white to yellowish becoming ochraceous to olive-brown with age. **Flesh** whitish, in two distinct layers; the thin upper layer soft and spongy, the lower one much thicker, hard and fibrous. Taste not distinctive, smell sweet and heady, sometimes of anise. Tubes 5–15(20)mm long, whitish. **Pores** 2–5 per mm, more or less circular, cream. Spores white, broadly elliptic to subglobose, 6.5–9×5–7µ. Habitat on deciduous trees. Season autumn. Rare. **Not edible.**

Gloeophyllum sepiarium (Wulf. ex Fr.) Karst. syn. *Lenzites sepiaria* (Wulf. ex Fr.) Fr. **Bracket** 2–3cm across, 5–12cm wide, 0.5–1cm thick, fan-shaped and often in tiered groups, corky; upper surface coarsely concentrically ridged and radially wrinkled, softly hairy at first later bristly, indistinctly zoned maroon to rusty darkening with age towards the point of attachment, lighter, even bright rusty-orange near the margin. **Flesh** rusty-brown. Taste and smell slight and not distinctive. **Gills** densely and

radially arranged and often fusing together irregularly giving a maze-like appearance, light ochraceous-rust drying tobacco-brown. Spores white, cylindric, 9–12.5×3–4.5µ. Habitat on coniferous trees or timber causing an intensive brown rot which rapidly destroys the infected wood. Season all year, annual. Uncommon. **Not edible.**

Incrustoporia semipileata syn. *Tyromyces semipileatus* (Peck.) Murr. syn. *Leptotrimitus semipileatus* (Peck.) Pouz. **Fruit body** usually forming a bracket 2–4cm across, 0.5–1.5cm wide, 0.2–2cm thick occasionally resupinate; upper surface whitish, older specimens becoming brownish or even blackish behind. **Flesh** white, succulent. Tubes very short, whitish. **Pores** 5–9 per mm, more or less circular, whitish then cream, very minute, scarcely visible to the unaided eye and glancing in the light. Spores white, exceptionally small, allantoid or sausage-shaped, 3–4×0.4–0.5µ. Hyphal structure trimitic; generative hyphae with clamp-connections. In the tubes there are hyphal endings which are curved and densely encrusted with crystalline matter. Habitat on

branches and twigs of deciduous trees. Season all year. Frequent. **Not edible.**

Datronia mollis (Sommerf.) Donk syn. *Trametes mollis* (Sommerf.) Fr. syn. *Antrodia mollis* (Sommerf.) Karst. **Fruit body** generally consisting of long narrow shelf-like, undulating, rather thin but tough, leathery brackets, often in tiers, measuring 1–7cm long, 0.5–2.5cm wide, 0.2–0.6cm thick, which are velvety and umber brown on the upper surface when fresh, later smooth and darker brown to almost black. **Flesh** pale brownish. Tubes 0.5–5mm long. **Pores** 1–2 per mm, angular, irregularly elongated or slot-like, greyish due to a whitish bloom which disappears on handling leaving the pore-surface yellowish-brown or umber. Spores subcylindric, 8–10×2.5–3.5µ. Hyphal structure dimitic. Habitat on dead deciduous wood. Season all year. Frequent. **Not edible.**

Phellinus ferreus (Pers.) Bourd. & Galz. syn. *Polyporus ferreus* Pers. **Fruit body** resupinate, initially forming small cushions 1–2mm across which are cinnamon-yellow, later fusing and becoming cinnamon-brown. **Flesh** rusty brown.

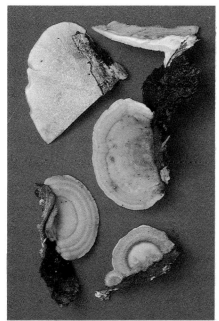

Coriolus hirsutus ½ life size

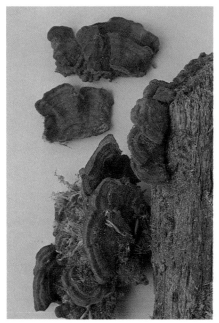

Hymenochaete rubiginosa ⅔ life size

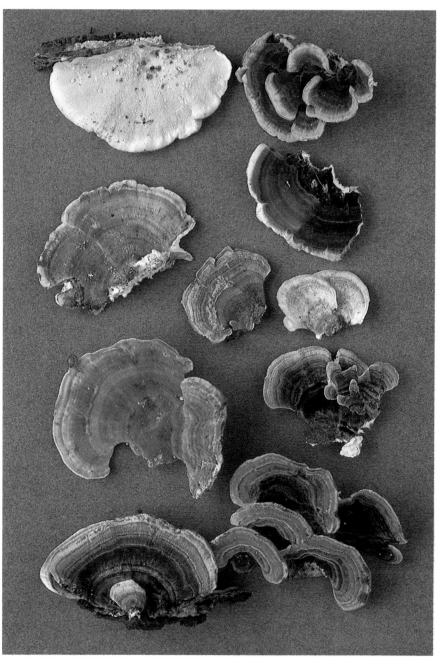

Many-zoned Polypore *Coriolus versicolor* ¾ life size

Tubes 2–5mm long in each of the 4–5 layers, rusty-brown. **Pores** 4–6 per mm, circular to angular, rusty-cinnamon. Spores hyaline, cylindric, 5–6.5×2–2.5μ. Setae thick-walled, fusiform with acute apex, dark brown. Habitat on dead branches of deciduous wood, especially hazel, causing an intensive white rot which rapidly destroys the wood. Season all year, perennial. Common. **Not edible.**

Dichomitus campestris (Quél.) Dom. & Orlicz syn. *Trametes campestris* (Quél.) **Fruit body** resupinate, convex, cushion-like, 2–12cm across, pale at first becoming yellowish or brownish, finally staining dark brown to black throughout. Tubes sometimes in 2–6 layers (in perennial fruit bodies), 3–10mm long. **Pores** 1–2 per mm, circular-angular, often irregular. Spores thin-walled, ellipsoid-cylindric, 9–12.5×3.5–4.5μ. Habitat on thin, dead branches of deciduous trees. Season autumn, annual or sometimes perennial. Rare – known only from Scotland. **Not edible.**

Coriolus hirsutus (Wulf. ex Fr.) Quél. syn. *Trametes hirsuta* (Wulf. ex Fr.) Pilát **Bracket** 4–

10cm across, 2–6cm wide, 0.5–1cm thick, single or in overlapping groups; upper surface covered in silvery hairs, concentrically zoned and contoured, whitish to yellow-brown or grey when young, greying with age. **Flesh** tough and leathery, white. Taste bitter, smell slightly of aniseed when fresh. Tubes 1–5mm long, white to yellowish. **Pores** 2–4 per mm, subcircular, white at first later cream, often tinted grey. Spores whitish, ellipsoid to subcylindric, 5.5–7.5×1.5–2.5μ. Hyphal structure trimitic. Habitat on dead wood of deciduous trees especially on fallen beech trunks in exposed situations. Season all year. Rare. **Not edible.**

Hymenochaete rubiginosa (Dicks. ex Fr.) Lév. **Fruit body** forming densely crowded, tiered brackets, very rarely resupinate, 2.5–6cm across, 2–4cm wide, often wavy or lobed at the margin; upper surface closely concentrically zoned deep rust-brown to date-brown, velvety at first becoming smooth and almost black with age. Fertile or lower surface rust-brown. **Flesh** thin, rust-brown, brittle. Spores whitish to yellowish or olive, broadly elliptic, 4–6.5×2.5–3μ. Setae 43–80×5.5–10μ, dark brown to almost

black, thick-walled, acutely fusoid or lanceolate projecting beyond the current basidial layer but some becoming buried in the thickening hymenium. Habitat virtually restricted to occurrence on very old rotting oak-stumps. Season all year. Common. **Not edible.**

Many-zoned Polypore *Coriolus versicolor* (L. ex Fr.) Quél. syn. *Trametes versicolor* (L. ex Fr.) Pilát **Bracket** 4–10cm across, 3–5cm wide, 0.1–0.3cm thick, leathery, usually forming large overlapping tiered groups; upper surface velvety becoming smooth with age, colour very variable, concentrically zoned black-green, grey-blue, grey-brown or ochraceous-rust, with a white to cream margin. **Flesh** tough and leathery, white. Taste and smell not distinctive. Tubes 0.5–1mm long, white drying yellowish. **Pores** 3–5 per mm, circular or irregularly angular, white, yellowish or light brown. Spores straw-yellow, ellipsoid, 5.5–6×1.5–2μ. Hyphal structure trimitic. Habitat on deciduous wood. Season all year. Very common. **Not edible.**
This is a very variable species and some authors recognize several forms.

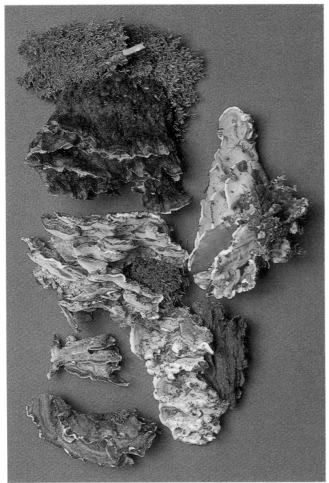

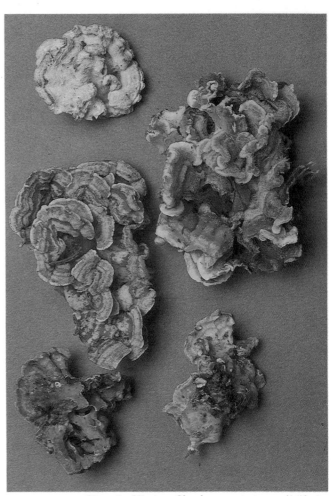

Bjerkandera adusta ½ life size

Silver-leaf Fungus *Chondostereum purpureum* ²/₃ life size

Bjerkandera adusta (Willd. ex Fr.) Karst. syn. *Polyporus adustus* Willd. ex Fr. **Bracket** 2–4cm across, 1–2cm wide, 0.3–0.6cm thick, leathery, often several fused together in tiers or in an overlapping group which may be 20cm across or more, undulate and leathery, drying hard; upper surface suede-like, grey-brown with a white margin when young, becoming darker and blackening at the margin with age. Taste sourish, smell strongly fungusy. Tubes 0.5–1mm long, grey. **Pores** minute, subcircular, smoke grey darkening with age. Spores straw yellow, ellipsoid, 4.5–5.5×2.5–3μ. Hyphal structure monomitic; generative hyphae with clamp-connections. Habitat on dead wood of deciduous trees. Season all year, annual. Common. **Not edible.**

Silver-leaf Fungus *Chondostereum purpureum* (Fr.) Pouz. syn. *Stereum purpureum* (Fr.) Fr. **Bracket** 1.5–3cm across, 1–2cm wide, 0.2–0.5cm thick, usually several brackets fused together and overlapping; extremely undulate, tough when fresh becoming brittle when dry; upper surface covered in dense white woolly hairs in concentric bands; lower surface dark violaceous or violaceous-brown in young specimens and becoming brownish with age, drying paler (lower specimens in photograph). Spores subcylindrical, 5–8×2.5–3μ. Hyphal structure monomitic; generative hyphae with clamp-connections. Habitat parasitic or saprophytic on various trees, especially members of the *Rosaceae*. Season all year. Common. **Not edible.**

This fungus is the cause of 'silver leaf' disease

which leads to the destruction of fruit trees; plum trees are particularly susceptible. The first visible sign of infection is silvering of the leaves due to the upper epidermis becoming separated from the rest of the leaf and lifting in patches. This effect occurs progressively along a branch and on cutting the wood appears stained brown by the fungus. If the wood is cut back until no infection is seen and the wound treated with a fungicide the fungus can be eliminated. Where silvering of the leaves occurs all over a tree simultaneously it is unlikely to be due to this fungus; this can be verified by examination of the wood for staining. This false silver leaf which has the same symptom, that of the upper epidermis lifting, is caused by physiological disturbance such as heavy pruning.

Hirschioporus abietinus (Dicks. ex Fr.) Donk syn. *Polystictus abietinus* (Dicks. ex Fr.) Fr. **Bracket** 1–3cm across, 0.5–2cm wide, 0.1–0.2cm thick, in overlapping rows or shelves; upper surface concentrically grooved, greyish, often with a greenish tint due to the growth of algae amongst the layer of woolly hairs covering the surface, margin pinkish and undulate. **Flesh** pale brownish or purplish. Tubes 0.3–0.7mm long, lilac when fresh drying reddish-brown. **Pores** 3–4 per mm, circular or angular becoming irregularly toothed, bright violet especially towards the margin of the cap but paling and brownish with age. Cystidia abundant, fusiform with slightly thickened walls and an encrusted apex, 12–35×5–7μ. Spores hyaline, oblong-ellipsoid, 6.5–8×3–4μ. Hyphal structure dimitic; generative hyphae with clamp-

connections. Habitat on dead fallen coniferous trunks and stumps. Season all year. Frequent. **Not edible.**

Hairy Stereum *Stereum hirsutum* (Wild ex Fr.) S. F. Gray **Fruit body** occasionally resupinate but normally forming tough leathery brackets 3–10cm across, 1–4cm wide, often in tiered groups, margin wavy and lobed; upper surface zoned ochre to greyish, hairy. Fertile or lower side bright yellow, duller brownish or greyish with age, smooth. Spores white, ellipsoid, amyloid, 6–7.5×3–3.5μ. Habitat on stumps, logs and fallen branches of deciduous trees. Season all year. Common. **Not edible.**

Stereum gausapatum (Fr.) Fr. syn. *Stereum spadiceum* (Fr.) Fr. **Fruit body** resupinate or forming small tiered brackets 1–4cm across, tough and leathery, thin-fleshed; upper surface zoned ochre-brown to greyish, finely hairy, margin white. Fertile or lower surface pallid to dark chestnut, smooth, bleeding red if cut when fresh. Spores white, oblong, amyloid, 7–8×3–3.5μ. Habitat on stumps, logs and fallen branches of deciduous trees, especially oak. Season all year. Common. **Not edible.**

Stereum rugosum (Pers. ex Fr.) Fr. **Fruit body** usually resupinate, occasionally forming small woody brackets; fertile surface buff often tinged pink, bleeding red if cut when fresh, drying more ochre and often cracking. **Flesh** whitish, thin, stratified. Spores white, elliptic, amyloid, 9–

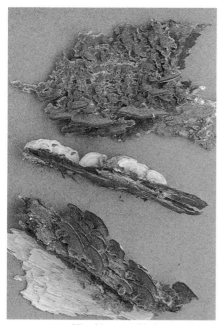

Hirschioporus abietinus ½ life size

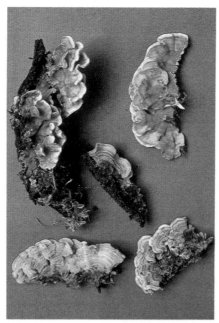

Hairy Stereum *Stereum hirsutum* ½ life size

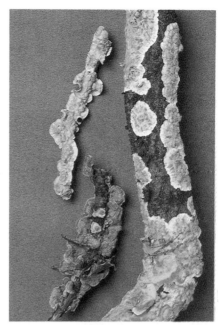

Stereum gausapatum ½ life size

13×3.5–5μ. Habitat on stumps, logs and fallen branches of deciduous trees, especially hazel. Season all year. Frequent. **Not edible**.

Ceriporiopsis gilvescens (Bres.) Dom. syn. *Poria gilvescens* Bres. **Fruit body** resupinate, initially small then merging into larger patches up to 10–15×2–5cm and 0.5cm thick, white, bruising or drying flesh-coloured, reddish-brown or ochraceous but remaining pale at the sterile margin. Tubes 1–4mm long, pale reddish-brown. **Pores** 3–5 per mm, more or less angular. Spores ellipsoid-cylindric, 4–6(7)×1.5–2μ. Hyphal system monomitic; hyphae thin-walled with clamp-connections. Habitat on logs and rotting stumps of deciduous trees. Season all the year, annual. Occasional. **Not edible**.

Cylindrobasidium evolvens (Fr.) Julich syn. *Corticium evolvens* (Fr.) Fr. syn. *Corticium laeve* Pers. **Fruit body** resupinate, 2–20cm across, white, cream or tan with white fimbriate margin; on vertical surfaces the fungus may form small delicate brackets up to 1.5×1cm. Spore-bearing surface cream then pinkish-ochre, cracking when dry. Spores white, pip-shaped, 9–12×6–7.5μ. Cystidioles thin-walled, elongate, fusiform, intermixed with the basidia but seldom emergent. Hyphae distinct, with obvious walls and with clamp connections at the septa. Habitat on logs or fallen branches. Season all year. Common. **Not edible**.

Schizopora paradoxa (Schrad. ex Fr.) Donk syn. *Irpex paradoxus* (Schrad. ex Fr.) Fr. syn. *I. obliquus* (Schrad. ex Fr.) Fr. syn. *Poria versipora* (Pers.) Lloyd syn. *Xylodon versipora* (Pers.) Bond. **Fruit body** resupinate, initially in small circular patches later fusing to cover large irregularly shaped areas, white to creamy-ochre. Tubes 1–5mm long. **Pores** 1–4 per mm, circular, oblong, angular or maze-like. Spores hyaline, ovoid, 4–6×3–3.5μ. Hyphal structure of tubes dimitic; generative hyphae with rather distinct walls and clamp-connections. Habitat on dead wood, usually of deciduous trees. Season all year. Very common. **Not edible**.

Stereum rugosum ½ life size

Ceriporiopsis gilvescens ⅔ life size

Cylindrobasidium evolvens ½ life size

Schizopora paradoxa life size

Phlebia merismoides ⅔ life size

Dry-rot Fungus *Serpula lacrymans* life size

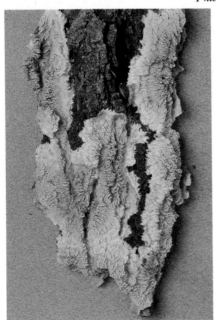

Phlebia merismoides (dull-coloured specimen)
½ life size

Phlebia merismoides Fr. syn. *P. radiata* Fr. syn.
P. aurantiaca (Sow.) Karst. **Fruit body**
resupinate forming round, oval or irregular
patches, 8–10mm across and 2–3mm thick,
margin fringed, surface very wrinkled with
radiating ridges, the colour varying from dull
flesh-colour or purplish to bright fluorescent
orange, especially at the margin. Spores white,

sausage-shaped, 4–7×1–3μ. Habitat on the bark
of dead deciduous trees, especially beech. Season
all year. Common. **Not edible**.

Dry-rot Fungus *Serpula lacrymans* (Fr.) Karst.
syn. *Merulius lacrymans* Schum. **Fruit body** 5–
50cm across, usually resupinate but occasionally
forming brackets on vertical substrates, arising
from whitish, pinkish, lilac or grey mycelium.
Flesh 2–12mm thick, greyish-white, spongy-
fleshy. **Pores** rusty-yellow becoming more
yellowish towards the thick, white sterile
margin. Spores rust-brown, elliptic, 8–10×5–
6μ. Habitat on worked wood in buildings
although the fruit bodies of the fungus may also
appear on non-organic substrates such as plaster
or brickwork. Season all year. Common. **Not
edible**.
Infection of wood occurs when it has become
sodden for some long time following prolonged
damp due to leaking roofs or pipes, either by
spores or by vegetative mycelium spreading
through brickwork. On germination of the
spores the mycelia exhibit two distinct modes of
growth. Firstly, numerous fine hyphae penetrate
the wood, producing enzymes which break down
the wood and enable the fungus to absorb
nutrients; as the wood dries it cracks into cubical
blocks and eventually disintegrates into brown
powder. It is the second mode of growth which is
most easily detected since it takes the form of
thick mycelial cords and cottony sheets
spreading over brickwork, metal, etc. enabling

the fungus to travel over areas from which it
cannot derive nutrients. The fruit bodies arise
from these mycelial cords.

Leucogyrophana mollusca (Fr.) Karst. syn.
Merulius molluscus Fr. **Fruit body** resupinate,
forming patches 3–10cm across, white and
smooth at first becoming wrinkled and forming
'pores' and then yellowing. Spores yellowish,
broadly elliptic, some dextrinoid, 4–6.5×4–5μ.
Habitat on coniferous wood, twigs or other
debris. Season autumn to winter. Rare. **Not
edible**.

Serpula himantioides (Fr. ex Fr.) Karst. syn.
Merulius himantioides Fr. ex Fr. syn. *Gyrophana
himantioides* (Fr. ex Fr.) Pat. **Fruit body**
resupinate, forming patches 2–5cm across,
smooth at first becoming irregularly wrinkled
forming reticulate 'pores', lilac at first then
drying umber, margin white, thin. Spores
yellowish-brown, elliptic, 9–10×6μ. Habitat on
dead conifer wood, especially on the undersides
of large logs. Season all year. Occasional. **Not
edible**.

Coriolellus albidus (Fr. ex Fr.) Bond. syn.
Trametes albida (Fr. ex Fr.) Bourd. & Galz. **Fruit
body** resupinate, or forming small brackets, 1–
3cm across, 0.5–1cm wide, 0.2–0.7cm thick;
upper surface finely hairy, white to light

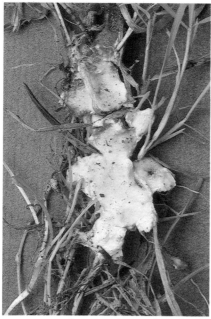

Leucogyrophana mollusca life size

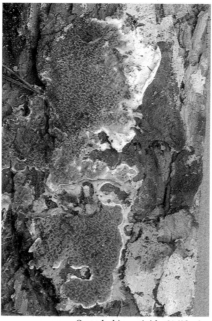

Serpula himantioides ¾ life size

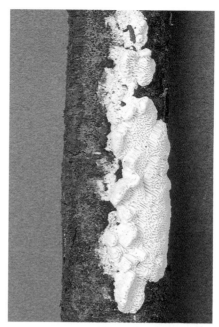

Coriolellus albidus life size

yellowish-brown. **Flesh** white. Tubes 2–5mm long. **Pores** 0.6–2mm diameter, angular, white or cream to pale buff. Spores cylindric-ellipsoid, 6–11×3–5μ. Hyphal structure dimitic; generative hyphae with clamp-connections. Habitat on fallen branches and logs of deciduous trees, causing brown rot of the wood. Season all year. Occasional. **Not edible**.

Coniophora puteana (Schum.) Karst. syn. *C. cerebella* Pers. syn. *Corticium puteanum* (Schum.) Fr. **Fruit body** resupinate, forming irregular patches 4–20cm across, creamy white at first then pale yellow becoming dirty chrome to olivaceous, margin broad, white, radiating, surface irregular, rough and warted. **Flesh** very thin. Spores olivaceous-brown, broadly elliptic, 11–13×7–8μ. Habitat on trunks, decaying wood or timbers; it is one of the major causes of wet rot in damp buildings. Season all year. Common. **Not edible**.

Meruliopsis taxicola (Pers.) Bond. **Fruit body** forming large resupinate patches, surface poroid-merulioid, waxy. **Pores** white to pinkish darkening on bruising or with age to reddish-brown or almost black, the margin remaining white. Spores curved-cylindric, 3–7×1–1.5μ. Habitat on conifer wood. Season all year. Rare. **Not edible**.

Merulius tremellosus Fr. **Fruit body** resupinate but more often forming small brackets; the resupinate form spreading radially and flowing into each other, margin covered in silky radiating fibres, the bracket form 1–5cm across, thin, flexible, semicircular and often tiered, margin hairy, upper surface white and hairy, Fertile or lower side orange-buff or pinkish appearing almost poroid. **Flesh** whitish, thin, gelatinous. Spores hyaline, sausage-shaped, 4–4.5×1–1.5μ. Habitat on stumps or fallen branches of deciduous, less frequently coniferous, wood. Season autumn to spring. Occasional. **Not edible**.

Coniophora puteana ¾ life size

Meruliopsis taxicola life size

Merulius tremellosus ⅓ life size

Merulius tremellosus (pale form) ½ life size

Peniophora quercina ²/₃ life size *Peniophora quercina* (young stage) ²/₃ life size *Peniophora lycii* ²/₃ life size

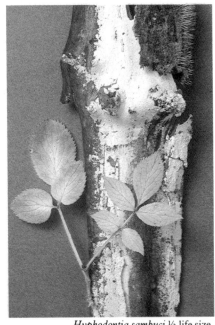

Peniophora incarnata ¾ life size *Hyphodontia sambuci* ½ life size *Mycoacia uda* ¾ life size

Hypochnicium vellereum ½ life size *Vuilleminia comedens* ¾ life size *Exobasidium vaccinii* ½ life size

Peniophora quercina (Fr.) Cke. **Fruit body** resupinate, forming ochraceous pink to purple grey patches 0.1–0.5mm thick which dry hard and brittle rolling away from the substrate and back on themselves to show the dark brown or black underside. **Flesh** relatively thick almost gelatinous, hyaline except for a narrow brownish zone adjacent to the substrate. Cystidia thick-walled, hyaline, fusiform, heavily encrusted with crystalline material, and often becoming buried as the hymenium thickens. Spores light red, curved cylindric, 8–12×3–4μ. Habitat on dead branches of deciduous trees especially oak. Season all year. Common. **Not edible.**

Peniophora lycii (Pers.) Höhn. & Litsch **Fruit body** resupinate, forming thin irregular patches on the undersides of branches, blue-grey with a violaceous tint. Cystidia club-shaped conspicuously encrusted in crystalline material and often becoming buried as the hymenium thickens. Dendrophyses hyaline, branched, encrusted with crystalline material. Spores pink, cylindric or somewhat curved, 9–13×3.5–5μ. Habitat on dead twigs and sticks of many deciduous trees. Season all year. Very common. **Not edible.**

Peniophora incarnata (Fr.) Karst. syn. *Thelephora incarnata* Pers. ex Fr. **Fruit body** resupinate, forming thin pale to bright orange or salmon-pink patches on the undersides of branches. Spores light red, narrowly elliptic, 8–12×3.5–5μ. Cystidia fusoid, encrusted with crystalline material and found at all levels in the thickening hymenium. Gloeocystidia thin-walled, elongated and somewhat vermiform. Habitat on wood of all sorts especially gorse. Season all year. Common. **Not edible.**

Hyphodontia sambuci (Pers.) Erikss. syn. *Thelephora sambuci* Pers. syn. *Hyphoderma sambuci* (Pers.) Jülich **Fruit body** resupinate, very thin, mealy, pruinose or chalky, white. Cystidioles narrowly fusoid, often capitate at apex. Spores ellipsoid, 4.5–6×3.5–4μ. Habitat on deciduous wood, especially elder. Season all year, especially autumn to winter. Very common. **Not edible.**

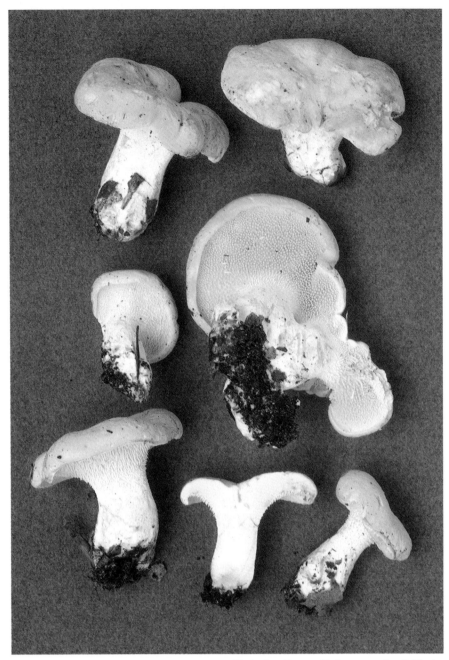

Hedgehog Fungus *Hydnum repandum* ²⁄₃ life size

Mycoacia uda (Fr.) Donk. syn. *Acia uda* (Fr.) Bourd. & Galz. **Fruit body** resupinate, very thin, bright lemon-yellow becoming more ochraceous with age, covered in crowded slender spines which become purple when treated with a drop of KOH. Cystidioles thin-walled, fusoid. Spores narrowly ellipsoid, 4–6.5×2–3.5μ. Habitat on fallen branches of deciduous trees. Season all year. Common. **Not edible.**

Hypochnicium vellereum (Ell. & Crag.) Parm. syn. *Corticium vellereum* Ellis & Cragin **Fruit body** resupinate, 2–10cm across, 0.1–0.2mm thick, white, cream or pink-buff, margin white, fibrillose in young specimens. Spores white, globose, with uneven thickened walls 7–8μ. In addition to basidiospores this fungus also produces apical or intercalary chlamydospores on hyphae in the subhymenial tissue. These chlamydospores are rounded to pear-shaped with thickened dextrinoid walls, and measure 8–10×6–8μ. Hyphal structure monomitic;

generative hyphae thin to somewhat thick-walled with clamp-connections. Habitat deciduous wood. Season late autumn to late winter. Occasional. **Not edible.**

Vuilleminia comedens (Nees) Maire syn. *Corticium comedens* (Nees) Fr. **Fruit body** resupinate, forming firm–gelatinous patches 1–13cm across below the bark, dingy lilac to pale flesh-coloured, slightly viscid and translucent when moist. Spores white, cylindric to sausage-shaped, 18–20×5–6μ. Habitat beneath the bark on dead, often still attached, branches of deciduous trees. Season all year. Common but inconspicuous; most easily found by observing the characteristically rolled-back bark of the host. **Not edible.**

Exobasidium vaccinii (Fuckel) Woron **Fruit body** forming a whitish or pinkish powdery spore-bearing layer on gall-like, thickened, distorted

leaves and shoots of members of the *Ericaceae*. Spores white, elongate, 10–20×2.5–5μ, becoming 3-septate at maturity. Habitat leaves and young shoots or flowers of certain members of the *Ericacea*; rhododendron, pot-grown azaleas, etc. (shown here on *Vaccinium*). Season late spring to autumn. Uncommon. **Not edible.**

Hedgehog Fungus *Hydnum repandum* L. ex Fr. **Fruit body** usually single. **Cap** 3–17cm across, flattened convex or centrally depressed, even, velvety at first then more suede-like, cream, yellowish or pale flesh-coloured. **Stem** 35–75×15–40mm, often off-centred, cylindrical, finely downy, white bruising yellow near the base. Taste bitter after a few seconds, smell pleasant. **Spines** 2–6mm long, whitish to salmon pink. Spores white, broadly ellipsoid to subglobose, 6.5–9×5.5–7μ. Habitat deciduous or coniferous woods. Season late summer to late autumn. Frequent. **Edible – excellent,** commonly sold in European markets.

241

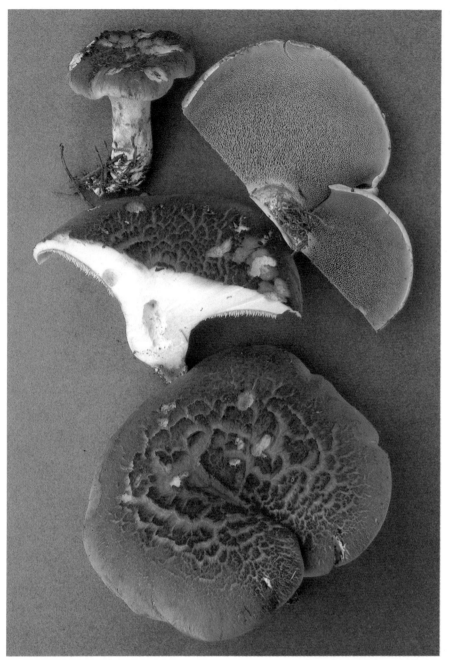

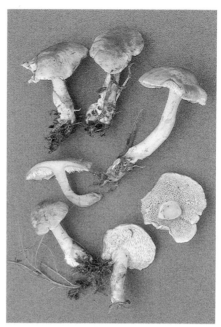

Hydnum rufescens ⅓ life size

Sarcodon imbricatum ⅔ life size

Sarcodon imbricatum (L. ex Fr.) Karst. syn. *Hydnum imbricatum* L. ex Fr. **Fruit body** single. **Cap** 5–20cm across, flattened convex at first later depressed, velvety then felty soon cracking deeply into coarse overlapping upturned scales of a dark reddish- or purplish-brown contrasting with the pale pink or flesh-coloured background. **Stem** 50–80×20–50mm, tapering or swollen at the base, whitish at first becoming brownish from the base upwards. Taste slight but bitter after a few minutes, smell slight, not distinctive. **Spines** 1–10mm long, whitish finally purplish-brown. Spores brownish, warted with irregular outline, 7–8×5–5.5μ. Habitat coniferous woods, especially on sandy soils. Season autumn. Rare – more frequent in Scottish pine forests. **Edible**.

Hydnum rufescens Fr. syn. *H. repandum* var. *rufescens* (Fr.) Barla Differs from *H. repandum* in the orange-brown colour of the cap, the smaller and less robust form, the non-decurrent spines and slightly larger spores, 8–10×6–7μ. Habitat deciduous and coniferous woods. Season autumn. Occasional. **Edible**.

Ear-pick Fungus *Auriscalpium vulgare* S. F. Gray syn. *Hydnum auriscalpium* L. **Cap** 1–2cm across, kidney-shaped, thin and leathery, covered with yellow-brown to chestnut or blackish hairs. **Stem** 10–140×1–2mm, joined laterally to the cap, swollen towards the base, bristly, dark brown to blackish. **Spines** 1–3mm long, dark flesh-colour to brown at first becoming paler as they are dusted with the ripening spores. Spores white, subglobose to broadly ovate, minutely spinulose, amyloid, 4.5–5.5×3.5–4.5μ. Habitat on buried decaying pine cones. Season all year. Occasional. **Not edible**.

Hydnellum caeruleum (Horn. ex Pers.) Karst. **Fruit body** solitary or fused with others. **Cap** 3–11cm across, convex to depressed, velvety to matted, at first white often with a blue margin, at length becoming yellowish- to rusty-brown. **Flesh** zoned bluish in cap, orange brown in stem. Smell of cucumber when cut. **Spines** 1–5mm

Ear-pick Fungus *Auriscalpium vulgare* ⅔ life size

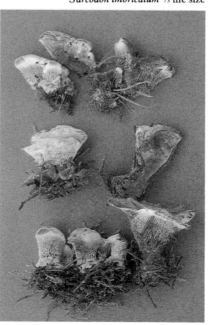

Hydnellum caeruleum ⅓ life size

long, bluish at first, then white, finally purplish-brown. Spores brown, irregularly lobed and warted, 5.5–6×3.5–4.5μ. Hyphae with clamp connections. Habitat conifer woods. Season autumn. Very rare – confined to Highland pine forest. **Not edible**.

Sarcodon scabrosum (Fr.) Karst. syn. *Hydnum scabrosum* Fr. **Fruit body** single or fusing with others. **Cap** 4–14cm across, flattened convex or centrally depressed, covered in down and smooth at first soon becoming cracked and scaly, background colour dirty yellowish covered in cinnamon, rusty or purplish-brown scales. **Stem** 25–100×10–30mm, tapering towards the base, downy to fibrous-scaly, dark flesh-colour eventually concolorous with cap scales, grey-green, blue-green or blackish green below. **Flesh** grey-green in base of stem. Taste bitter and acrid, smell mealy. **Spines** 1–10mm long, yellowish-white eventually becoming purplish-brown. Spores brownish, tuberculate (5.5)6–7.5×(3.5)4–5μ. Habitat coniferous and deciduous woods. Season autumn. Rare. **Not edible**.

Hydnellum peckii Banker apud Peck syn. *Hydnum peckii* (Banker apud Peck) Trott. **Fruit body** single or becoming fused with others. **Cap** 3–7cm across, flattened convex to depressed, uneven or knobbly and ridged or pitted towards the centre, velvety at first and often covered in red droplets, initially white then pale vinaceous or brownish-pink darkening from the centre outwards to reddish-brown, purple or almost black. **Stem** 5–60×5–20mm, cylindrical or tapered towards the base, velvety, concolorous with the cap. Taste and smell not distinctive. **Spines** 1–4.5mm long, white at first becoming pale purplish-brown. Spores brown, tuberculate, 5–5.5×3.5–4μ. Habitat coniferous woods. Season late summer to autumn. Uncommon – found in Scottish pine woods. **Edibility unknown**.

Hydnellum scrobiculatum (Fr. ex Secr.) Karst. syn. *Hydnum scrobiculatum* Fr. **Fruit body** single or fusing with others. **Cap** 2–4.5cm across, centrally depressed, radially wrinkled or ridged over the entire surface and usually coarsely roughened with spiky processes, velvety at first then fibrillose, finally shiny, initially whitish then pinkish to brown darkening towards the centre, bruising blackish. **Stem** 10–20×2–10mm, cylindrical, tapered or bulbous at the base, velvety or matted and wrinkled, concolorous with cap. Smell mealy. **Spines** 1–4mm long, whitish becoming purplish brown. Spores brown, tuberculate, 5.5–7×4.5–5μ. Habitat coniferous and mixed woods. Season autumn. Occasional. **Edibility unknown**.

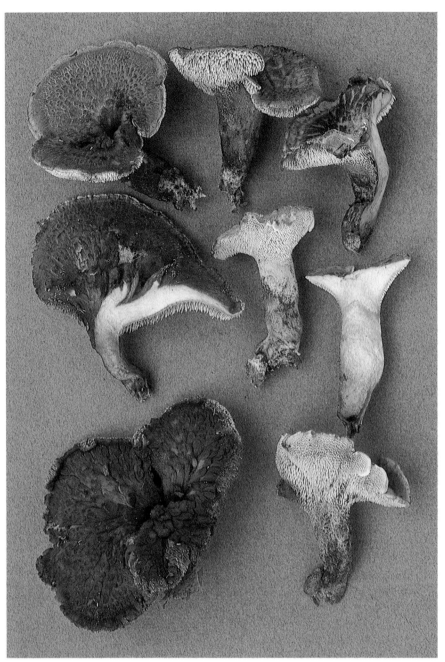

Sarcodon scabrosum ½ life size

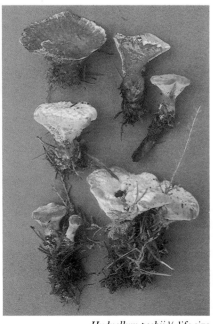

Hydnellum peckii ½ life size

Hydnellum scrobiculatum ⅔ life size

Bankera fuligineo-alba ²/₃ life size

Bankera fuligineo-alba (Schmidt ex Fr.) Pouz. syn. *Hydnum fuligineo-album* Schmidt **Cap** 4–15cm across, flat becoming centrally depressed, fleshy, initially pallid becoming yellowish-brown and darkening with age, usually found covered in vegetable debris. **Stem** 10–50×8–25mm, with well-defined white apex, brownish below. **Flesh** whitish in cap occasionally flushed pink, pallid to yellowish-brown in stem. Smell of fenugreek when dry. **Spines** 1–6mm long, whitish then greyish. Spores white, oval, minutely spiny, 4.5–5.5×2.5–3.5μ. Habitat pine woods. Season autumn. Rare except in Highland pine forests. **Not edible.**

Hydnellum concrescens (Pers. ex Schw.) Banker syn. *H. zonatum* (Fr.) Karst syn. *H. velutinum* var. *zonatum* (Fr.) Maas G. **Fruit bodies** usually fusing together. **Cap** 2–7cm across, centrally depressed, radiately ridged, covered in coarse knobs or secondary caps, white to creamy-pink and velvety at first becoming fibrous-scaly and tan to dark brown in concentric zones, often with blackish blotches. **Stem** 5–5.5×2–10mm, velvety to matted, concolorous with cap. Smell mealy. **Spines** 1–3mm long, whitish, then pinkish-brown, finally dark purplish-brown. Spores of irregular outline, 5.5–6×4–4.5μ. Habitat coniferous and deciduous woods. Season autumn. Uncommon. **Edibility unknown.**

Hydnellum spongiosipes (Peck) Pouz. **Fruit body** single or fusing with others. **Cap** 2–7cm across, flattened-convex or slightly depressed, surface smooth and uneven, usually with one or two concentric grooves, whitish-yellow and velvety at first becoming flesh-coloured to brownish or cinnamon, finally dark brown bruising reddish. **Stem** 10–90×5–30mm, swollen below with a very thick spongy felt-like tomentum, dark reddish-brown. Smell mealy. **Spines** 1–6mm long, whitish at first, later dark brown. Spores irregular, tuberculate, 6–7×4.5–5.5μ. Habitat deciduous woods, usually with oak. Season autumn. Uncommon. **Edibility unknown.**

Phellodon tomentosus (L. ex Fr.) Banker **Fruit bodies** tough, shallowly funnel-shaped, mostly fused together with adjacent specimens. **Cap** 1.5–4cm across, flat to depressed, downy at first becoming wrinkled or ridged, sometimes pitted in the centre, initially white then yellowish-brown and finally deep brown with darker colour zones. **Stem** 5–10×2–8mm, arising from a common mycelial pad, smooth to fibrillose and mottled, yellow-brown to deep brown. **Flesh** pale brownish in cap, dark brown in stem. Smell of fenugreek when dry. **Spines** 1–2mm long, white then grey. Spores oval, minutely spiny, 3–3.5×2.5–3μ. Habitat coniferous and mixed woodland. Season late summer. Uncommon. **Not edible.**

Phellodon melaleucus (Sw. apud. Fr. ex Fr.) Karst. syn. *Hyndum melaleucum* Sw. apud Fr. **Fruit bodies** usually fused together. **Cap** 1–4cm across, thin, funnel-shaped, centre roughened by pointed projections or pitted, velvety at first then radiately fibrous and wrinkled or grooved,

Hydnellum concrescens ⅓ life size

Hydnellum spongiosipes ½ life size

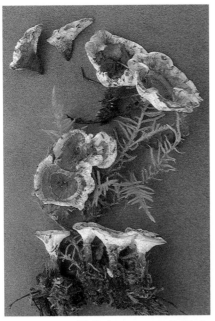

Phellodon tomentosus ²/₃ life size

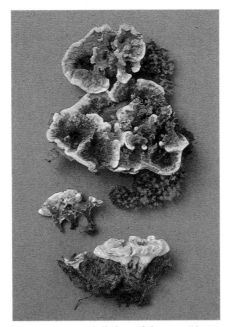

Phellodon melaleucus ½ life size

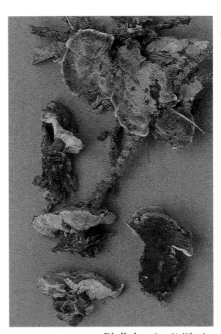

Phellodon niger ½ life size

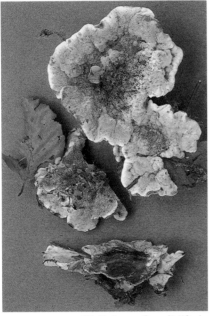

Phellodon confluens ²/₃ life size

Hericium ramosum ¼ life size

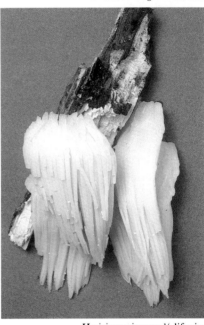

Hericium erinaceus ½ life size

initially white then greyish, often with blue tones, flesh-colour, reddish-brown or purplish-brown, finally almost black. **Stem** 10–20×1–5mm, often flattened, smooth or covered in fine fibres, blackish-brown. **Flesh** slate-grey with purplish tints. Taste slightly bitter, smell strong of fenugreek. **Spines** 1–2mm long, white then grey. Spores white, subglobose, spiny, 3.5–4.5×3–4μ. Habitat usually coniferous woods. Season autumn. Occasional. **Edibility unknown**.

Phellodon niger (Fr. ex Fr.) Karst. syn. *Hydnum nigrum* Fr. **Fruit bodies** mostly fused with one another. **Cap** 3–7cm across, flat or more frequently centrally depressed, velvety or downy at first then pitted or covered in roughened points, ridged and fibrillose towards the lobed margin, whitish then pale grey with lilaceous tints soon becoming purplish-black or black often with olivaceous tints on ageing, usually concentrically zoned. **Stem** 10–50×5–20mm, often swollen towards the base, rooting or arising from a mycelial pad with a central black woody

core and a velvety tomentum which is black at first then grey, grey-brown or olivaceous. **Spines** 1–3mm long, blue-grey at first finally grey. Spores white, subglobose, spiny, 3.5–4.5×2.5–3.5μ. Habitat usually coniferous woods. Season autumn. Rare. **Edibility unknown**.

Phellodon confluens (Pers.) Pouz. **Fruit bodies** usually fusing together. **Cap** 2–6cm across, flat to depressed, thickly downy at first, centre becoming roughened or pitted, initially white becoming cream to dark tan from centre out. **Stem** 10–20×5–15mm, stocky, sometimes very short, often tapering towards the downy base, white discolouring yellow- to grey-brown with age. **Flesh** white to grey-brown in cap, much darker in stem. Smell of fenugreek when dried. **Spines** 1–2mm long, white becoming grey or violet-tinged. Spores white, subglobose, spiny, 3.5–4.5×3–4μ. Habitat under beech, chestnut and especially oak, more rarely in mixed conifer woods. Season autumn. Rare. **Edibility unknown**.

Hericium ramosum (Mérat) Létéllier **Fruit body** up to 30cm across, attached to the substrate by a tough, repeatedly branched trunk giving rise to the delicate end-branches bearing the short spines 3–10mm long; pure white at first discolouring buff to brownish with age. Gloeocystidia present as elongated undulating organs with refractive contents. Spores subglobose, minutely warted, amyloid, 3.5–4×4–5.5μ. Habitat on deciduous logs and stumps, especially beech. Season late summer to autumn. Rare. **Edible**.

Hericium erinaceus Pers. **Fruit body** a solid cushion giving rise to long pendulous crowded spines; whitish at first discolouring yellowish with age, spines up to 6cm long. Gloeocystidia present as elongated undulating organs with refractive contents. Spores subglobose, minutely warted, amyloid, 4–5.5×5–6.5μ. Habitat growing from scars on living deciduous trees, especially beech. Season late summer to autumn. Occasional. **Edible**.

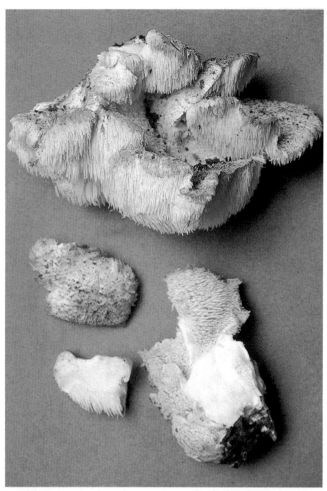

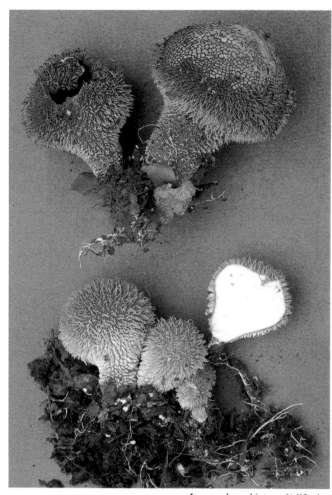

Creolophus cirrhatus ½ life size

Lycoperdon echinatum ¾ life size

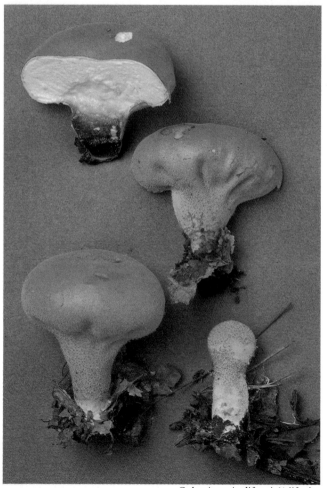

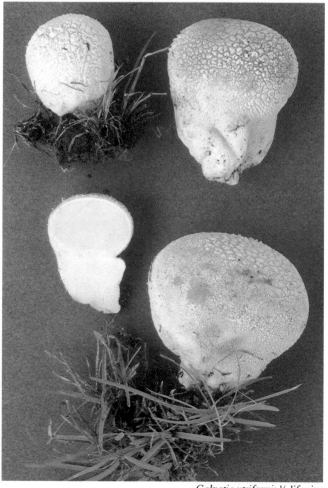

Calvatia excipuliformis ½ life size

Calvatia utriformis ½ life size

Creolophus cirrhatus (Pers. ex Fr.) Karst. syn. *Hydnum cirrhatum* (Pers.) Fr. **Fruit body** 5–10cm across, semicircular or shell-shaped and bracket-like, usually tiered, upper surface whitish to pallid ochraceous, often rough with fibrous scales or sterile spines. **Flesh** thick and soft, cream. Taste and smell pleasant. **Spines** cream, 10–15mm long. Spores white, elliptic, amyloid, 3.5–4×3μ. Habitat on trunks of deciduous trees. Season late summer to autumn. Rare. **Edible**.

Lycoperdon echinatum Pers. ex Pers. **Fruit body** 2–5cm across, subglobose tapering into a short stem, white becoming brown, outer layer forming pointed spines 3–5mm long, convergent at the tips in groups of 3 or 4, leaving a net-like pattern when the spines have become detached, opening by a central pore. **Gleba** purple-brown at maturity; sterile base occupying stem often small. Spores brown, globose, warted, 4–6μ in diameter. Habitat in deciduous woods and on heaths. Season summer to late autumn. Uncommon. **Not edible**.

Calvatia excipuliformis (Pers.) Perdek. syn. *Lycoperdon saccatum* Schaeff. ex Fr. syn. *C. saccata* (Fr.) Morgan syn. *L. excipuliformis* Schaeff. ex Pers. **Fruit body** 8–20cm high, pestle-shaped, head 3–10cm across, pale buff at first then brownish, outer surface of small spines or warts which soon disappear exposing the yellowish, papery inner wall of which the upper portion breaks away to expose the spores. **Gleba** purplish-brown at maturity; sterile base of sponge-like texture, brownish and occupying the entire stem. Spores olive-brown, globose and warted, 3.5–5.5μ in diameter. Habitat on waste ground, heaths, pastures and woodland. Season late summer to autumn but the sterile stalk and empty cup-like base of the head may persist for many months. Common. **Edible** when young. *This photograph shows unusually short-stemmed specimens; the young one (bottom right) is the most typically shaped.*

Calvatia utriformis (Bull. ex Pers.) Jaap syn. *C. caelata* (Bull. ex Pers.) Morgan syn. *Lycoperdon caelatum* Bull. ex Pers. **Fruit body** 6–12cm across, squat and pear-shaped when mature tapering towards the base, white to pale grey-brown finally darker brown, outer wall consisting of scurfy warts and soon breaking up into hexagonal patches leaving the fragile inner wall to flake off irregularly at the top. **Gleba** olivaceous-brown and powdery; sterile base thick, up to one-half of the fruit-body. Spores olive-brown, globose, warted, 4–5μ in diameter. Habitat in pastures or on heaths, usually on sandy soil. Season summer to late autumn but the old cup-shaped sterile bases often persisting from one season to the next. Uncommon – more frequent in the North. **Edible** when young.

Giant Puff-ball *Langermannia gigantea* (Batsch ex Pers.) Rostk. syn. *Lycoperdon giganteum* Batsch ex Pers. syn. *Calvatia gigantea* (Batsch ex Pers.) Lloyd syn. *Lasiosphaera gigantea* (Batsch ex Pers.) Smarda **Fruit body** 7–80cm across, subglobose, whitish and leathery, the outer wall breaking away to expose the spore mass, attached to the substrate by a root-like mycelial cord which breaks leaving the fruit body free to roll

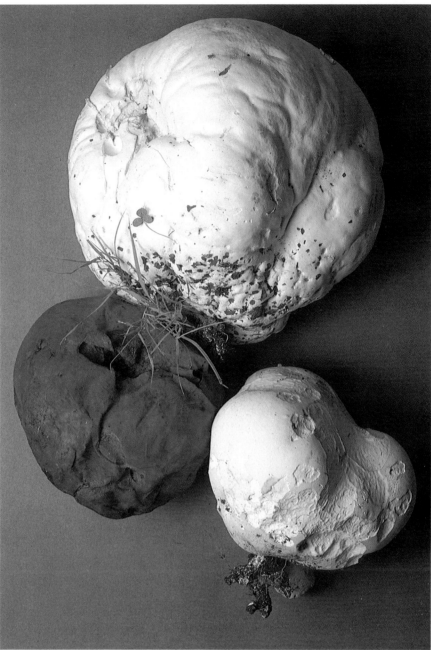

Giant Puff-ball *Langermannia gigantea* ⅓ life size

around and so scatter the millions of spores. **Gleba** olivaceous-brown and powdery at maturity; sterile base absent or rudimentary. Spores tawny brown, globose, finely warted, 3.5–5.5μ in diameter. Habitat in gardens, pasture and woods. Season summer to autumn. Uncommon but locally frequent. **Edible** when still white and firm – good.

Lycoperdon mammiforme Pers. syn. *L. velatum* Vitt. **Fruit body** 4–7cm across, 4–9cm high, subglobose with a broad umbo, tapering into a short stem, white at first then ochre-brown, outer wall breaking into large white or creamy cottony scales and leaving a ring-like zone around the base of the swollen head, inner wall thin and papery, opening by a central pore. **Gleba** finally dark purplish-brown; sterile base spongy, well developed. Spores chocolate brown, globose, warted, 4–5μ in diameter. Habitat in frondose woods on chalk soil. Season summer to autumn. Rare. **Edibility unknown**.

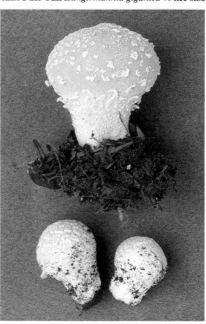

Lycoperdon mammiforme ½ life size

247

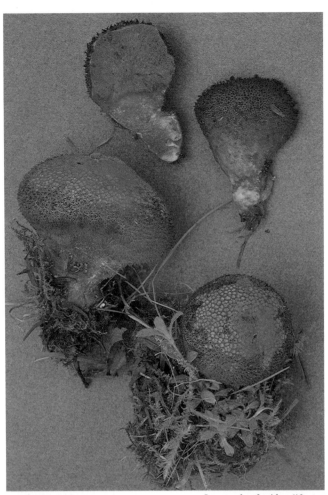

Lycoperdon foetidum life size

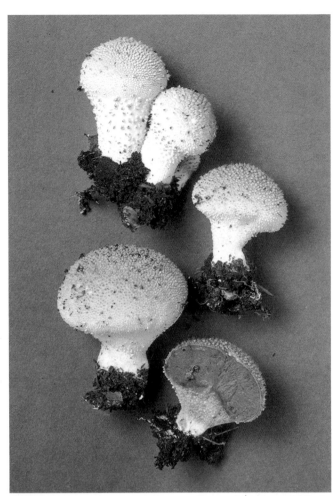

Lycoperdon perlatum ²/₃ life size

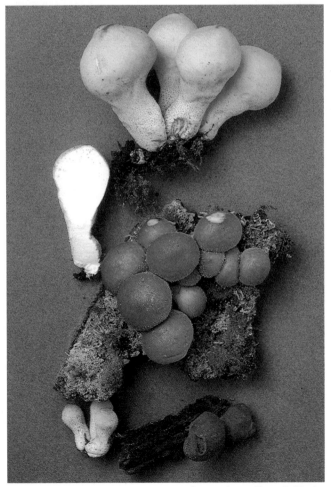

Lycoperdon pyriforme ²/₃ life size

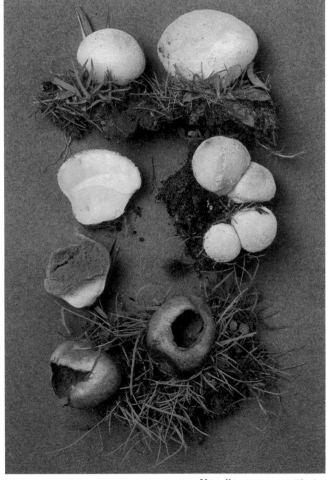

Vascellum pratense ½ life size

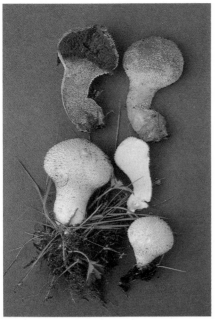

Lycoperdon pedicellatum ½ life size

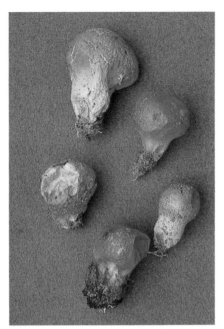

Lycoperdon spadiceum life size

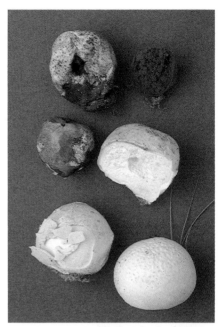

Bovista plumbea ⅔ life size

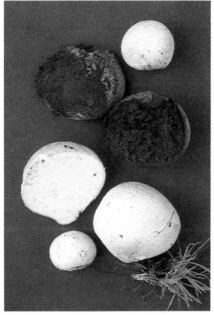

Bovista nigrescens ½ life size

Lycoperdon foetidum Bon. syn. *L. perlatum* var. *nigrescens* Pers. syn. *L. nigrescens* (Pers.) Lloyd **Fruit body** 1–4cm across, 1.5–3cm high, subglobose pinched into a short tapered base, outer layer of groups of fine pointed blackish-brown spines convergent at their tips but gradually wearing off leaving a net-like pattern on the light greyish-tan inner wall which is smooth and papery, opening by a central pore. **Gleba** eventually sepia; sterile base, spongy, well developed, occupying up to one-half of the volume of the fruit body. Spores globose, finely spiny, 4–5μ in diameter. Habitat on heaths or in coniferous or mixed woodland. Season summer to autumn. Frequent. **Edibility unknown**.

Lycoperdon perlatum Pers. syn. *L. gemmatum* Batsch **Fruit body** 2.5–6cm across, 2–9cm high, subglobose with a distinct stem, white at first becoming yellowish brown, outer layer of short pyramidal warts especially dense on the head, rubbing off to leave an indistinct mesh-like pattern on the inner wall which opens by a pore. **Gleba** olive-brown at maturity; sterile base spongy, occupying the stem. Spores olivaceous-brown, globose, minutely warted, 3.5–4.5μ. Habitat woodland. Season summer to late autumn. Common. **Edible** when young.

Lycoperdon pyriforme Schaeff. ex Pers. **Fruit body** 1.5–4cm across, 3.5cm high, subglobose to club-shaped, attached to the substrate by mycelial strands, whitish at first finally yellowish- or greyish-brown, outer layer of scurfy spines, warts, or granules, inner wall becoming smooth and papery, opening by an apical pore. **Gleba** olive-brown; sterile base occupying the stem spongy, but the cavities forming rather small cells. Spores olive-brown, globose, smooth, 3–4μ in diameter. Capillitium distinctive in being formed of brownish branched threads which lack all trace of tiny hyaline pores, all other members of the genus have poroid capillitial threads. Habitat in groups or swarms on rotten logs or stumps, often appearing to grow in soil but in reality attached to buried wood by the characteristic white mycelial cords. Season summer to late autumn. Common. **Edible** when young.

Vascellum pratense (Pers.) Kreisel syn. *V. depressum* (Bon.) Smarda syn. *Lycoperdon*

depressum Bon. syn. *Lycoperdon hiemale* Vitt. **Fruit body** 2–4cm across, subglobose narrowed into a short squat stem, white at first then yellowish flesh-coloured, finally light brown, outer layer scurfy and with some small white spines, inner wall smooth and shining opening by a small pore but eventually the upper part breaking away totally leaving the fruit body bowl-shaped. **Gleba** olive-brown; sterile base well-developed, separated from the spore mass by a distinct membrane. Spores olive-brown, globose, finely warted, 3–5.5μ in diameter. Habitat on lawns, golf-courses or pasture. Season summer to late autumn. Common. **Edible** when young.

Lycoperdon pedicellatum Peck. **Fruit body** 2–5cm across, 3–6cm high, subglobose head on a short stem, outer layer of spines 1–2mm long, single or converging at the tips, gradually wearing off to leave a net-like pattern on the pale brown papery inner wall which opens by a torn pore. **Gleba** finally cinnamon to olive-brown; sterile base well-developed, occupying the entire stem. Spores brown, broadly ovate to subglobose with a long stalk, minutely warted, 3.5–4.5×4–5μ. Habitat in rich soil in woods. Season late summer to autumn. Very rare – only two British collections to date. **Edibility unknown**.

Lycoperdon spadiceum Pers. syn. *L. lividum* Pers. **Fruit body** 1–2.5cm across, subglobose pinched into a short stem, greyish- to ochre-brown, outer layer scurfy, inner wall thin and granular opening by a small irregular pore. **Gleba** finally olive-brown; sterile base spongy, of rather large cells, whitish at first then yellowing, finally brownish, occupying up to one third of the volume of the fruit body. Spores olive-brown, globose, minutely warted, 4μ in diameter. Habitat on heaths, pasture, dunes, and waste ground on sandy soil. Season autumn. Uncommon. **Edibility unknown**.

Bovista plumbea Pers. ex Pers. **Fruit body** 2–3cm across, subglobose without a sterile base but attached to the substrate by a clump of fibres which often break leaving the fruit body free to roll about in the wind, outer wall white at first flaking off in large scales at maturity to expose the lead-coloured fragile inner layer enclosing the spore mass and opening by a circular pore.

Gleba clay to olive-brown. Capillitium of highly branched brown dendroid elements. Spores brown, oval with a long pedicel and finely roughened, 4.5–6×4.5–5.5μ. Habitat amongst short grass on lawns, golf-courses and pasture. Season late summer to late autumn. Occasional. **Edible** when young.

Bovista nigrescens Pers. ex Pers. **Fruit body** 3–6cm across, subglobose, slightly pointed below, without a sterile base but attached to the substrate by a single mycelial cord which often breaks leaving the fruit body free to roll about in the wind, outer wall white at first, flaking off in large scales at maturity to expose the dark purple-brown to blackish inner wall enclosing the spore mass and opening by a large irregular pore or extensive splitting and cracking. **Gleba** dark purple-brown. Capillitium of highly branched brown dendroid elements. Spores brown, subglobose with a long pedicel and finely warted, 4.5–6μ diameter. Habitat in grass and pastureland. Season late summer to autumn but persisting in old dried condition for many months. Uncommon – more frequent in the North and West. **Edible** when young.

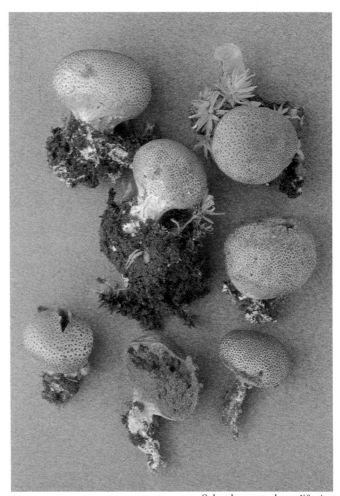

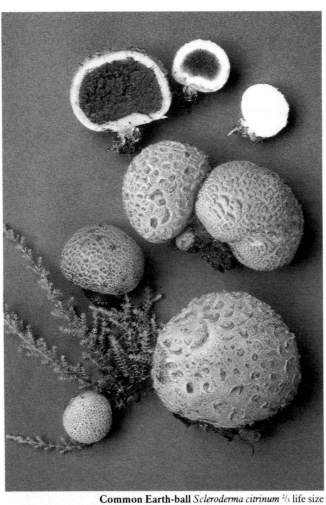

Common Earth-ball *Scleroderma citrinum* ⅔ life size

Scleroderma areolatum life size

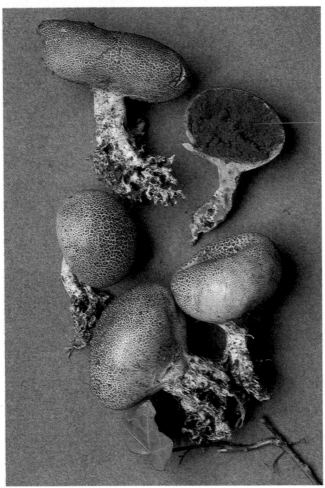

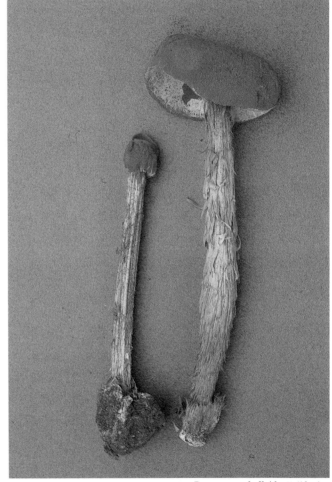

Scleroderma verrucosum ⅔ life size

Battarraea phalloides ½ life size

Common Earth-ball *Scleroderma citrinum* Pers.
syn. *S. aurantium* (Vaill.) Pers. syn. *S. vulgare*
Horn. **Fruit body** 2–10cm across, subglobose,
attached to the substrate by cord-like mycelial
threads, wall dirty yellow to ochre-brown, thick
and tough, coarsely scaly, breaking open
irregularly to liberate the spores. **Gleba**
purplish-black at first patterned by whitish
veins, powdery when mature. Spores brown,
globose, with a net-like ornamentation, 9–13μ in
diameter. Habitat on mossy or peaty ground on
heaths or in rich woodland, especially on sandy
soil. Season late summer to early winter.
Common. **Not edible**.
This species is sometimes parasitized by *Boletus
parasiticus* (p.204).

Scleroderma areolatum Ehr. syn. *S. lycoperdoides*
Schwein. **Fruit body** 1–3(4)cm across,
subglobose, tapering into a thick rooting stalk
which passes into a few strong mycelial strands,
yellowish-brown covered in smooth very dark
scales surrounded by a ring giving a dotted,
reticulate pattern when the scales have been
worn off, opening by an irregular slit or pore.
Gleba deep purplish-brown. Spores dark
brown, globose, 9–14μ in diameter, covered in
spines 1.5μ long. Habitat damp places on bare
ground or amongst sparse grass or moss. Season
autumn. Occasional. **Not edible**.

Scleroderma verrucosum (Bull.) Pers. **Fruit body**
2.5–5cm across, subglobose often flattened on
top, tapering into a long, thick stem-like base
which is usually prominently ribbed, yellowish
to brown covered in small brownish scales, the
thin leathery wall breaking open irregularly
above when mature. **Gleba** olive-brown. Spores
dark brown, globose covered in spines or warts,
10–14μ in diameter. Habitat on sandy soil in
woods or heaths. Season summer to late autumn.
Occasional. **Not edible**.

Battarraea phalloides (Dicks.) Pers. **Fruit body**
10–25cm high, consisting of a spore-sac borne on
a rigid ochre-brown stem covered in shaggy
fibres which is seated in a loose whitish
membranous cup. Initially the fruit body is
contained within the volva buried in sandy soil,
then as the stem elongates rapidly the spore sac is
pushed through the soil surface where it splits all
round exposing the powdery rusty brown spore
mass. Spores brown, subglobose to ovate, 5.0–
5.5(6.5)μ. Habitat on sandy soil. Season
summer. Very rare. **Not edible**.

Pisolithus arhizus (Pers.) Rausch. syn. *P.
arenarius* A. & S. syn. *P. tinctorius* (Mich. ex
Pers.) Coker & Couch **Fruit body** 6–12cm
across, 5–25cm high, narrowing below into a
thick stem-like base submerged in the ground,
ochraceous to olive-brown and resembling balls
of horse dung lying on the ground, with chrome
yellow markings on the submerged part, outer
wall very thin becoming brittle at maturity and
readily breaking apart to expose the dark brown
stony, gravel-like peridioles: pea-shaped
structures which contain the spores. Spores
cinnamon-brown, globose, warted, 7–11.5μ in
diameter. Habitat in sandy or well-drained
gravelly soil in fields or roadsides. Season
autumn. Very rare – only a few British
collections are known to date. **Not edible**.

Tulostoma brumale Pers. ex Pers. **Fruit body**
consisting of a globose head 1–2cm across
attached to a slender fibrous stem 20–50×3–
4mm. Head opening by a circular pore
surmounting a pale ochre to whitish cylindrical
mouth. Spores globose and finely warted, 3.5–
5μ in diameter. Habitat in sandy calcareous soil
or dunes usually amongst moss, formerly found
on old stone walls where mortar was used instead
of cement. Season autumn. Rare. **Not edible**.

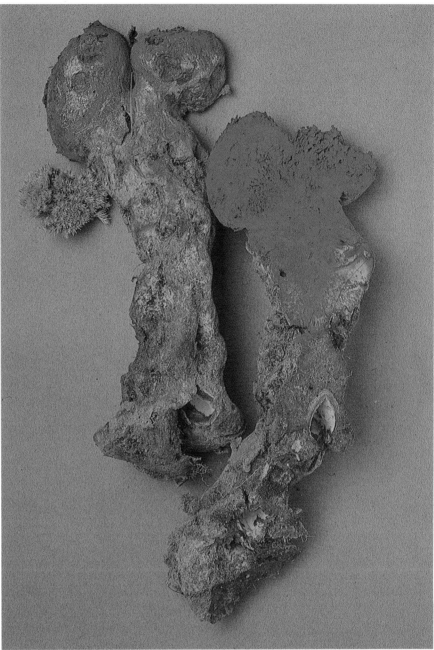

Pisolithus arhizus ½ life size

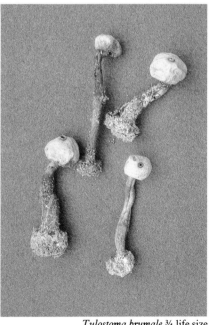

Tulostoma brumale ¾ life size

251

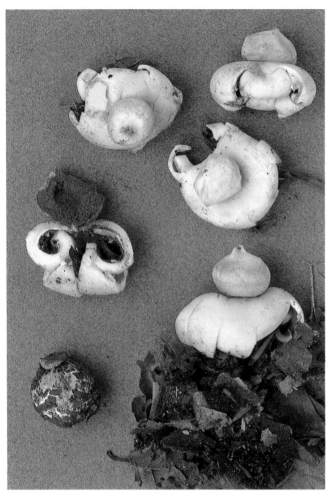

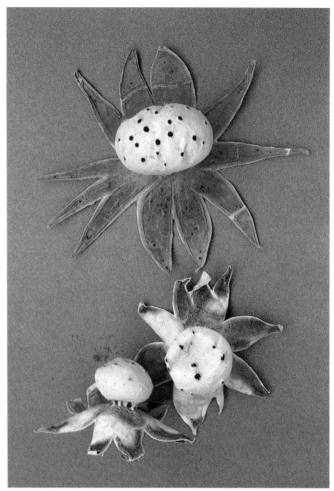

Geastrum sessile life size

Myriostoma coliformis ²/₃ life size

Geastrum sessile (Sow.) Pouz. syn. *G. fimbriatum* Fr. syn. *G. rufescens* Pers. ex Kits **Fruit body** opening to 2–3cm across, globose at first, splitting into 5–8 pointed rays, pale cream with flesh tinge. **Spore sac** 8–15mm across, sessile, pale cream to buff, opening by a central pore surmounting a slightly raised mouth, not delineated from the spore sac. Spores dark brown, globose, minutely warted, 2.9–3.5μ in diameter. Habitat on rich humus under deciduous trees. Season autumn. Uncommon. **Not edible**.

Myriostoma coliformis ([With.] ex Pers.) Corda syn. *Geastrum coliformis* With. ex Pers. **Fruit body** 2–10cm across, globose, outer wall covered in a brown fleshy layer which soon wears off to show pale buff under-layer, splitting into 5–12 pointed rays which curve back slightly raising the spore sac. **Spore sac** 1.5–5cm across, silvery-brown and minutely roughened, opening by several pores to resemble a pepper-pot, supported by several slender columns. Spores brown, globose, irregularly warted, 4–6μ in diameter. Habitat in sandy soil in fields or wood edges. Season late summer to autumn. Apparently extinct in Britain, the large specimen shown is from a collection made near Hillingdon in Norfolk in 1880. **Not edible**.
It is hoped that the publication of an illustration of this interesting fungus will lead to its rediscovery.

Rhizopogon luteolus Fr. **Fruit body** 1.5–5cm across, ovate to globose, whitish at first then dirty ochre-yellow, finally olive brown covered in

tawny mycelial strands, outer wall thick and tough. **Gleba** olivaceous at maturity. Spores olivaceous, oblong-elliptical, 7–10×2.5–3.5μ. Habitat sandy conifer woods. Season autumn. Rare but less so in Scottish pine woods. **Not edible**.

Geastrum rufescens Pers. syn. *G. vulgatum* Vitt. **Fruit body** opening to 5–8cm across, subterranean until splitting into 7–9 pointed rays which curve back and are covered in a pale vinaceous fleshy layer, drying more ochraceous brown. **Spore sac** 1.5–4cm across, on a short indistinct stalk, pallid to brownish, opening by a central, slightly elevated, fringed pore. Spores dark brown, globose, warted, 3–4.5μ in diameter. Habitat in deciduous and coniferous woods. Season summer to late autumn. Occasional. **Not edible**.

Geastrum coronatum Pers. syn. *Geastrum limbatum* Fr. **Fruit body** opening to 5–10cm across, outer wall splitting into 5–8 pointed rays which curve downward and become irregularly cracked. **Spore sac** on a short thick stalk, subglobose, grey-brown, opening by a central pore. Spores dark brown, globose, warted, 3.5–4.5μ in diameter. Habitat on soil in coniferous and deciduous woods. Season autumn. Rare. **Not edible**.

Geastrum triplex Jung. **Fruit body** 3–5cm across when unopened and bulb-shaped, opening to 5–10cm across, outer wall splitting into 4–8

pointed rays and covered in a thick, pinkish-brown, fleshy layer which cracks as the rays bend back under the fruit body leaving the spore sac sitting in a saucer-like base. **Spore sac** sessile, pale grey-brown with a paler ring round the slightly raised mouth. Spores dark brown, globose, warted, 3.5–4.5μ in diameter. Habitat amongst leaf litter in deciduous woods. Season late summer to autumn. Occasional, perhaps the most common member of the genus in Britain. **Not edible**.

Geastrum nanum Pers. **Fruit body** opening to 2–3cm across, splitting into 5–8 pointed rays covered in a fleshy layer which cracks and flakes off. **Spore sac** on a short stalk, pallid to greyish, opening by a central pore surmounting a sharply pointed, brown beak-like mouth. Spores dark brown, globose, warted, 3.5–4μ in diameter. Habitat in rich soil in deciduous woods. Season autumn. Rare. **Not edible**.

Geastrum quadrifidum Pers. ex Pers. **Fruit body** opening to 0.5–3cm across, outer wall splitting into 4–8 pointed rays which bend strongly downwards, the tips adhering to a basal membranous cup in the substrate as in *G. fornicatum*. **Spore sac** on a short stalk 1.5–2.5mm long which forms a ridge-like collar below the lead-grey spore sac, opening by a central pore surmounting a pallid, conical mouth. Spores brown, globose, warted, 3.5–5μ. Habitat in coniferous woods. Season autumn. Rare. **Not edible**.

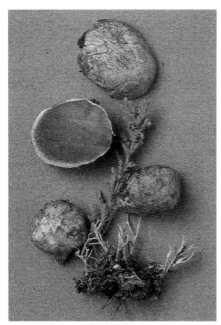

Rhizopogon luteolus ²/₃ life size

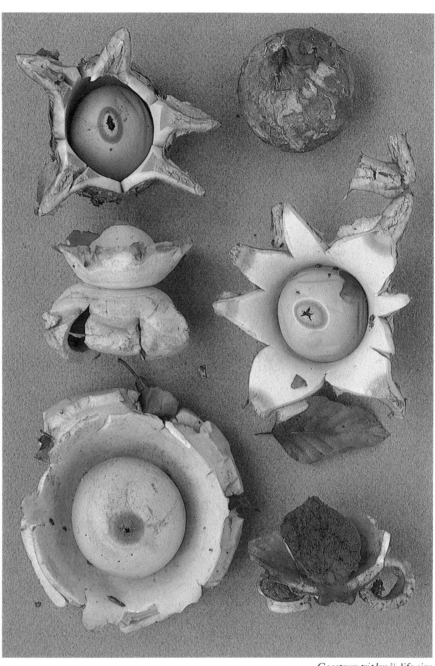

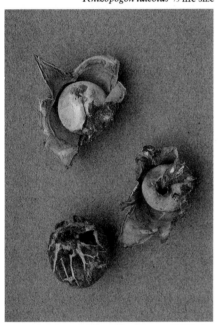

Geastrum rufescens ½ life size

Geastrum triplex ²/₃ life size

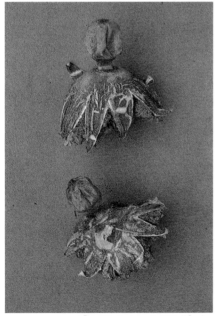

Geastrum coronatum ⅓ life size

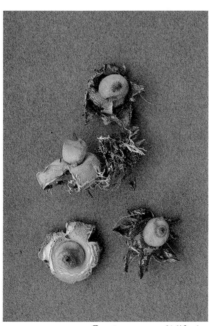

Geastrum nanum ¾ life size

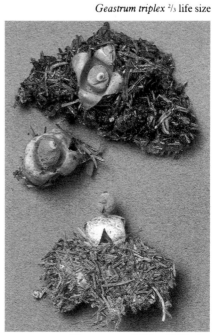

Geastrum quadrifidum ¾ life size

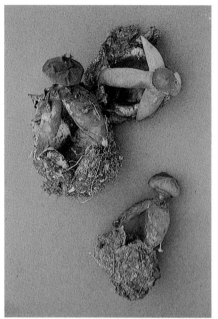

Geastrum fornicatum ½ life size

Geastrum pectinatum ⅓ life size

Astraeus hygrometricus ⅔ life size

Cyathus striatus life size

Cyathus olla ½ life size

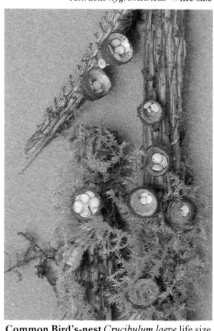

Common Bird's-nest *Crucibulum laeve* life size

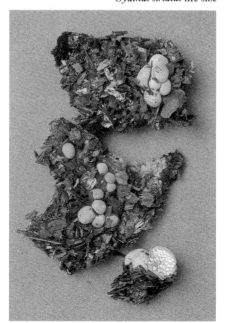

Nidularia farcata ¾ life size

Geastrum fornicatum (Huds.) Fr. **Fruit body** consisting of a brownish central globose spore sac, 1–1.5cm across, with an apical fringed pore, borne on a short stalk and carried clear of the surrounding leaf litter on four tall, narrow, downward-pointing rays standing on the tips of four similar but shorter, broader, upward-pointing rays which form a basal cup-like structure at the base of the fungus. Spores blackish-brown, globose, warted, 3.5–4.5μ in diameter. Habitat deciduous woods. Season autumn. Rare. **Not edible.**

Geastrum pectinatum Pers. **Fruit body** opening to 3–6cm across, outer wall splitting into 6–12 pointed brown rays which become irregularly cracked. **Spore sac** on a slender stalk 5–6mm long, lead-grey, opening by a central pore surmounting a conical, furrowed mouth. Spores dark brown, globose and warted, 4–7μ in

diameter. Habitat on soil in coniferous, more rarely deciduous, woods. Season autumn. Rare. **Not edible.**

Astraeus hygrometricus (Pers.) Morg. syn. *Geastrum hygrometricum* Pers. **Fruit body** 1–5cm across, globose, outer wall ochraceous tan to dark brown, splitting into 6–15 pointed rays on maturity when moist, closing and becoming hard and leather-like when dry. **Spore sac** 1–3cm across, pallid to dark greyish, thin and papery opening by a slit or tear forming an irregular pore. **Gleba** cocoa-brown at maturity. Spores cinnamon-brown, globose and finely warted, 7–10.5μ in diameter. Habitat dunes or sandy soil in woods, developing just below the surface and becoming exposed at maturity. Season autumn but persisting in good condition for up to a year. Rare. **Not edible.**

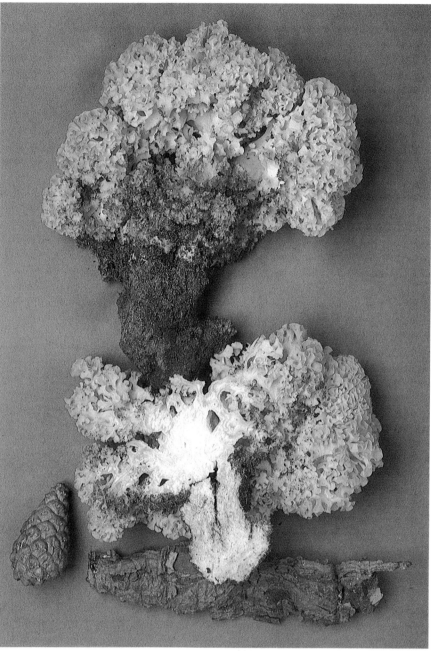

Cyathus olla Batsch. ex Pers. **Fruit body** 8–12mm across, 8–15mm high, trumpet-shaped, outer surface felty, yellowish-grey, inner silver-grey and smooth, containing several silver-grey 'eggs'. Spores ovate, 10–14×6–8μ. Habitat on soil, twigs and other organic debris. Season early spring to early winter. Occasional. **Not edible**.

Cyathus striatus Huds. ex Pers. **Fruit body** 6–8mm across, 7–10mm high, shaped like an obtuse inverted cone, outer surface tawny brown and covered in coarse tufts of shaggy hairs, inner shiny light to dark grey and fluted, containing several grey 'eggs' initially concealed by a whitish membrane across the mouth of the cup which withers at maturity. Spores elliptic, 15–22×3.5–12μ. Habitat on twigs, cones, stumps and other organic debris. Season early spring to early winter. Uncommon. **Not edible**.

Common Bird's-nest *Crucibulum laeve* (Huds. ex Relh.) Kam., Kam. & Lee syn. *C. vulgare* Tul. **Fruit body** first appearing as a dirty cinnamon-yellow, globose body becoming deeply cup-shaped, 4–8mm across and 3–7mm high, sessile, initially covered by an ochraceous membrane which withers and sloughs off at maturity revealing several dirty-white lens-shaped 'eggs' 1–2mm in diameter, each attached to the silvery inner surface of the cup by a minute cord, which contain the spores. Spores elliptic, 7–10×3–5μ. Habitat gregarious on wood, twigs and other vegetable remains. Season early autumn to early spring. Occasional but probably often overlooked. **Not edible**.

Nidularia farcata (Roth. ex Pers.) Fr. syn. *N. pisiformis* Tul. **Fruit body** gregarious, subglobose, sessile, 2–10mm across, golden-brown or flesh-coloured to cinnamon, surface cottony or powdered at first becoming smooth with age and breaking open irregularly exposing numerous reddish-brown lens-shaped 'eggs' 0.5–1mm across. Spores broadly elliptic 6–10×4–7μ. Habitat on partially rotted wood or sawdust. Season autumn. Rare. **Not edible**.

Cauliflower or **Brain Fungus** *Sparassis crispa* Wulf. ex Fr. **Fruit body** 20–50cm across, subglobose, cauliflower-like, comprising numerous flattened, crisped lobes on a short thick rooting stem, pale ochraceous to buff,

Cauliflower Fungus *Sparassis crispa* ½ life size

darkening with age. Smell sweetish, pleasant. Spores whitish to pale yellow, pip-shaped, 5–7×4–5μ. Habitat at the base of conifer trees or near by. Season autumn. Occasional. **Edible** when young and fresh; must be thoroughly cleaned.

Sphaerobolus stellatus Tode syn. *S. carpobolus* (L.) Schroet. syn. *Carpobolus stellatus* (Mich.) Desm. **Fruit body** 1.5–2.5mm across, initially globose and whitish becoming more ochraceous and splitting above into 5–9 minute orange-coloured rays, exposing the peridiole as a brownish ball containing the spores. This is projected over a range of up to 14 feet to disperse the spores by the sudden reversal of the receptacle which then appears as a translucent white sphere sitting on the star-shaped outer wall. Spores oblong, 7.5–10×3.5–5μ. Habitat on sticks, sawdust, dung and other organic debris. Season autumn. Occasional but possibly often overlooked. **Not edible**.

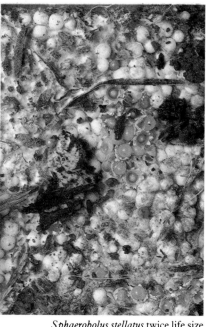

Sphaerobolus stellatus twice life size

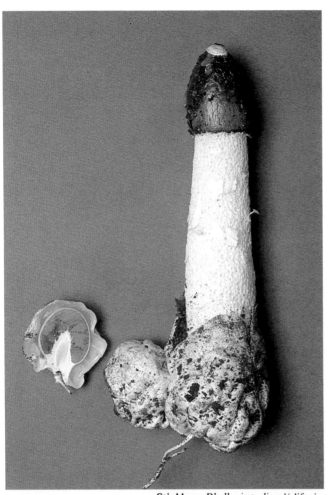

Stinkhorn *Phallus impudicus* ½ life size

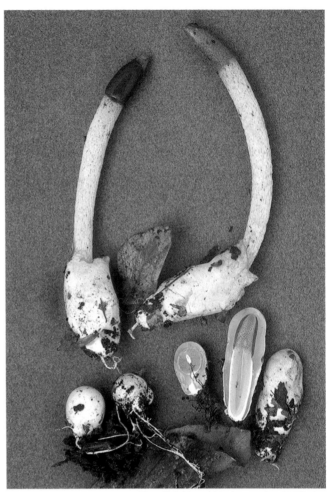

Dog Stinkhorn *Mutinus caninus* ¾ life size

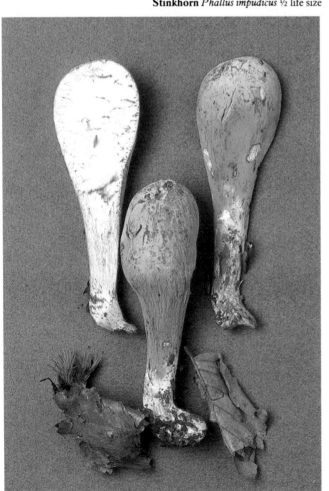

Giant Club *Clavariadelphus pistillaris* ½ life size

Clavariadelphus fistulosus ⅔ life size

Stinkhorn *Phallus impudicus* Pers. syn.
Ithyphallus impudicus (L.) Fr. **Fruit body**
initially semi-submerged and covered by leaf-
litter, egg-like, 3–6cm across, attached to
substrate by a cord-like mycelial strand. The
outer wall of the egg is white to pinkish but there
is a thick gelatinous middle layer held between
the membranous inner and outer layers. The egg
is soon ruptured, as the white, hollow stalk-like
receptacle extends to 10–25cm high, the
pendulous, bell-shaped head is covered by a
meshwork of raised ribs covered in dark olive
slime which contains the spores. This slime has a
strong sickly offensive smell which attracts flies
from large distances, the slime sticks to the legs
of the flies and thus acts as a means of spore
dispersal which takes place very rapidly,
exposing the underlying mesh of the cap. Spores
pale yellow, oblong, $3.5–4 \times 1.5–2\mu$. Habitat
associated with rotting wood which may be
buried in the soil, in gardens and woodland.
Season summer to late autumn. Very common.
The egg stage, which lacks the disgusting smell,
is **edible** though not tasty; it is said to be an
aphrodisiac presumably through association
with its phallic shape.

Dog Stinkhorn *Mutinus caninus* (Pers.) Fr. **Fruit
body** initially a semi-submerged egg as in *Phallus
impudicus* but much smaller, 1–2cm across and
more cylindric in shape, whitish-yellow, finally
rupturing when the hollow pitted receptacle
extends. **Stem** 10–12cm high, pale yellow-buff to
bright orange, surmounted by the narrow conical
orange-red head covered in dark olive slime
which contains the spores and has a very slight
sickly smell. Spores pale yellow, oblong, 4–
$5 \times 1.5–2\mu$. Habitat in leaf litter in woods. Season
summer to late autumn. Occasional. **Not edible.**

Giant Club *Clavariadelphus pistillaris* (Fr.) Donk
syn. *Clavaria pistillaris* Fr. **Fruit body** 7–30cm
high, 2–6cm wide, light yellow and deep
ochraceous bruising brownish vinaceous,
varying in shape from cylindric to conspicuously
club-shaped, simple, solitary or gregarious.
Flesh firm at first, becoming soft and spongy.
Taste bitter, smell sickly mushroomy. Spores
white or faintly yellowish, oblong ellipsoid, 11–
$16 \times 6–10\mu$. Habitat terrestrial, beechwoods on
chalk, especially in the South of England. Season
autumn. Rare. **Edible** – poor.

Clavariadelphus fistulosus (Fr.) Corner syn.
Clavaria fistulosa Fr. **Fruit body** 7–30cm high,
2–8mm broad, yellow then tawny, simple,
solitary or gregarious, acute then obtuse, often
deformed. Spores white, subfusiform, 10–
$18.5 \times 4.5–8\mu$. Habitat on twigs of frondose and
coniferous trees, especially beech. Season
autumn to winter. Rare. **Edible** but not
worthwhile.

Field or **Moor Club** *Clavaria argillacea* Fr. syn.
C. ericetorum Pers. **Fruit body** 3–5cm high, 2–
8mm wide, pale dirty yellow to greenish yellow,
simple, often gregarious. **Stem** distinct and more
deeply coloured. Taste slightly of tallow, smell
none. Spores white, ellipsoid or subcylindric,
$9–12 \times 4.5–6\mu$. Habitat heaths. Season summer
to autumn. Occasional. **Edible.**

White Spindles *Clavaria vermicularis* Fr. **Fruit
body** 6–12cm high, 3–5mm wide, white, simple,
in dense tufts, becoming flattened and grooved;
very brittle. Spores white, ellipsoid $5–7 \times 3–4\mu$.
Habitat in fields and grassy places. Season
autumn. Rare. **Edible** but of no interest.

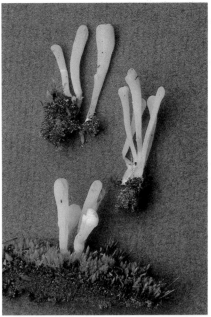

Field or **Moor Club** *Clavaria argillacea* life size

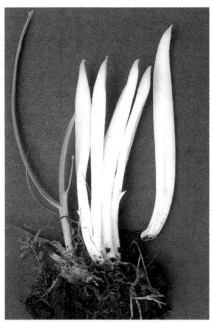

White Spindles *Clavaria vermicularis* ²/₃ life size

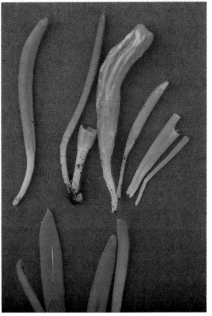

Clavaria rosea life size

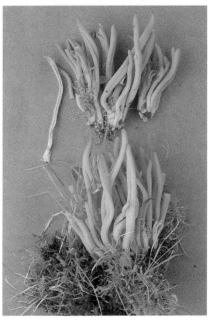

Clavaria fumosa ⅓ life size

Clavaria rosea Fr. **Fruit body** 2–5cm high, 1–
5mm wide, bright rose pink, simple, solitary or
in small groups, brittle. Spores white, ellipsoid,
$5–8 \times 2.5–3.5\mu$. Habitat in woods or amongst
grass. Season autumn. Rare. **Edible.**

Clavaria fumosa Fr. **Fruit body** 1.5–14cm high,
1.5–7mm wide, whitish, pale mouse-grey or
fuliginous, simple fusiform or spindle-shaped in
dense tufts, often twisted; brittle. Spores white,
ellipsoid, $5–8 \times 3–4\mu$. Habitat usually amongst
grass, in open situations. Season autumn. Rare.
Not edible.

Clavariadelphus junceus Fr. syn. *Clavaria juncea*
Fr. **Fruit body** 3–10cm high, 0.5–2mm wide,
pale ochraceous, solitary or gregarious, acute at
first becoming blunt when mature, rather rigid.
Flesh firm, not brittle. Taste acrid, smell sour.
Spores white, almond shaped, $6–12 \times 3.5–5.5\mu$.
Habitat amongst leaf litter in frondose woods, on
rotting twigs, petioles and other debris, rarely on
bare earth. Season autumn up to November.
Occasional but probably often overlooked. **Not
edible.**

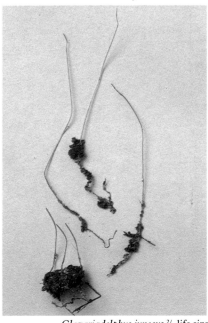

Clavariadelphus junceus ²/₃ life size

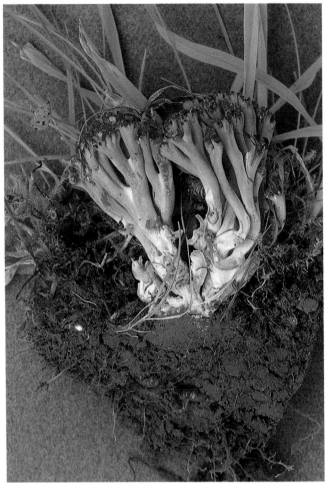

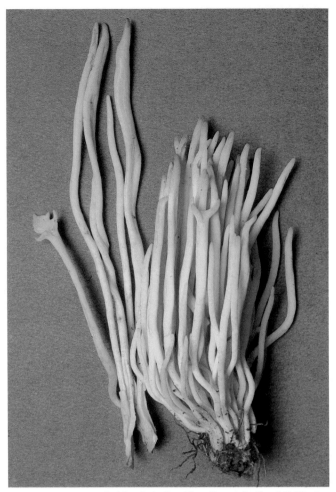

Clavulina amethystina ¾ life size

Golden Spindles *Clavulinopsis fusiformis* ¾ life size

Clavulina amethystina (Fr.) Donk syn. *Clavaria amethystina* Fr. **Fruit body** 2–6cm high, lilac-violet with lighter base, forming densely branched tufts. Spores white, subglobose, 7–11×6–8μ. Habitat terrestrial, in frondose woods. Season autumn. Rare. **Edibility unknown.**

Golden Spindles *Clavulinopsis fusiformis* (Fr.) Corner syn. *Clavaria fusiformis* Fr. **Fruit body** 5–14cm high, simple, yellowish withering brown at the tips, spindle-shaped in dense tufts. Spores white to yellowish, broadly ellipsoid to subglobose, 5–9×4.5–8.5μ. Habitat amongst grass on heaths. Season autumn. Occasional. **Not edible.**

Wrinkled Club *Clavulina rugosa* (Fr.) Schroet. syn. *Clavaria rugosa* Fr. **Fruit body** 4–12cm high, white or cream, solitary, gregarious, simple or with a few antler-like side branches, the surface often wrinkled and uneven. Spores white, broadly ovoid-ellipsoid to subglobose, 9–14×8–12μ. Habitat terrestrial, in woods. Season late summer to late autumn. Common. **Edible.**

Grey Coral Fungus *Clavulina cinerea* (Fr.) Schroet. syn. *Clavaria cinerea* Fr. **Fruit body** 2.5–10cm high, grey or ash-coloured, solitary, or gregarious forming densely branched tufts. Spores white, subglobose or broadly ellipsoid, 6.5–11×6–10μ. Habitat terrestrial, in woods. Season summer to autumn. Common. **Edible.**

White or **Crested Coral Fungus** *Clavulina cristata* (Fr.) Schroet. syn. *Clavaria cristata* Fr. **Fruit body** 2.5–8cm high, solitary or gregarious forming densely branched white tufts the tips of which become fringed or cristate. Spores white, subglobose, 7–11×6.5–10μ. Habitat terrestrial in frondose and coniferous woods. Season summer to late autumn. Common. **Edible.**

Clavulinopsis helvola Fr. syn. *Clavaria helvola* Fr. **Fruit body** 3–7cm high, 1.5–4mm wide, yellow to orange-yellow, solitary or in small groups, simple. Spores white or faintly yellow, subglobose to somewhat angular and bluntly echinulate, 4–7×3.5–6μ. Habitat terrestrial, in woods or in open situations amongst grass and moss. Season late summer to late autumn. Very common. **Not edible.**

Clavulinopsis luteo-alba (Rea) Corner syn. *Clavaria luteo-alba* Rea **Fruit body** up to 6cm high, 1–4mm wide, light to dark yellow or apricot, with whitish or pallid tip, simple. Spores white, ellipsoid, 5–8×2.5–4.5μ. Habitat in short turf or on lawns. Season autumn. Common. **Edibility unknown.**

Clavulinopsis corniculata (Fr.) Corner syn. *Clavaria corniculata* Fr. **Fruit body** 2–8cm high, egg yellow to ochraceous yellow with white down near base, gregarious in tufts, dichotomously branched with incurved crescentric tips. **Flesh** tough and firm. Taste bitter, smell mealy. Spores white, nearly globose, 4.5–7μ diameter. Habitat

terrestrial, in lawns, open pastures and woods. Season early summer to late autumn. Occasional. **Edible.**

Clavulinopsis cinerioides (Atk.) Corner syn. *Clavaria cinerioides* Atk. **Fruit body** up to 7cm high, pale pinkish grey, forming tufts which are strongly branched from the base upwards. **Flesh** tough. Spores white, globose, 4–6μ. Habitat on the ground in woods. Season autumn. Rare but possibly overlooked or confused with other common species. **Edibility unknown.**

Clavicorona taxophila (Thom) Doty syn. *Clavaria taxophila* (Thom) Lloyd **Fruit body** 8–18(30)mm high, 4–9mm wide at the flattened or concave apex tapering towards the stalked base, white, yellowing with age. Spores white, broadly elliptic to subglobose, 3–4×2–3μ. Gloeocystidia present in hymenium as elongated, thin-walled vermiform organs with oily contents. Habitat on damp rooting twigs, leaves and other debris of coniferous and deciduous trees. Season autumn. Rare. **Not edible.**

Typhula erythropus Fr. syn. *Clavaria erythropus* Pers. **Fruit body** 5–30mm high, fertile head white and cylindrical to fusiform, stem reddish-brown and thread-like, arising from an elliptical blackish sclerotium on the substrate. Spores white, oblong, 5–9×2.5–3.5μ. Habitat in deciduous woodland on fallen leaves, petioles or other herbaceous debris. Season autumn. Common. **Not edible.**

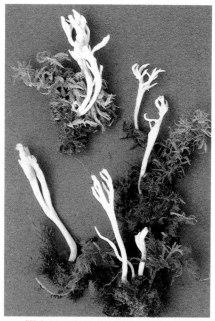

Wrinkled Club *Clavulina rugosa* ½ life size

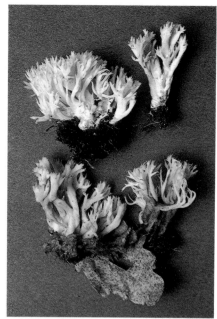

White Coral Fungus *Clavulina cristata* ½ life size

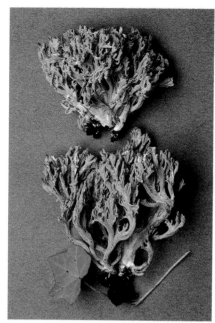

Grey Coral Fungus *Clavulina cinerea* ½ life size

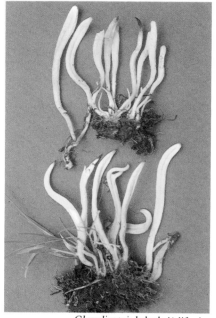

Clavulinopsis helvola ½ life size

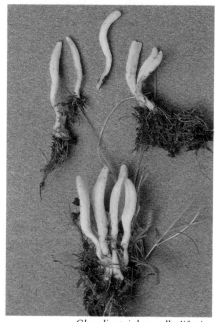

Clavulinopsis luteo-alba life size

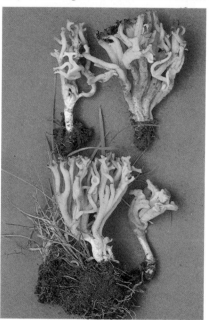

Clavulinopsis corniculata ½ life size

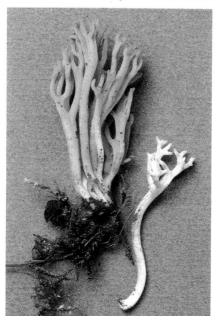

Clavulinopsis cinerioides ⅔ life size

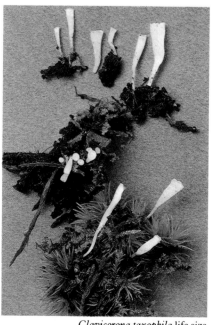

Clavicorona taxophila life size

Typhula erythropus just over life size

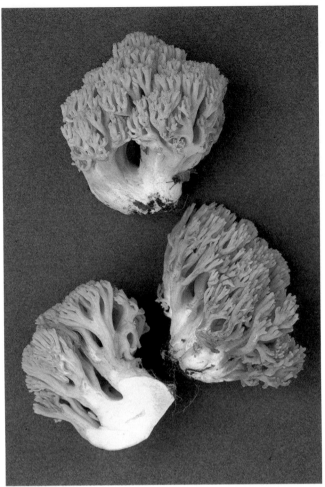

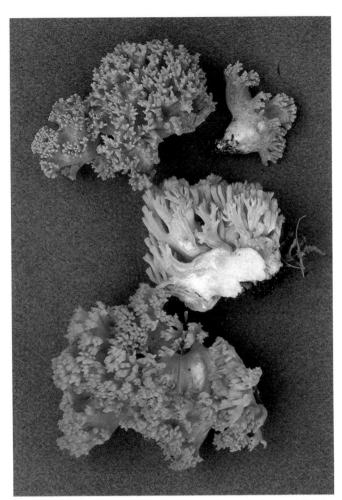

Ramaria flava ⅓ life size

Ramaria formosa ⅓ life size

Ramaria flava (Fr.) Quél. syn. *Clavaria flava* Fr. **Fruit body** 10–20cm high, 7–15cm wide, lemon- to sulphur-yellow becoming more ochraceous with age with numerous densely crowded branches. **Stem** 50–80×40–50mm with whitish base which often bruises reddish-brown especially with age. **Flesh** white to pale yellowish. Taste mild. Spores pale ochraceous, elliptic, roughened, 11–18×4–6.5μ. Habitat on the ground in mixed woods. Season autumn. Rare. **Edible** but has a laxative effect on some people.

Ramaria formosa (Fr.) Quél. syn. *Clavaria formosa* Fr. **Fruit body** 7–30cm high, 6–15cm wide, pinkish-ochraceous to orange-pink, lemon-yellow at tips of the numerous branches. **Stem** 30–60×25–60mm, whitish orange, itself much-branched. **Flesh** white or tinged orange-yellow, often bruising vinaceous to blackish. Taste bitter. Spores ochraceous, oblong, elliptic, roughened, 8–15×4–6μ. Habitat in humus in woods, usually deciduous. Season autumn. Rare. **Poisonous** – causes diarrhoea.

Lentaria delicata Fr. syn. *Clavaria delicata* Fr. **Fruit body** up to 3cm high, whitish becoming flushed pink or ochraceous, branched to several ranks. Spores white, ellipsoid 4.5–6×2.5–3μ. Habitat on rotting wood. Season autumn. **Edibility unknown**.
Lentaria is in the main a tropical genus and has not previously been recorded in Britain. The

only previous collection of this species, *L. delicata*, was made by Fries in Sweden in the early nineteenth century. It now seems well established in at least one site in the South of England, on a pile of weathered sawdust and rotting wood, where it has been collected in successive years.

Ramaria botrytis (Fr.) Ricken **Fruit body** 7–15cm high, 6–20cm wide, white at first becoming tan or ochraceous with pink, red or purplish tips, numerous thick, much-branched, crowded branches arising from stout stem (3–4×1.5–6cm). Taste and smell pleasant, fruity. Spores ochraceous, oblong-elliptic, longitudinally striate, 14–16(20)×4.5–5.5μ. Habitat terrestrial, in broad-leaved woods. Season late summer to late autumn. Rare. **Edible**.

Ramaria aurea (Fr.) Quél. syn. *Clavaria aurea* Fr. **Fruit body** 8–20cm high, 5–12cm wide, egg-yellow or ochraceous, densely branched with paler cauliflower-like tips, white at the plant base. Spores deep ochraceous, oblong, minutely roughened 8–15×3–6μ. Habitat on the ground in mixed woods. Season autumn. Rare. **Edible**.

Ramaria stricta (Fr.) Quél. **Fruit body** 4–10cm high, 3–8cm wide, ochraceous tinged with flesh-colour becoming darker or brownish cinnamon with age, tips of branches at first clear yellow then concolorous; all parts bruising vinaceous,

stem arising from white mycellum or rhizomorphs, passing into numerous dichotomous branches. **Flesh** white or pale yellow, tough. Taste slightly peppery, smell sweet. Spores cinnamon-ochraceous, oblong, minutely rough to almost smooth 7–10×4–5μ. Habitat on stumps of conifers and broad-leaved trees. Season late summer to winter. Uncommon. **Not edible**.

Thelephora palmata (Scop.) Fr. **Fruit body** 2–6cm high, 1–3cm across, comprising several erect, flattened, palmate purple-brown branches arising from a common stem 10–15×2–5mm. **Flesh** leathery. Smell fetid or strongly of garlic. Spores reddish-brown, angular and spiny, 8–11×7–8μ. Habitat on the ground near conifers. Season late summer to late autumn. Rare. Easily recognized by the strong smell. **Not edible**.

Earth Fan *Thelephora terrestris* (Ehrh.) Fr. **Fruit body** 3–6cm across, fan-shaped, vertical to horizontal, forming large clustered groups, reddish- to chocolate-brown, darkening to almost black with age, covered in radiating fibres, becoming paler and fringed at the margin. Lower or fertile surface clay-brown to pallid, irregularly wrinkled. Spores purple-brown, angular and warted, 8–9×6–7.5μ. Habitat in conifer woods or heaths, usually on sandy soil. Season late summer to early winter. Common. **Not edible**.

Lentaria delicata ²/₃ life size

Ramaria aurea ½ life size

Ramaria botrytis ²/₃ life size

Ramaria stricta ²/₃ life size

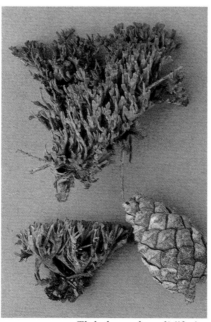

Thelephora palmata ²/₃ life size

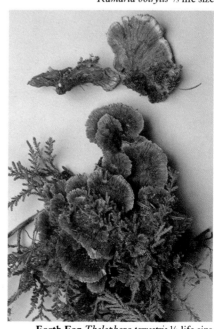

Earth Fan *Thelephora terrestris* ½ life size

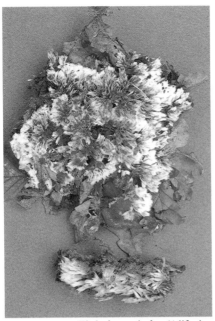

Thelephora spiculosa ½ life size

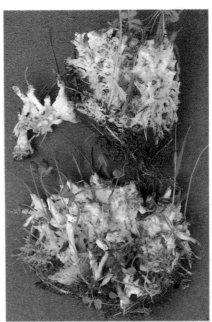

Sebacina incrustans ½ life size

Thelephora spiculosa (Fr.) Burt. syn. *Phylacteria spiculosa* (Fr.) Bourd. & Maire. **Fruit body** 2–15cm across, comprising numerous fine, cottony, spiky branches, purplish-brown becoming white at the tips. **Flesh** very thin, cottony. Spores umber, elliptic to subglobose with tiny spines, 7–12×6–7μ. Habitat encrusting dead twigs or leaf litter. Season autumn. Occasional. **Not edible**.

Sebacina incrustans (Bull.) Bres. syn. *Thelephora sebacea* (Pers.) Fr. **Fruit body** resupinate, incrusting the base of living plants, forming patches 3–10cm across, white, dusted with the white spores. Spores white, oblong to ovoid, 15–20×12–15μ. Basidia resembling hot-cross buns when viewed from above. Habitat incrusting grass, twigs and other organic debris. Season early spring to late autumn. Uncommon. **Not edible**.

Jew's Ear *Auricularia auricula-judae* St. Amans syn. *Hirneola auricula-judae* (St. Amans) Berk. syn. *Auricularia auricula* (Hook.) Underwood **Fruit body** 3–8cm across, ear-shaped, gelatinous when fresh drying hard and horny, outer surface tan-brown with minute greyish downy hairs, inner surface grey-brown, smooth, or often wrinkled and ear-like. Spores white, sausage-shaped, 16–18×6–8μ. Basidia elongated cylindric with three transverse septa. Habitat on branches of frondose trees, usually elder. Season all year, especially autumn. Very common. **Edible**.

Tripe Fungus *Auricularia mesenterica* (Dicks.) Pers. **Fruit body** disc-shaped at first then spreading laterally to form densely tiered gelatinous brackets 2–4cm wide; upper surface of bracket hairy, zoned greyish to grey-brown, paler at the lobed margin, lower surface reddish purple to dark purple with a white bloom, gelatinous and rubbery, coarsely and irregularly wrinkled. Spores white, subcylindrical to somewhat curved, 11–13×4–5μ. Habitat on stumps and logs of deciduous trees especially elm. Season all year. Common. **Not edible**.

Witches' Butter *Exidia glandulosa* Fr. **Fruit body** 2–6cm across, gelatinous, pendulous, disc-shaped at first and bearing tiny scattered warts, often becoming fused with adjacent fruit bodies, upper surface felty. Spores white, sausage-shaped, 10–6×4–5μ. Basidia resembling hot cross buns when viewed from above. Habitat on dead wood of deciduous trees; sometimes on dead parts of living trees. Season all year. Frequent. **Not edible**.

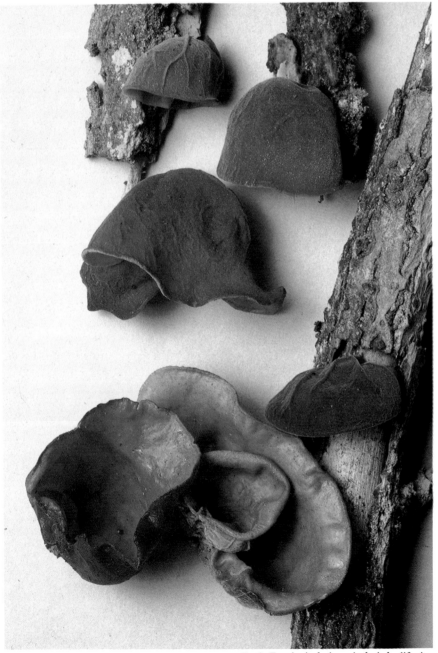

Jew's Ear *Auricularia auricula-judae* life size

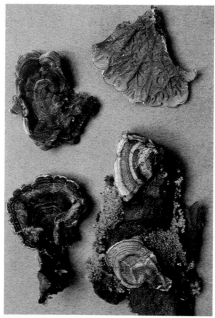

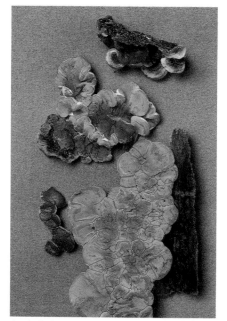

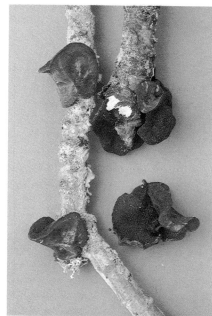

Tripe Fungus *Auricularia mesenterica* ½ life size

Auricularia mesenterica (young specimen) ½ size

Witches' Butter *Exidia glandulosa* ½ life size

Calocera glossoides life size

Dacrymyces stillatus ½ life size

Calocera cornea ½ life size

Calocera glossoides (Pers. ex Fr.) Fr. syn.
Dacryomitra glossoides (Pers.) Bref. **Fruit body**
3–10mm high, yellow, conical to club-shaped
and often compressed or longitudinally wrinkled
with a short distinct stem which becomes dark
blackish-brown on drying. **Flesh** firm
gelatinous, yellow. Spores white, narrowly
elliptical to subcylindric or sausage-shaped, 12–
14(17)×3–5μ, becoming three-septate at
maturity. Basidia shaped like tuning-forks.
Habitat on dead branches or stumps of oak.
Season early autumn to early winter.
Uncommon. **Not edible**.

Dacrymyces stillatus Nees ex Fr. syn. *Dacrymyces
deliquescens* (Mérat) Duby **Fruit body** 1–5mm
across, gelatinous, more or less cushion-shaped
often merging into one another, orange-yellow
becoming darker reddish and wrinkled with age.
Spores orange-yellow, sausage-shaped, 12–
15×5–6μ, becoming three-septate. Basidia
resembling tuning-forks. Habitat on damp,

decaying wood. Season all year. Common. **Not
edible**.

Calocera cornea (Batsch ex Fr.) Fr. **Fruit body**
4–10mm high, awl-shaped, rarely forked, tough-
gelatinous, yellow when fresh drying more
orange. Spores white, sausage-shaped, 7–10×3–
4μ. Basidia shaped like tuning-forks. Habitat
crowded on twigs and branches of deciduous
trees. Season all year. Frequent. **Not edible**.

Calocera viscosa (Pers. ex Fr.) Fr. **Fruit body**
3–10cm high, repeatedly dichotomously
branched, tough, gelatinous, deep golden to
orange-yellow, drying more orange. Spores
elliptic to slightly sausage-shaped, 9–12×3.5–
4.5μ, becoming one-septate at maturity. Basidia
resembling tuning-forks. Habitat on conifer
stumps and roots; very firmly attached. Season
autumn. Common. **Not edible**.

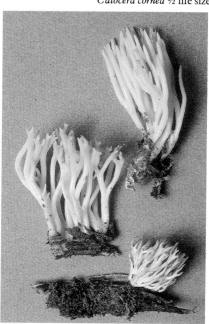

Calocera viscosa ½ life size

Yellow Brain Fungus *Tremella mesenterica* ½ size **Jelly Tongue** *Pseudohydnum gelatinosum* ⅓ size *Leptoglossum retirugum* life size

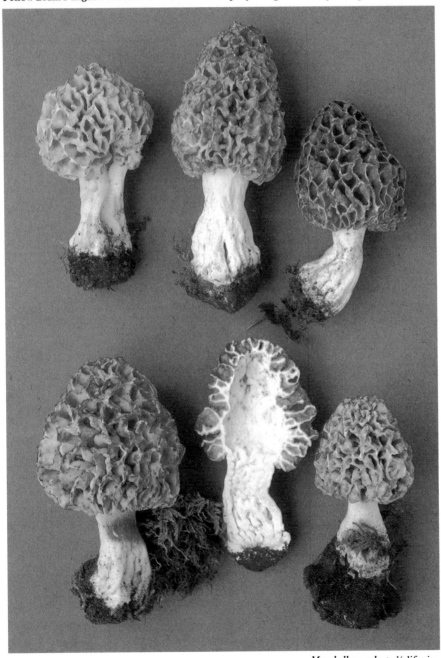

Morchella esculenta ½ life size

Yellow Brain Fungus *Tremella mesenterica* Retz. ex Hook **Fruit body** 2–10cm across, comprising soft, flabby, gelatinous lobes and folds, golden-yellow to orange, drying dark orange, horny, and brittle. Spores white, broadly ovate to subglobose, 7–10×6–10μ. Basidia resembling hot cross buns when seen from above. Habitat on dead deciduous branches, sometimes still attached to the tree. Season all year, especially late autumn. Frequent. **Not edible.**

Jelly Tongue *Pseudohydnum gelatinosum* (Scop. ex Fr.) Karst. syn. *Tremellodon gelatinosum* (Scop. ex Fr.) Fr. **Fruit body** 2–6cm across, spatula-like or fan-shaped, gelatinous, bluish-grey becoming brownish, upper surface finely roughened or downy; lower surface covered in whitish spines 2–5mm long. Spores white, broadly ovate to subglobose, 5–7×5μ. Basidia resembling a hot cross bun when seen from above. Habitat on conifer stumps. Season autumn. Uncommon. **Not edible.**

Leptoglossum retirugum syn. *Dictyolus retirugus* (Bull.) Quél. **Cap** 0.5–1.5cm across, cup-shaped then expanded with a lobed margin, whitish-pallid, sessile. Inner fertile surface whitish grey with folds or wrinkles radiating from the centre, often interconnected. **Spore print** white. Spores elliptic, 7–8×5–6μ. Hyphae lacking clamp-connections. Habitat usually on moss, very occasionally on dead grass or twigs. Season winter to spring. Uncommon. **Not edible.**

ASCOMYCETES *the spore shooters.*

Morchella esculenta Pers. ex St. Amans **Fruit body** 6–20cm high, very variable, fertile head round to ovoid or obtusely conical, pale yellowish-brown darkening and browning with age, ridges acute and forming an irregular honeycomb around the angular pits; stalk minutely scurfy, slightly swollen at the base and longitudinally furrowed, whitish to ochraceous cream. Asci 330×20µ. Spores cream, broadly elliptical, 16–19×8.5–11µ. Habitat in open scrub or woodland or on waste ground. Season late spring. Uncommon. **Edible** – excellent. Several forms are recognized in Europe; var. *rotunda* has a roundish ochre-yellow fertile head, while that of var. *crassipes* is grey-brown and the stalk granular and much swollen at the base; var *umbrina* is smaller than the type with a dark greyish-black fertile head.

Disciotis venosa (Pers.) Boud. **Cup** 3–15cm across, saucer-shaped with a short thick stalk, which is often buried in the soil, the inner surface dark brown and corrugate especially at the centre, the outer surface whitish and slightly scurfy. Asci 320×20µ. Spores broadly elliptical, 19–25×12–15µ. Habitat in lawns or on soil in woodland. Season spring. Occasional. **Poisonous** unless well cooked.

Common Morel *Morchella vulgaris* (Pers.) Boud. **Fruit body** 5–12cm high, fertile head ovoid, ridges obtuse and irregular, grey-brown becoming paler or ochraceous with age, pits irregular, dark grey-brown, later more ochraceous cream. Asci 330–20µ. Spores 16–18×9–11µ. Habitat in gardens and wasteland. Season late spring. Uncommon. **Edible**.

Verpa conica Swartz ex Pers. **Fruit body** 4–9cm · high, fertile pendulous head ovoid then bell-shaped, attached to the stalk at the centre, dark olive-brown; stalk cylindrical, whitish covered in brownish granules arranged in irregular horizontal bands. Asci 350×23µ. Spores elliptic, 20–24×12–14µ. Habitat under hawthorn scrub on chalk soil. Season late spring. Uncommon. **Edible**.

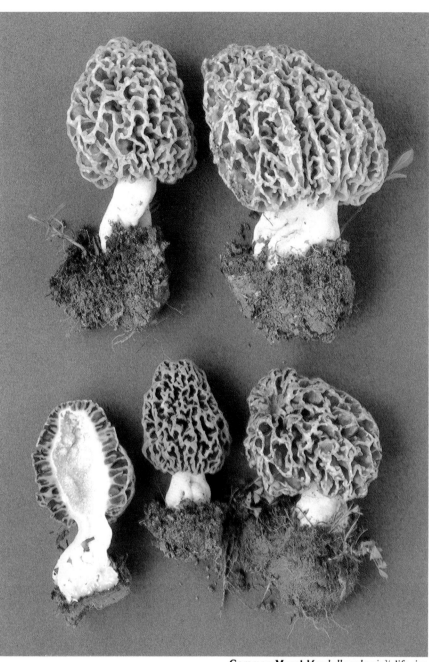

Common Morel *Morchella vulgaris* ²/₃ life size

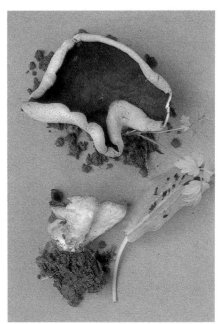

Disciotis venosa ½ life size

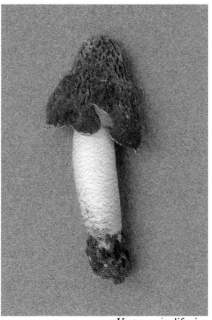

Verpa conica life size

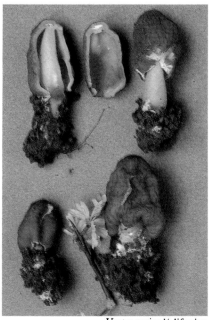

Verpa conica ½ life size

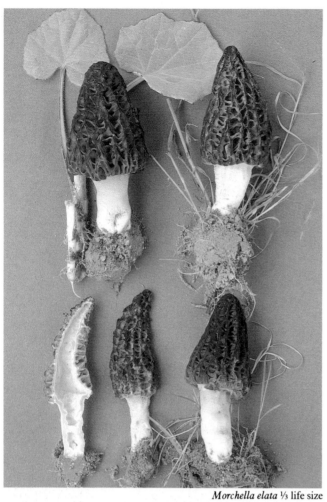

Morchella elata ⅓ life size

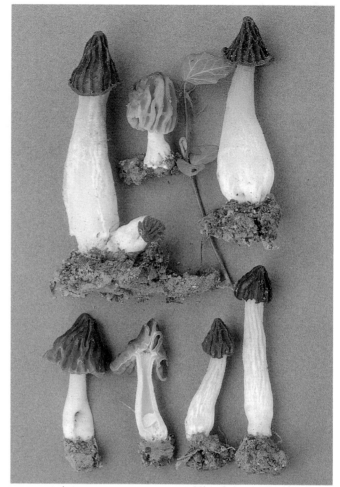

Mitrophora semilibera ½ life size

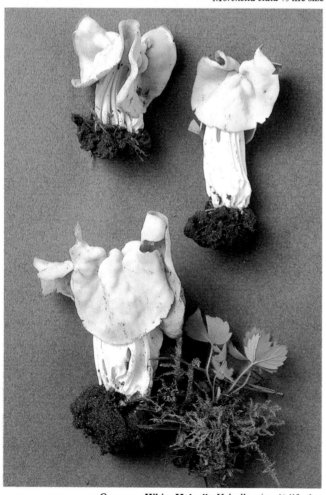

Common White Helvella *Helvella crispa* ½ life size

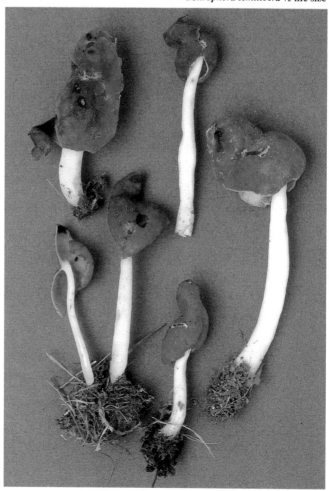

Leptopodia elastica life size

Morchella elata Fr. **Fruit body** 5–10(15)cm high, fertile head narrow and conical, ridges in more or less parallel vertical lines and blackening with age, pits rectangular, olive-brown; stalk cylindrical, coarsely granular, whitish to pale brown with age. Asci 300×20μ. Spores cream, elliptic, 18–25×11–15μ. Habitat conifer woods or on chalk soil. Season late spring. Rare. **Edible**. The variety var. *purpurescens*, differing from *M. elata* only in the pale violaceous colour of the fertile head, has been reported from Scotland.

Mitrophora semilibera (DC. ex Fr.) Leveille **Cap** 2–4cm high, conical with more or less vertical membranous ridges, dark olive-brown, lower part free of the stem as shown, as opposed to *Morchella* where the cap is attached to the stem. **Stem** 40–80×15–25mm, cylindrical, hollow, whitish cream and scurfy. Asci 450×25μ. Spores cream, 22–30×14–18μ. Habitat in damp woodland. Season spring. Occasional. **Edible** – not worthwhile.

Common White Helvella *Helvella crispa* Fr. **Cap** 2–5cm high, saddle-shaped and deeply lobed, convoluted at the centre, whitish with pale buff or tan underside. **Stem** 20–60×10–25mm white, hollow and deeply furrowed. Asci 300×18μ. Spores elliptical, 18–20×10–13μ. Habitat on pathsides in damp, deciduous woods. Season late summer to late autumn and occasionally in spring. Common. **Edible** – poor.

Leptopodia elastica Bull. ex St. Amans Boud. syn. *Helvella elastica* Bull. ex St. Amans **Cap** 1–3cm high, saddle-shaped and irregularly lobed, grey-brown to yellowish-brown, underside smooth, whitish drying ochraceous. **Stem** 40–70×3–7mm, whitish, often compressed. Asci 330×20μ. Spores 19–22×11–13μ. Habitat open ground in woodland. Season summer to autumn. Occasional. **Edible** – poor.

False Morel *Gyromitra esculenta* (Pers.) Fr. **Cap** 3–9cm across, irregularly lobed and extremely convoluted, brain-like, reddish-brown or darker. **Stem** 20–40×20–40mm, pale flesh-coloured, faintly grooved, becoming hollow in chambers. Asci 325×18μ. Spores elliptical, containing two or more yellowish oil droplets, 18–22×9–12μ. Habitat with conifers especially pines, usually on sandy soil. Season spring. Occasional. **Deadly poisonous** when eaten raw and harmful to many even when properly cooked. It is eaten in Eastern Europe after boiling and throwing away the water and then cooking, but nevertheless there are cases of poisoning recorded; evidence suggests the effect is cumulative, since poisoning may occur of people who have previously suffered no ill-effects. **Avoid**.

Black Helvella *Helvella lacunosa* Afzelius ex Fr. **Cap** 1.5–4cm high, saddle-shaped with convolute lobes, one lobe often pointing upwards and recurved, grey to blackish with paler underside. **Stem** 20–40×10–20mm, pale grey, hollow and deeply furrowed. Asci 350×18μ. Spores 17–20×10–13μ. Habitat in mixed woodland especially on burnt ground. Season summer to autumn. Frequent. **Edible** – poor.

Leptopodia atra (König ex Fr.) Boud. **Cup** 1.5–3cm high, folded back on itself into a twisted flattened dark-brown to blackish disc shape, with paler light grey underside. **Stem** 30–65×3–7mm, pallid clay colour, concolorous with cap or darker, slightly twisted, tough and full of white pith. Asci 250×15μ. Spores broadly elliptical, 17–18×11–12μ. Habitat mixed woodland. Season summer to autumn. Occasional. **Edibility unknown**.

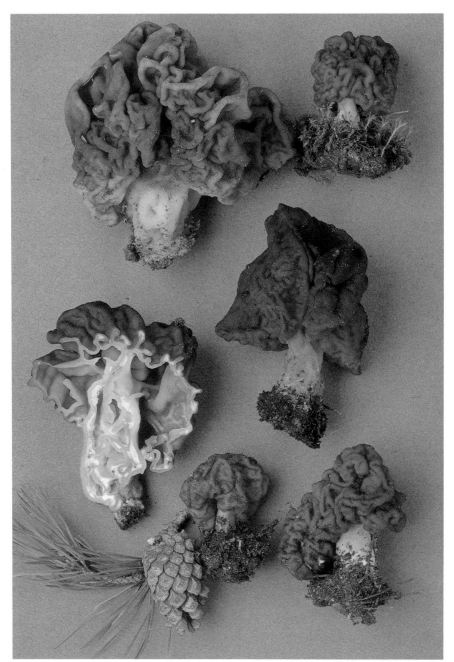

False Morel *Gyromitra esculenta* ¾ life size

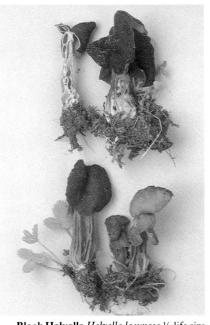

Black Helvella *Helvella lacunosa* ⅓ life size

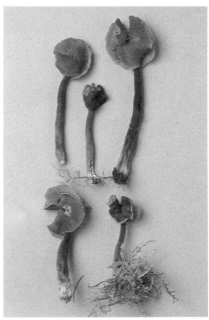

Leptopodia atra ½ life size

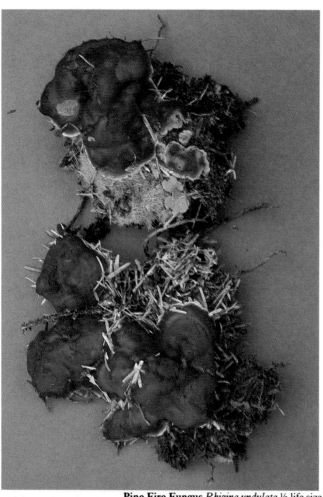

Pine Fire Fungus *Rhizina undulata* ½ life size

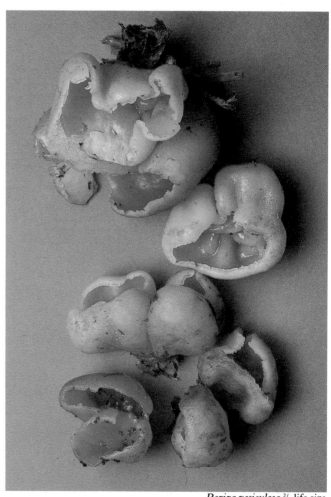

Peziza vesiculosa ²/₃ life size

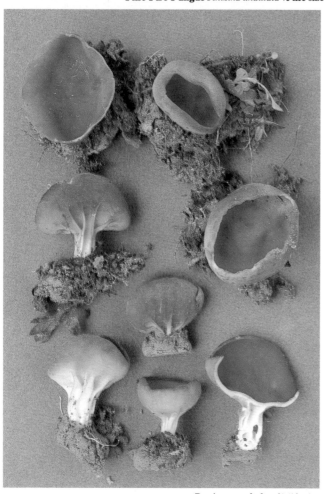

Paxina acetabulum ²/₃ life size

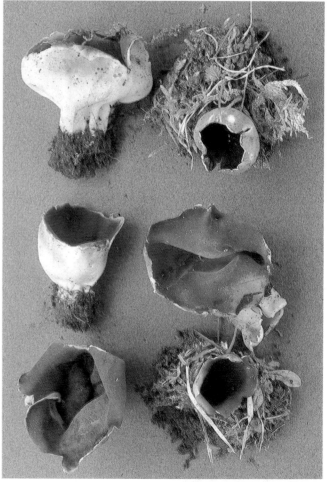

Paxina leucomelas life size

Pine Fire Fungus *Rhizina undulata* Fr. syn. *R. inflata* (Schaeff.) Karst **Fruit body** 4–12cm across, 2–8cm high, chestnut brown to black with a paler margin, forming irregularly lobed, wavy cushions. **Flesh** tough, thick, reddish-brown. Attached to the substrate by numerous whitish rhizoids growing down from the underside. Asci 400×20μ. Spores fusiform, containing two or more oil drops, 22–40×8–11μ. Habitat on conifer debris especially on fire sites. Season early summer to autumn. Occasional. **Not edible**.
Causes a serious disease of conifers known as group dying.

Peziza vesiculosa Bull. ex St.Amans **Cup** 3–8cm across, cup-shaped often with a strongly inrolled margin, often in clusters, sessile, inner surface pale yellowish-buff and often wrinkled, outer light buff, very scurfy. **Flesh** brittle, light buff. Asci 380×25μ, blued at the tip by iodine. Spores elliptical, smooth, 20–24×11–14μ. Habitat on manure, rotting straw bales and rich soil. Season all year. Common. **Poisonous** unless well cooked.

Paxina acetabulum (L. ex St. Amans) O. Kuntze syn. *Helvella acetabula* (L. ex St. Amans) Quél. **Cup** 4–6cm across, deeply cup-shaped, inner surface dark chestnut brown, outer paler and finely downy. **Stem** 10–40×20–30mm, whitish, deeply furrowed and strongly ribbed along the underside of the cup, more or less hollow. Asci 400×20μ. Spores broadly elliptical, 18–22×12–14μ. Habitat amongst leaf litter in woods usually on calcareous soil. Season spring to summer. Occasional. **Poisonous** unless well cooked.

Paxina leucomelas (Pers.) Kuntze syn. *Acetabula vulgaris* Fuckel **Cup** 2–4cm across, deeply cup-shaped but splitting at the margin, inner surface dark greyish brown, outer pale grey to buff and finely downy, not ribbed. **Stem** 5–15×10–15mm, whitish, ribbed, with ribs extending to base of cup. Asci 400×20μ. Spores broadly elliptic, 18–22×12–14μ. Habitat woodlands and heaths. Season spring to early autumn. Uncommon. **Poisonous** unless well cooked.

Peziza repanda Pers. **Cup** 3–12cm across, cup-shaped at first, expanding and becoming wavy and the margin toothed, sessile, inner surface pale ochraceous brown to chestnut, outer ochraceous cream and slightly scurfy. Asci 300–13μ, blued at the tip by iodine. Spores elliptical, smooth, 15–16×9–10μ. Habitat in leaves around stumps, large forms on sawdust. Season spring to autumn. Occasional. **Not edible**.

Peziza petersii Berk. & Curtis syn. *Galactinia sarrazinii* Boud. **Cup** 3–5cm across, cup-shaped and often clustered, sessile, inner surface reddish-brown with dark grey centre, outer reddish brown at the margin, dark grey towards the base, scurfy. **Flesh** thin, greyish. Asci 200×10μ, blued at the tip by iodine. Spores containing two oil drops, finely warted, 10–12×5.5–6μ. Habitat on burnt wood and soil often on bonfire sites. Season early summer to autumn. Uncommon. **Not edible**.

Peziza cerea Sow. ex Mérat syn. *P. tectoria* Cooke **Cup** 1–5cm across, cup-shaped, sessile, inner surface pale yellowish-buff, outer similarly coloured, scurfy, darkening towards the base. **Flesh** firm, whitish. Smell slight. Asci 350×16μ, blued at the tip by iodine. Spores elliptical, smooth, 14–17×8–10μ. Habitat on rotting sandbags, damp mortar and the soil between damp paving stones, often found in cellars. Season all year. Common. **Not edible**.

Cyathipodia corium (Wels.) Boud. **Fruit body** stalked, cup-like then expanded. **Cap** black and smooth, with outer surface appearing lighter due to downy hairs. **Stem** 8–15mm long, black, covered in a down of dark grey brown, thin-walled septate hairs. Asci 300×18μ. Spores broadly elliptic, smooth, containing one large oil drop, 20–22×12–14μ. Habitat on sandy soil often on dunes. Season summer to autumn. Uncommon but locally abundant. **Not edible**.

Macroscyphus macropus Pers. ex S. F. Gray syn. *Macropodia macropus* (Pers. ex S. F. Gray) Fuckel syn. *Cyathipodia macropus* (Pers. ex S. F. Gray) Dennis. **Cup** 1–4cm across, expanding and turning back on itself, inner surface grey-brown, outer appearing pale grey due to the dense covering of tufted, downy hairs. **Stem** 15–40×3–5mm, tapering upwards, often flattened or compressed, covered in tufts of grey downy hairs. **Flesh** thin, white. Asci 350–20μ. Spores fusiform, containing a large central oil drop with a smaller one at each end, 20–30×10–12μ. Habitat deciduous and coniferous woods. Season summer to autumn. Occasional. **Not edible**.

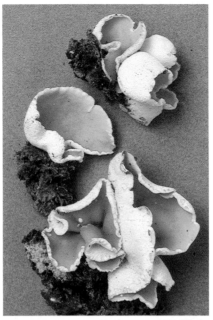

Peziza repanda ½ life size

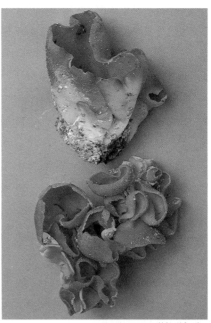

Peziza petersii ⅔ life size

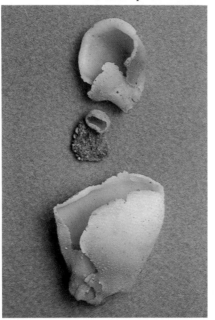

Peziza cerea ¾ life size

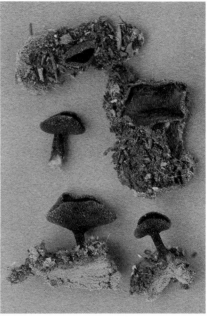

Cyathipodia corium ¾ life size

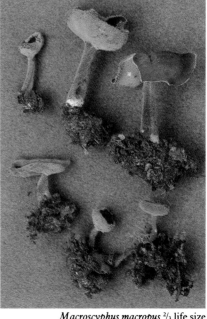

Macroscyphus macropus ⅔ life size

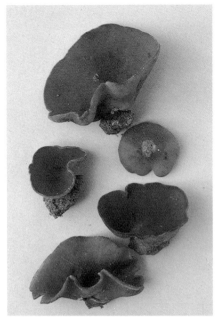

Peziza badia ²/₃ life size

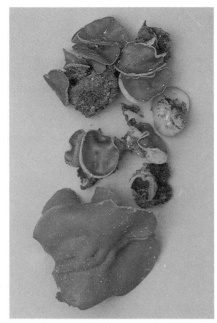

Peziza praetervisa ²/₃ life size

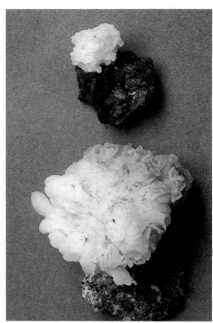

Peziza proteana var. *sparassoides* ½ life size

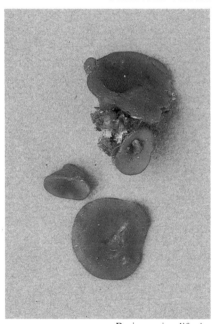

Peziza saniosa life size

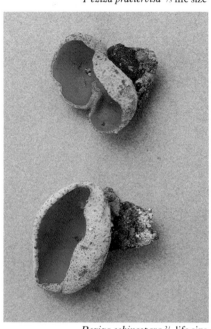

Peziza echinospora ²/₃ life size

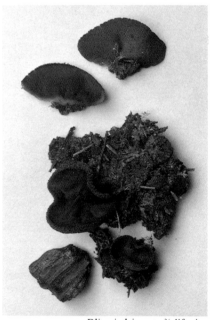

Plicaria leiocarpa ²/₃ life size

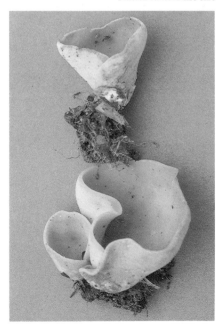

Otidea alutacea ²/₃ life size

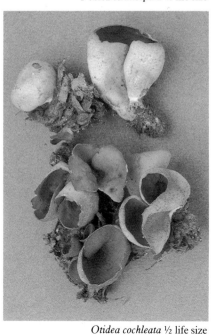

Otidea cochleata ½ life size

Otidea bufonia ⅓ life size

Flavoscypha cantharella ¾ life size

Peziza badia Pers. ex Mérat **Cup** 3–8cm across, cup-shaped, irregularly wavy with age, sessile, inner surface olive-brown, outer reddish-brown and slightly scurfy. **Flesh** thin, reddish-brown, yielding watery juice. Asci 330×15µ, blued at the tip by iodine. Spores elliptical, containing two oil drops, irregularly reticulate, 17–20×9–12µ. Habitat on soil especially on open clay banks or paths. Season late summer to autumn. Common. **Edible** when well cooked, poisonous if eaten raw.

Peziza praetervisa Bres. **Cup** 1–4cm across, cup-shaped and expanding, often in clusters, sessile, inner surface violaceous sometimes with a brown tint, outer paler and slightly scurfy. **Flesh** thin, mauve. Asci 250×10µ, blued at the tip by iodine. Spores containing two oil drops, finely warted, 11–13×6–8µ. Habitat on fire sites. Season autumn to summer. Common. **Not edible**.

Peziza proteana var. *sparassoides* (Boud.) Korf syn. *Gyromitra phillipsii* Massee **Fruit body** 3–12cm across and up to 25cm high, extremely convoluted and brittle, sessile, the inner, spore-bearing surface smooth and whitish with ochraceous tints, the outer flushed pinkish and scurfy. Asci 300×11µ, blued at the tip by iodine. Spores containing two oil drops, minutely warted, 10–13×6–7µ. Habitat on fire sites. Season autumn. Rare. **Edible**.

Peziza saniosa Schrad. ex Fr. **Cup** 1–1.5cm across, shallowly concave, inner surface dark blue-black, yielding bluish juice; outer dark grey-brown and scurfy. Asci 250×13µ. Spores coarsely warted, containing two oil drops, 14–16.5×7–9µ. Habitat on the ground in woods.

Season late summer to autumn. Rare. **Not edible**.

Peziza echinospora Karst. **Cup** 3–8cm across, cup-shaped with incurved margin, sessile, inner surface dark reddish-brown, outer whitish flushed brown and scurfy. **Flesh** thin, brown. Asci 300×14µ, blued at the tip by iodine. Spores oblong-elliptic, finely warted, 14–18×7–9.5µ. Habitat on burnt ground and charred wood. Season late spring to autumn. Common. **Not edible**.

Plicaria leiocarpa (Currey) Boud. **Cup** 1–6cm across, cup-shaped at first, soon expanding and becoming almost flat, sessile, inner surface blackish-brown, outer dull brown covered in black sooty patches. Flesh yellowish buff yielding yellowish juice on cutting. Asci 200×10µ, blued at the tip by iodine. Spores globose, smooth, containing several small oil droplets, 8–9µ diameter. Habitat on bonfire sites or on heaths after forest fires. Season autumn to spring. Frequent. **Not edible**.

Otidea alutacea (Pers.) Massee syn. *Peziza alutacea* Pers. **Cup** 2–4cm wide, 2–5cm high, lopsided and irregularly wavy with a split at the shorter side, inner surface clay-buff, outer pale fawn buff and slightly scurfy. **Flesh** thick, yellowish. Asci 250×15µ, not blued by iodine. Paraphyses slender, curved at tip. Spores containing two oil drops, 12–15×6–7µ. Habitat often in clusters, in soil in woods. Season late summer to autumn. Uncommon. **Not edible**.

Otidea cochleata (L. ex St. Amans) Fuckel syn. *O. umbrina* (Pers.) Bres. **Cap** 3–6cm across, subsessile, split down one side, inner surface tan to dark brown, outer ochraceous-buff, slightly

scurfy. Asci with tips not blued by iodine, 200–260×11–12µ. Spores 16–18×7–8µ. Habitat on bare earth or amongst sparse grass in deciduous or coniferous woodland. Season autumn. Rare. **Not edible**.

Otidea bufonia (Pers.) Boud. **Cup** 1–7cm across, cup-shaped and split at one side, becoming irregularly wavy, inner surface dark brown, outer slightly paler and minutely downy. **Flesh** thin, brown. Asci 160–200×10–12µ, not blued by iodine. Paraphyses slender, strongly curved at tip. Spores elliptic-fusiform, containing two oil drops, 13–15×6.5–7µ. Habitat roadsides, woodland. Season late summer to early autumn. Rare. **Not edible**.

Flavoscypha cantharella (Fr.) Harmaja syn. *Otidea cantharella* (Fr.) Sacc. **Cup** 1–5cm tall, elongate ear-shaped, inner and outer surface bright sulphur-yellow, base whitish. **Flesh** thin, white. Asci 150×10µ, not blued by iodine. Paraphyses slender, curved at the tip. Spores elliptical containing two oil drops, 10–12×5–6µ. Habitat in soil roadsides and parks in mixed woods. Season late summer to autumn. Uncommon. **Not edible**.

Hare's Ear *Otidea onotica* (Pers.) Fuckel syn. *Peziza onotica* Pers. ex Fr. **Cup** 2–6cm wide, 3–10cm high, lopsided, irregularly ear-shaped, attached to the substrate by a short, indistinct whitish stalk, inner surface ochraceous flushed pinkish, outer similarly coloured and slightly scurfy. **Flesh** thin, white. Asci 250×10µ, not blued by iodine. Paraphyses slender, curved at tip. Spores broadly elliptical, containing two oil drops, 12–13×5–6µ. Habitat in soil in deciduous or mixed woodland. Season autumn. Occasional. **Not edible**.

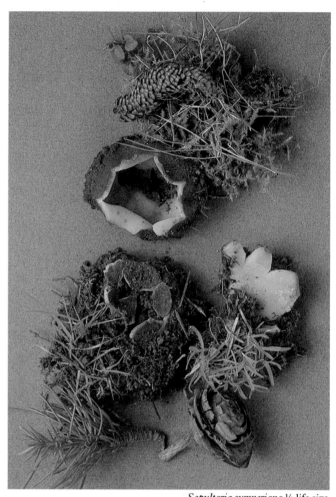

Sepultaria arenicola ¾ life size

Sepultaria sumneriana ½ life size

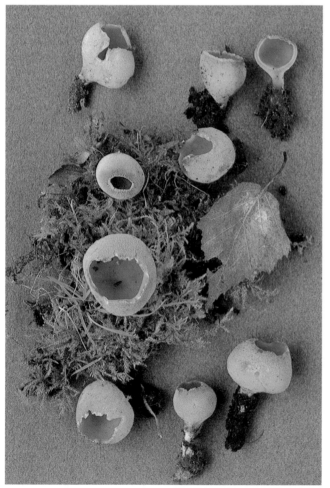

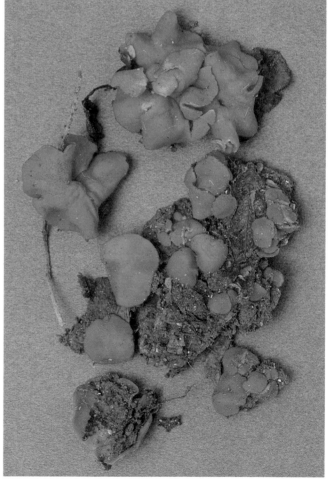

Tarzetta cupularis just over life size

Melastiza chateri life size

Sepultaria arenicola (Lev.) Massee **Fruit body** 1–3cm across, subterranean and subglobose only appearing on the surface when mature, resembling small insect burrows as the upper part splits open, disc cream-coloured. Asci 230×18μ. Spores containing two oil drops, 23–28×14–16μ. Habitat in sandy soil or silt. Season autumn to late spring. Rare. **Not edible.**

Sepultaria sumneriana (Cooke) Massee **Cup** 4–7cm across, initially a hollow sphere just below the soil surface later breaking through and splitting into several recurving lobes exposing the pale yellowish interior, exterior brownish, densely covered in dark hairs. **Flesh** thick and brittle, white. Asci 350μ long. Spores ellipsoid-fusiform containing two large oil drops, 30–37×14–16μ. Habitat under cedars. Season winter to late spring. Occasional. **Not edible.**

Tarzetta cupularis (L. ex Fr.) Lamb. **Cup** 1–1.5(2)cm across, sessile or with a rudimentary stem, remaining tightly cup-shaped even when mature, the margin irregularly and finely toothed, inner surface pale grey-buff, outer lighter due to its covering of fine pale down. Asci not blued by iodine, 300×15μ. Spores smooth, broadly elliptic, containing two large oil drops, 19–21×13–15μ. Habitat in damp, mossy woods. Season spring to autumn. Uncommon. **Not edible.**

Melastiza chateri (W. G. Smith) Boud. **Cup** 0.5–2cm across, saucer-shaped and sessile, inner surface vermillion orange, outer paler, covered in minute, downy brown hairs especially near the margin. Asci 300×15μ. Spores ellipsoid with coarse reticulation, 17–19×9–11μ. Habitat on bare sandy or gravelly soil. Season autumn to spring. Uncommon. **Not edible.**

Neottiella rutilans (Fr.) Dennis syn. *Peziza rutilans* Fr. **Cup** 0.5–1.5cm across, saucer-shaped with a short stalk at the centre almost buried in the substrate, inner surface bright yellowish-orange, outer whitish flushed orange towards the margin and covered in minute, downy white hairs. Asci 300×20μ. Spores broadly elliptical, reticulate, containing one or two oil drops, 22–25×13–15μ. Habitat on heathland or sandy soil amongst *Polytrichum*. Season autumn to winter. Frequent. **Not edible.**

Anthracobia macrocystis (Cooke) Boud. **Cup** 1–3mm across, shallowly disc-shaped then flattened, sessile, inner surface bright yellowish-orange, outer paler and dotted brown towards the margin by fine downy hairs. Asci 200×15μ. Spores oblong ellipsoid, smooth, containing two oil drops 16–18×7–8μ. Habitat in swarms on burnt ground. Season summer to autumn. Frequent. **Not edible.**

Scutellinia umbrarum (Fr.) Lamb. Differing from *S. scutellata* in its large size (up to 1.5cm), shorter, less conspicuous hairs (0.6mm long) and larger spores (20–22×14–15μ). The habitat and season of both species are similar.

Eyelash Fungus *Scutellinia scutellata* (L. ex St. Amans) Lamb **Cup** 0.2–1cm across, shallowly disc-shaped, inner surface bright orange-red, outer pale brown covered in stiff dark brown or black hairs up to 1,000μ long and 40μ wide towards the forked, rooting bases, narrowing towards the pointed apices, septate; visible without a lens as distinct 'eyelashes' rimming the margin. Asci 300×25μ. Spores elliptical and with a roughened exterior, containing several small oil droplets, 18–19×10–12μ. Habitat on damp soil or rotten wood. Season late spring to late autumn. Common. **Not edible.**

Humaria hemisphaerica (Wigg. ex Fr.) Fuckel syn. *Peziza hemisphaerica* Wigg. ex S. F. Gray **Cup** 0.5–3cm across, remaining cup-shaped, sessile, inner surface whitish, outer densely covered in stiff, thick-walled, dark brown septate hairs with acute apices, 500×20μ, or up to 1mm long at the margin. **Flesh** whitish. Asci 350×20μ, not blued by iodine. Spores broadly elliptical and coarsely warted, containing two oil drops, 20–40×10–12μ. Habitat on soil or damp rotten wood. Season summer to autumn. Occasional. **Not edible.**

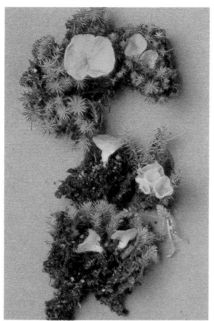

Neottiella rutilans life size

Anthracobia macrocystis life size

Scutellinia umbrarum life size

Eyelash Fungus *Scutellinia scutellata* ²/₃ life size

Humaria hemisphaerica life size

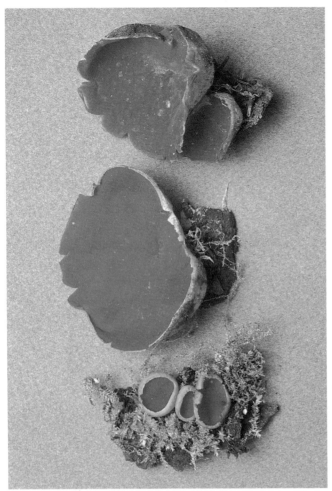

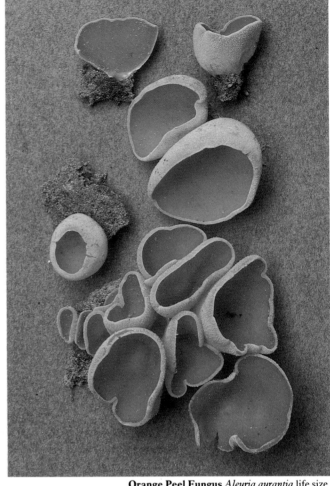

Scarlet Elf Cup *Sarcoscypha coccinea* life size

Orange Peel Fungus *Aleuria aurantia* life size

Scarlet Elf Cup *Sarcoscypha coccinea* (Fr.) Lamb syn. *Peziza coccinea* Fr. **Cup** 1–5cm across, cup-shaped, the margin becoming tattered as it expands, attached to substrate by a short stalk, inner surface bright scarlet, outer whitish and covered in white matted tufted hairs. Asci 400×16μ, not blued by iodine. Spores cylindric-ellipsoid containing several small oil droplets, 24–32×12–14μ. Habitat gregarious, on dead wood. Season early winter to early spring. Frequent especially in the West. **Edible**.

Orange Peel Fungus *Aleuria aurantia* (Fr.) Fuckel syn. *Peziza aurantia* Fr. **Cup** 0.5–10cm across, cup shaped becoming wavy and flattened, inner surface bright yellowish-orange, outer whitish, covered in fine white down visible under a hand lens. **Flesh** thin and brittle, whitish. Asci 220×13μ, not blued by iodine. Spores elliptical and coarsely reticulate, containing two oil drops, 17–24×9–11μ. Habitat gregarious, on bare soil, or amongst grass in lawns or at roadsides. Season early autumn to early winter. Common. **Edible**.

Geoglossum cookeianum Nannfeldt **Fruit body** 3–7cm high, 0.5–1cm wide, black, smooth, flattened club-shaped tapering into the narrower stalk. Asci 180×20μ. Paraphyses elongated terminally in a short chain of almost globose to barrel-shaped segments up to 8μ wide. Spores brown, subcylindric, seven-septate, 50–90×5–7μ. Habitat in grassland especially on sandy soils. Season autumn. Occasional. **Not edible**.

Trichoglossum hirsutum (Pers. ex Fr.) Boud. **Fruit body** 2–8cm high, 0.3–0.8cm wide, black, fertile head varying from flattened-cylindric to more

club-shaped tapering into the slender compressed, velvety stalk. Asci 220×20μ. Setae projecting between the asci numerous, thick-walled, black, stiff and pointed. Spores brown, subcylindric, 100–150×6–7μ, fifteen-septate at maturity. Habitat in grassland or amongst sphagnum on acid soils. Season late summer to autumn. Occasional. **Not edible**.

Trichoglossum hirsutum var. *capitatum* (Pers. ex Fr.) Boud. Differing from *T. hirsutum* only in the distinctly spade-shaped fertile head, identical in all other respects.

Microglossum viride (Pers. ex Fr.) Gillet **Fruit body** 1–5cm high, 0.2–0.5cm wide, olive green, fertile head smooth and deeply furrowed, club-shaped, stalk paler and distinctly scurfy. Asci 150×10μ. Spores cylindric to fusiform containing large oil drops, 15–20×5–6μ. Habitat often in dense clusters amongst moss in deciduous woods. Season autumn. Occasional. **Not edible**.

Mitrula paludosa Fr. **Fruit body** 1–4cm high, fertile head ovoid or club-shaped, smooth yellow to orange, stem white. Asci 150×8μ. Spores cylindric-ellipsoid, 10–15×2.5–3μ. Habitat on rotting twigs and leaves in damp ditches or amongst sphagnum. Season spring to summer. Occasional. **Not edible**.

Sclerotinia tuberosa (Fr.) Fuckel **Cup** 1–3cm across, initially deeply cup-shaped then expanding, inner surface tan to chestnut-brown, outer smooth and similarly coloured or paler.

Stem up to 10cm long, smooth and brown. Asci 170×10μ. Spores smooth and elliptic, with one small oil drop at either end, 12–17×6–9μ. Habitat arising from large black sclerotia on old tubers of *Anemone* or occasionally *Ranunculus*. Season early spring. Rare but probably often overlooked. **Not edible**.

Ciboria batschiana (Zopf) Buch. **Cup** 0.5–1.5cm across, concave at first then flattened, attached by a slender dark brown stalk up to 2cm long, inner surface cinnamon, outer similarly coloured and finely downy. Asci 150×8μ. Spores ellipsoid, 6–11×4–6μ. Habitat on old acorns. Season autumn. Occasional. **Not edible**.

Ciboria amentacea (Balbis ex Fr.) Fuckel **Cup** 0.5–1cm across, cup-shaped or more shallow, especially with age, inner surface light brown, outer similarly coloured and smooth, attached to the substrate by a slender light brown stalk up to 3cm long. Asci 135×9μ. Spores ellipsoid, 7.5–10.5×4.5–6μ. Habitat on fallen alder or willow male catkins. Season early spring. Occasional. **Not edible**.

Cudonia confusa Bres. **Fruit body** 2–3cm high, fertile head 7–12mm across, convex becoming centrally depressed, margin incurved, viscid, ochre-cinnamon to reddish-brown. **Stem** 20–30×1–2mm, more or less concolorous with head. Asci 105–120×10–12μ. Spores cylindric, 35–45×2μ, becoming multiseptate and budding in the ascus. Habitat in tufts in conifer woods. Season late summer to autumn. Rare. **Not edible**.

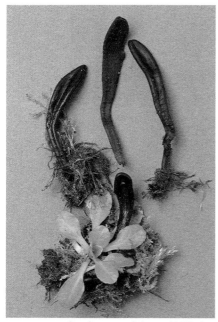

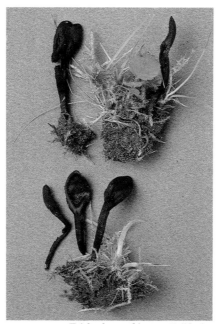

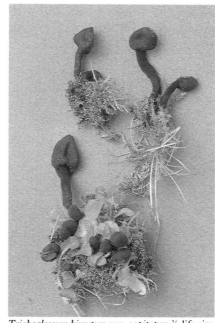

Geoglossum cookeianum ²/₃ life size

Trichoglossum hirsutum ½ life size

Trichoglossum hirsutum var. *capitatum* ²/₃ life size

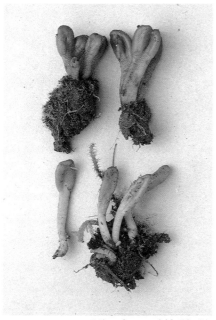

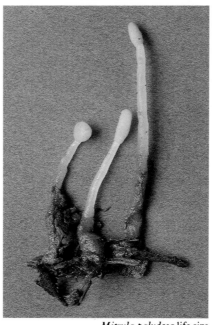

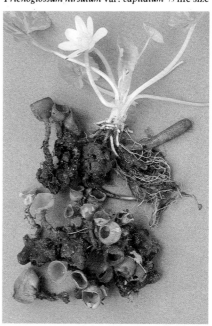

Microglossum viride life size

Mitrula paludosa life size

Sclerotinia tuberosa ²/₃ life size

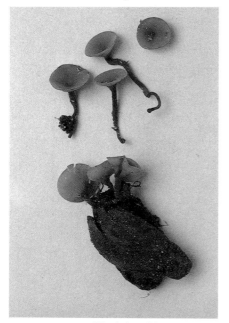

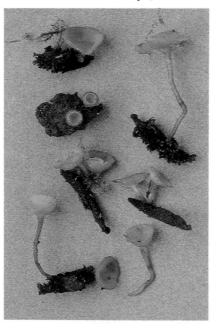

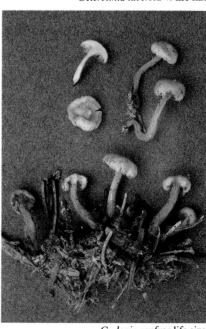

Ciboria batschiana ²/₃ life size

Ciboria amentacea life size

Cudonia confusa life size

275

Black Bulgar *Bulgaria inquinans* ¾ life size

Jelly Babies *Leotia lubrica* life size

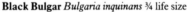

Black Bulgar *Bulgaria inquinans* Fr. **Fruit body**
1–4cm across, rubbery, globose with a tightly
inrolled margin when young and having a scurfy
brownish exterior, later expanding then
flattened, with a smooth black disc. Asci
200×9μ. Spores of two kinds; the upper four in
the ascus dark brown and kidney-shaped, the
lower four colourless but similarly shaped, 11–
14×6–7μ. Habitat gregarious on dead wood of
deciduous trees especially oak but less commonly
on beech. Season autumn. Common. **Not
edible**.
May be confused with *Exidia glandulosa* (p.281)
on first inspection but easily distinguished on
closer examination by the lack of small pimples
on the disc, characteristic of the latter, more
irregular shape and watery gelatinous
consistency. Also easily separated by taking a
spore print overnight on white paper; *Bulgaria*
has dark sooty-brown ascospores while the
spores of *Exidia* are colourless.

Jelly Babies *Leotia lubrica* Pers. **Fruit body** 1–
6cm high, viscid fertile head olivaceous ochre,
convex with inrolled irregularly lobed margin;
stalk 3–8mm wide, tapering towards the base,
ochraceous covered in minute greenish granules.
Flesh gelatinous in the head, stem becoming
hollow. Asci 150×10–12μ. Spores subfusiform,
20–25×5–6μ. Habitat in damp deciduous
woods, on path sides or under bracken. Season
late summer to late autumn. Frequent. **Not
edible**.

Rutstroemia firma (Pers.) Karst. **Cup** 0.5–1.5cm
across, cup-shaped expanding flattened and
wavy, attached by a short stalk 2–3mm long,
inner surface ochraceous brown, outer similarly
coloured and becoming wrinkled. Asci 150×8μ.

Spores narrowly elliptical, 14–19×4–6.5μ.
Habitat on fallen oak branches. Season autumn
to early winter. Occasional. **Not edible**.

Rutstroemia luteovirescens (Roberge) White **Cup**
up to 0.4cm across, concave at first then
flattened, attached by a long stalk of up to 12mm
long, inner surface olivaceous yellow-buff, outer
similarly coloured and smooth. Asci 150–12μ.
Spores elliptical often containing two oil drops,
12–15×5–7μ. Habitat on petioles of fallen
sycamore leaves. Occasional. **Not edible**.

Cudoniella acicularis (Bull. ex Fr.) Schroet. **Cup**
1–4mm across, convex with inrolled margin
attached to substrate by a long slender stalk up to
10mm long, white ageing brownish. Asci
120×13μ. Spores fusiform 15–22×4–5μ.
Habitat gregarious on rotting wood especially
oak. Season autumn to early winter. Occasional.
Not edible.

Bisporella citrina (Batsch ex Fr.) Korf &
Carpenter syn. *Calycella citrina* ([Hedwig.] Fr.)
Boud. **Fruit body** 0.5–3mm across, saucer-
shaped tapered below to a small base, bright
yellow becoming orange-yellow when old or
dried, exterior smooth. Asci 135×10μ. Spores
elliptical, containing two oil drops at each end,
9–14×3–5μ, often becoming one-septate.
Habitat gregarious in dense swarms on dead
wood of deciduous trees. Season autumn.
Common. **Not edible**.

Neobulgaria pura (Fr.) Petrak **Fruit body** 0.5–
2cm across, gregarious, subglobose at first with
the margin inrolled showing the smooth exterior,
becoming flattened on top or concave, flesh-
coloured often with a violaceous tint, gelatinous.

Asci 70×9μ. Spores elliptical, containing two
small oil drops, 6–9×3–4μ. Habitat on logs and
fallen branches especially beech. Season early
summer to early winter. Occasional. **Not edible**.

Neobulgaria pura var. *foliacea* (Bres.) Dennis &
Gamundi **Fruit body** up to 10cm across,
extremely convoluted, rubbery and gelatinous,
pale flesh-colour at first later darkening to
reddish purple. Similar in all other respects to *N.
pura* but less common.

Podostroma alutaceum (Pers. ex Fr.) Atk. **Fruit
body** 1–4cm high, 0.5–1cm wide, club-shaped,
whitish to pale ochraceous. Asci 80×4μ. Part-
spores broadly elliptical to globose, finely
warted, 4–4.5×3–4μ. Habitat attached to
rotting wood. Season autumn. Rare. **Not edible**.

Ascocoryne cylichnium (Tul.) Korf syn. *Coryne
cylichnium* (Tul.) Boud. Similar to *A. sarcoides*
but fruit bodies generally larger and more cup-
shaped, with larger spores (18–30×4–6μ) which
become multiseptate and bud off secondary
spores while still within the ascus.

Ascocoryne sarcoides (Jacq. ex S. F. Gray) Groves
& Wilson syn. *Coryne sarcoides* (Jacq. ex S. F.
Gray) Tul. **Fruit body** 0.1–1.5cm across, reddish
purple, sessile or on a short stalk, inverted cone-
shaped with flattened disc or concave tending to
cup-shaped, often irregularly lobed at the
margin. **Flesh** gelatinous. Asci 160×10μ. Spores
ellipsoid, containing two oil drops, 10–19×3–
5μ. Habitat gregarious on dead wood, especially
beech. Season late summer to early winter.
Common. **Not edible**.

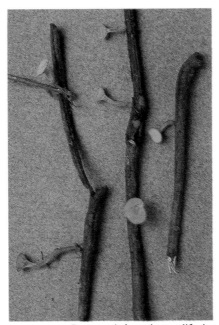

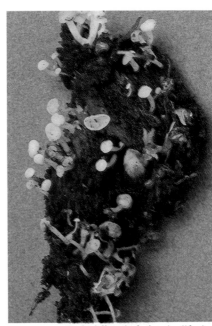

Rutstroemia firma life size

Rutstroemia luteovirescens life size

Cudoniella acicularis twice life size

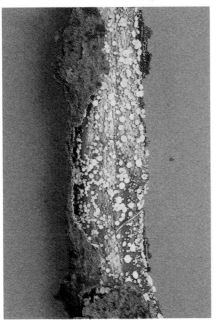

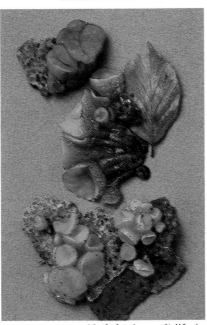

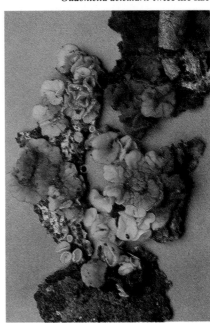

Bisporella citrina life size

Neobulgaria pura ⅔ life size

Neobulgaria pura var. *foliacea* ½ life size

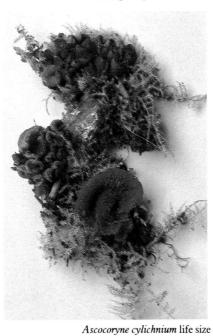

Podostroma alutaceum life size

Ascocoryne cylichnium life size

Ascocoryne sarcoides life size

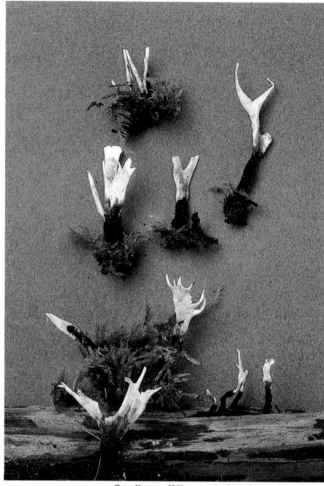

Green Wood-cup *Chlorosplenium aeruginascens* life size

Candle-snuff Fungus *Xylaria hypoxylon* life size

Green Wood-cup *Chlorosplenium aeruginascens*
(Nyl.) Karst. syn. *Chlorociboria aeruginascens*
(Nyl.) Karst. ex Ram. **Fruit body** 1–5mm across,
cup-shaped then flattened with a wavy, irregular
margin, attached to the substrate by a short stalk,
bright blue-green throughout. Asci $70\times5\mu$.
Spores fusiform, containing two small oil drops
situated at opposite ends of the spore, 6–
$10\times1.5–2\mu$. Habitat on fallen branches of
deciduous trees, especially oak. The mycelium
growing through the wood stains it
conspicuously blue-green. Season mainly
autumn although also found in spring to autumn.
The stained wood is often seen but the fruit
bodies are less frequent. **Not edible**.
The infected wood, known as 'green oak', was
formerly used in the manufacture of Tunbridge
ware, a traditional method of decoration where
woods of different colours were arranged into
blocks to give the desired pattern, compressed,
then cut transversely into thin strips of veneer.

Stag's Horn or **Candle-snuff Fungus** *Xylaria
hypoxylon* (L. ex Hook.) Greville **Fruit body** 1—
7cm high, subcylindric at first becoming
flattened and branched into an antler-like shape,
the upper branches powdered white, finally
tipped black when mature, stalk black and hairy.
Asci $100\times8\mu$. Spores black, bean-shaped, 11–
$14\times5–6\mu$. Habitat on dead wood. Season all
year. Common. **Not edible**.

Dead Man's Fingers *Xylaria polymorpha* (Pers.
ex Mérat) Greville **Fruit body** 3–8cm high, 1–
3cm wide, irregularly club-shaped passing into a
short cylindrical stalk below, black with a finely
wrinkled or roughened surface. **Flesh** tough,
white; the section shows the distinctive pattern
of the spore-producing cavities, the perithecia,
just below the surface crust. Asci $200\times10\mu$.

Spores blackish, fusiform, $20–32\times5–9\mu$.
Habitat in groups on stumps, usually beech.
Season all year. Common. **Not edible**.

Xylaria longipes Nitschke Similar to *X.
polymorpha* but altogether more slender. Spores
smaller, $12–16\times5–7\mu$. Habitat on stumps and
fallen branches usually of sycamore. Season all
year. Occasional. **Not edible**.

Xylaria carpophila (Pers.) Fr. Similar to *X.
hypoxylon* but generally much more slender.
Habitat on old, rotting beech masts. Season all
year. Occasional. **Not edible**.

Choiromyces meandriformis Vitt. **Fruit body** 4–
12cm across, irregularly subglobose, yellowish
brown. **Flesh** whitish to yellowish, marbled.
Smell strongly aromatic. Asci $180\times70\mu$, eight-
spored. Spores yellow, globose, $16\times21\mu$ in
diameter, covered in blunt spines. Habitat on
soil surface in frondose and mixed woods. Rare.
Edibility unknown.
Tuber magnatum Pico, the White Truffle, is very
similar but distinguished by the one- to three-
spored asci and elliptic, reticulate spores. It is
found in North Italy buried in deciduous woods.
Edible – excellent. (Not illustrated.)

Summer Truffle *Tuber aestivum* Vitt. **Fruit body**
3–7cm across, globose, covered in pyramidal
warts, blackish brown. **Flesh** whitish becoming
marbled grey-brown. Taste nutty, smell sweet.
Spores ovoid, reticulate, $20–40\times15–30\mu$.
Habitat buried usually near beech on calcareous
soil. Season late summer to autumn. Rare.
Edible – good.
The Perigord Truffle, *Tuber melanosporum* Vitt.,
differs in the covering of polygonal warts, and
the cut flesh turning violaceous-black. Spores

elliptic, spiny, $29–55\times22–35\mu$. Not British.
Edible – excellent considered the best truffle.
(Not illustrated.)

Lachnellula subtillissima (Cke.) Dennis **Fruit
body** 1–3mm across, globose at first becoming
cup-shaped, inner surface yellow-orange, outer
white and covered in long shaggy septate hairs.
Asci $156\times12\mu$. Spores oblong-ellipsoid, 6–
$11\times2–2.5\mu$. Habitat on pine twigs, less usually
on spruce. Season autumn. Rare. **Not edible**.

Ustulina deusta (Fr.) Petrak **Fruit body** forming
irregular wavy cushions or encrusting the
substrate, greyish white in the early stages soon
becoming brittle enough to crush between the
fingers, finally black and very brittle resembling
charred wood. Asci $300\times15\mu$. Spores black,
fusiform, $28–34\times7–10\mu$. Habitat on old dead
stumps or roots of deciduous trees especially
beech. Season late spring to summer, although
the blackened state may be seen all year round.
Common. **Not edible**.

Ergot *Claviceps purpurea* (Fr.) Tul. Most easily
recognized in the sclerotial stage, a violet-black
spindle-shaped structure longitudinally furrowed,
up to 1cm long, formed in the inflorescences of
grasses. In the autumn, the mature sclerotium falls
to the ground, over-wintering in this state until
late spring, when after a period of chilling, tiny
pale pinkish or purplish drumstick-shaped fruit
bodies develop from it producing thread-like
asco-spores, $100\times1\mu$. These infect other grasses
belonging to several genera including some of our
most important food crops, barley, oats, rye and
wheat. (Shown here on *Arrhenatherum elatius*
[*L.*]) Season – sclerotia summer to early autumn,
fruit bodies spring. Frequent. **Deadly poisonous**.
Poisoning by *C. purpurea* (ergotism) has been

278

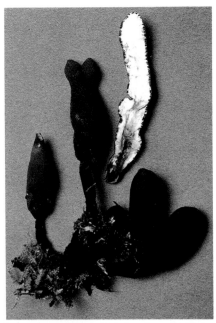

Dead Man's Fingers *Xylaria polymorpha* ½ size

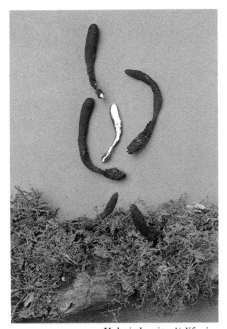

Xylaria longipes ⅓ life size

Xylaria carpophila ⅔ life size

Choiromyces meandriformis ⅔ life size

Summer Truffle *Tuber aestivum* ⅔ life size

Lachnellula subtillissima twice life size

recorded since the Middle Ages. Outbreaks were so sudden and inexplicable that many myths and superstitions grew up around the affliction, which was widely believed to be a divine punishment on sinners. Such were the beliefs and symptoms of the disease that for centuries, it was commonly known as Holy Fire. The poisoning can take two forms: that of a burning sensation in the limbs followed by their becoming gangrenous due to the constriction of blood vessels, or affecting the mind causing hallucinations, psychotic behaviour and convulsions.

The connection between ergotism and grain infected by *C. purpurea* was only fully realized this century. Pharmacological analysis of the sclerotia revealed a mixture of powerful chemicals, among them compounds related to LSD.

Even before the complexity of ergot's chemistry was understood, it was widely used for centuries by midwives to stimulate contractions and so aid childbirth. The crude drug is dangerous due to its many components and their side effects, however, the purified derivatives are now used in medicine in the treatment of migraine and other disorders as well as in obstetrics.

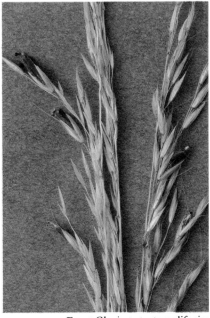

Ergot *Claviceps purpurea* life size

Ustulina deusta ½ life size

Hypoxylon fragiforme ¾ life size

Hypoxylon nummularium ⅔ life size

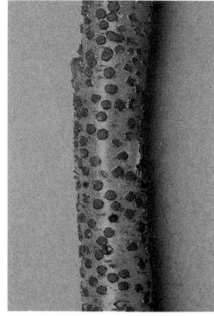

Diatrype disciformis over life size

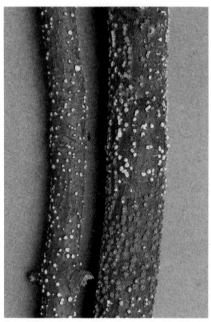

Coral Spot Fungus *Nectria cinnabarina* life size

Nectria peziza twice life size

Poronia punctata ⅔ life size

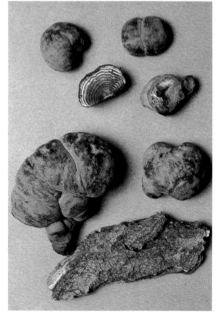

Cramp Ball *Daldinia concentrica* ½ life size

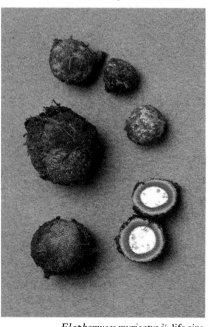

Elaphomyces muricatus ⅔ life size

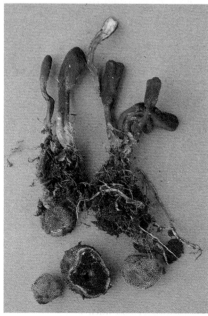

Cordyceps ophioglossoides ½ life size

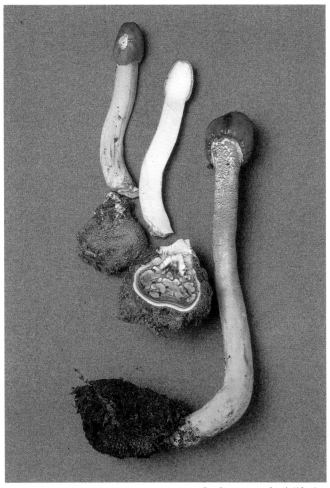

Cordyceps canadensis life size **Scarlet Caterpillar Fungus** *Cordyceps militaris* life size

Hypoxylon fragiforme (Pers. ex Fr.) Kickx **Fruit body** 0.1–1cm across, gregarious, hemispherical, bright salmon-pink at first becoming brick-red and later blackening, with a finely warted surface. **Flesh** hard, blackish. Asci cylindrical, 150×8μ. Spores dark brown, subfusiform, containing one to three oil drops, 11–15×5–7μ. Habitat dead beech. Season late summer to early spring. Common. **Not edible.**

Hypoxylon nummularium Bull. ex Fr. **Fruit body** forming a blackish, shiny crust on wood. Asci cylindrical, 125×12μ. Spores blackish brown, broadly elliptical to subglobose, 11–14×7–10μ. Habitat on dead beech. Season all year. Uncommon. **Not edible.**

Diatrype disciformis (Hoff. ex Fr.) Fr. **Fruit body** 1–3mm across, discoid, whitish at first soon blackish on the outer surface, remaining white-fleshed. Asci elongate club-shaped, 5μ wide. Spores curved, cylindrical, 5–8×1.5–2μ. Habitat on dead branches of deciduous trees, usually beech, emerging from below the bark. Season all year. Common. **Not edible.**

Coral Spot Fungus *Nectria cinnabarina* (Tode ex Fr.) Fr. **Fruit body** colonial and of two types: the perithecial fructification comprising crowded cinnabar-red flasks on a cushion-shaped base, the conidial state similar but forming coral pink pustules. Asci 70×12μ. Spores cylindric-ellipsoid with a single cross-wall, 12–25×4–9μ. Habitat on dead wood. Season all year. Common. **Not edible.**

Nectria peziza (Tode ex Fr.) Fr. **Fruit body** 0.2–0.4mm across, globose when fresh but collapsing

into a cup-like shape when dry (not shown), bright yellow. Asci 75–90×8–10μ. Spores 12–15×5–7μ. Habitat on rotting polypores and rotten wood, shown here on old *Polyporus squamosus.* Season all year. Frequent. **Not edible.**

Poronia punctata (L. ex Fr.) Fr. **Fruit body** 0.5–2cm high, flattened disc 0.5–1.5cm across, whitish dotted black with the tips of the perithecia when mature, attached to the substrate by a long black cylindrical stalk. Asci 180×18μ. Spores bean-shaped, smooth, 18–26×7–12μ. Habitat on horse dung. Season autumn. Although abundant in the last century, this species became quite rare in modern times due to the decline in the use of horses. **Not edible.**

Cramp Ball or **King Alfred's Cakes** *Daldinia concentrica* (Bolt. ex Fr.) Cesati & de Notaris **Fruit body** 2–10cm across, hemispherical to subglobose, brown at first soon black and shiny. **Flesh** concentrically zoned silver-grey and blackish. Asci 200×12μ. Spores black elliptical to fusiform, 12–17×6–9μ. Habitat gregarious on dead wood, especially beech and ash. Season all year. Common. **Not edible.**

Elaphomyces muricatus Fr. **Fruit body** 2–5cm across, globose, outer rind bright ochre-brown covered in pointed warts, inner much thicker and marbled purplish-brown; within these layers is an internal powdery spore mass which becomes grey-black as the spores mature. Asci globose, usually four-spored. Spores purplish-black, globose and warted, 18–24μ. Habitat subterranean in the top soil of pinewoods, less

frequently in deciduous woods. Season all year but most easily found in autumn when the parasite *Cordyceps ophioglossoides* which often attacks this species may be seen above ground. Rare. **Edibility unknown.**

Cordyceps ophioglossoides (Ehr. ex Fr.) Link **Fruit body** 3–10cm high, the club-shaped fertile head is initially yellow and smooth, later black and finely roughened, and tapers into a smooth yellow stalk. Spores breaking into elliptic-cylindric part-spores, 2.5–5×2μ. Habitat parasitic on species of *Elaphomyces.* Season autumn. Uncommon. **Not edible.**

Cordyceps canadensis Ellis & Everhart **Fruit body** 3–10cm high, the fertile head is oval to subglobose, chestnut brown to blackish, set on a tough yellow-olivaceous stalk up to 1cm thick. Asci very long×15μ. Spores breaking up into part-spores, 20–50×3–5μ. Habitat mainly in pine woods parasitic on species of *Elaphomyces* buried just below the surface (shown here on *E. granulatus*). Season autumn. Uncommon. **Not edible.**

Scarlet Caterpillar Fungus *Cordyceps militaris* (L. ex St. Amans) Link **Fruit body** 2–5cm high, bright orange-red, the slightly swollen fertile head has a finely roughened surface and tapers into a paler wavy stalk. Asci very long×4μ. Spores breaking up into barrel-shaped part-spores, 3.5–6×1–1.5μ. Habitat on dead larvae and pupae of butterflies and moths buried in the soil, the mycelium of the fungus replacing the insides of the insect. Occasional. **Not edible.**

Bibliography

General books

Collins Guide to Mushrooms and Toadstools, Morten Lange and F. Bayard Hora (Collins 1978)

Mushrooms and Toadstools, a field guide, Geoffrey Kibby (Oxford University Press 1979)

The Love of Mushrooms and Toadstools, Geoffrey Kibby (Octopus 1977)

Mushrooms and Toadstools, Ronald Rayner (Hamlyn 1979)

Mushrooms and Toadstools, Derek Reid (Kingfisher Ward Lock 1980)

The New Field Guide to Fungi, Eric Soothill and Alan Fairhurst (Michael Joseph 1978)

Mushrooms and other fungi, an illustrated guide, Augusto Rinaldi and Vassili Tyndalo (Hamlyn 1974)

A Field Guide in Colour to Mushrooms and Other Fungi, M. Svrček and J. Kubička (Octopus 1980)

The Encyclopedia of Mushrooms, Colin Dickinson and John Lucas (Orbis 1979)

Wayside and Woodland Fungi, W. P. K. Findlay (Warne 1967)

Wild Mushrooms, an Illustrated Handbook, Linus Zeitlmayr (Muller 1976)

Mushrooms, A Pilát and O. Ušák (Spring Books)

Mushrooms and Other Fungi, A Pilát and O. Ušák (Peter Nevill 1961)

Specialized works

Introduction to the History of Mycology, G. C. Ainsworth (Cambridge University Press 1976)

Common British Fungi, Elsie M. Wakefield and R. W. G. Dennis (Gawthorn 1950)

British Basidiomycetae, Carleton Rea (Cambridge University Press 1922)

Mushrooms and Toadstools, A Study of the Activities of Fungi, John Ramsbottom (Collins 1953)

Mushrooms of North America, Orson K. Miller Jr (Dutton, New York 1978)

The Mushroom Hunter's Field Guide, Alexander H. Smith (University of Michigan Press 1963)

Champignons du Nord et du Midi Vols I–VI, André Marchand (Paris 1971–80)

Champignons de Nos Pays, Henri Romagnesi (Bordas, Paris 1977)

I funghi dal vero Vols 1–3, Bruno Cetto (Saturnia, Italy 1970–80)

700 Pilze in Farbfotos, Rose Marie Dähnke and Sabine Maria Dähnke (AT Verlag Aurau, Stuttgart 1980)

Handbuch für Pilzfreunde Vols I–VI, Hennig, Michael and Kreisel Michael (VEB Gustav Fischer, W. Germany 1968–75)

Dictionary of the Fungi, Ainsworth and Bisby (sixth edn, Commonwealth Mycological Institute 1971)

New Check List of British Agarics and Boleti, R. W. G. Dennis, P. D. Orton and F. B. Hora (reprint, J. Cramer, W. Germany 1974)

How to Identify Mushrooms to Genus Vols I–IV, David Largent *et al.* (Mad River Press, California 1973–7)

British Fungus Flora Agarics and Boleti: Introduction, D. M. Henderson, P. D. Orton and R. Watling (HMSO 1969); Vol I *Boletaceae; Gomphidiaceae; Paxillaceae*, R. Watling (HMSO 1970); Vol. II *Coprinaceae*, part I (Coprinus), P. D. Orton and R. Watling (HMSO 1979)

Flore Analytique des Champignons Supérieurs, R. Kühner and H. Romagnesi (Masson, Paris 1974)

Die Blätterpilze Vols I & II, R. Ricken (Weigel, Leipzig 1910–15)

Coloured Icones of Rare and Interesting Fungi Vols I–XI, Derek Reid *et al.* (J. Cramer, W. Germany 1966–79)

Illustrations of British Fungi (Hymenomycetes), M. C. Cooke (London 1881–91)

Iconographia Mycologica, G. Bresadola (Milan 1927–33)

Flora Agaricina Danica, J. E. Lange (Copenhagen 1935–40)

The Non-gilled Fleshy Fungi, Helen Smith and Alexander Smith (Brown, Iowa 1973)

Kleine Kryptogamenflora: Die Röhrlinge und Blätterpilze, Meinhard Moser (Gustav Fischer, Stuttgard 1978)

Keys to the British Species of Russula, R. W. Rayner (reprinted from the *Bulletin of the British Mycological Society* 1968–70)

Die Russulae, Julius Schaeffer (reprint, J. Cramer, W. Germany 1979)

Die Milchlinge, W. Neuhoff (Julius Klinkhardt, W. Germany 1956)

Die Gattung Phlegmacium, Meinhard Moser (reprint, J. Cramer, W. Germany 1979)

Die Röhrlinge Vols I & II, Rolf Singer (Julius Klinkhardt, W. Germany 1965–7)

The Polypores, D. N. Pegler (*Bulletin of the British Mycological Society* Vol. 7, No. 1 (supplement) 1973)

Fungi Vol. I (Resupinatae), Vol. II (Pileatae), S. Domanski *et al.* (Foreign Scientific Publications Department of the National Centre for Scientific, Technical and Economic Information, Warsaw, Poland 1973)

The Polyporaceae of North Europe Vols I & II, Leif Ryvarden (Fungiflora, Oslo 1976–78)

The Corticiaceae of North Europe Vols II–V, John Eriksson and Leif Ryvarden (Fungiflora, Oslo 1973–8)

The Terrestial Hydnums of Europe, R. A. Maas Geesteranus (North-Holland Publishing Company, Amsterdam 1975)

A Chronological Catalogue of the Literature to the British Gasteromycetes, J. T. Palmer (J. Cramer, W. Germany 1968)

The Gasteromycetes of the Eastern United States and Canada, W. C. Coker and J. N. Couch (reprint, J. Cramer, W. Germany 1969)

The Birds Nest Fungi, Harold J. Bodie (University of Toronto Press, Canada 1975)

A Monograph of Clavaria and Allied Genera, E. J. H. Corner (Oxford University Press 1970)

British Ascomycetes, R. W. G. Dennis (J. Cramer, W. Germany 1978)

North American Cup-Fungi (Operculates), Fred J. Seaver (reprint, J. Cramer, W. Germany 1978)

Guide to the Literature for the Identification of British Fungi (third edn), Margaret Holden (reprinted from the *Bulletin of the British Mycological Society* Vol. 9, part 2, 1975)

Specialist booksellers

The Richmond Publishing Co. Ltd
Orchard Road, Richmond, Surrey

Wheldon & Wesley Ltd
Lytton Lodge, Codicote, Hitchin, Herts

Index
of English and botanical names by species and genera
Italic type indicates a synonym

luteolus, Crepidotus 189
luteolus, Rhizopogon 252
luteotacta, Russula 103
luteovirescens, Rutstroemia 276
luteovitellina, Omphalina 69
lutescens, Pluteus 120
luteus, Boletus 215
luteus, Suillus 215
lycii, Peniophora 241
lycoperdoides, Asterophora 76
lycoperdoides, Scleroderma 251
Lycoperdon 247
Lyophyllum 43

macrocephalus, Coprinus 176
macrocystis, Anthracobia 273
Macrolepiota 25
Macropodia 269
macropus, Cyathipodia 269
macropus, Macropodia 269
macropus, Macroscyphus 269
Macroscyphus 269
macrosporus, Agaricus 164
maculata, Collybia 54
maculata, Inocybe 150
maculata, Mycena 73
maculata, Rhodocollybia 54
maculata, Russula 106
maculatus, Gomphidius 191
magnatum, Tuber 278
Magpie Fungus 178
mairei, Russula 99
malachius, Cortinarius 130
malachius, Cortinarius 130
mammiforme, Lycoperdon 247
mammosus, Lactarius 85
mammosus var. *typicus, Rhodophyllus* 117
Many-zoned Polypore 235
mappa, Amanita 21
Marasmiellus 66
Marasmius 66
marcescibilis, Hypholoma 174
marcescibilis, Psathyrella 174
marchii, Hygrocybe 63
marchii, Hygrophorus 63
margaritispora, Inocybe 153
marginatum, Hypholoma 159
marginatus, Polyporus 228
mastoidea, Lepiota 27
mastoidea, Macrolepiota 27
maura, Mycena 68
maura, Myxomphalia 68
maura, Omphalia 68
maxima, Clitocybe 46
Maze-gill 233
Meadow Wax Cap 60
meandriformis, Choiromyces 278
melaleuca, Melanoleuca 44
melaleuca, Tricholoma 44
melaleucum, Hydnum 244
melaleucus, Phellodon 244
Melanoleuca 44
Melanophyllum 31
melanosporum, Tuber 278
Melastiza 273
meleagris, Psalliota 168
mellea, Armillaria 33
mellea, Clitocybe 33
melliolens, Cortinarius 128
merdaria, Psilocybe 171
merdaria, Stropharia 171
Meripilus 220
merismoides, Phlebia 238
Meruliopsis 239
Merulius 238
mesenterica, Auricularia 262
mesenterica, Tremella 264
mesophaeum, Hebeloma 147
metulaespora, Lepiota 28
micaceus, Coprinus 180
Microglossum 274
Micromphale 68
microrhiza, Psathyra 175
microrhiza, Psthyrella 175
militaris, Cordyceps 281
Milk-white Russula 91
Miller, The 113
miniata, Hygrocybe 63
miniatus, Hygrophorus 63
mitis, Panellus 189
mitis, Pleurotus 189

mitissimus, Lactarius 88
Mitrophora 267
Mitrula 274
mniophila, Galera 156
mniophila, Galerina 156
mollis, *Antrodia* 234
mollis, Crepidotus 188
mollis, Datronia 234
mollis, Trametes 234
mollusca, Leucogyrophana 238
molluscus, Merulius 238
Moor Club 257
Morchella 265
Morel 265
mucida, Armillaria 33
mucida, Oudemansiella 33
mucifluoides, Cortinarius 121
mucosus, Cortinarius 122
multipedata, Psathyrella 174
multizonata, Podoscypha 222
multizonata, Thelephora 222
muricatus, Elaphomyces 281
muscaria, Amanita 15
muscorum, Deconica 173
Mushrooms 160
musteus, Lactarius 83
mutabilis, Galerina 156
mutabilis, Kuehneromyces 156
mutabilis, Pholiota 156
Mutinus 257
Mycena 70
mycenopsis, Galera 156
mycenopsis, Galerina 156
Mycoacia 241
myomyces var. *alboconicum, Tricholoma* 37
myosotis, Flammula 146
myosotis, Naucoria 146
myosotis, Pholiota 146
myosura, Baeospora 68
myosura, Collybia 68
Myriostoma 252
Myxacium (Cortinarius) 121
Myxomphalia 68

Naematoloma 159
nanum, Geastrum 252
nanus var. *lutescens, Pluteus* 120
napipes, Astrosporina 153
napipes, Inocybe 153
narcoticus, Coprinus 178
naucina, Lepiota 25
Naucoria 156
nauseosa, Russula 100
nebularis, Clitocybe 48
Nectria 281
nemorensis, Cortinarius 130
Neobulgaria 276
Neottiella 273
nidorosum, Entoloma 115
nidulans, Hapalopilus 224
nidulans, Polyporus 224
Nidularia 255
niger, Phellodon 245
nigrescens, Bovista 249
nigrescens, Hygrocybe 60
nigrescens, Hygrophorus 60
nigrescens, Leccinum 211
nigrescens, Lycoperdon 249
nigricans, Russula 92
nigrum, Hydnum 245
nitida, Russula 103
nitrata, Hygrocybe 60
nitratus, Hygrophorus 60
nivea, Hygrocybe 65
niveus, Coprinus 178
Nolanea 117
norvegica, Russula 100
nuda, Lepista 113
nudum, Tricholoma 113
nudus, Rhodopaxillus 113
nummularium, Hypoxylon 281
Nyctalis 77

Oak Milk-cap 88
obliquus, Irpex 237
obnubilus, Lactarius 90
obrusseus, Hygrophorus 64
obscura, Collybia 57
obscura, Russula 110
obscuratus, Lactarius 90
obscurus, Marasmius 57

obturata, Stropharia 173
obtusata, Drosophila 174
obtusata, Psathyrella 174
obtusus, Cortinarius 139
ochracea, Conocybe 154
ochrochlora, Pholiota 144
ochroleuca, Russula 94
ochroleucus, Cortinarius 123
odora, Clitocybe 48
olearia, Clitocybe 186
olearius, Omphalotus 186
olidus, Cortinarius 128
olivacea, Russula 109
olivaceomarginata, Mycena 74
olla, Cyathus 255
Omphalia 69
Omphalina 69
Omphalotus 186
onotica, Otidea 271
onotica, Peziza 271
oortiana, Mycena 70
ophioglossioides, Cordyceps 281
Orange Birch Bolete 211
Orange Peel Fungus 274
oreades, Marasmius 66
oreadiformis, Lepiota 27
oreadoides, Collybia 54
oreadoides, Marasmius 54
orellanus, Cortinarius 134
orirubens, Tricholoma 37
osmophorus, Cortinarius 125
ostreatus, Pleurotus 182
Otidea 271
Oudemansiella 33
ovina, Hygrocybe 60
ovinus, Hygrophorus 60
Ox-tongue 224
oxydabile, Leccinum 212
oxydabile, Leccinum 212
oxydabilis, Krombholzia 212
Oxyporus 231
Oyster Mushroom 182
ozes, Collybia 57

pachypus, Boletus 202
pachyspermus, Coprinus 178
paleaceus, Cortinarius 139
pallidus, Lactarius 83
palmata, Thelephora 260
palmatus, Pleurotus 186
palmatus, Rhodotus 186
paludosa, Agrocybe 170
paludosa, Mitrula 274
paludosa, Russula 106
palustre, Lyophyllum 57
palustris, Collybia 57
Paneolina 182
panaeolum, Tricholoma 113
Panaeolus 180
Panellus 189
Panther Cap 18
pantherina, Amanita 18
panuoides, Paxillus 142
panuoides, Tapinia 142
Panus 186
parabolica, Mycena 73
paradoxa, Schizopora 237
paradoxus, Irpex 237
parasitica, Asterophora 77
parasitica, Nyctalis 77
parasiticus, Boletus 205
parasiticus, Xerocomus 205
Parasol Mushroom 25
parazurea, Russula 99
Parrot Toadstool 65
Parrot Wax Cap 65
parvula, Volvaria 112
parvula, Volvariella 112
patouillardii, Inocybe 149
Paxillus 142
Paxina 269
pearsoniana, Mycena 73
pearsonii, Cortinarius 130
peckii, Hydnellum 243
peckii, Hydnum 243
pectinatum, Geastrum 254
pedicellatum, Lycoperdon 249
pelianthina, Mycena 72
pellucidipes, Drosophila 175
pellucidipes, Psathyrella 175
penetrans, Flammula 143
penetrans, Gymnopilus 143

Peniophora 241
pennata, Drosophila 174
pennata, Psathyrella 174
Penny Bun 192
Peppery Boletus 194
Peppery Milk-cap 77
percincta, Conocybe 154
perennis, Coltricia 218
perennis, Polystictus 218
Perigord Truffle 276
perlatum, Lycoperdon 249
perlatum var. *nigrescens, Lycoperdon* 249
peronata, Collybia 57
peronatus, Marasmius 57
personatum, Tricholoma 114
petersii, Peziza 269
petiginosa, Inocybe 154
Peziza 269
peziza, Nectria 281
Phaeolus 222
phalloides, Amanita 18
phalloides var. alba, Amanita 18
phalloides, Battarraea 251
Phallus 257
Phellinus 228
Phellodon 244
phillipsii, Galerina 157
phillipsii, Gyromitra 271
Phlebia 238
Phlegmacium (Cortinarius) 123
phoeniceus, Cortinarius 140
pholideus, Cortinarius 132
Pholiota 144
Phylacteria 262
phyllophila, Clitocybe 50
picaceus, Coprinus 178
picipes, Polyporus 218
pilatianus, Agaricus 167
Pine Fire Fungus 269
pinicola, Boletus 194
pinicola, Cortinarius 122
pinicola, Fomitopsis 228
piperatus, Boletus 194
piperatus, Lactarius 77
piperatus, Suillus 194
Piptoporus 227
pisiformis, Nidularia 255
Pisolithus 251
pistillaris, Clavaria 257
pistillaris, Clavariadelphus 257
placomyces, Agaricus 168
platyphylla, Collybia 44
platyphylla, Oudemansiella 44
platyphylla, Tricholomopsis 44
Pleurotellus 186
Pleurotus 182
Plicaria 271
plicatilis, Coprinus 180
plumbea, Bovista 249
plumbeitincta, Conocybe 154
plumbeus, Lactarius 83
Plums and Custard 43
Pluteolus 120
Pluteus 118
Poached Egg Fungus 33
Podoscypha 222
podospileus, Pluteus 118
Podostroma 276
Poison Pie 147
polychroma, Russula 106
polygramma, Mycena 70
polymorpha, Xylaria 278
polymyces, Armillaria 33
Polyporus 218
Polystictus 218, 236
popinalis, Clitocybe 114
popinalis, Rhodocybe 114
populinus, Fomes 231
populinus, Oxyporus 231
Porcelain Fungus 33
Poronia 281
porosporus, Boletus 202
porosporus, Xerocomus 202
porphyrea, Psalliota 160
Porphyrellus 206
porphyria, Amanita 21
porphyrocephalus, Agaricus 160
porphyrophaeum, Entoloma 116
porphyrophaeus, Rhodophyllus 116
porphyropus, Phlegmacium 128
porphyrosporus, Boletus 206
porrigens, Pleurotellus 186